T0366489

THE

PUBLICATIONS

OF THE

Lincoln Record Society

FOUNDED IN THE YEAR

1910

VOLUME 31

FOR THE YEAR ENDING 30TH SEPTEMBER, 1934

Lincolnshire Church Notes

MADE BY

William John Monson

F.S.A.

AFTERWARDS SIXTH LORD MONSON OF BURTON

1828—1840

EDITED BY HIS GRANDSON

JOHN NINTH LORD MONSON

F.S.A.

PRINTED FOR

THE LINCOLN RECORD SOCIETY

BY

THE HEREFORD TIMES LIMITED, HEREFORD

1936

First published 1936
Unaltered reprint 2005, 2013

ISBN 978-0-90150-372-5

Transferred to digital printing

A Lincoln Record Society Publication
Published by The Boydell Press
an imprint of Boydell & Brewer Ltd
PO Box 9, Woodbridge, Suffolk IP12 3DF, UK
and of Boydell & Brewer Inc.
668 Mt. Hope Avenue, Rochester NY 14620, USA
website: www.boydellandbrewer.com

A CIP record for this title is available
from the British Library

This publication is printed on acid-free paper

Printed in Great Britain by
4edge Ltd, Hockley, Essex

PREFACE

More than twenty-five years ago my kinsman, Canon Arthur Roland Maddison, commenced the publication of these CHURCH NOTES in *Lincolnshire Notes & Queries*, but he died before he had finished his task. To have them all printed in book form has long been my desire. My grandfather's love for all things connected with Lincolnshire and Lincolnshire folk was so great that I feel that such a publication will form a fitting memorial to him. I owe the realisation of this wish to the courtesy of the Lincoln Record Society and to the encouragement, advice, and help of my friend, Canon C. W. Foster, Hon. D.Litt. It has been a great privilege for me to have had him as guide, mentor, and untiring collaborator in the production of this volume. Canon Foster's patience and ever helpful kindness have been inexhaustible, so I gladly take this opportunity to pay an affectionate and grateful tribute to him for enabling me to produce the volume and make it fit for the special purpose I have in view.

To the Members of the Record Society I express my thanks for their long-suffering patience during the delay in the appearance of the volume. This delay has been due to my desire to see that, by careful checking and counterchecking, the greatest possible accuracy should be obtained. That the Society should permit these CHURCH NOTES to appear as one of their volumes has been a particular satisfaction to me, for I feel certain that had the Society been in existence during my grandfather's lifetime, he would have been an enthusiastic supporter of it in every way in his power.

To my friend, Mr George Gibbons, M.A., F.S.A., I tender my warm thanks, not only for the immense trouble he has taken in checking the inscriptions in many of the churches, but also for his invaluable assistance in a large part of the heraldry. The efficient treatment of this aspect of the NOTES has called for much specialised knowledge, and I have therefore been very fortunate in securing his co-operation. Without the labour bestowed on

the heraldry the volume would have lacked much of its usefulness and interest. Mr Gibbons has also read the proofs.

The Incumbents of the two hundred and twenty-seven parishes mentioned in the NOTES have almost without exception given me every help in the tedious work of checking the inscriptions. To them I tender my sincere thanks for the interest they have shown in seeing that the inscriptions in their churches are correctly recorded. Amongst the many kind friends who have also rendered efficient help in checking inscriptions, I should like especially to mention Captain W. A. Cragg, M.A., F.S.A., who verified a number of the inscriptions in his neighbourhood. His assistance has been particularly valuable, for he was able to refer to the notes made by his great uncle, Mr John Cragg, in the nineteenth century, whose burial is recorded at page 385.

Amongst others whom I should like especially to thank are, Mrs Rudkin, of Willoughton ; Miss Kathleen Major, B.Litt., Librarian of St Hilda's College, Oxford ; Miss M. Wood, of Sleaford ; Canon Foster's nieces, the Misses Sybil Ingoldby, and Margery, Marion, and Barbara Wilson ; Captain J. W. Hayes, of Spalding ; The Reverend C. A. Norris, rector of North Witham ; and Mr Hugh Paget, of Aswarby.

I also desire to record my sincere thanks to Miss Florence Thurlby, Canon Foster's most efficient private secretary. To her I owe much for the valuable assistance she has given in checking, correcting proofs, and compiling the indexes, as well as in carrying out many of those countless duties which fall to the lot of an Editor. To the Hereford Times Company also I am indebted for the care and patience which they have bestowed upon the work.

MONSON

Burton by Lincoln
 Michaelmas, 1935

CONTENTS

ILLUSTRATIONS

FRONTISPIECE

Portrait of William John Monson, afterwards 6th Baron Monson

MAP IN THE POCKET

Churches contained in the CHURCH NOTES

The Council of THE LINCOLN RECORD SOCIETY wish to make their grateful acknowledgments to Lord Monson, the Society's President, for generously defraying the cost of printing this edition of his Grandfather's CHURCH NOTES.

ABBREVIATIONS

A.L. – – – – – Arthur Staunton Larken (see page xi).

(C) – – – – – Now covered by seats, organs, flooring, etc.

(D) – – – – – Disappeared.

Monson – – – William John Monson, afterwards Sixth Lord Monson

MS i—xii – – – The twelve volumes of MS at Burton Hall, from which the CHURCH NOTES are printed.

(R) – – – Removed to another position.

PRINTED BOOKS

Churches of Holland – *An Account of the Churches in the Division of Holland in the County of Lincoln.* London, 1843.

G. M. – – – – The *Gentleman's Magazine.*

Jeans – – – – *A List of the Existing Sepulchral Brasses in Lincolnshire,* by G. E. Jeans. Horncastle, 1895.

L.R.S. i. – – – The Lincoln Record Society, vol. i, *Lincolnshire Church Notes made by Gervase Holles, A.D. 1634 to A.D. 1642,* ed. R. E. G. Cole. Lincoln, 1911.

Lincs. N. & Q. – – *Lincolnshire Notes & Queries.* Horncastle.

Trollope, *Sleaford* – – *Sleaford, and the Wapentakes of Flaxwell and Aswardhurn,* by the Ven. Edward Trollope, archdeacon of Stow.

INTRODUCTION

William John Monson, afterwards the sixth Lord Monson, the compiler of these CHURCH NOTES (for brevity's sake hereinafter called Monson), was the only child of Colonel the Honourable William Monson, fourth son of John second Lord Monson and his wife Anne, the youngest daughter of John Debonnaire, whose family, of considerable antiquity in France, settled in England after the revocation of the Edict of Nantes. He was born on the 14th May, 1796, at Negapatan, Madras, and spent the greater part of his early childhood in India, where his father served from 1785 to 1806, first in the 52nd Regiment, and subsequently in command of the 76th. Monson's school life began with Mr Roberts at Mitcham in May, 1804. This was a preparatory school, popular with parents whose sons were intended for Eton. Roberts was an unconventional character, and his school methods were undoubtedly peculiar, but the success of his school was not adversely affected by his eccentricities. A good many of Monson's contemporaries there rose to eminence in future life. To give two examples only: Edward Stanley, afterwards Lord Derby, and prime minister, and Edward Bouverie Pusey, later the famous Dr Pusey.[1] Monson in writing the memoirs of his early school life, fifty years later, admits having but a hazy recollection of Stanley, who was his junior, except his striking characteristic—family pride. Nothing seemed to give the little boy greater satisfaction than spouting,

'Charge, Chester, charge, on, Stanley, on.'

Of Edward Pusey and his brother Philip, Monson makes the following remarks in the same memoirs:

'I think Edward was liked better than his brother Philip, he was much smaller, a pretty gentle fellow with a round smiling face. Much as my many contemporaries have altered in later years none so much as he has done. I do not see a vestige in the thoughtful aged face of the great Dr Pusey that recalls the small beaming features of little Edward. Here also I have no recollection of singularly precocious talent, but both the Puseys were forward for their age.'

[1] Edward Stanley was born in 1799, and Pusey in 1800. They were therefore respectively three and four years younger than Monson.

The five years that Monson spent at Mitcham laid the foundations of no small scholarship, so that in going to Eton in May 1809 he took Upper Remove, and passed into the Fifth Form in June of the same year. He was more than half way up the Upper Division in 1812 when he left, after three happy years, notwithstanding Keate's rigid rule.

He went to Christ Church, Oxford, in January, 1814, and took his degree in November, 1816. He began his Oxford Memoirs the last year of his life, but they were never finished. This is to be regretted since they would have formed, with the Mitcham and Eton Memoirs,[1] an interesting trilogy of early nineteenth century school and college life. The more so, since he retained up to his death a vivid recollection of the appearance, character, and peculiarities of the boys and men who were his contemporaries, and with whom he associated in those early days. It is well to emphasise this, for his remarkably tenacious memory played a great part in all his research work, and was of great assistance in his passion for accuracy.

In February, 1817, he was admitted as a student of Lincoln's Inn, just before he began a series of journeys to the Continent, which lasted, with short intermittent periods in England, until 1825. During these journeys he visited the greater part of northern, central, and southern Europe. That these prolonged tours were deliberately planned and carried out with a view to continuing his general education, and that he was not purely ' on pleasure bent ', is very evident from his diaries and letters. These papers show a very observant nature and a strong desire to profit by the opportunities which travel afforded. It is also apparent from various sources that he was soon considered an authority on art, history, and archæology by those with whom he was thrown during his travels.

That from an early age he developed a special taste for genealogy and archæology and other antiquarian subjects is evident, and that his interest therein was serious is proved by the fact that,

[1] Monson's Memoirs of his Mitcham school days were published in *Etoniana* in November, 1925, and those of his life at Eton in the same periodical in November, 1921.

not long before his twenty-second birthday, he was elected a Fellow
of the Society of Antiquaries, an honour vouchsafed to few of his
age even in those days.

In 1828 he married Eliza, daughter of Edmund Larken. The
honeymoon was spent travelling through England ; and ended
with a visit to Lincolnshire to see the various parishes and churches
associated with the Monson family. This resulted in the first
CHURCH NOTES being made. The daily entries in his diary indicate
clearly that Mrs Monson shared wholeheartedly his antiquarian
interests, a happy opening to what was to be a happy married
life.

There can be no doubt that these first CHURCH NOTES were made
with a view to obtaining material for his Family History, but by
the time he had finished these early visitations he realised what
vast sources of information Lincolnshire churches could supply
for the compilation of a County History of a really comprehensive
character. It is certain that, up to the time of his succession to
the title in 1841, the idea of writing such a history so deeply
attracted him that he lost no opportunity of collecting information
on the subject from many different sources. In this he was aided
by a peculiarly retentive memory. For instance, it is related that
after reading a will over a few times, he was able to commit its
substance to writing—a very useful gift in days when the slightest
attempt to make notes of the contents of a will at Doctors' Commons
was at once checked by vigilant officials. The voluminous corre-
spondence and mass of documents that he left, carefully classified,
in the family library bear witness to his ceaseless studies, and the
high esteem in which he was held by his many correspondents on
all matters connected with archæology, heraldry, and antiquarian
subjects. He was fortunate in enlisting the help of his brother-
in-law, Arthur Staunton Larken, who later became Portcullis
Pursuivant of Arms, and afterwards Richmond Herald ; and of
John Ross, a Lincolnshire antiquarian of considerable ability.

Shortly after his succession to the title Monson started on a
three years' tour to the Continent with the whole of his family.
During his travels he wrote at least two volumes of the six large

manuscript tomes of his Family History. This work became of such absorbing interest to him that he eventually abandoned the idea of writing the County History which he was continually pressed by his contemporaries to undertake. It is however clear from Ross's letters to him that he allowed Ross access to all the materials he had collected, and there is at Burton to-day a splendid manuscript history of the City of Lincoln, written in Ross's beautiful hand and illustrated by him with water colour drawings of no mean artistic merit, as well as a great collection of notes and drawings relating to almost all the parishes in Lincolnshire arranged according to the wapentakes.

Monson died on 17th December, 1862, in his sixty-seventh year ; old for his age, judging from present day standards, but still full of enthusiasm for all matters relating to his life's hobby. In consequence of his almost complete deafness in later years, he seemed to be out of touch with ordinary life, though in reality, thanks to his very observant nature, he was very much alive to what was going on around him. His favourite room at Burton was his Library overlooking the cricket ground that he made, well known in those greater days of Lincolnshire cricket, where an England XI once played XXII of the County. Here in this library one can picture him sitting all day, surrounded by his beloved books and papers, answering in his fine handwriting his many correspondents.

His manhood had been passed during the period of strong religious revival, which included a great movement for the restoration and even rebuilding of the ancient churches in England, many of which had fallen into a sad state of disrepair, if not of ruin, in the eighteenth century. It is estimated that some thirty millions sterling were spent in this work, much of it being unwisely spent, as we now realise. Every age however has its period of vandalism and neglect so far as churches and their monuments are concerned. John Weever, referring to their condition in 1631, says,

'And also knowing withall how barbarously within these his Maiesties Dominions, they are (to the shame of our time) broken downe, and utterly almost all ruinated, their brasen Inscriptions erazed, torne away, and pilfered, by which inhumane, deformidable act, the honourable memory of many vertuous and noble persons deceased, is extinguished,

and the true understanding of divers Families in these Realmes (who have descended of these worthy persons aforesaid) is so darkened, as the true course of their inheritance is thereby partly interrupted.'[1]

Monson's CHURCH NOTES were compiled before the nineteenth century spirit of renovation became active in Lincolnshire. Hence their value ; for much of what he records disappeared during the passion for restoration. What he himself thought of this zeal for restoration, and how much he disapproved of it, is shown by the following extract from a letter written by him in 1860 :

'. I want to go to Lincolnshire as early as I can even if I return, for they are pulling down an old Church, a family Church I was going to call it since it has a chapel attached to it that for centuries has been used for our last home, and the incumbent is a violent Utilitarian and wants to destroy a noble screen and probably other dear old relics, which I must endeavour to rescue. I am Protestant to the back bone and if it served religion would be an iconoclast, but it does not, and that is the honest truth. To introduce new fangled paraphernalia and to destroy old memorials to which the honest parishioners attach no improper notions are two very different things.'

And rescue them he certainly did, for what was removed in 1860 was carefully stored by him at Burton, and, in 1914, long after his death, replaced in the church, where his body rests.

Such was the man. It has been thought desirable that the reader of the CHURCH NOTES should be given some idea of the character of their compiler, so that he may the better understand how a work of this kind, unusual even in those days, came to be undertaken. The portrait of Monson, which forms the frontispiece of this work, was painted in his thirtieth year. It is one of several at Burton and has been especially chosen as representing him at the time he began the CHURCH NOTES. The artist, Yellowlees, who according to Bryan was known as the little Raeburn, became popular as a portrait painter both in Edinburgh and London during the first half of the nineteenth century.

The CHURCH NOTES are contained in twelve small volumes with paper-covered boards, measuring $7\frac{1}{4}$ x $4\frac{5}{8}$ inches. They are pre-served in the library at Burton, and consist of copies of monumental inscriptions, to which particulars of coats of arms and extracts from parish registers are added. They deal with two hundred and twenty-seven parishes, the distribution of which is shewn in the

[1] *Ancient Funeral Monuments*, Introduction. London, 1631.

map at the end of this volume. The twelve volumes are evidently
a fair copy of the original notes, which were probably written in
pencil in the several churches, since the days of the fountain pen
had not yet come. Monson's intention was not to print them
as they stand, but rather, as has been stated, to use them as a
body of evidence for the purpose of Lincolnshire history and
genealogy.

Most of the NOTES were made by Monson himself. Sometimes
he was accompanied by Arthur Larken. Occasionally he seems
to have depended upon other people, and this applies especially
to the churches in Holland. The NOTES made by Monson himself
were carefully done, though no doubt they contain mistakes which
are due, sometimes to difficulty in reading the inscriptions, and
sometimes to mere human fallibility. Some of the other NOTES
shew less care. The copying of inscriptions is not so easy a matter
as might be thought ; and many a time when the copyist is making
his fair copy at home, he will wish that he had noticed this or that
detail more closely, and that he could look at the monument again.
The present editor therefore decided to have the NOTES checked
so far as possible, and a manuscript copy of them relating to each
church was sent to the Incumbent of the parish for his perusal
and verification. Then again, when the manuscript had been set
up in type, a proof was submitted to the Incumbent, except in
those instances where it was possible to have the work done by
another competent person. Many of the monuments have dis-
appeared and many inscriptions have become illegible since the
NOTES were made, and a good deal of time has been spent in
checking the statements in these inscriptions by pedigrees, by
parish registers, by the bishops' transcripts of parish registers in
the Diocesan Registry, and by the available printed sources. Some
of the printed sources, however, have proved somewhat unreliable,
as for instance, Jeans' *Sepulchral Brasses*, and *Churches of Holland*,
published by T. N. Morton in 1843, both of which contain many
surprising errors.

The NOTES do not profess always to be *literatim* copies of the
inscriptions. For instance, there are many unimportant variations
from the originals as *e.g.* son *for* sonne, daughter *for* davghter, wife

for wyfe, Jan. *for* January, 1st *for* 1ˢᵗ, 5 *for* 5th, the *for* yᵉ. The
punctuation also of the inscriptions has not always been followed,
and the use of large or small capitals or of Old English characters
has not been strictly observed. These variations have not been
corrected except in specially important inscriptions. With these
exceptions pains have been taken to secure accuracy. It might
sometimes appear that here and there an inscription involved a
physiological improbability or even an impossibility. In such
instances the dates have been checked by entries in parish registers,
or in the bishops' transcripts, or by other evidence. If in this
way the improbability or impossibility has not been resolved, *sic*
has been added after the date which causes the difficulty. Some
instances may be given. At Haugh (page 177) it is stated that a
daughter of the Reverend William Oddie and Martha his wife was
born 4 February, 1766, and that another daughter was born
12 August in the same year. No other evidence is available, and
therefore *sic* has been printed after the latter date. At Horbling
(page 198) it is difficult to reconcile some of the numerous dates
relating to the Tomisman family. Here the difficulty is resolved by
the parish register which shows that there were three successive
generations in which the husband and wife were named William
and Elizabeth. At Stragglethorpe (page 346) an inscription records
that Sir Richard Earle died 25 March, 1667, aged 60, while the next
monument states that another Sir Richard died 13 August, 1697,
aged 24. Is there here, it might be asked, a mistake in the age
of the second Richard ? The pedigree of the Earle family, however,
shows that there were two more Sir Richards, who died in 1678
and 1679 respectively, between the two whose inscriptions are
printed here.

In the printed text, when a monument has been removed to
another position in the church since Monson's day, the fact has
been indicated by R enclosed in round brackets ; when it has
disappeared by D, and when it is probably covered by seats, organ,
etc., by C, similarly bracketed. Additions to the author's NOTES
have been enclosed in heavy square brackets.

It is important to remember that the NOTES do not always
contain all the memorials in a church. In some instances monu-

ments which are visible now may have been hidden a hundred years ago : but it is impossible to account for all the omissions in this way. At Louth, for instance, many important monuments are passed over. The plan, which was originally entertained, of supplying in this edition the inscriptions omitted from the NOTES had to be abandoned, since it would have increased the size of the volume unduly.

In the library at Burton there is a fine copy of Gervase Holles' Lincolnshire Church Notes,[1] with the arms in colours, which was presented to Monson by Archdeacon H. K. Bonney, D.D., in 1853. In these notes, which were made in the years 1634–1642, Holles gives descriptions of some of the older monuments in the churches, and these have generally been omitted from Monson's NOTES ; thus conclusively showing that he purposely did not note features and facts, details of which could be found elsewhere ; and that the NOTES were compiled rather in the nature of an *aide-memoire*.

Monson was an expert in heraldry, a subject which a hundred years ago was part of a polite education more often than it is at the present day. In editing this volume, a large amount of research has been expended on the armorial bearings. The arms have been identified so far as possible, and the names of the families which bore them have been added within square brackets. For this purpose works of reference, which did not exist in Monson's day, have been available, such as Burke's *General Armory*, Papworth and Morant's *Ordinary of British Armorials*, and Fox-Davies' *Armorial Families*. From these sources it has been possible to correct various obvious errors in the NOTES. Where more serious emendations have been made the corrections have been enclosed in square brackets. It has not been, however, always possible to give the names of the families to which the coats belong. This is so because it is sometimes impossible to tell what the arms depicted on a monument really represent, unless they are familiar. For instance, the different kinds of beasts, birds, and fishes cannot always be distinguished, and sometimes a charge may be any one of half a dozen different objects. Or the tinctures or colours may

[1] The original manuscript containing these Notes is Harleian MS. 6829, in the British Museum. It was edited by the late Canon R. E. G. Cole as the first volume of the Lincoln Record Society, in 1911.

not be given, or may perhaps have perished. The difficulty is increased when there are quarterings, for then the arms cannot be blazoned with confidence until it has been ascertained, from an examination of the pedigree of the owner of the principal coat, what arms he was entitled to quarter. In monumental heraldry there occur many instances of arms being assumed, with or without variation from authentic coats, by persons who are not entitled to bear them, seeing that they are neither descended from an ancestor who was entitled to bear those arms, nor have they themselves obtained a grant of arms. In such instances it has seemed advisable to make as few corrections as possible, but rather to let Monson say what he saw.

As regards the memorials and inscriptions themselves, apart from their genealogical and antiquarian interest, the ordinary reader will find some entertainment in perusing them. They vary much according to their date, and frequently throw some light on the condition of life and the mentality of the period to which they belong. At times they are quaint and even comic : thus at Fiskerton (page 123), in 1806, there died George Harrison,

' who, during the short period of a bustling life, endeavoured to bestow the means of happiness on those he knew,'

and at Langtoft (page 221), in 1703, there died William Hyde, who

' labour'd the greatest part of his life with unparalleled chearfullness and courage, under the most exquisite torments of the gout, in hope of a blessed resurrection.'

Crowland supplies several quaint inscriptions, such as the tomb of Mr Abraham Baly (page 101), who was buried in 1704 with two children who died in ' enfantry ' :

' Mans life is like unto a winter's day.
Some brake there fast & so departs away.
Others stay dinner then departs full fed.
The longest age but supps & goes to bed.'

This verse is repeated with some verbal changes at Holbeach (page 192).

At Long Sutton (page 357) a stone records :

' Here lyeth the body of John Bailey, surgeon, who was murdered in the Spring of 1794. Alas poor Bailey and Rebekah his wife.'

There also (page 358) is another small stone :

' In memory of Walter Johnstone gent. and drover from Dumfries in Scotland ; he was a good companion, a faithful friend, and a fair dealer. He died November ye 21, 1747, aged 51.'

At Belton in the Isle (page 39) it is said of Jane Penelope Steer, who died in 1826, at the age of twelve :

> ' Her course was gentle as the newborn babe
> Her mind more noble than the towering wave
> Her heart was wrap'd within a charming frame
> It burst ! ! she died ! ! but spotless was her name.'

At Lutton (pages 256–7) is found :

> ' Thy busy and inquisitive eye
> Seems to demand what here doth lye
> If that I must disclose my trust
> Tis great lemented prudent dust
> If yet unsatisfyed thou'lt know
> And eurg me further read below
> Here lyeth the body of Mr Ruben
> Parke of Lutton who deceased the
> 10 of July 1659, in the 63 yeare
> Of his age.
> Hence Quarrell Nature tell she shall
> Repeate her clymactericall.'

At Claxby by Normanby (pages 87–8) an inscription to William FitzWilliams, who died in 1634, contains the quaint exhortation :

> Weepe, poore men, weepe here our mortality
> Laied a Maister in Hospitality.
> How he was religious, faithfull, constant,
> Twenty seauen Qvietus est's demonstrant.
> From wordly troubles he nere found true rest,
> Untill from God he had Quietus est.

Quietus est, i.e. ' he is quit ', a formula, which appears as early as the reign of Henry I in the rolls of the Exchequer, signifies that a debtor has discharged his debt. The liabilities which FitzWilliams discharged were, no doubt, the debts of poor persons.

The memorial tablets to the women record virtues so many and charms so great that space does not admit of extensive quotations, but the tribute to Elinor Ball in Holbeach church (page 190), in 1718, may be cited :

> ' Say marble or at least weep out the praise
> Of the deceased fairer her character
> Than thy smooth polish. Pen of steel can nere
> Her vertues write nor poets loftiest layes.
> Pure as thy spotless gloss her love will shine
> Both conjugal and filial and adorn

Thy monumental trophy. Never urn
Held mortal ashes truly more divine.
In her no place could envious censure find
Her generous birth nere to ambition fired
The beauties of her person but conspired
To enhance the charming beauties of her mind.
Innocent as the babe that caused her death.
Her charity diffusive as the sun
And active equally. Tread lightly on
Her grave for such was she lyes underneath.'

Long Sutton supplies two remarkable illustrations of large families, namely, Mary wife of Nicholas Wileman (page 355),
' who died in childbed November the 30, 1740, in the 40 year of her age, after bearing him twenty two children, of whom eighteen all died very young.'

And (page 359) :
' Elizabeth the wife of John Sowter who departed this life May 26, 1701, in the 28 year of her age, who had 9 children, sons and daughters, and 6 of them lye very near her in this alley.'

But Lincoln Cathedral supplies, on the monument of a former Dean of Lincoln, what is probably the most remarkable record of this kind (page 245) :
' Here lyeth the body of Michael Honywood, D.D., who was grandchild and one of the 367 persons that Mary the wife of Robert Honywood, esq., did see before she dyed lawfvlly descended from her that is 16 of her owne body 114 grandchildren 228 of the third generation and 9 of the fovrth.'

At Goxhill (page 150) there is the following charming inscription to Mary Ann Pearson, who died in 1800, aged 15 years :
' How happy is the child of grace
Who knows her sins forgiven
This earth she cries is not my place
I'd rather go to Heaven.'

An inscription which will be of interest to many in New England is found at Walcot by Folkingham to the memory of John Quincey, junior, who died in 1773 (page 397) :
' Think nothing strange
Death happeneth to all
My Lot's to day
Tomorrow thine may fall.'

In fact the CHURCH NOTES reveal many links existing between Lincolnshire and New England, for the index contains such other well-known names as : Bellingham, Bradford, Grant, Lee, Mather, Pelham, Pell, Shaw, Standish, Whiting.

Monson, when compiling his NOTES, did not confine himself to the memorials of members of the county families, but included all and sundry, much to the advantage of the genealogist. For in Lincolnshire, after the convulsions caused by the Wars of the Roses, the Suppression of the Monasteries, and finally the Civil War, many of the old families sold or lost their properties, or even themselves disappeared, being superseded by prosperous yeomen and merchants. The NOTES consequently provide, in a handy form, interesting evidence of the gradual fall of the old order and rise of the new, over a long period of years. This is sad reading in some cases, but at least the NOTES bring back to living memory some of the great names of the past, otherwise long since forgotten and now only living, as Lord Chief Justice Crewe eloquently said, 'in the urns and sepulchres of mortality'.

Aisthorpe

Notes taken in the church of Aistrope, 16 August, 1835—
This is a modern plaster building consisting of a nave, chancel, and tower at the west end. The east window is a single lancet one.

A white marble tablet against the east wall south of the altar (R) :

> To the memory of | the Rev^d Timothy Mangles A.M. | late rector of this parish | who departed this life October 5, 1803 | aged 33. | He was a tender husband | a kind father | a zealous minister of the Gospel | and in all the relations of life | displayed the endearing qualities | of a good heart | and a truly christian disposition.

A lozenge shaped tablet against the north wall (R) :

> In the aisle | opposite this stone | lie the remains of | Elizabeth the infant daughter | of John & Frances Milnes | born Aug. 21, 1828 | died Jan^y 5, 1829.

On a black tablet against the east wall of the chancel north of the altar, of marble (R) :

> In memory | of George Roberts gent. | who died July 1st, 1760 | in the 53 year of his age. | His disconsolate widow | erected this monument intending it | for him and herself.

A white marble lozenge against the north wall of the chancel (D) :

> Five feet | south of this stone | lie the remains of | Anne Townsend | born 3 June 1789, wedded 25 Feb. 1818, | and died August 16, 1820 | Daughter of John Milnes Esq. of this parish | wife | of the Rev^d Thomas Townsend the rector | to whom | by her affection for him | and by her devotion to her | Saviour's precepts | she gave | a fortaste of | future blessedness.

[Sunk into the pavement in front of the altar are two small brass crosses, with the inscriptions :

> Anne Townsend aged xxxi, fell asleep August 10, 1820.
> Thomas Townsend, Rector, aged lxxxv, fell asleep July 15, 1833.]

A flat stone in the chancel (D) :

> Here lieth Charles Stafford Mather | who died August 14, 1773, aged 5 years.

[The church was entirely rebuilt in 1868.]

(MS vii, 179–181.)

A

Alford

Notes taken in the church, 19 August, 1835—

A very handsome monument south of the chancel: on an altar tomb lie the figures of a knight and his lady in the costume of the middle of the 17th century. He in cuirass and cuisses, large boots, bands, and flowing hair. She with a hood and long tresses. Above them against the wall on a black slab is an inscription in gold letters which has been restored, but not well:

> Here lyeth the body of Sr | Robert Christopher knt, who | finished this life on the 16 day | of February 1668, in the 63 | yeare of his age, and of Dame | Elizabeth his wife who dyed | on the 21 day of November | 1667, in the 50 year of | her age. | They had issue Elizabeth their | onely child, now wife of the | Right Honble Bennett Lord | Sherard of Stapleford in the | county of Leicester.

A parallel black marble slab has been left blank on the east side. These arms above—Argent, a chevron gules between 3 torteauxes [Sherard] ; impaling—Argent, a chevron between 3 pineapples gules [Christopher] ; on a chief sable a crescent or. Crest— A peacock's tail erect, issuing from a coronet gules. At the west end of the altar tomb is the above impalement alone with the crest—An arm couped above the wrist, holding a pineapple [Christopher]. Since the arms above the monument are those of Sherard impaling those of Christopher, it is not unlikely after all that the monument was that of Lord Sherard and his wife.

On the opposite north wall of the chancel (R) is a stone tablet with the bust above of a female in the costume of the 17th century with necklace round her neck. The monument is surmounted by a coronet and these arms at the bottom of it, viz., 3 coats, apparently a husband impaling 2 wives, one on each side. The centre is— Gules, a saltier argent [Nevile] ; the dexter—2 bars or, a chief ermine [for Hardinge] ; the sinister—Argent, a saltier engrailed gules. The inscription has been painted over so much that very little of it is now legible, what can be decyphered is:

> Near to this | place lyeth the | body of Eliz.[1] the | daur (the rest illegible).

In the chancel (R) a white and grey monument with an urn over it:

> In memory of | Samuel Duckering | who was lay rector of this parish | 39 years | and departed this life | the 9 day of March, 1800, in the 55 | year of his age.

On a flat stone within the altar rails (D):

> Thos Hamson [*rectius* Harrison] | gent. departed this | life July 12, 1722.

On a black stone next to it (R):
> In | memory of | Rev. Abraham Walker | vicar of Alford |
> who died the 27 day of August | 1777 | in the 62 year of
> his age.

On a stone in the chancel at the entrance (D):
> In | memory of | Will. Field gent. | ob. Dec. 5, 1791 | ætat. 55.

On a stone in the chancel (D):
> In|memory of | John Baldock | who departed this life | the
> 23 of Feb. 1778 | aged 81.

On an old stone just under the screen is carved the figure of
a priest under a Gothic arch, with this round the verge in church
text:
> [Hic] iacet dominus Ricardus de Walton [*rectius* Watton]
> quondam vicarius istius ecclesie qui obiit an' d'ni MCCC
> cui*us* a*nime* propicietur deus.

On a black stone in centre aisle:
> Thomas Wayet gent. | died 12 April 1796 | aged 73 years. |
> Ann his wife | died 7 August 1785 | aged 71 years. | Edmund
> Wayet | died 15 May 1804 | aged 55 years.

Next to the last to the west has been an old stone with 4 shields
at the corners cut but now almost obliterated—the first to the
east has been quarterly of 4. The second is—Ermine a buck's
head cabossed [? Parker]; the two to the west are defaced. There
have been 3 inscriptions but now illegible: on one apparently are
these letters CLL YL.

On nearly the next stone have been brasses of two figures
kneeling and an inscription now gone.

On a black stone between the two last:
> Here lies the body of | Mr Thos Williamson | inter'd 31
> March 1766, | æt. 74. | Also | Mary his widow | inter'd 29 June
> 1778, æt. 86.

On a stone to the west:
> In memory of Mr | Thomas North | of Wainfleet All Saints |
> who departed this life | February the 28, 1731, | in the 60
> year of his age.

On a brass plate in the cross passage of the nave (R):
> Here and nigh unto this | place lieth the body of | Mr Will^m
> Key who died May | y^e 7, 1753, aged 61. Also Mrs | Eliz^th
> Key his wife who di | ed Dec 20, 1761, aged 67. | Also Mr
> Thos Key son of | the above Will. and Eliz. | Key who died
> Feb. 27, 1764, | aged 47. Also Mary Key | daughter of Tho^s
> and | Dorothy Key who died | May y^e 30, 1765, aged 2
> years.

On a white marble tablet in the north aisle :
> To the memory | of Thomas Williamson gent. | who died on the 28 day of March 1766, | in the 74 year of his age. | This monument is erected by his widow. | She died on the 26 day of June 1778, | in the 86 year | of her age.

On another to the west of the last :
> In memory of | Emman : Dewsnop clerk | who was vicar of this church 48 years | and departed this life April y^e 11, 1753, | aged 87 years. | Also of | Mercy his wife who died May y^e 17, 1747, | aged 79 years. | They had seven children two of which viz. | John & Mercy lie interred with them | near this place and the only surviving ones | Charles Joshua and Martha | out of a due regard to their memory | have erected this monument. | Blessed are the dead who die in the Lord | For they rest from their labours.
>
> Rev. 14, 13 Verse.

On another more to the west :
> Near | unto this place | lieth amongst her | ancestors the body of | Elizabeth Lake | who departed this life | May the 19, 1752, | aged 21 years & 5 months. | Preserve me O God for in thee have I | put my trust. Psalm xvi & verse y^e 1st. | Also | Ann Lake | sister to the above Elizabeth Lake | who dyed the 9th of May 1794, | aged 71 years & 10 months. |
> Lord have mercy upon us $\Big\}$ Litany.
> Christ have mercy upon us

On a tablet next against the south wall above the letters Alpha and Omega and XP (for Christ) ; the inscription in capitals :
> Sacred | to the memory of | Richard Harby Esquire | who died on the 1 day of July 1822, | in the 60th year of his age. | Also | of Matilda his wife | who died on the 18 day of July 1812, | aged 62.

On a small brass plate in the cross passage of the nave (D) :
> J A² | born at Addlethorpe | in 1721, | died at Alford | in 1789.

A tablet against the south wall commemorates that Mrs Mary Wayett of Stamford gave by will dated 5th Oct. 1831 to the Minister and Churchwardens of Alford £200 to be laid out for the poor, and the interest to be given to them on St Paul's day.

The church consists of a nave and 2 aisles divided from it by 4 pointed arches, supported on lofty octagonal columns with capitals worked in foliage. The chancel is separated by a lofty pointed arch, the head of which has been walled up. There is a carved screen of 5 arches, and the chancel windows are decorated with a few fragments of painted glass, one of which seems to be a chevron gules. The pulpit is carved in oak in the style of the

17th century. The font is modern. There is a large south porch with a room over it, and the tower is at the west end faced with brick and contains five bells. Outside the north east corner where the chancel abuts on the nave and north aisle are the remains of three steps seeming to be part of the steps to the rood loft, and the appearance of a door blocked up with new brick work.

[See also *Lincs. N. & Q.* xi, 37–41 ; Dudding, *History of . . . Alford,* pp. 104–109.]

(MS viii, 119–128.)

NOTES

[1] Probably Elizabeth daughter of George Nevile of Ragnall, co. Nottingham, who married, first, William Hardinge of Foss, and, secondly, John Hopkinson of Lincoln's Inn, and was buried at Alford 13 November, 1636. [2] The initials are those of John Andrews.

Algarkirk

Notes taken in the church, 4 August, 1834—

In the recess of the window north of the altar is a large marble urn surmounted with the crest of a griffin issuing from a ducal coronet. The pedestal is of grey marble bearing this inscription on a white slab :

M. S. | Caroli Beridge LL.D. | hujus Ecclesiæ Rectoris | qui obiit die 12 Junii|

Anno $\left\{ \begin{array}{l} \text{Domini MDCCLXXXII.} \\ \text{Ætatis LXXI.} \end{array} \right.$

To the west of this is a handsome pyramidal monument of marble with these arms below—Argent, a saltier engrailed between 4 escallops sable [Beridge] ; impaling—Paly of 8 azure and argent, on a chief gules 3 talbots' heads erazed or [Marsh]. Crest—A griffin's head erazed sable, issuing from a ducal coronet or :

Near this monument lie the remains | of the Rev. Basil Beridge, rector | and patron of this church, who died | the 2ᵈ of Nov. 1678, aged 65 years, | Goodeth the relict of Basil Beridge, | who died the 25 of Nov. 1681, | The Rev. Basil Beridge M.A., who died | the 28 of Decʳ 1686, aged 25 years, | Ann the daughter of Charles and Barbery Beridge, | who died the 27 of April 1693, aged 4 years, | The Rev. Charles Beridge, rector and patron | of this church, who died the 2ᵈ of Dec. 1693, aged 35, | Revᵈ. Basil Beridge, rector and patron of this | church, who died the 13 of Octʳ 1739, | aged 53 years, | Charles Williamson, son of Charles and Lettice Beridge, | who died the 7 of Octʳ 1744, in his infancy, | The Revᵈ John Beridge, vicar of Worthington in Essex, son of Basil Beridge, | who died the 18 of Octʳ. 1744, aged 32 years, | Mary the relict of Basil Beridge, | who died the 10 of Jan. 1752, aged 65

years, | Basil Beridge late of Pinchbeck, esq., | who died the 27 of Feb. 1752, aged 44 years, | Lettice the wife of the Rev^d Charles Beridge LL.D., | who died the 6th of Nov. 1778, | aged 63 years.

To the west of the last is a grey and white marble monument with these arms over, Beridge impaling—Sable, 2 bars argent ; on a canton of the last a stag tripping of the field [Buckston]. The crest of Beridge :

> To the memory of | John Beridge M.B. | late of Derby | [son of the Rev^d John Beridge] | who died Oct. 17, 1788, | in the 45 year of his age, | after a lingering illness | which he supported | with religious fortitude and resignation, | This marble was erected | by his afflicted widow | Martha daughter of George Buckston | of Bradbourn in the county of Derby esq.
>
> These hallowed stones an English heart infold,
> Warm tender steady simple just and bold.
> A Christian who observed his Saviour's law,
> To man with charity to God with awe.
> This tribute Beridge to thy tomb is due
> Pure as thy virtues as thy friendship true.
>
> <div align="right">William Hayley.</div>

To the west is an oval grey tablet with the arms of Beridge and this inscription in capitals :

> Leonardus Beridge S.T.P. | Vicarius de Sutterton | obiit 1^{mo} April 1791, | Ætat. 53.

Still more to the west is a sarcophagus of white marble with Beridge, impaling—Ermine, on a bend gules a sword proper, pommelled or, a chief azure [Gladwin]. On an inescucheon—Argent, 2 chevrons between 3 mullets azure [for Tanfield]. Above the sarcophagus is an obelisk adorned with an urn and bearing this inscription :

> Sacred | to the memory of | the Rev^d Basil Bury Beridge, | patron & rector | of Algarkirk cum Fosdyke, | and | Prebendary of Sleaford | in the church of Lincoln, | who | died Feb. 23, 1808, | aged 71 years.

On the sarcophagus in continuation :

> Also of his first wife Dorothy Beridge, | daughter of Henry Gladwin, esq., of Stubbing in the county of Derby, | who died June 4, 1792, aged 58 years. Also of Frances Beridge his second daughter, | who died October 10, 1808, aged 13 years, | and whose remains are interred in the church of Abbots Leigh | in the county of Somerset. | This monument in testimony of her affection | & respect for their memories | is erected by his widow Dorothy Beridge, | daughter of John Tanfield, esq., | of Carthorp in the county of York.

[Inscription on brass in the south transept :
Here lies buried Basil Beridge, of this Church, alike Rector
and Patron, and one of the Clergy of Convocation or the
Assembly Ecclesiastic, who married Goodethea, daughter of
Thomas Brook, Knight, by whom he had two children, to
wit, Basil and Anna ; they however died in childhood and
are buried near this spot as is also the aforenamed Thomas
Brook. The aforenamed Basil Beridge was Rector of this
Church for 42 years, full of zeal for his flock, for his loyalty
to the King and the Anglican Church long time sore afflicted
by the Rebels, of a devotion and piety unfeigned, highly
esteemed by his fellows, kindly to his household, and to
all men of discernment acceptable. Alas ! he died on the
2nd day of November, in the 65th year of his age, 1678.
Go, traveller, and follow in his steps.
To the memory of this devout and learned man, Charles
Beridge, his adopted heir and successor in this Church raised
this monument.
His successors pray that (if so may be), their bones may
rest undisturbed until the Resurrection Day.]

[See also *L.R.S.* i, 167–8 ; *Churches of Holland ;* Jeans,
pp. 1–2, Supp., 1–2.]

(MS v, 161–165.)

𝕬𝖑𝖛𝖎𝖓𝖌𝖍𝖆𝖒

Notes taken in the church, 24 August, 1835—

Outside the church on the south side, within rails, on a flat stone :
Here lieth the body | of Humphry Maddison | late of Alving-
ham Abbey, | gentleman, deceased, | third sonn of Sr Ralph |
Maddison of Fonnaby | in the county | of Lincoln, knight, |
who departed this | life January the | nineteenth 1671, |
aged 70 yeares. | Also Nathl son of the above | Humphry,
who dyed Oct. 1709. | Also Nathl grandson of the | above
Nathl, he dyed April | the 25, 1737, in the 26 year | of his age.

On an altar tomb, close by, within the same rails :
In memory of | Sarah Maddison | wife of John Maddison, |
Esq., of Gainsborough, and | daughter of William Pur | ver,
Esq., of Hull, de- | parted this life May ye 7, 1767, | aged 39
years. | She was a most dutiful daughter, tender & | affec-
tionate wife, a sincere friend, charitable | to the poor, beloved
by all who well knew her | when living, and lamented by
all when dead. | Here lieth the body of the | above named
John Maddison, Esq., | who died July ye 5, 1785, aged 66
years. | And also of Elizabeth Maddison | relict of the above
John Maddison, Esq., | she dyed July 15, 1801, aged 55 years. |
Also Mary daughter of the above named | John & Elizabeth
Maddison. | She died January the 9, 1802, aged 22 years.

In the church on a neat grey and white marble monument surmounted by an urn against the north wall of the chancel :

> In the blessed hope of a joyful Resurrection are | deposited on the north side of this church yard the earthly remains of | John Emeris B.D. and those of his infant daughter. | He was rector of Stoughton Parva, Bedfordshire, | Perpetual curate of Alvingham and Cockerington, | and many years fellow of C.C. College, Oxford. | In him | his parishioners lost a faithful minister, | his acquaintance a benevolent and steady friend, | his wife and children a kind and affectionate | husband and parent.

On a flat stone in the nave :

> In memory of John Mad | dison late of Alvingham | Abbey, gent., who departed | this life Dec[r] 25, 1749, | in y[e] 63 year of his age.

This church consists of a nave and chancel with a tower at the west end. It is kept in a very good state, having been rebuilt[1] in 1806. The font is octagon and plain. On an old stone over the south door are these arms painted—Or, a fesse between 2 chevrons sable [Walpole]. On a hatchment these arms—Argent, 2 battle axes in saltier sable [Maddison] ; impaling—Argent, a pale sable charged with a sword in pale proper [Nelthorpe]. Crest— an armed arm grasping a battle axe [Maddison].

[See also *Lincs. N. & Q.* x, 145–6 ; *G. M.* 1867, part ii, 81.]
(MS vi, 103–106.)

NOTE

[1] It would be more accurate to say that the church was restored.

Aslackby

Notes taken in the church, 29 July, 1833—

On a flat stone in the chancel within the altar rails (D) :

> Here lieth the body of | the Rev[d] Mr Thomas Raven, | vicar of this parish, who | departed this life March | the 23, 1720, aged 52 years.

On a stone next to the last (D) :

> Here lieth the body of | Mary Raven, wife of the | said Rev[d] Mr Raven | who departed this life | August the 9, 1726 | aged 60 years.

On another stone within the altar rails (D) :

> Here lieth the body of | the Rev[d] Charles Hyett | Master of Arts | late of Oriel College Oxford | & curate of this parish | who dyed on the 5 day of July | 1759 | in the 39 year of his age.

On another stone (D) :
> Here lyeth the body of | ye Revd Mr Charles Bywater | rector of this church | who departed this life | November ye 9, 1751, | aged 55.

On a brass plate also in the floor within the altar rails (D) :
> Martha Barwis | aged 8 years | 1822. | Of such is the kingdom | of God.

On another brass plate near the last :
> Sacred | to the memory of | the Revd Joseph Barwis, | 30 years vicar of this parish, | who departed this life | April 3, 1828, | aged 65 years.

On a stone before the altar rails in the chancel (D) :
> Here lyeth the body of | Mary the wife of William | Garland, gent., who | departed this life April | ye 2nd Ao Dom. 1738 | in the 66th year of her age. | Here lies ye body of | Mary Garland daughter | of William and Mary | Garland, gent. | She departed this life | August ye 20, 1758, | aged 51.

On another stone in the chancel (D) :
> Here | lieth the body of | William Garland gent. | who died September 6, 1725, | in the 63rd year of his age. | Also of | Anne Garland | youngest daughter of the above | William Garland, | who died December 17, 1786, | aged 71 years.

On a flat stone in the chancel there is an inscription but so much worn as to be illegible ; the word ' die ' can be traced ; the inscription was round the edge.

On another flat stone (D) :
> Hic jacet Robertus | Garland junior | qui obiit die Martis | quarto die Octobris | apud Sleeford | Anno Domini | 1664 ætat. 5 ann.

On a black stone in the nave :
> In memory of | Mary Quincy, | one of the daughters | and coheiresses of | John Quincy, | died 6 January 1780, aged 88.

On a white and black marble tablet against the south wall :
> In the earth beneath this tablet | rest the remains of | Samuel Newzam | who died 11 of February 1826, aged 88 years. | Also of Ann the wife of | Samuel Newzam | who died 1st of February 1799, aged 62 years. | Also of John the son of | Samuel and Ann Newzam | who died 20th of April 1788, aged 20 years. | Likewise of Henry the son of | Samuel and Ann Newzam | who died 21 of January 1802, aged 31 years. | Mortals be wise, remember judgment and prepare to die.

Another tablet more to the west with white marble slab :
> Near this place | are deposited the remains | of Thomas Green | who departed this life May 11, 1793, | aged 49 years. |

Also Susannah his wife | who died Feb. 16, 1801, | aged 52 years. | To whose sacred memory | this monument is erected.

On a flat stone below is the same inscription.

Another to the west, with urn above inscribed ' Tempus fugit ' :
Sacred to the memory of | Samuel Darby | who departed this life | March the 28, 1819, | aged 54 years. | Seek not to learn who underneath doth lie. | Learn something more important, learn to die.

On a circular tablet against a pillar south of the nave (R) :
In memory of | Colby Graves | who departed this life | June the 24, 1799, | aged 17 years. | Near this place also | lie the remains of | Grace Graves | mother of the above | who died May 14, 1824, | aged 75 years.

Another tablet against a pillar on the north side of the nave (R) :
Sacred | to the memory | of | Colby Graves | who died May 3, 1791, | aged 41 years. | Life how short | Eternity | how long.

A flat stone in the nave (D) :
Here lieth the | body of Robert Graves. | He departed this life | the 25th of May 1765, | aged 67 years.

Another more to the east (D) :
Here lieth the body of | Margaret the wife of | Robert Graves who | departed this life | May y^e 18, 1732, | aged 35. | By her side lie two of | their children Robert and | Ann, died infants. | Here lyeth the body of | Mary the wife of Robert Graves who | departed this life | Decem. y^e 14, 1752, aged 47. | Here lieth the body of | Mary the daughter of | Robert and Margaret | Graves who departed | this life July y^e 22^d, 1754, | aged 23.

[On the nave floor :
Mary the wife of Robert Graves died Dec. 14th, 1752, aged 23. Here lyeth the body of Mary the daughter of Robert and Mary Graves who departed this life July 22nd, 1754, aged 23. (From John Cragg's notes, 1793.)]

This church consists of a nave and 2 aisles supported upon 3 pointed arches rising from tall clustered columns ; a chancel, and a pinnacled tower at the west end. The font is octagonal, panelled with shields and quatrefoils alternately. The battlements of the south aisle are curious, somewhat in the Saracenic style.

[See also *L.R.S.* i, 219–20.]

(MS ii, 231–240.)

Aswardby

Notes taken in the church, 14 August, 1835—This church is no better than a barn. It is built of stone and tiled, with a wooden turret for a bell at the west end. There is no division into aisles

or chancel. We could not procure the key but as we had a perfect view of the church through the windows we discovered that it contained no monumental memorial whatever.

[See also *Lincs. N. & Q.* xi, 41, *L.R.S.* i, 210–11, where some inscriptions are given. It is unlikely that W. J. Monson could obtain a complete view under the disadvantageous circumstances which he mentions.]

(MS viii, 165.)

Aubourn

Notes taken in the church of Auborne, 10 August, 1833—

On a flat black stone within the communion rails with these arms above, 1st shield—Quarterly, 1st and 4th, [Gules], a saltier ermine [Nevile]; 2nd and 3rd, [Or] fretty [gules], on a canton [per pale ermine and or] a galley [sable] [Nevile of Bulmer]; 2nd shield— [Sable], 6 escallops or, 3, 2, and 1 or (Estoft); 3rd shield—Ermine, on a fess [gules], 3 escallops [or] [Ingram]—part is broken off:

Here lyes the body of | Sir Christopher Nevile, kt, | who married first | Katharine the daughter | of Thomas Estoft of | Estoft, Esq. She dyed in | the year 1668 & lyes | very neare | is Katharine | [daught]er of Sir Arthur | Ingrame of Temple Nusome | now survivinge, but dyed | without children the 18 | day of November An' Dom' | 1692.

On a black stone next to the south:

Here lyeth y⁰ body | of Catharine Dame Nevile only | daughter of Arthur Ingrame, Bart., | of Temple Newsam in Com. Ebor. | by his last wife, second wife | and relict of Sʳ Christopher | Nevile, knight, of Aubour. None | can well describe with justice | the meekness manners piety | and charity she was so eminently | indowed with. | She departed this life | April y⁰ 4, 1715, an ornament | to her own and an honour | to the family she married | into. | Pity it is so mean a stone | should cover such high virtue.

On a black [stone] next, still more to the south:

Here lyeth the body of | Bryan Nevile, Esq., only son of George | Nevile, Esq., of Thorney by Sarah Copley his | last wife relict of John Copley, Esq., and | daughter of Bryan Cooke, Esq., of Wheatley | in Com. Ebor., near his beloved wife, whose | fondness to her when alive, tenderness | to his children, charity to his neighbours, | & piety to God must ever recommend him | as the best of Xtians. He deceased March | 25, 1725, ætat. 74. His 4 surviving chil | dren out of y⁰ duty and respect they owe him | join in this only acknowledgement left to | the memory of so worthy a father.

[Next stone :
 Elizabeth Nevile, | Nov. 30, 1745.
 Christopher Nevile, | Jan. 14, 1772 | aged 60.]

A black stone to the extreme south within the altar rails. Arms above—[Gules], a saltier ermine [Nevile] ; in an escucheon [Or], on a cross [sable], 5 crescents [argent] [Ellis] :

Here lyeth the body of Martha eldest daugr | & co-heir of Tho. Ellis, Esq., & of Jane his wife, | eldest sister & co-heir of Sir Chris. Nevile, knt. | By her husband Brian, a younger son of | Geo. Nevile of Thorney, Esq., she had a | numerous issue & continuing long in a broken | state of health made her request to him | when ere it should please God to put an end | to her being in this world to lye in her Dr | grandmother's grave under whose strict | example of piety she had had her first | impressions, wch hapning ye 30 of March 1710, | in ye 58 yr of her age, her grandmother having | paid ye same debt to nature ye 11 of Sepr 1683, | after a separation of near 27 years, their | bodys have here met again to mingle in | till at ye sound of ye last trump | they shall appear glorifyed in ye presence | of ye Lamb to joyn together in hallelujahs | to him to all Eternity.

A white marble tablet against the north wall of the chancel (R) :

Near this repose the ashes of | Eliza Jane daughter | of Lieut. Genl George Robert Ainslie | and Sophia Charlotte his wife. | At the age of nineteen her gentle spirit | passed to its Creator | August 3, 1825.

An achievement of Gules, a saltier ermine [Nevile] ; impaling —Sable, 3 lions passant in bend between 2 double cottises argent [Browne] ; Crest—A bull's head guardant argent, issuing from a ducal coronet or ; motto—Ne Vile [Nevile].

2d Atchievement of the arms of Nevile, impaling—Nevile of Bulmer ; crest and motto the same.

In a recess in the north wall of the church are the fragments of a monument which seem once to have been in this place. An alabaster figure of a man kneeling, in armour, bareheaded, with a ruff round his neck, his legs broken off ; in which are also preserved a shield of arms—Gules, a fesse between 3 water bougets ermine [Meres]. On a black marble slab this inscription in capitals :

In memoriam | Antonii Meres Armigeri Belli Ducis præstantissimi Medicis | Optimi Theologique Celeberrimi Alumnus ejus Proneposque | Maternus Henricus Sterrell posuit. | Filios habuit Johannem Kenelmum Josephum et | filias Gartrudam Janam Mariam Katherinam et Annam. | Obiit undecimo die Martii Anno D'ni 1587, etatis suæ 76.

A very handsome white marble monument against the east wall north of the altar, flanked by 2 Corinthian pillars, surmounted

by an urn. The arms below—Quarterly, 1st and 4th, Nevile;
2nd and 3rd, Nevile of Bulmer :

Christopherus Nevile, Eques auratus, ex | antiqua familia de
Grove de Rabi | Hic situs est. | Resurgant etiam in hunc
lapidem nomina trium | parentum in oblivione quadam hic
prope jacentium | Georgii Avi sui qui obiit An' Dom' MDCLII |
Jervasii Patris Equitis Aurati qui anno proximo | Maxima
virtutis Fama ipsum insecutus est | Chatharinæ et matris
suæ filiæ Rich. Hutton Mil. | Unius quondam justiciariorum
de Communi Banco | Quæ post obitum Jervasii Triginta
fere annis | Vitam viduæ egit eximia Pietate. | Ex tali
eminenti stirpe ortus est Christopherus | Fructusque edidit
Genuinos | Nobis enim reliquit Memoriam finitæ Vitæ |
Justitia Hospitio Beneficiis illustrissimæ. | Jaceat corpus
suum silenti inhumatum Orco. | Ipsa ubique loquetur et
tradet nomen suum posteris | fama meliori quam possunt
hæ literæ marmoreæ | ipsis etiam et magis durabili. | Sese
dedit lubenter morti et efflavit spiritum suum | Decimo
octavo die Novembris |

Anno $\left\{\begin{array}{l}\text{Ætatis suæ LXI} \\ \text{Humanæ salutis} \\ \qquad\text{MDCXCII}\end{array}\right.$

On a handsome marble monument against the north wall of
the chancel with a medallion bust in profile of a Lady and these
arms over—Quarterly, 1st, Nevile ; 2nd, Nevile of Bulmer ; 3rd,
Argent, a chevron between 3 cross crosslets gules ; 4th, Argent, on
a plain cross sable 5 crescents or [Ellis] ; on an inescocheon—Azure,
a pheon argent, and a border of the last [charged with 8 torteaux—
Sharpe]. This inscription on a slab below the bust :

To the memory of Elizabeth Neville daughter of | George
Sharpe Esq., of Barmby, in Nottinghamshire, | and wife of
Christopher Neville, Esq., | of Wellingore in Lincolnshire. |
She died the 21 day of November | in the year of our Lord
1745, | aged 30 years.

In the chancel are flat stones to the memory of :

William Lambe died May 25, 1801, aged 63.
William Lambe died 9 April 1826, aged 56.
Sarah his wife died Dec. 26, 1829, aged 56.
William son of W^m & Sarah Lambe born March 29, 1796,
 died May 10, 1798.
John & George Lambe sons of the same died infants.
Mary wife of W^m Lambe died Sept. 2^d, 1822, aged 34.
Mary their infant daughter.
Rachel Mawer Lambe infant daughter of W^m & Rachel Lambe,
 born 4 August, & died 4 November, 1827. Also William
 died an infant.

Sarah wife of Robert Robinson died March 14, 1807, aged 69.
[Thomas Lamb died July 13, 1813, aged 67.
Also Ann daughter of Thomas & Elizabeth Lamb died Dec.
12, 1815, aged 21.
Robert Lamb, senior, died Dec. 26, 1810, aged 75.]

[South side of sanctuary a white marble slab surmounted by an urn on black foundation :
Sacred to the memory of Lady Sophia Nevile, wife of Christopher Nevile, Esq., of Wellingore and daughter of Baptist Earl of Gainsborough, obiit November 5th, 1780 ; also placed in same vault 2 of their infant children Horatio Thomas and Lucy Elizabeth.]

The church is small ; it consists of a nave, chancel and tower at the west end. The altar is raised very high from the level of the chancel by 2 steps. The font is an octagon panelled in quatrefoils.

(MS xii, 39–46.)

Aunsby

Notes taken in the church, 12 August, 1834—This church consists of a nave, and aisles, chancel, south porch and a tower and spire at the west end. The nave is divided from the south aisle by 3 very light and elegant pointed arches springing from clustered columns with beautiful foliated capitals, and from the north aisle by 2 Norman arches, the capitals of which are adorned with figures. The arches leading to the chancel and to the tower are both pointed. The chancel is divided from the termination of the aisles on the north side by a Norman, and on the south by a pointed, arch. The font is of Norman character, round and massy, with four attached pillars. The steps to the antient rood loft are still remaining (D).

A flat stone within the altar rails with this inscription round the edge in old capitals (R):
Here lieth the body | of John Coulthurst of Ounsby gentleman, | who was buried | the 27 day of December Anno Dom'i 1627.

To the south is another old stone with the inscription round the edge but nearly effaced:
Johan the wife of | John Colthurst | of Ownsbie . . . (the rest gone)[1].

On a brass plate let into the first mentioned stone (R):
Here lyeth interred the body of | John Colthurst of Aunsby, gent., | husband of Faith Colthurst | who departed this life on the 14 | day of October in the year of our Lord | 1678, devoutly resigning his soul | to God in perfect assurance of a happy | Resurrection and glorious immortality.

Another brass plate let into the second stone (R) :
> Here lyeth interred the body | of Faith Colthurst widow, | the late wife of John Colt | hurst, gent. She departed this | life the 17 day of Decem. 1679, | to enjoy with her said hus | band eternall Felicity at | their Resurrection.

A flat stone to the north of these in capitals :
> Here lies | the Rev. M^r Benj. Stokes | the late | pious studious charitable | rector of | Aunsbye and Demblebye | A.D. 1721.

A flat stone in the chancel in capitals (R) :
> Here lieth the body of John Colthurst | buried the 19 day of January 1678, | and Jane his sister buried the 2^d day of | August, 1680, | the son and daughter of William | Colthurst and Mary his wife.

Another to the north in capitals :
> Here lieth the | body of Mary Col- | thurst the daughter of William and | Mary Colthurst | his wife. She depar | ted this life the | 16 of October | 1684.

To the west is an old stone with the inscription round in large letters, but partly effaced :
> Heare under this stone lyeth the body of Elizabeth wife to William was buried 13 of Sept. 1610.

To the north is a flat stone with an inscription round the edge in old character mostly effaced but what remains is :
> Hic iacet Edwardus quondam xl cuius anime propicietur deus Amen.

A flat stone more to the north, in capitals :
> Here lieth interred Alice | the wife of H. Williamson. | She died March 27, 1709.

Another to the north in capitals partly broken off (R) :
> Here lieth the body . . . | M^r Henry Will[iamson] | deceased Oct. the . . . | 1709, | late rector of Aunsby.

A flat stone on the floor of the south aisle of the chancel the inscription in capitals :
> Here lyeth the | body of Edmund Wat | son who was buried | Januarii the 9, | 1688.

Another to the north in capitals :
> Here lyeth the body of | M^r Thomas Watson, who | departed this life | March the 26, 1706, | in y^e 74 year of his age.

Another slab more to the north in capitals :
> Elizabeth y^e wife of | M^r Tho. Watson | died Mar. 29, 1709.

(MS v, 127–132.)

NOTE

[1] Perhaps Jane the wife of the John Coulthurst, who was buried in 1627.

𝕭𝖆𝖗𝖉𝖓𝖊𝖕

Notes taken in the church, 12 October, 1840—This has been a handsome and spacious old church, but some of the repairs which may have been necessary on account of its dilapidated state have not been conducted judiciously. The nave is separated from the two aisles by four pointed arches, but the organ loft (D) occupies as much as one at the end of the nave. The pulpit (D) is painted in a very gaudy manner, especially a figure of an angel over the sounding board with a golden trumpet and sky blue drapery. The chancel is entirely partitioned off from the nave and is by far the handsomest part now left. The roof has not been ceiled, but left with its old timbers supported on brackets of angels bearing shields. On the interlacing of the groins are some old carving of roses. The wooden tablets (R) of the benefactions affixed to the north wall near the entrance and also on the west wall of the north aisle are curious inasmuch as a rude coloured picture of the benefactor is placed before the account of the benefaction.

The first of these is of Joseph Knowles, apprentice of London, and son of Richard Knowles of Bardney deceased. This Joseph at the age of xxv years departed this life ye x day of August in the year of Grace 1603, and left £30 by his will dated ye second of August to be laid out in land to give bread every Sunday to 12 poor people. John Knowles, senior, gave £10 to further the gift of his nephew. The second tablet runs as follows :

William Hurstcroft | late of Bardney, | who departed | this life the second | day of May in the | year of our Lord | 1630, who in his last will and testament | besides other charitable deeds did | also give one house in Boston to ye poor | of Bardney & Newport in Lincoln | equally to be divided for ever.

There are no tombs or inscriptions in the body of the church now visible. It has been floored from the old stones. A few still remain in the chancel.

On a flat stone :

In memory | of the Revᵈ | Mr G. Blennerhaysett | late vicar hereof, | who departed this life | Janʸ 26, 1778, | in the 60th year of his age.

On another :

In memory | of | Francis Brown | late of Hull | who departed this life | 8 Sept. 1786, | aged 9 years 11 months.
How loved how valued once avails thee not
To whom related or by whom begot
A heap of dust alone remains of thee
'Tis all thou art and all that we must be.

On another stone :

In memory of | Mary the wife of | Thomas Bartholomew | died February the 12, 1776, | aged 53.

On an old stone is carved a cross, with :

C. S.
May 27
1715.

The old stone to the daughter of Lord Willoughby and wife of [Henry] Andrews was destroyed when the church was repaired.

[Hanging on the walls of the belfrey :

Vinsent Ward died 6 March 1766. By his will dated 1760 did leave the interest of £3 to be given in bread on Candlemas Day.

Thomas Kitchen late of Tupholme. By his will dated the tenth day of Oct. 1711, he left his estates at Fulletby Moorby Belchford and Low Toynton, to found a free school for the teaching of the poor children of Bardney, Tupholme, and Bucknall. Salary of the Master £20, the overplus of rent and repairs to apprentice a poor child in Southrey.

Wooden tablet in belfrey :

William Norris died Feb. 15th, 1705. He left the interest of £2 to be given in bread on Holy Thursday annually.

John Bennington died 1690. He left the interest of £8 to be given in bread on the Circumcision of Our Saviour annually.

John Lightfoot died 22 Oct. 1722. He left the interest of £3 to be given in bread on All Saints Day.]

[See also *L.R.S.* i, 239.]

(MS x, 63–66.)

Barholme

Notes taken in the church, [*blank*] August, 1831—

On a brass plate (R) set on a bracket against the chancel wall with these arms cut on it—2 bars nebule . . . , on a chief 2 arrows in saltier . . . between 3 towers . . .[1] :

Reader hereunder lies my friend | who as he lived so did he end | his dayes in peace expecting then | a blessed resurrection when | his God should please so let us all. | From earth wee come to earth wee shall | Francis Fordham gent. departed this life Aº D'ni 1641.

On a handsome marble monument against the east wall of the north aisle with a shield of arms above, but now effaced :

Underneath | are deposited | the mortal remains of | Richard Walburge | of the town of Stamford in this county, gent.,| and lord of this manor of | Barholme cum Stow, | which by

B

the blessing of God upon his endeavours | he purchased
himself in the year of our Lord 1705, | and | would you have
a perfect image of the deceased | behold him as he was, | An
exemplary faithful christian | a zealous Protestant of the
Church of England, | always firm to its doctrine and dis-
cipline | and a devout and constant attendant on its service, |
the best of husbands and most affectionate father, | a kind
and valuable relative, | a wise master, a loyal subject, | steady
to his friends & obliging to his enemies, | most industrious
in his calling & just in his dealings, | an able and faithful
guardian, | a true lover of learning, | an active promoter of
pious charities, | and a liberal contributer thereto, | who
after he had eminently acquitted himself in all these | severall
characters fell asleep in the Lord on the 27 day | of May
Anno Dom' 1751, and in y^e 54 year of his age, | in an assured
hope of a joyful resurrection | and in expectation of being
gathered unto him | when the Almighty shall appoint. |
There yet remains Elizabeth his mournful widow | [eldest
daughter of Ed^md Curtis late of Stamford aforesaid gent.], |
who, in memory of her dear departed consort, and as | a
pledge of her great esteem and affection for him, | erected
this monument, | to whome she bare 1 son & 3 daughters
all living, viz. | Simon, Elizabeth, Margaret, & Catherine, |
the hope and comfort of their afflicted mother.

On a flat stone by the arch to the tower :
In memory of | Sarah, dau^r of John Dowsing clerk | (vicar
of Middleton in the county of Norfolke) | and Sarah his wife |
who departed this life | on the 11 day of December 1781, |
aged 26 years.

On the south front of the tower under the battlement is this
inscription :
1648 I H | Was ever such a thing | since the creation, | a new
steeple built in | the time of vexation.

[See also *G.M.*, 1862, part ii, 737–41; Jeans, Supp., 2.]

(MS i, 29–32.)

NOTE

[1]Evidently the arms of Fordham, Barry wavy of six or and azure,
on a chief gules two arrows in saltire between as many castles
argent.

East Barkwith

Notes taken in the church, 12 August, 1833—

On an old stone in the chancel in church text round the edge :
Hic iacet Will*elm*us de Alford cuius *anime* propicietur Deus.

There are some other old stones the inscriptions effaced, one with the figure of a priest and another coffin shaped with a crescent on it.

The church consists of a nave and south aisle resting on 4 pointed arches, a chancel, and tower at the west end. The font is octagon, adorned with the Insignia of the Crucifixion.

(MS xii, 77.)

West Barkwith

Notes taken in the church, 12 August, 1833—

An old stone (D) in the chancel with this inscription round the edge in old character :

. ux : Thomæ de Ed obiit to die April Aº D'ni MCCCLXXXX cujus anime

There is another old stone with a cross, and another now quite broken and illegible.

The church consists of a western tower, a nave, and chancel.

(MS xii, 53.)

Barrow on Humber

Notes taken in the church of Barrow, 2 September, 1835—

In the north aisle a marble monument (R) against the wall with these arms over—Argent, a chevron between 3 boars' [or, perhaps, brocks'] heads azure ; crest—A boar passant azure [for Broxholme] :

Here lyeth the body of Lieut. Col. | W^m Broxolme son of Jo. Broxolme Esq. | and Troath his wife relict of Sir Hen. | Foulks knt Bann^{rt}. He dyed in the fifty | ninth year of his age & on the 4 day | of April 1684 ; he was a true son of | the Church of England in w^{ch} faith he | dyed, a loyall subject to his king w^{ch} | he manifested in several parlements, | a discreet & good magistrate in his cou | ntry, and a most worthy just friend, | reall in all true kindness without | any mixture of dissigne ; in fine he | was a brave just & a generous man, | and dyed lamented by all that | knew him.

On a marble tablet more to the west in the north aisle (R) :

The Rev^d John Brockbank | died Dec^r 27th, 1800, | aged 44 years. | As an able instructor of youth, | sincere clergyman, | and an upright man, | his character was respectable. | As an affectionate husband, | his memory will long be dear | to his disconsolate widow.

More to the west on a white and grey marble monument in capitals
(R) :

> In memory | of the Rev. Will. Trevor, A.M., | forty years
> vicar of this place, | who died 20 Feb. 1794, aged 74. | Also
> of Hepzibah his wife | who died 17 Dec. 1787, aged 61. |
> Also of the Rev^d W^m Francis Trevor | who died 29 April 1784,
> aged 34. | Of Hepzibah Trevor | who died 16 Sept. 1791,
> aged 42. | Of Rob^t Brook Brydges Trevor | who died 2 Oct.
> 1764, aged 11, | their children, and of two others | in their
> infancy.

Opposite these two last monuments are flat stones also to John
Brockbank and Will. Trevor (D).

On a flat stone in the north aisle :

> In memory of | Elizabeth Kirke | daughter of Theophilus
> & Elizabeth Kirke | who departed this life | August 6, 1814, |
> aged 33 years.

Within rails at the west end of the south aisle stands an altar tomb
(now level with the floor) with a grey marble slab and this
inscription in gilt letters :

> Beneath this marble lieth interred | the remains of the | Rev^d
> Mr Rob^t Kirke, A.M., | late vicar of this place. | He departed
> this life the 22 | of May 1755, | in the 51 year of his age.

On the front of the east end of the tomb (now on the north wall
of the chancel) :

> R.K. being dead yet speaketh. | Keep stedfast in the faith, |
> Be constant at private and publick worship, | Be charitable, |
> Do justice, love mercy, live soberly, | and the Peace of God
> be with you Amen.

On a similar altar tomb by its side to the south (now level with
the floor) :

> Here | lyeth the body | of | Mrs Abigail Kirke | relict | of
> the late Rev^d Mr Kirke | died | Nov. 21, 1767, | aged 56 |
> years.

Above these monuments is a very neat painted glass window of
the Ascension (D) given by Mr Kirke who left money to keep it
in repair and if not required for that purpose to go to the poor of
the parish.

There are flat stones (D) at this end of the church to Molly Kirke
who died 15 Jan^y, 1800, æt. 50, Elizabeth Kirke who died 7 Dec.
1800, æt. 41, and to Abigail Kirke.

On a flat stone at the west end of the nave (R) :

> Sacred | to the memory of | the Reverend | Edward Henry
> Hesleden, clerk, | M.A., late fellow of Mag. Coll. Oxon, |
> vicar of this parish | who departed this life | February 14,
> 1828, | aged 53 years.

On a flat stone in the nave (D) is an inscription much rubbed to Elizabeth wife of Will. Smith daughter of Samuel and Grace Hudson who died Feb. 16, , æt. 34 years.

There is a flat stone in the nave (R) to John Brown who died 2 April, 1781, æt. 68, and on the same stone to John Wilson, died 3 March 1784, æt. 53.

A white marble monument against the east wall of the chancel (R), north of the altar, these arms over—Azure, six martlets, on a chief argent, three bucks' heads cabossed proper [Uppleby]; on an inescucheon—Azure, on a chevron between three bucks tripping or as many martlets gules [Robinson]. Crest—a buck's head couped at the neck quarterly argent and proper, attired sable [Uppleby]. This inscription in capitals :

> Sacred to the memory of | George Uppleby Esquire, | A gentleman of the Privy Chamber to George III, | in the discharge of his public duties | as a Deputy Lieutenant and Magistrate of this county, | his zeal tempered with a strict regard to Justice | and united with gentleness and patience, | enabled him to decide with equity and | so to heal animosities | as to secure to himself kindness esteem and gratitude. | He married Sarah the only child of | Charles Robinson Esquire of Beverley, | and sole heiress of her grandfather William Gildas Esqʳ | of Bardney Hall, by whom he had seven children, | Sarah, Charles, Dorothy, Eliza, George Crowle, George | and Lucy, | all of whom except George Crowle survived him. | He died April 25, 1816, in the 65 year of his age. | His affectionate widow erects this tribute of respect | to her husband's cherished memory.

On a grey marble tablet with a white urn above against the east wall (R) south of the altar :

> In memory of | Roger Uppleby | who died the 25th of | Decʳ 1780, | aged 22 years.

A blue flat stone in the chancel :

> Here lieth the body of Mr James | Houseman, Senʳ, who died the 24th of | October 1715, in the 88th year of | his age. | Here also lieth the body of Mr | James Houseman, Junʳ, his only child, | by Margaret his wife, now surviving | daughter of Mr John Matson, merchant | at Dover. He died the 1st of February | 1715, aged 31 years. | Also here lieth the above said | Mrs Margaret Houseman | who died | the 9th of February 1719, aged 87 years.

On an old stone (D) to the north of the last has been an inscription round the edge but now entirely effaced, but the words cto die mensi.

A flat stone to the south (R):

> Here lies ye | body of Mr Robert Lamb | he departed this life ye | 3 of April 1721.

A stone more to the west (R):

> Here lyeth the body of Robert | Hardy who departed this life | yᵉ 21 of June, Anno 1711, aged 64. | Hold stand and see what | Hear yᵉ Lord hath done | He hath summoned me and | Tacken home his son. | My glass is run my time | Is now at Hand | That I may go unto yᵉ Holy land | Remember youth as thou | Art so once was I | So learn to live | And fear not for to dy | Since death from sin | Hath set me free : then | Friends prepare to follow me.

Another to the south (R):

> Here lieth yᵉ body | of Robert Hardy of | Barrow who departed | this life July yᵉ 23, 1729, | aged 31 years. | Also Joyson his wife who | departed this life Decᵇʳ | yᵉ 21, 1766, aged 66 years.

Other stones [in the chancel] in memory of :

> Robert Hardy died 23 May 1770, æt. 43.
> Mary his wife died 26 Jan. 1812, æt. 82.
> John Hardy died 22 Aug. 1814, æt. 62.
> Susannah his wife died 12 June 1826, æt. 77.

A stone at the east end of the nave much rubbed (D):

> Here lyeth | the body of the Revᵈ | Mr Joseph Foxlow | late vicar of this parish who | was buried [*blank*] October | 1728, æt. 35 years.

This church consists of a nave and aisles on the north side resting on 5 arches, of which 4 are round and the easternmost pointed. On the south side are 4 pointed arches, a chancel divided by an arch which is blocked up, and in the head is a large modern window, a pinnacled tower at the west end, and a south porch.

[See also *Lincs. N. & Q.* x, 146.]

(MS vi, 145–154.)

Barton Saint Mary

Notes taken in the church, 1 September, 1835—

In the south chapel of the chancel against the south wall, with these arms above—

Sable, a lion rampant between eight crosslets argent [Long]. Crest— :

> Near | this tablet | is interred yᵉ body of William Long of | Louth, Justice of the Peace for many years. | He married Mary daughter of John | Tripp, gent., once Mayor of Hull |

by whom he had issue 5 sons | & 7 daughters of which
3 | survived him, viz., | Elizabeth, Mary, & Frances. | By
his will gave 200£ to be | laid out in a purchase of land for |
yᵉ education of children ; | also a tenement and yard | for
better convenience | of yᵉ Vicarage House. | Obiit 26 Martii,
1729, | Ætat. suæ 85.

On a slab below the monument is inscribed :
The above named John Tripp devised | lands for the main-
tenance of the | blew coats | and Lady Rand his daughter |
gave 4£ per ann. to the | Minister of this town to preach | an
annual sermon, | and forty shillings | per ann. to the poor.

In the same south chancel aisle are these flat stones to :
Elizabeth wife of Robert Edward Johnson died 4 Dec. 1834,
æt. 55.
Martin Robinson died 16 June 1782, æt. 81.
Thomas Robinson died Nov. 9, 1771, æt. . .
Susanna his wife died Sept. 3, 1792, æt. 82.
Harriet Atkinson died March 21, , æt. 85.

On an old stone in the chancel :
Hic iacet Ricardus Haubord quo*ndam* | capell*anus* p*arochialis*
istius loci q. | obiit [primo] die mensis aprilis anno domini
MCCCC septuag : I. cuius anime propicietur deus.

The description [by Gervase Holles (L.R.S. i, 78)] of the monument
to Jane the wife of John Shipsea is very accurate but he omits
the following inscription on the shaft :
Sic mortua | est Rahel | et sepulta | Gen. 35, v. 19.

The inscription [by Gervase Holles, *ibid.*] on the verge of the flat
stone to Simon Seman runs thus :
Hic iacet Simon Seman quo*ndam* civis et vinitarius ac
Aldermanus London qui obiit xi die mensis Augusti anno
domini millesimo CCCC trigesimo tercio cuius anime et omnium
fidelium defunctorum propitietur deus Amen amen.

The arms Holles describes are now gone but two shields still remain
in brass. I think with a cypher of I H S.

[At the four corners in the brass are the Man, the Lion, the Ox,
and the Eagle.]

In the south aisle are these inscriptions on flat stones to :
John Wilbar, gent., died 4 March 1811, æt. 66, and to Jane
wife of the preceding died 12 March 1830, æt. 84.
Anne dauʳ of John & Anne Bennett, granddaughter of John
& Margaret Saunderson, died 3 Aug. 1758, æt. 9.
John Alcock died 5 Novʳ 1823, æt. 26.
Lucy his wife died 29 Oct. 1825, æt. 33.
Anne Hudson Alcock their dauʳ died 11 Sept. 1821, æt. 5
months.

William Hudson died 22 Oct. 1814, æt. 69.
Lucy dau^r of William & Margaret Hudson died 5 April 1790, æt. 2.
William son of John Haworth Hudson and Jane died 5 Aug. 1816, æt. 2.
John Haworth son of the same 15 Oct. 1816, æt. 4.
John Uppleby Hudson died March 1820, æt. 6 months.
Thomas Haworth died 16 March 1768, æt. 53.
Eliz. his widow 26 Sept. 1802, æt. 82.
Thomas their son died 1755, æt. 5.
David their son died 10 Nov^r 1815, æt. 72.
Elizabeth Scrivener their dau^r died 4 June 1827, æt. 82.
Mary wife of John Lunn died 21 Nov. 1831, æt. 58.
Elizabeth grandaughter of the above and dau^r of William and Elizabeth Robinson died 9 Jan^y 1833, æt. 10 months.
Robert Cooke died 28 August 1822, æt. 49.
Elizabeth his wife died 16 Dec^r 1823, æt. 58.

There are flat stones in the nave to the memory of :
John Bygott died 19 March 1821, æt. 25.
George Bygott died 30 May 1804, æt. 70.
Ann his wife 14 June 1801, æt. 67.
George Bygott their son died 2 Feb. 1788, æt. 24.
Robert their son died 17 Nov. 1799, æt. 29.
James Bygott died 20 June 1810, æt. 59.
James Bygott died 26 May 1805, æt. 61.
Martha his wife died 17 Dec^r 1812.
Peggy their daughter died 15 Feb^y 1815, æt. 42.
William Bygott 15 Dec^r 1810, æt. 72.
Margaret wife of Robert Bygott died 10 Feb. 1794, æt. 56.
Robert Bygott died 13 May 1810, æt. 74.
Susanna their daughter died 14 July 1835, æt. 68.
John son of Richard and Sarah Johnson died 12 June 1792, æt. 16.
Richard Johnson died 26 Sept. 1809, æt. 68.
Sarah his wife died 5 Sept. 1829, æt. 87.
Richard Kennington died 12 July 1809, æt. 52.
Anne Kennington died 20 March 1820, æt. 21.
Susanna wife of Richard Kennington died 18 Aug. 1831, æt. 70.
John Kennington died 6 March 1759, æt. 48.
Sarah his wife 26 Jan^y 1796, æt. 78.
Joseph Cook died 5 Oct. 1785, æt. 77.

In the chancel within the altar rails are three large blue stones which have had brasses round the edges, now gone. On one, a

cross botone is cut, and on another two figures which have had their hands and faces composed of brass. A stone[1] of the same kind is in the south aisle of the chancel, and another old blue stone has been used for William Long, Esq's, name to be cut on it. At the east end of the north aisle is a similar stone with two figures cut on it ; their heads and hands in brass now gone.[2]

A blue flat stone at the east end of the south aisle :
> Here lieth the body of | John Saunderson gent. | who died on the 30th of | October 1757, aged 63 years. | Also the body of Mrs | Margaret Saunderson | his widow who died on the | 16 November 1757, aged | 60 years. | Also the body of John Saunderson | gent. son of the above | John and Marg[t] Saunderson | who departed this life | 28 Oct. 1778, aged 57 | years.

A stone collateral to the south of the last :
> Under this stone are | deposited the remains of | Lætitia Saunderson | widow of John Saunderson | gentleman. She died | on the 9th day of December | 1792, æt. 64 years.

A modern brass plate in the floor of the north aisle in capitals :
> Sacred | to the memory of | Sarah Hatherell | who died 25 June 1824 | aged 76 years.

A flat stone in the north aisle (R) to the memory of :
> Richard Evans gent. died 28 Dec. 1831, æt. 44. Also Richard his son died 27 May 1823, æt. 1 year & 2 months.

[At the west end of S. James's aisle is a flat stone with this inscription :
> Here lyeth the bodye of Ann Arnold late wife of Thomas Arnold who leved fiftye sex yeares, and was buried the 2 of Desember, Anno D'ni 1637.]

[See also *Lincs. N. & Q.* x, 186 ; *L.R.S.* i, 78–80 ; Jeans, 5.]

(MS vi, 171–178.)

NOTE

[1] This name is now illegible. All the brasses are gone, but the stone may be identified with that of William Lorymer, whose will was proved at Lambeth, 19 November, 1458 (P.C.C., 14 Stokton), and he provided that his body was to be buried in the chapel of the church of the B.V.M. of Barton, before that altar of St James, under a blue stone lying in the same place. The ' south aisle of the chancel,' mentioned in the text, was the chapel of St James.

[2] This north aisle is St Thomas' aisle. In this aisle Richard Adinot founded a chantry at the altar of St Thomas of Canterbury, and the two figures on this stone, which lies to the north of the altar, may be those of Richard and his wife.

Barton Saint Peter

Notes taken in the church, 1 September, 1835—

Against the east wall of the chancel a marble monument of white and grey with these arms over—Argent, on a pale sable a sword proper [for Nelthorpe] :

> Sacred | to the memory | of Sir John Nelthorpe Baronet | formerly of Barton, but late of Scawby, | in this county, who departed this life | the 14 day of June 1799, | in the 55 year of his age. | This marble was erected by his son | Sir Henry Nelthorpe Baronet | as a testimony of his affection | for a tender parent.

On a handsome marble monument against the north wall (R) :

> Below this tablet | are deposited the remains of | William Graburn, Esq., | late of Kingsforth in this parish, | who departed this life the 20 November 1826, | aged 59 years. | Upright, and of manners irreproachable, | he was respected, humane, generous, cheerful, | and sincere, he was beloved by all who knew him. | Also two children of the above, | viz. George, who died the 22 March 1822, | aged 17 years, | and Charlotte who died the 18 January 1827, | aged 24 years.

On a white marble tablet (R) beneath the above, with these arms under—Two cross bones saltierwise between four fleur de lis. Crest—A pheasant [Gatty] :

> Sacred to the memory of | Mary the wife of | Robert Gatty, Jun^r, Esquire, | of Finsbury Square, London, | eldest daughter of | William Graburn, Esq., of Kingsforth, | who departed this life 10 March 1823, | aged 28 years, | and was buried in St Andrew's church | Holborn, London.

On an old stone at the east end of the chancel round the verge :

> [Johannes] Cole quondam vicarius huius ecclesie qui obiit tercio die mensis Junii anno domini MCCCCCXXI cujus anime propic[ietur Deus].

On an old stone very much rubbed :

> de Maresco[1] Capellanus quondam vicarius . . .

On a monument against the north wall at the west end of the north aisle :

> Sacred to the memory | of Thomas Scrivener | who departed this life 11 of Nov^r 1774, | aged 66 years. | Also | Elizabeth Scrivener his wife | who died 21 of Jan^y 1780, | aged 60 years. | Also | Thomas Scrivener son to the above | who died 5 of May 1805, | aged 50 years.

On a white marble monument over the north door in the north aisle :

> Near this place | are deposited the remains of Elizabeth Tombleson | relict of Joel Tombleson of Lincoln, | and daughter of | Thomas and Elizabeth Scrivener, | who departed this life the 5th of Feb^y | 1819, aged 74 years.

Monument against the west wall at the end of the south aisle :

> In memory of | Mrs Elizabeth Willan | who died the 13 of Jan^y 1779, | aged 69 years, | relict of the | Rev^d John Gelder ; and of the | Rev^d Thomas Willan, late vicars | of Barton upon Humber.

On a stone monument (D) against the south wall close by the inscription now becoming much obliterated :

> Mrs Mary Allanson | of All Hallows Barking, | London, | was buried Feb. 27, 1734, | aged . . . | Mrs Penelope Allanson | daughter of Mr Allanson, | wife of the | Rev Mr Gelder, | was buried Feb. 7, 1738, | aged 45.

On a monument next to the east :

> Here lie the remains of the | Rev^d John Gelder, clerk, | who during the course of | 37 years assiduously performed | the duties of his office as vicar | of this and St Mary's parishes, | obiit May 7, 1751.

On a brass in the south aisle these arms engraved over—Quarterly, 1st and 4th, bendy of 6 [argent and gules], over all 3 bucks' heads cabossed [or] [Beechcroft]; 2nd, A lion rampant; 3rd, A bend. Crest—A beech tree surrounded by paling :

> Richard Beechcroft, Esq. | of London | died 23 July 1813, | aged 39 years.

[This brass is affixed to a much older stone which still retains marks of an inscription round the border.]

On a blue flat stone at the east end of the south aisle :

> Here lyeth the body of Mr | Kirke Nelthorpe gent. who | departed this life July the | 26, 1734, aged 42 years.

[Adjoining are two similar Nelthorpe stones dated 173 . and 1749.]

On the flat stones in the south aisle are inscriptions to :

> Joseph Brown Gt, died 21 Sept. 1829, æt. 63.
> Margaret Roberts died 13 June 1822, æt. 75.
> John Watt Brown 3 son of Robert Gt died 20 Feb. 1820, æt. 4 months (D).
> Henry Browne 4 son of Joseph Gt. died 22 May 1829 æt. 25.
> William Clarke died 12 Dec. 1805, æt. 38.
> Robert Ward surgeon August 28, 1809, æt. 38 (R).

Inscriptions on flat stones in the north aisle to :

Helen wife of W^m Marris, Jun^r, Gt, died Jan^y 1, 1775, æt. 35 (R).

Arabella daur of Mainwaring & Susan Branston died 22 Nov^r 1775, æt. 35.

Mainwaring Branston died 12 Oct. 1785, æt. 80.

Susanna Branston died 10 March 1795, æt. 88.

Frank Abraham died 16 Feb. 1813, æt. 46.

Eliz. daur of Richard Eddie, surgeon, & Sarah died July 5, 1822, æt. 12.

Will^m Hesleden, Esq., Sol^r, died 7 March 1823, æt. 72.

Eliz. his wife daur of Mr W^m Smith of Hatcliffe died 20 March 1822, æt. 72, & their children Eliz., Jane, & John.

William Heselden Graburn son of John Uppleby Graburn & Elizab. died 8 Nov. 1828, æt. 3 weeks and 3 days.

Inscriptions on flat stones in the middle aisle to :

William Benton died Feb. 7, 1807, æt. 27.

Will. Benton surgeon died 2 Jan^y 1800, æt. 49.

Thomas & Frances Benton parents of William. He died 18 March 1762, æt. 36, she Aug. 8, 1767, æt. 45.

William Sissons died 25 Oct. 1771, æt. 72.

Isabella his wife died 12 Sept. 1785, æt. 74.

Richard Richmond died 21 Feb. 1817, æt. 81.

Isabella his wife daur of W. & I. Sissons died 26 July 1818, æt. 79.

Benjamin Mackrell 18 Feb. 1812, æt. 64.

Anne his wife died 4 May 1811, æt. 81.

John Scrivener died 2 Nov^r 1800, æt. 60.

William his brother died 22 Jan. 1801, æt. 58.

Isabella wife of Richard Barrett died 16 April 1776, æt. 57.

Richard Barrett died 9 Nov^r 1799, æt. 82.

Captⁿ Richard Thorley died 16 April 1807, æt. 53.

Mary his relict 27 Oct. 1833, æt. 79.

Mary Margaretta Frideswide Worthington 6 Feb. 1823, æt. 10 weeks.

Anne Latham died 31 Dec^r 1831.

Anne wife of Robert Scrivener died 6 June 1744, æt. 33.

Mary their daur died 4 June 1736, æt. 3.

Robert Scrivener her husband died 22 Oct. 1788, æt. 77.

Robert Scrivener died 28 March 1822, æt. 85.

On the south wall of the chancel is an elegant monument of white marble in the ancient English style, formed by a canopy of three ogee arches, crocketed, trefoiled, with finials :

In memory of | William Gildas Esq. | who died on the 5 of November 1780, | aged 70 years. | This marble was erected by his | grandaughter Sarah the wife of | George Uppleby, Esq^r, of

Barrow, | in testimony of his merit and | her affection. | Sarah Uppleby, | who inscribed the above memorial, | departed this life | on the 3ᵈ day of January 1832, | aged 74 years. | By pure and exalted wisdom, gentle charity, | and self renunciation, by Holy Love | for the Lord God her Creator and Saviour, | and by a cheerful resignation to his will, | we humbly believe her happy Spirit | was prepared for the everlasting joys of Heaven.

A small yellow and white marble tablet having a white sarcophagus, surmounted by an urn from which hangs a broken flower. On the urn is inscribed the words MARIA LVCY. The inscription below in capitals :

Sacred | to the memory of | Maria Lucy the beloved child of | Robert and Dorothea Marriott | of Barton Lodge | who to the inexpressible grief | of her afflicted parents | departed this life the 19 of July | 1823 | in the twelfth year of her age.

A modern brass plate in the chancel floor (D) :

George Graburn | the sixth son of | William Graburn, Esq. | died 22 March 1822, | aged 16 years.

A flat blue stone in the nave, the inscription round the verge in capitals :

Here lyeth the body of Anthony Empringham of Barton upon Humber, yeoman, who departed this life the tenth day of August 1698, in the sixty third year of his age.

Another stone to the south of the last :

Here lieth the body of | Simon Empringham, yeo | man, late of Kettleby Thorpe, | who departed this life yᵉ | 15ᵗʰ of Decembʳ, in yᵉ year 1723, | in yᵉ 40 year of his age.

Another stone more to the west :

William Emperingham of | Barton died November the | 24, 1752, aged 64 years. | Also Elizabeth his wife who | died January the 12, 1744, | aged 56 years, | by whom he had issue four | daughters, Elizabeth, Isabell, | Ann, and Milia.

A white marble monument over a pillar of the nave looking southward, this inscription in capitals :

In memory of | Thomas Marris of Barton upon Humber | in the county of Lincoln, gent., who | died 19 December 1797, aged 92, | and of Elizabeth his wife who died 28 | January 1800, aged 73, | of Sarah their daughter who died in | June 1769, aged 13, | of Robert their eldest son who died | 19 January 1791, aged 46, | of Joseph another of their sons who | died 23 Aug. 1808, aged 58, | and of seven of their children who | died in infancy, all of whom are interred | near this place. |

And also in memory of John another of | their sons who was on board the Repulse | Frigate when lost at sea in the year | 1777 ; he was then in the 22 year of his age.

There are flat stones below to the memory of :
Mary daur of Thomas & Mary Marris, died 4 Dec. 1772, æt. 9 months.
Sarah daur of the same, died 20 April 1783, æt. 6.
Thomas Marris, died 3 Jan. 1794, æt. 65.
Mary Marris, died 3 Decr. 1807, æt. 73.

On a modern brass plate in the nave in capitals :
Beneath this stone | are deposited the remains | of the | Reverend William Uppleby | late vicar of this church | who departed this life | on the seventh day of April | A.D. 1834, | æt. 74.

In the eastern window are 2 figures in painted glass, one of which is a knight in white armour bearing on his shield and cuirass— Argent, a plain cross gules. This most probably represents St George. The other figure is clad after the manner of a pilgrim in a blue robe covered with a white mantle, his head covered with a cap bearing an escallop shell. In his right hand is a sword and in his left a book [for St James of Compostella].

In the east window of the south aisle remain 2 shields : (1)—1st and 4th, Gules, a saltier argent charged with a rose (?) of the field [Nevile] ; 2nd and 3rd, Gules, on a fesse between six cross crosslets or a crescent sable [Beauchamp] ; (2) Quarterly, but the first quarter is nearly gone ; part of a cross engrailed or remains, and the rest has been filled up with a piece of blue glass ; 2nd and 3rd—Gules, a cross sarcely argent [Bek] ; 4th, Gules, a water bouget argent.

[Near this window is a tomb slab of blue stone. All that remains of the brass upon it is a piece containing the feet of the figure, and another piece with the following inscription :
Hic jacet Robertus Barnetby de Barton armiger qui obiit xx die mens' Septembr' a' d'ni mill'o cccc xl° cujus anime propicietur Deus Amen.]

On the north wall of the chancel are four atchievements (D) :
I. A lozenge of arms, Nelthorpe with the Ulster coat, impaling— Or, two bars gules, a bend over all azure.

II. Quarterly, 1st and 4th, Nelthorpe, as before ; 2nd, Sable, a cinquefoil argent, a chief checquey or and azure [Hobson] ; 3rd, Gules, a saltier argent, surmounted of another azure [Andrews] ; impaling 2 wives, the 1st wife, in chief—Quarterly, 1st and 4th, Argent, 3 bars wavy azure, over all a bend or ; the 2nd wife— Argent, a fesse gules between three rooks proper ; 3rd, Argent,

three martlets within a double tressure flory argent, in base or two bars gules, over all, a bend azure. Crest of Nelthorpe.

III. Quarterly 1st and 4th, Nelthorpe ; 2nd, [Hobson] ; 3rd, [Andrews] ; an inescucheon bearing the arms of the first wife in the last atchievement.

IV. Nelthorpe, impaling—Or, fretty gules, on a chief azure three water bougets or [Willoughby]. Crest of Nelthorpe.

Another atchievement (D) is at the end of the south aisle, viz. Nelthorpe, impaling—Or, a bend sable charged with three roses proper [Cary].

[See also *Lincs. N. & Q.* x, 180 ; *L.R.S.* i, 80–1 ; Jeans, 5–6.]

(MS vi, 155–169.)

NOTE

[1] This is evidently Robert Saltmerssh (*de Salso Marisco*), chaplain, who was instituted to the vicarage, 18 June, 1424 (Lambeth Register, Chichele i, f. 240d.).

Bassingham

Notes taken in the church of Basingham, 10 August, 1833—

On a flat stone in the chancel (D) :

Elias Bishop, Batchelor | of Divinity, late rector | of this parish, died Jan. | 18, 1742, aged 52. | Elizabeth his wife | died Jan. 10, 1735, | aged 31.

On the next flat stone (D) :

Hic jacet Jacobus Metford | A.M., per sexaginta fere annos | rector hujus ecclesiæ, obiit | 4to die Januarii A.D. 1720, | ætatis suæ 88.[1]

On another flat stone (D) :

Here | lies the body of | Sophia Jane | eldest daughter of the Rev. D. S. Wayland, A.M., | vicar of Kirton in Lindsey | and perpetual curate of | Thurlby in this county, | and Jane his wife. | She died on Sunday Feb. 13, | 1825, aged 77 years. | The ornament of a meek and quiet spirit | is in the sight of God of great price.

On another flat stone (D) :

Ursley Thompson wife of | Will. Thompson gent. | departed this life Nov. 22, | 1721, | in the 44th year of her age.

On a board against the north wall of the church are the names of the benefactors (R) :

Sir William Thorold, Knt & Bart, & Lady Anne Thorold his wife, gave by deed, dated Sept. 21st, 1670, the sum of forty shillings yearly for ever to be distributed to eight of the poorest people of this parish on St Thomas's day by

the minister, churchwardens and overseer of the poor, or
any three of them, so that the minister be one, to be paid out
of the close commonly called Tuft Hill.

John Lambe of this town, by his last will 1670, gave twelve
pounds, the interest of which was to be paid by the rector
& overseers to the poor at Christmas & Easter by equal
portions.

John Garnet of this town, by his last will 1672, likewise gave
twelve pounds, the interest of which was to be paid by the
rector & overseers to the poor at Christmas & Easter by
equal portions.

The parishioners with these legacies and their own contribu-
tions, bought the poore Close.

Sir Christopher Nevil Knt 1692. gave to this parish thirty
pounds, the interest of which was to be paid by the Rector
& overseers to the poor at Christmas & Easter by equal
portions. The money was laid out in the purchase of
Harrisons Moor, north of the Fen lane.

Robert Jessop left to the poor of this parish by will dated
Jan 4th 1714, a rent charge of Ten Shillings a year for ever
to be paid on St. Thomas's day, out of a close known by
the name of the four Acres, which lyes south of Linga
Lane.

Poole Savage, Gentleman, late of Lincoln by his last will dated
31st July 1823 gave £200 the interest of which was to be
distributed every Christmas by the minester & church-
wardens amongst the poor of the parish of Bassingham whom
they should think fit objects of Charity.

On a handsome white marble tablet against the north wall of the
chancel in capitals (R) :

In memory of | Poole Savage, gentleman, | who after having
for the space of thirty five years | fulfilled the duties of a
confidential situation | in the city of Lincoln | with exemplary
faithfulness and ability | And | having adorned his Christian
profession by his | Decided piety his unostentatious benevo-
lence | and uniform consistency of conduct | departed this
life the 28th August 1828. | In humble yet firm hope of a
happy Eternity | through the alone merits of an ever blessed |
Redeemer | ætat. 50.

On a flat stone in the chancel (D) :

Here | lyeth the body of Martha widow | of the late Mr John
Grant | and daughter of Joseph Farmory | of Normanton
in the county of | Nottingham, gent.; she died the | 12 of
March, A.D. MDCCXLII, aged | 60 years.

This church consists of a nave and south aisle supported on
three pointed arches with round columns, a chancel, and north aisle

used as a school, a screen from the nave to the chancel, and a tower at the west end. There has once been a north aisle which appears from the piers and arches in the wall. The pulpit is carved and has on it I M D R 1674. There are some old pews and benches, and the poor box is very curious ; it is inscribed W S 1668. The font is octagon, pannelled in quatrefoils and shields.

[See also *L.R.S.* i, 243.]

(MS xii, 35–38.)

NOTE

[1] He was instituted 15 March, 1660–1, which makes an incumbency of 60 years.

Bassingthorpe

Notes taken in the church of Basingthorpe, July 12, 1834— This church consists of a nave and south aisle divided by three Norman arches and a tower and spire at the west end. The chancel is divided from the nave by a fine Norman arch with the billet moulding. The arch between the nave and tower is sharp pointed. There is a south porch, and in the south aisle a piscina. On the south side of the church yard stands a fine old manor house of stone with bay mullioned windows, the chimneys tall, and the gables ornamented with battlementing. A. L.[1] could not learn if this was the house of the Coneys of Basingthorpe.[2] It is and was inhabited by M[r] Gibson for thirty years, and is used as a farm house.

There is only one monumental memorial in this church on a flat stone in the chancel (R) rather rubbed :

In memory of | Mr Edward Powers | who dep[ed] this life | Dec. xxii, MDCCIX | in y[e] 67 year of | his age.

(MS v, 15–16.)

NOTES

[1] That is Arthur Staunton Larken, W. J. Monson's brother-in-law.

[2] This was the house of the Coneys.

Baston

Notes taken in the church, [*blank*] July, 1833—

On a flat stone in the chancel :

Here lieth the body | of Thomas Norton | who died Sept. y[e] 23, 1751, | aged 49 years. | Also Fra[s] his wife who | died May y[e] 2[d], 1759, aged | 68 years.

On another stone :

Here | lieth the body of | George Norton, Esq. | who died | June 15, 1823, | aged 56 years.

c

On another stone :

>Here | lieth the body of | T. G. Norton | who died | November 28, 1831, | in the thirteenth | year of his | age.

On a black stone in the chancel :

>Here | lieth the body of | Jacob Sawbridge, Esq. | late Lieutenant Colonel | in the first troop of | Granadier Guards | who died May 26, 1796, | aged fifty two years. | He was the only son of | Jacob Sawbridge, Esq. | of Canterbury, and | Ann Brodnax his wife | both deceased.

Another flat stone to the south much rubbed (D) :

>Hic jacet Edwardus | Stokes quondam vi | carius ecclesiæ | Sep. 7, | Anno Do' 1638.

Another flat stone to the south of the last (D) :

>Here lieth the body of | Elizabeth Standish who departed | this life April yᵉ 3, 1750, in | the 45 year of her age.

On a black stone tablet on the east wall of the chancel (R) :

>Sacred | to the memory of | William Hunt, Esq. | who died | April 5, 1823, | aged 70 | years.

On a tablet on the north side of the nave (D) :

>Sacred | to the memory of | Ann Tidswell | wife of | Benjamin Tidswell, Esq. | of Chorlton House | near Manchester | who departed this life | January 21, 1830, | aged 57 years.

On a black and white tablet against a pillar on the south side of the nave :

>Sacred to | the memory of | Edw. Johnson who died | February 1ˢᵗ, 1824, aged 74 years.

Flat stone in the nave, at the west end, rubbed (D) :

>Here | lyeth the body of | George Fo . m . .[1] yeoman | who departed this | life November the 6th, | 1679. | Near also lyeth | Catherine his wife | who departed this | life November the 26,

In the south aisle is a stone in which have been brasses of 2 figures with labels from their mouths and an inscription under, but now all gone.

At the east end of the same aisle has been another brass inscription now also gone (D).

<div style="text-align: right">(MS i, 127–131.)</div>

NOTE

[1] This inscription was evidently difficult to read in W. J. Monson's day, and it has now disappeared. The surname should probably be Banner, for the only burial about that time is that of George Banner on 6 November ; and it was a common practice at that time to bury a person on the day of his death. George Bonner had 4 hearths in the Hearth Tax Return of 23 Charles II. The burial of his wife Catherine is not to be found at Baston.

Baumber

Notes taken in the church, 17 October, 1840—This is a good modern built brick church, consisting of a nave separated from a north and south aisle by three pointed arches, and a chancel. It is entered at the west end by a neat Norman door.

On a flat stone in the north aisle (R) in old text:
> Orate pro animabus Johannis Eland armigeri Alicie et Elizabethe uxorum eiusdem qui Johannes obiit xix die Marcii Anno domini millesimo cccc° lxxiij cujus que animabus propicietur deus [sic].

This inscription is cut round the stone.

In the chancel on a grave stone on the south side:
> Here lieth the body of Priscilla | the wife of Francis Clinton alias | Fynes, Esq. who departed this | life Feb 15, A.D. 1679.

On a grave stone on the north side of the chancel:
> Here lieth the body of Francis | Clinton alias Fynes, Esq., grandson | of Henry Lord Clinton, Earl of | Lincoln, who departed this life | Feb. 5, A.D. 1681.

On a tablet on the south side of the arch between the church and the chancel:
> In a vault beneath near his beloved wife | lie the remains of John Willson, Esq. | for many years a resident of this parish. | He married Nov. 9, 1780, Mary | youngest daughter of John Tunnard | of Frampton Hall in this county, Esq. | By her he had 7 children, | six of whom survive him. | After suffering for some years | by a paralytic affection, | he was suddenly removed | from this mortal scene | at his house in Broadgate, Lincoln, | Feb. 1, 1816, aged 61 years.

On a tablet on the north side of the same arch:
> Near this place | lieth interred the body of | Mary the wife of | John Willson | who departed this life Aug. 9, | 1789, | aged 35 years. | Also | Elizabeth their daughter | who died in her infancy | March 27, 1785.

On a tablet in the south wall of the church:
> Sacred to the memory | of Joseph Barker | who was interred near this place | March 10, 1776, aged 50. | Likewise of Sarah Rowlands | relict of the above Joseph Barker | who was interred April 7, 1795, aged 53. | Likewise of the Rev^d Ellis Rowlands, | many years minister of this place, | who was interred Nov. 13, 1797, | aged 52.

On a grave stone on the left hand immediately on entering the church:
> Here lieth the body | of Mr Robert Southwell | Inter'd Aug. 8, 1724, | aged (the rest effaced).

[See also *L.R.S.* i, 135–6; Weir, *Horncastle*, p. 54.]

(MS ix, 231–234.)

Beckingham

Notes taken in the church, 10 August, 1833—

A brass plate in the floor of the chancel the inscription in capitals :

> Thomas Williamson sacræ theologiæ professor | Roberti Williamson sacræ theologiæ professoris | filius natu maximus et rector ecclesiæ de | Beckingham resurrectionem pie expectat. | Obiit anno ætatis suæ XLVIII et salutis nostræ | MDCXXXIX.

On a black tablet against the south wall of the chancel :

> Near this place lyeth | the body of the Rev. Mr | Thomas Robinson | Master of Arts late of | St Johns College Cam | bridge & curate of this | parish who departed | this life yᵉ 5ᵗʰ of March, | 1769, | aged 61 years.

On a brass plate is a stone tablet against the north wall of the chancel in capitals :

> Near | this place lies the body | of Mr Robert Hacket A.M. | of the Society of Magdalen | College in Oxon and | Rector of this church. | He was a descendant of | that worthy and learned | Prelate of the Church | Dr John Hacket Bishop of | Litchfield and Coventry. | He died December | the 19, 1733, | aged 29 | years.

This church consists of a nave, two aisles supported by four pointed arches springing from clustered columns, a chancel having in the east window some good painted glass at the top, the lower part blocked up by the altar screen ; in the other windows are some painted glass. The south porch is a fine Early English one, with the chevron and dog-tooth moulding. At the west end is a pinnacled tower.

[See also *L.R.S.* i, 226 ; Jeans, 6.]

(MS xii, 19–20.)

Beesby in the Marsh

Notes taken in the church of Beesby, 18 August, 1835—The church of Beesby consists of a nave, a south aisle divided from it by four pointed arches, a chancel, and wooden tower at the west end. The font is octagon, supported on a shaft of clustered pillars. The roof of the church is thatched, except the aisle which is leaded. There is no monument or inscription whatever in the church.

[See also *Lincs. N. & Q*, x, 202.]

(MS vi, 119.)

Belton in the Isle of Axholme

Notes taken in the church of Belton, 10 September, 1835—

An altar tomb[1] in the north aisle with a black table slab surrounded by iron rails. Arms—Three crescents [Ryther]; impaling—A saltier engrailed [Francke]. [Above the arms are two crests—(1) A jack boot spurred (Ryther); (2) A hawk (Francke)]:

> Here lyeth the body of Rob. | Ryther Esq. jun., who departed | March the 7, Anno Dom' 1695, | in the 44 year of his age.

On a similar altar tomb[1] next to the last with the arms and crest of Ryther:

> Here lyeth the body of Rob. | Ryther, Sen., Esq., who departed | Octo. the 18, Ann. Dom. 1693, | in the 62 year of his age. | Also | to the memory of Rebecca Barton widow | one of the daughters of Rob. Ryther, Esq. | and Margaret his wife, | which Rebecca married to her first husband | Edward Hartopp, Esq., and to her second husband | John Barton, Esq., both of London, | by neither of whom she left any issue living. | The s[d] Rebecca died the 4 day of January 1741, | aged 77 years, | & lies buried in St Andrews Church Holbourn | London.

On a white marble tablet against the north wall with these arms quarterly—1st and 4th, Or, on a bend sable 3 eagles displayed [for Popplewell]; 2nd and 3rd, Or, a mullet sable [Steer]; impaling—. . . . a tree, on a chief or a mullet. Crest—A greyhound's head:

> Sacred to the memory of | Robert Popplewell Steer | Esquire of Doncaster | in the county of York, | who departed this life | on the 28 day of | September, in the year | of our Lord 1826, | aged 45 years, | and whose remains lie | interred near to this monument. | He was an amiable man | in private life, and distinguished as | a kind husband | an affectionate father, | and a sincere friend.

On a monument against the east wall in the Bellwood burying place, as well as the last, with an urn over:

> In | memory of | Katharine late wife | of Alan Johnson Esq. of | Temple Belwood in this | Parish, who was the elder of | the two daughters and coheirs of | Richard Poplewell Esq. late of the same place, by Elizabeth his | late wife, whose maiden name was | Smith of Newland Park near | Wakefield in Yorkshire, which | said Katharine died 31 Jan[y] 1786, | aged 69 years | and lies interred in this chancel.

The old altar tomb of Belwood stands on the north side of the chancel, between it and the present Temple Belwood burying place. On it lies a figure, but the face quite mutilated, down the breast is a cross, there are three pannels on the south side of the tomb, in each of which a shield; the most western has this

coat—A fess embattled between three escallops . . . The next shield has a bordure engrailed, but no bearings ; and the third is quite plain :

On a flat stone (D) in front of the Belwood burying place, and at the end of the north aisle ; the inscription runs in double lines and capitals round the verge and is very deeply cut :

> Here lyethe Robert Movnsovn [esq., late of Belton, and was buried the third of Avgvst, A.D. 1555, whom God] hath called to his mercy. Also here lyeth Margaret Movnsovn [his wife only daughter and heiress of Francis Belwood, esq., bvried 24th] of Ivly Aº Domini 1570.

The spaces left blank[2] are where the edge of the stone is under the raised floor of the Belwood chapel.

An ancient flat stone in the north aisle (R) has had an inscription round the verge, the south side of which has been shamefully destroyed by the laying down of a pipe for the stove ; what remains is :

> Hic jacet Willelmus Evers Armiger et Agnes uxor eius filia et heres Willelmi Gardiner [qui obiit 3 die mensis Feb. et Agnes 16 die mensis Nov.] MCCCCC.

A flat stone in the north aisle in capitals (D) :

> Hic jacet corpus sub hoc | Tumulo Johannis[3] Sheffeld | Armigeri nuper de Beltoft, | secundi filii Roberti Sheffeld | militis qui obiit 6ᵗᵒ die Novembris | Anno D'ni 1526, et Corpus | Janæ Sleford nuper de Beltoft | senioris filiæ Johannis Sheffeld | quæ obiit 27 die Novembris, A.D. 1588.

Below in more modern characters :

> Here lyeth the body | of Richard | gentleman.

The rest is hid under the iron rails of yᵉ Belwood burying place.

Another old stone (D) has an inscription in two lines round the verge in old capitals, but much defaced what remains is :

> Hic jacet Robertus Ca[ister] . . Braken qui obiit . . . die Januarii Anno Hic jacet Robertus Caister filius prædicti Roberti sui animam exanimavit Novemb. die 5, an

A flat blue stone in the Belwood burying place, being a chapel partly railed off, north of the chancel. These arms cut over— Popplewell impaling Ryther. Crest—a cubit arm embowed . . . , holding a javelin. Below this inscription in italics :

> Hic jacet Catherina uxor | Robᵗˡ Popplewell Arm'i | filia Rob. Ryther Armⁱ | Quæ obiit 9º Janⁱ 1711, | 50 ætatis suæ, | ex qua Rob. Popplewell natus | et Ric. Popplewell hæres | solus superstes.

Below in common characters :

Also here lieth the body of Robert | Steer, Esq., late of Santoft. He | departed this life yᵉ 24 of October | 1773, aged 60 years.

Another to the north, arms the same as the last, in italics also :

Hic jacet Rob. Poplewell armʳ | 12ᵘˢ Davidis Poplewell | qui obiit 24 10ᵇʳⁱˢ, Anno Dom. 1720, | ætatis suæ 69°. | Etiam Rob. Robⁱ Poplewell qui | ob. Lond. 170²⁄₁, 15 Ætat. suæ. | Juvenis multis numˢ absolutus. | Etiam Rob. Ric'i Poplewell | Arm. qui ob. 2ᵈᵒ 7ᵇʳⁱˢ 1719, | 4ᵗⁱ Ætat. suæ.

Below in common characters :

Here also lies interred the body of Elizabeth Steer | relict of Robert Steer, Esq., late of Santoft Grove and one | of the coheiresses of Rich. Poplewell, Esqʳ, late of | Temple Belwood in the parish of Belton. She departed | this life on the 11 day of March, in the year of our | Lord 1780, & in the 61 year of her age.

Another to the north, arms Poplewell impaling—Per saltier . . . 2 trefoils slipped palewise [for Smith] :

Here | lies yᵉ body of Richard Poplewell, Esq. | late of Temple Belwood in yˢ Parish, | who departed this life 16 April 1752 | in the 64th year of his age. | He was 2ᵈ son of Robert Poplewell | late of Temple Belwood aforesaid, by | Katheᵉ his wife, one of the daughters of | Robert Ryther, Esq., of Belton. | The sᵈ Richard was sheriff of yᵉ County | of Lincoln in yᵉ year 1739, and by | Eliz. his wife, one of the daughters | of John Smith of Newland near | Wakefield in yᵉ county of York, Esq. | which sᵈ Eliz. died at Wakefield yᵉ 22 | Oct. 1751, aged 56, & is buried in Wakefᵈ | church. He had three children vidᵗ., | Robert, Katheᵉ, & Elizᵗʰ.

On another more to the north :

In memory | of Frances the wife of | Richard Ryder Popplewell Steer | of Santoft Grove, who departed | this life the 22ᵈ day of May | 1784, in the 25 year | of her age.

On a brown stone more to the north, in capitals :

In memory of W. P. B. Johnson Esq. | born 18 of April 1788, | died 3ᵈ of April, 1831.

A white marble tablet against the south pillar of the arch to the north aisle, in capitals :

Sacred | to the memory of | Jane Penelope, | eldest daughter | of Robert Popplewell | and Elizabeth Steer, | who died in the 1 day of | March 1826, | aged 12 years and 2 months. | Her course was gentle as the | newborn babe | Her mind more noble than the | towering wave | Her heart was wrap'd within | a charming frame | It burst !! she died !! but | spotless was her name.

[On the east face of the westerly of the two pillars dividing the chancel from the north choir is a small brass tablet with the inscription in italic letters :

> Here lieth the body | of Eliz. wife of Mr Rich'd | Taylor of Hyrst, who | departed this life | the 30th Nov. 1728, | Aet. 50.]

(MS vii, 91–100.)

NOTES

[1] The two tombs have been lowered, and the railings removed, to make way for the organ.

[2] The missing words have been supplied enclosed in square brackets from the collections of John Ross.

[3] John Ross gives this name as Roberti.

Bicker

Notes taken in y^e church, 30 September, 1839—This church is built upon a curious plan. The west end of the nave rests upon two fine Norman arches decorated with the nail head and chevron moulding. The westernmost pier is circular, the next is clustered. To the eastward of this is the tower supported on four lofty Early English arches springing from clustered columns, and having deep architrave mouldings. Beyond the tower, the nave and aisles continue supported on three English arches on each side which have plain piers. The chancel, which is only three paces in length, is entered by a low rectangular arch (D), the top of which is only about half the height of the building, so that the east window is visible over it. This window is a fine Early English one, lancet, of three lights, having shafts and mouldings. In the north wall is a lancet, and in the south a Decorated window. On the south side are three Early English stalls. The clerestory of the western nave is Norman, and very good ; that of the eastern low, consisting of two lancet windows, and two round ones. The other windows of the church are mostly Decorated. There are no transepts, but the aisles are straight through from east to west, and are entered from y^e tower by Early English arches. There are seven bells. The south porch is Early English, and the upper part of the tower has four Decorated early windows. The Norman clerestory on the exterior northern side is very handsome and perfect, and has the cornice formed by a nebule moulding which likewise appears on the north side.

A white stone tablet against the west wall of the south aisle :

> In memory of | the Rev^d Benjamin Hinckerman, | M.A., who was vicar of | this place during the | term of 28 years. | Interr'd Aug. y^e 28, 1744. | Obiit in charitate omnibus. | Christiana his | wife died Feb^y 24, 1747.

On a black flat stone in the chancel (D) :
> In memory of | the Rev^d Anthony Bailey | Minister of this church | & Gosberton 21 years, | who died Dec^r 5, 1795, | aged 50 years.

The eastern part of the south aisle is enclosed for the purpose of a school. The font is Norman.

[See also *L.R.S.* i, 171 ; *Churches of Holland.*]

(MS ix, 217–219.)

Billingborough

Notes taken in the church, 27 July, 1833—

On a white marble tablet south of the chancel with an urn above :
> Near this place | lieth interred the body of | the Rev^d John Towers | vicar of this parish and | Threkingham, who departed | this life November 3, 1802, | aged 82 years.

On another very similar to the east of the last :
> Sacred to the memory | of John Essington, gent., | who died on the xxviii of Oct^r, | in the year of our Lord MDCCXCIX, | and in the Lxviith year | of his age.

On an oval marble tablet against the north wall of the chancel :
> M. S. | Roberti Kelham | ecclesiarum de Billingburgh | Threkingham et Walcot vicarii | quidem plusquam 50 annos | viri probi docti faceti | qui ob. 23 Apr. 1752, æt. 75, | necnon Mariæ Kelham | quæ obiit enixa 19 Oct. 1728, æt. 41. | Rob. Kelham et Avisia Cathrop | soli ex duodecim liberis superstites | ut perpetuum sui amoris | et mæroris parentum | optimorum testimonium | hoc monumentum | posuere.

On a stone, painted like marble, against the north west of the chancel (R) :
> Sacred | to the memory of | William eldest son of the late | William Westmoreland, Esq., | who departed this life | February vi, MDCCCXXVIII, | aged 50 years, | beloved, respected, and lamented.

On a flat stone much defaced (D) :
> [Tumu]lantur | hic Thomas, | Maria, et Maria, | ætat. infantili | omnes R^{tl} Kelham | vicarii et Maria | uxor : liberi | Thomas ob. Dec. | . . 1714, Maria | Mart. 20, 1715, | Maria 2^{da} Apr. | 23, 1717.

There is a little more but too much defaced to be legible.

A tablet commemorates that, on 29 Sept., 1827, Thomas Buckberry of Billingborough, gent., bequeathed £100 to be distributed in bread on the first Sunday in the months of November, December, January, February, and March.

A white marble lozenge-shaped tablet against the south corner of the arch to yᵉ chancel, surmounted by yᵉ crest of a goat's head [Toller] :

> Johannes Toller | Armiger | serviens ad legem | obiit decimo quarto die Novembris, | Anno Domini 1737, | ætat. 53. | Moritur ut vivat.

A circular tablet below (D) :

> Revᵈᵘˢ Brownlow Toller, ll.b., | Johannis filius, | obiit quarto die Septembris, | Anno Domini 1791, | ætat. 61, | cui vivere fuit Christus mori lucrum | Memoriæ sacrum Annæ uxoris | Revᵈˡ Brownlow Toller, ll.b., | quæ annos nata 69, diem obiit | supremum mensis | Januarii 27, 1803.

Another still more below (D) :

> Sacred to the memory of | William Westmoreland, Esq., | who departed this life 28 Sept. 1816, | in the 70th year of his age.

Marble tablet against the south wall :

> To the memory of | John Saywell, gent., | who departed this life | the 3 of April 1777, | aged 45 years, | also Lydia his wife | who departed this life | December 1st, 1796, | in the 56th year of her | age.

A handsome marble tablet more to the west, with urn over, and inscription in Gothic characters :

> Sacred | to the memory of | Mary Wayet. | She was born March 31, 1770, | and died Dec. 6, 1831.

Another tablet over the south door :

> To the memory | of John Greenham | who died 11 December 1793, | aged 58 years. | Also Elizabeth his wife ! who died 5th March 1795, | aged 61 years.

Another still more to the west with these arms below—Quarterly, 1st and 4th, Argent, a bend wavy sable [Burton] ; 2nd and 3rd, Argent, a lion rampant between 7 fleur de lis sable [Buckminster]. Crest : An armed arm holding a spear proper. Motto : Ab illustri pago :

> Josephus Burton, gen. | obiit xxviii die Septembris | mdcclxi | in anno ætatis suæ | lxxii. | Thomas Burton gen. | filiusque illius | obiit xxvii die Decembris mdcclxii | in anno ætatis suæ xlvi.

A marble tablet against the wall at the west end of the nave :

> In memory of | Thomas Buckberry gent. | of this parish, | who died 7 June 1828, | aged 74 years.

A similar one below :

> Sacred | to the memory | of Mary the wife of | Thomas Buckberry, gent., | who departed this life | 12 March 1809, | aged 50 years.

Another still lower :

> Sacred | to the memory of Eliza the wife of | James Cuthbert
> Mason, surgeon, | who departed this life 15 August 1810, |
> aged 24 years, | the only child of | Tho. and Mary Buckberry. |
> Life how short, | Eternity how long.

This church is spacious and consists of a nave and two aisles
supported on three lofty pointed arches springing from high
clustered columns, a chancel, and a fine tower and spire at yᵉ west
end of the south aisle. The west window is of four lights in the
decorated style, as are the other windows. There are eight
clerestory windows each side.

[See also *L.R.S.* i, 189.]

(MS ii, 221–228.)

Bitchfield

Notes taken in the church, 12 July, 1834—This church consists
of a nave and north aisle divided by three Norman arches on tall
columns, a chancel separated by a pointed arch from the nave,
and a tower and spire at the west end. To the north of the arch
to the chancel is a pinnacled small niche, and by the pillar next
to it is a grotesque head supporting a bracket. The rafters of the
roof are supported by figures holding shields, and at the inter-
sections are ornamented. The font is octagon, pannelled with
shields in quatre foyles, but it is so much daubed with paint that
the bearings could hardly be discovered. These I made out :
(1) a lily ; (2) a bend between three roses ; (3) a mullet ; and
(4) a bend surmounted by a mullet. The east end of the north
aisle is used as a vestry. The only register A[rthur] L[arken]
could find in the chest was a modern one of marriages. On the
communion chalice is this inscription :

> Edward Saul, vicar, gave this | flagon to the church of Bich-
> field, | 1668.

On a blue flat stone (D) in the chancel is a brass plate, bearing a
lozenge of these arms—. . . , on a chevron . . . between 3 falcons
heads erazed . . . as many cinquefoyls [Jackson] ; and this
inscription in capitals :

> Here lyeth interred | the body of Elizabeth | Lack, daughter
> in lawe | to Phillip Dallowe, | esquire. Shee depar | ted this life
> the 28th | day of September, | Anno D'ni 1661, | Ætatis
> suæ 11.

On a flat stone (D) to the north of the last, with these arms cut
above, much rubbed, but seem to be—on a fesse between
3 lions seiant . . . as many crescents . . . ; crest—on an esquire's
helmet a demy lion rampant. Inscription in capitals :

> Hic jacet corpus | Philippi Dallowe | armigeri civis et |

senatoris Londinii | et hujus comitatus | irenarchæ, qui obiit | secundo die Augusti, | Aᵒ D'ni 1666.

On another stone (D), more to the north, in capitals :
Mary the wife | of | Master John Woodroffe | was | buried March yᵉ 12, | Anno Dom' 1685.

On another, to the north, in capitals :
Here lieth the | body of Will | iam Woodroffe | gent. who dyed | Octob. 17, | Aᵒ D'ni | 1652.

On a flat stone in the north aisle (D) :
In | memory of | Edward Bleuit | who died Novʳ 5, 1802, | aged 46 years.

(followed by some verses not worth transcribing.)

In the nave is a large blue stone (R) in which have been brasses of a man and woman with labels issuing from their mouths, and of two sets of children, inscription and four shields at the corners, the whole now gone.

(MS v, 11–14.)

Blyborough

Notes taken in the church, 12 September, 1835—

A fine tomb (R) of brown sand stone under the arch which divides the chancel from the north chapel on which is the figure of a priest in cope[1] and stole with a cross down his breast, on which are 4 water bougets, his hands are clasped and his head rests on a cushion supported by two angels, whose heads are broken off. The face of the priest is mutilated, but the figure and inscription very perfect, the feet rest upon a greyhound which has also been decapitated.

The inscription runs round the cornice in church text :
Hic iacet dominus Robertus Conyng quondam rector istius ecclesie qui obiit tercio die Mensis Maii anno domini millesimo ccccxxxiiij cuius anime propicietur deus amen.

At the east end or foot of the monument these arms—A cross charged with 5 water bougets ; and on the south side are three shields ; two of them are hid by a pew. The others are—(1), Quarterly, France and England ; (2), three water bougets. The cornice under the ledge of the altar slab is ornamented with roses and lions' heads.

On an altar tomb in the chapel north of the chancel (R) :
Here lyeth the body | of Edmund Southcote, Esq. | of Blyborough in the | County of Lincoln, Junior, | who departed this life | on the 28 of March 1725, | in the 47th year of his age. | Credo videre bona Domini | in terra viventium.

On a flat stone in the same chapel :
Here lyeth the | body of Edmund | Southcote, Esq. | who departed | this life on the | xxiiii of June | mdccxv, | in the |

sixty fourth | year of his age, | Expectans | expectavi | Dominum | et intendit | mihi.

On the next stone to the above more to the east :
Here lieth the | body of Dorothy | the wife of | Edmund Southcoat | Esq. who died | October 19, | Anno Dom. | 1714, | in the 60 year | of her age. | I waited long | for my | Salvacion.

On a white marble oval tablet (R) against the east wall of the chapel :
To | the memory | of | John Broadley, Esq., & Elizabeth his relict, of | Blyborough in this County. He departed this life | at Bath, the 25 of October 1794, aged 64, and was | interred in the Abbey Church of that City. His widow | died at Blyborough on the 2ᵈ of April, 1823, in the 89 year | of her age, and her remains are deposited in | the family vault adjoining this | tablet.

On a white marble tablet (R) against the east wall of the chapel with an urn over the inscription in capitals :
In this vault | are deposited the mortal remains of | Peter John Luard of Blyborough, | formerly Captain in the 4th Dragoons, | who died May 23, 1830, | in the 76 year of his age, | and of his wife Louisa Luard | daughter of the late | Charles Dalbiac, Esq. | She died January 4, 1831, | in the 70 year of her age. | To the memory of the best of parents | this monument is dedicated | by their grateful children.

An atchievement (R) against the east wall of the chapel—Quarterly, 1st and 4th, Sable, a lion rampant or, holding an estoile argent [for Luard] ; 2nd and 3rd, Gules, a chevron between three estoiles or ; impaling—Or, a tree proper, on a chief gules a black knight issuing with arms extended [Dalbiac]. Crest : A demi lion or, holding an estoile argent. Motto : Prospice.

Another atchievement (D) of a lozenge—Or, a chevron gules between three curry combs sable ; on an inescucheon—Gules, a chevron between 3 mullets or.

The church has had a north aisle divided from the nave by three very broad arches, the columns having foliated capitals. The arch between the nave and chancel is pointed, and a low tower at the west end. There is a chapel on the north of the chancel part of which is now wholly walled up. On the north side of the Communion table has been an ogee arch with a very handsome finial. It is now blocked up, but it was under this obviously that the Conyng tomb formerly stood. The font is an octagon, and the base of the shaft is scupltured with flowers.

(MS vii, 5–10.)

NOTE

[1] The vestment is a chasuble.

Blyton

Notes taken in the church, 5 September, 1835—This church
consists of a nave and aisles resting on three pointed arches on
each side ; a chancel divided by a low pointed arch ; with a
pinnacled tower, containing three bells at the west end. The
chancel was rebuilt about 1822. The west pillars of the south aisle
are clustered ; the others are octagonal. The font is of the usual
octagonal form, ornamented with foliage. There are a piscina
and locker at the east end of the south aisle.

On a flat stone within the altar rails :
> Sacred | to the memory of | the Rev^d John Alderson | who
> was 44 years curate | of Blyton. | He departed this life | March
> 17, 1830, | aged 84 years. | Blessed are the poor in spirit for
> theirs is | the kingdom of Heaven. | Also of Nancy wife of |
> the above Rev^d John Alderson | who departed this life | Sep-
> tember 4th, 1832, | aged 42 years. | The Sacrifices of God are
> a broken | Spirit : A broken and a contrite Heart, | O God,
> thou wilt not despise.

Flat stones in the chancel to the memory of (D) :
> William Harrison, died 29 Dec. 1816, æt. 64, of Wharton.
> Anne his relict, died 3^d May 1829, æt. 70.
> Elizabeth their dau^r, wife of X'fer Rogers of Gainsbro', died
> 11 July, æt. 35.
> Henry their son died an infant, 3 Sept. 1828.
> William Brumby of Wharton, 4 June 1779, æt. 41.

And in the nave to :
> Abigail wife of John Welch, died 23 Sept. 1816, æt. 75 (D).
> William Wright of Wharton, died 10 May 1818, æt. 78.
> Sarah his wife, died 23 Dec^r. 1811, æt. 63.

On a brass plate against the south wall of the chancel in capitals :
> Memoriæ Sacrum. | In expectance of the Resurrection | Here
> quietlye sleepe the little bodyes of William | and Elizabeth
> 2 of the children of S^r | John Wray of Wharton, knt and bart,
> and | the Lady Grisella his wife having | only seen the world
> and left it.

| Obiit | Ille Nov. 17 | A° D'ni | 1613 | mense ætat. | primo |
| | Illa Mart. 3 | | 1615 | | sexto. |

> Heu vix ostensam terris cur pallida sexus
> Funere crudeli Mors utriusque rapit
> Progeniem Cælis ut pignus utrique Parentum
> Filia sit Matri filius arrha Patri.
> Whom scarce the world yet saw say cruel death
> Why didst of each sex one deprive of breath,
> That either parent might in Heaven have one
> To be their pledge till they in person come.

[See also *Lincs. N. & Q.* xi, 41 ; *L.R.S.* i, 148 ; Jeans, 7.]

(MS viii, 187–189.)

Boothby Pagnell

Notes taken in the church of Boothby Paynell, July 12, 1834—
This church is handsome. It consists of a nave and aisles separated
by two Norman arches, a chancel, and a tower at the west end,
also a south porch. The arch from the nave to the chancel is
pointed, and that to the tower round. The chancel has a north
aisle or chapel divided from it by two pointed arches, and enclosed
by a railing close by the steps leading to the altar is in appearance
the base of a cross or pillar with a hole for the insertion of the shaft.
The east window is of five lights and decorated. In the chancel
windows is a little stained glass but no arms. On the south west
pinnacle of the tower is a shield bearing two chevrons [Paynell].
Over the chancel gable is an ornamented cross.

In the chapel north of the chancel against the north wall is a
handsome monument (R) of white marble having a bust of a man
in flowing wig, and a lady in the costume of Charles II time. Over
them is a blank shield of arms, and the monument is ornamented
with cherubs, drapery, etc. Below the busts is this inscription on
a white slab :

Ex antiqua Lloydorum de Melverley apud Salopienses familia |
Elizabetha Francisci Tyrwhit de Kettleby in hoc com. Linc.
armigeri. | Deinde Abelis Litchford armigeri hujus ecclesiæ
patroni et manerii | domini itemque monumenti istius marmorei
authoris conjux fæmina | præstantissima pia misericors modesta
in pauperes effusa virtute | omni et divitiis ornata ingenio
et forma clara magna cum spe beatæ | resurrectionis animam
Deo reddidit 28 Oct., A.D. 1696, ætatis suæ 63. | Tu autem
Lector quod tuum est age | Supremi Judicii memor.

Of the antient family of the Lloyds of Melverley in Shropshire
Elizabeth | wife first of Francis Tyrwhit of Kettleby in this
County of Lincoln, Esq., | afterwards of Abel Litchford, Esq.,
patron of this church, lord of this manour, | and owner of this
marble monument, an excellent woman, pious, merciful,
modest, | abounding in her charity to yᵉ poor, adorned with
every virtue and with riches, | eminent for her wit and beauty,
in great hopes of a blessed Resurrection, | rendered up her
soul to God yᵉ 28 day of October 1696, aged 63 years. | Do
you reader what becomes you being | Mindful of the last
Judgment.

On a brass plate (R) against the wall east of the last monument
with three shields of arms over—(1) [Sable], a fret [argent], a crescent

for difference . . . [Harrington]; (2) the same impaling—[Gules], a fesse between 3 water bougets ermine [Meres]; (3) the impalement alone. The inscription in capitals :

> Here lie the bodies of Katherine late wife | of Thomas Harrington of Boothby Paynell Esq. | and of Henry, Thomas, Margaret, & Eliza :, theire | children, w^ch Katherine died the 5 of May An'o | 1623, and left issue 5 sonnes Francys, | John, James, Charles, Edward, & one daughter Martha.

On a flat stone (D) in the floor below the monument :

<center>✠</center>

> Quod mortale est | Abelis et Elizabethæ | quibus erigitur monumentum | nobilius sub hoc uno marmore | defunctum vitam unam beatam | expectat | ad superos | præivit illa in antiqua fide | Secutus est hic in iisdem vestigiis | Vir vere justus post Deum Regem | summo semper obsequio colens | Amicus verus. | Cætera docet votiva tabula.

<center>✠</center>

> All that is mortal of | Abel & Elizabeth, | for whom the more noble monument | is erected, deposited under this one | marble expects one happy life, | to Heaven she went before | in the antient faith, | He followed in the same steps, | a man truly just after God, always | most religiously serving his king, | a true Friend. | The monumental tablet tells the rest.

On a flat stone (D) to the south of the last much effaced by damp :

> Here lieth interred the body of | Mr John Litchford alias [Row | land], heir to Abel Litchford | Esq., for whom the more [noble] | monument is erected, | who departed this life | June y^e 9, 1718, | and in the [31st] year | of his age.

Another more to the west in capitals (D) :

> Here lieth the body | of Elizabeth Litchford | the wife of John | Litchford, Esq., and | daughter of | Benjamin Rowland | of Sleaford in the | county of Lincoln, | who died October the [20th, | 1753, in the 40th year of her age].

On the floor of the chapel are more flat stones, seemingly to this family, but so effaced by damp as not to be legible (D).

On a neat white marble tablet (R) against the south wall of the chancel :

> The Rev^d John Rowland Litchford late rector | of this parish ob^t 25 Nov^r 1818, Et^s. 70. | He married Ann eldest daughter of | Thos Litchford, Esq., | by whom he had a numerous issue. | Will^m, Jane, & Judith died in his lifetime, | and Dorothy shortly after him. | From a sacred regard to his memory | this monument is erected by | Jno. R. Litchford, Esq., his eldest son.

There are flat stones (D) below to the memory of :
> Jane and Judith fourth and fifth daughters of Rev^d J. R. Litchford. Jane died 12 March 1818, æt. 29. Judith died 19 Oct. 1816, æt. 25.

On a flat stone (D) within the altar rails much rubbed :
> Here lieth y^e body of | Faith Garland, relict of John | Garland of Aslackby, gent., | and y^e second daughter of | John Colth[urst] of Aunsby, gent., | who departed this life October | the 10, 1707, aged 71.

Another close by in capitals (D) :
> James the son of | William and Faith | Parkins, departed | this life y^e 8 of | October 1695.

A flat stone in the chancel (D) :
> Here lies interred the Rev^d Robert Rowland | late worthy rector of this parish, | who died the 11 of Feb. Anno Dom'i | 1780, | in the 72 year of his age, | and of his pastoral care the 47.

A flat stone (D) commemorates Robert Pickin, died 14 Nov., 1808, and Mary his wife, died 22 March 1818, æt. 64.

By the entrance to the chancel is an old stone, once having an inscription round it in church text. All that remains is, 'istius eccl'ie qui cuius anime.' It has a cross cut on it, and near the steps to the altar is a similar stone with a cross but no inscription to be seen.

On a blue flat stone (D) at the entrance of the north chapel :
> Near to this stone lie the remains | of William Rowland, gent., | fourth son of Robert Rowland | alias Litchford, esq., | who died 27 March 1760, | aged 52 years, | leaving one son and three daughters | to the sole care of his widow, | Mrs Mary Rowland, | who departed this life | the 8 day of April 1815, in the | 89 year of her age. | Gratitude with filial affection inscribes | this stone to her memory.

There are also flat stones (D) to commemorate the deaths of several children of William and Mary Rowland, viz. :
> Martha died October 19, 1750, aged 9.
> William died 20 March 1757, aged 5.
> Thomas died 28 January 1758, an infant.

[See also *L.R.S.* i, 196.]

(MS v, 17–24.)

Boston

Notes taken in the church, 24 July, 1834—

Against the north wall of the chancel is a grey stone monument (R) with a brass plate having this inscription on it in capitals,

these arms being cut over—A fesse between three wolves' heads erazed [Howe] :

> Abdias Howe ss.t.p. | ecclesiæ Bostoniensis præpositus | In elucidandis S. Scripturis peritissimus | In adstruenda pura evangelii doctrina eximie pollens | In revincendis erroribus solide acutus | Hanc postquam ecclesiam xxii annos salutifero | Dei verbo fidissime pavit | Vitæ probitate spectatissima erudivit | Morum gravitate et authoritate colendissima decoravit. | Summa denique prudentia moderatus est | Morte tandem non opinata sed nec immatura ereptus est | In cælestis ecclesiæ sortem cooptatus | Luctuosum sui desiderium bonis omnibus relinquens | et relicturus | Dessiit esse Mortalis Feb. xxvii, a.d. mdclxxxii, | ætatis suæ lxvii. | Hoc quicquid monumenti dilectissimo suo conjugi | Uxor mæstissima posuit.

A marble tablet (R) more to the east in capitals :

> This tablet was erected by | Adjutant Charles Wilford | of the 40th Regiment Native Infantry | of the Madras Presidency | in grateful remembrance of | his beloved mother | Charlotte Wilford | who departed this life the 21 May 1826 | aged 47 years.

A marble tablet, surmounted by an urn, against the north wall of the chancel (R) :

> Near this place | lye the remains of | Mr John Webber, first | Organist of this church, | who died May the 5th, 1741, aged 46 years. | This monument was erected | to his memory by his musical | friends.

Against the wall at the south east corner of the nave is a brass plate (R) set in wood, with the bust of a man cut over, in ruff and skull cap with this inscription in capitals :

> Memoriæ sacrum | Thomas Lawe senator Bostoniensis | Postquam ter præfecturam hujus Burgi ornaverat | et lxxi annos in vivis compleverat naturæ vectigal exolvit | anno salutis mdclvii 3o die Octobris | Mortalitatis suæ spolia, Resurrectionis et | Immortalitatis Pignora hic deposuit. | Thomas Lawe filius ejus natu maximus adhuc mærens | Hanc ceream Paterno sepulchro accendi curavit | ao salutis mdclix xo die Augstl | Epitaphium | Dum justa persoluta sunt huic Funeri | Tenebat omnes unus atque idem dolor | Nec miror. animos omnium devinxerat | Inopum Benignus Hospitalis Divitum.

Over this in a wooden frame are these arms—. . . . on a bend 3 maunches [Thory] ; impaling—A chevron between 3 garbs [Derby].

In an old niche in the wall of the north aisle, square headed, is a brass plate with these arms quarterly of 16 coats, viz. :

> i. 3 cups . . . jessant boars heads . . . [Bolle].
>
> ii. . . . 3 maces . . . [Pulvertoft].
>
> iii. . . . 2 bars . . . , in chief 3 roundles . . . [Angevin].

IV. . . . a chevron . . . between 3 escallops . . . in chief, and a cross croslet fitchy . . . in base [Dalderby].

V. . . . a chevron . . . between 10 cross croslets , 6 in chief, 4 in base [Haugh].

VI. . . . a chevron between 3 bells . . . [Bell].

VII. Per pale indented . . . and [Holland].

VIII. . . . a chevron . . . between 3 wings . . . [Nanfant].

IX. . . . 3 foxes. . . . [Nanfant].

X. Chequy . . . and . . . , a chief ermine [Coleshill].

XI. Fretty . . . a canton . . . [Hewis].

XII. . . . 3 chevrons . . . [Archdecon].

XIII. fretty [Blanchminster].

XIV. a chevron between 3 cross croslets , a border . . . semée of roundles [Fitzwilliam].

XV. . . . , a chevron between 3 croslets . . . , and a lion passant in chief . . . [Mablethorpe].

XVI. . . . 2 bars engrailed . . . [Stayne].

The inscription below in capitals :

Here lieth Richard Bolle of Haugh in yᵉ countie of | Lincolne, esq., sonne & heire of Richard Bolle of | Haugh & of Marria his wife, daughʳ & heire of | John Fitzwilliams of Mablethorpe, esquire. Hee | had yssue by Jane his first wife, Daughʳ to Sʳ Willᵐ | Skipwith of Ormesbie, knight, Charles Bolle his sone | & heire apparent, who died in his life tyme ; Marie | married to Anthony Tourney of Cavenbie, esquire ; | Anne married to Leonard Cracroft, gent. ; Gertrude | married to Leonard Kirkman of Kele, gent. ; & Ursula | married to John Kirkman, gent. Hee had no yssue by | Anne his second wife. Hee had yssue by Margaret his third wife, | Richard, Jhon, & Jane. Hee died on yᵉ sixt daie of | Februarie 1591, & in yᵉ 85th yere of his age, after hee had sundrie tymes had charge in Fraunce, Scotland | & yⁱˢ Realme & had bene twise Sheriff of yᵉ said countie.

At the east end of the south aisle by the east window is an achievement with these arms—Quarterly, 1st, Per bend or & azure indented, 2 crosses patées counterchanged (Smyth) ; 2nd, Argent, a bear salient sable, chained or [Barnard] ; 3rd, Gules, on a cross argent 5 mullets sable [Randolph] ; 4th, or, 3 bars sable.

On the other side of the window is another atchievement with the arms—1st, Smyth ; 2nd, Gules, a chevron between nine croslets or [Kyme] ; 3rd, [Randolph] ; 4th, Argent, an eagle displayed double tete sable, charged on the breast with a trefoyle slipped or [Stukeley].

[See also *L.R.S.* i, 153–6 ; Jeans, 7–14 ; Pishey Thompson, *The History and Antiquities of Boston*, 191–198 ; *Churches of Holland*, 44–67.]

(MS v, 181–186.)

𝔅𝔬𝔲𝔯𝔫𝔢

Notes taken in the church, 25 July, 1833—

On a white marble tablet against the south wall of the chancel :

> To the memory of | William Foster | of this parish gent. | and of Mary his wife. | He departed this life | March 6, 1759, aged 57 years. | She died Decr 10, 1771, | aged 67 years.

On a brass plate against the wall west of the above, with these arms above—Azure, a fleur de lis argent [Digby] ; impaling—Gules, 3 lions rampant argent [Pauncefoot] :

> James Digby, Esq., | obt Aug. 20, Anno Domini 1751, | ætatis suæ 44.

On a marble monument next to the preceding, an urn above, and below the arms of Digby, impaling—Azure, a saltier or between four bezants, a chief ermine [Hyde]. Crest—An ostrich

> Sacred to the memory | of | James Digby | of Red Hall in this parish, esquire, | a deputy lieutenant of this county, | who died August 7, 1811, | aged 76 years. | In this church also are deposited | the remains of his parents, | James son of Kenelm Digby | of North Luffenham in the county of Rutland, | esquire, and Elizabeth his wife. | The youngest and only survivor | of their numerous issue, | Henrietta Pauncefoot, | as a tribute | of affectionate regard and grateful respect, | caused this monument to be erected.

On a monument of white marble next to the last, with a figure of a female weeping over an urn above, and below a scull, the inscription in two ovals :

> Sacred | to the memory of | George Pochin, esq., | of this place, | colonel of the | Leicestershire Regimt of Militia, | deputy lieutenant and magistrate | for the counties of | Leicester and Lincoln. | In his public capacity he was | deservedly esteemed a good soldier, | faithful, upright, and active magistrate, | of inflexible probity | and unwearied attention. | His benevolence | and uniform integrity | gained the respect and love | of all who knew him. | He died May the 13, 1798, | aged 66 years.

On a second oval is the following :

> Sacred | to the memory of | Eleanor Frances | Pochin, widow of the late | George Pochin, esquire, | of this place and daughter of | Sr Wolstan Dixie baronet | of Bosworth Park in the county | of Leicester. | Her many virtues gained her | the esteem of all good men. | She was a pious christian, a sincere | friend, and to her servants | a kind indulgent mistress. | In the charitable distribution | of an ample fortune she | appeared to consider herself | as the delegate of Heaven. | She died on the | 15 day of July 1823, | aged 76 years.

A grey marble monument with white slab on the north wall of the chancel :
> To the memory | of George Digby | who died May 12, 1797, | aged 56 years.

On a flat stone (D) :
> In memory of | George Breton | who died Dec. 23, 1791, | aged 80 years.

The font is old and curious and stands at the west end of the nave.

The following is carved in compartments in old character :
> Super : omne : nomen : Jhesu : Christi.

A small marble tablet at the east end of the south aisle against the wall (R) :
> Sacred to the endeared memory | of George Cowie Nicholls, | the beloved son of George and Mary Nicholls. | He died March 27, | in the year of our Lord 1831, | aged 6 months and 12 days.

A flat stone at the west end of the south aisle (D) :
> Here lyeth | the body of the Revd W. Dodd | vicar of Bourne, | he died August 6, 1756, aged 54. | Also Elizth his wife, | she died May 23, 1755, aged 55.

A white marble tablet above the most western pillar of the nave :
> In memory of | Thomas Rawnsley, Esq., | a deputy lieutenant | of this county, | who departed this life | August 8, 1826, in the 71 year of his age.

Another under the arch looking west :
> In memory of | Deborah | wife of Thomas Rawnsley | who died April 16th, 1808, | and six of their children | who died infants.

Flat stone on the floor below (D) :
> Edmund son of T. & D. | Rawnsley died Nov. 22, | 1788, in the fourth year | of his age.

A flat stone at the east end of the north aisle, with arms cut above— Per pale [or and azure], on a chief [gules] three leopards' faces [of the first] [Caldecott]. Crest—A raven . . . [Caldecott]. Motto : Quid non pro patria (D) :
> In memory of | John Caldecott | who died the 7th of April 1755, | aged 67 years.

A flat stone in the nave :
> In memory | of Alice Hyde the wife | of John Hyde, | who died July ye 26th, 1737, | aged 32.

More to the east on another stone (D) :
> In memory of | Catherine the wife of | the Revd Humphrey Hyde | vicar | of this parish, only | daughter of the late | John Hyde, gent., | died May the 11th, 1790, | aged 46.

On a flat stone to the north of the pulpit (D) :
In memory | of | Mary Ellen & Jos : Turner | the infant children of | the Rev^d Joseph & | Hannah Dodsworth, | who departed this life | in the year of our Lord | 1823.

On a blue flat stone in the chancel (R) :
In memory of | Hargate Dove, gent., | who died | July 8th, 1810, | aged 66.

Another to the north (R) :
To the memory of | John Dove, gent., | who died Jan^y 27, 1809, | aged 90 years. | Elizabeth Dove | wife of the above | John Dove | who died Feb^y 19, 178 . . , | aged 60 years.

Another smaller stone (D) :
James Digby, | Esq., | who died August | the 7th, 1811, | aged 76.

Against the south wall of the chancel are two hatchments : (1) Or, a chevron gules between 3 horse shoes sable, differenced by a crescent [Pochin] ; impaling—Azure, a lion rampant and a chief argent [Dixie]. Crest—On a wreath of colours a harpy or. (2) a lozenge bearing the same arms (D).

The following list of benefactors is affixed to the gallery at the west end of the nave (D) :
William Fisher of Bourn, gent., by deed 1627, & will 1635, gave estate at Tumby of £30 per an. for almshouses.
William Trollope, by will 1636, founded an hospital.
Nicholas Rand, by will 1637, lands in Holbeach & 8 acres in Bourn for the poor.
John Brown, Esq., of Stamford, gave £8.
Robert Harrington of Grays Inn, by will 14 July 1654, proved 1657, gave to the poor lands in Witham on the Hill.
Sir Thomas Trollope of Caswick, Bart., by will 1654, £100 for a workhouse.
Thomas Wilcox of Bourne, by will 1660.
Brownlow E. of Exeter, in 1726, gave an engine.
Mathew Clay of Bourne, gent., in 1742, gave the branch.

The church consists of a nave, two aisles and a chancel, with a tower at the west end. Once there has been two, but tradition reports that one was overthrown by Cromwell. The nave rests on four Norman arches springing from circular massive columns.

[See also *L.R.S.* i, 196–7 ; Jeans, Add., 1 ; *G.M.*, 1862, part ii, 739.]

(MS ii, 157–168.)

Braceborough

Notes taken in the church [*no date given*]—

On a flat stone in the chancel (R):
> Here lieth the body | of Richard Osborne, | gent., who departed | this life September yᵉ | 24 day, 1707, | in the 42 year of | his age.

On another flat stone (R):
> Here lyeth the body of | yᵉ Revᵈ Mr Joⁿ Chesel- | den rector of this | parish, who died March | yᵉ 14th, 1752, aged 55 years.

On a flat stone near the last but one (R):
> Here lyeth yᵉ body of | Frances yᵉ daughter | of Edward Osborne | and Frances his wife, | who departed this life | November the 24 day, 1707, | aged 16 weeks.

On a marble monument (R) against the east wall of the chancel north of the communion table:
> In memory of | Charlotte Anne Bowman | wife of Joseph Bowman | of Shillingthorpe, | she was an affectionate consort, | an indulgent mother, | a benevolent neighbour, | and having patiently endured | the pain of a severe and lingering disorder | calmly expired in Christian confidence | 20th March 1814, aged 42. | Blessed be thy remembrance | O virtuous woman.

A tablet against the wall on the south side of the arch from the tower (R):
> Titus Livie, Esq., | late whole store keeper | of his Majesty's yard | Halifax, Nova Scotia, | who died March the 10th, 1804, | aged 51 years.

Another white tablet opposite (R):
> In memory of | Henry Hatsell, Esq., | who died 7 Janʸ 1831, | aged 41 years.

Tablet against the north wall, an urn above and these arms below —In a lozenge—Ermine, on a bend gules, three escallops or (Wansey) ; impaling—Per pale gules and vert, three lions rampant counterchanged:
> Jane Wansey | died June 18th, 1805, | aged 25. | To the memory | of | a beloved and only child | parental affection | mournfully inscribes this | tablet.

On a flat stone in the chancel (R):
> Beneath | lie the remains of | mistress Elizabeth Cheselden, | wife of the Revᵈ John Cheselden, | formerly rector of this parish, | who died January III, MDCCLII, | aged LI years.

And on another close adjoining (R) :
> Beneath | lie the remains of the | Reverend John Cheselden, |
> formerly rector of this parish, | who died March XIV,
> MDCCLII, | aged LV years.

The following lines inscribed beneath the foregoing two :
> These stones were put down by their son Anthony Cheselden
> of London | in remembrance of a good father & tender
> mother MDCCLXXX.

There remains a stone (R) on the north side of the chancel in
which according to Holles were the brasses of Thomas de Wastney,
and his wife. There still are visible places for 4 shields, two over
the head of the knight, and two over the head of the lady ; also
for the figures and for an inscription all round.

[See also *L.R.S.* i, 198–9.]

(MS i, 117–121.)

Bracebridge

Notes taken in the church, 10 August 1833—

On a flat stone in the chancel :
> In memory | of Eliz. wife of Benjamin Hodson | late vicar of
> Bracebridge | who died Jan. 9, 1747, | aged 57 years. | Near
> here also lieth the | body of Geo. son of the | said Benjn and
> Eliz. Hodson. | He died May the 24, | 1752, aged 22.

On another flat stone :
> Here lyeth the body of | Robert Hodson | who departed this
> life | May 19, 1749, aged 35 years. | My body's buried deep
> within this grave | My faith's in Christ alone my soul to
> save.

An old stone in the nave, the inscription round the edge in old
character :
> Hic jacet Joh'es fframpton de Bracebridge qui obiit
> Anno d'ni mill'imo XXI. Cujus anime propicie*tur*
> Deus Amen.

On the slab of a standing tomb in the south aisle :
> Hic jacet Katherina 2da filia & | cohæres Joh' Wilson de
> Sheepwash Ar. | ux. Sa. Ludington de | Bracebridge Ar.
> Obiit 9 die Oct. | [16]79, Anno Ætat. 27. | If lasting life in
> well hewn stone were found | Such had the stone been that
> had cover'd th' ground.

On a flat stone in the south aisle :
> Here lies | Letticia Loding | ton ye daughter | of George |
> Lodington, Esq., and | Emma his wife | who departed | this
> life ye 16 | day of Nov. | 1723.

A broken stone and partly under a pew :
> Here lieth the body of | Mary Lodington the | daughter of Sir Richard | Halford of Wistow in | Leicestershire, baronet, | wife of Samuel Loding | ton of Bracebridge, Esq., | died Nov. 28, A.D. 1709.

On a stone tablet against the north wall :
> In memory of the Revd Thomas Nocton | vicar of the church 40 years | who died March the 25, 1802, aged 72 years. | As in Life beloved | so in Death lamented.

A flat stone in the nave :
> Here lieth the body | of | Mary Nocton | the wife of Tho. Nocton of . . . | who departed this life | the 16 day of April 1775, | in the 76th year of | her age. | Beati mortui qui in Domino moriuntur.

Another more to the east :
> Here lieth deposited the body of | Tho. Nocton, gent., | Patron of the living of Bracebridge, | late of Washingbro', deceased, | who departed this life | Sept. 13, 1766, | in the 72 year of his age.

A blue flat stone at the east end of the south aisle in capitals :
> Here lieth the body of | Frances Ludington | daughter to George Saunderson | of Thoresby, Esq., | wife to Samuel Ludington | of Bracebridge, Esq., died | June ye 30, A.D. 1687. | Here also lieth the body of | Samuel Ludington, Esq., | interred the 8th day of | January A.D. 1712. | Here lieth interred the body | of Emma the wife | of George Ludington, Esq., | who died August 14, 1733, | in the 35 year of her age.

On another more to the north in a pew :
> Here lies interred the body | of George Ludington, | Esq., | who died January ye 4th, MDCCXLV, | aged 59 years.

This church which is small consists of a nave and north aisle supported by 3 pointed arches, a chancel, and tower at the west end.

<div align="right">(MS xii, 47–51.)</div>

Brinkhill

Notes taken in the church, 17 August 1835—This church consists of merely a nave and chancel, with a niche for a bell at the west end. In the chancel is a stone (D) with a cross with a large stem, inscription round the edge, all now effaced except ⚜ ' hic '. The font is circular on a massy shaft circled with smaller pillars. In the churchyard is the shaft of a cross.

[See also *Lincs. N. & Q.* xi, 43.]

<div align="right">(MS viii, 167).</div>

Brocklesby

Notes taken in the church of Broclesby, 30 August 1835—The
church is an old building but in excellent repair, consisting of nave,
chancel, and west tower. The chancel is divided from the nave
by a very elegant pointed arch, and is ornamented by the remains
of painted glass. The floor is also handsomely paved, the windows
light and elegant.

Against the north wall of the chancel is a handsome marble
monument surmounted in the middle by the arms of Pelham—
Quarterly, 1st, Azure, three pelicans vulning themselves argent
[Pelham] ; 2nd, Gules, two buckles or [Pelham] ; 3rd, Or, fretty
azure [Willoughby] ; 4th, as the 1st. On the west side are the
same quarterings, impaling—Quarterly, 1st, Argent, two lions
passant sable [Catesby] ; 2nd, Or, two bends argent, within
a bordure gules [for Mountford] ; 3rd, Or, two bars gules, over
all a bend argent [for Martindale] ; 4th, Gules, a fret or, and
a chief argent [Cranford]. On the east side also are the Pelham
quarterings impaling—1st and 4th, Gules, a saltier argent [Nevil] ;
2nd, Gules, three lions passant in a bordure or [Earl of Lancaster] ;
3rd, Or, fretty gules, on a canton a galley [Nevil of Bulmer].
Over the centre shield is the crest of the peacock with tail displayed.
Beneath these arms are the figures of a knight and a lady kneeling.
He has his hands clasped and raised before him ; one of hers rests on
a skull ; behind him are three sons kneeling ; one of them has a
skull near him. Behind her are three daughters (one carrying a
skull) also kneeling, beneath are the following inscriptions in four
compartments in capitals :

> Hic jacet Guill. Pelham miles in juven | tute sua apud
> Scotos Gallos & Un | garos ob militiam celeberrimus in pro |
> vectiore ætate apud Hibernos Regni | Præfectus apud Belgas
> exercitus | mariscallus munitionis bellicæ sub | augustis.
> principe Regina Elizabetha | Promagister. | | In uxorem
> duxit D'nam Eleanoram Henrici | comitis Westmerlandiæ
> filiam quæ hic simul | sepulta jacet . de ea tres filios
> totidemque | filias genuit e quibus tres adhuc sunt supers |
> tites quorum senior Will. monumentum istud in | perpetuam
> parentum memoriam consecravit. | Obiit Flissingæ mense |
> Decembr' 1587 | | Boath livd at once but not at once did
> die, | Shee first, hee last, yet boath togeither lye, | Hee greate
> in deedes of armes, shee greate in byrthe, | Hee wise, shee
> chaste, boath now resolvd to yearth. | Needes must ye slendre
> shrubbs expect their fall | When statelye oakes fall down
> & ceders tall | | Bragge not of valoure for ys woorthye knight |
> Mightye in arms by deathe has loste his mighte. | Boaste not
> of honour, nobler was there none | Then Ladye Ellenore
> that now is gone. | Joy not toe much in yowthe, these children
> three | were as yow are, as they are shall yow bee.

On a white painted tablet above the last-mentioned monument :
Pietati & Solertiæ S. | Depositum magistri Thomæ Æton
Presbyteri Boswor | thiæ in agro Leicestrensi nati, hujus
Ecclesiæ Broclesbien | sis quondam Rectoris, & Scholarchæ
eximii hic subtus jacet. | qui plures per annos gregem hic sibi
concreditam tam vita exemp | lari quam officiis omnimodo
divinæ animarum curæ incum | bentibus, fideliter pascendo
et pubem juventutem, Non solum | e familia nobili Pel-
hamiana tunc temporis sicut longum supra | et ad præsens
hic florenti verum etiam circumquaque vicinam | et remo-
tiorem non tantum in ipsa studiorum incude positam, sed |
provectiorem etiam scientiis liberalibus tantum non vniversis |
arte perquam exquisita, methodo non vulgari sed mysterii
instar | penitus proficienti sedulitate opera indefessa imbuendo
perficiendo | atque exinde de patria sua optime emeritus
mortalem summa cum | laude absolvit telam suique reliquit
desiderium charissimum et annorum | satur anno a partu
virgineo 1626 placide Christiane admodum | in Domino
obdormivit | Cujus memoriæ meritissimæ e discipulis suis
| olim unus minimulum hoc meliori multo | dignæ gratitudinis
ergo posuit memoriale | Anno Domini 1668.

On the south side of the chancel is a splendid monument consisting
of an altar tomb of marble, with a large black slab at the top, on
which are the recumbent figures in alabaster of a knight and lady.
The former, who is raised about a foot higher than the other, is
clothed in plate armour, his head bare and resting on a pillow. He
has a ruff round his neck, his hands are clasped, and his sword
hangs in an embroidered belt at his left side. At his feet is a
peacock in its pride, thereon a crescent. His lady in a plaited
gown and stomacher, with close sleeves and an embroidered mantle.
She has a ruff round her neck, and her hands are clasped. Her
head rests on a cushion, embroidered, and at her feet is her crest,
a head crowned, couped at the neck. At the base of the tomb
are the kneeling figures of eleven sons and eight daughters ; seven
of the sons wear a military habit with cloaks and boots, and two
more are in civil costume. The remaining two are little ones and
hold skulls, as do two of the elder ones. Three of the eight
daughters are infants in swaddling clothes, and two are little,
and hold skulls ; the remainder are dressed like their mother.
Above the large figure is this shield of arms—Quarterly, 1st, Azure,
three pelicans vulned or, with a crescent difference [Pelham] ;
2nd, Gules, two buckles and belts . . . [Pelham] ; 3rd, Fretty,
azure [Willoughby] ; 4th, Gules, a saltier [Nevil]. Crest—A peacock
in his pride proper. Below, the following inscription in capitals
on a black slab :
Gulielmus Pelham nuper de Brocklesby in Com. Linc. Eques
Auratus. | in celeberrimis Academiis, Strasberg: Heidleberg:

Wittenberg: Leipsick: Parisiens: | & Oxoniens : magna cum
curâ educatus Artib. Liberalib: imbutus et linguas | Germanicā
Gallicā; Latinā; (nec Græcarū Rudis) non solum Callens
sed prompte | eloqui edoctus ; Ab his domiciliis Mars
distraxit ubi post varias pugnas Obsidio | nes &c sed non
sine Vulnerib: Rus se contulit Anna*m* filiam Caroli Willughby
Baronis de Parrham castam virginem | connubio sibi junxit,
ex qua liberos viginti utriusque sexus dei benedictione
accepit, | quorum septem filii & tres filiæ in vivis sunt.
Vixerunt cæteri. Reliquo temporis | consumpto justitia'
exequendo orando, scribendo, pauperes sublevando sacra Biblia
| antiquos Patres et neotericos legendo magna' gloria' adeptus
est et quid in his | profecerit Meditationes in S'ti Johan[s]
Evangeliu' editæ observationes in omnes testa | -mentorum
tam veteris qua*m* novi libros & Diatribe | in Sacramentu*m*
cæne Domini manu suâ | scriptæ & posteritati reservatæ in
perpetuum testabuntur hisce rebu*s* & annis circiter | sexaginta
transactis fide in Christu*m* constanti & charitate erga proximos
inviolabili placide in Domino obdormiens spiritu' Deo Patri
spirituu*m* corpus terræ matri | in die Resurrectionis magno cu*m*
incremento recepturus commendavit 13 Julii An' D'ni 1629.

On the eastern and western fronts of the tomb is a shield bearing
the arms of Pelham impaling Willoughby with the crests of both.

[See also Surtees Society, liv, *Diary of A. de la Pryme*, 156–7,
160–1.]

(MS vi, 125–130.)

𝔅rant 𝔅roughton

Notes taken in the church of Broughton, 9 August 1833—

A black tablet against the north wall of the chancel with these
arms above—Argent, two dolphins hauriant embowed proper,
chained or [Colston]. And below the inscription the same arms
impaling—. . . , on a bend three leaves . . . (no colours) (R) :
M.S. | amicissimo indulgentissimo viro Thomæ | Colstono
immatura nimium morte rapto | Hoc tristissimi amoris et
obsequi | monumentum marito chariss : | patrique pientiss.
uxor | liberique cum lachrymis | posuit | Vixit annos 44
obiit A° a Christo nato Millesimo | Sexcentesimo quinqua-
gesimo septimo | septima die Decembr. | Truth needs not
varnish neither can we frame | A statelier figure for thee then
thy name | For hee that Colston truly accents sayes | As
much as verse can sound as art can raise | He that would write
thine epitaph indeed | Must take the volume of thy life
indeed | How virtue had its seeds time, how it grew | How all
was water'd sweetly by Heaven's dew | What a rich crop of
goodness thou didst bear | Amidst thy family and friends so

deare | Must know the joyes of thy chaste nuptial bed | The comforts issuing from two sons wed | How thy indulgent eye and prudent care | Taught even at once thy children love and care | How just commands mixed with perswasions mild | Each servant made pay duty like a child | Thy peace within and they noe wars without | Thy wise resolves to every neighbours doubt | How thou could'st take up jarrs, make men agree | In this rough age without the law or fee | Then in the rich perfume of thine own praise | Embalm'd thoult lye, we shall not need to raise | Trophies the vast expenses of vain wealth. | Thy worth will be best monument to thyself. | Sic amicitiæ cultorem æquissimum defuncti mærens vere | et sine fuco gratitudinis ergo prosecutus est. G. H.

An oval grey marble tablet against the south wall these arms over in brass—Ermine, on a fesse 3 mullets [or] [Lister]:

Near this place | lie the remains of | Mathew Lister | late of Burwell Park | in this County Esq. | He died on the 15 day of Jan. 1786, | aged 80 years. | Years following years steal something every day | At last they steal us from ourselves away.

On a brass plate in a grey marble tablet over the south door:

In memory of | John Harrison | who died July 1, 1811, | aged 68 years. | Also of | Mary his wife | who died March 1, 1793, | aged 36 years. | And of | George their son | who died November 20, 1798, | aged 11 years.

On a white marble tablet more to the west:

Near this place | are interred the remains of | Richard Robinson | who died 15 Oct. 1811, | aged 71 years. | Also | the remains of | Mary Robinson his wife | who died the 2d of Feb. | 1789 | aged 44 years.

A flat stone in the south aisle (D):

Mr Robert Cummin | died May the 9th, | 1796, | aged 79 years.

Another stone at the west end of the south aisle (R):

Here lieth interred the body of | Mathew Thomas Lister, son of Mathew Lister, Esq., | and Mary his wife | who departed this life | October 15, 1787, aged 18 | years.

On a flat stone in the nave in two columns rather rubbed (D):

Here lieth interred the body | of George Harrison, Gent., | who departed this life | the 1st day of . . . 177 . , | aged 81 years.
Here also lies interred the | body of Eleanor the wife | of Harrison Gent. | She departed this life | the . . 1 day of Nov. 1782, | aged . . 7 years.

On another more to the east (D):

> Here lyeth the body of | Robert Eastland, Gent. He | died Nov. the 3, MDCCL , aged . . . years.

This church has been fully described in the Gentleman's Magazine, 1804, part i, p. 105, but the chancel has been lately repaired and has the arms being those of the Rector over the door—Argent, a canton sable, and a crescent for difference [Sutton]. Crest—a griffin's head. Motto—Tout jour Prest. In the village is a curious old House of a square plan with mullioned windows. Over the

door this

<div style="text-align:center">

G

W A

1658

</div>

In Harl. MSS. 1233, folios 107–8, is this note which, as it differs from the epitaph as given in 6829, I here insert:

> In yᵉ Quier at Brent Broughton is written on a flat grave-stone this: Orate pro anima Johannis Thorold utriusque Juris baccalaurei quondam Canonici Collegii de Southwell qui obiit Anno 1468, 29 Septembris. The scucheons about the stone are all gone. This was 2 Henry VII.

[See also *L.R.S.* i, 226–8 ; *G.M.*, 1804, part i, 105.]

<div style="text-align:right">(MS iii, 235–240.)</div>

𝔅urton 𝔠oggles

Notes taken in the church, 26 July 1833—

On a monument against the east wall of the chancel, the inscription on a black stone with these arms over—Quarterly, 1st and 4th, Gules, two helmets in chief, and a garb in base or [Cholmeley] ; 2nd, Lozengy and a fesse sable, fretty or [? Cheney] ; 3rd, Or, three cocks sable (R):

> Robertus Cholmeleius ex veteri | et honesta | Cholmeliorum familia | profectus ordinis armigeri, vir in | rebus agendis dum viveret acer | et industrius, in proficienda Re- | ligione vere Christianus, conci- | onatorum divinique Verbi interpre- | tum studiosissimus, et sane per- | hospitalis in hoc tumulo humatus | est qui uti pie juste et per- | quam honeste vixit inter suos | ita sanctissime fidelissimeque | maxima amicorum corona vitam | cum morte commutavit, 4º Idus Junios Aº | D'ni 1590, ætatis sexagesimo quinto.

Underneath is the figure of a man in a long robe, and two shields, each bearing the same quarterings of Cholmeley as those above, all in brass.

On a white marble tablet on the south wall of the chancel (R):

> Sacred | to the memory of | the Revᵈ John Cholmeley | second son of | the late Montagu Cholmeley, Esq., of Easton, | and 3 years & 7 months rector | of this place, where he will long

be remembered | with gratitude and affection | as the faithful pastor of the flock committed to his care. | His ministry was short, like a warning voice it was heard, | it is gone, | be ye also ready. | He died on the 4 of November 1814, | aged 41, | and left a widow, one son & two daughters | to lament his loss. | ' Blessed are the dead who die in the Lord, | for they rest from their labours.'

There are brasses fixed in the wall, under the south window of the chancel, of a knight and his lady, their hands clasped as if in prayer, and between them a shield of the four quarterings of Cholmeley, impaling— . . . on a saltier engrailed, five roundles . . . , between four lions passant [Lacy] (R).

A white marble slab in the floor of the chancel of a lozenge shape (D) :

> Augustus Fredericus | filius | Francisci et Saræ Randolph | obiit Feb^{arii} die 20^{ma} | An. Dom. 1818, | mensem agens quin^{mum}.

In the chancel are the effigies in stone of two knights in mail, and cross-legged, but the bottom of the legs are broken off. One of them is with hands clasped and in the attitude of prayer ; the other is drawing his sword and bears a shield (R).

On a monument in the south aisle, of white and grey marble, with an urn over (R) :

> Sacred to the memory of | John Hopkinson, Esq., | who died Sept. the 16, 1777, | aged 50 years, | and | Mary Hopkinson his wife, | who died Dec. the 27, 1785, | aged 64 years. | Their remains are deposited | under the two adjoining gravestones | beneath this tablet, which is here | erected as the last tribute of | filial affection and gratitude.

There is a wooden tablet which commemorates that John Speight by his last will, dated 20 July 1734, gave certain lands for instructing the poor (D).

A black marble monument against the east wall, north of the altar ; arms above—two shields ; 1st, Azure, three crosslets fiche or ; impaling—Gules, a fess ermine, between three suns [Watson] ; 2nd, Azure, three crosslets or ; impaling—Azure, a man's leg couped at the thigh armed or, between two lances argent, their points or [Gilbert] :

> Elizabetha | optima charissimaque conjux | Johannis Adamson | hujus ecclesiæ rectoris | multiplici morbo olim vexata | fracta tandem non victa | magnum reliquit sui desiderium | Majus pietatis exemplum | exultans, obiit 28º die Martii | 1692 | H.S.E. | (Etiam) | Johannes Adamson A.M. | hujus ecclesiæ per XLIX annos rector | pius et beneficus | obiit A.D.

MDCCXVIII | æt. suæ LXXIII. | Katharina demum | xxv annos totos viro suo superstes | jamque plusquam tres annos octo- genaria | ævi matura jamdudum cælosque anhelans ¡ In pace moritur iv Idd' Maii MDCCXLIII. | Katherina Adamson | filia Johannis Adamson A.M. | hujus ecclesiæ rectoris | obiit 12 Aug. Anno Dom. 1772, | ætatis suæ 78.

On a flat stone within the altar rails very much rubbed (D):
Elizabeth Aiscough | wife of William | Aiscough | departed this life | Novemb. 25, 1632.

On a stone tablet against the south wall of the chancel (R):
Gulielmi | Johannis Hopkinson et Luciæ | olim uxoris ejus dilectissimæ filii | M.S. | Qui annos viginti tres natus in eo jam erat | Ut pater in multis rebus agendis socius consilio | rumq: adjutor fieret | Cum eheu duram rerum | humanarum vicem ! |ingens ille ei Decus et prope|Animi solatium si superstes erat protinus febre | derepente sæva correptus est qui paucos | intra dies in ipso proh dolor ! flore interiit | quorum huic spei summa adolescenti | contigit honestas . Vultus ut suâ gratiâ | exornatus ita simplex plane et placidus | Et ingenuus sine contentione vox | suavis non languens neque canora | ingenium felix mira virtutis indoles | et virilis prorsus animi constantia cum | singulari morum suavitate conjuncta | quidque primæ ætatis quâ commendatio |esse videatur summa insuper accessit | verecundia cæterarum virtutum | Custos comes ornamentum.

Mater } obiit { Oct. 16º 1717º
Filius } { April 6º 1737º

Reliquiæ utriusque infra sitæ sunt | ad soli subjectæ umbilicum.

The church consists of a nave, two aisles, and a chancel. The nave and aisles are supported on three pointed arches with plain columns. From the chancel to the nave the arch is also pointed, and there is a screen (D). A tower with a spire at the west end.

[See also *L.R.S.* i, 248 ; Jeans 15.]

(MS ii, 201–208.)

Burton by Lincoln

Notes taken in the church of Burton, 5 August 1833—
On a flat stone within the communion rails (R):
Christopher Randes Esq. yᵉ sonne of | Thoˢ yᵉ eldest sonn of Hen. Hol= | bech alias Randes, D.D., Bᴾᴾ of Roch- | ester & Lincoln, Reg. Hen. 8, | leaving yᵉ hopeful progenny | of 5

sonnes & 3 daughters by | his virtuous wives Faith Dighton | & Katherine Moundeford, Feb. yᵉ 4, Anno | D'ni 1639. Fell asleep in yᵉ Lord | ætatis suæ 66.

On a flat stone, an inscription partly round the rim and partly extending into the centre of the stone on a label, the characters in good preservation, but one end is hid under the altar step. It differs, as will be seen, from Hollis' copy :

Hic jacet Robertus Suttun armiger nuper maritus d'næ Margarete filie Edwardi Suttun militis domini . . . relicta Joh'is Gray militis d'ni Powys, qui quidem Robertus obiit xxv die Novembris, Anno d'ni M°. D° XLV° quorum animabus propicietur Deus amen.

Four shields. The first—Quarterly, 1st, [Or], on a chevron gules 3 crescents [argent], between three annulets [gules] [Sutton] ; 2nd, chevron between three garbs [Sheffield] ; 3rd, three boars' heads couped ; 4th, [Argent], fretty [gules] [Boys]. The second shield is the arms of Sutton above, and the boars' heads below ; impaling— Quarterly, 1st and 4th, [Or], a lion rampant [vert] [Sutton] ; 2nd, Quarterly, (1 and 4), two lions ; (2 and 3), a crosslet ; 3rd, Quarterly, (1 and 4) ; (2 and 3), a saltier.

Against the north wall of the chancel is a handsome monument of black and white marble. In a recess kneel the figures of a man in armour, save the head, and his lady opposite, before an altar on which are books. Behind him are the figures of four sons and behind her four daughters. On the ground in the front of the altar is an infant. Over the man and over two of the daughters is a scull. Above his head are these arms—Azure, on a chevron or three roses gules [Rands] ; impaling—three fleur de lis [Moundeford]. Over her, five fleur de lis [for Moundeford]. At the top are the arms—Azure, on a chevron or three roses gules [Rands], between two pyramids of blue marble.

Below this in two columns are the following lines :

Tu quisquis fueris dives sapiens generosus | Sis patiens clemens sis liberalis amans | Dona tot hoc uno tumulo sunt clausa viator. | Ara fuit miseris area et aperta bonis | Quid tua deliquit pietas non conscia culpæ | Hoc nisi culpa fuit te potuisse mori.

In the second column :

En quam terra sinu defunctum læta recepit | et tumet adventu facta superba suo | Tu Rosa Christe Rosis clypeo nil aptius Urnam | Christopheri suavem nomen honosque dabunt. | Friend I desire noe needless Prayers of thee | But prayse God for his Saints and soe doe wee.

Below the figures is this :

To the pretious memory of hir dearest husband. | Neare unto rest the bodys of Christofer Randes Esq. & Katheren his |

wife, daughter of Tho : Moundeford of Lon, Dr in Phy :, by whom he had | issue 5 sonnes, Tho :, X'ofer, Moundeford, Hen :, John : & 3 daughters Mary, | Briget, & Elizabath.

The said $\left\{ \begin{array}{l} \text{X'ofer.} \\ \text{Kather.} \end{array} \right\}$ departed $\left\{ \text{Feb. 4, A}^o \text{ D'ni 1639.} \right.$

This church is small but neat. It consists of a nave and chancel which are modern, and a tower at the west end which is antient. At the east window are the Royal arms, and those of Lord Monson with the badge of the moon and the sun in painted glass.

[See also *L.R.S.* i, 117.]

(MS i, 213–215.)

𝕭urton 𝕻ebwarbine

Notes taken in the church, 15 August 1836—This church consists of a small modern nave and tower, in length about twenty paces, and on the north side of the nave, at the west end, a small transept or chapel with two Decorated windows and ornamented buttresses of the same style. One window is now blocked up. There are the remains of an arch in the west wall of the chapel. The font is a plain round one, on a tall pillar. There are several old stones with crosses cut on them on the floor of the nave.

Against the south wall of the small chapel is a very fine monument of black and white marble, consisting of two arched recesses orna- mented with rosettes etc., and flanked by two black Corinthian pillars with gilt capitals, and surmounted with a pediment bearing this shield of arms which is so much effaced by damp as to be scarcely discerned—Quarterly of six, 1st, [Azure, a pair of barnacles or, Horseman] ; 2nd, Or, a cross vert [Hussey] ; 3rd, Argent, a bend wavy, cottised sable [Nesfield] ; 4th, Barry of six ermine and gules [Hussey] ; 5th, Per pale chevronnee, argent and gules [Say] ; 6th, Gules, four fusils in fesse, argent [for Cheney]. Crest—On a torce or and argent, a horse's head. On the monument is the recumbent alabaster figure of a knight in plate armour. His head is bare and rests on a pillow. His arms are raised in prayer, but the figure is dreadfully mutilated, and the whole monument has suffered so much from the ravages of the damp, that it seems in a fair way of being totally destroyed. There are some remains of armour placed on the tomb. On a black marble slab in the first recess is the following inscription in capitals :

Memoriæ sacrum | Thomas Horsemanus, Eques Auratus, Thomæ Horsemani | Armigeri quondam domini hujus Manerii et Elizabe- | tæ unius filiarum et cohæredum Roberti Husei | militis, filius et hæres, | ab ineunte adolescentia | liberaliter institutus a latere fuit ornatissimo | viro Gulielmo Baroni

de Burghley summo Angliæ | Thesaurario, postea in Famulitium Reginæ | Elizabethæ adscriptus per 40 annos Serenis- | simæ Reginæ ministravit et prægustatoris | Munere perfunctus fuit.

On a similar tablet in the other recess :

Vir summa fide eximia constantia Morumque | probitate insignis XXVI die Novembris Anno | Domini 1610 ab hac luce migravit plenus | dierum atque cum in Corpore per 74 annos | tanquam migraturus habitasset . | Hujus memoriæ | Thomas Horseman Armiger eius e | fratre Nepos et hæres hoc | Monumentum charissimæ | pietatis ergo dicavit.

A stone on the floor near the monument, having had the figures of a man and woman in brass. The man is gone, but appears to have been dressed in a cloak. The woman remains in the dress of Charles I's time, having a veil. The following inscription is on a brass plate below the figures in capitals :

Here lieth interred the body of Thomas Horsman | Esq^r who was Lord of this Towne, he tooke to | wife Mary the daughter of John Tredway of Easton | in Northamptonshire. He departed this life the 2^d of | Aprille in the yeare of our Lord 1631, whose wife | in her pious memorie erected this memoriall.

Under a low arch in the north wall of the chapel is a tomb, a little raised from the ground, which has a bust in brass and two shields, now all gone, and this inscription cut round the verge now much mutilated. What remains appears to be :

Dame Alice de Pettewardyn gist icy | File de | Longchampe S. Henri. | Deu de Sa alme eyt merci.

On a flat stone in the nave with these arms cut over—. . . . a saltier [Yorke], impaling—. . . a bend between three garbs . . . Crest—An esquire's helmet and torce . . . and a horse's head erazed . . . (R) :

Wilhelmus Yorke Arm : | Filius Wilhelmi Yorke de Lessingham Equitis | obiit 2^{do} die Januarii | Anno 1725.

Another stone more to the east in capitals (D) :

Here lieth the body of | Joseph son of Thomas Smith | and Anne his wife interred | Jan. the 30, 1696, aged 16 years, | and by him lieth Ann Tho., Tho., | and Thorold Smith, sonnes | and daughter of Thomas Smith | and Anne his wife.

On an old stone to the west of the last in the old character much effaced, what remains appears to be (D) :

✠ Hic jacet | Walteri de | q: obiit XI die m | MCCCCXXVII cui

On another fragment of stone :

. . ptember y^e 30, 17

On a stone let into the wall high up on the north side of the tower arch, almost obliterated by whitewash (D) :

> Near this place lieth Anne | wife of Thomas Smith, the dau^r | of M^r Joseph Thorold of Boston, | and by her 3 children and | grandchildren | sisters aged years.

[See also *L.R.S.* i, 211–12 : Jeans, 15–16 ; Trollope, *Sleaford* 349–52.]

(MS vii, 211–215.)

Burwell

Notes taken in the church, 19 August 1835—This church is prettily situated on the side of a hill and clothed with ivy on the outside. It consists of a nave and chancel separated by a Norman arch ornamented with the chevron moulding, and a tower at the west end. The chancel is on much higher ground ; therefore there is a gradual ascent from the west. The upper half of the tower is brick ; on the south of the altar is a water drain,[1] and on the north a large carved bracket in the east wall.

Against the south wall of the chancel is a handsome black marble monument, flanked by two Doric pillars. The arms over—Sable, a bend[2] between six billets, argent [Alington, of Swinhope], impaling—Ermine on a fesse sable, three mullets or [Lister, of Burwell]. The crest is gone. Inscription on a black slab in italics :

> M.S. | Under this monument | lyeth interr'd the body of Hugh | Alington[3] of Stanigott in the | county of Lincoln Esq. ye son and | heir of Henry Alington Esq. | descended from ye family of ye | Alingtons of Horseth in ye county of | Cambridge who had to wife in second | marriage Jane the daughter of S^r | Martin Lister late of this place kt | by whom he had issue Hugh and Barbara. | Hugh died young in ye life time of his | father and lyeth here also interr'd | Obiit Junii 3º Anno Dom. 1674 | Ætatis suæ 39.

On the north wall of the chancel is a handsome white and grey marble monument with these arms—Ermine, on a fess sable three mullets or [Lister] ; on an escocheon—Or, on a bend between six cross crosslets sable three garbs of the field [Bancroft] :

> In memory of | Mathew Dymoke Lister Esq. | who died February the 9, 1772, aged 39 years, | and of Lydia, | only child of Joseph Bancroft, merchant of Manchester, | and widow of the above Mathew Dymoke Lister, | by whom she had issue, Mathew Bancroft, | John Joseph, and Lydia Boughton, | who died April the 28, 1792, aged 49 years. | Also of Grace | widow of Sir Edward Boughton, Bart | of Lawford in the county of Warwick, | wife of Mathew Lister, Esq., | and mother of the above Mathew Dymoke Lister, | who died in February 1779, aged 77 years. | The above were buried in the vault underneath. | Also in memory of Mathew

Lister, Esq., | who died Jan 15, 1786, aged 79 years and 9 months, | and was buried at Brant Broughton in the county of Nottingham [*sic*]. | This marble is erected by their descendant, | not for the purpose of drawing forth their merits or of recording | their virtue, but as an humble and grateful tribute of | affection to their memory.

A small marble tablet to the east of the last in capitals :

In memory of | Charles James | second son of Mathew Bancroft | and Sophia Lister, | who died at Guilford April 14, 1808, | aged 9 months, | and was buried in the vault of John Martyr, Esq., | of that place.

An old flat stone in the chancel partly hid by the steps to the altar, the inscription round the edge in old character (D) :

[D'nus Will's Cope]man quondam vicarius istius ecclesie, qui obiit anno D'ni MCCCCLXXXXIIIJ cuius anime propicietur [Deus. Amen].

At the west end of the nave are flat stones to the memory of :

Ann Kent died 8 July 1817, æt. 67.

John Kent died 16 Nov. 1808, æt. 72.

Elizabeth wife of John Kent died 17 June 1769, æt. 21.

Outside the church close under the south wall of the chancel is an altar tomb covered with a black slab, these arms cut on it— , three pallets . . . , over all a bend . . . [for Barkham]. Crest—Two arms couped at elbow, holding a sheaf of arrows ; this inscription below :

Here lyeth yᵉ body of Robert Barkham, | Esq., second son to Sir Robᵗ Barkham | of Totenham High Cross in yᵉ county | of Middlesex, kt, married Frances | second daughter of Sir Martin Lister | of Burwell in yᵉ county of Lincoln, | kt, & had issue Frances, Susanna, Mary, | Robert, Edward, & Michael, dyed yᵉ | 19 of May 1691, aged 47.

There are stones at the west end of the nave to :

Martha Wainwright died 6 March 1780, æt. 94.

Thomas Elvidge died 31 Jan. 1780, aged 65.

Mʳ James Ashby buried 8 April 1769, æt. 74.

Elizabeth his wife died Aug. 28, 17 . . .

The font is octagonal, pannelled with shields in quartrefoyles. The following inscription is round the base in old character in two lines :

Orate pro animabus Thome FitzWilliam, et Margarete ux' eius qui hunc fontem fieri fecerunt Aᵒ D'ni MCCCC⁴LXVIII.

[See also *Lincs. N. & Q.* x, 202.]

(MS vi, 183–187.)

NOTES

[1] This is a double piscina. [2] The bend should be engrailed. [3] For Hugh Alington, see Maddison, i, 7. [4] This part of the date is rather doubtful as the stone has been damaged, but the style of the font renders it probable that it was the fifteenth century.

Castle Bytham

Notes taken in the church, 16 July, 1834—This church consists of a nave and north aisle divided by three pointed arches, a chancel, north transept, and tower at the west end. At the end of the transept is an early English lancet window of three lights. It has a north porch, and in the church are some remains of old pewing, but it is generally removed, the church having been newly pewed. The chancel is large, and on the north side is an altar-tomb under a very large and beautiful ogee quatrefoiled arch ornamented with the ball in hollow moulding, with a fine crocketed canopy surmounted by a very handsome finial. The font is adorned with niches in trefoiled ogee arches divided by pinnacles. There is neither figure nor inscription remaining:

A white marble tablet north of the altar:

> Sacred | to the memory of | the Hon^ble William Moore | who departed this life | Nov^r 20, 1810, | aged 72 years.

A flat stone below commemorates the same.

A neat white marble tablet against the north wall of the chancel, the inscription in capitals:

> Sacred | to the memory of | Lucy wife of Walter Larkham, Esq., Surgeon, | and 6^th daughter of Henry Hopkinson, Esq., | who died in London of malignant cholera, 6 August 1832, | aged 29 years | and in the 7th month of her marriage. | This tablet was erected by her husband | in this place for the more durable record of his affection | amidst her new and attached relatives. | Her remains are deposited in the vault of St John's church, | Waterloo Road, Lambeth, Surrey.

A tablet of stone against the south wall of the chancel:

> Sacred | to the memory of | William Hopkinson | who died the 14 of July | 1793, | aged 62 years. | Also | Elizabeth relict of | William Hopkinson | who died 23 April 1817, | aged 86 years.

A similar one collateral to the west:

> To the memory of | Mary Eliz^th wife of | Henry Hopkinson, Esq., | who died | the 10 day of Oct. 1810, | aged 48 years. | Also two of their children, | Henry and Elizabeth. | Her children rise up and call her | blessed, Her husband and he | praiseth her.

Another more to the west collateral:

> Sacred | to the memory of | Henry Hopkinson, Esq., | only son of William Hopkinson | and Elizabeth his wife, | who departed this life | July the 17, 1825, | in the 71 year of his age. | He served the office of | High Sheriff in the county of | Lincoln in the year 1799. | This monument of their affection | was erected by his seven surviving | daughters.

In the chancel are flat stones to the memory of :
John Tennant, died 31 Oct. 1820, æt. 30.
Richard Green, gent., died Sept. 7, 1790, æt. 65.
John Dawkines, gent., died Feb. 9, 1812, æt. 53.

On a black tablet with an obelisk over against the wall north of the arch to the chancel in two columns :
Sacred | to the memory of | William Exton | who departed this life | January 15, 1789, | in the 59th year | of his age.
Sacred | to the memory of | Sarah wife of | William Exton | who died Sep. 11, 1807, | in the 69 year | of her age.
In memory of | Elizabeth daughter of the above | Willm and Sarah Exton, | who died | Aug. 24, 1819, | aged 55 years.

On a neat grey and white marble monument against the south wall of the nave with an urn above :
Sacred to the memory of | John Coverley, gent., | who departed this life Feb. 26, 1816, | aged 57 years. | Also to the grateful remembrance of his | dearly beloved parents. | John Coverley his father | died Jany 26, 1787, aged 77 years. | Jane Coverley his mother, | died Jany 4, 1815, aged 84 years.

On a flat stone in the nave in capitals much rubbed :
Here lyeth the body | of Thomas Wil , | Gentl , died | the day of | March. 7 | His age

On a flat stone more west (D) :
In | memory of | Alice relict of | James Wildman | who departed this life | September 6, 1818, | in the 74 year of her | age.

On another :
In memory of | Jarvis Wildman | who died Feb. 29, 1812, | aged 81 years.

Other flat stones in the nave to the memory of :
Mary wife of Saml Christr Hardy of Austen Lodge com. Leicest., died Oct. 17, 1804, aged 23.
George Hurst, died Sept. 12, 1783.
Francis Derry, died 1 Feby 1806, aged 78.
Mary his wife died Feb. 4, 1803, ætat. 68.

Two wooden tablets against the wall of the nave record the following charitable donations to the poor of this place (D) :
1716, Mrs Lydia Lee of Stamford left 20 shillings to the poor annually on St Thomas day, out of lands in Market Overton, co. Rutl., and 10 to the Minister at Castle Bytham to preach a sermon for her on the 2d Sunday in every November.
1720, Mrs Hannah Mills wife of William Mills of Exton, gent., left the interest of £10 to be paid to the poor on St Thomas day.

1733, Nicholas Mills of Castle Bytham, gent., left the interest
of £10 to be paid on St Nicholas day annually.

April 18, 1783, Mr Robert Hurst left £50, the interest to be
paid to the poor annually.

Endymion Canninge of Brooke, co. Rutland, Esq., gave the
interest of £10 to be paid annually.

John Cade of Castle Bytham gave the interest of £10 to be
given annually to the poor in bread.

[See also Wild, *The History of Castle Bytham*, 97–100.]

(MS v, 43–50.)

Little Bytham

Notes taken in the church of Bytham Parva, 16 July, 1834—
This church is curious. It consists of a nave and south aisle divided
by round arches resting on plain columns with nail-head moulding,
a chancel, south porch, and tower of Norman character at the west
end, with a Decorated (late) spire with windows. The cornice of
the tower is curiously ornamented [with quatrefoiled circles on
the east side, and with diamonds on the south side]. The chancel
is divided from the nave by a pointed arch, and on the north side
there has been a tomb under an arch with a crocketed canopy
over adorned with the hollow and ball moulding, and flanked by
two pinnacles one of which is broken off. A stone seat runs round
the chancel—[a very rare feature]—and in the place where to
appearance the altar has been are two pieces of stone projecting
out of the wall. On the south side is a double piscina, and at
each corner is a bracket. It is also separated from the nave by
an old screen. In the north wall of the nave is a niche with a
crocketed canopy and finial. In the south aisle is a trefoiled
piscina. The font is a plain octagon. On the south side of the
chancel, blocked up, is a Norman door with the billet moulding,
and in the head of the arch are two birds. The outer moulding of
the door is diaper fashion. There is a door to the north aisle,
blocked up, also Norman, with the nail-head and zig-zag or
chevron moulding, very handsome. These two doors are worthy
of examination. There is no monumental memorial of any
description in the church.

(MS v, 41–42.)

Cantwick

Notes taken in the church, 7 August, 1833—

On a white marble monument against the north wall of the chancel
with an urn above :

Near this place | is deposited all that was mortal of | Coningsby
Sibthorp, Esquire, LL.D, | who having long endured | the

extremity of pain with exemplary patience | at the age of 75, on the 13 day of August A.D. 1788, | placidly resigned the breath of life | to Him who gave it. | He was an active and upright magistrate of this county, | Colonell of the southern regiment of its militia, | and thrice chosen to represent the ancient city of Lincoln | in Parliament, | throughout life in every social relation | his character and manners inspired respect and love, | to his neighbours he was hospitable, | to his tenantry indulgent, | to all kind and beneficent, | but chiefly he was endeared to the children of his brother | whom being himself unmarried | he cherished with an affection scarcely less than paternal. | He was a true old English Country Gentleman, | a character in these times rare in all times highly estimable. | To his memory | in obedience to the last will of his brother | Humphry Sibthorp, M.D., | this monument | is with pious respect erected | by Humphry the sole surviving nephew son and heir. | Such has been the dispensation of Providence | of their collected fortunes | A.D. 1800.

On a flat stone :
Mr Wm Wetherall | died 22 July 1785, | aged 56 years. | Benjamin Wetherall | died March 10, 1799, aged 65 years. | Clarissa Wetherall | his daughter | died March 7, 1786, | aged 20 years. | Margaret & Sabina died in their infancy.

On a flat stone partly defaced :
Here lyeth ye Body | of Nath. Clarke | rector of Cannick who | dyed July 31, 1683, | & Eliz. his wife who | dyed Sept. 18, 1684, | in ye hope of a joyful | & glorious resurrection. | Here also lieth the | body of Susanna Clarke | daughter of the a Bove-mentioned | who departed October | 29, 1721, ætat. 77.

Next to the last another flat stone :
Here lyeth the body | of Susanna Clarke | of the city of Lincoln, spin : | who departed this life | Dec. 25, 1771, | aged 75 years.

An atchievement against the north side of the nave—Quarterly, 1st and 4th, Argent, two bars gules in a border sable [Sibthorp]; 2nd and 3rd, Or, a bend azure between three leopards' heads cabossed gules [Waldo]. First crest—A demi lion argent, holding a fleur de lis sable [Sibthorp]. Second crest—A monkey proper, chained azure. Motto : Nil conscire sibi.

On a hatchment against the south wall the four quarterings of Sibthorp, impaling—Gules, a chevron argent between three griffins' heads erazed or [Ellison]. Crest—A demi-lion argent, holding a fleur de lis.

On a marble tablet against the south wall of the chancel, in capitals :
Near this place | are interred the remains of | the Revd John

Sharrer | vicar of Canwick for upwards of 25 years. | He
departed this life on the 25 day of April | in the year of our
Lord | MDCCCXVIII, | aged 72 years.

On a flat stone within the altar rails :
Here lyeth the | body of Thomas | Lodington gent. | de
Merton Coll. in | Oxon., obiit 3 die Jan. | 1694, ætat. 21 years.

On the same stone :
Here lieth the body | of Mr John Wetherall | one of the senr
aldern | of the city of Lincoln, | who departed this life | Sep.
first, 1750, | aged 67.

On a blue stone to the west of the last :
Here lieth the body | of Sarah the wife of | John Wetherall
of the | city of Lincoln, who dyed | March 28, 1720, in | the
36th year of her age, | was grand-daughter | of the Rev. Mr
Nath: Clarke | Rect. of Canwick. | Here also lieth Ann
the | wife of John Wetherall | one of the senr aldermen | of
the city of Lincoln, was | grandaughter of the | Revd Mr
Nath. Clarke Rect. | of Canwick, died July 16, | 1745,
aged 49.

Another more to the south :
In memory of Ann wife | of Mr Thos Wetherall | merchant
of Gainsbro' | who departed this life Jan. 30, 1793, | aged
52 years, | also | Mr Tho. Wetherall | who died Dec. 29, 1795, |
aged 60 years.

A flat stone under the Communion table partly broken :
. | daughter of | Sarah Wetherall of
. . . | city of Lincoln who | died July 31, A.D. 1714, | aged
4 years. | A child of Love a child of Grace | Who now beholds
the blessed face | Of its sweet Jesus blessed above | And
reigning with ye King of Love | Pitying her parents for their
grief | And pointing to their sole relief | Calling Pappa and
Mamma to her. |

A flat stone in the south (R) :
Here lieth the body | of Margaret Reid | who died Jan. the
11, 1773, | aged 66.

(MS iii, 167–174.)

Careby

Notes taken in the church, July 16, 1834—This church consists
of a nave and south aisle divided by three pointed arches resting
on tall columns, a chancel, south porch, and a tower at the west
end. The arch from nave to chancel is blocked up. At the west
end, in a neat loft, is a well toned organ presented by the present
rector the Rev. J. R. Deverell, who has also given the pulpit and

reading desk. Over the altar is a copy by the rector of the picture at Burleigh of our Saviour blessing the elements, and the east window has been put in by the rector who has painted the glass in it.

North of the altar is an ancient tomb, the upper part of which is hollowed out, and has the half figures in relievo of a knight in chain mail with a coif or chapeau of the same, his hands crossed on his breast, and at his left side is a lady in robe and wimple, her hair fastened on each side of the face in rolls, her hands similarly clasped. The lower part is solid and on it is a shield bearing these arms— . . . two bars . . . in chief three escallops.

To the west of the last, without the rails is a tomb, a little raised from the ground, bearing the effigy of a knight in chain mail with a chapeau of the same, with brassards and genouailles of plate, his legs are crossed and hands clasped. He wears a surcoat open at the bottom of the front, and his sword hangs at the left side, his head is supported by a pillow held by angels, but their heads are lost, his feet on a lion. His spurs are gone, but the leathers by which they were fastened are visible. These two monuments are in beautiful preservation, especially the latter, and well worthy of attentive examination.

Against the north wall of the chancel is a handsome marble monument with these arms above (they are painted in utter defiance of Heraldic rules, but the colours may be known from a hatchment near)—Azure, a chevron between six escallops argent [for Hatcher]; impaling two wives—(2nd wife), Quarterly, 1st and 4th, Or, a plain cross vert [Hussey]; 2nd and 3rd, Barry of six ermine and gules [Hussey]; (1st wife), Gules, on a bend wavy argent three shovellers sable, beaked gules [Rede]. Crest—A cubit arm gules, fretty or, holding a laurel branch proper [for Hatcher]. This inscription below in italics :

> Underneath lieth the body of | Thomas Hatcher Esq. | descended of that antient family of the | Hatchers, for many generations Lords of | this Manour. | He was born November the iii^d, MDCLX | and dyed September the vi^th, MDCCXIV. | He had 2 wives but no issue ; the first was | Grace daughter of William Harbord, Esq., | the second was Jane daughter | of Sir Charles Hussey of Caythorpe in this | county, Bart., | who surviving him, | in memory of her indulgent husband, | erected this monument | Anno Dom. MDCCXXXI.

This follows in plain characters :

> Here is also interred the body of | Jane relict of the said Tho. Hatcher | who departed this life June the 3, 1735, | in the 80 year of her age.

On a flat stone in the floor below in capitals :

> Sepulchrum | Hujus Familiæ | ex Impensis | Thomæ Hatcheri | Armigeri | Anno Domini 1711.

On a modern brass plate in the chancel floor (D):
> Here lie the bodies of Margaret | and Mary Watson whose
> sincere | friendship and goodness was | a valuable treasure. |
> Mary Watson died the 10 of March, | 1726, | in the sixty sixth
> year of her age.

In the chancel is a large blue stone which once had the brasses of
a woman and inscription now gone (R). At the west end of the
nave is a stone with a cross cut in it.

[See also *G.M.*, 1862, part ii, 504.]

(MS v, 51–54.)

Carlby

Notes taken in the church, 20 July 1833—

On a flat stone in the chancel to the north:
> Here | lyeth interred the | body of Vrsvla | relict of Captain |
> Edward Holford | who departed | this life the tenth | day of
> May 1704, | & in the 43 year | of her age.

On a flat stone next to it on the south:
> Here | lieth interred the body | of Captain Edward Holford |
> who departed this life | the 9th day of February 1699, | in
> the 67 year of his age.
> T. B. | died 1769, | aged 66 years.

On a grey marble monument with white slab against the wall
south of the altar:
> Beneath this marble lies the body | of Elizabeth Clarke |
> late the amiable and beloved wife | of John Clarke of Stam-
> ford Baron | who died on the 8th day of Dec. 1792, | aged
> 56 years, | was by the infinite mercy and goodness | of the
> Almighty translated from | a world of pain and trouble |
> to a world of endless joy and happiness, | where with other
> blessed spirits | she's celebrating her Maker's praise. | Blest
> be the Bark which wafts thee to the shore | Where death
> divided friends shall part no more | To join thee there here
> with thy dust repose | Is all the hope thy hapless husband
> knows.

On a flat stone within the altar rails:
> Here lieth interred the | body of Mary relict of | Lister Tighe
> Esq. | who departed this life | the 20th day of Dec. | in the
> year of our Lord | 1709, | and in the 70th year of her
> age.

Upon another to the south almost obliterated what is legible is:
> Frances Tighe relict of | John Tighe one of yᵉ | daughters
> of Sir Thomas | Allen of Finchley Knt, | deceased the 24th
> of August | 1675, aged 35 years.

A flat stone in the chancel:

> Here | lieth interred the body of the | Rev[d] William Purkis, D.D., | twenty six years | Rector of this parish | who departed this life | February 25th, 1791, | aged 55 years. | John Tigh Esq. died March 11 1780, | aged 56 years.

A black flat stone to the south:

> Eliz. Clarke | died Dec. the 8th, 1792, | aged 58 years.

The church is not large or handsome. It consists of a nave and two aisles and a chancel with a tower and spire at the west end. These notes were taken with some difficulty owing to our not being able to obtain the key of the church, and therefore being obliged to copy the inscriptions through the windows.[1]

[See also *L.R.S.* i, 199–200 ; *G.M.*, 1862, part ii, 502.]

(MS ii, 5–8.)

NOTES

[1] These inscriptions have been checked by the Reverend H. P. Talbot, and, although they were copied by W. J. Monson, under such disadvantageous circumstances, they needed but little correction, and no additions.

Carlton le Moorland

Notes taken in the church of Carlton in Moorland, 10 August 1833—

On a brass plate against the north wall of the chancel, these two shields above—1st shield : On a cross five eagles displayed between four lions' heads erazed [Peterson]. Crest—a lion passant. 2nd shield : Quarterly, 1st, Three bars wavy, between nine roundles, on a chief a cannon between two anchors [Gonson] ; 2nd, On a fret nine roundles in a border ; 3rd, Per pale a saltier wavy counter-changed, voided ; 4th, On a chief three wolves' heads [Stidulf]. Crest—A goat's head couped guttee :

> Memoriæ sacrum | Roberti Peterson filii Gulielmi Peterson Armig. et | Ursulæ uxoris ejus filiæ Benjamini Gonson armigeri | et questoris Regiæ classis Qui post hanc vitam | cum laude et virtute peractam multum desiderati | hinc ad meliorem feliciter commigrarunt Ille sci | licet 20 die Martii anno D'ni 1608, ætat. suæ 67. | Hæc vero 20 die Maii 1611, ætatis suæ 57. Quibus | unica tantum suscepta proles Ursula Thomæ | Disney filio et hæredi Edwardi Disney Arm'i ma|trimonio sociata Eaque binos filios eidem peperit | viz. Edwardum qui Jan. 15, 1610, menses natus undecim | necnon Thomam qui April' 25, 1612, unum natus annum | & 5 dies e vita sublati hic etiam depositi jacent | Iidem Thomas et Ursula uxor eius hoc officii amoris | & doloris eorum monumentum mæstissimi consecrarunt.

On a white tablet with an urn over it south of the chancel (R) :
> Sacred to the memory of | Peter Halliday | who departed this life 3 Jan. 1796, | aged 42, | also to the memory of | Sarah Challans his mother | who departed this life 6 April 1796, | aged 75. | Blessed are the dead who die in the Lord.

On a white marble tablet next to the last with an urn over it :
> Sacred to the memory of | John Halliday M.D.| who died April XXII, MDCCLXXX, | aged XXX years. | Not less esteemed | for the amiable qualities of his heart | than admired | for the universality of his knowledge and | brilliancy of understanding, | with unremitting industry | he attained to a degree of eminence in his profession | superior to most | at so early an age, till languishing | under the affliction of a tedious disorder, | which he supported | with patient resignation, calm fortitude, | and | religious acquiescence, | he composedly awaited | his dissolution | to ascend those immortal regions | where his virtues | can alone | be truly ascertained | and justly rewarded.

On a brass plate in the chancel floor :
> Here | lieth the body of the Rev^d | Henry Smith A.M. who was | vicar of this church 37 years | and departed this life in the | 28 day of September 1762, | aged 72 years.

On loose brass plates that have been taken out of the church floor :

On the first plate[1] :
> Here | lies the body of Mr | Richard Eastland, | he departed this life | September the fourth, | Anno Dom. 1712, aged 56. | Also Anne his wife, | she departed this | life July the | sixth, Anno Dom. | 1736, aged 73.

On the third plate[1] :
> In memory of | Mrs Mary Eastland | who departed this life | May the 19 day, 1739, | aged 44, daughter of | Mr Richard and Mrs Ann | Eastland.

On a flat stone [on floor of chancel] :
> In memory of | the Rev. | Thomas Seddon | late vicar, | who died the twentieth | day of March 1799, | aged 73 years. | Philippa daughter of | the Rev. | Thomas and Ann Seddon | was buried the sixth day | of September 1761, aged 4 years.

A brass plate let into a stone against the north wall of the chapel these arms over—Quarterly of six coats, 1st and 6th, On a fesse three fleur de lis (Disney) ; 2nd, a fesse dauncey between three escallops [Dyve] ; 3rd, three lions passant guardant [Amundevill] ; 4th, . . . , on a chief two mullets ; 5th , billetty . . . , a lion rampant. The inscription in capitals :
> In hac capella iacent Johannes Disney secundus filius | Johannis Disney de Norton Disney Armig. et pater | Gulielmi

Disney de Norton prædict. qui uxorem | duxit Elizabetham filiam [*blank*] Walcott de | Walcott Armig. ex qua tres filios Thomam scilicet | Jacobum et Anthonium genuit et obiit circiter | anno D'ni 1556, ac etiam prædictus Thomas Disney armig. | filius et hæres . . . Johannis prædicti qui uxorem duxit | Katharinam filiam Augustini Porter de Belton | Armig. ex qua filios 4 viz. Edwardum Johannem Hen | ricum et Thomam genuit Obiitque 17 Aprilis 1568. | Necnon Edwardus Disney prædict. Armig. cui nupta | fuit Jana filia Willhelmi Thorold de Harmeston | Armig. ex qua 5 filios suscepit vizt, Thomam Henricum | Gulielmum Johannem et Richardum totidemque filias | Katharinam scilicet Janam Mariam Annam et Elizabetham. | Atque obiit 7 Septembris Anno D'ni 1595, ætatis suæ 46.

On a white marble tablet (R) against the north wall surmounted by an urn :

In memory of | Robert Tonge gentleman | who died 26 November 1795, | aged 59 years. | Also of | Elizabeth his wife | who died 30 Nov. 1811, aged 69 years, | and of Eleanor their daugh^r who died | in her infancy.

A brass plate in the floor below (R) records the same people.

An oval black marble tablet more to the east :

Near this place | lie the remains of | John Tonge | late | of Grantham in this county, | chemist and druggist, | who died 6 of Oct. 1817, | aged 32 years.

On loose brass plates lying in the chancel having been taken up from the floor of the chancel :

The second plate[1] :

Here lyeth y^e body of | Sarah Eastland who | departed this life July | the 20, 1725, aged 26. | Memento[2] mori. | Here lyeth also y^e body of | Gill Eastland by his mother | who departed this life March | the 12, 172$\frac{5}{6}$, aged 8 months.

The fifth plate[1] :

In memory of Mr. Joseph | Tonge who departed | this life July | 21, 1765, aged 54 | years.

The fourth plate[1] :

In memory of Mrs Rebecca | Tonge the wife of | Mr Joseph Tonge who | departed this life | 9 Sept. 1764, aged | 57 years.

On a flat stone in the chancel :

In memory of | Anne wife of | the Rev^d | Thomas Seddon, | vicar, | who died the thirtieth | day of July 1785, | aged 65 years.

Another more to the west :

In memory of | Anne Brocklebank | who in her first marriage |

was the wife of | Peter Halliday, | and in her second of | the
Rev^d W. Brocklebank. | She died Sep. 23, | 1820, | aged
59 years.

The church consists of a nave and chancel, and north chapel
now used as a school, with a pinnacled tower at the west end.

[See also Jeans, 17–18.]

(MS xii, 27–34.)

NOTES

[1] These plates are now affixed to the south wall of the chancel,
above the door. [2] A skull is carved here.

North Carlton

Notes taken in the church, 2nd Sept., 1828—This day we made
an excursion to North Carlton. I shall first begin with the church.
It is a very neat, small edifice, but contains only two memorials
of the Monson family. These are inlaid brasses in the chancel.
One, about 12¾ inches by 5⅝ inches, rather to the south of the
chancel, is as follows in capitals :

Here lieth the body of S^r Robert | Mounson k^{nt} the 3 sone
of S^r John | Movnson of Sovth Carleton in the | covnty of
Lincolne who | was the last pvrcheser of | North Carleton
after the | death of his father.

In the right hand bottom corner are the following arms—Or, two
chevronels gules, with a mullet for difference [Monson] ; impaling—
. . . , a cross between four cinquefoils . . . [for Clayton].

The other brass, measuring 22½ inches by 5⅝ inches, is rather to
the northward, in capitals :

Here lieth the body of Edward Monson | Esq. the eleventh
son of S^r John Monson | Jvn^r late of Bvrton Barr^t who
departed | this life Sept^r 7^{th} Anno Dom : 1714, aged 46
years.

Above the inscription are the arms of Monson, with a martlet for
difference.

[See also *Jeans*, Supp. Add., 3.]

(MS Supp., 28–29.)

South Carlton

Notes taken in the church, 1st September, 1828—The church
is a very neat building and the approach to it down the hill, pretty.
Over the porch of entrance is an old cross. In the aisle is a stone
with an inscription round it but now almost illegible, a little further
on one from which brasses of inscription and arms have obviously
been torn, and nearer the chancel another in which also there has

been a brass for an inscription. All these probably were Monson monuments. In approaching the chancel is a handsome old oak screen, and over the arch in the carving are four shields, the two centre are obviously the Monson arms impaled with those of Anderson and Oxenbrigge, but those at the side, in being repainted, are left only Monson, impaled with argent and with azure. In the two first mentioned only is the bloody hand.

The Monson burial chapel is on the north of the chancel. The first object on entrance which must attract the eye is the splendid marble standing tomb to Sir John Monson. The knight and his lady, the former in complete armour, lie extended, their heads resting on cushions ; one of his arms falls over his thigh, the other is at his side, as are both of hers. He has both beard and moustachios, the legs have been broken off ; her figure is more perfect ; she is in a figured dress, and the length is about 5½ feet. They lie under a canopy supported by six grey marble columns. It has been richly ornamented in the ceiling and with the following decorations on each side : On the east the monument is surmounted by the arms of Monson impaled with—Argent, a lion passant between three crosses patee fiche [gules] for Dighton. Beneath, on the pediment, in a small shield are the arms of Monson impaled with Anderson. At the base of this side are two figures, male and female, kneeling at a desk with books before them. They are mutilated, the male figure being partly divided. On the south side the canopy bears the inscription, and on the frieze of the pediment are the arms of Monson, impaled with—Per bend indented or and azure, two crosses patee counterchanged (Smith). The next shield, Monson, impaled with—Argent, a saltier between four martlets gules [Clayton]. And the last shield on this side, being the Monson arms, with—Argent, a bend undee sable (Wallop). No doubt these are the coats of Anthony, Sir Robert, and Sir William Monson. On this side are at the base two female and one male figures. The female figures, one in particular, are very perfect, but the male is without his head. The height of the most perfect figure (they are all kneeling) is three feet. The west side is surmounted by the Monson quarterings, as thus, Monson, Hussey, Nesfield, Hussey, Say, and Cheney. These are in a large shield. Beneath was a coat of arms on the frieze, but now broke down ; there are no figures on this side. On the north side are the arms of Brown, Reresby, and Dymock, impaled with Monson on the frieze. On this side also there are two women and one man, but much mutilated. The length of the monument where the pillars rise is 7 feet 4 inches, but from the base 9 feet 10 inches. The breadth 6 feet above, below 8½ feet. The kneeling figures are as to the men in ruffs and half armour, the women in frills with a head-dress thrown over the head. There were more figures round it. Three men and two women are lying in the corners of the chapel.

F

In the inner part of the chapel are the tombs of Sir H. Monson and Lord Monson and the atchievements of the 2nd, 3rd, and 4th Lord Monsons. In the outer part of the chapel are two iron helmets and two iron gauntlets.

[See also *L.R.S.* i, 150.]

(MS Supp., 18–21.)

NOTE

The great tomb, which is described above, was the work of Nicholas Stone, statuary and master mason to James I and Charles I, and architect, as is shewn by an entry in one of Stone's note books in the Soane museum, a copy of which was sent to the present Lord Monson by Mr Walter L. Spicer in 1913.

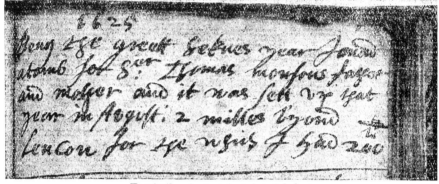

Facsimile of what is printed below

1625

Be[ng] the greett seknes year I mad a tomb for S[er]: Thomas Monsons father and mother and it was sett vp that year in Avgvst, 2 milles b'yond Lencon for the which I had 200[ll]

Stone, who was born near Exeter in 1586, and died in London in 1647, studied for his craft in London under Isaac James, and in Holland under Pieter de Keyser, son of Hendrick de Keyser, the famous sculptor. Returning to London in 1614, Stone executed various works in London. He is best known by his monuments, which are in the late debased Renaissance style, known as Jacobean. Among the tombs made by him were those of Thomas Sutton in the Charterhouse, Sir Thomas Bodley at Oxford, Dr John Donne in a winding-sheet in St Paul's cathedral, and Lord-chief-justice Coke at Titteshall in Norfolk. An account-book of Stone's, containing details of many such works, which had been purchased by Horace Walpole, was sold at the Strawberry Hill sale to Sir John Soane, and is now in the Soane museum, Lincoln's Inn Fields.

Caythorpe

Notes taken in the church, 9 August, 1833—

The following inscriptions are on brass plates in a chapel north of the tower, which here stands in the centre of the church between the nave and the chancel :

> Here is the body of Charlotte | Hussey wife of Sir Edward | Hussey who dyed Aug. 30, | 1695, in the 31 year of her | age, by whom S^r Edward | had eleven children.

> Here is the body of Ann | Hussey daughter of S^r | Edward Hussey and | Charlotte his wife who | departed out of this life in | April 1696, in the sixth yeere | of her age.

> Robert Hussey son of Sir | Edward and Elizabeth | Hussey was born May the ninth, | 1706, and departed out of | this life on the 31 of the | same month.

> Here is the body of Daniel | Hussey son of S^r Edward | Hussey and Charlotte | Hussey, he departed out | of this life Nov. 1696, in the | 4th year of his age.

A handsome marble monument against the east wall of the north aisle, ornamented with cherubs and garlands, these arms above— Quarterly 1st and 4th, Barry of six argent and gules [Hussey]; 2nd and 3rd, Or, a cross azure, a crescent sable [Hussey]; impaling—Or, 3 calthrops and a chief sable [de Vic] :

> Underneath | lies the body of | Sir Edward Hussey of Wel- bourne, Bart, | son and heir of Sir Charles Hussey of the second branch | of the antient and noble family of the Husseys, | a gentleman of great learning, virtue, integrity, | and singular love to his country, which he served | many years in parliament with honor | as one of the representatives of the city of Lincoln. | He had by his first [wife] Charlotte, only daughter of | Daniel Brevint, D.D., Dean of Lincoln, eleven children, | who all dyed unmarried except two, viz. | Charlotte late wife of Thomas Bochin[1] Esq., | and Sarah, first the wife of Robert Cawdron, | and now of Weston John Smith, Esq. | By his second wife Elizabeth daughter of Sir Charles de Vic, Bart, | (son of Sir Henry de Vic, Bart), | he had three sons and one daughter, viz. | Anne Charlotte, Henry, Robert, and Edward. | Sir Edward dyed February XIX A.D. MDCCXXIV aged LXV. | Henry succeeded him in his honour and estate, and dyed unmarried | February XIV, MDCCXXIX, aged XXVII. | Anne Charlotte, Robert, and Edward dyed young. | In memory of her husband and children who all lie here | Elizabeth his widow set up this monument | A.D. MDCCXXXII intending it both for them and herself. | Near this place lieth the body of the said | Elizabeth Lady Hussey. | She died January the XXI, | A.D. MDCCL aged LXXVIII.

On a white tablet against the north wall :
> Rebecca Pickworth Atkin | sister of the late Capt^n Pickworth
> Horton and wife | of Mr John Atkin who was of Asgarby
> in this county, | died at Lambeth in Surrey, | August 7,
> 1817, | aged 35 years, | her remains being deposited near
> this place. | We wept when we remembered Zion. Psalm
> CXXXVII.

On a small monument adjoining :
> Sacred to the memory of | Pickworth Baxter Posthumus
> Horton Esq. | son of Pickworth Horton | late Captain in
> the 61 Regiment of Foot, | who at the age of 28 years | fell
> in the arms of victory | at the battle of Salamanca | on July
> 22, 1812, | as he lived honorable & beloved | so he died
> glorious. | Art thou indeed dear youth for ever fled | So quickly
> numbered with the silent dead | Yet though we now lament
> with deepest woe | We patient bow for God ordained it so.

On another monument with these arms—Argent, three martlets in
pale sable between two flanches or charged with two lions passant
of the 2^d ; crest—A buck's head erazed [the arms of Browne] :
> In memory of Wm. Pickworth gent. | the remains of a family
> who lived | in good repute some hundred | years in this
> parish. | He died Oct. 29, 1745, aged 45 years. | Also Rebekah
> wife of Mr James Horton | daughter of W^m & Cath. Pick-
> worth | who died August 18, 1753, | aged 24 years. | Also
> Cath^e wife of the above W^m Pickworth | who died July 22,
> 1782, aged 76 years, | also Pickworth Horton gent. | who
> died Sept. 18, 1783, | aged 31 years.

At the west end of the north aisle a black tablet with these arms
under—Gules, a bend engrailed argent, on which three escucheons
azure [for Shield] ; the motto—Pro Rege Lege Grege :
> In a vault | near this place | lie the remains | of | William
> Shield Esq. | who departed this life | on the 29 Nov. 1812, |
> aged 53 years, | also of | Sophia daughter of | William & Jane
> Shield | who died in the year 1811, | aged 12 years, | likewise
> of Henrietta | an infant.

On a white tablet above :
> Sacred | to the memory of | Rich. Metheringham gent. | who
> died Feb. 19, 1783, | aged 65 years. | Also | Ann relict of the
> above | Rich. Metheringham gent., | and only daughter of |
> Henry Swan surgeon, | late of Fenton in this county. | She
> died Sept. 28, 1789, | aged 58 years.

On another tablet :
> In a vault beneath | are deposited the remains of | Alexander
> Bassett | second son of Alexander | Richard and Elizabeth
> Bassett | of Frieston | who died on the 26 day of July 1807, |

aged 3 years & 2 months. | Happy infant early blest | Rest in peaceful slumber, rest. | Also Ann widow of | Lieut. Col. William Atkinson | of the 69th Regiment, | and mother of the above | Elizabeth Bassett. | She died Feb. 13, 1830, | aged 86 years.

A handsome white marble monument against the east wall of the south aisle. In the middle is the bust of a man in a cap, on a pedestal, inscribed ' W^m Palmer fecit ', these arms over—Quarterly, 1st and 4th, Azure, a cross or; 2nd and 3rd, Barry of six argent and gules [Hussey]; impaling—Or, an inescucheon within an orle of martlets sable [Brownlow]. On a white marble slab below the bust this inscription in italics :

Here lyeth | waiting for the | Resurrection the body of | the Hon. Sir Charles Hussey of Caythorpe in the county of Lincoln, Bart., Lord of | this Mannour and one of the Gentlemen of his Majestys most Hon^{ble} Privy Chamber in | extraordinary, and dear husband of Elizabeth eldest daughter of S^r William Brownlow | of Humby in the said county, Bart., by whom he had seven sons and eight daughters | who, serving his country in Parliament Anno XIII° of king Charles the II as knight of the shire | for the said county, departed this life at London, December II in the XXXIX year of his | age, and was interred here December XVI, A.D. MDCLXIV. | And near him lye the bodys of his said wife Elizabeth who was born August IX, | MDCXXX, and dyed at London, December XXV, A.D. MDCLXXXVIII, | whose extensive charity and affection to her children nothing could exceed. | And of Mrs Anne Brownlow XIX child of the same Sir William Brownlow, Bart., who died | August VI, MDCCXX, aged LXVIII, | whose whole life was employed in doing good to the afflicted and distressed. | And of Mrs Anne Hussey a maiden daughter of the said S^r Charles Hussey who died | August VI, MDCCXXVII, aged LXXII. | She was steadfast in the Religion of the Church of England, a true lover of her family, | and her sincere friendship and goodness made her justly valued by all that knew her.

A brass plate in the floor of the pew below :
A. H.² ob. Aug. 6th, 1727. | She was a daughter to S^r Charles | Hussey of Caythorp, knt and bart. | He was one of the Bed Chamber and Privy Councellor to his sacred | Majesty King Charles y^e second. He married Elizabeth y^e eldest | daughter of S^r Will^m Brownlowe, | bart., of Humby in the county | of Lincoln, by whom he had | seven sons and eight daughters.

On another near (D) :
Thomas Hussey Esq. son of S^r | Edw. Hussey, Bart., by his first | wife Charlotte only child of Dan^l | Brevint, D.D.

and Dean | of Lincoln, departed this life May | the 30, 1720,
in the 25th year of his age.

On another more to the west (D) :

Here lyeth the body | of Anne Brownlow daughter | of Sr
William Brownlow of | Humby in the county of Lincoln,
Bart., | who departed this life on ye 5th day of | August 1720,
aged 72 years.

Another near in capitals partly hid by a bench (D) :

Here lieth the body of Augustine Reed | who departed this
life | the 23 of April 1687, ætatis suæ 39.

On a black tablet against the south wall :

Near | this place lieth the body of | John Holmes gent. |
who departed this life May 14, 1783, | aged 83 years. | Also
Millicent Holmes relict of | the above who died Jany 24,
1795, aged 88.

On a white stone tablet more to the west :

Near this place lyeth the body of | Mrs Mary the wife of |
John Holmes, gent., 2nd daugh- | ter and coheir of William
Thorpe | of Fenton, gent., interred Sept. 5, | An : Do : 1730,
aged 62 years. And of | Mrs Judith ye eldest daughter | of
ye said John & Mary | interred March ye 31, 1717, | aged
19 years. And of | Mrs Elizabeth ye 4th daughter | of ye
said John & Mary | interred March 16, A. Do. 1732, | aged
24 years, waiting for a joyful Resurrection | in dust doth
lye, | a most affectionate wife | and loving children by : |
And also of Mrs Mary the 2nd daughter of ye said John &
Mary | interred Dec. ye 21, A. Do. 1745, | aged 46 years. |
Underneath lyeth the body of John | Holmes, gent., interrd
Dec. ye 20th | An. Do. 1726, aged 78 years. | Nihil certius
mortc Hora nihil incertius.

A small square marble tablet more to the west :

To the memory | of Edward Smith, gent., | who died 3 June,
1773, aged 66, | & Eleanor his wife | who died Feby 3, 1783, |
aged 71 years.

A black tablet more to the west :

Sacred to the memory | of Mrs Ann Smith | who departed
this life | the 26 of Feb. 1806, | aged 62 years.

Another more to the west :

To the memory of | Edw. the son of | Ed. & Eleanor Smith |
who died 21 of August 1799, | aged 57 years. | Also of Edwd
his son | who died 1st of March 1784, | aged 6 years.

A stone monument ornamented with two pillars to the west of
the south door :

Near this place | lyeth the body of | Robert Dawson, gent., |
who departed this life | April ye 3, 1729, aged 73 years. |

Also near this place lyeth | the body of | Henry Dawson, gent., | nephew and devisee of the | abovesaid Robert, who | departed this life Nov. 19, 1738, | aged 32 years. | And also near this place lyeth | the body of Frances daughter | of Henry Dawson, gent., and | Mary his wife, who departed | this life Feb^y 8, 1739–40. | And Robert son of the above Henry | died June 15, 1758, aged 25 years. | Also Sarah daughter of the above Rob^t | and Sarah his wife, died June 27, 1759, | aged 10 months.

This church is curious from having no nave but two aisles resting on three handsome pointed arches with lofty pillars. The tower is between these, and the chancel and the four arches that support it are lofty and fine. Above it is a tall spire. Over the arch from the body to the tower is a curious painting partly covered by white wash, representing the Last Judgement. Over the Hussey monument in the north aisle are five pennons of their arms.

[See also *L.R.S.* i, 232.]

(MS xii, 5–18.)

NOTES

¹ This name should be Pochin. ² This was Anne Hussey, who died unmarried.

Claxby by Normanby

Notes taken in the church, 29 August, 1828—

On a brass plate, measuring 17 inches x 5½ inches, in a stone in the middle of the chancel, very near the communion table, in capitals :

Here lies Iane Burnaby wife of Richard Burnaby | of Rugbie in the county of Warwicke, Esq., daughter | of Iohn Monson of Northorp in the county of | Lincoln, Esq., by Mary FitzWilliams his II^d wife, | who died the 27th of March 1653.

On another brass, measuring 10⅝ inches x 9 inches, also in the chancel, a little more to the west of the previous one, and near her father's stone, with the arms of Monson (with a martlet for difference), impaling FitzWilliams, with the following inscription in capitals :

Here lyeth the body of Mary Monson | wife of Iohn Monson of Northorpe | in the covnty of Lincolne, esqvire, | and davghter of William FitzWilliams, | of Claxby in the sayd covnty, esqvire, | who departed this life the XXIX | of Avgvst A° D'ni MDCXXXVIII.

The inscription to her father begins :

Gulielmus FitzWilliams Armiger | a° ætatis suæ altero supra LXXX | Arma Militiæ huius deposvit | Weepe, poore men, weepe

here our mortality | Laied a Maister in Hospitality. | How
he was religious, faithfull, constant, | Twenty seaven Quietus
est's demonstrant. | From worldly troubles he nere found
true rest, | Untill from God he bad Quietus est.
Anno D'ni 1634, | mense Julii die decimo tertio | vivat in
æternum.

[See also *L.R.S.* i, 99–100 ; *Lincs. N. & Q.* xix, 49–51.]

(MS Supp., 11–12.)

𝔑orth ℭockerington 𝔖t 𝔐ary

Notes taken in the church of South [*sic*] Cockerington, 24 August,
1835—This church has been rebuilt by the late Mr Emeris, and
consists of a nave and south aisle, which are parted by two pointed
arches, chancel, and tower at the west end of the south aisle. The
church is in an unfinished state, not being floored as the munificent
rebuilder did not live to complete it. In it remains the figure of
a knight which is much mutilated ; the legs and arms are gone.
He is in plate armour with a gorget of mail. It is ascribed to Sir
John de Cockerington, but more probably was one of the family
of Scotney.

[See also *Lincs. N. & Q.* x, 204.]

(MS vi, 109.)

ℭoleby

Notes taken in the church, 8 August 1833—

Against the south wall of the chancel a white marble monument,
with an urn above, and these arms below—Ermine, on a fess [sable],
three mullets or [Lister] :

> Sacred to the memory of | Mary Lister | second daughter
> and coheir of Thomas Lister of Coleby | in the county of
> Lincoln, Esq. | She was a woman of very good sence, | sub-
> missive and condescending to her superiors, | affable and
> courteous to her equals, | easy and humane to her inferiors,
> agreable and obliging to all, | of strict virtue and singular
> piety to her great Creator | to whom she rendered her soul
> the 6th of March A.D. 1734. | She was the last of the antient
> family of the Listers of Coleby, | and left her estate to her
> nephew Thomas Scrope, | son of Gervase Scrope of Cockering-
> ton in the county of Lincoln, Esq., | who in gratitude to her
> memory erected this monument.

On a flat stone in the aisle :

> To the memory of | Susanna the wife of | John Oxby | who
> departed this life | the 13 day of July 1812, | aged 50 years.

A blue flat stone within the altar rails :
> Here lyeth the body of | Mary Lister | the 2ᵈ daur and coheir of | Thomas Lister of Coleby Esq., who departed | this life March the 6, A.D. 1734, | aged 47 years.

The church is curious. It consists of a nave separated from the north aisle by two Norman arches with the billet moulding, resting on plain round columns, and from the south aisle by two arches pointed springing from clustered columns with foliated capitals. At the east end of the chancel are three lancet windows and a pointed arch from the nave to the chancel. The south porch is Norman, and the font also of that style, being square on a base, and ornamented with a range of intersecting arches having a pillar at each corner. At the west end is a tower with a crocketed spire. There are some old benches.

<div align="right">(MS iii, 163–165.)</div>

Corby

Notes taken in the church, 26 July, 1833—

On a stone in the chancel floor (R) :
> To the memory of | The Revᵈ John Hutchins A.M. | late master of the | Grammar School | of this town, Rector of | Foldingworth and Harston, | Chaplain to his | Grace the Duke of Rutland, | and one of his Majesty's | Justices of the Peace | for this county, | Died the 7 day of March | 1797 | in the 42 year of his | age.

In the chancel is a stone in which have been the brasses of two figures, with inscriptions, and four shields of arms, but now gone ; and a second stone close by which has also had similar brasses.

Upon a stone at the east end of the north aisle (D) :
> Mr Richard Cony of London, | son of | Major Richard Cony of Corby, | grandson of | Sʳ Thomas Cony of Basingthorp, | was buried here | Sept. 15, | 1704.

On a black monument against the north wall of the north aisle, with these arms under—Sable, a fesse between three cocks or [Wilcox] :
> M. S. | Francisci Wilcox A.B. | Hujus ecclesiæ ministri et | Ludi literarii annos prope quinqua | ginta, magistri necnon de Bitchfield, | Vicarii viri libris et virtutibus | plurimis ornati qui cum Christi vexillo | annos septuaginta et quatuor meruisset | ut Cœlum quod diu anhelasset opportune | arriperet lubens fato cessit anno salutis 1776 | In eodem fere tumulo jacent cineres | Annæ uxoris mulieris ob insignem pietatem | summam probitatem vigilantem bonæ | Parentis curam magnum sui apud liberos | desiderium relinquentis |

decessit Jan[11] 1764, ætat. 59, | monumentum hoc amoris et | Mæroris perpetuorum testem | charissimi posuerunt Liberi.

A stone tablet against a pillar at the west end of the nave :
Richd Kirk son of | Rob[t] & Mary Kirk | departed this life Feb. 16, 1793, | aged 57 years. | Mortals be wise, | Remember judgement | and learn to die.

On another more to the south :
To the memory | of Robert Kirke | who departed this life October 30, 1776, | in the 66th year of his age. | Also Mary wife of Robert Kirke, died | May 4th, 1783, in the | 72 year of her age.

On a flat stone below :
Sacred | to the memory of | Mary Williamson | wife of | Curtis Williamson | who departed this life | May 17, 1800, | aged xxxi years. | A lingering illness did me seize | which wore my strength away | which made me crave eternal rest | which never will decay.

A stone tablet against the wall of the north chancel :
Erected to the memory of | Mrs Ann wife of | Mr John Wade, gent., | and daughter of Mr | George Morris, gent., | of Barrowby. She departed | this life March 1, 1772, | aged 81 years.

A brass plate in the floor below :
Mr John Wade, | died Nov. 22, 1794, | aged 76 years.

On a flat stone within the altar rails in capitals (D) :
Exuvias hic reliquit | Edwardus Woodroffe generosus | quas deposuit evadens terris | 26[to] die Februarii | Ano D'ni 167¾. | Dum jubente Christo | Resurgant immortales.

The church consists of a nave and two aisles supported on four clustered columns with pointed arches, a chancel, and north aisle. In the east window are these arms—Azure, two bendlets between six martlets argent [for Luttrell]. At the west end a tower.

(MS ii, 195–200).

Corringham

Notes taken in the church, 5 September, 1835—This church consists of a nave and aisles resting on the north side on two Norman and two pointed arches, and on the south on four lofty ones of the latter style, a chancel which is divided from the nave by a Norman arch with receding mouldings, a south porch, and a tower at the west end. The font is massive and ancient, some old benching remains, and part of the north aisle is divided off by a screen of good style ; it is now used as a school.

On the north wall of the chancel is a flat-headed arch with corbelled heads to support it, and over the centre a bust or head of a priest. Below the arch is an altar tomb, covered with a black slab, round which an inscription is cut in Saxon letters. It is now much defaced and all that can be decyphered is as follows, but Holles has given the inscription entire :

Hic : Iacet : Willelmus : De : Lagare : Quondam : Archidiaconus : Lincolnie : et : Prebendarius : huivs : ecclesie ✠

A grey marble monument with a white sarcophagus against the south wall of the chancel, these arms over—[Gules], a fesse between three boars' heads couped [erminois], on a canton the arms of Ulster [Becket]; impaling—. . . . a lyon[1] rampant, in chief three mullets . . . [Wilson]. Crest, a boar's head :

Sacred | to the memory of | Sir John Beckett, Bart, | of Somerby Park in this parish | and of Leeds | in the county of York. | He died Sept. 18, 1826, | in the 84 year of his age. | His remains are deposited in the choir | of the parish church of Leeds.

A grey tablet with a white urn over against the opposite wall :

Sacred | to the memory of | Richard Beckett | of the | Coldstream Regiment of Guards | who fell at the Battle of | Talavera de la Reyna in Spain | on the 28 of July 1809, | aged 27 years. | He was killed by a musket shot| while actively discharging his duty as | Brigade Major to the Brigade of Guards | which formed part of the British Army | in that memorable engagement. | Dulce et decorum est pro Patria mori. | This tablet is erected | by the afflicted father | of a dutiful and dearly | beloved son.

A flat stone in the chancel :

Here lyeth the body of | Mary the wife of William | Fulbeck of Dunstall, Gent., | dyed November the 5, 1690, | aged 34 years. | Here lyeth the body of | William Fulbeck of Dunstall, | gent., dyed October the 3, 1717, | aged 73 years.

Another collateral :

Here lieth the body of Mary the | wife of John Wells, who departed | this life the 20th day of August 1770, | aged 50 years. | In memory of John Wells who | departed this life April 15, 1791, | aged 69 years. | Also Elizabeth Wells daughter of Francis & Mary Wells who | died an infant.

On another :

Here lyeth the body of | John Wells of Dunstall, gent., | dyed January the 8th, 1795, | aged 55 years.

A stone also to Francis Wells and Mary his relict.

A brass plate against the north wall of the chancel. Arms below—
Argent, three boars' heads erazed vert [for Broxholme] :

> Anno D'ni MDCXXXI. | To the Glorie of God and for the pious
> remem | brance of their dear brethren Robert and Thomas |
> Broxholm, gent., late of Corringham in the countie of |
> Lincolne, deceased, and here interred. Henry and Mary |
> Broxholme (yet surviving) have erected this memorial, | who
> with their deceased brethren aforenamed having | lived
> together above 60 yeares, and for the most part of | this
> time in one famely and most brotherly concord, | comfortable
> to each other, beloved of their neighbours, cha- | ritable to
> the poor, constant in the profession of the | true Religion,
> doe suppose (by the favour of God) to dye | in the same
> Faith and here to rest together with them in | one and the
> same hope of a Glorious Resurrection.
>
> Though to be four in person they were knowne,
> Yet both in will & minde they were but one.
> One father on one mother them begot,
> And they made up one fourefold true-love-knot.
> They kept one famely, and which is rare
> They had no jarrings neither discords there.
> None of them were agreeu'd or discontent,
> What either or the other gave or spent.
> In one plaine path they walked all their daies,
> Nor judgeng nor invieng others waies,
> Nor so much seeking for the worlds esteeme
> As to be truly that which they did seeme.
> One Faith, one Hope, one Love they (living) had,
> Which them the members of one body made.
> Though none of them had husband, child or wife,
> They mist no blessing of the married life.
> For to the Poore they ever were insteed
> Of husband, wife and parent to their need.
> This they who knew them witness and beleeve,
> That when immortal bodyes these receive,
> They shall make up the Vergine traine of those
> Who wait upon the LAMB where'er he goes.

On a brass plate against the wall over the old tomb, on which are
cut two figures of a man and woman kneeling at a desk or table
on which is a skull, and three children below. Above the man is
the shield of arms— . . . , three eagles displayed gules. Above
the figures is written :

> Mortvorvm monvmenta Vivorvm Docvmenta.

[Issuing from the mouth of the man are the words : Morte quæsivi
regnum, and from the woman's mouth the words : Quæsiti spero
semper habere dotem. Under the skull is written Sequentvr, non
præcessere.]

On the table is inscribed :
Det Deus ut sit hæreditarium.

Below the figures is this inscription :
Memoriæ | Henrici Clifford | Sacræ Theologiæ Bacalarei
istius ecclesiæ una cum | Stow prebendarii hujusque Vicarii.
Religionis | sinceritate vitæque integritate celeberrimi
sacrorum | Dei mysteriorum oraculi, verbi divini dispensa-
toris | Fidelissimi ac frequentissimi. ducentis in vxorem |
Elinoram filiam Richardi Iackson gen. per quam | filios
habuit Henricum Georgium et Thomam. | Obiit decimo
sexto die Februarii A'o ætatis 52, | An. Dom. | 1628, | Conjux
mæstissima a viro charissimo | divisa has æreas lineas
dicavit.
In cineres Phœnix ex pulvere nullus inanis
 Pulvis es aut parias funditus aut pereas.
Tu clerum, Lector, populum tu consule, dicunt
 Hoc ævum huic similem non peperisse virum.
Tetrastichon. W. H.

[See also *Lincs. N. & Q.* xi, 43 ; *L.R.S.* i, 149 ; Jeans, 20–1, and
Supp., 4.]

(MS viii, 195–201.)

NOTE

[1] This should be a wolf. Mary the wife of Sir John Becket was
the daughter of Christopher Wilson, bishop of Bristol.

Cotes by Stow

Notes taken in the church of Coates near Stow, 4 Septem-
ber, 1835—

On a brass plate in the wall on the north side of the chancel with
these arms—Or, on a chevron sable, between three demi-lyons
passant guardant gules, crowned or, as many cups covered of the
last [Butler] ; crest—A horse's head couped quarterly . . .
and :
Here lyeth the body of Mr Anthony | Butler son of Anthony
Butler of | Coats in the county of Lincolne, | Esq., who dyed
the ninth day of Aprill | in the yeare of our Lord 1673, being |
the last heire male of this family.

On a brass plate in the south wall of the chancel there are engraved
figures of a man in armour and a female in ruff and dress of the
end of the fifteenth century, kneeling at an altar. Over the man
are the Butler arms and crest ; over the female the Tirwhit, viz.—
Gules, three lapwings or, a mullet for difference ; and between
these coats, one of the Butler and Tirwhit arms impaled. These
arms have all originally been coloured. Beneath the two principal

figures are five sons and three daughters kneeling at an altar. The sons have these names over them, (1) Joannes, (2) Gulielmus, (3) Carolus, (4) Antonius, (5) Thomas. John and Charles carry skulls in their hands. The girls have these names over, (1) Helena, (2) Martha, (3) Helena. The first Helena carries a skull. This inscription beneath :

> Carolus primogenitus Antonii Butler de Cotes juxta | Stowe beatæ Mariæ armigeri duxit Douglassiam | Marmaduci Tirwhit de Scotter armigeri tertiam filiam. | Obiit Aprilis XVII, MDCII, annum agens XLII.

Another brass on the south wall of the chancel represents a man in armour and a female in a ruff with hands clasped ; and between them is a babe placed upright in swaddling clothes, and over it the arms of Butler impaling—A saltier (Yorke). Over the Butler arms is the Butler crest ; over those of Yorke a monkey's head erazed. Above the shield is this legend in church text :

> Non habemus hic manentem ciuitatem | sed futuram inquirimus.

Under the baby is this inscription :

> Priscilla unica | eorum proles | obiit infans.

And under the whole is this inscription :

> Hic subtus requiescit Gulielmus Butler filius Antonii | Butler de Cotes in comitatu Lincoln armigeri natu | secundus qui duxit in uxorem Elizabetham Georgii | Yorke de Ashby in Kesteven eiusdem comitatus | armigeri Filiam Qui quidem Gulielmus immatura | morte præreptus obiit uicesimo octauo die Aprilis | Anno domini 1590, et sue ætatis 26.

On an altar tomb on the north side of the chancel a brass of the Butler arms, impaling—Quarterly, 1st and 4th, On a chief three martlets [Wogan] ; 2nd and 3rd, Paly of six, on a fess gules three mullets [? Meyrick]. This altar tomb is obviously the one of Henry Hansard.

On a flat stone in the nave an inscription is thus far legible. It is round the verge :

> Hic simul humati jacent
> Generosi prostrati
> Hansard Henric*us* uxor [Joanna] Ricard*us*
> [Filius, et hæres eorum],
> Cui detur Nardus.
> [Cælicus] rex Jh'us quibus [sit] modo p*r*opitius. Amen.

In the south window of the nave is some painted glass of the Tirwhit arms, and to the west of the mullion—Argent, a fleur de lis sable [Fishbourne]. In one of the panes above is an 𝕽. On the north side of the nave in a window are the Butler arms.

On a stone in the chancel an inscription (R) of which all that is legible is as follows :

Hic quon[dam in orbe vivens] Hansard Henricus [humatur,
Armiger, arma gerens, honor sic cito superatur.
Uxores binas habens, Joanna Aliciaque] vocantur
Sub lapide [que latens, horum et] corpora in pace locantur.

There is a beautiful carved oak screen and over it a rood loft quite perfect. The church consists of a nave and chancel, and bell turret at the west end. There is a recess on the north side of the nave which has held a tomb. It is altogether a very interesting little building, and owes probably to its secluded situation the preservation of its brasses and old flat stones. Not many years ago I understand the windows were full of painted glass which were wantonly shot at and broke by a resident at the farm.

[See also *L.R.S.* i, 145–6 ; Jeans, 19–20.]

(MS vii, 65–68.)

Covenham St Bartholomew

Notes taken in the church of Covenham St Barth[w], 24 August, 1835—

On a stone at the west end in the wall is an inscription to John Wallis who died Decr 27, 1773, æt. 73, and Mary his wife died May 15, 1776, æt. 76.

In the chest in the church are preserved the brasses[1] which had been taken from an old stone in the chancel, one is the brass figure of a man in plate armour with his hands clasped before him, and a lion at his feet, the other has this inscription in church text :

Hic iacet Joh'es Skypwyth armiger qui obiit xv die mensis |
Julii Anno D'ni Mill'imo ccccxv cujus anime propicietur
deus. Amen.

This church consists of a nave, chancel, and south transept rather small, with a wooden low tower at the intersection. In the chancel is a stone (R) in which has been a figure and two shields now taken out, and another smaller one similarly deprived. The font is curious, though not nearly in such good preservation as in the sister church. It is an octagon, having the representation of the Trinity on one and the Virgin on another pannell, and in the other the apostles in pairs, St Peter with his keys, St Andrew with his saltier. The base is supported by four angels each holding a shield, but the bearing effaced. There is a south porch and three bells.

[See also *Lincs. N. & Q.* x, 205 ; Jeans, 21–2.]

(MS vi, 111–112.)

NOTE

[1] These brasses are now affixed to a stone in the floor of the chancel, which covers the grave of John Skipwith, 1415.

Covenham St Mary

Notes taken in the church, 24 August, 1835—This is a handsome church, though small. It consists of a nave and chancel, with an embattled tower at the west end, and a south porch. The windows are perpendicular and contain remains of painted glass. In one is a turreted tower depicted. In the north wall of the chancel is a cinqfoyled ogee arch, seemingly a tomb, but no figure is remaining. In the south wall is a piscina in which it is said the water rises in summer. The font is very beautiful and curious. It is octagonal, supported on a fluted shaft and bearing the emblems of the Crucifixion on shields. On one shield is a lantern (?). It is ornamented round the lower edge with a border of strawberry leaves very beautifully sculptured, and at the upper edge with the ball and hollow moulding. It is altogether in very beautiful preservation. A stone in the chancel has had an inscription and two shields in brass now gone.

On another is cut :

. MCCCCXXXI cuius anime propicietur deus

[See also *Lincs. N. & Q.* x, 205.]

(MS vi, 113.)

Cowbit

Notes taken in the church, 6th August, 1835—The church consists of a nave and chancel, the former of brick only, and a tower of stone, which is thatched, at ye west end. The tower leans slightly to the west as if the foundations had sunk. In it are a good perpendicular door and window, and above the window is a tabernacled niche from whence a statue has been removed. In the chancel are four grotesque heads supporting the ribs of the roof. On the south side of the altar is a piscina. In the vestry is the fragment of a cross which appears to have been removed from the churchyard.

On a flat stone in the chancel (D) :

To the memory | of | Mrs Elizabeth wife of | the Rev^d Joseph Mills, | who died Aug^t 8th, 1763, | Ætatis suæ 25. | Also | two of their sons who died | infants. | St John 5th, ver. 28–29. | The hour is coming in the which all that | Are in the graves shall hear his voice | And shall come forth.

Close inside the south porch is the fragment of an old stone (D) which has once had an inscription round the edge in ye church text.

[See also *Lincs. N. & Q.* x, 206 ; *Churches of Holland.*]

(MS vi, 7–8.)

Creeton

Notes taken in the church, 15 August, 1837—This is a small church consisting of a nave, chancel, a small south transept, and a tower and spire of Early English character at yᵉ west end. The general character of yᵉ church is Norman. The arch separating the nave from yᵉ chancel is of that age and there is a curious south door in yᵉ same style. There has been formerly a north aisle as appears from two Norman arches bricked up in yᵉ wall. The window of yᵉ transept is lancet, and yᵉ east window modern in imitation. The arches in the wall have low plain columns. The arch from yᵉ nave to yᵉ tower is between Norman and Early English. There are two bells. The font is octagonal on a round pillar. The church contains no monumental inscription of any kind, but there has been a brass plate in a stone now gone (D). In the churchyard is the lid of a stone coffin. The church is prettily situated on a hill looking over the few houses that compose the village.

(MS ix, 95.)

Croft

Notes taken in the church, 21 July, 1834—This is a handsome church. It consists of a nave and aisles divided by five pointed lofty arches resting on octagonal columns, a chancel, south porch, and pinnacled tower at the west end. The chancel and east end of the aisles are divided off by a very beautiful carved screen. The pulpit is of carved oak, very handsome, bearing the date 1615, and the inscription 'William Worship Doctor in Divinitie'. In the nave is a brass eagle and stand for the lesson reading ; there is a considerable quantity of antient pewing ; the font is octagonal pannelled with shields in niches on a very large basement stone. In the wall south of the altar is a plain piscina. On the door of the south porch is this inscription in capitals outside, 'God save the King 1633', inside 'Harbar: Newst Eade: Gorge Whiting, church wardones'.

On the south-west buttress of the tower high up is this inscription cut in capitals :

Mr John Person | And Richard | Corbett | churchwarde | ns, Mr Everard | Deighton vicar | Aᵒ D'ni 1656.

On the north side of the chancel is a very handsome monument of marble. On an altar tomb under an arch is the figure of a knight in half armour, bare headed, with peaked beard, kneeling before a desk, and his lady opposite to him in black gown with leading strings, and at the top are these arms—Argent, three martlets in pale sable between two flaunches of the last each charged with a lion passant guardant of the field [Browne]. Crest

—A griffin's head ermine between two wings sable. At the base of the tomb are the sculptures of eight sons and seven daughters. This inscription on a black slab in capitals over the heads of the large figures :

> Memoriæ sacrum | Heere lyeth Valentine Browne, knight, | sonne & heire to S^r Valentine Browne, | which was treasurer and vitteler of | Barwicke, & dyed treasurer of Ireland | in y^e Raigne of Queene Elizabeth. He mar | ried Elizabeth Monson one of y^e daughters | of S^r John Monson of North Charlton. They | lyved together 25 years & had yssue | 8 sonnes & 7 daughters, S^r Valentine, John, | Thomas, William, Henery, Edmond, Antho | ny, & Robert, Elizabeth, Mary, Jane, Ann, | Isbeth, Margaret, & Katharine. | Thys tombe was erected by John Browne | second son to S^r Valentine Browne | at his own proper coste & charge.

A black tablet at the side of the monument bears this in common character :

> Prædicat iste lapis quod tu moriare Viator | Qui subtus jacet hic venere te docuit | Fortis erat prudens bene largus Religiosus | Sic sibi sicque suis vixerat atque Deo | Cui lavs et honor in æternum.

On the eastern pillar on a similar tablet nearly illegible is this in capitals :

> All buildings are but monuments for Death,
> All cloths but winding sheets for our last knell,
> All daintes fattening for the worms beneath,
> All curious musick but a passing bell.
> Thus death is nobly waited on for why
> All things we have is but Death's livery.

A monument apparently copied from the last, being exactly similar, having the arms and crest of Browne above, and the two kneeling figures with the inscription on a black slab :

> Memoriæ sacrum. | Here lyeth Jo. Browne second sonne of | S^r Valentine Browne, knt, & servant to | Kinge James in his Privy Chamber who | had two wives, y^e first was Cicely Kirkman | one of y^e daughters & heires of Willi | am Kirkman of Easter Keale in the | covntie of Lincolne gent. She lived | with him but 20 weekes, & dyed with | out issue, ætatis 21, 1614. | The other wife was Francis Herbert | one of y^e daughters of Richard Herbert, | Esq., of Montgomery Castell, she lived & | had issue by him [blank].

At the south east corner of the nave is a large monument of stone flanked by two pillars, and surmounted by these arms—Sable a fesse or [Bond]. Crest—A saracen's head in profile proper ; with this motto—'Plus splendet in Atro'. Below is a skull and the

arms are repeated on the pillars and the frieze. The inscription is in capitals :

> Here lyeth Willyam Bonde gentlman | who dyed Anno Dom. 1559 leaving two | sonnes Nicholas Doctor in Divinitie | and George Doctor in Physicke, the | elder sonne who dyed the . . . | et etatis . . . And here is buryed, | which in remembrance of his most kynd | father haith erected this lytle moniment. | Bondus eram doctor medicus nunc vermibus esca | Corpus terra tegit spiritus astra petit | Ardua scrutando, cura, morbis, senioque | Vita molesta fuit mors mihi grata quies.

On the floor at the entrance to the chancel is a large stone having once had the brasses of two figures with inscription, and a smaller one close by with one figure and inscription, all now gone.

A lozenge shaped canvas framed tablet (D) against the south wall bears this inscription in capitals, the date is torn :

> The Reverend | and learned Dr | William Wor- | ship, S.T.P., De- | ceased Dec. 24, | 1625.

On a brass plate in the floor below in capitals :

> Here lyeth the body of Agnes Worship | a woman matchless both for wisdom and | godlyness. She was the wyfe of William | Worship, doctor of Divinitie, and | minister of Croft, and departed this | life the 6 daie of Maye Anno 1615.

At the east end of the south aisle is a large stone having in brass the bust of a knight in hauberk and chaperon of mail with his hands clasped ; two shields below now gone ; and an inscription round almost effaced, and what is left illegible.

[See also *Lincs. N. & Q.* xi, 232–5 ; Oldfield, *Wainfleet*, pp. 135–9 ; Jeans, 22.]

(MS iv, 247–252.)

Crowland

Notes taken in the church, August 7, 1835—

A black stone tablet against the south wall of the chancel :

> Beneath | lieth Mary the | wife of Robert | Darby who departed | this life January the 19th, | 1728–9, aged 30 years, | cujus animæ propitietur | Deus. | She whose unblemished life a husband blessed | From cares & labour here is come to rest | Chaste Love and tender Mother all thats good | she daily shewed as well as understood | The poor have lost a friend I a good wife | But she I trust hath gained eternal life.

A painted tablet to the east of the last (R) :

> Beneath | this stone lieth | interred the body of | Francs Cherrington | relict of | William Cherrington | who died

Aug : 1, 1787, | aged LX years. | Reader stay, it is but just | Thou dost not tread on common dust | For underneath this stone doth lie | One whose name can never die | Trace her through all the series of Life | You'll find her free from envy hate & strife.

Another painted tablet close by but on the east wall in capitals (R) :

Here lieth interred | the body of M^r James | Brown late of Crow- | land who departed this life Octob^r y^e 25, 1684. And he gave by | surrender for a | charitable use ele | ven acres of land unto y^e Poor | of Crowland for ever, | and did appoint M^r James Hampson W^m | Maltby & William Antony feoffees | in trust to dispose | of the rent year | ly upon St James | his day.

On a flat stone within the altar rails :

In memory of | Luke Cowley, gent., | who departed this life | October 18th, 1723, | aged 84. | The same propitious day which gave him birth | after a life well spent resumed his breath. | In memory of Mary the | relict of Luke Cowley, gent., | who departed this life | February the 15, 1730, | aged 81.

A black stone south of the last in capitals :

The Rev^d James Blundell, Rector | of this parish 25 years, | died March 24, 1834, | aged 61. | James Whitsed Blundell | died Jan^y 29, 1826, | aged 14. | Anne Radcliffe relict of | John Radcliffe, gent., | late of Athertone, Lancashire | died April 2^d 1821, | aged 72.

On an old stone partly hid under the altar rails :

. re y^e body of | John Baley | th who died | y^e 11, 1714, | ed 74 years | XI monethes.

On a flat stone in the chancel :

Here | lie the remains of | the | Rev^d Moor Scribo B.A. | rector of this parish | 42 years, | who departed this life | July the 13th, 1808, | in the 85th year | of his | age.

Another more to the west :

Under this stone | lies the body | of | Robert Lincoln, esq., | who died Dec^r 28, 1810, | aged 55 years.

A grey marble monument with the inscription in a white oval, surmounted by an urn :

Near | this place in a vault | lie the remains of William Wyche | who departed this life | Dec^r 7, 1807, aged 57 years. | Spes in Deo. | William son of William & Abigail Wyche | died Jan^y 28, 1810, aged 28 years. | Multis ille bonis flebilis occidit. | Abigail Wyche relict of | William Wyche senior | who departed this life | March 16, 1834, | aged 82 years.

A grey and white marble monument surmounted with a sarcophagus to the west of the last :

> Sacred to the memory of | John Smith | who departed this life | 19 Nov. 1826, | aged 52 years. | Also of Mary daughter of | John & Mary Smith | who departed this life | 13 January 1824, | aged 21 years.

To the west of the last is a white and veined marble monument with a cherub over :

> In memory of | Mary the wife of | Zachariah Fovargue | who departed this life 20 Feb^y | 1763, aged 39 years. | To the memory of | Zachariah Fovargue | who departed this life y^e 21^st day of | June 1778, aged 69 years, | Also Zachariah their son aged 18 months.

A painted stone tablet more to the west :

> In memory | of | Martha relict of | Zach. Fovargue who departed this life | April y^e 27, 1792, | aged 58 years.

A wooden tablet against the north wall of the nave :

> Beneath this place six | foot in length against y^e Clarks | pew lyeth y^e body of M^r | Ab^m Baly. He died y^e 3^d of Jan. | 1704. Also y^e body of Mary his | widow, she dyed y^e 21 of May 1705. | Also y^e body of Abr^m son of y^e | s^d Ab^m & Mary : He died y^e 13 Jan. | 1704. | Also 2 w^ch dyed in there | enfantry [*sic*]. Mans life is like | unto a winter's day. Some brake | there fast & so departs away. | Others stay dinner then departs full | fed. The longest age but supps & | goes to bed. O Reader then behold | & see as wee are now, so you must be. | 1706.

On a stone tablet against the north wall at the west end :

> To y^e memory of | Anne y^e wife of John Crawford, esq., | who was buried Sept y^e 6, 1731. | Also Jn Crawford, esq., | who was buried April 9, 1762, aged 75 years, | and Jennet y^e wife of Hugh Crawford, M.D. | Also Ch^s Crawford | son of the said John & Anne Crawford | who was buried Jan^y y^e 12, 1778, aged 60 years, | and Hugh Crawford, M.D., | son of the above Jn^o and | Ann Crawford, died Sept. y^e 27, 1788,| aged 72 years. | Also M^rs Margaret the second | wife to the above D^r Hugh Crawford, | died Feb. y^e 1, 1801, aged 76 years.

On a black flat stone in the nave :

> In memory of | Susannah the | wife of Robert Sharpe, gent., | who departed | this life the 2^d | day of February | Anno Dom. 1724, | aged 56.

On another stone more to the west :

> Sacred | to the memory of | Step. Cherrington, gent., | late of Postland, | departed this life Feb. 5, | 1826, | aged 72 years.

A small brass plate against the north wall :

> Beneath are interred the remains of | Joseph Bothway | who died July 12, 1812, | aged 70 years. | Also Mary & Catherine his daughters who | died infants.

In the space under the tower are stones to the memory of the Hurry's, Knighton's, Harrison's, Cowling & Robartts.

Over the inner door of the porch of the tower, outside, is a wooden tablet with the following inscription painted on it in some parts very faintly :

> William Hill sexton 32 | years, lost his sight by walking in snow when 40 | years of age, & yet he acquir^d all the facili- | ties of those who meet this malady in youth. | His acuteness almost superseded this loss, since | he could walk in and about the town, & could | go in the churchyard and find each & every | grave he was desired to point out. He died | Jan^y 27, 1792, aged 65 | years. | Deus nobis haec otia fecit. | To record his singular faculties & their esteem | The parishioners erected this tablet in 1818.

[See also *Churches of Holland ; G.M.*, 1796, part ii, 920–1 ; 1829, part i, 209 ; 1841, part i, 604.]

<div align="right">(MS v, 221–231.)</div>

𝔇𝔢𝔢𝔭𝔦𝔫𝔤 𝔖𝔱 𝔍𝔞𝔪𝔢𝔰

Notes taken in the church, 21 July, 1831—This church has been lately repewed and floored. The pews are neat and adorned with tracery work. The pew belonging to Mr Pawlett has the arms of Sir Thomas Whichcote on small shields round the pew, viz.— Ermine, two boars passant [gules] ; on an inescucheon—the arms of Ulster. The pew of Mrs Greaves has his arms in the same manner. The font has been moved from its original situation under which there was a well of water.

On a black marble tablet against the wall at the east end of the south aisle with an urn over and a cherubim under :

> Near this place | lieth interred the body of Jane | the wife of y^e Rev^d David Walker, | clerk, vicar of Baston & curate | of this parish, daughter & only child | of Thos & Sarah Bailley of this | parish, whose ingenuous mind, gentle | manners, religious disposition, | filial piety & conjugal affec-tion, | rendered her the delight of her | parents, the joy of her husband, & | a pattern for all, she lived much | respected & died greatly & deservedly | lamented May the 22^d, 1752, | aged 21 years.

On a black tablet, close by the south door, of marble :

> Near this place | are deposited the remains | of Samuel Sharpe, gent., | late of this parish, | who departed this life in peace |

the 5th day of October, | in the 64 year of his age, | Ann. Dom. 1765. | With him expired a sincere friend, | a desirable companion, and an honest man.

On a black and white stone tablet over the south door :
Near this place lie the remains | of William Buck | who died March 29, 1778, | aged 59 years, | Anne his wife who died June 1st, | 1768, aged 33 years, | Thomas their son who died | June 21, 1780, aged 21 | years.

In the vestry room is a stone tablet, the upper part of which is hidden by the ceiling ; what is visible is (D) :
Also Mary his wife died | June the 3rd, 1800, | aged 60 years.

On a handsome grey marble pyramidal monument against the wall at the west end of the north aisle, with an urn above and these arms under—Azure, an estoile or [Hogard] ; impaled with— Argent, on a bend gules three boars' heads of the first. Crest—A boar's head argent. The inscription is on white marble in two compartments :
(1) Sacred to the memory of | John Deanes Hogard Esq. | who departed this life June 9th, 1798, | aged 45 years. | He was one of his Majesty's | Deputy Lieutenants for the | County of Lincoln, also a Lieutenant | in a troop of Cavalry, | raised by the Hundred of Ness, | in defence of monarchy and for | the protection of property. | His mind was adorned with much | useful knowledge & in him shone | with peculiar brightness the valuable | qualities of hospitality, generosity | and integrity. | His widow, Susanna Hogard, sensible | of his merit and out of pure conjugal | affection, has caused this monument | to be erected to his memory.
(2) Also to the memory | of Thomas Hogard, gent., | who died May the 31st, 1794, | aged 77 years. | Also of Ann his wife | who died April the 27th, 1785, | aged 69 years, | father & mother of the | said John Deanes Hogard, Esq. | Also of Sarah Hogard former wife | of John Deanes Hogard, Esq., | who died January the 16, 1790, | aged 32 years. | Also of Thomas Hogard his | brother, who died April 22nd, 1782, | aged 32 years, | and of Ann Sharp | his grandmother, | who died March 4th, 1774, | aged 86 years, | Also of Elizabeth Kingston | his aunt, who died January the 7th, 1785, | aged 54 years.

Below this monument on the floor are these stones (D) :
Here lieth interred | the body of | Mr Thomas Hogard | who departed this life | April the 22nd, 1782, | aged XXXII years.

On another more to the eastward :
Here lieth the body of | Mrs Elizabeth Kingston | wife of Mr Edward Kingston, | and preceding him the wife of | Mr

Henry Hogard. | She departed this life | January the 7th, 1785, aged 54 years.

On another to the eastward of the preceding :
John Deanes Hogard | died June 9th, 1798, | aged 45.

In the chancel are these grave stones :
Beneath this stone lie interred | the remains | of Ann relict of | John Pawlett | who departed this life | August yᵉ 26th, 1798, | aged 61 years.

On another stone with these arms cut above—Per fess crenellé and in chief a dove rising, in base a fleur de lis [for Mason] :
In memory of | Thomas Mason, gent., | who died March 27th, | 1765, | aged 75.

On another stone :
Here's | buried the remains of | John Pawlett, | who died Nov. 27th, 1786, | aged 50. | Also John son of yᵉ said | John & Ann his wife, | who died in his | infancy.

On another stone :
Here lieth the body of | Ann wife of | John Pawlett | who departed this life | February yᵉ 18, | 1777, | in the 60 year of her | age.

On another stone :
In memory of | Joseph Fairchild | who died | May yᵉ 27, 1802, | aged 64 years.

On another stone :
Near this place lieth | the | remains of | Samuel Pawlett who died | June yᵉ 24th, 1782, | aged 28 years.

On another stone :
In memory of | John Fairchild | who died | June yᵉ 17, 1812, | aged 17 years.

On another grave stone :
In memory of | Fraˢ Fairchild | who died | March yᵉ 10th, 1794, | in the | 25th year of his age.

The living of Deeping St James is in the gift of Sir Thomas Whichcote, Bart., and the incumbent is the Revᵈ [Christopher] Whichcote.

Close by the south wall of the chancel, under some tracery work on a raised slab, is the figure of a knight cut in stone, but it is so much effaced that nothing can be discovered but the rude shape of the figure.

[See also *L.R.S.* i, 198.]

(MS i, 5–12.)

Market Deeping

Notes taken in the church, 25 July, 1831—

On a black marble tablet against the south wall of the chancel, with an urn above, this inscription on grey marble :

> To the memory | of William Bailey, Esq., | who died February 1st, 1812, | aged 87 years.

On a handsome black and grey pyramidal monument against the north wall of the chancel, with these arms above—Gules, on a bend ermine three fleur de lis sable ; impaling—Azure, a cinquefoil ermine within a bordure engrailed or [Ashley]; and this inscription on white marble :

> In memory of | the Rev^d Andrew Borradale and Frances his wife, | after an education in the Charter House | and at Jesus College in Cambridge | where he took the degree of M.A. He was made a | Lieutenant of the Dragoons by the Duke of Marlborough | in the year 1706 ; he married the daughter of | Colonel Jacob Ashley of the County of Norfolk, | soon after which he quitted the army, | entered into holy orders & became rector of this place, | where he constantly resided for the space of 42 years, | and for a long time acted as one of his | Majesty's Justices of the Peace. | He had issue by her 14 children, | of whom four only survived him. | He died March the 23, 1752, aged 68 years, | and lies interred in a vault below with Frances his wife | who died March the 3rd, 1741, aged 60 years. | As a testimony of his duty & gratitude their youngest son | Captain Jacob Borradale caused this monument to be erected.

On a flat stone (R) in the chancel with these arms cut above—an escutcheon within an orle of martlets [for Maydwell]; impaling— on a chevron between three martlets . . . as many fleur de lis [? Massingham] :

> In memory of | the Rev^d Lawrence Maydwell, A.B., | 36 years Rector of this parish, | who died the 14 of March 1788, | aged 68 years, | also of | Katharine Maydwell his mother | who died the 28 of December 1762, | aged 76 years.

On a flat stone to the north of the last (D) :

> In memory of | the Rev^d James Bradfute, M.A., | curate of this parish, | who died June y^e 18, 1789, | aged 76 years.

On another flat stone (R) more to the north :

> Beneath | are deposited the mortal remains of | the Rev^d Joseph Monkhouse, | upwards of 28 years rector of this parish, | who died | the 4th of September 1828, | in the 66th year of his age, | also | Elizabeth his wife | who died | the 12th of April 1816, | in the 63rd year of her age. | The memory of the just is blessed.

On a flat stone (R) to the east of the above :
In | memory of | Anna Maria Maydwell, | widow and relict
of | the Rev^d Lawrence Maydwell, | who died Sept. 24th,
1803, | aged 82 years.

To the south of the above on a flat stone (R) :
In | memory of | Eleanor Maydwell | eldest daughter of | the
Rev^d Lawrence Maydwell | and Anna Maria his wife | who
died Sept^r 20, 1803, | aged 55 years.

To the south of the above on a flat stone (R) :
In | memory of | Anna Maria Maydwell | youngest daughter
of the Rev^d | Lawrence Maydwell | & Anna Maria his wife, |
who died April 5th, 1817, | aged 62 years.

On a flat stone (D) to the west of that to the Rev^d J. Bradfute :
Here | lieth the body of | Frances wife of | Charles Hardwick, |
who died | June 7th, 1815, | aged 49 years.

To the west of the above :
Here | lieth the body of | Charles Hardwick, | who died |
August 8th, 1807, aged 49 years.

On a flat stone in the south aisle (D) :
M.S. | A.L. | the wife of Robert | Laxton, clerke, | was here
interred | Aug. 25, | 1671. | In memory of | Anne wife of
George | Featherstone departed | July the 3rd, 1729, | aged |
70 years.

To the south of the above on a flat stone (D) :
Here lyeth the body | of George Feather- | stone who
departed | this life the 11th day | of May 1721, aged 68 |
years.

On a flat stone in the nave (D) :
In memory of | Seth Smith | who died March 12, 1830, |
aged 60 years.

To the west of the last (D) :
In memory | of Mary relict of the | said Seth Smith | who
died | May the 7th, 1802, | aged 71 years.

On another flat stone more to the west (D) :
In memory of | Seth Smith | who died | September 21, 1795, |
aged 64 years.

To the west of the last on a flat stone (D) :
Here lies | the remains of | Thomas Hall | who departed
this life | February 22, 1788, | aged 77 years, | also of | Mary
his wife | who departed this life | April 21, 1785, | aged 72
years.

On a flat stone by the entrance of the tower (D) :
Katherine | the daughter of | John & Elizabeth Clifton | died
in her infancy | August the 27, | 1810.

On a flat stone by the vestry room (D) :
> Sacred | to the memory of | Henry Butler | who died June
> y^e 27, 1801, | aged 77 years.

[In the south porch, a plain mural tablet :
> Hester the wife | of George Gibson | daughter of y^e Rev^d |
> M^r Walter Barnes | died Nov^r 5, 1751, | aged 49. | Virtutis
> Amatrix.]

On a flat stone near the font (D) :
> Sacred | to the memory of | Henry Butler | who departed
> this life | Dec. 21, 1826, | aged 66 years.

On a flat stone by the south gallery stairs :
> Here | lies the remains | of Mary wife of | John Gibbs, | who
> departed this life | the 25th day of January | 1791, | aged
> 39 | years.

On a black stone tablet against the wall at the east end of the
south gallery (R) :
> In the memory of | William Goodale | who died April y^e 9,
> 1716, | aged 110. At the age of 50 he | married Hannah
> his wife who | was then 25 years of age ; & had issue | by
> her 15 children. At his death | (having been married 60
> years) his | youngest son was 30 years of age. | Also of Hannah
> his widow | who died April y^e 21st, 1723, | aged 92.

[See also *L.R.S.* i, 197.]

(MS i, 13–22.)

West Deeping

Notes taken in the church, [*blank*] August, 1831—

On a handsome marble monument, against the wall of the south
aisle to the east of the porch, with these arms above—Quarterly
1st and 4th : Per bend crenellee argent and gules ; 2nd and 3rd :
Gules, a fox salient argent. Crest—On a torce, a stork proper
[for Figg] :
> Near this place lie interred | the remains of | Frances wife
> of | Richard Figg, gent., | who departed this life June 29,
> 1762, | aged 32 years. | Also to the memory of | Richard
> Figg, gent., | who died Sept. 6, 1785, | aged 64 years. | Also
> of Mary their daughter who died | in her infancy. | As a
> testimony of respect this | monument was erected by | Richard
> Figg their grandson | Anno Domini 1809 | and re-erected by
> Mary Figg | his widow in the year 1819.

On a handsome marble pyramidal monument against the wall of
the south aisle, to the west of the porch, with a large urn and a
lozenge of arms—Gules, a fox salient argent. Crest—on a torce
a stork proper :
> To the memory of | Mary the wife and afterwards the widow
> of | John Figg, gent., | formerly of this village, | and daughter

of | Thomas and Frances Bate | of Ailsworth, Northampton-
shire, | who departed this life the 20th of November 1827, |
aged 76 years.

On a handsome marble monument at the west end of the south
aisle with the arms of Figg above :
Sacred to the memory of | John Figg, gent., | who died
September 27, 1792, | aged 45 years. | Also of John Figg,
gent., the son of | John and Mary Bate Figg, | who died
May 21, 1812, | aged 38 years. | Also of Richard the son
of | Richard and Mary Figg | who died May the 22nd, 1813, |
in his infancy. | Also of John the son of | John and Mary
Figg | who died November 15, 1813, | aged 8 years. |
Also of Richard Figg, gent., the son | of John and Mary
Bate Figg, | who died August 26, 1816, | aged 45 years. |
Erected by Mrs Mary Bate Figg 1813.

On a very handsome marble monument against the wall of the
south aisle, with the arms of Figg above :
Near this place lye the remains | of Richard Figg, gent., |
who died Dec. 6, 1729, aged 84 years, | Anne his wife who
died March 22nd, | 1714, aged 62 years, | Richard their son
who died May 18, | 1718, aged 23 years, | William their son
who died April 3, | 1736, aged 45 years, | John their son
who died February 14, | 1732, aged 52 years, | Mary widow
of the said Will^m Figg | who died June 11, 1769, aged 77 years, |
and four sons of the said Will^m & Mary | who died in their
infancy. | This monument was erected by | Richard Figg
only surviving son | of the said Will^m and Mary out of | pity
and affection to the best of | parents.

On a neat marble tablet at the east end of the south aisle, with the
crest of Figg over :
Sacred | to the memory of | Mary the wife of | John Figg |
who died May 31, 1819, | aged 42 years.

On a flat stone below the monument of Richard and Anne Figg :
Here lies interred the remains of | Rich. Figg, gent., | who
died | September y^e 6th, 1785, | aged 64 years.

On a flat stone close by the south porch (D) :
Here lie | the remains of Frances | daughter of John & Sarah
Lowe, | wife of Richard Figg, | gent., who died June 29,
1762, | aged 32 years, | Also of | John Figg, gent., | who died
Sept. 27, 1792, | aged 45 years. | Also of | Mary wife of | John
Figg, gent., | and daughter of Thomas and Frances Bate | of
Ailsworth, Northamptonshire, | who died Nov. 20, 1827, |
aged 76 years.

On another more to the north (D) :
Here lie | the remains of Sarah Lowe relict of | John Lowe |
late of Bourne in this county. | They left issue only one

daughter [viz.] | Frances wife of Richard Figg. | The said [Sarah] deceased Augst 11, 1757, | aged 77 years. | Also | Mary daughter of | the said Richard & Frances Figg | who died August 29, 1757, | in her infancy.

On another more to the west (D):
John Figg, gent., | son of John & Mary Bate Figg, | died May 21, 1812, | John son of | John & Mary Figg | died Novr 15, 1813, | Mary wife of the above | John Figg, gent., | died May 31, 1819.

On a flat stone in the nave (D):
Sacred | to the memory of | Richd Figg | the son of Richd and Mary Figg | who died | in his infancy | May 22, 1813.

On another more to the north (D):
Sacred | to the memory of | Richd Figg, gent., son of John & Mary Bate Figg | who died Augst 26, 1818, | aged 45 years. | Farewell, vain world, as thou hast been to me | Dust and a shadow, these I leave with thee. | The unseen vital substance I commit | To him thats Substance Life Light Love to it. | The leaves and fruits are drop'd for soil and seed | Heaven's heir to generate heat and feed. | Then also thou wilt flatter and molest, | But shall not keep from everlasting rest.

On another flat stone (R) in the nave partly hid by a pew:
In memory of Alice the wife of | Joseph Wilford | and daughter of | Thomas and Sarah Dove | who died February 21, 1821, | aged 29 years. | Also of | Sarah the daughter of | Josh. & Alice Wilford | who died April 5th, 1821, | aged 5 months.

On another more to the north (R):
Sacred | to the memory of | James son of | James and Alice Haynes | who died Septr 8, 1789, | aged 21 years. | 'Tis time dear parents that you cease to mourn | For me whose breath will never more return. | Oh think what agony my sickness gave, | Nor greave to lay me in the silent grave | For now I dwell in heavenly |

On a grave stone in the north aisle:
In | memory of | James Haynes | who died Novr. 1, 1801, | aged 63 years. | In memory of | Alice wife of | James Haynes | who died Septr 18, 1813, | aged 78 years.

On another to the south of the above:
Here's | buried the remains of | Nicholas Munro | who died | April ye 26, 1787, aged | 76 years | Sarah his wife | who died Octr 12, 1774, | aged 74 | years.

On another flat stone to the east of the last:
Sarah daughter of | Thos and Frances Dove | died Septr 22d, 1793, | aged 9 years. | Mary their daughter | died in her infancy.

On a flat stone in the nave (D) :
 Here | lieth the remains | of Alice the wife of | Robert White |
 who departed | this life | the 23ʳᵈ day of December | 1773, | in
 the 81 year of her | age.

On another to the west of the former (D) :
 Here lieth interred the body | of | Robert White | who departed
 this life | Augᵗ yᵉ 15th, 1792 | in the 88 year | of his age.

On a flat stone in the chancel (D) :
 Here lieth the body | of John Allin who | departed this life |
 July the 8th, 1739, | aged 47 years. | Think on Death.

On another within the Communion rails (D) :
 Here lie the remains | of Richard Austin, | clerk, who was
 rector of | this parish 38 years. | He departed this life July
 the | 9th, 1741, in the 68th year | of his age.

On another to the south of the last, very much effaced (D) :
 Here lieth Benjamin | son of Mr Benjamin | Cuthbert and
 Elizabeth | his wife who died Jan. | yᵉ 17, 1690. | Also Benj.
 there | older son died in t . . . | 1700.

[At the west end of the north aisle (D) :
 Sacred | to the memory of | Mary wife of | John Figg | who
 died May 31st, 1819, | aged 42 years.]

The font of this church is curious. It is an octagon, with a
shield of arms on each front—On the 1st, . . . , two bars
. . . . in chief . . . three roundles . . . [Wake]; the 2nd seems
to be—. . . . , a fesse lozengy and between five
fleur de lis ; the 3rd— . . . , three chevronnels ;
the 4th—. . . , a fesse . . . ; the 5th— , a fesse
between five crosses . . . ; the 6th— ; the 7th—Verrey
. . . . ; the 8th—Checquey and

 [See also *L.R.S.* i, 198 ; *G.M.*, 1862, ii, 739.]

(MS i, 33–44.)

𝔇𝔢𝔪𝔟𝔩𝔢𝔟𝔶

Notes taken in the church, 11 July, 1834—This church is small
and of no beauty. It consists merely of a nave and chancel, with
a bell turret of wood at the west end. The arch between the nave
and chancel is Norman, of which character is the font, which is
square and small on a tall column. The windows are all modern
but the east one which is decorated and of two lights. The house
of the Pell family is said to have stood close by the church yard,
and is now pulled down, and a small farm house, built seemingly
of the materials, is inhabited by Mr Cox. It is a rectory
and the incumbent is the Revᵈ John Neville Calcraft of Hayseby.

On a flat stone within the altar rails in capitals, much rubbed :
> Here | lyeth the body | of Richard Pell, esq., | who | departed
> this life | Novemb^r the 27, | Anno Domini 1690, | ætat.
> suæ 45(?).

On another more to the north also in capitals :
> Here lyeth the body of | Anne Pell relict of | Henry Pell,
> esq., | who departed this life | the sixteenth day of | Sept.
> Anno Dom. 1733, | ætatis suæ 67.

Another more to the north in capitals :
> Here lyeth the body of | Henry Pell, esq., | who departed
> this life | September the 27, 1730, | aged 60 years.

More to the north :
> In memory of | Katherine the wife | of John Buckworth, |
> citizen and linnen draper | of London, daughter of | Henry
> Pell, esq., of this | Parish, and one of the three | sisters and
> remaining | coheiresses of that most | antient and worthy
> family, | who departed this life | the 30 day of April, in the |
> 33 year of her age, | Annoque Domini 1742.

On a flat stone in the chancel :
> In memory of | Elizabeth Pell | daughter of Henry Pell, esq., |
> late of this parish, and one of the | three sisters and remaining |
> coheiresses of that most ancient | and worthy family, | who
> departed this life the 30 day of | October 1767, in the 71
> year of her age. | Seek ye the Lord while he may be found, |
> Call ye upon him while he is near.

Another more to the north in capitals, much rubbed :
> Here resteth in hopes of | a joyful Resurrection y^e | body of
> y^e Rever^d M, Richard | Moore, late minister of the | Gosple
> in this parish, | who departed this life | Janu. y^e 8, Anno
> Dom. 1715 | ætatis suæ 77. | Also Mary his wife and |
> three of their children | who died infants.

More to the north in capitals, rubbed :
> Here lyeth y^e body of | Jane daughter of | Anthony Boryton
> esq., | and Elizabeth his wife | who departed this life | Feb^y
> y^e 7, 1735, aged 33.

Upon the three steps to the reading desk is this inscription in
capitals ; but they have been taken up and put down in no
order :
> M^{rs} Margaret Pell, | daughter of | Richard Pell sq . . . | and
> Jane his wife, | who dyed | Sept. y^e 18, 1671, | ætatis 15, |
> lyeth here | interred.

On a flat stone in the nave in capitals :
> Richard Pell | son of | Henry Pell, esq., | and Anne his wife, |
> dyed | an infant | Sept. 5, 1699.

On another stone to the west of the last, with this inscription in capitals in double lines round the stone, partly hid by a pew :

> Here lyeth the hard Pell, esq., and Elizabeth his wife, who departed this life the 9th day of September Anno D'ni 1662.

<div align="right">(MS v, 3–8.)</div>

Donington in Holland

Notes taken in the church of Donington, 4 August, 1834—This is a handsome church. It consists of a nave divided from its aisles by seven narrow pointed arches rising from octagonal pillars, a chancel entered by a fine pointed arch, the head of which is blocked up, and a tower and spire at the south side, lofty and handsome. The east and west windows are similar, Decorated with five lights. There is a gallery running along the north aisle, appropriated to the partakers of Mr Cowley's charity, as appears by an inscription thereon. In the wall north of the altar is a niche with four steps in it, for what purpose it is not easy to conjecture. In the opposite south wall is a piscina. By the easternmost window of the north aisle is a small female figure in relief, in an attitude of prayer. The font is octagonal, adorned with arches and columns of the Early English style ; it stands in the south-west corner of the church.

Against the north wall of the chancel is a neat white marble tablet surmounted by an urn, with this inscription in capitals :

> In memory of | Captain Mathew Flinders, R.N., | who died July 19, 1814, | aged 40 years, | after having twice circumnavigated the globe, he was | sent by the Admiralty in the year 1801 to make | discoveries on the Coast of Terra Australis. | Returning from this voyage, he suffered shipwreck, | and by the injustice of the French Government | was imprisoned six years in the | Island of Mauritius. | In 1810 he was restored to his native land, and not | long after was attacked by an excruciating disease, | the anguish of which he bore until death | with undeviating fortitude. | His country will long regret the loss of one whose | exertions in her cause were only equalled by | his perseverance, | but his family will more deeply feel the | irreparable deprivation. | They do not merely lament a man of superior intellect, | they mourn an affectionate husband, | a tender father, a kind brother, | and a faithful friend.

At the bottom is a bas relief of a ship in full sail.

A tablet against the wall above the last :

> In memory of | Mr John Flinders, | Farmer & Grazier, | formerly of Ruddington near Nottingham, | but afterwards of this parish, | who died April the 13, 1741, | aged 59 years.

A similar tablet to the west of the larger one :
> In memory of | Mr John Flinders, Surgeon, | of this parish, | who died December the 26, 1776, | aged 63 years.

Another to the east of the monument :
> In memory of | Mr Mathew Flinders, Surgeon, | of this parish, | a man of exemplary life, | amiable manners and superior abilities. | He died May the 1, 1802, | aged 52 years.

A small round tablet against the south wall of the chancel (D) :
> Sacred | to the memory of | Hannah Charlotte wife of | the Revd John Wilson, | who died April XXVIII, MDCCCIX, | aged XLII years. | She was a humble yet firm believer | in Jesus. | From him she received such talents | as rendered her life | honorable, exemplary and useful. | In Him she rejoiced as her strength | and portion while living, | and when dying she triumphed | through Him | over her last enemy.

On a flat blue stone in the chancel :
> Here lyeth the body of | Jane the wife of Mr John Cole | who departed this life the 22 | day of Octr 1741, | aged 25 years.

Another more to the west (D) :
> In memory of | Mr John Cole who departed | this life the 13 day of January | 1735, aged XLV years. | Also Mary his wife who died the | 22 day of July 1736, aged 37 | years.

On another still more to the west :
> Hic jacet | Thomas Pooles | agri Lincoln indigena et incola | cohortiumque civicarum | ibidem per annos 55 | E Ducibus | qui satur dierum | huic maligno valedixit mundo | quinto die mensis Novembris | Anno D'ni MDCCXVI, | ætat. suæ XCVIII. | In cujus memoriam | hoc qualecunque | gratæ mentis μνημόσυνον | mærens posuit | consanguineus ejus et hæres | institutus | Johannes Belgrave.

On another stone to the north :
> Here lyeth the body | of Mrs Anne Barnes | who died in the year | 1693.

A neat white and grey marble pyramidal monument against the wall at the south east corner of the nave in capitals :
> In | memory of | Mary Holland | who died August 16, | 1836, aged 25 years. | Also 5 children who died | in their infancy.

Between two of the clerestory windows on the north side of the nave is a white marble monument (R), bearing this inscription in capitals :
> Sacred | to the memory of | Ann the wife of | Jonathan Gleed | who died 27 October 1813, | aged LXXI ; | Also Thomas

Arnall Gleed | their eldest son | who died 13 February 1814, | aged XXXIX ; | Also Jonathan Gleed, gent., | who died 17 March 1820, | aged LXXII.

On a stone set up against the last pillar of the nave westward :
In memoriam | Johannis Poole | Generosus [*sic*] | obiit Maii 29º, | Anno Domini 1722, | ætatis suæ 31.

A stone monument against the wall at the west end of the nave :
This is | in memory of | Mary the beloved wife of | Mr Robert Long who departed | this life the 29 day of Jany 1716, | in the 31 year of her age. | A wife most faithfull, virtuous, and fair, | A mother tender of nine children dear. | This also is in memory of Robert, Mary, | Penelope, Miles, and Elizabeth Long, five of | their children who died in their infancy. | Such innocence no doubt is ever blest | In Heaven their souls, in earth their bodies rest.

A stone tablet against the wall of the south aisle :
The remains of | Antony Birks, | author of | Arithmetical Collections | and Improvements, | were interred | near this place | Sept. 9, 1769, | in the 68 year | of his age. | The remains of Elizabeth Birks, | relict of the above Mr Anthony Birks, | were interred near this place | Nov. 11, 1774, | in the 75 year | of her age.

At the west end of the nave is a flat stone which has had once a brass of inscription, but it is now gone.

On a flat blue stone in the nave :
Here lieth the body of | Thomas Cowley, gentleman, | interred the 17 day of July 1721, | aged 96.

On another blue stone more to the east :
Here lie the remains of | Mrs Jane Wetherall, | whose friendship was steady & sincere, | her charity private yet diffusive, | her conversation easy and agreable, | and | as she lived respected, so she died lamented | by her acquaintance, | October 23, 1753, | aged 39.

Another stone to the east of the last with these arms cut over—
. . . . , a stag at gaze . . . within a double tressure flory
Crest—An escallop . . . [for Ward] :
Sacred | to the memory of | John Ward, gent., | Attorney at Law, of | this town many years, | who departed this life | December 31, 1773, | in the 62 year of his age, | eminently conspicuous in his profession.

To the east of this last is a large stone which has once had in brass the figure of a man between his two wives, and an inscription below, the whole is now gone.

On another blue stone still more to the east in capitals :
> John Holland | died December | the 28, 1791, | aged xxx
> years. | Also | Mary relict of | John Holland | died November |
> the 10, 1807, | aged XLII years. | Also | Biddy daughter of |
> John and Mary Holland | died February | the 1, 1811, | aged
> XXIII years.

[See also *L.R.S.* i, 171 ; *Churches of Holland.*]

(MS v, 143–154.)

Dowsby

Notes taken in the church, 27 July, 1833—

On a white marble tablet south of the chancel with these arms
under—Or, a saltier gules between four leaves vert, on a chief azure
a lion's head erased between two battle axes. Crest—An arm
grasping a branch [Burrell] :
> Of the family of the | Burrells | formerly proprietors of this |
> parish | are deposited in the adjoining school | the remains
> of | Richard, | Redmayne, | John, | Elizabeth, | Thomas, |
> William, | Thomas, | Redmayne.

On a flat stone :
> Here lieth the body of Sarah the daughter of | Humfrey
> Hyde, clerk, | and Mary his wife, who | departed this life
> January | the 16, 1740, who died an | infant.

Two white marble tablets on a black slab against the north wall
of the chancel. Arms over—Gules, a saltier or between four
bezants, a chief ermine [Hyde] :
> In | memory of | the Rev^d | Humphrey Hyde, | late rector
> of this place | & vicar of Bourne in this | county, | died
> January 18, 1807, | aged 70 years.
> In | memory of | Mary Hyde, | sister | of the said Humphrey, |
> who died February 2^d, 1811, | aged 73 | years.
> They both lie interred in the chancel of this church.

A flat stone in the chancel :
> In memory of | the Rev^d | Humphrey Hyde, | rector of this
> place | and vicar of Bourn in this | county, | died January
> 18^th, 1807, | aged 70.

The church consists of a nave and aisles separated by three
pointed arches with clustered columns, a chancel, and north aisle
used as a school, and a tower at the west end. Under an arch in
the south wall of the chancel, on a raised slab, is the recumbent
figure of a woman in a long robe and coif with her hands clasped
over her breast. This, according to Holles, was Ethelred wife of
S^r Will. Rigdon.

[See also *L.R.S.* i, 192–3 ; Jeans, 22–3.]

(MS ii, 217–219.)

Dunholme

Notes taken in the church, 5 August, 1833—

An old marble monument against the south wall of the chancel about twenty feet high. Between two pillars an aged man in a gown, and with pointed beard, is kneeling at a faldstool on which is a book. Over the pediment are three coats of arms placed one above the other, the highest is—Ermine, a griffin segreant gules [Grantham]; impaling—Per saltier or and azure, on a fesse sable three crescents argent. The 2nd shield—Grantham, impaling—Argent, a lion rampant, crowned, double queue gules [St Paul]. The 3rd shield—Quarterly of four, 1st, Grantham; 2nd, Gules, an estoile above a crescent or [Tooke]; 3rd, Argent, two bars azure [Hilton]; 4th, Argent a chevron between two crescents in chief, and a crosslet fiche in base or [Gegge]. Crest—A lion's head erazed. Underneath this motto: As God shall gravnt qoth Gravnth'. The inscription is behind the figure on a black slab:

> Robert Grauntham of the Blacke | Movnckes near the citie of Lincolne, | esquier, sonne of Hvghe Gravn- | tham, esquier, was borne at this | Dunham the 17 day of August a° | dom. 1541, caused this monument to be | erected to the memori of this famili, | humbly commended his soule to God | and his bodie to be buried here & | died the . . . (No date of death, but the figures ' 19 ' have been cut obviously since.) [Robert was buried 19 January, 1617–18.]

There is an old stone in the chancel which has had an inscription round the rim, all now effaced except the words "die Augusti" (D).

A neat white marble monument against the north wall of the chancel in capitals:

> To the memory of | Mary the wife of Thomas Carr who died | on the 2d Feby 1830, aged twenty five years. | Her remains were interred in the vault | of St Mary Abbott's church at | Kensington near London, in Niche no. 16. | As a tender memorial of her | endearing disposition and unaffected | piety, this monument is erected | by her affectionate husband. | Thomas Borrell Carr the infant son of | Thomas and Mary Carr died | aged 3 months, and was buried in the | adjoining church yard.

A flat stone within the altar rails (D):

> In memory of Hannah | the wife of Samuel Hugh- | son who died April 24, 1751, | aged 45 years.

A flat stone in the chancel (D):

> Here lyeth the body | of Martha wife | of Richard Bennett | who departed this life | June the 2d, 1746, | aged 63 years.

On two other stones (D) :

> In memory of | Edward the son | of Samuel and Hannah |
> Hughson who died | Nov. 25, 174 . . , aged | 3 years.
>
> In memory of Jane Hughson | daughter of Samuel Hughson, |
> gent., and Hannah his wife, | who died July 1759, 1752 [*sic*], |
> aged 4 months.

On two other stones in the chancel (D) :

> In | memory of Hannah | Hughson daughter of | Sam¹
> Hughson, gent., | & Hannah his wife, | who died Sept. the
> 20th, |
>
> In memory of | Eliz. Bennet | who died Aug 13, | anno salutis
> nostræ 1740, | ætatis suæ 18.

(MS iii, 117–120.)

Dunsby

Notes taken in the church, [*blank*] August, 1831—This church is
small but neat, the tower is very handsome of the florid Gothic
style of architecture. Round the font is this inscription in old
character :

> Jh's X'ps Maria Baptista (with the letters each placed in a
>
> P
> little circle) R I | |
> C

The living is in the patronage of the Charter House and the
incumbent is the Rev : W. T. Waters.

On a black marble tablet against the south wall of the chancel :

> Near | this place lieth yᵉ body | of the Revᵈ | Irton Murthe-
> waite | who departed this life Dec. 4ᵗʰ, | 1793, | in the 44 year
> of his age. | Also | two children who died infants.

On a white marble tablet to the west of the last :

> Sacred | to the memory of | Eliz. Fothergill | who died July
> 31, 1811, | aged 65 years. | Also of her grand-daughter
> Catherine | the daughter of | the Revᵈ Wᵐ & Catherine
> Waters.

On a white marble tablet against the north wall of the chancel :

> H. S. E. | Martha | Uxor Johannis Baskett | Hujus ecclesiæ
> Rectoris | Quæ egregiis animi | Corporisque | Dotibus
> instructa | bonæ spei | vitam bonam fundamentum | feliciter
> posuit | ob. x Dec. 1746, | æt. 33.

On a flat stone within the communion rails (D) :

> Resurgemus. | Here lyeth yᵉ body of yᵉ Revᵈ | Mʳ Charles
> Lydgould, | Rector of this parish, | who died Aug. 25, 1701, |
> aged 42 years, | together with Eliz. his | daughter & Mich :
> his son, | both infants.

On another to the south of the last (D) :
> Here lyeth yᵉ body of | Mrs Mary Lydgould, | mother of
> yᵉ [blank], | who died Jan. 29, 1701, | aged 84.

On another to the south of the last (D) :
> Here lieth | the body of | relict of Mr John Greene |
> who deceased Oct. 21, 1700, | in yᵉ 38 year of her age.

In the vestry is an old stone with this inscription round the edge,
in old character, as far as it is decypherable (D) :
> Hic jacet Havisia uxor Edmundi Wylughby ar to que
> obiit XVII die Januarii anno dom

In the belfry is another old stone on which all that is legible is as
follows :
> Atwike de Downsby qui obiit XIX Augusti Aᵒ
> D'ni MCCCCCXLII.

[See also L.R.S. i, 194–5 ; Associated Societies' Reports, x, 231–4.]

(MS i, 63–66.)

Edenham

Notes taken in the church, [blank] July, 1833—The fine monu-
ments of the Bertie family within this church are fully described
in the Gentleman's Magazine for Jan. 1808, vol. 78, part i, pp.
17–22, with the exception of the following :
On a tablet of white marble against the wall at the east end of
the south aisle :
> In memory of | the Revᵈ John Bland, M.A., | Chaplain to his
> Grace Peregrine | third Duke of Ancaster, | rector of
> Willoughby and of | Theddlethorpe St Helen's, | and one of
> His Majesty's Justices | of the Peace for this county. | He
> lived many years | with his truly noble Patron | and received
> signal marks | of his favour, friendship, | and confidence, |
> and died the 19 day of January | 1761, in the 67 year of his
> age, | and desired this inscription | to perpetuate his grateful
> sense | of the favours | he was honoured with.

[See also L.R.S. i, 204–5 ; Jeans, 23–4, Supp. 5–8.]

(MS xii, 81–82.)

South Elkington

Notes taken in the church, 14 August, 1833—

A flat stone to the memory of John Oldham who died Oct. 8, 1801,
æt. 65 (D).

A flat stone to the memory of Samuel Trout who died July 19, 1792,
æt. 84 (D).

A flat stone to the memory of Elizabeth relict of Samuel Trout who died Sept. 15, 1832, æt. 75.

In the nave are also flat stones to the memory of (D) :
Mary Chatterton who died Oct. 21, 1805, aged 31.
Robert Chatterton who died April 6, 1822, aged 46.
William Alcock died July 24, 1791, aged 47.
Robert Alcock his brother died March 31, 1797, aged 71.

And in the south aisle a flat stone to the memory of Samuel Trout died May 7, 1804, aged 71 (D).

This church consists of a nave and south aisle resting on four pointed arches springing from plain round columns, a chancel, and a tower at the west end opening to the nave by a sharp pointed arch. There appears to have been once a north aisle from the clerestory windows remaining on that side. The font is an octagon, pannelled in quatrefoils. The church has lately been repaired.

[See also *Lincs. N. & Q.* xi, 235 ; *L.R.S.* i, 127.]

(MS iv, 89–90.)

Elsham

Notes taken in the church, September 2, 1835—

On a small stone (D) in the aisle rudely cut and much obliterated :
Mary Smith ye daughter | of Thomas Smith was | buried ye 29 Decem., | An. Domini 1689, æt. su. 15, | who was willing for to . . . | (defaced).

On a flat stone in the chancel (R) :
Depositæ hic exuviæ | beatæ animæ Judithæ Paley | uxoris G.P., A.M., | Rdl hujus eccl'æ V. | Quæ fidem crebra s. s. s. lectione | assiduoque S. Trinitatis cultu | sustentavit aluit firmavit | hinc turbatiores animi affectus | compressu fovit leves | Prudens facilis beneficii | vitam placide et constanter exegit | eo populares officio propinquitatem studio | Pietate coluit maritum | ut cum hujus luctuosa orbitate | ingens illorum certet desiderium | Dilecti mariti causa hanc vitam invita | causa dei magis dilecti libens reliquit | Tantam virtutem ex oculis sublatam | Utinam repræsentent superstites | et imitando tradant posteris | ut qui plurimo conjugem honore prosequitur | voto potiatur maritus | sibi in solamen multisque in fælicitatem | sempiternam cessuro | obiit 27 Maii 1728.

On a flat stone in the altar rails (R) :
Here lyeth the body of the | Reverend Mr William Paley, A.M., | vicar of this parish upwards of | fifty too years, who departed this life June the 10, 1757, aged 77. | A friend sincere who never flattery knew | Pays what to merit and desert is due |

When on this stone what yet few marbles can | He truly says here lies an honest man | Who justice and mercy loved | And walked humbly with his God.

These two atchievements are against the north wall :

(1), A lozenge of arms gules, a cross between four fleur de lis, argent [Ashhurst] ; impaling—Or, on a fesse dancetty azure three estoiles argent ; on a canton of yᵉ second a sun proper [Thompson].

(2), Quarterly 1st and 4th, Or, a crow proper [Corbett] ; 2nd and 3rd, A fesse dancetty, and a canton [Thompson] ; impaling—Or, a cross fleury gules [Ainslie]. Crests—1st, on a torce argent and sable an elephant argent ; on his back a tower or [Corbett] ; 2nd, On a torce azure and or an armed arm, vested gules, cuffed argent, holding four ears of wheat or [Thompson].

This church consists of a nave and chancel not divided, with decorated windows, and an Early English tower at the west end, the door of which is old carved oak, carved with arches foliated. The font is plain and octagonal. The sculptures mentioned by Weir cannot be better made out.

[See also *Lincs. N. & Q.* x, 206–7.]

(MS vi, 179–181.)

Evedon

Notes taken in the church, 16 August, 1836—This church consists only of a nave and chancel, separated from each other by a pointed arch, springing from short round columns perfectly plain, and a tower at the west end with a gallery for singing. In the north wall are two pointed arches with columns similar to the former, and in the south wall one arch into which a window has been introduced. There have therefore been aisles on both sides. The east window is modern. The font is octagon, pannelled with shields, (1), J. H. S. ; (2), the arms of Hardeby ; (3), pannelled with niches ; (4), A fesse dancette between five talbots' heads, apparently [? Spayne] ; (5), AR (conjoined) ; (6), Hardeby again ; (7), is hid by a pillar of the wooden gallery ; (8), , a chevron between three escallops apparently.

Against the front of the wooden singing gallery is fixed a brass plate, in which are the figures of a man in a long gown, and a woman in a ruff and stomacher, with five sons and eight daughters attired after the same fashion, kneeling at a desk. Above are these arms— . . . , a fesse dancette between ten billets 4 and 6 [for Hardeby] ; impaling—On a fesse three fleur de lis [Disney] ; and below the figures the following inscription, the first part in capitals :

Memoriæ Sacrum | Danieli Hardeby de Evedon in com. Lin | coln armigero Uni Justiciar' D'ni | Regis ad pacem

in com. præd. | Just did this justice lieue and dying just | As
all good mortalls ought, sleeps here in dust | Blest sleepe
where dying ashes do receive | A Heavenly Body from an
earthly grave.

Filii	{ John, Bryan, William, Charles, Edward, }	Filiæ	{ Elizabeth, Mary, Katherine, Mary, Susan, Ann, Susan, Judith. }

A white marble monument against the north wall of the nave
with these arms— three battering rams . . . [Bertie];
impaling—Azure, a fesse dancette between ten billets or [Hardeby].
Crest—A saracen's head affronté proper :

Here lyes the | Bodys of the Hon : | Sir Peregrine Bertie
3ᵈ son to | Robert earl of Lindsey and Lord Great | Chamber-
lain of England and Governor | of the City of Lincolne in the
Civil Wars | under King Charles the first, & Ann his | wife,
daughter and coheiress of Daniel | Hardeby of Evedon, Esq.,
by whom he | had sole issue Elizabeth married to yᵉ | Right
Hon : William Lord Widdrington | Baron of Blankney now
deceased, who to | perpetuate the memory of her father | and
mother erected this monument in | the year of our Lord
1705.

A tablet of stone against the north wall of the chancel :
Near this place lyeth yᵉ body | of yᵉ Reverend | Mr Rowland
Fox late rector | of Evedon, Master of Arts, | who departed
this life | on the seventeenth | day of February | in yᵉ year
of | our Lord 1722, | in the 48th year | of his age.

On the opposite wall is another common stone tablet having three
inscriptions, the first on the left hand is as follows :
Near this place lieth | interred the remains | of William Bailey,
gent., | who died June 26th, 1801, | in the 78th year of | his
age.

On the right side :
Near this place lieth | interred the remains | of Elizabeth
wife of | William Bailey, gent., | who died Jan: 29, 1750, | in
yᵉ 33ᵈ year of | her age.

The third inscription is as follows :
Near this place lieth interred the | remains of Maria the
daughter | of John & Anne Bailey of Thorney | who died
May 4, 1804, | aged 24 years.

Beneath is a flat stone to Anne wife of William Bailey, but it is
mostly hid by a pew.

On a flat stone at the entrance to the chancel :
In memory | of Mrs Barbara Heffield | who departed this life |
Novembᵣ 19, 1743, | in the 28 year of her | age.

On a flat stone under the altar :
> Catharine Dubar Bailey | daughter of | William Bailey,
> Esq., | and Catharine Dubar | his wife, | ob. May 30, A.D.
> 1806.

A flat stone at the west end rubbed :
> Here lyeth the body of Mar | garet daur of James and |
> Elizabeth Boulton who departed this | life the 25 of May
> (? 1761).

On another stone :
> Here lieth the body of Ann | daur of James & Elizabeth |
> Boulton who departed this | life yᵉ 24 of October | 1757.

See also *L.R.S.* i, 214–15 ; Jeans, 24.]

(MS vii, 217–222.)

Fiskerton

Notes taken in the church, 6 August 1833—

On a white marble tablet (R) against the east wall of the chancel
with these arms, the colours of which are nearly gone—A cross
[for Sedgwick] ; impaling—On a fess three bucks' heads cabossed.
Crest—A garb :
> Josephus Sedgwick | hujus ecclesiæ rector | et Lincolniensis
> canonicus, | obᵗ 22 Sept. An. Dom. 1702, | ætat. suæ 74.

On a flat stone in the south aisle (R) :
> In memory | of | Peter Lely, gentⁿ, | late of Lincoln, who
> died | August 1761, æt. 63. | Also of Mʳˢ Frances Lely | his
> widow who died | May 16, 1782, æt. 79. | Near this place also
> are | interred the remains of | Mʳˢ Bridget Mapletoft | aunt
> of the above nam'd | Frances Lely.

The following stones are both adjoining (R) :
> To the memory | of | Anne Field wife of | Jonathan Field,
> esq., | and eldest daughter of | Peter Lely, gentⁿ, she died
> Dec. the 11, 1797, aged 74 years.
>
> To the memory | of Sarah Lely | neice of Robert Lely, esq., |
> who died July the 1st, 1798, | aged 23 years.

On a flat stone to the west of the last three :
> In | memory of | Original Skepper | who departed this life |
> June the 7th, in the year | of our Lord 1811, | aged 59 years.

In the school room which occupies the east end of the north aisle
there are two stones which have had inscriptions round the edge
but now quite erased.

A tablet of wood records that Robert Parkinson of Reepham,
gent., by will dated 1 May 1819, left to William Greetham of
Stainfield Hall co. Linc., esq., £40 in trust to be distributed to the
poor in bread on St Thomas' day.

A flat stone at the west end of the nave :

Here | lieth the body of | William Hurd, gentleman, | late of Ketsby in this county | who departed this life | the 23ᵈ of March 1763, | aged 66 years. | Also the body | of Jane Hurd his wife | who died May 1ˢᵗ, 1774, | aged 79 years.

On two other stones to the south :

Here lyeth the body of | Farmery Robinson | who departed this life Sep. yᵉ 6th, | 1741, aged 41. | Also adjoyning | the body of Anne Robinson | his wife who died Feb. the 10th, | 1745, aged 39.

Here lyeth the body | of David Robinson | junʳ who departed | this life Sept. yᵉ 17, | anno D'ni 1715, | in yᵉ 28th year of | his age.

A stone at the west end of the south aisle :

Here | lie the remains of | Robert Parkinson | who departed this life | at Reepham on the | fifteenth day of June MDCCCXIX, | aged LXXIII.

A large blue flat stone to the east of the last :

Here lies the body of | George Harrison, esq., | late of this parish, who, during the short | period of a bustling life, endeavoured to | bestow the means of happiness on those | he knew. That his nobler part now | rests in peace is the humble hope | of Mary Harrison | his only surviving daughter, | who has placed this stone to his memory. | He died December the 1st, in the year 1806, | aged 57 years. | His infant daughter Sarah Harrison | is also buried in the same grave.

This church consists of a nave and two aisles ; on the north side they are supported by two Norman arches and on the south side by two pointed arches, a chancel and two aisles, the north used for a school, and a pinnacled tower at the west end. The font is curious ; it is an octagon supported on a circular pillar and four smaller ones surrounding it.

[See also Jeans, 25.]

(MS iii, 131–136.)

𝕱leet

Notes taken in the church, July 22, 1833—

On a white marble lozenge-shaped slab against the south wall of the chancel :

Hic | infra conditur | corpus | Thomæ Lodington[1] | quondam hujus ecclesiæ | rectoris qui obiit 12 Aug. |

Anno { salutis 1729.
 { ætat. suæ 45.

Ex dono Gulielᵐⁱ Brecknock.

On a white marble monument ornamented with cherubs, against the south wall of the chancel; above— , on a bend engrailed three roses [Jay]:

> Marmor | hoc juxta recubat cadaver | Triste Wilhelmi Iaii, celebris | Gentis extinctæ manet ampla virtus | Sola superstes. | Rebus afflictis miserisque fida | Hospitali pane reluxit aula, | Conjugum & rara pietate, solus | Defuit hæres. | Cum decennalis quater isset orbem | Sol, & accessit trieteris una. | Proximis triste ingemuit valete. | Quid valet orbis ? | Desideratissimo marito | Ian. viges : Sept : 1706. | In cælum reverso | posuit Elizabetha Iay | uxor mæstissima.

On a black stone in the floor of the chancel :

> Susanna | wife of John Jay, Esq., | daughter of Richard and | Ann Parke obt 17 June 1679.

And on the same stone lower down :

> Here lyeth the body of William | Jay, gent., who departed this life the 27 day of January | Anno Dom. 1706, | in the 43d year of his age.

On a black stone in the floor rather west of the last with these arms cut above— , on a pale . . three stags' heads cabossed in a border . . . [for Parke]; impaling— . . . , on a bend three bulls' heads couped . . . a crescent difference [Heton]:

> Here lyeth ye body of Richard | Parke, gent., who married | Ann the daughter of Thomas Heton, | Esq., ye 8th day of January 1625, by | whom he had three sonnes and two^2 daug | hters, at his death there only survi | ved Ann, Elizabeth, Susannah. He | departed this lyfe ye 4th day of February | 1651, aged 50 years. | Anne Parke relict of the said Richard | obt 18 March 1682. | Here also lyeth the bodies of Thomas and | Elizabeth the daughter and | son of the above said Richard | Parke, gent., and Ann his wife.

At the entrance to the chancel is a stone from which the brasses have been taken seemingly of a priest with an inscription.

On a grey and white tablet against the wall north of the altar :

> Beneath is interr'd all that was mortal | of the Revd James Ashley, | twenty two years rector of this parish. | A man whose admirable and highly cultivated powers of mind | were only equal'd by the generosity and goodness of his heart, | who, after a life spent in the conscientious discharge | of the sacred duties of his profession, | tho' worn down with continued affliction, | which he bore with Christian fortitude, | calmly resign'd his soul into the hands of his Maker | August 7th, 1806, aged 63 years. | Be ye also ready, for in such an hour | as ye think not the Son of Man cometh. Matt. ch : 24th v. 44th.

A neat marble tablet against the north wall of the chancel :

Sacred to the memory | of Mary, the wife | of the Rev^d Rich^d Dods, A.M., | Rector of this parish | who departed this life the 9th of Nov^r 1812, | in the 21st year of her age. | Piety sincere and fervent, | Humility deep and unaffected, | an unreserved devotedness to the service of God, | and an earnest and unceasing solicitude | for the temporal and spiritual interests | of her fellow creatures | were the graces which marked and adorned her character ; | and these were derived from faith in that Saviour | Who loved her and gave Himself for her.

On a flat stone in the chancel these arms cut over— , on a fesse . . . between three roundles each charged with a lion's head erazed, . . . a griffin passant between two escallops . . . [Green] ; impaling— . . . , on a pale . . . three stags' heads [for Parke]. Crest—An ostrich :

Here lyeth the body of | Elizabeth the wife of John Green | of this parish, Esq., who departed | this life the 19th day of January | Anno Domini 1729, | ætatis suæ 30, | which said Elizabeth was the onely | daughter of Reuben Parke of Lutton, Esq., by | Mary Hoste one of the daughters of James | Hoste, Esq., of Sandringham in the county | of Norfolk.

Upon another close by :

John | son of John & Susanna Jay, Esq., | ob^t 28 Dec. 1691.

Across the last mentioned stone :

Adjacent lyeth John son of Wm. and Eliza. | Jay, Gent., ob^t 13 May 1697, ætat : 10 weeks.

Over the entrance to the chancel is this inscription :

Rev^d James Ashley, rector, John Winchley, John Ashfield, churchwardens, 1787.

The church is small, consisting of a nave separated from the north and south aisles by five arches pointed with high columns, a chancel with the east window blocked up ; most of the windows are modern but in one at the east end of the north aisle remains a shield of arms viz., England with a labell of five points, B. The tower and spire stand at the south side of the church and are entirely separated from it and seem to have been thus built originally.

In the account of Fleet in the *Gentleman's Magazine*, alluded to below, are also these further particulars—The church is dedicated to St Mary Magdalen and is a rectory. It is a neat stone edifice having lately been very much repaired and beautified. The steeple is distant about twenty feet south west from the west end of the nave ; it contains five bells with the following inscriptions :

1. Joseph Mallows of East Derham in Norfolk 1758.
2. Jhesus be our spede 1589.

3. Fili Dei vive Anno Domini 1573. I's miserere nobis.
4. William Denniss and William Winkley, churchwardens,
Lister and Pack of London fect 1766.
5. Thomas Norris made me 1652.

It mentions that on the label in the arms painted on the glass
each point is charged with three fleur de lis.

On a slab in the church yard near the north door in Saxon capitals
(R), and then nearly defaced, was the following :
Priez : pvr : les almes : Richard : Attegrene : Agneys : sa femme:
priez : quatre : vinz : iovrs : de : pa

[Tablet on the floor of south aisle :
Here | lieth the body | of Thomas Fairfax, gent., | who
departed this life the | 29th day of March Anno D'ni : | 1771, |
in the 56th year of his age.

Formerly at west end of the churchyard, now removed to the inside
of the church :
Here lieth the body of Michael Iohnson surgn | who died the
16 day of Feb. 1721, ætatis suæ 61. | Surgeon Johnson from
the Bull in Fleet, | He's not dead, he's only laid here to sleep. |
They say he's dead. Alass he cannot Die, | He's only changed
to Immortality, | His image graved on Man God's right doth
shew, | His image 'tis, let Cæsar have his dew.

Barber-Surgeons' Company of (Exeter)—Quarterly sable and argent;
over all on a cross gules a lion passant guardant or ; on the 1st
and 4th quarters a chevron between three fleams argent ; on the
2nd and 3rd quarters a rose gules seeded or, barbed vert, regally
crowned proper. Motto—De præscientia Dei. Written on the
 THE
cross—SUR GINS. Supporters—two leopards.]
 ARM

[See also *Churches of Holland ;* Trollope, *Sleaford*, 240-1.]

(MS ii, 25–32.)

NOTES

Various readings in *Gentleman's Magazine*, 1798, part ii,
p. 1094 : 1 *for* Lodington *read* Bodington. 2 four.

Folkingham

Notes taken in the church, 29 July, 1833—

On a white marble tablet against the south wall of the chancel :
Near | this place | lyeth the body of ye | Rev. Richard Toller,
M.A., | who departed this life | the 12 of Jany 1752, | aged
63 years. | Blessed are the dead wch | die in the Lord.

On a black monument against the north wall of the chancel :
To the memory of | the Rev^d Isaac Cookson, Sen^r, | Vicar of
Osbournby, Helpringham | and Walcot, in the county of |
Lincoln, and master of the Free | Grammar school in this
place. | He departed this life February | the 23, 1784, ætat.
57. | Also of Ann his wife | who died May the 7, 1784, | ætat.
54. | Δόξα ἐν ὑψίστοις Θεῷ

On a black tablet in the south aisle :
To | the memory of | Mr John Rugeley | late of this town
Apothecary | who died Sept. 30, 1780, | aged XXXI years. |
Quis desiderio sit pudor aut modus | Tam chari capitis.

On a black tablet next to the last in the south aisle :
Near this place | lies the body of | John Morrell | who died
28 August 1781.

On a flat stone in the south aisle (D) :
Maria Qweningbrowh | died the IV day | of April 1698. | Here
lieth the body | of Anne the wife of | Edward Greenberry |
who died May XXII, | 17[55, aged] 66.

On a stone in the south aisle has been an inscription in capitals,
but now defaced ; only the word " Brown " is legible. Underneath
is the following more modern memento (D) :
Here lieth the body | of Edward Greenberry | died May XXIII,
1766, aged LXXXI.

On another (R) :
Here | lieth the body of | Edward Greenberry | who departed
this life | October 28, 1798, | aged 74 years.

On a stone at the west end of the nave (D) :
Hic in humo | situs est reverendus | Dominus Thomas Martin |
nuper rector ecclesiæ | parochialis de Kirkby | Underwood
obiit die Aug. | the XV, MDCCXIX, ætat. 42.
[Here lyeth Elizabeth wife of Thomas Martin who died
January 24th, 17 . .
Here lyeth the body of Mary the wife of Abraham Craven
who departed this life April 16th, 1719.
Here lieth the body of Abraham Craven who died January
17th, 1792, aged 35.]

On a stone at the west end of the south aisle :
In a vault | underneath this | stone | lies the body of | William
Hall | late of Pointon | in this county | who died Feb^{ry} 3, |
1829, | aged 83 years.

On a stone in the south aisle (R) :
To | the memory of | Cornelius Maples, gent., | who departed
this life | Jan. 13, 1789, | aged 64 years.

On a marble tablet against a pillar south of the nave (R) :
> Here rest in hope of a joyful resurrection | on the last day, | Mary the daughter of | John and Mary Eastland, | ob. Sep. 1, 1786, æt. 2 years and 10 months. | Francis the son of | John & Mary Eastland, | ob[t] Dec. 16, 1811, æt. 17 years. | John Eastland, | ob[t] April 12, 1815, aged 75 years, | Elizabeth the daughter of | John and Mary Eastland, | ob[t] May 30, 1815, ætat. 23 years. | Mary the daughter of | John and Mary Eastland, | ob. Nov. 13th, 1824, ætat. 38 years. [Mary relict of John Eastland ob[t] Sept. 22nd, 1831, ætat. 82 years.]

Another tablet against the westernmost pillar :
> This marble is erected as a token of filial respect | to perpetuate the memory of | Benjamin Smith, Esq., | who died 27 January 1807, | aged seventy five years. | Also sacred to the memory of | Elizabeth relict of the above | who was released from suffering | borne with exemplary patience | the 6th of May 1820, aged 78 years.

A tablet against the pillar opposite on the south side ; arms— Ermine, on a chief azure three mullets argent, a border gules [Douglas] ; impaling—Or, five lozenges conjoined in fesse gules [Pinkney]. Crest—a hand couped at the wrist proper, holding a heart sable, thereon a crescent argent. Motto—Spero Meliora.
> This monument | is piously erected | by his affectionate widow | to the memory of | Daniel Douglas, Esq., | who having exemplarily discharged | with uncommon ability | the social and active duties of life, | eminently distinguished | for his friendly disposition, | love of peace and harmony, | finished his course here | much regretted, | August the 10, 1793, | aged 58.

Another tablet against the easternmost pillar of the same side (R) :
> A tribute | of affectionate attachment | to the memory of | the Rev[d] Edward Smith | who died the 17 of February 1813, | aged 33 years ; | his short life was marked by a consistency | of conduct rarely surpassed, | by truth and sincerity, | by the purest piety, | by the most active benevolence.

On a flat stone in the nave (D) :
> Here lieth the body | of Edmund son of Richard and Elizabeth | Eastland | who departed this life | Nov. 17th, | 1761, aged XXII. | Francis Eastland | was buried the 30th | of Dec[r] 1811, | aged 17.

Another (D) :
> Here lieth the body of | Jeremiah ye son of Daniel | Douglas who departed | this life April 1st, 17[03], | aged 21 years, | Jeremiah Douglas son of | the said Daniel Douglas | who departed this life | March 29, 1710, aged 14.

These on flat stones in the nave in memory of (D):
Richard Eastland died March 16th, 1759, æt. 60.
Elizabeth his wife died 1761, æt. 55.
Elizabeth Eastland buried 30 June 1813, æt. 33.
Daniel Douglas died [blank] June 1705, aged 17.
Daniel son of Daniel Douglas died May 25 1711, aged 24.

[Let into a slab under the tower by the north east pillar. Evidently a fragment cut off from a larger inscription:
Also of | Daniel Douglas, Esqre | son of | Daniel & Eliz: Douglas | whose death is recorded | on the pillar near this place.]

This church consists of a nave, two aisles, chancel, and tower at the west end, pinnacled nave and aisles, divided by three pointed arches with plain piers, a little painted glass in the windows.

[Stones in the floor of the west transept (D):
Here lyeth the body of Eleanor the wife of Edward Kitching who departed this life November the 30th, anno d'ni 1723, aged 56 years. A loving, faithful wife Sleapeth here in the dust.

In the north aisle:
In memory of Elizabeth Burton, relict of Mr Anthony Burton, who died ye 24th April 1729, aged 59.

In the floor of the nave:
Here lieth the body of Daniel Douglas who departed this life January 6th,, aged 47 years.
Here lieth the body of Daniel Douglas son of Daniel Douglas who departed this life May 23rd, 1743, aged 54.
Here lieth the body of Elizabeth the wife of Daniel Douglas who departed this life April 29th, 1709, aged 48 years.
Here lieth the body of Elizabeth the wife of the 2nd Daniel Douglas who departed this life October 23rd, 1783, aged 73 years.
Also John Douglas son of the said Daniel Douglas who departed this life March 29th, 1740, aged 44.
Here lieth the body of Richard son of Richard and Elizabeth Eastland who departed this life July 20th, 1755, aged 21. Multis ille bonis flebilis occidit.
Here lieth the body of Richard Eastland who departed this life July 26th, 1759, aged 66 years.
Here lieth the body of Elizabeth the wife of Richard Eastland who departed this life Jan. 21, 1765, aged 54 years.
Mary the daughter of John and Mary Eastland, she departed this life Sept. 1st, 1786, aged 2 years and 10 months.

[See also *L.R.S.* i, 219; Trollope, *Sleaford*, pp. 511–14.]

(MS i, 203–211.)

Frodingham

Notes taken in the church, 11 September, 1835—This church consists of a nave and two aisles resting on the north side on three sharp pointed Early English arches, ornamented with the toothed and ball moulding, and springing from circular columns with massive capitals. The arches on the south side are of a later style with octagonal shafts. The chancel is Early English with a lancet window of three lights at the east end. The roof is open to the timbers, but the arch to the nave is blocked up. A tower at the west end. The east window of the south aisle is a singular one. The font is circular with a clustered shaft. A good Early English arch in the south porch.

On a flat stone within the altar rails (D) :

> Here lyeth | the body of | Charles Healey | of Frodingham, | gent., | who dyed | May the 12, aged | 53, in the year of our Lord | 1698.

On another more to the north (D) :

> Here lyeth yᵉ | body of Mary Healey | of Gainsborough widow | of Charles Healey late of | Frodingham, gent., she | dyed yᵉ 10 of March | 1768, aged 59.

Another more to the south (D) :

> Here is the | body of Elizabeth | the wife of John Healey | Esqʳ, she died 1 of March | 1740, aged 67.

A blue stone to the east of the last (D). The arms cut over—. . . . , four fusils in pale [for Healey] ; impaling— . . . , a mascle between three roundles . . . [Osbaldeston]. Crest—A dragon's head :

> Reader, | Here rests | Elizabeth the second wife of | John Healey, Esq., | she was one of the daughters | of Sir Richard Osbaldeston, knight, | and left | this world (with not one like her in it) | the 7th of May 1749, in the 57 year | of her age.

On another stone :

> Here | lieth the body of | John Stow, gent., | of Frodingham, | who was buried July the 8 | 1689.

Another to D. E. Saunders of London, died 5 Decʳ 1820, æt. 52.

A black tablet, with gold letters, against the north wall ; arms over—Argent, four fusils in pale gules [Healey] ; impaling—Argent a mascle inter three pellets [Osbaldeston] :

> In memory of | John Healey, Esqʳ, | who dyed the | seventh day of May | 1750, | aged 63 years.

On a black tablet next similar to the last :

> Near this place | lie the remains of Geo. Healey, Esq., | who died Feb. 18, 1794, | aged 78 years. | Jane Healey, wife of the above | named Geo. Healey, | died Dec. 24, 1799, | aged 82 years.

Next to it another, with the Healey arms :
> In memory of | George Healey, Esq., | who died the twenty |
> eighth day of May | 1824, | aged 78 years.

A white marble tablet against the south wall of the chancel :
> Near to this place | are deposited the remains of | Mary Jane
> eldest daughter of | Henry and Mary Elizabeth Healey of |
> High Risby. | She died the 26 of June 1834, | aged 15. | Her
> afflicted parents have caused | this tablet to be erected
> to the memory | of a beloved child who in humble | resignation
> of the divine will bore | a lingering illness with Christian |
> fortitude and exemplary patience.

A flat stone below :
> Here | lie the remains of | John Healey, son | of George Healey,
> of | Gainsburgh, Esq., who died | the 6 of February 1789, |
> aged 34 years.

A black tablet (D) at the west end of the nave to the memory of
Austin Maw servant of G. Healey, Esq., 25 years, died 28 Dec^r
1801, æt. 60.

A flat stone (D) in the north aisle to William Clarke of Bromby,
gent., died 9 Dec^r 1782, æt. 85.

Others in the nave (D) to :
> William Clarke of Bromby died 30 April 1713.
> William Clarke of Bromby, gent., died 6 May 1802, æt. 78.
> William Grant Barber Clarke his only son died 7 May 1788,
> æt. 23.
> Jane wife of Richard Rogerson of Broughton.

[See also *Lincs. N. & Q.* xi, 176–178, 195.]

(MS viii, 229–234.)

Fulbeck

Notes taken in the church, 9 August 1833—

On a stone monument against the north side of the north aisle
under the window, the arms in a corner of the stone—Azure, three
gauntlets or, with a crescent difference. Crest—A bull's head
argent, armed or, issuing from a ducal coronet of the same
[Fane] :
> In | memory | of M^r William Fane second son of Sir Francis
> Fane Kt. of the Bath | by the Right Hon^ble Elizabeth relict
> of John Lord Darcy and Mennell who, | after 10 years travell
> in France, Flanders, Germany, Italy, Turky, Jerusalem, | and
> the Holy Land, in the 40^th year of his age, departed this life
> y^e 3 of June 1679. | Also Henry y^e 3^rd son dyed Nov. 27 and
> was buried here Anno 1686. | He was ever obedient to his
> parents, faithfull to his trust, beloved for his good | disposition

and particularly by M^rs Grace Fane his sorrowful sister
who | caused this monument to be erected for him y^e 10 of
July 1679. | Edward Fane 5^th son of Sir Francis after visiting
Jerusalem & other parts dyed at London | Dec. y^e 15, 1679,
aged 37.

Upon another stone monument like the last further to the west
in the north aisle :

In | memory | of M^r Thomas Ball who dyed y^e 10 day of
Febru. 1673 in y^e 74^th year of his age. | His wife was Elizabeth
daughter of M^r Thomas West of Doncaster, by whome | hee
had six sons and left onely one daughter Elizabeth survivinge. |
Hee was 50 years a faithfull servant to S^r Francis Fane, Kt.
of y^e Bath, | second son of Francis earle of Westmoreland,
and travelled w^th him into | Holland, Denmark, Germany,
Loraine, Switzerland, Italy, Naples, | France and Flanders,
where hee considered y^e courts and camps of | most of y^e
European Princes, their splendor & mutabilitie, concluding |
with y^e preacher, there was nothing new under the sun and
y^t all was | vanity and onely one thing necessary, to fear God
and keep his commandments. | Soe doth F. F. who fixed
this stone 1674.

A monument of stone under the east window of the north aisle,
three coats on each side the stone as follows—(1), Quarterly, France
and England, a label ermine [John of Gaunt] ; impaling—Gules,
three Catherine wheels or [Swinford], within the Garter, and a
ducal coronet over. (2), Gules, a saltier argent, charged with a
rose of the field [Nevile] ; impaling—Gules, a fess between six
crosslets or, a crescent for difference [Beauchamp]. This is sur-
mounted by a baron's coronet. (3), Nevile ; impaling—1st and
4th, Quarterly, France and England ; 2nd and 3rd, Or, a chevron
gules [Stafford], surrounded by the Garter, and surmounted by a
baron's coronet. (4), exactly the same as the last, surrounded
by the Garter, but surmounted by an earl's coronet. (5), Nevile,
impaling—Argent, on a chevron within a bordure azure three
escallops of the field [Fenne], surmounted by a baron's coronet.
(6), Nevile, impaling—Or, two bars argent ; on a chief quarterly
France and England [Manners], surmounted by a baron's coronet.
In the centre is an urn upon a pedestal, and on the last three shields
—(1) (the centre), Azure, three gauntlets or [Fane] ; impaling—
Gules, a saltier argent, charged with a rose of the field, Nevile,
surmounted by a baron's coronet. (2), Fane, impaling—Argent—
three lions rampant azure, surmounted by an earl's coronet [Mild-
may]. (3), Azure, semee of crosslets, three roses argent [Darcy] ;
impaling—[Argent], a fess dancette, between three leopards' heads
cabossed sable [West]. Also this coat—Quarterly, 1st, Fane ;
2nd, Nevile ; 3rd, Or, fretty gules, on a canton argent [a galley—
Nevile of Bulmer] ; 4th, Quarterly argent and gules, on the 2nd

and 3rd quarters a fret or ; over all, a bend sable [Spencer]. At the bottom this motto : Ne vile Fano ; and these inscriptions, which are divided by the pedestal :

> Un Dieu—Un Roy. Cor Unum—Via una. | Nomen alterum quære—obiit An⁰ 1680, Ætatis 69.

A white marble monument against the east end of the north aisle :

> Sacred to the memory | of | the Honourable Henry Fane | son of Thoˢ Earl of Westmoreland | who departed this life Friday June IV, | MDCCCII, | in the LXIVᵗʰ year of his age, | he left a widow | and numerous family of children | to deplore the loss | of | a most affectionate husband | and | the best of fathers.

On a white marble tablet against the north wall of the north aisle with an anchor above :

> To the memory of | Vere Fane | second son of Lieutenant General | Sir Henry Fane of Fulbeck, | Knight Grand Cross of the Bath. | He lost his life in the service of his country, | having perished with every one of his brother seamen, | the crew of his Majesty's brig of war Algerine, | off Hydra | in the Gresian Archipelago, | on the 8ᵗʰ day of January 1826, | in the 19ᵗʰ year of his age. | His proper sense of all his moral obligations, | the excellence of his disposition, | and his high professional qualities and character, | fitted him as it seemed for a prosperous course | of worldly felicity and honour. | But the Almighty has dealt yet more graciously with him | by removing him to immortality | before his fair prospects had been clouded by misfortune, | or his innocence endangered by temptation.

A white and grey marble monument north of the chancel (R) :

> In memory | of George Smith, gentleman, | who died 24 day of Oct. 1806, | in the 95ᵗʰ year of his age, | also of | Elizabeth Smith his neice | who died 18 July 1813, | in the 74ᵗʰ year of her age.

On a stone in the nave (D) :

> Sacred | to the memory of | James Horton, gent., | of this place, late of | Manchester, merchant, | who died the 26 of June | in the year of our Lord 1756, | aged 54 years. | He married Rebecca daughter of | William and Catherine | Pickworth of Caythorpe in this | county ; she died at Manchester | August the 18, 1753, aged 24, | and is interred in | St Anne's church, Manchester, | left issue three children, | Pickworth who died Sept. 1783, | aged 31, and lies interred at Caythorpe, | Catherine Dubar died |. in this (The bottom is effaced).

Round the Fane pew is this inscription :

> My son, Fear thou the Lord and the King and meddle not | with them that are given to change. Prov. 24, 21.

A stone monument (D) at the east end of the south aisle against the wall; the arms over—Sable, three goats salient argent [Thorold]; impaling—Argent, on a bend sable three owls of the field, a crescent for a difference [Savile]:

> In | memory | of Timothy Thorold Doc^r of Physick who was interred here y^e 25 of Dece*m*. 1641, and Eliz. his wife | onely daughter of Gabriel Savile of Newton, esq., shee was interr^d here the 29 of Oct^r 1669. They had five sons | W^m their surviving son was buried here y^e 13 of Oct^r 1663. They had three daughters, Eliz. the eldest married | Rich Thornhill of Marham, gent., both interred here, Mary y^e youngest married Anthony Williams of | Swarby, gent., Martha y^e second daughter married Tho. Lucas of Hollowell in y^e county of Northampton, | gent., they had 2 sons, Thomas and W^m, Thomas y^e eldest having spent near six years in the University of Oxford | being outwardly accomplished and inwardly qualifyed with piety, prudence and learning, to his Parents and Friends | great satisfaction, and others y^t knew him, Departed this life at the age 23, and was interred here y^e 21 of April | 1680, to y^e great grief of his father & mother who caused this monument to be erected for him. Here lieth also interred | the body of the before named Martha Lucas who dyed Feb. 16, and was buried Feb. 19, An^o 1686.

A black marble monument flanked by two grey Corinthian pillars against the wall to the north of the last mentioned, these arms over, viz.—On a chevron, between three stags tripping or, three roses [Robinson]; impaling—Argent, three martlets in pale, between two flanches sable [Brown]. And these below—Quarterly, 1st and 4th, Per pale indented or and azure; 2nd and 3rd, viz., [Robinson]:

> To the memory of | Elizabeth daughter of S^r Leonard Brown, knt, and relict of | Robert Robinson of Branston | in the county of Lincoln, gent., | who died in the year 1683. | Also John Robinson, gent., son | and heir of Robert and Eliz^th Robinson | who died January the 1^st, 172$\frac{5}{8}$, aged 74, | as also Elizabeth Grandaughter of | the above Rob^t and Eliz^t Robinson | and wife of Benjamin Jessop, gent. | She died September the 29, 1747, | in the 60 year of her age. | Likewise of the above | Benjamin Jessop, gent., son of | Robert Jessop of Marston | in this county, | who departed this life | the 4^th day of October 1762, | in the 70 year of his age.

A flat stone below commemorates the same Benjamin Jessop (D):

A monument of stone against the wall of the south aisle:

> Near this place | lies interred the body of | Elizabeth Shaw | daughter of Richard Shaw, yeoman, | and Mary his wife |

who departed this life | October 22, 1736, | aged 24. | She was
pious towards God, | dutifull to her parents, | loving and kind |
to her relations and friends, | and agreeable to all her acquaint-
ance. | Also Mary mother of the above | Eliz^t Shaw died
April 6, 1756, aged 65. | Also Richard Shaw, husband of the
above | Mary & Father of the above Eliz^th Shaw, | died
April 22, 1758, aged 74.

A black tablet against the south door :

To the memory of | Susannah wife of | Michael Atkinson |
who departed | this life November y^e 17, | 1744, aged 22 years. |
Also to the memory of | Michael Atkinson, gent., | who
departed this life | August 10, 1758, aged 43. | Also of Michael
Atkinson son of the above | who died April the 6^th, 1807, |
aged 62 years.

A grey marble pyramidal monument more to the west, in capitals
on a white slab (D) :

Near | this monument | are interred the remains | of M^r
Francis Atkinson | late of Leadenham | in this neighbourhood
who died | on the IX day of March | MDCCXCV, | in the XLIII
year | of | his age.

Another to the west of the last surmounted by an urn :

In memory of Thomasine | the wife of Michael Atkinson | of
the city of Lincoln, Att^y at Law, | who died 31 day of March
1805, | in the 34^th year of her age, | greatly lamented by her
family | and friends, | to whom she rendered herself | deservedly
dear | by a uniform exercise | of every moral & domestic
virtue.

A black slab at the west end of the south aisle (D) :

Here | lie interred the remains of | Ann the 2^d wife of | Mich^l
Atkinson, gent., | who died Feb. 13, 1771, | aged 47 years.

On a white marble tablet against the north wall of the chancel in
capitals :

Sacred | to the memory of | Elizabeth Sharp | wife of Thomas
Sharp | who departed this life | September the XIX, MDCCCXIX, |
in the 59 year of | her age. | Also of Thomas Sharp, | Surgeon
in this village XLIV years, | who died the XX of November
MDCCCXXV, | in the LXIV year of his age.

On a similar one below also in capitals :

To the memory of Elizabeth Barker | relict of Christopher
Barker, | Surgeon, | who died on the VII of May MDCCCI, |
aged LXVIII. | Also of George Fawcett, | Surgeon, | who died
XXVI of August MDCCLXXXIII, | aged XXXIII years.

On a flat stone in the nave (D) :

In memory of | Ann | wife of | Abraham Swain, yeo., | who
dyed | ber y^e 8, 1739, | aged 31 years.

This church consists of a nave separated from its aisles by three pointed arches rising from round columns, a chancel, and a tower pinnacled at the west end. It is very prettily covered with ivy.

[See also *L.R.S.* i, 228–9.]

(MS iii, 241–254.)

Fulstow

Notes taken in the church, 17 August 1833—The church is at present a mean building, consisting of nave and chancel, no tower. The bell hangs over the west end.

There is an old stone in the chancel, but the inscription which runs across the stone is illegible.

Placed upright against the wall of the west end is the figure (R) of a Knight Templar, his legs crossed, but broken at the bottom, his hands clasped, a shield on his arm. Over his head a lion couchant which may probably have been removed from under his feet. The whole is covered over with yellow ochre.

Next is the figure of a female (R), also placed upright against the west wall. There are the remains of a canopy over her head and the hands are clasped. It is covered with whitewash.

[See also *Lincs. N. & Q.* xi, 196.]

(MS iv, 3.)

Gedney

Notes taken in the church, 22 July 1833—In the chancel there are the remains of brasses, three seem to have been figures with inscriptions under them, the fourth a cross.

Against the south west [wall] at the entrance to the chancel is a white marble monument— . . . a lion rampant, looking to the sinister [? for Welles] :

> In memory of Mary the wife of | Robert Millington of this parish | great grand-daughter | of St John Wells, Esq., | of Alford in this county, | who died 17 Aug. 1831, | aged LVI years.

On a black marble tablet about the middle of the north wall of the north aisle :

> To the memory of | Worrall Palmer, gent., | of this parish, | who died October the XXIVth, MDCCCXXV, | aged LVIII years. | Also of Margaret Palmer | relict of the above | who died August XXX, MDCCCXXVI, | aged LIII years. | Them also which sleep in Jesus will God | bring with him. 1 Thess. IV, 14.

A very handsome old monument against the south wall of the south aisle, the entablature supported by three Corinthian pillars ; and

above three shields of arms : in the centre—Sable, a fess between three fleur de lis argent [Welby]. On the right hand—Sable, three spear heads argent [Apryce]. On the left—[Welby] ; impaling [Apryce]. Between the pillars are a man and woman kneeling at a desk on which are books. Below is the following inscription partly under the man, partly under the woman, in capitals :

> Here under lyeth buried the bodies of Adlard Welby | of Gedney, Esq., and Cassandra his wife the daugh- | ter of William Apryce of Washingleys in y^e parish | of Lutton in the county of Huntingdon, Esquier, | by whom he had issve fower sons and one daugh | ter, viz. William, Richard, Robert, John, and Susan, | being all livinge at his death, who departed this | life the xi day of August An. 1570, being of the | age of LXIII yeares, and Cassandra departed y^e xxii | of February An. D'ni 1590, being LX years of age.

The second column under the woman as follows :

> This monument was made at y^e cost & charges of S^r | William Welbie, Knight of the Honourable order | of the Bath, together with Robart Carr of Aswerbye, | esquier, the last husband of Cassandra, mother to y^e | foresayd Will'm, & wife to y^e above named Robart, & | was finished in the moneth of May 1605, being in y^e | raigne of our soveraine Lord James by the grace of | God of England Fraunce & Ireland king the | third, and of Scotland the eight and thirtieth.

On a brass plate against the south wall, west of the last, much rubbed and very illegible, though not old :

> Sacred to the memory of | Mary Ann Windett | daughter of | James & Ann Windett | who is interred opposite | 29 Dec. 1817, aged 7 years . . months. | Also of Maria & William who | died infants in London.

A white circular tablet on grey marble against the south wall :

> Mr | James Long | died December 16, 1786, | aged 60 years. | Mrs | Dorothy Long | died June 7, 1791, | aged 66 years. | Also 7 children | died infants.

Upon a flat stone in the south aisle near the last tablet :

> Underneath this stone are interred | in the hopes of a joyful resurrection | the earthly remains | of Elizabeth the wife of | James Long | who departed this life | the 12 day of April 1817, | in the 49 year of her age.

On another stone close by :

> Underneath this stone are interred | in the hopes of a joyful resurrection | the earthly remains | of James Long, gent., | who departed this life | the 12th day of February 1824, | in the 72 year of his age.

On another stone adjoining (D) :

> Underneath this stone are interred | in the hopes of a joyful

resurrection | Elizabeth wife of | James Long | who departed
this life | the 11th day of January 1809, | in the 50 year of
her age.

On another stone (D):

In memory of | Mary daughter of | Mr James and Elizabeth
Long | who died July 5, 1797, | aged 6 years.

On another stone:

Elizabeth daughter of | James & Elizabeth Long | died
March 2, 1781, | an infant.

On another stone:

William son of | James & Elizabeth Long | died March 20,
1794, | aged 10 months.

On a white marble slab in the floor of the nave:

To the memory | of Lydia the wife | of Nicholas Mathews,
clerk, | and also of Anne their daughter. | Lydia departed this
life | on April yᵉ 16, 1750, | in the 30 year of her age | and
Anne on Oct. yᵉ 13, | 1749, | aged 6 months. | Flere et
meminisse relictum est.

On a black marble slab in the middle aisle:

In memory of | Michael Athey | who died | Janʸ 11, 1826, |
aged LXXXV. | Elizabeth | his wife | died March 17, 1826, |
aged LXXXVI.

There is an atchievement suspended near the chancel as follows:
Quarterly, 1st—Or, a pale engrailed between two lions rampant
sable; 2nd—Per fesse argent and azure, a pile counterchanged,
charged with a buck's head cabossed or; 3rd—Per pale gules and
sable, an eagle or, in chief two mullets argent; 4th—As the first;
impaled by (which ought to have been first emblazoned)—Azure,
two chevrons embraced between three estoiles argent. Crest—an
estoile argent (D).

A marble monument against the wall at the east end of the south
[? aisle], with arms below—Sable, a chevron between three fleur
de lis argent. Crest—An armed arm azure, holding a sword proper
issuing from a cloud proper [Welby]. Motto—Per ignem per gladium:

Here under lyeth the body | of William Welbye, Esq., | who
departed this life the 17 day of April 1726, in the 58 |
year of his age. | He was lineally descended from Adlard
Welbe of Gedney, Esq., and | Cassandra his wife whose
monument is on the south side | of the church near this place,
to | the inscription on which this re | fers and to whose
memory | this is dedicated by Adlard | Welbye his brother
who was left his sole executor.

A similar one more to the south with arms and crest of Welby under,
and this motto—Per Ignem Per Gladium:

Near this place lieth | interred the body of Adlard | Welbye,

Esq., the youngest of the | four sons of Adlard Welbye, Esq., |
executor to his eldest brother W^m | Welbye, to whose memory
he erect- | ed the monument adjoyning, & in y^e | same
grave with him are deposited | the bodies of his said brothers, |
William & John Welbye, y^e 4th brother | having perished at
sea, | none of them | having left issue, that ancient & worthy |
family is hereby become extinct, he | died y^e 15 of June
1728, in y^e 58 year of | his age, and as he lived in the exercise
of all | Christian & moral virtues, so left a | memorial of
his charity by a perpetual | donation of five pounds a year
for | the relief of such industrious poor | of this parish as do
not receive collec- | tion. His father Adlard Welbye | left
fifty shillings per ann. to y^e | poor : many of his ancestors |
having been benefactors to | this parish before him.

Above these monuments are two atchievements with the Welby
arms.

On a black tablet against the wall at the east end of the south aisle
with arms over—Gules, on a fesse argent, between three garbs in
chief and a lion passant in base or, the words ' Vivens Vives ' [for
Whitley] :

Near to | this place | lyeth the body | of Edward Whitley,
gent., | who departed this | life February y^e 17th, | 1761,
aged 73 | years.

On a flat stone in the floor below, defaced by damp :

Hic jacet corpus Esteræ filiæ Augustini | Fish Vicar' hujus
Ecclesiæ et Catherinæ | uxoris eius quæ ex hac luce placide
migra- | vit X'ti nomine 11º die Julii 1690, ætat. 20º, | Jacobus
filius Augustini et Catherinæ Fish | Presbyter spei haud
vulgaris obiit | apud Londinum April 28^vo sepultus est |
Ecclesia Sabaudiensi 1710, ætat. 25º. | Catherina uxor
amantissima Augustini Fish | obiit Feb. 13, 1711, ætat. 51º. |
Liberis Conjugi et sibi. | Augustinus Fish A.M. vicar obiit |
Maii 13º, 1713, | ætatis 70.

On a flat stone in the north aisle (D) :

Here lyeth interred | the body of Elizabeth | daughter of
Humph | ery and Elizabeth | Graves who departed | this life
the 27 day | of July 1711, in the 13 | year of her age.

On a flat blue stone in the nave near the entrance to the chancel :

In memory of | Perigrina the wife of | William Benson who |
departed this life | December y^e 28th, 1745, | aged 51. | Also
the body of William Benson | who departed this life August
19th, | 1750, | aged 58 years, | and also his son who died
in | his infancy.

On a small stone more to the east :

Here lies | interred the body | of Robert son | of Robert &

Amy | Pulvertoft | who departed this life | the 21st of July 1783, | in his infancy.

On another large blue stone :

Beneath this marble are interred | the remains of Elizabeth wife of | William Bothamley | who departed this life | January 29, 1793, | aged 36 years. | Also | one child died an infant. | Also | beneath are deposited the earthly | remains of | William Bothamley | who departed this life | January 19, 1806, | aged 53 years.

Over the door at the south is the following inscription in capitals of old character :

Pax Xp' i sit huic domui et omnibus | habitantibus in ea hic requies nostra.

This is a very handsome church. It consists of a nave and side aisles divided by six fine pointed arches, and a chancel, with a tower at the west end. The east window of the north aisle is filled with very beautiful painted glass, and in another window of the same aisle are these arms—Argent, three lions passant sable. There is also in all the other windows of the church some painted glass. There are twelve clerestory windows, very handsome.

[See also *L.R.S.* i, 178–80 ; Jeans, Supp., 8–9 ; *Churches of Holland.*]

(MS ii, 33–47.)

Gedney Hill

Notes taken in the chapel, 30 August, 1836—This chapel consists of a nave with aisles, chancel, and a tower of the perpendicular style at the west end, divided by a pointed arch from the nave. The aisles are separated from the nave by wooden supports without arches. No arch to the chancel. The windows are modern, and those of the clerestory garret. Font—octagon, pannelled. A south porch, and in the tower five bells, three old and two new ones. In the churchyard is the handsome shaft of a cross on a pedestal and basement of two steps.

A stone tablet against the north wall of the chancel ; on a book this :

" Be not slothful but followers | thro' faith and patience to inherit the promises."

Above a crown, and this inscription :

In memory of | Mary Kingston, | a sincere Christian. | How loved, how valued once avails thee not | To whom related or by whom begot | A heap of dust alone remains of thee | 'Tis all thou art and all the proud shall be. | She died, the 16 day after the birth of her 2d child, | the 8th of May 1815, | in the 26 year of her age. |
Life how short, Eternity how long.

A white and grey marble tablet opposite :

> In memory | of Jacob Decamps | who departed this life | the 8th of Septem^r. 1770, | aged 71 years. | Also Susanna his wife | who departed this life | the 7 of August 1758, | aged 64 years.

A flat stone in the chancel :

> In memory | of | the Rev^d | Richard Hayforth | curate of this parish | seven years. | He died the 2^d of Feb. | 1788, | aged 56 years.

A blue flat stone in the nave :

> Here lieth the remains | of the Rev^d David Burrell A.B. | pastor of this place thirty years, | to whose memory a friend has | inscribed this stone for the sake | of gratitude. He departed | this life January 25, 1779 | in the 68 year of his age.

A blue flat stone to the west :

> Here lieth interred | the body of Sarah the wife of | Robert Skin who departed this life | the 3^d of October 1737, | aged 75 years. | Here lieth interred also | the body of the said Robert Skin | who departed this life the 5 of July | 1740, aged 61 years.

Another to the west :

> In memory | of | Joseph Scribo | who departed this life | August the 24, 1781, | aged 56, | Also of Susannah his wife | who departed this life | June 13, 1768, | aged 32.

Another to the west under the singing gallery at the west end (D) :

> Under this marble | lieth interred the body | of Thomas Cherinton, Gent., | he was XXXVI years one of the | feoffees in trust for the lands | belonging to this Chapel, | who departed this life | the 16 of February 1789, | aged 56 years. | And of Mary his daughter | who died the 7 of April 1771. | Also of Sarah his wife | who died the 16 of Dec^r 1814, | aged 77 years.

<div align="right">(MS ix, 33–37.)</div>

Glentworth

Notes taken in the church, 14 September, 1835—

On the south side of the chancel a white marble monument, representing a canopy under which are three heads, and on each side stands a cherub in attitudes of grief. The pediment is supported by two Corinthian pillars and over it are these arms—In a lozenge paly of six argent and azure, on a bend sable three annulets or [Saunderson] ; impaling—Azure on a chief or three martlets gules (Wray), but much defaced. Above, the crest—A talbot argent, spotted sable [Saunderson] ; below, at the base, this inscription in two compartments :

> (1) D O M | S | near this place lies the body of the Hon^ble |

Elizabeth Saunderson, widow of Hon^ble Nicholas | Saunderson, eldest son of the R^t Hon^ble George Lord | Viscount Castleton of the kingdom of Ireland, | by whom she had only one son, Wray Saunderson, | who dyed without issue in her life time. | She was the only daughter and heir of Sir John Wray | of Glentworth, Baronet, | who was great grandson of S^r Christopher | Wray, Lord Cheif Justice of England | in the reign of the renowned | Queen Elizabeth. | She had great virtues | and a greater desire of concealing them | was of a severe life. | (2) Yet of an even conversation, | courteous to all, but strictly sincere, | humble without meanness, | liberal but not profuse, | devout without ostentation, | to her friends and relations beneficent, | to the poor charitable | even beyond her death. | She exchanged her earthly for an heavenly habitation, | at the city of Yorke the 7 day of April | Anno Dom. 1714, in the 50 year of her age, | having settled a good part of the estate of the Wrays | of Glentworth in the counties of Lincoln, Norfolke and Yorke, upon her next | Heire male Sir Cecill Wray, Baronet, | who out of respect and gratitude has caused this | monument to be erected | to her memory.

On a tablet against the north wall :

This monument was erected by the Hon. & Rev. J. Lumley, | to the memory of his late worthy & much esteemed friend, | the Rev. George Bassett, | who died at Bath the 16 of December 1796, | aged 57. | Near this place are also interred | his parents the Rev. William Bassett | who died in 1765, aged 63, | archdeacon of Stowe, & 40 years vicar of Glentworth, | and Elizabeth his wife, the daughter of | George Whichcot of Harpswell, Esq., | by whom he had 13 children, | she died in 1774, aged 71. Ed. Hurst fecit.

The monument to S^r C. Wray will be found described in the interleaved notes to Weir's *Lincolnshire*.

The church consists only of a nave separated from the chancel by a handsome pointed arch resting on dwarf columns with trefoil capitals. The church has been quite modernised with circular headed windows and ceiled roof, the floor paved with red tiles, and no flat stones whatever.

[See also *L.R.S.* i, 146–7.]

(MS vii, 33–36.)

Goltho

Notes taken in the church, 13 August, 1833—

On a stone in the nave :

Hic jacet Tho. Grantham | Tho. Grantham de S. | Katharinæ juxta | Lincoln mil. filius qui | duxit Doroth. Alford | obiit No : die 22 | Anno D'ni 165 . . | FF.G. H.M.P.

On a stone quite close, but very much rubbed, and partly hid under a pew :

 Hic ja | Tho. | |

 om. Ebor. | pepe |

 et 2 fil . . | . . obiit die Aug.

 A. | 1673 | FF.G. H.M.P. | vivit post funera

vi

On a stone in the nave have been brasses of a knight, and two shields of arms, and inscription round the edge—all gone.

An old stone with this inscription round the ledge in old characters :

 Hic jacet d'na Margareta Mustill mo' . t . pri[or]issa huius loci que obiit XVI k'l'as Marci A. D'ni MCCCCCVIIJ° cuius anime propitietur Deus Amen.

In the middle of the stone is a cross, ✠.

On a flat stone near the door :

 Sacred | to the memory of | Margaret Dynely Fowler | widow of | Joseph Fowler, | formerly of Goltho, | who died on the 13 of April 1816 | aged 71 years. | Also of Mary Ward, spinster, | her twin sister, | who died on the 26 of Sep. 1815. | Blessed are the dead which | die in the Lord.

This church is small ; it consists of a nave and chancel, with a niche for a bell at the west end. In a window of the nave at the north side are these coats of arms repeated, though they have been taken out and put in again without order—Gules, six pears, three, two, and one or. Sable, a bend between three pellets [Alford]. Two crests—One on a torce argent and gules, a demy griffin segreant gules [Grantham]. The other, On a torce or and gules a boar's head couped or ; in its mouth a broken spear argent [Alford]. Motto—Comme Dieu Grantit. [Grantham]. Below this inscription :

 Tho Grantham | Fran. Grantham filius

 Monumenta. hæc.

 (MS xii, 57–58.)

Gosberton

Notes taken in the church, 17 July, 1833—

On a brown veined marble monument pannelled with white marble, against the north wall of the chancel, the arms are sculptured under—Checquy azure and or, a fess ermine. Crest—A salamander in fire. Motto—" Victrix Fortunæ Sapientia " [Calthrop] :

 This tablet | is consecrated by filial affection | to the memory of | John George Calthrop, Esquire, who died March 14, 1815, | aged 65 years. | Also of Ann his wife who died December 24, 1806, | aged 53 years. | The victory of Jesus Christ over

Death giveth to their | sorrowing children a sure and certain hope of being | again united to these beloved and excellent parents.

In the south transept under an arch the recumbent figures of a knight with his hands clasped across his breast, in mail, and his legs crossed ; and the figure of a lady.

On a stone in the nave before the entrance to the chancel :
Here lyeth y^e | body of Barbara | the daughter of | John and Barbara | Calthrop who | departed this | life October y^e 30, | 1716.

On the same flat stone are also the following :
Here lyeth the | body of Richard | the son of John | and Barbara | Calthrop who | departed this | life June y^e 2^d, | 1718, | aged 3 years.
Here lieth y^e body | of John y^e son of | John & Barbara | Calthrop who | departed this | life June y^e 16 | 17[18] (rubbed).
Here lieth the body | of Thomas the son | of John & Barbara | Calthrop who | departed this | life December y^e 14, | 1727. Also Barbara their daughter an | infant departed this life y^e 11 of March | 1728–9, and is interred here.

On a flat stone north of the preceding :
Here lieth interred the body of | Barbara the wife of Mr J^no Calthrop | who departed this life the 20 day | of Aprill Anno D'ni 1729, | in the 33 year of her age. | Also | here lieth interred the body of | John Calthrop gentleman | who departed this life the 6 day | of October Annoque Dom. 1740, | in the 50 year of his age.

On a stone further north of the last :
Here lyeth interred the | body of Mary the daught | er of Mr John Calthrop | and Barbara his wife | deceased who departed | this life the 10 day | of December Anno D'ni . . . | aged

On another stone more to the north :
By the remains of his grandfather | here lies the body of | Richard Calthrop, gent., | who died | on the 17 of April 1762, | at the age of 38 years. | In the same grave | are two of his children | and seven more survived him. | His relict, | Mrs Mary Calthrop, | died on y^e 23 of January 1780, | in the 52 year | of her age.

On a stone still more north of the last :
Here lieth the body of Mr | Richard Calthrop who | departed this life y^e 19 day | of January Anno Dom. | 1710, | in the 53 year of his age. | Mary his wife | ob^t 14 Feb. 1693.

On a stone still further north :

> In memory of Martha relict of | Richard Calthrop, gentleman, | who was interred the 7th day of May | Annoque Dom. 1719, aged [blank] years. | Also | Elizabeth relict of Hugh Christopher, | gent., & daughter of Richard Calthorp, | gent., was interred the 2 day of April | Annoque Dom. 1732, aged 37 years. | And | Anne relict of Mr Nathaniel Garland | and daughter of Richard Calthorpe, gent., | was interred the 23 day of February | Annoque Dom. 1739, aged 42 years.

On a flat stone still north of the last with these arms sculptured at the top—Checquy, azure and argent a fesse ermine [Calthrop]; impaling—Vert, a fess charged with three roundles . . . between a greyhound current in chief, and three [covered cups] in base [Kelham]. Crest—A salamander in the middle of flames :

> Mr Richard Calthrop | of Boston merchant | died | on the 8th of Nov. 1759, | in the 59 year | of his age | and | is here interred.

Another flat stone furthest north of the foregoing range :

> Here lies the body of | Mr Thomas Calthrop | who died | on the 25 of July 1761, | in the 58 year | of his age.

On a flat stone at the west end of the nave :

> John | the son of | Mr Robert Allen | by Ann his wife | died January the 10, 1790, | aged 25 years. | Ann their daughter | died May the 29, 1779, aged 18 years. | Six other sons and five daughters | died in their infancy. | Ann | the wife of | Mr Robert Allen | died July 29, 1790, | aged 53 years.

On a stone near the above :

> Robert Allen, gent., | died July yᵉ XI, MDCCCV, | in the LXXII year of his age.

On another flat stone :

> In memory of | Elizabeth Allen | daughter of Mr Robert Allen | by Ann his wife | who died Dec. 10, 1795, | in the nineteenth year of her age.

On another flat stone :

> Sacred | to the memory of | Sarah the wife of | Mr John Willerton | who departed | this transetory life | May 4, 1808, | aged XXXVIII years.

On a flat stone at the south west end of the nave and under the pews :

> Here | is deposited the body of | Mr Francis Dyson | who died Octob. [blank] | MDCCLXX, | aged 49.

And on another stone close by :

> In memory of | Mr Robert Peach | who departed this life | May 25, 1781, | aged 34 years.

K

White marble tablet against the wall to the south of the altar (R) :
In memory of | Squier Calthrop, | formerly of Boston, | a
man of principle, | and one who feared God, | born 4th Jan.
1746, | died 7 Oct. 1827.

A large flat black stone at the entrance to the chancel :
In memory of | Ann daughter of | Daniel & Penelope Allenby |
of London, | who was suddenly taken away | from the tender
endearments | of her disconsolate friends | while on a visit |
at the house of her uncle, | John George Calthrop | of Gosber-
ton, | on the 5th of October 1794, | at the early age of |
seventeen years and ten months. | Sacred to friendship be
this hallowed strain, | Entombed with relatives here Anna
lies, | Angels triumphant swell the heavenly train, | Which
waft her spirit to the distant skies, | Her parents grief was
as their love sincere, | And o'er her urn affection drops a tear.

Upon another close by :
Here lye | Frances & Margaret | daughters of | Tho. Townsend
Vic. and | Anne his wife | ob. 1724, | ætat. 1mo.

On a flat stone in the north transept :
To the memory of | Ann | the wife of | Robert Kemp | who
departed this life October | the 1st, 1798, in the 63 year of
her age. | Also four grandchildren died in their infancy. |
Robert Kemp | departed this life July 5th, | 1817, | in the
84th year of his age.

Another to the north of the last :
To the memory of | Robert Kemp | who died Oct. 12, 1817, |
aged 50 years.

A grey and white marble monument against the south side of the
arch from the nave ; arms below—Chequy azure and or, a fesse
ermine [Calthrop] ; impaling—Argent, a chevron ermine between
three talbots passant sable [? for Dobbs]. Crest—On a torce
gules and argent, a salamander in a flame of fire proper. Inscription
in capitals :
In a vault | at the foot of this pillar | are deposited the remains
of | John Calthrop, M.A., | vicar of Kirton XL years, | vicar
of Boston XXXIX years, | a prebendary of the Cathedral
church | of Lincoln, | a representative of the clergy of this |
diocese in convocation, A.D. MDCCLXXIV, | and an acting
magistrate for these parts | XXI years. | Having filled these
several stations | ably, and honorably, and discharged | all
his relative duties faithfully, | he departed this life | to receive,
as we trust, in another | through the merits of his Saviour, |
an abundant recompense of his labours, | XVII May A.D.
MDCCLXXXV, ætat. LXVI. | In the same vault are deposited
the remains of | Mary Calthrop his relict | who died XVII Jan.
A.D. MDCCC, ætat. LXXVII.

On a flat stone in the nave :

Squier Calthrop | died Octr. 7, 1827, | aged 81 years.

Upon another to the west of the last :

Here lies | Francis Eastland | of this parish, gent., | who died July 16, 1804, | aged 69. | Mors Christi vita mihi. | Here lies deposited | all that was mortal of | Mrs Anne Eastland wife of | Francis Eastland | of this parish, gent., | who departed this life | the 19 Octobr 1797, aged 50 years. | If e'er lost worth could claim a sigh sincere, | Stay passenger and pay that tribute here. | Here flourished once whilst heaven did life impart | A soul seraphic and the purest heart. | From wisdom's sacred fount she largely drew | Knowledge divine, and practised what she knew. | To all alike her friendly help displayed. | Where pity prompted charity obeyed. | Such was her wealth whate'er was wanting here | Is now completed in a happier sphere.

A tablet against the wall on the east side of the south door in capitals (R) :

In memory of | John Robinson, | born March 9, 1748, died May 17, 1821, | and of Mary his relict daughter of the late | Dinham Atkinson of Horncastle, | born June 2d, 1754, died June 27, 1822. | They lived respected and they died lamented.

A similar one on the west side of the same door, also in capitals :

In memory of | Robert Robinson | born June 21, 1749, died April 17th, 1790. | And of Rebecca his relict, | daughter of the late | Revd John Tatam vicar of Whaplode, | born October 31st, 1750, died November 12, 1810. | Also of Robert their eldest son | born August 30, 1782, died March 31, 1803, | and of two children who died in their infancy.

On a flat stone near the north door :

Elizabeth | daughter of John | and Sarah Willerton | died June 27, 1823, | aged 26 years. | In memory of Miss Elizabeth Willerton | who departed this life | on the 18th day of March 1795, | in the 38th year of | her age.

On another more to the south :

Sacred | to the memory of | John Willerton | who departed this life | January 18th, 1822, | aged 57 years.

In the south transept is affixed a table of Benefactions (D) of which the following is an abstract :

Mr John Burton gave 3 acres 3 roods in Surfleet abutting on Henry Herons, Esq., for the poor of Surfleet and Gosberton.

Anthony Death gave 2 acres 2 roods for the poor of Gosberton.

Lord Tyrconnell gave 10s. to the minister to preach on Ascension day, a black gown on St Luke's day for the poorest man in Gosberton, & 2d in white bread on St Thomas day.

Sir C. Montague, kt, gave 3 acres to the poor of Gosberton.

John Calvary gave 1 acre near Henry Heron's to the poor of Gosberton.

Ann Martin of Wigtoft gave 10s. per an. to ditto.

John Horn of Linn gave £20 with £5 more from the parish which purchased 1 acre 2 roods.

Henry Harvey gave 12s. per an., 10s. on St Thomas day for service, & 2s. to buy 12 penny loave on Christmas day for 12 poor widows.

John Shaw of Gosberton in 1614 gave £3 1s. for coals to be bought at Midsummer and sold to the poor.

Thomas Read of Gosberton in 1616 gave £2 for coals.

Mr Will. Lacy gave 2 roods of land for proceeds to be distributed on Candlemas day.

Richard Calthrop, Martha Calthrop, & John Calthrop gave 1 acre of an estate in Quadring to produce 10s. for the vicar for preaching a Commemoration sermon yearly on the death of Richard Calthrop, and the rest to be given in white bread to the poor.

Mr Henry Cawood gave to the poor of Gosberton 6 acres & 1 rood in Quadring, the rent to be disposed of as follows— a blue gown to be given to the poorest man in Gosberton on the 1st Novr yearly, & the rest to be laid out in white bread for the poor on Easter Monday ; also 4 tenements for widows ; also the interest of £10 to be paid to the minister of Gosberton to preach a sermon on his funeral day for ever.

William Lambert gave 20s. yearly for ever to Gosberton, charged on lands of William Taylor being in Gosberton to be paid on St Thomas day.

John Runton gave £10 to Gosberton, the interest to be laid out in white bread to be given on 1st of Feb. for ever.

Mr John Pell gave an acre & a rood for ever to Gosberton, lying in Gosberton, the rent to be given every Good Friday.

Mr John Wright gave to Gosberton yearly 20s. for ever, to be paid from ye farm in tenure of Will. Smith in Gosberton, or any other of his lands, to buy white bread to give on Candlemas day for ever, & if it is not paid the feoffees may distress.

Mr Edw. Cawood gave to Gosberton a rent charge of 30s. per an. on 17 acres of ground called John of Cheales on Michaelmas day for ever, also 20s. payable out of a messuage &c. on Michaelmas day. Also 20s. on Michaelmas day for these uses, a blew gown to the poorest man in Gosberton annually on ye 5th Nov., & the rest to be spent in white bread on Candlemas day & the day on which his funeral

shall happen, & on Whit Monday. Also 10ˢ. a year of 14 acres belonging to G. Theed, Esq., for a sermon to be preached on his funeral day for ever.

The church is large and very handsome. It consists of a nave divided from the two aisles by four fine pointed arches. There is a transept with fine windows. The west window is very large, of the perpendicular style of architecture. There is a fine tower, and crocketted spire at the intersection.

In Dodsworth MSS. 45, fol. 686, is the following :
>In Eccl'ia de Gosberkirke in com. Linc.
>Hic jacet Nicholas de Rye miles et Edmundus filius ejus pro quorum animabus propicietur Deus. Tumulus alabastrinus cum effigie, super pectus a \ bend et in fenestra australi Nicolaus Rye Margareta uxor eius Cecilia mater eius me fieri fecerunt in honorem b'æ Marie.

In Insula Australi :
>Orate pro anima Joh'is Bole et Catharine consortis sue Thome Edmund et Juliane consortis sue Will'm Flouter et Agnetis consortis sue Will. de C[elle et] Jo. consortis sue et pro fratribus et sororibus gildæ Johannis Baptiste qui istam fenestram fieri fecerunt Ano D'ni 1465.

[See also *L.R.S.* i, 172–3 ; *Churches of Holland ;* Kaye, *History of Gosberton,* pp. 78–90.]

(MS i, 139–157.)

Goxhill

Notes taken in the church, 31 August 1835—Many of the inscriptions, viz. those of Wentworth and Skinner, have been already taken in the *Gentleman's Magazine,* 1797, part ii, p. 913. It would therefore be useless to repeat them, but some also have been omitted that relate to families of respectability.

On a black stone in the chancel within the altar rails (R) :
>Here lyeth the body of | John Sandes of Goxhill, gent., | who married the daughter | of Robert Middlemore, Esq., | and had issue by her 5 sonnes, | Robert, John, Edward, George, | and Will., and 3 daughters, | Elizabeth, Ann, & Dorathy. | He dyed the 21 day of | December in yᵉ year of our | Lord 1664, being the 74 | yeare of his age.

On a stone next to it (R) :
>Here lyeth the bo | dyes of John | and Robert Sandes sonnes | of Mr Robert Sandes | and Anne his wife | 1669.

On a black stone in the chancel (R) :
>In memory of | William Hildyard, Esq., of | Grimsby, who died the 2ᵈ of | December 1781, aged 67 years. | Also Frances relict of the above | William Hildyard who died | the 25 of

April 1811, aged 77 years. | Also of Charlotta the daughter | of William & Frances Hildyard. | She died the 21 of March 1782, | in the 14 year of her age.

On a stone next to the last (D) :
Here lyes | interred the body of Henry | Hildyard of Goxhill, Esq., he | departed this life the 16 | of September 1722, | aged 38 years. | Here lyes also Mary | his only daughter who | was enterred Feb. 21, | in yᵉ year of our Lord | 1710.

On another stone more to the west (R) :
In memory of | Wᵐ Markham, Esq., | of Barton upon | Humber who departed | this life Novʳ yᵉ 10, | 1780, in the 71 year | of his age.

A stone monument, partly painted, against the north wall of the chancel : there is a coat of arms underneath—A bend papillionis, and over the shield an arrow and human bone saltierwise :
Near | this place lies interred | the body of | Mary Ann Pearson | daughter of John & Ann Pearson, | she died Dec. 4, 1800, | aged 15 years. | How happy is the child of grace | Who knows her sins forgiven | This earth she cries is not my place | I'd rather go to Heaven. | Also the body of Ann Pearson | their daughter | who died in her infancy.

On a white marble tablet against the wall of the south aisle :
Nigh this place | lieth interred the body | of Mr Thomas Wyer who | departed this life May the 2ᵈ, | 1787, aged 40 years. | His Hands while they his alms bestowed | His Glory's future harvest sowed | The sweet remembrance of the just | Shall flourish when he sleeps in dust. | In the same vault are interred the remains | of Mary Ann daughter of the said Mr | Thomas Wyer and Ann his wife, she | dyed the 24 of October 1800, in the 16 | year of her age. | Like some fair flower the early spring supplies | That gaily blooms yet e'en in blooming dies.

[See also *Lincs. N. & Q.* x, 207–9.]

(MS vi, 135–139.)

Grainsby

Notes taken in the church, August 25, 1835—This church, which was rebuilt about a year ago, is a small building consisting of a nave and chancel, between which is an old screen, and a tower at the west end, in which are three bells, and a south porch. The font is a plain round one. The church does not contain a single monumental inscription.

[See also *Lincs. N. & Q.* x, 209.]

(MS vi, 189.)

Greatford

Notes taken in the church, 16 July, 1833—

A marble tablet on the south wall of the chancel (R), with these arms under—Argent, a chevron between three crescents sable [for Lafargue]:

> Hic jacet | Petrus Lafargue | Stamfordiæ in comitatu Lincolniensi | clericus, | obiit die Martii 16, Ann. Dom. 1804, | qui | Piorum resurrectionem expectans | Deo omnipotenti | spiritum reddidit | sperans | vitæ mercedem honestiæ | privatæ quidem | sed non minus mansuetudine et liberalitate | tam erga proximos quam suos | abundantis.

On a marble tablet next the last (R):

> Near this place | are deposited | the remains of | William Roden | who died April 15, 1810, aged 65 years. | Also of Ann Roden his wife | who died Oct. 6, 1805, aged 57 years. | To perpetuate the memory of the | best of parents | this tablet is erected | by their affectionate children, | William, John, & Thomas.

On a stone in the chancel this inscription in an oval (D):

> Sacred to the memory of | Mrs Willis wife of the | Rev. Thomas Willis | July 6, 1784, | aged 23.

On an oval in a stone, close to the above (D):

> July 10, 1783, | sacred to the memory | of | one of the best of men | who was possessed of every virtue | which adorns human nature.

On a stone in the middle aisle (D):

> In memory | of yᵉ | Rev. D. Myers | obᵗ Dec. 2, A.D. | 1780, | Ann. ætat. 31.

On a stone adjoining (D):

> Ann | daughter of the Rev. | Mr D. Myers & Ann | his wife was buried under | this stone May the | 30, 17.8, aged 4 | years.

On a stone still more to the west (D):

> In | memory of | Barbara Duncombe | who died Oct. 21, 1801, | aged 16 years.

Another flat stone in the centre of the church (D):

> In memory of | Edward Thompson | who departed this life | the 21 of January 1732, | in the 55 year of his age.

On another flat stone near the above (D):

> Here lies interred | the body of Mary Pearce | widow and relict of | Thomas Pearce, Esq., | formerly of Abingdon Street, | Westminster, | who departed this life the 17 of Dec. 1794, in the | sixtieth year of her age.

In the porch on a stone fixed against the north wall :
> Here lieth the body | of Robert Bonner dece | ased March
> the ' heth ' | Anno Do. 1661.

On a stone close to the above against the wall of the porch also :
> Near this place | lyeth interd ye body | of Elizabeth ye wife |
> of Robert Bonner | who departed this | life May ye 9, 1709.

In a transept chapel with the lower part of the stone covered by
the pews (D) :
> Near this place | lye the remains of | Francis Browne, Esq., |
> who departed this life | August ye 18, 1751.

On a stone close to the above (D) :
> Here lieth the body of | Edward Browne, Esq., who | departed
> this life May ye | 15, 1713, | in the 72 year of his age. | Honestys
> best. (The rest covered by the pew.)

On a stone next to the preceding (D) :
> Here lyeth the body of | Elizabeth ye wife of | Edward Browne
> of | Greatford in ye county of | Lincolne, Esq., who depar- |
> ted this life ye third of May 1701.

On a stone adjoining :
> In memory of | Susan Layng | daughter of the late | Rev.
> Peter Layng, | M.A., rector of Everdon | and Farthingston
> in the | county of Northampton, | she died in this parish |
> April the [9th, 1803].

At the east end of chapel or north transept is a handsome monument
of white marble, with the bust above of a man, ornamented with
books. It was sculptured by Nollekens : in capitals :
> Sacred to the memory of | the Revd Francis Willis, M.D., |
> who died on the 5th of December 1807, | in the 90th year of
> his age. | He was the third son of the Revd John Willis of
> Lincoln, | a descendant of an ancient family of the same
> name | that resided formerly at Fenny Compton in Warwick-
> shire. | He studied at Oxford, was fellow & some time
> vice-principal | of Brazen-Nose College where, in obedience to
> his father, | he entered into Holy Orders, | but pursuing the
> bent of his natural taste & inclination | he took the degree
> of Doctor of Physic | in the same University | and continued
> the practice of the profession | to the last hour of his life. |
> By his first wife Mary, | the youngest [daughter] of the Revd
> John Curtois | of Branston in this county, | he had five sons
> who survived him. | By his second wife he had no issue. |
> Initiated early in the habits of observation & research, | he
> attained the highest eminence in his profession, | and was
> happily the chief agent in removing the malady | which
> afflicted his present Majesty in the year 1789. | On that
> occasion he displayed | an energy and acuteness of mind |

which excited the admiration & procured for him | the esteem of the nation. | The kindness & benevolence of his disposition | were testified by the tears and lamentations | which followed him to the grave.

On another close by against the same wall, with an urn at the top, by the same sculptor and in capitals :

Sacred to the memory of | Mary | the youngest daughter of the Rev. John Curtois | of Branston in this county. | She married the Rev. Francis Willis, M.D., in 1749, | and was the mother of five children, | Francis, John, Thomas, Richard, & Robert Darling, | she died on the 17th of April 1797, | in the 73 year of her age. | Her manners were gentle and unassuming | and her whole life was worthy of imitation.

On a small marble slab between the two :

These monuments | were erected by the surviving sons, | a pious testimony | of their affectionate regard & esteem | for the memory | of their revered and much honoured parents.

The arms on a black slab above—A chevron . . . between three mullets [Willis] ; impaling—Paly a fesse checquy [for Curtois]. Crest—A mullet within an annulet. Motto : Integrity.

On a black stone at the entrance of this chapel :

Mary Maria Millington | wife of Langford Millington, Esq., | of Berners Street, London, and | Rushford Lodge, Suffolk. | She was one of the daughters | of the late Thomas Warren, Esq., | special pleader of the Inner Temple ; | she died 24 May 1801.

There was an old octagon font.

[See also G.M., 1862, part ii, 737.]

(MS i, 107–115.)

Greetwell

Notes taken in the church, 6 August, 1833—

On a black stone within the altar rails with these arms over— Three crescents, a canton ermine [Dalyson] :

Here lyeth Robert Dalyson | of Greetwell in the countie | of Lincoln, gent. the second sonn of | William Dalyson, one of the | Justices of the Kinges Bench | in the time of Queene Mary, wch | Will' was second sonne to Will' | Dalyson of Laughton in ye said | countie, esq. and ye said Robert | died the 25 day of Aprill in the | yeare of our Lord 1620.

On a flat stone in the chancel adjoining the last (D) :

John Bullen, gent., | obiit July 4th, 1800, | aged 33 years.

A small flat stone also within the chancel rails (D) :

Conradt Weck Lely | the youngest son | of Rich. Lely, esq.

There are some old stones with bits of inscription round the edge, but quite broken up, and there is a black stone with white letters, but now almost entirely obliterated.

On a white stone fixed into the south wall of the chancel (R) :

H. E. | Anna Lavinia Lely | Rich. Lely Ar. | filia | Natu 2^{da} | Ipsissima (pene dixeram) venustas | Ob. x^{bris} die 21, 1733, æt. A⁰ 5^{to}. | Snatched from my ravished eyes becalmed to rest | Here sleeps the lovely Fondling of my breast | Just shewn the world but destined not to stay | Her reason's dawn diffused too bright a ray | Perfection's bloom see, see ! she wings her flight | A radiant Angel to the realms of light | Heaven claims the pretty charmer, Heaven she's thine. | This tear no more—and patient I resign. | Scripsit | posuitque Pater | saxum.

A grey tablet against the north wall of the chancel (R) :

Tranquille admodum | hic juxta obdormiscit | Rebecca | Ricardi Lely arm. | Petri Lely Equitis | Car. II Pictoris | Nepotis natu maximi. | tenella pars | et ornatior longe | et exoptatissima. | vixit | ut moritura : | at si plura forsan desiderentur, | Plura fari | Facundiores vetant lachrymæ. | Humanioribus vitæ hujus muneribus | gaudiis suspiriisque querulis | supremum vale | dixit | Januarii die 3⁰ A.D. 1734, ætat. A⁰ 32. | Gone ? Gone ? that thought stabs home, pale speechless dear, | Death stole thee gently though he could not spare. | Midst white-robed Saints, all Rapture ! may we meet, | Empyreal bliss ! from whence there's no retreat. | Oh we have loved ! sweet dream of fondness past, | Sighs now succeed and I have smiled my last ! | Lapidem devovit | Epigraphen excogitavit | conjux | haud integer | superstes.

A flat blue stone (D) in the nave with two shields or arms over—1st . . . three crescents . . . a canton ermine [Dalyson] ; 2nd, two lions passant [for Littlebury]. Inscription in capitals (D) :

Here lyeth S^r Thomas Dalyson of | Greetwell in the county of Lincoln, | knt, third son of Will^m Dalyson, esq., | one of the Justices of the King's Bench | in y^e time of Queen Mary, w^{ch} William | was second son of Will^m Dalyson | of Laughton in y^e said county, esq. | Here also lyeth Dame Anne, wife | of y^e said S^r Thomas one of y^e daughters of Humphrey Littlebury | of Stansby in ye county aforesaid, | esq., w^{ch} Thomas dyed y^e 20th | of March in ye yeare of our | Lord 1625, and ye said Anne | dyed ye 9 of May following, they | had between them children | whereof two were daughters. | They left alive their | eldest son George Charles & Martha.

This church is small, consisting only of a nave and chancel, and a tower at the west end. The font is curious.

(MS iii, 143–148.)

Haceby

Notes taken in the church, 11 July, 1839—This church is small, consisting only of a nave with a south aisle, south porch, chancel, and tower at the west end. The aisle is divided from the nave by two Perpendicular arches with octagonal piers. The chancel, which is entered by a Norman arch, has two small lancet windows set deep in the wall, and a square east window of a modern date. The arch entering the tower is four-centred, with massy round piers having plain capitals ; and the tower itself is very thick, the two lower stages, apparently Norman, having two small windows of that period, and the upper storey decorated, of no beauty. It contains two bells. The few windows in the church are perpendicular, of which character is also the porch, the inner door of which is square headed, having quatrefoyles in the spandrils of the arch. The font is a plain octagon. The church is neatly kept.

On a flat stone in the chancel in capitals :
Rebecca Baseley | Octr 7th, | 1716. | James Percival | died Feby 7, 1757, | aged [66].

Another to the south of the last, also in capitals (D) :
Carolus Baseley A.M. | Hujus ecclesiæ Rector | obiit 4º die Octobris. Anno $\begin{cases} \text{Domini 1731.} \\ \text{ætatis suæ 65.} \end{cases}$

Another stone more to the west :
Here lieth the body | of Catharine the wife of | James Percivall | and daughter of | Charles & Susannah Beasley | who died Sept. 17, | 1771, | aged 75.

[In the chancel :
Reliquiæ Rich. Charles, Art. Mag. ob. Nov. 5th, 1690.
Susanna uxor primo Richardi Charles, deinde Caroli Baseley, A.M. ob. 6th May 1729.

[See also *L.R.S.* i, 220.]

(MS ix, 187–189.)

Haconby

Notes taken in the church of Hacconby, 27 July, 1833—

On a flat stone at the west end of the nave much defaced (D) :
Susanna Coning[ton] | of Leake | departed this . . . | . . . Jan. 8, 1714.

Just before the altar is an old stone but so defaced now as to be almost illegible. The following appears to be part. It is in very old character (D) :
. de . . . VII. Joh'is de Thorp | propitie-tur. An : D : MCCCC : XXIIII

In the schoolroom, which was once a chapel north of the chancel, is an old stone with the following inscription in the south wall (R) :

An Epitaphe on | Invested with white robes a priest divine | One who in doctrine and in life did shine | He was to all a patterne of true love | Now is posses'd with blise in Heaven above | Alas my brother oh ! his glories great | Unvalued pleasents with a windeing sheet | Delights immortal spring where mortal ends | Lament we not o're much who be his friends | In faith he lived unwearied of his paines | Eternal joyes in Death seene are his gaines. | Our faithful | Steward deceased 8brls 3

The schoolmaster says the date was originally 1510,[1] but broken off in moving the stone. It will be perceived that the verses form an acrostic of John Audlie.

A black tablet against the north wall of the chancel (R) :

Augustus Henry Hopkinson | born 20 June 1798, died 10 Oct. 1801. | Tho' cut off as a rose in the morning | Tho' his years were as a shadow | Which passeth away his memory | Smelleth sweet for ever.

A wooden tablet over the north door of the chancel sets forth that Henry Fryer, Esq., of Stamford Baron Northamptonsh: bequeathed by will, dated 10 Jan. 1828, £30, the interest to be distributed in meat about Xmas annually for ever amongst the poor at Stainfield, at the discretion of the minister of Morton (D).

The church consists of a nave, and two aisles resting on three pointed arches, a chancel, and south aisle now used as a school. At the west end is a handsome tower and spire, the windows of the latter have crocketted canopies ending in a finial. At each angle is a pinnacle crocketted. Over the gable at the east end of the nave is a curious old cross. In the chancel is a very ancient chest adorned with carved work worthy of attention.

[See also *L.R.S.* i, 195.]

(MS ii, 211–213.)

NOTE

[1] John Audley became vicar in 1631.

Hainton

Notes taken in the church, 12 August, 1833—

On an altar monument, on the north side of the chancel, these shields of arms—First shield : 1st and 4th, Or, a greyhound current between three leopards' heads cabossed sable, in a border gules [Heneage] ; 2nd and 3rd, Gules, three garbs or [Preston]. Second shield : the same, impaling—Argent, three bars gules, in chief a greyhound current sable [Skipwith]. Under, is the figure in

brass of a man kneeling, but the head is gone ; there is this label
however left, which issued from his mouth—'Pater de celis de*us*
miserere nobis '. On his tabard are the quarterings above given.
Opposite, is the figure in brass of a woman with the arms impaled
in the second shield on her cloak ; and this label from her mouth—
'Jh'u redemtor mundi de*us* miserere nobis '. Behind her, is the
figure, also in brass, of her daughter with the Heneage quarterings
on her gown. The inscription is as follows in old character :

> Here under lieth Sir Thomas Henneage, knight chief gentil-
> ma*n* of the prevey Chamber to y^e | kinge of famous memorye
> King Henry th' eight sonne & heyre of John Henneage Esq. |
> who maried Kateryne daughter of Sir John Skipwith knight
> whiche Sir Thomas and Kate | ryne had isshu Elizabeth
> nowe being wyffe to the right honourable the Lorde
> Willoughbye | of Parham the said Sir Thomas Henneage
> departed this liffe the xxith daye of August in the | yere of
> our Lorde God MCCCCCLIIJ uppon whose soule Jh'u haue
> mercy Amen.

An elegant marble monument against the north wall of the chancel,
an urn below, round which five young children are grouped
decorating it with garlands and in attitudes of grief. Above is
the figure of a female emerging from clouds and borne up by two
cherubs. The inscription is at the base :

> This Monument is erected | by G. R. Heneage Esq^{re} of
> Hainton-Hall, Lincolnshire | to the memory of his deceased
> Wife, | Frances Anne | second Daughter of the late Gen^l
> Ainslie ; | as a mark of his affection and respect. | She was
> born October 12th 1781 | died March 12th, 1807 ; | leaving
> Issue | Georgina Eleanor, George Fieschi, | Edward, Frances
> Anne, | Catherine.

A handsome grey marble monument against the east wall of the
north chapel (R), consisting of an arch supported by Corinthian
pilasters. The arms are nearly effaced, but supposed to be
Heneage ; impaling—Or, [a fesse] between three wolves' heads
erazed proper [for Hunloke]. In the centre is the bust of a gentle-
man as large as life, and below the two busts of his wives. This
inscription is under the male bust :

> This monument is erected to the memory of George Heneage, |
> Esq^r whose remains are laid in the vault within this chapel |
> being the repository of the ashes of his ancestors for many
> centurys | He was a person of strict justice and unblemish'd
> integrity, | an indulgent father, a tender husband, and a
> constant true friend. | His conversation was easy, agreable
> and innocent, his wit lively, | and his judgement sound,
> improv'd and enlarg'd by a generous | education, a perfect
> knowledge of mankind, and of the manners | of the politest
> countrys in Europe, he had a natural candour | and sweetness

of temper which inclin'd him to compassionate the | poor
and distress'd, and which made his charity always both | large
and extensive. He deserv'd well of, being a friend to all |
mankind and dy'd much valu'd and lamented Dec^r 31 :
1731 | aged 57.

Underneath is the following :

Præsentat Tibi hoc Marmor | non fictas vanasque defunc-
torum imagines, media enim | quam hic suspicis effigies
sublimi fronte venustaque oris | dignitate insignis in lucem
revocat (quantum ars potuit) | Georgium Heneage Arm'
e vetusta illustrique Heneagio- | rum stirpe ortum qui in hoc
sacrario inter majores | antiqui nominis magnæque famæ
viros, cineres suos | requiescere voluit. Qualis erat, dum
vixit, si fama tace- | ret hoc saxum paucis eloquatur : inerat
illi morum | simplicitas pietate institutisque Christianæ
disciplinæ | condita : inerat comitas felicitate ingenii ornata
cum | tristi severitate tum levitate impudica æque abhorrens |
Justitiam et integritatem præ ceteris virtutibus maxime |
semper coluit, a simulata fide fucatâque virtutis specie |
aversissimus adeo ut nunquam non maluit esse, | quam
videri, bonus. Amplam rem sibi a patribus deductam | non
illecebris ingluvie*que* mala strinxit, hâc bene | meritos
muneravit, inopes sustentavit : titulos & honores | non
ambivit, antiquitate generis, gloria Majorum propriis*que* |
virtutibus satis nobilitatus. Sic vitam instituens | (quod
rara est felicitas) otium optabile, minime vero aut | sibi aut
aliis inutile cum dignitate consecutus est. | Diem supremum
obiit bonis omnibus valde desideratus | prid. kal. Jan'rii
Annos natus LVII, | MDCCXXXI°

And between these two previous inscriptions are these lines :

Quorum animabus | propitietur deus Amen.

On the north of the monument is a tablet with this inscription :

On his right hand is placd the effigies of his first | wife Mary,
the only daughter and heiress of the | Rt Hon^ble William
Lord Petre, Baron of Writtle | in the county of Essex, a lady
of uncommon merit & | great beauty, humble pious & Charit-
able, adornd with | all those accomplishments which became
a person of | her birth and fortune, as well as those priuate
vertues | which were requir'd in a wife and parent. She
dyd June | 4^th 1704, and is buried in the vault within this
Chapel. He | had Issue by her, George Heneage ; William |
who dy'd an infant, and Mary Bridget who dy'd | and was
buried at Pontoise in the year 1717, Aged 14.

On the south of the monument is another tablet, with the following
inscription :

On his left Stands the Busto of his Second Wife, Elizabeth |
daughter of S^r Henry Hunloke of Wingerworth in the | county

of Derby, Baron^t, by Catharine the sole daughter | and heiress of Francis Tyrwhit of Kettleby in the | county of Lincoln, Esq. This lady the truly mournfull | relict of her deceased husband desired (tho' yet living) | that her effigies might be placed by his, as a token of her | Conjugal Affection. She was a faithful obliging and | obedient wife, and received for twenty six years | the deserved return of her late husband's most constant | and tender affection. She had issue by him six sons | and three daughters, all now living, except Ursula | the second daughter who dy'd an infant and was bury'd | within this chapel. | She died July 3ᵈ 1735.

In the north chapel are two stones, small, bearing the following inscriptions on them in church text :

Hic iacet Henrie Martyn cui*us* a*nime* p*ropicietur* Deus Amen.

Hic iacet d*ominus* | Will' Maltbi | | cui*us* a*nime* p*ropicietur* De*us* Ame*n*.

On a brass plate in the floor of the north chapel, having above it the figures of a man in gown with loose sleeves, and a lady in a long gown and square cap, a shield of arms over, but now gone :

Hic jacet Joh'es Henege et Alicia uxor eius qui obiit xxii die mensis Septembris anno D'ni mill'imo ccccxxxv, cui*us* a*nime* p*ropicietur* De*us* Amen.

Against the north wall of the chapel is an altar tomb on which are now placed two old helmets and some other pieces and fragments of armour.

Above on a brass plate in the wall is this inscription in old character :

Hic jacet Joh'es Hennage Armig. et Katerina uxor eius | qui quidem Joh'es obiit ult. die mensis Marcij Aᵒ D'ni Mᵒ | cccccᵒ xxxᵒ quor*um* a*nimabus* p*ropicietur* De*us* Amen.

On the west side of the chapel is a very fine monument of white stone. In a recess formed by two fluted Ionic pillars is the figure of a man in armour, bareheaded, with a ruff and peaked beard, kneeling on a cushion before an altar, on which is a book. His lady is opposite him, kneeling in a similar recess, and dressed in a long gown and ruff. On the pediment above are three shields of arms. In the middle one—Quarterly, 1st, Or, a greyhound current sable between three leopards' faces azure, a border engrailed gules [Heneage] ; 2nd, Gules, three garbs or [Preston] ; 3rd, Argent, two bars and a canton gules [Buckton] ; 4th, Gules, a crosse flory between four trefoils or. Crest—On a torce or and gules, a greyhound current sable [Heneage]. On the south side, the four quarters just mentioned ; impaling—Quarterly, 1st and 4th, Vert, on a fess argent a boar passant sable [Cope] ; 2nd and 3rd, Argent,

a cross botony sable. On the north side, this last impalement alone. Below the figures this inscription, in capitals, in two columns :

(1) Here lyeth John He*n*neage | late of Haynton Esquier & | Anne his wife y^e daughter & | Heyre of John Cope of Hel- | meden in y^e countie of Norht : | Esquier || (2) w'ch John He*n*neage died y^e last | of July 1559 & y^e said Anne | y^e 5 of February 1587, & had | issue betwixt them living at | theire death, George, John, & | William, Katharine & Mary.

Below are two shields of arms—(1), Heneage ; impaling—Quarterly, 1st and 4th, three garbs or [Preston] ; 2nd, Argent, two bars and a canton gules [Buckton] ; 3rd, Gules, a cross flory between four trefoils or. (2), the four quarters of Heneage ; impaling Quarterly, 1st and 4th, Azure, a lion rampant argent [Wymbish] ; 2nd and 3rd, Argent, three cinquefoils gules [Darcy]. On the south side is a shield much defaced, but the bearings appear to be the four quarters of Heneage, impaling the boar on a fesse and the cross botony. In the centre of the chapel is a beautiful altar tomb of marble, which has been coloured, on which is the recumbent figure of a knight in plate armour, much ornamented and damasked with gold, bareheaded, lying on a mat, his head on a cushion, and at his feet his crest, a greyhound courant sable on a torce or and gules [Heneage]. His hair and beard are black, and his hands are clasped over his breast in prayer, his sword is gone. At the base of the tomb on the south side are two shields of arms—(1) the four quarterings of Heneage with the addition of these two—5th, Vert, on a fess argent a boar passant azure [Cope] ; 6th, Argent, a cross botony sable ; impaling—Quarterly, 1st, Argent three cinquefoils gules [Southwell] ; 2nd and 3rd, Quarterly, i and iv, Azure, on a fesse between two chevrons sable three crescents argent [? Tendring] ; ii and iii, Or, a chevron between ten crosslets gules [Holbrook] ; 4th, Ermine, two annulets interlaced sable, on a chief of the last three crosses patee argent [Wychingham]. (2) The other shield is the four first quarters of Heneage ; impaling—Quarterly, 1st and 4th, Sable, a lion rampant argent [Wymbish] ; 2nd and 3rd, Argent, three cinquefoils gules, seeded or [Darcy]. On a black slab between the two shields in gold capitals—

Georgius Henneage miles Thomæ | H. militis a fratre nepos et hæres | masculus : defuncta uxore Eliza- | betha unica filia et herede | Ricardi Southwell militis : iterum | nuptus est Olive Brittonie sed | nulla suscepta prole, avitas | Sedes Hayntoniens : sibi jure | hereditario devolutas, ger- |mano fratri Gulielmo H: | armigero reliquit moriens | 16 die Octobris A° Christi | salvatoris 1595 et ætatis | suæ 74 ipse charus chariss : | infensis dum vixit infestus. | hic tandem annis morboque | exhaustus corpore correpsit in | terram ut anima subvolaret in caelos.

On the north side are two shields, (1) the four quarters of Heneage ; impaling—the second two last quarters. (2) the six quarters ; impaling—Quarterly of six, 1st & 6th, Quarterly, Per fesse indented argent and gules, in the first quarter a mullet sable [Bretton] ; 2nd, Argent, a chevron between three eagles' legs erazed sable [Yermouth] ; 3rd, Gules, two lions passant guardant argent, crowned or [Felton] ; 4th, Argent, on a chief gules four lozenges conjoined or [Charles] ; 5th, Azure, on a fesse between two chevrons sable three crescents argent [for Gerbridge]. On a black slab between ye two shields, in gold capitals :

> Sr George Henneage of Haynton | knight sonne & heire of John | H: Esquier & of Anne his wife | ye onely daughter & heire of | John Coope of Helmeden in | ye countie of North't' Esquier : | twice maried yet dying with | out issue ye 16 day of Oct- | ober in ye 37 yere of ye | happy raigne of Q : Elizabeth | lieth here buried whereby | holdinge his heavenly he left | his earthly inheritance unto | Will'm H : nowe of Haynton | Esquier his naturall | brother & heire | maile.

At the south side of the chapel is a splendid monument of marble. In a recess before an altar, on which is a cloth fringed with gold, is the kneeling figure of a man bareheaded with a falling collar on a cushion ; opposite him are his two wives dressed in ruffs and long gowns, one with a stomacher, and each having a long veil fastened round the head with a fillet of gold. The altar is inscribed, ' Deus propitius esto | michi peccatori Luc. 18. 13 | Jesu fili David Miserere Mei | Luc. 18. 38.' Before the man is a book inscribed in capitals, ' Miserere mei | Deus secundum magnam misericor | diam tuam et secun | dum multitudinem miserationum | tuarum Dele iniquitatem meam, Ps. 51. 1.' Before the woman, ' Adjuva nos Deus salutaris noster et propter gloriam nominis | tui Domine libera | nos et propitius esto peccatis nostris propter nomen tuum Psal. 79. 9.'

On the pediment are the arms, six quarters, of Heneage, their crest, and over the crest on a pedestal is the figure of an angel with gold wings ; the pedestal inscribed in capitals, ' Surgite mortui venite ad judicium.'

At the east corner is a representation of Adam and Eve before the tree of knowledge, and below, ' Sicut in Adam omnes moriuntur ita in Christo omnes vivificabuntur 1 Cor. 15. 22.' At the west corner the Resurrection ; and below, ' Ubi tua O mors Victo | ria Ubi tuus O Sepul | chrum stimulus 1 Cor. 15.' On the east pillaster of the recess is a lamp burning, below written, ' Post tenebras | spero lucem '. On the west is an hour glass. In the recess over the man are these arms—the six quarters of Heneage ; impaling— Quarterly, 1st and 4th, Argent, a fleur de lis sable [Fishbourne] ; 2nd and 3rd, Or, on a bend [wavy] azure three fish naiant argent.

Over the woman the impalement just mentioned. Above the figures this inscription in capitals in two columns :

(1) Peccatum tua Mors Mors XPI, | Pæna Gehennæ, judicium, vita tibi | sunt hæc sex memoranda | (2) Omnia transibunt, nos ibimus, ibitis | ibunt Nam simul omne perit, | Quod fuit, est, et erit.

Between the figures is this inscription on a black slab in gold capitals :

Here lyeth William Henneage of Haynton | Esq. whose first wyef was Anne the | daughter & coheire of Raulfe Fysheborne | of Cotes, Esq., by whome he had issue | lyving at ye making of ys monument viz: | Thomas, George, Anne, & Katherine, whose | mother dyed ye 29 of July Aº 1585 | & 4 years after her death | he took to wyef Iane Brussels who | did serve our now Soveraigne | Quene Elizabeth in her bed chamber | & in her privye chamber by ye space | of 24 yeares next beefore her | deathe who departed out of this | transitory world ye 24 of September | 1596 and ye foresaid William dyed | ye 29 of March 1610, aged 91.

Below these, at the base of the monument, are two figures of their sons in armour and cloaks, and two daughters, dressed as their mother, kneeling before an altar. Over the first son, the arms of Heneage ; impaling—Or, a saltier between four martlets sable [Guyldford]. Over the second, Heneage ; impaling—Argent, three bars sable [Bussey]. Over the first daughter—Sable, a wolf salient, and a chief or [Wilson] ; impaling—Heneage. Over the second, some bearing effaced ; impaling—Heneage. On a black slab over the altar, this inscription in gold capitals :

The above named Thomas Henneage is | now maryed to Barbara ye dawghter | of Sr Thomas Gyldeford knight, & | George is maryed to Mary ye daughter | of John Bussy of Haydor Esq. & Anne | is maryed to Nicholas Wylson Esq. sonn | & heir to Thomas Wylson, Esq. late | one of ye secretaryes to our sovraigne | Lady Queene Elizabeth & Katheryne is | maryed to William Ayscoughe Esq. sonne | & heire to Edward Ayscoughe of Kelsey Esq.

A handsome monument of white marble against the south wall of the chapel east of the door, flanked by two pilasters, and surmounted by an urn ; at the sides are the insignia of death ; and below the arms [and crest] of Heneage :

Præstantiss : viris | D. Georgio Henneage Equiti aurato, cui Pater | D. Thomas Henneage ordinis equestris, mater | Barbara filia D. Thomæ Guildford equestris itidem | dignitate clari, uxor Elizabetha filia unica | Francisci Tresham Arm. quin et proles quidem | numerosa Filius autem unus et tres filiæ. die | Obitus, Denatus A.D. 1659, ÆS. 75. | Georgio Henneage Arm. prædicti D. Georgii | Filio cui uxor Faith, filia D.

Philippi Tyrwhit | Baronetti, proles etiam numerosa, superstite fillo et | filiabus pluribus, Denatus A.D. 1667, ÆS. 44. | Georgio item Henneage Arm. dicti Georgii | Arm. filio cui proles etiam magna, superstites | quidem ex prima uxore Maria filia Thomæ Kemp | Sussexiensis Arm. tres filii et duæ filiæ, et ex | altera Francisca filia D. Moyser filius unus | et una filia, Denatus A.D. 1692, ÆS. 40. | Qui cum majoribus suis et propinquis | in Dormitorio vicino, familiæ Henneageanæ | dicato secundo excepto Georgio Bathoni | Sepulto, cujus tamen cor hic habetur, requiescunt, | Eorum memoriæ pie consulens prædicta | Faith Henneage | posuit.

A white marble monument against the wall of the north aisle, arms effaced ; [crest—A sea-horse couchant or—Jenkinson] :

Hoc intra Sacrarium, | quo moribunda cineres depositos esse Velit, | requiescit lectissima fæmina | Francisca Jenkinson ; | Thomæ Thoroton de Screeton in agro Nottingham | filia unica : | Johannis Jenkinson Arm' de Wykam Orient' Com' Lincoln | Uxor merito dilecta | Pudica, casta, pia, | Summa Innocentia, Morum gratissima Simplicitas | Suavitas ingenii amabilis, benignitas Innata, | et gratior veniens in pulchro corpore | Virtus illæsa intacta, | omnium facile delicias reddiderunt ; | tandemque a Morte renascentem | ad Cælos evexerunt | Obt : ivto : Non' Junii | An : nata xl | MDCCXXXII.

On a flat stone in the chancel :

V. R. | Rowlandus Curtois A.M. | ecclesiæ Paroch. de Hainton vicar. | nec non | rector de Hatton | obiit | xii Cal. Martias | An. ætat. suæ 38, | salutisque nostræ | 1722.

This church consists of a nave separated from its aisles by three pointed arches, a chancel with a north chapel, and a tower at the west end. The font is octagonal, pannelled with shields in quatrefoils.

[See also *Lincs. N. & Q.* xii, 37–44 ; Jeans, 29–30.]

(MS iv, 49–65.)

Great Hale

Notes taken in the church of Hale Magna, July 14, 1834—This church consists of a nave divided from each aisle by five lofty pointed arches, springing from plain round columns ; a south porch ; and pinnacled tower at the west end ; but no chancel. The tracery has been removed from the east window and several others, what remains is of a Decorated character. The font is a handsome octagon with niches set in square quatrefoyles in a peculiar style, worthy of remark ; it has a modern oak cover. At the west end of the north aisle is a handsome oak screen.

Against the wall of the north aisle is a handsome monument of
alabaster, consisting of two compartments; in the upper one are
the small figures of a gentleman in cloak and doublet, and a lady
opposite, kneeling at a desk. Above—Argent, a chevron between
three martlets sable [for Cawdron]; impaling—Sable, a cross
flory, between four escallops argent [Samson]. In the lower
compartment are two female figures kneeling at a desk; above
the one the arms of Cawdron; impaling—A chevron engrailed
between two bucks' heads cabossed [Nedham]; and over the other
—Cawdron; impaling—A lion rampant [Fauckonbridge], this
inscription below:

> To y^e sacred & perpetual memory of | Robert Cawdron of
> Little Hale in y^e Coun. of Linc. | gent. who departed this
> life y^e 30 day of Decem | ber 1665, Ann. ætat. suæ LVI, being
> three times | married, first unto Katharine daughter of
> Edward | Nedham of Elston in y^e Coun. of Leices. gent.;
> 2^dly | unto Susanna Fauckenbridge relict of Richard Gamble |
> gent.; lastly unto Elizabeth Sansome y^e relict of | John
> Woods gent., now living, which said sorrow | ful widow,
> out of tender affection she beareth | to her deceased husband,
> caused this monument | to be erected at her own proper
> charge and | cost, this 20 day of May 1668. | The memory
> of the just is blessed, but y^e name of y^e wicked shall rot. |
> Virtus post funera | Nil desperandum Christo duce auspice
> Christo.

On a brass plate set in a stone tablet west of the monument, these
arms over—On a chevron engrailed . . . three escallops [King];
inscription in capitals:

> Here lyeth interred the body of Ann | Cawdron wife of
> Robert Cawdron of | Great Hale, Esq., one of the daughters |
> of Edward King, Esq., who was buried y^e | XVIII of July
> 1625, w^ch said Robert | Cawdron had by the said Ann his
> wife | X sonnes and VI daughters.

On another brass plate set in stone, below the monument, in
capitals:

> Hic requiescit in Domino Franciscus Cawdron | Filius Roberti
> Cawdron Armigeri qui ob Fæli | cissimam Indolem moresque
> suavissimos magnum | sui apud omnes desiderium relinquens
> corpus | humo dolorem Amicis Cælo animam commendavit. |
> Hoc monumentum Amoris et Mæroris perpetu- | um Testem
> charissim' eius Frater Anthonius | Cawdron posuit | obiit
> An^o 1660, | ætatis suæ 31.

To the east of the larger monument is a white marble tablet, with
the arms of Cawdron above, and below Cawdron, impaling two
wives—(1) Sable, on a chevron argent three escallops [King];
(2) Argent, a lion passant between two bars gules [for Williams].

On the tablet are cut the figures of a man in half armour kneeling at a desk, and behind him nine sons, and opposite his two wives, followed by six daughters ; before them three sons lye in grave clothes with their heads on skulls, and one daughter likewise. Above is this inscription in capitals :

Memoriæ Sacrum | Roberti Cawdron Armig. vitæ integerrmi in egenos | largissmi in Patria fidissmi, uxores duos habuit | 1am Annam natam Edwardo King Armigo quæ peperit | ei 10 filios et 6 filias 2dam Mariam viduam Jo'is Austen | Generosi e qua 3 filios et vnam filiam . mortuus est | die 11mo Martii Ao 1650, ætatis suæ 73. | Eleonora filia obsequentissma parenti | amantissmo lugens posuit. | Antoni' fil' fecit.

In the north east corner of the aisle is a small monument of stone, with two black columns, with the arms nearly effaced, but seemingly Cawdron impaling—Two lions passant [Dymoke] :

Here lieth the body of | Robert Cawdron Esq. who by Jane | his wife one of the daughters of | Sir Charles Dymoke, knt, left issue | five sons [vizt] Robert, Dymoke, | Edward, Lewis, & George, & three | daughters [vizt] Jane, Eleanor, & | Anne, & departed this life the 11 | of July 1714, to whose memory | this monument was erected | by Jane his widow.

Opposite to the last is a stone tablet with this inscription in gold letters on a black ground :

Near this place lies interred | Jane relict of Robt Cawd- | ron, Esq., late of this | parish. She was daugh | ter of the Honble Sir | Charles Dymoke, kt, | Champion of England, | a most loving wife, a kind | & tender mother, an excellent | mistress, & a sincere friend. | This small monument is most | gratefully erected by her oblig'd | son & servt Wm Lomax. She died | ye 22 May 1733, aged 67.

On a flat blue stone in the floor below these monuments (R) :

Here lyeth the body of Robert | Cawdron, Esq., who by Sarah his wife | youngest daughter of Sr Edward | Hussey of Welborn, Baronett, had | issue one daughter, viz. Elizabeth. He | departed this life October ye 18, 1728, | in the 41 year of his age. | Here lieth the body of Mrs | Sarah Smith, wife of Weston John | Smith, Esq., of this parish. She was | the youngest daughter of Sr Edwd | Hussey, Bart., of Welborn in this | county, who departed this life | the 17 of May 1767, in the 80 year of | her age.

To the south is another blue stone with the arms of Cawdron cut on it, impaling—On a chevron . . . three pears (seemingly) :

Resurgemus | Uterque.

Near is another large blue stone which once had the brass of a large cross with long stem, and above the bust of a priest. Inscription round the edge ; in it is cut R. C. 1665. The brasses are all gone.

On two flat stones parallel, close by :

> Here | lyeth the body of | Samuel Sanson, | gent., who departed
> this | life August 7, 1769, | aged 63 | years.
> Here | lieth the body | of Mary relict of | Samuel Sansom, |
> gent., | who departed this life | December 23, 1790, | aged
> 70 years.

In the south aisle at the east end is a large stone which has once
had an inscription round it, but it is worn quite smooth except
at the south east corner where this is visible in church text 'VI,
MCC' On the stone is cut :

> Here lieth the body | of Maria Gaskarth, widow, | who
> departed this life the | 3ᵈ of May 1737, aged 36.

[See also *L.R.S.* i, 189 ; Jeans 30–1 ; Trollope, *Sleaford*, 371–4.]

(MS v, 33–39.)

Halton Holegate

Notes taken in the church, August 15, 1835—

On a flat stone in the chancel :

> In memory of | Jane the wife of Mr Jno. Brackenbury | of
> this Parish, | who died sincerely lamented by all | her friends &
> acquaintance | the 5th of Aug. 1786, aged 29, | after a long
> and painfull illness which | she bore with the greatest patience |
> and resignation. | Also of | John Brackenbury, gent., | equally
> regretted and respected, | who departed this life | on the 21
> of August 1826, | in the 73 year of his age.

Near this is a stone in which has formerly been a brass of a long
stem and tabernacle work at top, all now gone.

At the east end of the south aisle is a low kind of altar tomb, the
top of which is covered by a very large black slab, which has once
been nearly wholly inlaid with brass, the whole of which has been
torn out. On this slab is laid (having been evidently removed
from elsewhere) the recumbent figure of a knight in mail hauberk,
and gorget or coif of the same, with a helmet of plate, the visor
open. The brassards and genouailles are also of plate, as are the
gauntlets, and his armour from the foot to the knee is of the same,
lined with mail. Over his hauberk is a surcoat confined by a belt
crossing the shoulder and buckled at the hips, whence the sword
hangs. The belt is studded with cinquefoyles, his hands are clasped
over his breast, and on his left arm hangs his shield, heater shaped,
bearing a lion rampant [perhaps for Halton]. His head rests on a
pillow, and his feet, which are crossed, on a couchant lion. On
the whole, the figure is in a good state of preservation, except the
face, the features of which are much mutilated.

Near this on the floor is a coffin-shaped [stone] which bears round
its edges, in Saxon characters, which are in perfect preservation,
the inscription to ' Sir Water Bek ', mentioned by Holles.

At the east end of the north aisle, which is separated by a screen from the other part, is an old stone with the figure of a female in brass in the costume of Charles I reign, viz., the boddice and falling collar. One of her hands is crossed over her breast, the other hand holds a book. This portraiture is executed in very good taste, and is much like Hollar's figures. This inscription on a brass plate below in capitals (R) :

> Here lies buried the body of | Bridgett the wife of John | Rugeley, daughter and heire | of Thomas Thorey who de- | ceased the 15 day of May in y^e | yeare of our Lord 1658, | ætatis suæ 21.

The stone in which this brass has been inserted has had formerly an older inscription, and canopied cross in brass, now gone.

On a flat stone next to the last :

> Here lyes y^e body | of Sarah Smith late | wife of Benjamin Smith, | gent., who departed | this life y^e 17 of March | Anno Dom. 1699.

On another much rubbed (D) :

> Here lyeth y^e body of Benjamin | Smith, gent., who departed | this life y^e of | An. Dom. 1708(?).

On a brown stone to the west of the last (D) :

> Here lyeth y^e body | of Katherine Smith | late daughter of | Benjamin Smith, | gent., & Sarah his | wife who depart- | ed this life January | the 29, Anno Dom. | 1697.

This church consists of a nave and aisles, resting on four pointed arches which spring from octagonal columns, a chancel, and tower at the west end. Both of these are separated from the nave by pointed arches. There is a south porch which is of the Perpendicular style, and very handsome, having a square-headed door with quatrefoyles in the spandrils of the arch, and a parapet which is very beautifully pannelled in quatrefoyles in squares, with a dripstone below ornamented with y^e ball in hollow moulding. Below it is a vacant niche and above a shield having the rebus,

 The font is circular, supported on four massive short pillars on a basement of two steps. There remains a good deal of old pewing and screenwork. There has formerly been a south aisle to the chancel of two arches, which are now blocked up, and the aisle removed. The character of the church is Perpendicular apparently, though the windows are mostly despoiled of their tracery, and the roof of the chancel having been lowered, blocks up the head of the east one. In the tower are six bells.

[See also *Lincs. N. & Q.* xi, 108–110 ; *L.R.S.* i, 164 ; Jeans, 31.]
(MS viii, 153–157.)

Harmston

Notes taken in the church, 8 August, 1833—

A handsome white marble monument against the south wall of the chancel between two Corinthian pillars, the bust of a gentleman in a peruke and the dress of the time of George I ; on each side an angel in an attitude of grief. Above are the arms, but the colours nearly obliterated—Quarterly, 1st, Argent, three goats salient sable [for Thorold] ; 2nd, Three bars gules on a canton vert, [a martlet—Hough] ; 3rd, Argent, a cross potent sable between four pellets [Brehaugh] ; 4th, [Argent, a bend between six pellets—Marston]. Crest—A stag passant :

> Here lies the body of Sir George Thorold, knt & bart, who built new this church and chancel | in the year 1717, and was Lord Mayor of the city of London in 1720. | He was 4th son of Charles Thorold, esq., of London, who was 2d son of Thomas Thorold, esq., of Harm | ston and of London, who was 3d son of Wm Thorold, esq., of Harmston, who died in the | year 1616, who was eldest son of Wm Thorold, esq., of Harmston, who died in 1586, and they | both lie buried near this place, who was 2d son of Sir Wm Thorold of Marston, who died in the | year 1569, and left the Lordship of Harmston to the abovesaid Wm Thorold his 2d son who was only | brother to Sir Anthony Thorold of Marston. | The above Sir George Thorold married Mrs Eliza. Rushout in 1713 daughter of Sir James Rush- | out, bart, of Northwich in Worcestershire, by whom he had a daughter who died young, and he | departed this life the 29 of October 1722, aged 56.

On a flat stone in the chancel close under the last monument (R) :

> Sacred to the memory | of | Isabella Margaret Thorold | who died March 13, 1832, | aged 30 years.

On a grey marble monument on which has been a white slab, now fallen off and broken, but the inscription still remains perfectly decipherable ; above this is an urn (R) :

> To the memory of | Samuel William Thorold an infant | who was born on the xxxist day of October MDCCLXXVI, | and died on the xxvi day of February MDCCLXXVII. | Accept sweet babe what only we can give | Thou in our tender bosoms long shall live | Thee fairest flower just opening into day | Death cruel death untimely snatched away | With plaintive accents we weep o'er our love | Tho' heaven invites thee to its joys above. | Samuel and Anne Thorold his afflicted parents | have erected this monument.

Stones in the north aisle (D) :

> Sacred | to the memory | of | William Millington, | aged 55, | who died March 1, | 1812.
>
> Sacred | to the memory | of | Eleanor the wife | of | William Millington, | aged 51, | who died June 7, | 1810.

On another stone (D) :

> In memory | of Wᵐ Millington | who died November 7, 1761, |
> aged 40 years ; | also W. Wattson | who died November yᵉ
> 23, 1762, | aged 76 years.

On another flat stone (D) :

> To the memory of | Susanna Millington relict of | William
> Millington | who died November 21, 1783, | in the 67 year
> of his age. | Laden with years by sickness prest | This pious
> matron came to rest | A fair example of good life | She was
> a chaste and loving wife | Her house did shew her prudent
> care | She knew both how to spend and spare. | Mourn not,
> she's gone where tears do cease | Her upright life did end
> in peace.

A very beautiful monument of grey veined marble, about twelve
feet high from the ground, against the north wall of the chancel,
between two Corinthian pillars, on a pedestal is the bust of a man,
and at the sides are two weeping boys winged, one having his foot
on a scull. On the pediment, a shield of arms partly defaced—
quarterly, 1st, Sable, three goats salient argent [Thorold] ; 2nd,
Argent, three bars gules, on a canton azure a martlet or [Hough] ;
3rd, [Argent, a cross potent between four pellets—Brehaugh] ;
4th, Argent, a bend raguly sable between six pellets [Marston].
At the bottom of the monument is this inscription on a white
marble slab :

> M. S. | Here lieth the body of Sʳ Samuel Thorold, bart, who
> was seventh son of | Charles Thorold, esq., and brother to
> Sʳ George Thorold, bart, who | is also here interred, of whom
> it may with strict justice be truly said that as he | was blest
> with a very plentiful estate so he wanted not a heart to make
> a | proper use of it, for notwithstanding his natural inclination
> directed him to yᵉ choice | of a retired life, he was never
> more delighted than when proper opportunities | presented
> for his shewing his benevolence to mankind by endeavouring
> to make others as | happy as he himself desired to be, and
> tho' the world might have a loss from his | retirement in
> yᵉ want of that sincere & friendly converse which he always
> practised, | yet as it did not proceed either from pride or
> moroseness but merely from a studious | disposition and a
> disapprobation of all vain ostentation in public life, every
> wise man will | readily excuse him. He departed this life
> the 1ˢᵗ January 173$\frac{7}{8}$, in the 65 year of his age.

On a brass plate against the east wall of the chancel north of the
altar in capitals (R) :

> Here lyeth the body of Mrs Margaret Thorold, widowe, |
> sometimes the wife of William Thorold of Harmston, esq., |
> deceased, by whome shee had 19 children whereof 8

were | sonnes, viz., William, George, Richard, Anthony, Edmond, Thomas, | Phillip, and Henry, and eleven daughters, viz., Jane, Anne, | Mary, Susan, Fravncis, Sara, Elizabeth, Fravncis, Judith, | Prudence, and Martha. Shee departed this life the 20th | daye of April Anno D'ni 1616, being aged 80 yeares.

A similar one below in capitals also (R) :

Here lyeth the bodye of William Thorold, esq., the | eldest sonne of William Thorold of Harmstone, esq., | deceased, who was second brother unto Sr Anthony Tho | rold of Marstone, knight, deceased. He departed this life ye 8 | daye of August Anno D'ni 1616, being aged 59 yeares & 7 months.

On a flat stone at the west end of the south aisle (R) :

Here are deposited the remains of | Samuel Thorold, esq., | for many years lord and possessor | of the manor of Harmston, | who was born December | the twenty ninth, 1749, | and died January the 19, 1820, | aged 70 years. | Also the remains of his | beloved infant | Samuel Jane [sic] Thorold | who was born February the tenth, | 1819, and died November the twelfth | the same year.

Between the two Thorold monuments are hung up two helmets with the crest of Thorold, a stag tripping, two pair of gauntlets, a sword, and two pair of spurs, and a shield of arms, but not to be made out.

The church consists of a nave and aisles supported upon three pointed arches resting on plain columns, a chancel, and a tower at the west end. The font is hexagonal, ornamented with grotesque heads and roses alternately. Over the arch between the nave and chancel is a picture (R) of the adoration of the Magi.

[See also *L.R.S.* i, 240 ; Jeans, Add. 1–2.]

(MS iii, 181–188.)

Harpswell

Notes taken in the church, 29 August, 1828—

There are two monuments to the Whichcote family ; one is a flat stone in the chancel inscribed thus :

Here lyeth the body of | George Whichcot, Esq., who | departed this life Sept. the 7th, | 1720, | aged 67 yeares.

The other is a marble monument on the southern wall of the chancel, with the following inscription :

To the memory of Thomas Whichcot, Esq., | who died October 3rd, 1776, aged 76. | He was the son of Colonel George Whichcot, | Esq., who died September 7, 1720, aged 67, |

and his wife Frances Catharine, | daughter of Sir Thomas Meres, knight, | of Kirby Bellers in the county of Leicester, | and Kirton in Holland, Lincolnshire, | who died August 1731, aged 62. | His first wife was Elizabeth Maria | daughter of Francis and Mary Anderson | of Manby, who died April 1731, | aged 21. | She left him two daughters | viz. Frances Maria and Catharine. | His 2nd wife was Jane the daughter | of John Tregagle, Esq., | who died Jan. 2, 1764, aged 61. She left him | an only daughter viz. Jane Whichcot.

There is also a written copy, hanging on a pillar in the church, of a deed of gift which accompanied a clock presented in 1746 by Thomas Whichcot, in which grateful allusions are made to the suppression of the Scotch rebellion and the hope expressed that the clock whenever it struck would remind the parishioners of their deliverance. (MS Supp., 14–15.)

Notes taken in the church, 14 September, 1835—

On an old stone just before the altar rails in church text (R) :
Hic iacet dominus | Will'm's de Beachaump | rector istius eccl'ie.

On the north wall of the chancel are two brasses seemingly let into wood, one of a man in armour, standing on a lion, with his sword crossed before him, the other a female in the dress of Henry 6th time, with the extraordinary cap that projects behind and is peculiar. These brasses were formerly in a stone in the church, and were placed here by Dr Baily.

On a tablet against the south wall (R) :
Sacred to the memory | of | the Revd Thomas Dawson, | late vicar of North Kelsey | and perpetual curate of Harpswell 30 years, | who died March 25, 1804, | aged 58 years. | Also Mary his wife who died March 2, 1822, | aged 72 years. | Likewise Edward their son who died Sept. 28, 1823, | aged 37 years. | And Elizabeth their daughter who died Feb. 12, 1789, | in the third year | of her | age.

In the south aisle (R) :
A flat stone to John Wallace who died 20 April 1786, æt. 44.
Near this is a stone which had a brass now gone.

Under an arch in the south aisle a figure on an altar tomb of the size of life, with hands clasped across the breast, in a long robe plaited ; but it is uncertain whether a man or woman. On the head appears something like a caul or tonsure. [It represents William de Harrington, rector of Harpswell, circa 1346.]

The church consists of a nave and south aisle separated by two Norman arches and one pointed. One of the pillars is round, and

one octagon. In the east window of the south aisle are some fragments of painted glass (R). The font is round, with a range of sharp pointed arches encircling it. There has been a north aisle but now gone.

On a stone in the tower under the clock is this inscription :
> Upon | the 9 of Octr | 1746, | T. Whichcot Esq., | gave this clock to | ye parish of Harpswell | in memory of the | victory obtained | by his Royal Highness the | Duke of Cumberland | over the Rebels in | Scotland at the battle | fought Apl the 16, 1746, | near | Culloden.

[See also Jeans, 31.]

(MS vii, 29–31.)

Harrington

Notes taken in the church, 17 August, 1835—

Upon a black stone in the chancel in capitals (R) :
> Here lyeth the body | of Henry the younger | son of Vincent | Amcots, Esq., by Amy | his wife. He was | born Jany the 21, | 1684, and dyed May | the 18, 1705.

Upon a black marble stone next to the last to the south (R) :
> Here lyeth the body of | Mrs Mary Amcotts daughter | of Vincent Amcotts, Esq., | late of Harrington, by | Amy his wife. | She was born the second | of February Anno Dom. 1681, | and dyed November the | 18th, 1697.

Upon a black stone (R) to the south of the last with these arms cut above—Quarterly, of six, 1st, A tower triple turretted between three covered cups [Amcotts]; 2nd, Barry of six, over all a lion crowned [Wasthouse]; 3rd, Gutte a castle [Hambrough]; 4th, On a bend cottised three escallops [Dawtrey]; 5th, On a bend cottised three eagles' heads erazed [Solaye]; 6th, three chaplets in bend between two bendlets [Saxton]; impaling— Quarterly also of six, 1st and 6th, Three lioncels rampant [Mildmay]; 2nd, A canton charged with a mullet [le Rowse]; 3rd, A chevron embattled between three catherine wheels [Cornish]; 4th, A fess checquy between six annulets [Barker]; 5th, Two bars, on a canton between three pheons a chevron charged with an eagle's head erazed between two mullets [Hill] :
> Here lyeth the body of Vincent Amcots | of Harrington in the county of Lincoln, | Esq., son of Vincent Amcots of Lankton | in the same county, Esq., who departed this | life the 25 of May Anno Dom. 1686. | He had to his first wife Helen Webberley | daughter of Anthony Webberley of East | Kirkby in the county of Lincoln, Esq., | who died having no issue. | His second wife was Amy eldest daughter | of Henry Mildmay of Graces in Little | Baddow in the county

of Essex, Esq., by | his first wife Cecilia, one of the | daughters and coheires of Walter | Barker of Haughmond in the | County | of Salop, by whom he left two sons & one | daughter, viz. Vincent, Henry, and Mary.

On a white marble sarcophagus against the north wall of the chancel :

Sacred to the memory of | Charles Amcotts, Esquire, | son of Vincent and Elizabeth Amcotts | of Harrington in this county, | who died on the 14th of April 1777, aged 47 years. | He possessed | every virtue which adorns the Christian | and benevolence of heart | which rendered him at once respected and beloved. | This tribute to his memory is erected by an affectionate niece, | anxious to preserve the recollection of his many | estimable qualities.

On an old broken stone in the chancel round the verge :

✠ Hic iacet ccccxxx cuius anime propicietur Deus Amen.

Upon another more to the south (D) :

. . . . Joh'is Copuldyk mil . . . obiit XVI die mensis Augusti

There are also two coffined shaped stones but the inscriptions illegible (D).

A black marble monument, flanked by two pilasters, against the north wall of the chancel, these arms above—Quarterly, 1st, Argent, a chevron between three cross crosslets gules [Copledike] ; 2nd, . . . a saltier between four crosslets or [Friskney] ; 3rd, Or, on a fesse gules three roundels argent [Huntingfield] ; 4th, Lozengy, gules and ermine [Rokeley] ; 5th, Or, a bend and chief gules [Harrington] ; 6th, Gules, a chevron vaire [? Leake]. Over the two pilasters are shields—(1) on the west side—Copledyke ; impaling—Or, a cross sable charged with four escallops, in first quarter a mullet . . . [Ellis] ; (2) on the east—Copledyke ; impaling—Argent, three bars dancy sable, an escucheon in chief ermine [Enderby]. This inscription below the first part in capitals :

Pretious to the memory | of Tho. Copuldike late of Harrington | in Com. Linc. Esq. the son of Tho. Cople : | 3 brother of John Cop : Esq. | son & heir to Sir John Cop. | He married first Martha ye daughter | of Sir William Ellis of Lincoln. | Mary his second wife & executrix | the daur of Richard Enderby | of Metheringham in Com. Linc. gent. | He deceased Anno D. 1658, the 4th | of September, aged 72. | Ultimus antiquæ stirpis jam conditur urna | Quem Deus æterna felicitate beat | Sic genus et proavi fugiunt sic omnia secli | Ast animis sanctis cælica regna manent | Lector abi, satis est, posthac te vivere Christo | Atque mori mundo sit tibi cura Vale !

Of antient stock here lies the last and best | Who hath attained
to his eternal rest. | This monument bespeake not him alone. |
It saith the family with him is gone. | But Heaven received
Saints, they're happy then | Which live as Saints although
they die like men.

A handsome grey marble monument (R) with a white sarcophagus
above to the west of the last, these arms below—Argent, a tower
triple turretted between three covered cups azure, on a canton
the arms of Ulster, on an escucheon of pretence the same without
the canton. Crest—a squirrell sejant gules cracking a nut or
[Amcotts] :

Sacred to the memory of | Anna Maria Amcotts | wife of
Sir Wharton Amcotts of Kettlethorpe | in this county, Bart,
daughter of | Vincent & Elizabeth Amcotts of Harrington, |
born the 11 of April 1725, died the 1st of July 1800. | In
her were united the mild virtues of a Christian | with every
female excellence | as she lived beloved she died lamented |
more particularly | by her daughter Elizabeth Ingilby
Amcotts | wife of Sir John Ingilby of Ripley | in the county
of York, Bart, | who out of grateful respect to her memory
on her death | took the name of Amcotts | and has erected
this monument to perpetuate | the remembrance of her
beloved parent.

On a flat stone within the altar rails :

Here lyes the body of Mrs Amy Hall eldest | daughter &
coheir of Henry Mildmay of Graces | in the county of Essex,
Esq., by Cecily his first | wife daughter and coheir of John
Barker of | Haghmond in the county of Salop, Esq. | By
her first husband Vincent Amcotts of this | place, Esq., she
had 4 sons & 3 daughters of | which Vincent only is now
living. | By her second husband Thomas Hall late of | Kettle-
thorp in this county, Esq., she had one son | named Charles
who is now living. | She was born the 14th of February An.
Dom. 1648, | and dyed the 20th of February 1712.

A flat blue stone in the chancel :

Sacred | to the memory | of Vincent Amcotts, Esq., | eldest
son of | Vincent and Elizabeth | Amcotts | died the 23 May
1730 | aged 10.

A stone collateral to the last one on the north :

Sacred | to the memory | of Vincent Amcotts, Esq., | who
died 26 August 1733, | aged 50.

Another also collateral to the north :

Sacred | to the memory | of Elizabeth Amcotts | relict of |
Vincent Amcotts, Esq., | who died the 12 July 1765, |
aged 71.

Another also collateral more to the north (R) :

> Sacred | to the memory of | Elizabeth Amcotts | daughter of | Vincent and Elizabeth | Amcotts | died the 10 May 1762, | aged 38.

Another to the west of these :

> Sacred | to the memory | of Charles Amcotts, Esq., | son of | Vincent and Elizabeth Amcotts | died the 14 April 1777, | aged 47.

[On the south of chancel, a grey marble tomb, with canopy over, and two figures kneeling, a knight in armour, and lady ; and 13 shields, 5 along the top, 3 on a line with the two figures, and 5 at the base—(1) Argent, a chevron between three crosses botonne gules [Copledike] ; quartering—Lozengy ermine and gules [Rokeley]. (2) Copledike ; quartering—A bend, . . . and a chief . . . [Harrington]. (3) Copledike ; quartering—Or, on a saltire engrailed five mascles . . [? Leake]. (4) Copledike ; impaling— Quarterly gules and vair, a bend or [Constable]. (5) Copledike ; impaling—On a bend argent three mullets [Clifton]. (6) Copledike. (7) Quarterly, 1st, Copledike ; 2nd, Rokeley ; 3rd, Harington ; 4th, Leake. (8) Quarterly, 1st and 4th, [Sable], on a bend between three lions passant guardant or three hazel leaves [Etton] ; 2nd and 3rd, Barry wavy of six argent and (9) Copledike ; impaling—Or, on a fesse . . . three plates [Huntingfield]. (10) Copledike ; impaling—Argent, on a chevron, between three griffins' heads erazed, a mullet or for difference [Tilney]. (11) Copledike ; impaling—Ermine, on a chief indented sable, 3 crosses tau argent [Thurland]. (12) Copledike ; impaling—Or, on a chevron between three annulets . . . as many crescents of the first [Sutton]. (13) Gone (Holles, L.R.S. i, 130, gives Copledike ; impaling—Argent three lions passant guardant gules for Littlebury).

> Here lieth John Copledike, esquire, sonne and ayre to Sir John Copledike, knight, late of Harrington, deceased, Who dyed the 4to April 1585, and Ane Etton his wyfe who dyed the x° June 1582.

On the north of chancel, a mural memorial marble and slate, with Copledike arms above, a knight in armour and lady kneeling, with two children (all marble figures), with the following inscription :

> Here lyeth the body of Francis Copvldyck, esq., brother and next heire of John Copvldyck, esqvire, which John Copvldyck was sonne and heire of Sr John Copvldyck, knight, of Harrington in ye county of Lincolne, wch foresayd Francis dyed the xxixth of December 1599, which foresayd Francis married Elizabeth one of the daughters of Lionell Reresby of Thrybargh in the county of York, esq., and had issue by her one sonne and a daughter which died in theyr infancy.

In the tower—there is evidence of its having been removed from

the chancel—a grey marble tomb, with a brass set in mural tablet over, with Copledyke arms, and this inscription :

Here lyeth S^r John Copledike, knight, late of Harrington, deceased, who died the twelfth of December 1557, and Elizabeth Littlebury his wife who died the 12th July 1552.

There are still two bench ends in the presbytery with the shield of Copledike, and one complete bench in the quire.

In the nave, on the south, a recumbent stone figure of a knight in mail armour, legs crossed, hands upraised ; may be this represents Sir John Harrington.]

This church consists of a nave and chancel, and a tower at the west end built by Mrs Cracroft within a short time. The font has eight shields on it—[(1) Huntingfield impaling Rokeley. (2) Copledike quartering Rokeley. (3) Huntingfield. (4) Copledike impaling Tilney. (5) Copledike impaling Leake. (6) A quatrefoil pierced between three crosslets [? for Umfraville]. (7) *Blank.* (8) Copledike.]

[See also *Lincs. N. & Q.* xi, 105–108 ; *L.R.S.* i, 129–131 ; Jeans, 32.]

(MS viii, 99–107.)

Haugh

Notes taken in the church, [probably August, 1835]—

On an old stone in the chancel, round the verge, in church text :

Hic iacet Joha*nn*is Hagh armig*eri* qui obiit xviii die mensis Julii anno d'ni [m]cccc[lviii] cui*us* a*n*ime propicie*tur* de*us* Amen.

These arms are in the centre of the stone, a chevron between ten croslets [Haugh].

On another to the west of the last, round the verge, in church text :

Hic iacet Isabella q*uon*dam uxo*r* Rad*ulphi* [*rectius* Ricard*i*] de Hagh fil' Joha*nn*is Belle de Boston que obiit Sept. die Febr. a° D'ni. m°ccccxvii cui*us* a*n*ime propicietur Deus Amen.

On an old stone more to the north, in lines :

+ Hic iacet | Agnes Clouc [*for* Clour] s'c'da | uxor Joha*nn*is de Hagh.

On an old stone to the east of the last, round the verge, in old character :

Hic iacet domin*us* Robertus de Wynceby quo*n*dam vicari*us* isti*us* ecc*les*ie qui obiit iiii k*al*. Marcii anno D'ni millesimo ccccxxv cui*us* anime propicie*tur* om*ni*potens Deus.

On an old stone in the nave, in lines, in church text :
> + Hic iacet | Joha*nn*a de Welby | prima uxor Joha*nn*is | de Hagh.

On a flat stone in the chancel :
> To the memory of | Martha | the wife of the Rev. William Oddie, | who died the 13 of September 1773, | in the 37 year of her age.

On a stone next to it :
> In memory of | Martha daughter | of the Rev. W^m Oddie | and Martha his wife, | born August y^e 12, 1766 [*sic*], | died Feb. 6, 1771, | in the 5^th year of her age.

Next to it :
> In memory of | Ann daughter of | the Rev. Will. Oddie | & Martha his wife | born Feb. the 4, died | Sept. the 24, 1766. | Also | of William their son, | who died April 20, 1774, | aged 15 months.

On a broken stone, in church text :
> + Hic iacet Thomas de Ha *pr*opiciet*ur* Deus Amen.

On another, in church text also :
> Rad*ulph*i Hagh cccc

An old flat stone under the Communion table, with an inscription round in old church text :
> + Hic iacet Thomas de Hagh qui obiit xxiij die Decem. an*n*o D'ni mcccc[xx] cuius a*nime pr*opiciet*ur* Deus Amen.

Close under the south wall of the chancel is a similar stone, with the inscription round the edge, but so mutilated and defaced by damp as to render nearly the whole of it illegible ; what remains is :
> xii die Aprilis mcccc

To the west of this is a stone having a cross cut on it, which once had an inscription round its edge in Saxon characters, but it is now so broken and worn by damp as to be illegible ; perhaps the word 'HAUG ' may be decyphered.

The church consists of a nave and chancel, separated by a Norman arch, with a brick turret for a bell at the west end. In the east wall north of the altar is a niche. The font is octagonal, with the window pannelling of decorated character.

[See also *Lincs. N. & Q.* x, 209–10 ; vii, 33–5.]

(MS vi, 97–100.)

Haugham

Notes taken in the church, August 19, 1835—This is a mean barn-like church with no distinction into nave, aisles, or chancel. The font is modern, the roof thatched, and a south porch.

This church contains no memorial of interest ; there are flat stones
to the memory of :
>Edward Cartwright died 27 Feb. 1826, æt. 67.
>Sarah his wife died 23 June 1811, æt. 48.
>N. Cartwright an infant 1794, E.W.C. 1811.
>John Waterland died 23 Jany 1761, æt. 44.
>Martha his dau[r] died 1 Sept. 1761, æt. 3.
>Mr Edward Hyde died 15 Jan. 1740, æt. 59.
>Edward his son died 9 June 1761, æt. 30.
>Daniel Hide late of Tathwell died 13 March 1758, æt. 74.
>Catherine his wife died 11 March 1771, æt. 73.
>Julin Ballet Jany 13th, 17 . . ., aged 68.
>Frances wife of Petch Bilby, & dau[r] of Julin Ballet died
> 19. Sept. 1781, æt. 42.
>Anne Bilby daur of Petch died 31 Aug. 1762.
>Robert Bilby died May [26, 1774], æt. 76.

[See also *Lincs. N. & Q.* xi, 46.]

(MS viii, 173.)

Haydor

Notes taken in the church, 12 August, 1834—This is a very
handsome church. It consists of a nave and aisles divided on each
side by four pointed arches springing from clustered columns, a
chancel with a north chapel, a south porch, and elegant tower and
spire at the west end. The font is a handsome octagon with niches
and pannelling. There are but one or two pews in the church,
the plan of benching being with good taste preserved, though the
seats are not old ones. There is a great deal of painted glass re-
maining in the windows, particularly in those of the north aisle.
In the first window westward of that aisle are three figures, the first
crowned in armour of gold, bearing on his shield and surcoat—
Azure, a cross flory between four martlets or, from which it may be
conjectured to be the figure of Edward the Confessor. The second
is the figure of St George in white armour, bearing on his shield—
Argent, a plain cross gules. The third is another crowned head,
attired in golden armour, the arms on his shield appear to be—
Azure, three crowns, two and one or, which were the bearings of
King Arthur. The window is filled up above with architectural
designs. In the next window are three figures of saints, and a
small figure in a round pane of a female on horseback, her veil
streaming behind. At the top is a representation of the Trinity ;
at the bottom of the window is this legend as far as it could
be decyphered from the mortar and dirt with which it was
encrusted :
>Orate pro anima Alfredi
>sororis sue.

In the south aisle is some more glass, but none of consequence. The font is handsome, octagon, pannelled in niches.

In the chapel north of the chancel against the west wall is a very beautiful monument, reaching nearly to the ceiling, composed of grey marble, the work of Scheemakers. On a black sarcophagus in the midst is the bust of a lady, and on each side is a boy weeping. Above are these arms—Quarterly, 1st and 4th, Argent, on a chevron azure three garbs or [Cradock] ; 2nd and 3rd, Sable, two cross bones in saltier argent [Newton] ; an inescocheon—Or, on a chevron azure a martlet between two pheons of the field [Warton]. Below the sarcophagus this inscription on a white slab :

> Near this place lies the body of | Susanna Lady Newton. | She was daughter of Michael Warton of Beverley in the county | of York, esq., and sister and coheiress of S^r Michael Warton of the | same place, knt. She married first sir John Bright of Badsworth in | the county of York, baronet, by whom she had no issue, and after | S^r John Newton of Barrs Court in the county of Gloucester, bart, | by whom she had one son the Honourable Sir Michael Newton, | Bart & Knight of the Bath, married to the Rt Hon^ble the Countess of Conningesby, | and one daughter Susanna married to William Archer of Welford in the county of Berks, esq. | She departed this life April the 19, 1737, in the 86 year | of her age. | Having ordered by her will a monument, this was in obedience | to her command erected by her daughter and executrix, Susanna Archer, | in the year of our Lord 1737.

To the north of the last is a handsome mural monument of a pyramidal form, composed of grey and white marble, with the arms of Newton, and an inescocheon as in the former one ; below this inscription :

> Here lies the body | of Sir John Newton, baronet, | who departed this life February the 12, 17$\frac{33}{34}$, aged 83, | By his first wife Abigail | daughter of William Heveningham, esq. | he had issue one daughter named Cary, | married to Edward Coke esq. of Holcomb in Norfolk, | and by his second wife, | daughter and coheir of Michael Warton, esq., | of Beverley in the county of York, and widow | of Sir John Bright of Badsworth in the same county, | he had issue one son named Michael [married to Margaret Countess of Coningsby, and one daughter Susanna, married to] William Archer, esq., of Welford in Berkshire. | This monument was erected in memory of the deceased | by the Lady Newton his widow.

Against the north wall of the chapel, close by the last, is a very handsome monument of light grey marble and white, flanked by two Corinthian pillars, and surmounted by an urn and wreaths

of flowers. Below are the arms—Cradock and Newton quarterly, impaling— per cross . . . and . . . a bordure entoyre of escallops [Heveningham]. It bears this inscription :

> Here lieth in hopes of | a glourious resurrection | Abigail | the wife of John Newton of Thorpe | in yᵉ county of Lincoln, esq., | daughter of William Heveningham of Heveningham, | Suffolk, esq., and Mary daughter and | heiress of John earl of Dover. | She lived soe as if she meant to die young. | Even her youth was pious & exemplary, | In wᶜʰ she diligently hearkened to yᵉ law of God & her maker, | And by yᵉ same steps with a gentle hand | She led into the way of virtue her own offspring. | John her eldest she prepared betimes for heaven | And for griefe almost followed, & now lyes buried by him. | She left a daughter Carey, | about six years of age, | In whom it appeared what the prudence of a mother, | Neither fond nor severe, could effect even in so tender years. | By a peculiar art her children both stood in awe & loved her. | After a tedious sickness she died big with child, | And was to the last more desirous that should live than she. | She had all yᵉ virtues that became a wife a mother & a child. | She deserved a longer life here, but more an eternal one. | She died May 11, in the year of our Lord 1686, [and] of her age 26. | John dyed July 18, in yᵉ year of our Lord 1681, of his age 4 years.

To the east of the last is a splendid monument of white veined marble, reaching nearly to the roof, the production of Scheemakers. In the middle is a sarcophagus crowned by an elegant urn ; on each side is a female figure, the one with a book and the other in a desponding attitude holding an inverted torch. It is very beautifully executed. In the front of the sarcophagus is this inscription :

> Near this place is interred the body of Sʳ Michael Newton, bart, Knight of the most honorable order of the Bath. | He was the son of Sʳ John Newton, bart, of Barrs Court in yᵉ county of Glocester, by Dame Susanna the widow | o᷄ Sʳ John Bright Barᵗ of Badsworth in yᵉ county of York, and sister and co-heiress of Sʳ Michael Warton of | Beverley in yᵉ said county. | He married in yᵉ year 1730 Margaret Countess of Coningesby, daughter & coheiress of Thomas earl of Coningesby | By his wife Frances, daughter of Richard Earl of Ranelagh, & he had issue one son John viscount Coningesby | who died an infant in yᵉ year 1733, aged about two months. | He represented yᵉ boroughs of Beverley & Grantham in four different Parliaments and discharged | yᵉ trust reposed in him by his constituents wᵗʰ a steady & uniform regard to yᵉ real interests of his country. | Nor did yᵉ example of a corrupt & venal age, enslaved to ministerial influence,

mislead his | judgement, nor did yᵉ offer of an honourable employment divert his resolute attachments | from yᵉ pursuit of patriotism. He died April 6, 1743. This monument | was erected in the year 1746 by his sister and heiress | Susanna Archer of Welford in yᵉ county of Berks.

To the east of this against the wall is a plain but elegant monument of white marble, the work of Rysbrack ; below is a countess's coronet and the letter C :

To the memory | of | Margaret countess of Coningesby | who departed this life | June 12, 1761, | aged 52. | Lady Frances Coningesby | with whom from their childhood | she had always been connected | by the strictest union | of kindred & concordant hearts | inscribes this marble | as a lasting testimony | of the unutterable grief | inviolate friendship | and tender affection | of an only & inconsolable sister, | lost to all comfort | but from the hope | of their being happily reunited | in a better world, | in Love | indissoluble & eternal.

A flat stone on the floor in capitals :

Here lies the body | of John Newton son | and heir of John | Newton, esq., who | was born the 26 |day of October 1677, | and died the 18 | day of July 1681.

A stone to the west bears the name of John viscount Coningesby, son of Sʳ Michael Newton, born 16 Oct. 1732, died 4 Janʸ 1732–3.

On another stone to the west in capitals :

August 2ᵈ, Anno D'ni 1671. | Here lieth buried the body | of Dame Elizabeth Eyre | wife to Sir Jervaise Eyre | of Rampton in yᵉ county | of Nottingham.

There are a few other stones bearing the names and deaths of those who are also commemorated on the monuments.

On a brass plate in chancel floor in capitals :

Hic jacet resurrectionem justorum expectans Henricus | Pight clericus Artium Magister rector ecclesiæ de Hayder in | agro Lincolniensi nec non prebendarius prebendæ de Hayder | cum Walton in ecclesia cathedrali beatæ Mariæ Lincolniensis. | Obiit Martii 29, Anno Dom. 1675, et ætat. suæ LXX.

On another brass plate in capitals :

Hic jacet resurrectionem jus- | torum expectans Isaacus Carter | clericus Artium Magister rec- | tor ecclesiæ de Hayder in agro | Lincolniensi necnon præbendarius | præbendæ de Hayder cum Walton | pertinentis ad ecclesiam cathe- | dralem beatæ Mariæ Lincolnien- | sis. Obiit vicesimo nono die Novem- | bris Annoque Dom. 1687, ætatis suæ 40.

A flat stone more to the west in capitals rubbed (D) :

> Josephus Weld A.M. | Postquam huic ecclesiæ per | annos
> 39 incubuit rector | quam moribus et doctrinis | ornavit, |
> Hic tandem placide obdormivit | Summo [*blank*] rationem |
> redditurus vol Anno Ætat. 79. [Anno] Dom. 1726.

In the south aisle is a brass plate which records the death of Gervase
Barker, gardener to Sir John Newton, bart., 34 years, died Nov. 4,
1724, aged 57 years, & Elizabeth his wife, who died May 22, 1731,
in the 70 year of her age.

In the chancel is a curiously carved old oak chest, and hanging
from the walls are the tattered remnants of banners, helmets,
escocheons, &c., of the Newton family with their crest, a blacka-
moor's head.

[See also *L.R.S.* i, 209 ; *Lincoln Date Book*, pp. 150-2 ; Trollope,
Sleaford, pp. 381-3.]

(MS v, 107–117.)

Heckington

Notes taken in the church, [*blank*] August, 1831—

In the chancel under an arch is the recumbent figure of a priest
in his robes, his feet resting on a lion, his face is mutilated.

On a brass plate in the nave near the entrance to the chancel, with
the inscription in old character :

> Here lyeth John Cawdron whyche decessed yᵉ XXVIIJ day of
> Novebʳ yᵉ yer of our Lord God MCCCCLXXXVIII, For Goddes
> love pray for me, Thou weytet not what nede I have to the,
> For charite say a pat : nost. & ave.

On another brass plate in the nave near the north transept, this
in old character :

> Here lyeth Willᵐ Cawdron sumtyme Baylyf of Hekington
> whyche deptᵈ thys world the last day of Aprill in the year
> of our Lord God MDXLIIII, upon whose sowlle God have mercy.
> Amen.

On a flat stone to the south of the last, with the inscription cut
round in church text, partly effaced :

> Hic jacet Henricus Cawdron qui obiit x die M. CCCCCIJ
> cuius *anime propicietur* Deus. Amen.

In the south transept there is a flat stone, in which have been
brasses of a knight and lady with their children, and with arms
and inscription, but all now gone.

On a flat stone in the nave near the entrance to the chancel with
inscription cut round :

> Cawdron que ux. Will. obiit x die Martii An.
> MCCCCCIX cujus *anime propicietur* Deus. Amen.

On a flat stone in the chancel with the arms cut above—. . . . ,
two bars wavy , in chief a lion passant Crest—A
demy lion rampant [for Taylor] :

> Hic jacet Guilielmus Taylor generosus | quem largiter opibus
> ornabat Deus. | Ille Deo cultum persolvit | Rem honeste
> faciendi sibi legem indixit | injuriæ memoriam deposuit |
> incommodis in rebus proximos suppeditavit | Et egenis in
> perpetuum succurrit. | Obiit spe fretus Resurrectionis | 2^{do}
> die Maii anno salutis 1723°, | Ætatis suæ 73, | in proximo
> Franciscus filius ejus sepelitur | invitum quem Mors acerba
> surripuit | annos habentem solos triginta septem | 15° die
> Aprilis An° D° 1720.

On another more to the south :

> Here lyeth the body | of Ann Taylor the wife | of William
> Taylor, gent., | who departed this | life the 21 day of July |
> 1714, in the 63rd year | of her age. By him she | had issue
> five sons and one | daughter. She was the | daughter of
> Mr Richard | Noble and Bridget his wife of Waltham in the |
> county of Leicester.

On another stone more to the south :

> Here lyeth the body of | Mr Anthony Taylor the son | of
> William Taylor, gent., and Anne his wife buried the 5th
> day | of March 1713, in the 32 year | of his age. He married
> the | onely daughter of Edward | Booth of Alderchurch,
> gent., | who had issue by her four sons | and four daughters. |
> Here lieth also the body of | William the son of Anthony |
> Taylor, gent., and Mary his wife, | born October the 17, 1704,
> buried | October the 24, 1704. | Here | lyeth also the body
> of Edward | the son of Anthony Taylor, gent., | and Mary
> his wife, born May | the 25, 1706, buried March the | 5th,
> 1706. Here lieth also | the body of Mary the daughter | of
> Anthony Taylor, gent., and | Mary his wife, born July the
> 28th, | 1709, buried August the 11, 1709. | Here lieth also the
> body | of Elizabeth the daughter of | Anthony Taylor, gent.,
> and Mary his | wife, born February the 23, 1712, | buried
> February the 28, 1712.

On another flat stone more to the north :

> In memory of | Katherine the wife of Anthony Taylor | of
> this parish, esq., | and eldest daugh^r of John Lawrence | late
> of Barnes | in the county of Surrey, esq. | She departed this
> life | much lamented on the 9th day of June 1765, | aged
> 53. | And also of Anthony Taylor | late of this parish, esq., |
> who departed this life in the | 25 day of November 1773, |
> aged 66 years. | He was a kind husband, an | affectionate
> parent, and a sincere | friend.

On a flat stone in the chancel :

> In memory of | William Wetherill | who died May 18, 1810, |
> aged 53 years. | Also four children | who died in their infancy.

On another flat stone :

> Sacred | to the memory of | John Searson Simpson, gent., | who died Nov^r the 7th, 1777, aged 42 years. | Catherine Simpson wife of the above | and daughter of Anthony Taylor, esq., | died Oct. 31st, 1790, aged 63 years. | Catherine Simpson daughter of the above | died Sept. 9th, 1788, aged 17 years. | John Noble Simpson son of | John Anthony Simpson | died an infant Nov^r 28th, 1801. | Sarah wife of John Anthony Simpson | died May the 12, 1801, aged 32 years. | John Anthony Simpson, gent., | died Dec^r the 1st, 1800, aged 38 years. | John Anthony Simpson son of the above | died May 20th, 1814, aged 15 years.

On a flat stone in the nave :

> Here | lieth the body of | William Taylor, | gent., | who died Nov. 15, 1781, | aged 73 years.

On another to the west of the last :

> Sacred | to the memory of | John Taylor, | gent., | who died June 25, 1818, | aged 71 years.

On a stone tablet over a fire-place near the south door :

> Mrs | Faith Ovens | died February 10th 1795, | aged 82 | years.

On a flat stone in the south transept called ' Winkills Choir ' :

> Sacred to the memory of | Richard Christopher, | gent., | who departed this life May 22nd, 1809, | aged 66 years. | Also | Harriet Thorney Clark, | daughter of the above | Rich^d Christopher, | who departed this life Jan. 22, 1810, | aged 23 years.

On another flat stone :

> Sacred | to the memory of | Susanna relict of | Richard Christopher, gent., | who departed this life | Feb^y 10, 1826, | aged 70 years. | Also | Harriet Thorney Christopher, | grand-daughter of the above, | who departed this life | April 13, 1825, | aged 6 months.

On another stone :

> Here lieth the body of | John Christopher, gent., | who departed this life Aug^t 23, 1793, | aged 80 years.

[See also *L.R.S.* i, 191–2 ; Jeans, 33 ; Trollope, *Sleaford*, 389–96.]

(MS i, 93–101.)

Helpringham

Notes taken in the church, 14 July, 1834—This church is very fine. It consists of a nave and aisles divided by four pointed arches springing from clustered columns, a chancel, with a lofty tower, and pinnacled and crocketed spire at the west end, entered by a very beautiful door with receding mouldings of great depth.

It has a south porch. Between the nave and the chancel is a handsome decorated oak screen, but the head of the arch is blocked up with the King's arms, Commandments, etc. At the west end of the nave is a gallery (D) of oak in the modern style, but handsome of its kind, for the singers. In the south wall of the chancel are three stone stalls with round arches trefoiled, and a piscina. In the south aisle is a piscina with crocketed canopy ; and against the first pillar on the north of the chancel is a similar one, but blocked up. Near it is a grotesque figure supporting a bracket. The font is circular, on a massive black marble basement. It has a range of arches round it, but has been daubed to look like veined marble. There were four pillars round, but one only remains.

A brass plate within the north wall of the chancel, within the altar rails, the inscription in capitals :
> Here lieth the boddie of An | thonie Newlove, the elder, | patron of the vicaridge of | this church of Helpringham | whoe departed this world ye | fift day of October 1597.

A marble tablet against the east wall north of the altar :
> In memory of | Boaz Baxter late of | this place, gent., who died | Augt 31, 1804, aged 74 years. | Likewise of Frances his wife | who dyed Decr 18, 1814, | aged 80 years. | Also | seven children and | two grandchildren | who died infants.

On a flat stone within the altar rails in capitals :
> Here lyeth ye body of | Mary the daughter of | William Cawdron, gent., | and Mary his wife | buried March ye 14, 1719, | aged 28.

Another more to the north in capitals :
> Here lieth | the body of | William ye son | of William | Cawdron, gent- | til., and Mary | his wife who | was buryed | the 7th day of | September 1695.

Another to the west of the last in capitals :
> Here lyeth ye body of | William Cawdron, gent., | who was buried | August ye 29, | 1720, | aged 54.

Another to the south in capitals rubbed :
> Here lyeth ye body of | Elizabeth the wife of | John Craven | who was buried | Jan. ye 18, 1719, | aged 21.

Another more to the south :
> In | memory of | William Shilcock | who died Sept. 2, 1829, | aged 31.

On another stone :
> In memory of | John Baxter, gent., | who died August the 7, | 1757, aged 57 years.

On the floor are more stones to the same family.

On a wooden tablet against the south wall of the chancel in gold letters on a black ground :

> Near | this place | lyeth Constance wife | of John Spring-thorp | died August 28, 1741, aged | 69 years, also three of his sons, | viz. Thomas, John, and Sam¹. | Thos died April 28, 1740, | aged 26, John died Auguᵗ | 4, 1740, aged 24, Samuel | died Oct. 28, 1740, aged | 19 (followed by the trite verses beginning ' Affliction sore ', etc.).

On a similar one more to the west :

> Near | this place lie | interred the bodies | of John, William, and Anne, | sons and daughter of John | and Mary Allen who died as | follows, John Allen 24 April | 1749, aged 16 years, Anne | Allen 13 May 1749, aged 22 | years, William Allen 26 May | 1749, aged 18 years. (Some verses not worth transcribing follow.)

There are flat stones in the chancel to the memory of :

> John Milner died May 25, 1786, æt. 37.
> Ann relict of John Willbourn, & formerly wife of John Milner, died June 26, 1809, æt. 54.
> John son of Samuel and Elizabeth Milner died 28 June 1804, æt. 1.

On an oval black tablet against the wall of the north aisle :

> Near this place | are deposited the remains of | Susannah | the wife of Geoᵉ Mitchinson of Grantham, | eldest son of the Revᵈ T. Mitchinson vicar of this parish. | She died in the full assurance of Faith April 5, 1820, | aged 29 years. | For if we believe that Jesus died and rose again, | even so them also who sleep in Jesus | shall God bring with him. ɪ Thess : 4 : 14.

Another tablet to the west of the last in gold letters on a black ground :

> In memory of | Catharine the wife of | Revᵈ Thomas Mitchin-son | vicar of this parish | who departed this life | after a long and severe illness, | borne with Christian patience | and resignation, | on the 13 day of April 1821, | aged 60 years.

On a flat stone near the entrance to the chancel :

> In memory of | Mary the wife of John | Springthorp who was buried | Nov. the 2ᵈ, 1754, | aged 51 years.

[See also *L.R.S.* i, 186 ; Jeans, 33–4 ; Trollope, *Sleaford*, 400–3.]
(MS v, 25–32.)

Hibaldstow

Notes taken in the church of Hibalstow, 2 September, 1835—This church, which is a mean modern building, rebuilt to an old tower in the year 1799, as is mentioned in a gallery at the west

end. In the tower are three bells. The font is octagonal, with strawberry leaves down the lower edge. There is no monumental memorial whatever, except an old stone (D) near the pulpit, having had an inscription round the edge, entirely defaced.

[See also *Lincs. N. & Q.* xi, 46.]

(MS viii, 181.)

Holbeach

Notes taken in the church, 22 July, 1833—

On a white marble monument on the south of the chancel, the arms carved above, but too high to be in sight, two cherubs under in alto relievo :

> In memory | of Samuel Richardson, Esq., | an upright magistrate | tender husband indulgent parent | generous friend | & benevolent to all mankind. | He married Elizabeth | the second daughter & coheiress | of Benjamin Sanderson, gent., | by whom he left two children Sigismund & Mary | and departed this life | the 10 day of Febr^y | 1736, aged 56.

On a stone monument with a marble slab next to the last, with these arms under—Sable, a chevron between three crosslets fiche argent [for Richardson] ; impaling—Sable, a griffin segreant between three mullets argent [Short] :

> In memory of | Sigismund Richardson, gent. and | merchant, | in all stations of life for his | amiable behaviour greatly | and justly esteemed. | He married Carew the eldest | daughter of Edward Short of | Litchfield in Staffordshire, | gent., | by whom he had two sons | and one daughter viz. John, | Sam^l, and Elizabeth. | He died Jan. 4, 1747, | aged XXXII.

On the north wall of the chancel on a stone painted like marble, with law books above :

> Near to this place lie interred the remains | Mr Philip Ashley, attorney at law, | and steward to the Right Hon^ble Lord Eardley, | who died the 19 day of Dec^r 1794, | aged 50 years. | Vir bonus erat. | Also of Margaret the wife of the said | Philip Ashley | who died the 11 day of May 1788, | aged 47 years, | and of Mrs Levina Davey Foster | widow of Mr W^m Foster of Stamford | who died the 4th day of Sept^r 1793, | aged 56 years.

On a black stone in the chancel (R) :

> M. S. | Radulphi Peirson Armigeri | qui obiit | 21 Martii A.C. 1711, | ætatis 65. | Item Susanna Peirson | uxoris suæ quæ obiit | 13 Feb^rl A.D. 1713.

Near this there has been a brass of an inscription now gone.

Against the south wall, in the corner of the north aisle, a white marble monument with these arms under—Quarterly, 1st and 4th,

Argent, a double-headed eagle displayed sable [Stukeley] ; 2nd and 3rd, Argent, two bars [sable] charged with six escallops of the field [Flete] ; impaling—Sable, a chevron engrailed between three swans' heads erazed argent [Squire] :

> Here lieth the body of | Sarah Stukeley the widow of Adlard Stukeley late of | Holbeach, gent., | who died the thirty first day of | January 1730, | in the sixty eighth year of her age. | A mother who with every grace was blest | With all the ornaments of virtue drest | With whatsoe'er religion recommends | The best of wives of mothers and of friends | And tho' by death her body's turned to dust | 'Tis fitt we still commemorate the just | 'Twas here she did adore the highest Lord | Who to her soul great comfort did afford | 'Twas here she did with pleasure and content | Receive God's holy word & sacrament | Since then she loved this sacred place so well | 'Tis very meet that here her name should dwell.

On a monument of grey and white marble against the east wall of the north aisle, with the arms of Stukeley under, with this escucheon over—Argent, two talbots passant sable :

> Sacred | to the memory of | Adlard Squire Stukeley, Esq., | for many years one of his | Majesty's Justices of the Peace | for these parts. | He died June the 13, 1768.

On a tablet of white marble against the east wall of the north aisle :

> Tho^s Wood | son of Tho^s & Eliz^th Wood | of Holbeach Marsh | died 8 Nov. 1812, aged 19 years. | His affectionate parents erected | this tablet to the memory | of a dutiful son.

Above it is another white marble tablet :

> Elizabeth the wife of | Thomas Wood | died Aug. 4, 1823, | aged 58. | In the hope of a joyful resurrection to | eternal life through the mercy of God and | the merits of her Redeemer.

On a black marble monument (D) against the north wall of the north aisle, with these arms above—Chequy or and azure, a fess ermine [Calthorpe] ; impaling—[Argent], on a chief [vert] a cross tau between two mullets or [Drury] ; crest—A wolf's head couped :

> Here lieth interred the body of | Robert Calthorpe, gent. He | married Eliz. Drury one of | ye daughters of John Drury | of Holt House in ye county of | Norff., esq., who departed this | life the 16 day of March in the | year of our Lord 166$\frac{6}{7}$, aged 66 years.

Below in black letters on a gilt ground :

> Here also lies y^e | body of Jonathan | Calthorpe, gent., and grand | son to the above mentioned Robert, | who departed this life the 27th of | Feb. 1711–12, aged 25.

On a white marble tablet above the last :
> To the memory of | William Willders | who died Nov. 22,
> 1805, aged LVII years. | Ann relict of the above | died March 29,
> 1820, | in her LXIII year.

On a black monument in the north aisle :
> To the memory of | Richard Fawssett | surgeon | who died
> April 8th, 1811, | aged 71, | and of | Mary Fawssett | his wife |
> who died February 24th, 1819, | aged 76.

On a black monument next to the last :
> Sacred to the memory of | William Bingham | obiit Aug^t 14th,
> 1824, | aged 69 years. | Also Mary relict of the above & fourth |
> daur of Francis & Eliz. Holliday | [obit March 18th, 1850, |
> aged 83 years.]

These two next on flat stones in the north aisle :
> Adlard fil. | A. & S. Stukeley, | ob. 4 March 1694. | Sarah
> fil. A. & S. | Stukley ob. 28 Octo- | b^r 1692.

On another flat stone close by (D) :
> Jana Stukeley | filia | Adlardi Stukeley generosi | & Saræ |
> peramantissimæ et charissimæ | conjugis suæ | obiit | 23
> Augusti | anno salutis nostre 1690, ætat. suæ 2.

On another flat stone (R) :
> Hic recubant cineres pulchra de stirpe Johannis | Ampleford
> atavis Hic requiere suis | pallida mors subito rapuit juvenilibus
> annis | ætatis verno tempore raptus erat | Ultimus e maribus
> generosa stirpe creatur | ultimus antiqui nominis ille fuit |
> Deplorat proles sua se charissima conjux | deplorat socii
> flentque dolentque sui. | Obiit XII Januar. | Anno D'ni 1701, |
> ætat. XXIX.

On another flat stone in the north aisle :
> Here lieth interred the | body of Thomas Ampleford, | gent.,
> who departed this | life the 30 day of March | in the year of
> our Lord | 1700, in the 67 | year of his age.

On another (D) :
> Here lieth the body of | John Harris who departed | this |
> life the 15 day of Nov. | Anno Dom. 1711, | in the 46 year of
> his age.

On another flat stone :
> Here lieth the body of Mrs Jane Ampleford | who departed
> this life the 3 day of October | 1700, | in the 39 year of her
> age. | Though for our loss we cannot chose but grieve | This
> comfort shall our passions yet receive | That Heaven is joyful
> and thy blessed state | Shall be a means our griefs to mitigate. |
> O what a happy state it were if we | Had no more cause of
> sorrow but for thee.

On another flat stone partially rubbed (D) :

> Here lieth the body | of Martha the wife | of John Bennet, clerk, | who departed this life | the 19 of July Anno | Dom. 1731, ætat. suæ 64 | Here also | lieth the body of Lucius | Henry son of Richard Disney, | gent., and Spincke his wife | who died 17 day of October | Anno Dom. 1717.

On another flat stone :

> Sacred | to the memory of | Mrs Elizabeth Yerburgh | relict of the late | Richard Yerburgh, Esq., of Frampton, | and formerly of | Dymoke Cawdron, esq. | (of this place) | who died March 30, 1800, | in the 80 year of her age. | Also Sarah the wife of | John Phipps, daughter of | the above Mrs Yerburgh, | who died May 16, 1802, | aged 56 years.

On a black stone with these arms—three swans' heads erazed [Collay] :

> Sarah Callow | died 11 Feb. 1738, | aged 49.

Close by on a black stone :

> Here lieth the body | of Henry the son of | William and Sarah Callow, | he departed this life | the 23 of July 1724, | æt. 11 years.

On a monument against the first pillar at the west end of the middle aisle, with these arms above—Ermine, a lion rampant sable [Ball] ; impaling—Azure, on a chevron three roses [Rands]. The crest— A demi-lion rampant sable, holding (R) :

> In memory of Elinor | the wife of Philip Ball, gen., | of this parish, and daughter of | Christopher Rands of South Hyckham in the county of Lin | coln, deceased, ye 24 of Jan. 1718, | aged 42 years. | Also Mary their daughter an | infant buried with her. | Say marble or at least weep out the praise | Of the deceased fairer her character | Than thy smooth polish. Pen of steel can nere | Her vertues write nor poets loftiest layes. | Pure as thy spotless gloss her love will shine | Both conjugal and filial and adorn | Thy monumental trophy. Never urn | Held mortal ashes truly more divine. | In her no place could envious censure find | Her generous birth nere to ambition fired | The beauties of her person but conspired | To enhance the charming beauties of her mind. | Innocent as the babe that caused her death. | Her charity diffusive as the sun | And active equally. Tread lightly on | Her grave for such was she lyes underneath.

Below is a hand pointing to the stone underneath.

On the second pillar is a similar monument ; above, the arms of Ball, impaling—Sable, a chevron between three lions' heads, erazed or. Ball crest above (D) :

> Near | this place lies interr'd | the body of Richard | Ball of Holbeach, gent., | who | was a chief promoter | of trade and merch- | andise, and brought | the benefit and advan- |

tage thereof to the place | of his residence, | a laudable example for | posterity, he departed this | life June the 21, 1721, | ætat. 68.

A hand also here pointing down.

Against the west wall north of the tower this monument :

To the memory | of | Joseph Harrisson, esq., | who | departed this life | on the | 11 of Nov. 1809, | in the | 41 year of his age. | In the midst of life we are in death.

The arms under—Azure, a fleur de lis argent [for Harrison]. It is executed in yellow and white marble.

Under the preceding a white sarcophagus :

Charles Harrisson | of | Jesus College Cambridge | died the 9 of April 1825, | aged 22. | Weep not for him, in his spring time he flew | To that land where the wings of the soul are unfurled | And now like a star beyond evening's cold dew | Looks radiantly down on the tears of this world.

On a black stone at the west end of the north aisle :

In memory of Jonathan Barnard, gent., | who departed this life the 13th of | April Anno Domini 1721, in the 28th | year of his age.

On a black marble tablet against the wall at the east end of the south aisle (D) :

Near this place rest the remains of | Mr William Brown | a native of Bingham in Nottinghamshire,| but for some years | a grocer and draper in this town, he died | universally respected | April 4, 1811, in the 40th year of his age. | An honest man's the noblest work of God.

Upon another more to the south (D) :

In memory of | Mrs Mary Brown relict of | Mr William Brown a native also of Bingham | in Nottinghamshire, at which place | she died July 25, 1814, | aged 34 years, and was brought here for | interment with her husband | on the 29th of the same | month.

On a marble monument to the south of the last with arms above— Quarterly, 1st and 4th, Argent, three snowdrop flowers slipped proper [for Palmer] ; 2nd and 3rd, Azure, three fleur de lis argent ; impaling— , a chevron between three lions' paws, erazed sable [Brecknock].

To the memory of | Mr Samuel Palmer | who died the 19 of June 1741, | in the 41st year of his age. | Also to the memory of | Mrs Ann Palmer | relict of | Mr Samuel Palmer | and daughter of | Mr James Brecknock, M.D., | who died the 11th of Sept. 1781, | in the 72 year of her age.

A grey and white pyramidal monument to the west of the last mentioned :

Near this place | lieth the body of | John Wilkinson, gent., | who died April 2nd, 1771, aged 58 years.

Another one more to the west, arms below—Argent an oak tree, fruited proper, over all a fesse azure charged with a cinquefoil between two estoiles argent [Watson] :

> Sacred to the memory of | Elizabeth the wife | of Mr Jonathan Watson of Holbeach | and daughter of Mr John Watson | of the same place | who departed this life Decem. 1st, 1773, | aged 34. | Also three of their children who died infants.

A similar one more to the west :

> In memory of | Ann Davey | the wife of Jacob Davey, gent., | who died on the 3rd day of September 1813, | aged 61 years. | The above Ann Davey | was daughter of | Abraham Sheath, senr, gent., | formerly of Boston in this county, | an excellent father and sincere friend. | Ann Catherine Davey | their child | died an infant.

A small oblong marble tablet below :

> Here lieth the body of | Jane Davey, spinster, | the daughter of Jacob Davey late of | Holbeach, gentleman, by Margaret his wife | who departed this life the 16 day of | March 1755, aged twenty four years, | Extreamly | affable courteous, humane and charitable, | as she was greatly respected whilst living, | so at her death was universally | lamented. | Life is a journey of a winter's day | Where many breakfast & then post away | Some few stay dinner & depart full fed | Fewer that sup & then retire to bed.

A yellow marble tablet with white slab more to the west, with arms of Watson—viz., Argent, an oak, fruited proper, over all, on a fesse azure a cinquefoil between three estoiles argent :

> To the memory | of Mrs Elizabeth Watson | wife of Mr John Watson | who departed this life April the 4, 1768, | aged 57 years. | Also of | Mr John Watson | who died February the 14, 1771, | aged 64 years.

Upon another, close by the south door, arms over—Quarterly, 1st and 4th, Azure, three arrows or [for Brecknock] ; 2nd and 3rd, Argent, three fleur de lis sable [? for Palmer] ; impaling—Or, a chevron azure, between three lions' heads sable. Crest—An arm in a sling proper :

> In memory of | James Brecknock, M.D., | who departed this life | December 23d, 1746, | aged 66 years.

A brown stone tablet on the west side of the door :

> To the memory | of Edward Worley son of | George Worley & Judith | his wife born at little Houghton | in Northamptonshire | Feb. 5, 1738–9, | died of the small pox | in this parish October 26th, 1763. | A youth of distinguished abilities | of a most obliging & sweet disposition | and of whom his parents had justly | conceived the greatest hopes.

On a black flat stone in the south aisle :
Here lyeth interred ye body | of Mr John Rix | who departed this life May ye 27th, | 1718, in ye 43 year of his age. | Here also lyeth interred ye body | of Martha relict of ye said Mr | John Rix who departed this | life Feb. ye 7, 1730, in ye 60th year | of her age. | They left only one daughter surviving.

A brown stone monument against the west wall in two columns :
(1) Near this place lieth | the body of John Northon, gt, | who departed this life ye 27th of April 1751, | aged fifty four years. | And likewise | Avis Northon his first wife who | died the 15th day of September 1724, | aged 27 years, | and Mary their daughter who | died the 30th day of May 1734, | aged 11 years, | and 8 children infants | by Margaret Northon his widow | now living.
(2) Near this place lieth | the body of Margaret the | widow of Mr George Sutton | of Folkingham in this | county | who departed this life the twenty second | day of March 1750, | aged seventy eight years. | In memory of Margaret Northon | who died Novr 7, 1779, | aged 76 years.

Upon a flat stone to the west in the south aisle :
To the memory | of Edward Davey, gent., | who died March 19, 1754, | in the 37 year of his age. | Also Mary his wife who died July | the 21, 1748, aged XXXIV years. | Also five of their children, namely, | Jacob, Mary, Jacob, & Edward, | who died infants, and William | who died Nov. 14, 1760, aged 14 years. | Also to the memory of Ann Rhodes | second wife of Edward Davy and | afterwards wife of Laurence Rhodes, | gent. Her remains are deposited in a | vault adjoining the next pillar on the | east, she died Feby ye 2d, 1787, | aged 74 years.

Upon another more to the west :
Sacred | to the memory of | Mary Davey Key | the wife of John Key | who died on the 26th of May 1801, | aged XXXII. | Also of their six infant children, | namely |

1 Edward Davey Key	Mary Robinson Key 4
2 Robinson Key	Levin Key 5
3 Davey Key	Mary Key 6

At the east end of the stone lie the remains | of her maternal grandfather | Edward Davey, | And at the west end the remains of her | maternal aunt Esther Betham. | Qualis vita Finis ita.

Upon another more to the south :
Sacred | to the memory of | John Key, gent., | who died on the 10th of June 1810, | aged XLVII years.

Upon another to the west of the last :
In memory | of Esther wife of | Mr Brian Betham | of

Peterborough surgeon | who departed this life | the 28th of Nov. 1766, | aged 27 years. | Also of | Levina the widow of | Mr Mathew Robinson, surgeon, | and sister of the above | who departed this life | the 3rd of March 1823, | aged 79 years.

On another to the west (D) :

William Slater esq. | died July 1st, 1829, | in the 74th year of his age.

On another to the west (D) :

In memory of | Zachariah Johnson | who departed this life | Sep. XXVI, MDCCCXXVI, | aged LXVI.

On another more to the west with an edging of marble round (D) :

Sacred to the memory | of Mr Aaron Thompson | who departed this life | the 30th of Septem. 1795, | aged 75 years. | Also of John Torry Elston | son of Torry and Elizabeth Elston | late of Holbeach, | now of , merchant, | who died the 14 of February 1794, | aged 8 years, | and one child died an infant.

Another to the north (D) :

In memory of | John Hursthouse | gent. | who was interred June 11, | 1787.

Upon another to the west of the last mentioned (D) :

Here lieth the body of | William Everson, | mercer, | who departed this life Octr 12, 1761, | aged 46 years. | He had issue 2 sons | who both survived him. | Sacred | to the memory of | Mary relict of William Everson, gent., | who departed this life March 16th, 1795, | in the 85 year of her age.

A flat stone at the east end of the south aisle (D) :

Sacred | to the memory of | Michael Keightley | who departed this life | Octr the 20, 1785, | aged LXVII years. | He lived justly esteemed & respected | and died worthy & much lamented.

Another to the west of the last (D) :

Sacred | to the memory of | Mary relict of Michael Keightley, gent., | who departed this life | April 13th, 1794, | in the 76 year of her age, | a virtuous, well disposed, | charitable, good, christian. | Also George son of | Michael & Mary Keightley | who departed this life | April 19, 1787, | aged 32 years.

On a small one more to the north (D) :

Here | lieth the body of Eliz- | abeth the daughter of | John and Avis Northon | who departed this life | the 23rd day of July | 1719, | in the 1st year of | her age. | Also John son of | John and Margaret | Northon died May | 17th, 173[1] . .

Upon another more to the west (D) :

In memory of Avis | the wife of John Northon | who departed this life ye 11th | day of September 1724, in the 27th | year of her age.

On a black flat stone to the west of the last (R) :
> In memory of | Mr Bartholomew Northon, | mercer, | who died April 27, 1763, | aged 42, | Also one child in its infancy.

Another to the south (D) :
> There | lieth the remains of the | Rev^d John Northon, | curate of Gedney | upwards of 40 years, | during which time his conduct | was such as deserved the mark | ed esteem of his parishioners, | he died on the 2d April 1814, | aged LXVIII, | lamented by all his friends | and acquaintance.

On another (D) :
> In memory of | Esther the wife of John | Ratcliff, gent., who departed | this life the 21 of February | 1724, in the 33d year of her | age.

On a flat stone close by the font (D) :
> John | Thos Everson Harrison | died August 8, 1795, | aged 3 years. | Of such is the Kingdom | of God.

A grey pyramidal monument with white slab, against the north corner of the arch to the chancel, with an urn over, and these arms below—Quarterly, 1st and 4th , a cross couped . . . [for Everson] ; 2nd and 3rd , three fleur de lis. Crest—A stag's head (R) :
> Sacred to the memory of | John Everson, esq., | died the 29 of January 1801, | aged 61. | Thomas Everson, gent., | died Jan^y 17, 1808, aged 67. | Margaret Everson relict of the above | named Thomas Everson died Jan. 10, 1827, | aged 81.

A similar one on the south corner of the arch, arms below—Azure, a chevron ermine, cotised or, between three martlets of the last [for Northon] (D) :
> Near this place lie the remains | of Edward Northon, esq., | late major of the Royal South Lincolnshire Militia, | in which regiment he served upwards of thirty years. | He departed this life the 25th of April 1797, | aged 60 years. | This monument is erected to his memory | by his affectionate and only sister Ann Buckworth | wife of Theophilus Buckworth | of Spalding in this county.

This is a very beautiful church. The nave is separated from its two aisles by seven fine pointed arches springing from lofty clustered columns. The style of the church is of the Decorated period and the windows very handsome. The clerestory has fourteen. The arch to the tower is open and very lofty. The tower has a groined roof, and is surmounted by a spire. On the north side is a porch flanked at the entrance by two curious round towers. On the south side is another porch which has a very remarkable acute pointed arch, more so than any I remember to have seen. The spire is crocketted, and the whole church presents a beautiful example of the architecture of the reign of Edward III. At the

west end of the north aisle is a very handsome altar tomb, on which is the recumbent figure of a knight clad in plate and mail, his hands clasped over his breast, with his feet resting upon a lion, and his hand upon what is apparently a crest, being the head and neck of a man clothed in a coif or garment of net work. Round the tomb are eight shields, viz.— , three lions passant [Littlebury] ; and three bars ermine (Kirton), alternately. This monument is ascribed to a Sir Humphry Littlebury, and the arms are those of the family.

On a brass plate in the nave much rubbed is this inscription in the old character, now hardly legible. The parts, now obliterated, have however been preserved by an entry of one of the vicars in the register, in the third volume, on the flyleaf :

> Orate pro anima [domine] Johanne Welby [quondam] filie Richardi [Leake], militis, [nuper uxoris Thome Welby, armigeri, que obiit xviii die mensis Decembris], an[no domini MCCCCLXXXVIII, cujus anime propicietur] deus, Amen.

There is a curious font in the church ; it is octagon, supported on a pannelled basement, and raised by two steps from the ground. On each face of the top is the figure apparently of a saint, but too much mutilated to be discovered with certainty.

[See also *L.R.S.* i, 178 ; Jeans, 34 ; *Churches of Holland ;* Macdonald, *Holbeach Parish Register,* 66–109.]

(MS ii, 71–107.)

Holton Beckering

Notes taken in the church, 15 October, 1840—This is one of the handsomest churches in the prettiest village in this part of Lincolnshire. It is entered by a very handsome porch on the south side, with a Gothic doorway beautifully crocketed and lighted by side windows of three mullions. Carved outside on the stone wall of the church are two shields ; one to the west of the porch bears— Three water bougets [? Roos] ; impaling two lions passant ; the other on the east, just where the nave joins the chancel, bears— Three water bougets ; impaling—Checquy [Bekering]. Inside, the church consists of a nave divided from a north and south aisle by three pointed arches on each side, and a chancel. In the windows are some fragments of painted glass, and there are some old flat stones (D) which have had inscriptions, but now defaced.

Against the north wall of the north aisle is a marble tablet with these arms—Party per pale or and azure, on a chief gules three leopards' heads cabossed or [Caldecot] ; impaling—Party per

chevron engrailed gules and argent, three talbots' heads, erazed counterchanged (Duncombe) :

> In memory of Gilbert Caldecot Esqr | Colonel of the Royal North Lincoln Militia | who died July 6th, 1796, | aged 86 years. | Also of Thomas Caldecot, Esq., M.D. : F.A.S. : | who died at Bath January 15th 1802, | aged 63 years. | Also of | Sarah Caldecot daughter of Gilbert Caldecot Esqr | and wife of Thomas Caldecot, | who died at Llanbedrog, Caernarvonshire, N. Wales, | January 9th 1825, aged 62 years.

This last monument is close to the vault of the Caldecot family which is under a chapel north of the chancel, and the roof of which causes the floor of this chapel to be elevated some feet above the flooring of the chancel. One stone in the north aisle has had a brass now gone.

On a marble tablet on the north side of the chancel :

> Sacred to the memory of | Mary Margaret the beloved wife of the Rev. John Hale A.M. | rector of this parish, | who departed this transitory life on the 22 Feb. A.D. 1817, | aged 36 years. | Not more as a testimony of his sincere affection and regret | than solemnly to warn the thoughtless | that in the midst of life we are in death, | and to make known to posterity a singular pattern of | blameless and endearing manners and of every domestic virtue | her afflicted husband hath caused this | monument to be erected.

N.B. Mr. Hale rector of Holton gave me the following few particulars of the Caldecots, lords of Holton, whose place is close by and now tenanted by Mr Burton. Gilbert Caldecot had only one surviving daughter, his heir, by his wife who was a Duncombe of ye present Lord Feversham's family. This daughter married contrary to her father's wish, a Dr Reid who took the name of Caldecot after Gilbert's death ; by her he had issue, and his eldest son, the present Mr Caldecot, owner of Holton, married a daughter of Mrs Hale. Mrs (Reid) Caldecott, after her husband's death, remarried, at Bath, Mr Wm Lloyd Jones who married her for her money, and to whom the present Mr Caldecot pays £200 per An. to keep him from cutting down timber at Holton.

(MS ix, 241–243.)

Holywell

Notes taken in the chapel, 16 July, 1834—This church contains no monumental memorial. It is prettily situated in the midst of trees in the park of General Reynardson and consists merely of a nave, and a tower at the west end supported on four arches. The door is of Norman character and curious. The east window is filled with pieces of old painted glass put together confusedly, and

at the top are three shields. The first bears the arms of Reynardson viz.—Or, two chevrons engrailed gules, on a canton gules a mascle argent ; crest—A tiger or leopard's head erminois, murally crowned or. The second bears Reynardson—impaling—Argent, on a chevron sable five horseshoes or ; crest—A cameleopard statant chained or [Crispe]. The third is Reynardson—impaling—Three eagles displayed in fesse or ; crest—An eagle displayed or [Wynne].

[See also *G.M.*, 1862, part ii, 739.]

(MS v, 55.)

Horbling

Notes taken in the church, [*blank*] August, 1831—The church is large and built in the form of a cross with a low tower in the centre.

On a stone tablet against the north wall of the chancel :
Near this place lyes | the bodies of | Thomas Thimbleby | and Jane his wife. | He departed this life | May 23, 1727, aged 65 | years. She departed Nov. | the 2nd, 1727, aged 57 years. | Thomas gave to the poor of | Horbling 6ˢ per annum, | Jane gave 4ˢ per an. to be | disposed of yearly on | Good Fryday for ever.

On another tablet, to the west of the last :
Sacred | to the memory of | Thomas Tomisman | who died 9th of June 1804, | aged 20 years. | Also | of Henry Tomisman | who died 20 August 1808, | aged 17 years, | and also | six other children who | died in their infancy.

On another tablet, further to the west :
To the memory of | William Tomisman | who died 1st of August 1817, | aged 84 years. | Also of | Elizabeth his wife | who died 27th March 1819, | aged 70 years.

On a stone tablet, to the west of the last :
Sacred | to the memory of | Sarah the daughter of | William & Elizabeth Tomisman | who died 6th June 1798, | aged 23 years | Also | of Mary Tomisman who | died 15 September 1799, | aged 19 years | Also | of Elizabeth Tomisman | who died 12 May 1800, | aged 23 years.

On a marble tablet against the south wall of the chancel :
Sacred to the memory of | Eliz. daughter of | Will. & Elizᵗʰ Tomisman | who died Feb. 3, 1814, | aged 2 | years.

On another to the west :
Sacred to the memory of | William Tomisman | who died Jan. 22, 1816, | aged 38 years.

On a marble monument in the north transept with the arms above

—[Argent], two lions passant guardant [sable] [for Brown];
impaling—[Argent], a saltier [azure] [Yorke]:

Here is interred y^e body of Mr Edward Brown of Hor | bling
who died y^e 27 of March 1692 in y^e 49 year of his | age. In
his life he served his country and was a benefac- | tor to this
parish, for by his last will (bearing date y^e 7th | day of Feb.
1691) he bequeathed in manner following | Then I give that
my farm in Wigtoft in the tenure of Nicholas | Davison of
the yearly rent of eleven pounds fifteen shill. | to the use
and benefit of the parish of Horbling for ever & | my will is
that the rents and profitts of the same shall be implo- | yd as
followeth that is to say that thirty shillings be yearly | paid
for the rent of some convenient house in Horbling for y^e |
dwelling house of y^e teacher & five pounds yearly to be for |
y^e quarterly [stipend] that is to say five and twenty shillings
the quarter to some | honest & sober person either a man or a
woman that shall be of y^e | Protestant reformed religion &
that is well qualified for y^e | teaching ten poor children whose
parents are at that time | or were when living inhabitants
of Horbling to read English | till they can read well in the
Bible & also for y^e catechizing | y^e said four children &
instructing them in y^e Christian Re- | ligion & I will that
twenty shillings be yearly laid out | to buy Bibles, primers,
psalters and Catechisms for y^e said poor | children & I will
that three pound ten shillings be yearly la- | yd to the putting
one poor child of the town aforesaid | Apprentice to some
handy craft trade and what shall remain of | y^e rent & profitts
of y^e said farm necessary & incident charges | thereunto
belonging be deduced shall be disposed of at y^e | discretion
of y^e trustees mentioned in y^e aforesaid will | In perpetual
memory whereof Philippa Brown | his wife [daughter of
Mr William Yorke of Leesingham] | at her charge placed
this monument.

On another handsome marble monument against the north wall, with
these arms—Argent, two lions passant guardant sable [Brown]:

Erected | to the memory of | Edward Brown, Esq., | who
departed this life March the | 18, 1731, in the 85 year | of
his age, | a person excellent both in his publick & | domestic
character, of steady loyalty, | sincere Religion, a lover of
virtue without | ostentation, of great humanity probity & |
beneficence much esteemed for his affability | and charitable
disposition. | He gave the sum of two hundred pound to |
procure the bounty of Queen Anne for a | perpetual augmenta-
tion of the vicarage of | this church together with divers
pieces of | fair & costly plate for the holy communion, | and
left by his will the sum of twenty pound | to be employed
in the most proper manner for | the sole use & benefit of the

poor of Horbling. | These donations are exposed in this publick manner | not for ostentation but for imitation.

On a marble monument with the arms of Brown under :
Near | this place lyes the remains of | Elizabeth Brown spinster | daughter of Thomas Brown gent. | & Anne his wife. | She was by nature endued with a clear understanding | conspicuous to all who [lived] with her & chiefly | exercised in the good act of reconciling contending | parties by the principles of vertue with charity & | humanity which were constantly employed in the pious | ends of consolation to the afflicted | & liberality to the | distressed. She was singularly happy in the choice of her | acquaintance with whom a friendship once contracted was ever | after sincere & inviolable strictly observing the duty & | affection due to her parents. | Actuated by these principles after a long & painful | affliction endured with the greatest temper & resignation | she dyed possessed of the love & esteem of all who | [knew] her Sept. yᵉ 2nd, 1737, aged 21. | Quicquid amas cupias non placuisse nimis. | Also of Mary | another of their daughters who | dyed May the 5th, 1751, | aged 37. | Also of the above named father who dyed Jan. yᵉ 3rd, | 1759, in the 73 year of his age.

On another stone tablet, in the transept :
Hic jacet | Jana uxor Edwardi Brown gen. | Filia Thomæ Bristowe de Beesthorpe | Armig : | Mater tredecim liberorum | Obiit undecimo die Septembris [1699] | ætat. 48 | non sine lachrymis.

Above this is a hatchment with the arms of Browne ; impaling— Ermine, on a fess, cotised sable, three crescents or [Bristowe] (D).

On a neat marble tablet against the wall of the south aisle :
Sacred to the memory of | Harriet the wife of | Benjamin Smith | of this parish | who died August 15, 1808, | in the 23ʳᵈ year of her age. | The Lord gave & the Lord hath taken away | Blessed be the name of the Lord.

On a flat stone in the nave with the arms cut above, three shuttles Crest—A hand [Shuttleworth] (D) :
Here lyeth the body of | Thomas Shuttleworth | of Brigend, Esq., who dyed | 1st of May 1695, aged 59.

In the north transept is a fragment of moulding with these arms on a shield in the centre—Quarterly, 1st, A fesse indented . . , between six billets . . . [de la Laund] ; 2nd, . . . a lion salient double queued ; 3rd, On a fesse . . . between six gauntlets three crosses botony fitche [Wyke] ; 4th, . . a cross between six falcons [Tey] ; supported by a man and woman kneeling.

[See also *L.R.S.* i, 192 ; Peet, *Registers of the Parish of Horbling*, xxi–xxv.] (MS i, 71–79.)

Howell

Notes taken in the church, August 11, 1834—This church consists of a nave and north aisle, divided by two round Norman arches resting on plain columns, a chancel, and north chapel, with a bell niche and gable double at the west end. The font is octagonal, with shields in quatrefoyls, the bearings that remain are :

(1) [Or], a bend [azure] between six martlets [sable—Luttrell].
(2) . . . a plain cross.
(3) Ermine five fusills in fesse gules [Hebden]; impaling—Gules, a bend ermine [Rye].
(4) Ermine five fusills in fesse [Hebden].
(5) . . . , a chevron . . . between three chaplets.
(6), (7), and (8) are effaced.

On the step leading to the altar are these words plainly to be perceived, ' Hic Deum adora '.

In a wall south of the altar are two square recesses going far back.

In the chapel north of the chancel, under a low arch in the north wall, is a stone with the half figure of a female, executed in the sunken style, in a wimple, with her hands clasped ; a little lower on the stone is a similar figure of a smaller size, appearing to represent an infant, but on opening the tomb some ten years back the remains of two skeletons of equal size were found lying back to back.

Opposite to this is a mural monument of marble, much dilapidated, flanked by two Corinthian pillars, having the figures of a knight in half armour kneeling before a desk, with his lady opposite in a black plaited robe, veil, and ruff. The arms are effaced, and below the figures is this inscription in capitals in two columns :

(1) Here lieth Sir Charles Dymoke of Howell, knight, | second son to Sr Edward Dymoke of Scrielsby, | knight, Champion to ye Crowne of England, wch Sr | Charles married Margaret widow to Mr Anthon : | Butler of Coates, esq., who also here lieth, | by whom first shee had five sonnes viz. | Charles, Willm, Anthony, John, & Henry, & one | daughter Katherine, wife to Sr John Langton, | knight, & by Sr Charles had one dau'r | Bridget who died in | her infancy.

(2) To whose memory | in grateful testimony of his love & | reverent respect Sr Edward Dymok, | knight, nephew to ye sayd Sir Charles | hath made & erected | this monument.

There is no date nor do I see any place for one.

An old flat stone at the west end of the nave with this inscription round :

Hic iacet Ricardus Boteler de Howell qui obiit 2º die mens'

Augusti a*nn*o d*om*i*ni* MCCCCLVII et Matilda uxor eius que obiit VI die Januarii anno supradicto quorum a*nim*abus p*ro*picietur Deus.

Another stone in the chancel has this inscription round :
[Nicholaus de] Hebden miles qui mensis Aprilis aº d'ni MCCCCXVI cuius a*nim*e p*ro*piciet' Deus [*blank*] Katerina [*blank*] mensis Novembr' aº d'ni MCCCCXXVII.

To the north of the last is another stone, but the inscription is effaced, and still more to the north is another stone which has on it, still legible, ' obiit XV die ' ; the rest is effaced.

Another further to the north is quite illegible.

A stone within the altar rails bears the figure of a priest in his canonicals cut on it ; with this inscription round :
Hic iacet magister Joh'nes Croxby quondam rector istius ec*clesi*e qui obiit die mensis aº d'ni MCCCC . . . cui*us* a*nim*e p*ro*picietur Deus.

On a flat stone in the chancel in capitals :
Here lyeth | yᵉ body of Joseph | son of yᵉ Reverend | Mʳ Joseph Greenhill | & Catharine his | wife, he depᵈ this | life Jan. yᵉ 12, | 1719.

In the possession of Edmund Brookes, esq., of Howell, is a fragment of painted glass which was dug up near his house ; it bears two swords and two griffins' heads or. It is understood that they have no old register or records, they being taken away by the Dymoke family, as it is reported, about half a century ago.

[See also *L.R.S.* i, 187–9 ; Trollope, *Sleaford*, pp. 409–11.]
(MS v, 101–105.)

Ingoldsby

Notes taken in the church, 30 July, 1833—

On a flat stone in the nave (R) :
Here lies the body | of Mr Fortunatus Hew- | et son of John Hewet, | gent., and Eliz. his wife | who died May the 21, 1701, ætat. 66.

The font is octagonal, with a shield on each side ; but they are all plain except on the east, where is a chevron charged with three crosses botony.

Flat stone in the nave (R) :
Here lieth the | body of pious Mrs | Mary Paget who | was exalted to the | Great God and | Our Saviour Jesus | Christ on the day | of his Ascension | May 6th, 1725.

This church consists of a nave and two aisles, separated on the north by three Norman arches with round columns, on which are

foliated capitals, and south by three pointed arches, a chancel, and a tower at the west end. Painted glass in the east window of the south aisle, and arms—Argent, a chief dancee azure [Nevile]. Argent, three cinquefoils azure. Very old north and south doors and old pewing.

[See also *L.R.S.* i, 204.]

(MS ii, 241–242.)

Irnham

Notes taken in the church, 26 July, 1833—

On a white marble monument against the south wall of the north chapel with arms under, nearly effaced impaling —A bend between two escallops or [for Petre] :

> Infra | jacent corpora Johannis Thimelby Armig^{ri} | (cujus progenitor Richardus Thimelby de Pollam | duxit filiam et hæredem Godfridi Hilton militis | cujus mater erat filia et hæres Andreæ Luttrell mil. | et per hoc connubium diversa maneria et hanc totam | parochiam de Irnham sibi et successoribus suis per | multas generationes in directo descensa unde ortus | acquisivit) Ac etiam Dorotheæ uxoris ejus filiæ | Illustrissimi Domini Domini Roberti Petre | Baronis de Writtle | propter beneficentiam eximiam charitatem | aliasque Christianas virtutes ambo | admodum insignes | Qui quidem Johannes obiit vicesimo quinto | Junii anno MDCCXII | ætatis suæ septuagesimo octavo Dicta autem | Dorothea ex hac vita migravit nono Decembris | Anno MDCCXX ætatis suæ | octogesimo sexto | quibus propitietur Deus. | Nati sunt eis duo filii ambo in infantia surrepti | et una filia Maria nunc vidua Thomæ Gifford de | Chillington in agro Staffordiensi armigeri | quæ in memoriam charissimorum | parentum hoc posuit.

On a black stone in the floor under the above monument :

> ✠ The Hon. Dorothy Thimelby | daughter to the Rt Hon^{ble} Robert | Lord Petre dyed the 9 of Dec^{r} | 1720, aged 86 years, and | is here interred. | Requiescat in pace.

On a similar black stone next to the last :

> ✠ John Thymelby, Esq., | the last heire male of his | ancient family died 25 | of June 1712, aged 78 years, | and is here interred. | Requiescat in pace.

On a white marble oval monument against the north wall of the chapel with these arms under—Per fesse argent and gules, a lion rampant per fesse sable and argent [Percy] :

> Juxta sepelitur corpus | Gulielmi Percy ex antiqua | familia apud Stubs Walden | In agro Eboracensi obiit 18º | Junii Anno Domini MDCCXIX | ætatis 59º | Cui propitietur Deus |

In memoriam charissimi patris sui | hoc posuit | Unica ejus filia | Elizabetha Percy.

On a stone under the above monument :
Here | lyeth the body | of William Percy, gent., | who dyed June yᵉ 18, | 1719.

On a stone also in the pavement of the north chapel :
✠ To the memory of | the Reverend | Mr Henry Brent | many years chaplain | to Lord and Lady | Arundell | who departed this life | the 9 day of January 1787, | aged 70. | Requiescat in pace.

In the centre of the pavement is the brass of a knight under a canopy, with his feet on a lion, and this inscription in old character :
Hic jacet Andreas Loutrell miles dominus de Irnham qui obiit vi^to die Septembr' a° domini millesimo ccc° nonagesimo cuius anime propicietur Deus.

In the north aisle on a flat stone :
✠ To the memory of | the Reverend | Thomas Walton chaplain | to Lord and Lady | Arundell | at Irnham | who departed this life | on the 14 day of May 1797, | aged 60 years. | Requiescat in pace.

On a flat stone in the middle of the nave :
Be it remembered | that the tomb stone | which was over the | remains here | interred of | Sʳ Andrew Lutterell | knight | Lord of Irnham | who departed this | life in the year of | our Lord 1394 [sic], was | in 1788 removed into | the family chapell | in this church.

There is in the chancel the brass of a knight, but the lower part of the legs with the inscription are gone.

On the floor of the chancel :
✠ Her lyeth the body of | Edward Ignatius | Newton, esq., | who departed this life | the thirty first of January | 1795, | ætat. suæ 42.

A very handsome canopied tomb (R) still remains on the north side of the chancel. There are three ogee arches crocketted above, and adorned with pinnacles between. The fretwork is very beautiful, and in tolerable preservation. No figure or inscription.

An atchievement (D) against the south wall of the chapel— Quarterly, argent and sable, a label gules for difference [Conquest] ; impaling—Azure, on a chief or, a demi lion gules, with a border argent [Markham]. Crest—apparently a tree but torn.

In the chapel north of the chancel, against the south wall, is a handsome monument of yellow and white marble ; at the top a

medallion in basso relievo of Faith, Hope, and Charity, this inscription below in capitals :

Benedict Conquest of Irnham | in the county of Lincoln, Esq., | ob : the 27 of October 1753 æt. 45. | And Mary his wife daughter of | Thomas Markham of Ollerton | in the county of Nottingham, Esq., | ob. the 2ᵈ of February 1745, æt. 38.

Upon another white slab below also in capitals :

Stop and attentive view this scene of death | Another lies this hallowed earth beneath | Happy in virtue calm resigned serene | Tho' doomed by sickness to a life of pain | A father lies whom rich whom poor approved | In death lamented as in life beloved | Five children once to bless their lives were given | Two rapt in infant innocence to Heaven | Two more Thus God resumed the gifts he gave | Met just in opening youth an early grave | One only one remains with weeping eye | The spot to point out where their relics lie | Christina pays this duty to their fame | And marks the marble with a parents name | Hail shades for ever honoured lov'd & mourn'd | Tho' what was dust be now to dust returned | All is not dead, gone is the vital breath | But virtue lies immortal e'en in death | Blest are those hearts which felt the poor mans woe | Those eyes whence charity taught tears to flow | And tongues which once could misery beguile | Make orphans happy and the widow smile | Rest here, cries hope, in mercy rest secure | Parents of Arundell and of the poor.

On a white marble monument against the south wall of the chapel above is a woman weeping over an urn :

✠ | D. O. M. | Near this place | are deposited the remains | of the honourable | Maria Christina Arundell | eldest daughter and coheir of | Henry Lord Arundell, 8th Baron of Wardour | and Count of the Sacred Roman Empire, | by Maria Christina only daughter and heir | of Benedict Conquest, Esq., of Irnham Hall | in this county. | She married February 3rd, 1785, James Everard | eldest son of the honourable Everard Arundell | by Ann only daughter and heir of John Windham, Esq., | of Ashcombe in the county of Wilts. | After a long and painful illness | she closed a life of charity benevolence and virtue | by a pious death February 14, 1805, | aged 40 years. | She hath opened her hand to the needy | And stretched out her hand to the poor. | The woman that feareth the Lord | She shall be praised. Proverbs chap. 31. | Requiescat in pace. | Henry Lord Arundell dying Dec. 4, 1809, | was succeeded in his titles | by James Everard Arundell, Esq., | now ninth Lord Arundell of Wardour | who erects this monument | to the memory of | his deceased Maria.

On a neat marble tablet below :

M. Eliz : Blanch Arundell | Nata Aug. 6, 1800. | Obiit July 7

1802. | Ascend my child obey the Almighty's will | Console my heart and be my Angell still.

On a large blue flat stone in the floor :

⹋ To the memory of | Mary Conquest sole wife of | Benedict Conquest of Irnham in | the county of Lincoln and of Hough-ton | Conquest in the county of Bedford, | esq., and daughter of Thomas Markham | of Ollerton in the county of | Notting-ham and of Claxby in the | county of Lincoln, esq., who departed | this life the 2ᵈ of Febʸ 1745, | æt. 38. | Requiescat in pace. | Who can find a virtuous woman for her | price is far above rubies. Prov. 31.

In this chapel also are deposited the | remains of Benedict Conquest aged | 2 months and 8 days buried Sep. 11th, 1739, | and Mary Conquest aged 4 months 2 | weeks and 6 days buried Jan. 10, 1736, | son and daughter of | Benedict Conquest, Esq., | and Mary his wife.

A collateral one to the north :

⹋ To the memory of | Benedict Conquest of Irnham | in the county of Lincoln and late | of Houghton Conquest in the | county of Bedford, esq., who | departed this life the 27 of October 1753, | ætat. 45. | Blessed is the man who thinks on | the needy and poor in the evil day | The Lord will deliver him He hath | distributed he hath given to the poor | and his memory is benediction. | Ps. 40 and 111 and Eccl. 45. | In this chapel also are deposited | the remains of John Thymelby | Conquest, esq., younger brother of | the said Benedict Conquest, esq., | who was buried Oct. 26, 1736, ætat. 20. | Requiescat in pace.

On a flat stone in the chancel in capitals :

Sam. Breton, Esq., Lieut- | tenᵗ of her Majesty's ho | rse Guards, Adjutant | in yᵉ Netherlands after | his Travels into Turkey, | aged 62, Dec. 1708.

On another to the east much rubbed :

Lucy Breton wife of | [John] Breton rectʳ sis- | ter to Mathew John- | son, esq., clerk of the | Parliament, departed | Oct. 9, Anno Dom. 1706. Take | yᵉ heed Watch and pray | lest yᵉ know not the | time.

A hatchment (D) over the door to the north chapel : On a sable eagle double-tete a shield—Quarterly, 1st and 4th, Sable, six martlets argent [Arundell] ; 2nd and 3rd, Azure, a chevron between three lions' heads erazed or [Wyndham] ; impaling—Quarterly, 1st and 4th, Arundell ; 2nd and 3rd, Quarterly, argent and sable, differenced by a label argent [Conquest]. On another—Arundell ; an escocheon—Quarterly, 1st and 6th, Quarterly, argent and sable [Conquest] ; 2nd, Azure, a bend between six martlets or [Luttrell] ;

3rd, Argent, three palets sable, in bend four mullets of the last [Thimbleby]; 4th, Argent, a lion rampant gules; 5th, Argent, a chevron sable between three boars' heads couped sable [Swinford].

This church consists of a nave and north aisle supported by three arches pointed; a chancel and north chapel, also separated by three pointed arches, the easternmost one blocked up; an old Norman arch from nave to tower; a great deal of ancient pewing, on one the date 1618 E.C. This is on the south side of the chancel.

[See also Jeans, 36–7.]

(MS ii, 181–194.)

East Keal

Notes taken in the church, 14 August, 1834—
On a black stone in the north aisle:
> Here lyeth the body of | Hellen the wife of Peter | Short, Esq., and daughter | of John Bishop late of | Stickford, Esq., who died | the seuenth day of January | 1702(?) | in the thirty ninth yeare | of her age.

On a stone close by:
> Heer lyeth interred the | body of Peter Short cittisen | and merchant taylor of | London, lord of this man- | ner, who departed this | life the tenth of August | in the five and fiftieth | yeare of his age, 1681.

On another stone in the pew to the east of the last (C):
> Here lieth the body | of John the son of | Peter Short, Esq., | who died the 18 day | of April 1707, in the | fifteenth year | of his age.

On an old stone (D) in the nave has been an inscription in church text, round the verge, what remains are at the two extremities:
> humant^r lapide corpora obiit . . . die decem. A° d'ni MCC

A fragment of a stone to the north of the last has this only (D):
> Hic jacet Robertus Tom . . .

A stone monument against the east wall of the south aisle, the sitting figure of a woman in gown and collar, about half the size of life, a cord is round her waist, she holds an inverted torch in her right hand and her left elbow rests on a skull. On each side is a fluted pillar and on the pediment above the following line on the cornice, ' Mat.—Non est mortua sed dormit 9: 24.' Underneath is an inscription of five lines, but now so defaced as to be generally illegible; it is in capitals; what can be decyphered is as follows:
> Svsanna · Kirkhan · being · wife · to d |
> this · monvment · erected | . . . had
> . | ea . . . de
> | . . . the 2, IV

In the chancel is a stone (D) from whence a brass plate of a figure and inscription has been taken.

On a flat stone in the south aisle (D) :
> Here lieth interr'd the body of | John Hastings, gent, who departed | this life March ye 27, 1721, aged | 73 years. | Here also lieth ye body of Brigett | ye wife of John Hastings, gent., | who departed this life | February ye 18, 1684, aged 30 years.

On a flat blue stone close by :
> Here lyeth the body of | Robert Hastings, gent., | buried December the 20th, | Anno Dom. 1730, | aged 47.

This church consists of a nave divided from its two aisles by four pointed arches springing from clustered columns, a chancel separated by a screen, and tower at the west end, pinnacled. The arch leading from the tower to the church is blocked up at the bottom. Over the screen are the Royal Arms &c. with the name of Cha. Kirkham and Robt Hastings, churchwardens, 1757. The font is octagon supported on a pillar, surmounted with grotesque heads, and pannelled with roses and a lozengy ornament alternately. It stands on a basement of two steps. In the tower are five bells. A little old pewing in ye church (D).

[See also *Lincs. N. & Q.* xi, 87–8.]

(MS viii, 79–82.)

Kelstern

Notes taken in the church, August 14, 1833—This church consists of a nave and chancel, and tower at ye west end of the nave, but small, a north porch, and some old pewing and benches.

Against the north wall of the chancel within the altar rails is a fine monument of marble (R) in a recess flanked by two pink veined marble pyramids or obelisks, the figure of a lady in the costume of the Elizabethan age, sitting with her left foot on a skull, and her left hand, which holds an hour glass, resting on a table, at her feet is an infant in a coffin. On one side over the recess is a representation of the setting sun, *Occidit ut oriatur* inscribed below. On the other a clock, and below *Qualibet expectes tamen.* At the top are two winged boys holding spades, under the one on the west *Nil sine labore*, and on the east *In alto requies.* Over the figure this inscription on a black slab in capitals :
> Franciscus South eques auratus dilectissimæ | suæ conjugi Elizabethæ South hoc mo | numentum amoris testimonii ergo | posuit | Quæ potui lachrymans persolvi funera conjux | Quæque lubens volvi non dare dona dedi | Dona dedi queis (si fuerint pia numina votis | Concessura meis) tecum ego spero

frui | Interea pro te mihi fas sit amare relictas | [Filiolas casti pignora bina tori] Quotque mihi et natis quot charo tristia Patri | Liquisti totidem det tibi læta Deus.

At the base of the monument on a black slab is this inscription in capitals:

Heere lyeth Dame Elizabeth South eldest | daughter to Sr John Meeres of Auborne, | knight, by Barbara his firste wife, dau- | ghter to William Dalyson, esq., one | of ye justices of ye kinges Bench & late | wife to Sr Frauncis South of Kelsterne, | knight, to whom shee bore 4 daughters, | Joane, Elizabeth departed, Barbara, & | Frauncis survivinge, she dyed ye 7 day of June Anno Do' 1604.

Opposite the last monument on the south wall is one (R) of white and variously coloured marbles, with these arms over—Argent, two bars gules, in chief a mullet or, a crescent for difference [South]; impaling—Argent, fretty sable, on a canton gules a cinquefoil or [Irby]. On the east side is a shield of the arms of South, and on the west that of Irby. At the base is a winged skull, and above it is written ' Volentes ducit nolentes trahit '. The inscription is in capitals:

Memoriæ sacrum. | Heere lieth buried in the vaulte | the bodie of Dame Anne South, | seconde wife of Sir Frauncis South | of Kelsterne in the countie of | Lincolne, knighte, and seconde | daughter to Anthonie Irbye of | Whaplad in Hollande in the said | countie, esquire, and Alice his | wife. She had issue by hir saide | husbande six sonnes vizt. John, | Frauncis, Anthonie, Thomas, Charles, | and Henrie, and fyve daughters | vizt Alice, Elizabeth, Anne, Jane, | and Elizabeth. She lived ver | tuouslie and dyed in sounde | faithe and in the feare of | God the XIIth day of May in ye | yeare of or Lord God 1620.

On a flat stone in the chancel (R):

Here lyeth the body | of Christopher Hildyard | of this town, esquire, | who departed this life | August the 28th in the | year of our Lord 1719, | aged 51 years. | Here | also lieth the body of | Christr Hildyard, Esqr | (son of the above saide | Christr Hildyarde) who departed this life | June the 17, 1749, | in the 36th year | of his age.

In the nave are flat stones (D) to the memory of:

Mr John Redman died June 15, 1748, aged 85.
Elizabeth his wife died July 5, 1741, aged 70.
William their son died March 30, 1742, aged 38.

[See also *Lincs. N. & Q.* xi, 230–2.]

(MS iv, 143–147.)

Kettlethorpe

Notes taken in the church, 15 September, 1835—This church has been modernised, and consists of a nave and chancel divided by a large pointed arch, and a tower at the west end. The font is modern. Against the east wall is a beautiful bracket supported by an angel who bears a shield—Quarterly, France (modern) and England. On the bracket is a small modern figure (R) of Justice in alabaster.

A plain stone tablet (R) against the east wall of the chancel in old characters :

> Juxta hunc locum iacet Joh'es | Becke artium magister quon | dam Rector istius ecclesiæ qui | vero e vita excessit xviijto die | mensis Maii anno dom. 1597. | I am a becke or river as you know | And watered here ye church ye schole ye Pore | While God did make my springes here for to flo | But now my fountaine stopt it runs no more | From churche and schole mi life is now berefte | But to ye poore foure pounds I yearlye lefte.

A grey tablet with a white urn of marble against the south wall :

> This monument | is erected as a tribute of respect | to the memory of an indulgent husband | and affectionate parent | the Revd Hugh Palmer | who died 6th of December 1799. | He had been rector of Kettlethorpe | for twenty years in which parish | he lived beloved and died regretted | by all who knew him.

On the ledge of the east window are three urns (D) of alabaster, with these inscriptions (R) :

> Thomas Hall Armr | obiit Nov. 12 1698 | Elizabetha uxor eius | Jan. 3, 1677.
> Carolus Hall Armigr | obiit Decbris 1 1669 | Anna uxor eius | Jun. 18 1660.
> Carolus Hall Armr | obiit Decbris 17 | Anno Christi 1700.

A white and brown marble monument against the north wall of the chancel with an oval of white marble, surmounted by an urn on which are these arms— , a chevron engrailed between three lions' heads, erased [Hall]. The inscription in capitals :

> Sacred to | the memory of | Charles Hall, esqr, | only son of Thomas Hall of Kettlethorpe, | esq., by Amy eldest daughter & coheiress of | Henry Mildmay of Graces in the county of | Essex, esq., & | relict of Vincent Amcotts of | Harrington in the County of Lincoln, esq. | He died | the 21 day of August in the year of our Lord 1743, | aged 53 years. | Let those who had the happiness of his friendship, | in justice to his memory | speak of | his many amiable & social virtues, | but let this marble | eternally declare | his invariable adherence

to the | laws and constitution of England. | Also to the memory
of | Sarah Hall, | only daughter of the said Thomas | by his
first wife Elizabeth, | daughter of Sir Robert Abdy of Albins |
in the county of Essex, bart. | She died Dec. 8, 1707, | aged
30 years.

A blue flat stone in the chancel in capitals :
Here lyeth the body of Thomas | Hall son of Charles Hall
of | Kettlethorp in the county of | Lincoln, esqʳ, who departed |
this life the 12 day of Novemb- | er Anno Dom. 1698. | He
had to his first wife Eliza- | beth daughter to Sir Robert |
Abdy of Albins in the county | of Essex, barrᵗ., by whom
he | left one daughter, viz. Sarah. | His second wife was Amy
the | eldest daughter of Henry | Mildmay of Graces in Little |
Baddow in the county of Essex, | esq., by his first wife Cecilia |
one of the daughters and coheirs | of Walter Barker of
Haughmond | in the county of Salop, esq., by | whom he
had one son, | vizᵗ. Charles.

Another stone to the south of the last (D) :
Here lieth | the body of Darwin Stow | of Fenton, gent., &
Mary | his wife, the daughter of | George Nevile of Thorney,
Esq., | by whom he had issue | seven sons & five daughters. |
He died in the sixty second | year of his age on yᵉ | sixteenth
day of April | Anno Dom. 1724, | & his wife in the fifty fifth |
year of her age | upon yᵉ 23ᵈ day of March | Anno Dom. 1719.

On another more to the south in capitals (D) :
Here lieth | the body of | Charles second | son of Charles |
Hall of Kettle | thorp, esq., who | departed this | life [blank] |
of Septe | mber Anno Dom. | 1700, aged 48.

An old stone much defaced, further to the north (D) :
Hic jacet Elizabetha | (? honorata) Gulielmi | Meekly generosi
uxor | quæ obiit undecimo die | Junii Anno Dom. 1605,
unam | filiam tresque filios illi | peperit et fluxit.

On a stone to the north :
In the vault beneath | lieth the remains of the | Revᵈ Thomas
Craster | who died March the 27, 1806, | aged 62 years.

Under the font (which is in the centre of the chancel) is a blue
stone, but all uncovered by it is : Frances Quincey died July the
4ᵗʰ, 1771.

On another stone (D) :
In the vault beneath | lie the remains | of | The Revᵈ Hugh
Palmer | who died 6 December 1799, | aged 66 years. | Hugh
Palmer | died 11 November 1805, | aged 33 years. | And |
Mary Accadia Palmer | died August the 15, 1815, | aged
49 years. | And also | Mary Palmer | relict of the above | Revᵈ
Hugh Palmer | died October the 20, 1819, | aged 82 years.

On a blue flat stone more to the west :

Here lyeth the body of | Charles Hall only son | of Thomas Hall of Kettlethorpe | in the county of Lincoln, esq., | by Amy eldest daughter of Henry Mildmay | arm. and relict of Vincent Amcotts | of Harrington, esq. He departed this | life the 21 of August Anno Dom. 1743, | aged 53 years.

On another stone further west :

Here lyeth the body of | Mrs Sarah Hall daughter of | Tho. Hall of Kettlethorp | in yᵉ county of Lincoln, | esq., by Elizabeth his wife | daughter of Sir Rob. Abdy | of Albins in Essex, bart. | She was born yᵉ 21st of | Decʳ A'no Dom. 1677, & | dyed yᵉ 8 of Decʳ 1707, | in yᵉ 30 year of her | age.

A white stone much rubbed, to the west of the last (D) :

Here lyeth the body of Mr Gervas Cole who departed | this life September [11] | in the year of our Lord [1747] | aged fifty three.

On another stone, in two compartments, rubbed (D) :

(1) Here lieth | the body of | Mr Robert | Cole of Fenton | who departed | this life | November yᵉ | 7, in yᵉ year | 1720, aged 39 (?). | Here lieth the | body of Mr John | Cole of Fenton | who departed | this life | November the | 29, in the year | 1703, aged 68.

(2) Here lieth | the body of | Mrs Ellen Cole | of Fenton | by her lost | son. She | departed this | life January | , 1713, | in yᵉ . . . year of | . . . age.

On a stone to the west (D) :

Here | lies the body of | Gervas Cole, gent., who | departed this life May 6, | 1792, aged 29 years.

A black stone more to the west :

In this vault lie | the remains of | Timothy Pymm, gentle-man, | late of Nottingham, | who departed this life at Fenton | October the 5th, 1783, | in the 81 year of his age. | Also | in this vault lies | deposited the remains of | Mr Thomas Huck | late of Fenton | who departed this life | January 20, 1786, | aged 43 years.

A black tablet against the north wall :

Near | this place was interred the body | of Gervas Cole, gent., who departed | this life May the 6th, 1792, aged 29 years. | Also Mary Cole relict of the above | who died June 3ᵈ, 1822, | aged 67 years.

A black tablet next to the last :

Near to this place are interred | the body of Gervas Cole who died Sep. | 11, 1747, aged 53 years. Also Elizabeth Cole | wife of Gervas Cole died Janʸ 15, | 1777, aged 75. Also

Gervas Cole | son of the said Gervas & Eliz. Cole. | He died
Nov. 28, 1771, aged 41 years. | Also Eliz. wife of Gervas
Cole died | June 14, 1796, aged 77 years.

A flat stone outside the west door (D) :
Here lies | interr'd the body of Amy Hall | daughter of
Charles Hall | rector of Kettlethorpe. | She departed this
life May the | twentieth, Anno Domini one | thousand seven
hundred and | twenty three, in the twenty | seventh year
of her age. | Take heed watch & pray for yᵉ know not (the
rest broken).

(MS vii, 153–165.)

Kirkby Laythorpe

Notes taken in the church, 16 August, 1836—This church consists
of a nave and north aisle, resting on four Early English arches,
which spring from plain round columns, a chancel divided from
the nave by a small screen, a tower at the west end. The font is
octagonal, of a pattern similar to that at Evedon, but the bearings
of the shields are defaced. In the east window of the north aisle
is the following coat of arms—Azure, a chevron between three
trefoyles, slipped or [Sleaford]. In one of the nave windows are
some slight remains of painted glass. A few of the steps to the
rood loft yet remain, and some ancient benching. The arches
lean excessively northwards, and are supported by props.

A brass plate in the window sill south of the chancel in capitals :
Here lyeth yᵉ body of yᵉ learned & pious | Tho : Meriton,
B : D :, late rector of this | church, & Asgarby. & prebend of
yᵉ church | of Lincoln | donor of a charitable bequest to
yᵉ poore | of each parish, also yᵗ of his birth for ever. | He
married Elizabeth Pearks of a good family | in Worcestershire,
by whom he had | one only son who, dying in his infancy, |
was here also interd July yᵉ XI, MDCLXXXIIII. | He lived
belov'd & reverenc'd for his great learning | and exemplary
vertue ; & dyed yᵉ XIIᵗʰ of Janʸ An'o Domini | MDCLXXXV, in
yᵉ XXXXVIIIJ yeare of his age, much la- | mented, especially
by his deare & loving wife, who | cavs'd this inscription in
memory of him.

Another on the opposite side of the window :
Resurgemus. | depositum Mariæ | conjugis chariss. Jacobi |
Adamson de Sleaford | filiæ Roberti Garland | hujus eccl'ie
nuper rectoris | obiit VII Augvsti | MDCLVII.

A plain black tablet on the east wall south of the altar (R) :
In memory | of Gascoigne son of the | Revᵈ Mr Gascoigne
Wright | and Penelope his wife | who died July 31st, 1767, |
aged 22.

Under the altar is a large stone which has had on it two half length figures, an inscription and shield in brass, all now gone.

A flat stone in the north aisle :

> Here lyeth y^e body of | Robert son of Robert | and Dorothy Sanderson, their | third son, who deceased | Feb. y^e 13, 1722.

Another to the east of the last :

> Here | lyeth the body of | Faith Sanderson the | wife of Robert San | derson who departed | this life Janu. the 19, | 1704.

At the west end of the north aisle a flat stone, with the following inscription round the edge, much rubbed :

> Here lyeth the | body of Master Thomas Pylate who | departed this | life March y^e 14 (the rest effaced).

Another flat stone, more to the east, in capitals, rubbed :

> Here lyeth y^e body | of Mr John C it | who departed this life | March y^e . . , 1688.

On a flat stone by the south door is this inscription in capitals round the edge :

> Here lyeth the body of Christian late wife of Mr Georg Sanderson who departed this life Decem. y^e 11, 1681.

There is another stone on the step of the door, but it is too much defaced to be decyphered.

Another flat stone in the north aisle :

> Here lyeth y^e body of | Robert y^e son of Robert & | Dorothy Sanderson | who deceased [December 12] | 1720.

[See also *L.R.S.* i, 212 ; Trollope, *Sleaford*, pp. 417–18.]

(MS vii, 231–235.)

Kirkby Underwood

Notes taken in the church, 29 July, 1833—

On a wooden tablet against the north wall :

> Whereas some well disposed person did formerly give | to the parish of Kirkby Underwood the sum of £32 | to remain a town stock for ever, the interest thereof | to be distributed by the discretion of the overseer to | the poor of this parish 20 shillings, part of the said | interest to be given on Xmas day yearly and 12 shillings | the residue on Easter day. This inscription was in | the year of our Lord MDCCLV made and in this | church affixed for the better establishing and per- petuating | the said charity. The Rev^d John Jones, LL.B. rector | Rev^d Charles Hyett A.M. curate &c. | Generous benefactor that did this gift bestow | Altho' forgot nor we thy name do know | Yet in those happy realms above thou'rt known & blest | In the peaceful mansions of eternal rest.

The church is small and poor. It consists of a chancel, rebuilt in 1826, a nave and south aisle, supported by three pointed arches with clustered columns. There appears to have been once a north aisle from an arch which is left built up in the north wall. A tower at the west end with a pinnacle at each angle. Font, octagon. Many old benches in the church. It contains no monumental memorial whatever.

(MS ii, 229-230.)

Kirton in Holland

Notes taken in the church of Kirton, 4 August, 1834—This is a very beautiful church. It consists of a nave divided from its aisles by six lofty pointed arches and pillars, a chancel, and tower at the west end, with a south porch. It has once been larger, having two transepts and the tower at the intersection, but in 1820 they were pulled down, and the tower rebuilt at the west end. The font is octagon, handsome, pannelled with shields in niches, having this inscription on the basement stone in the old character :

> Orate pro anima Alani Burton qui hanc fontem fieri fecit A.D. MCCCCV.

The altar piece is a painting of the Adoration of the Magi, but is by no means excellent. On a pew in the nave on the south side are these arms— , a bend of three mascles . . . ; crest—A demy swan [? Browne].

A grey and white marble pyramidal monument against the wall north of the chancel, surmounted by an urn, with this inscription in capitals :

> Near this place | are deposited the remains | of William Watson gent. | who departed this life | February 1, 1805, | in the 73 year | of his age. | Also of Mrs Mary Watson | the relict | of William Watson gent. | with whom she lived | in the happiest union | forty nine years | and having for a short time | survived him | she passed from | this vale of mortality | December 14, 1805, | aged 70 yeares.

A stone tablet to the west with an inscription on a black marble slab :

> Near this place | are deposited the remains | of Jane wife of | Edw. Watson gent. | She departed this life | on the 27 day of May | A.D. 1806 | Ann. Ætat. 34.

A white marble tablet against the south wall of the chancel with these arms below—Azure, a chevron between three escallops, within a bordure all or [Colby] :

> Near this place lyeth | Dixon Colby M.D., | obt 21 Nov. 1756 | ætat. suæ 77, | and likewise | Elizabeth his wife | obt 21 Oct. 1739 | ætat. suæ 59.

A blue flat stone in the floor partly hid by a pew, the inscription in capitals :

> Samuel Bridg son of Step . . . | Bridg departed this life . . | Aprill yᵉ 30 and was | interred May the 2ᵈ da . . | Anno d'ni 1657. | My uncles name I have | and do enjoy his grave | betwixt my parents dear | My Bones are lodged here.

A large stone more to the west, with this inscription in italics :

> M.S. | Pickering Colby, gent., | et Mariæ uxoris suæ. | Vir qui non Annis vel literis | sed pietate et integritate morum | vitam suam honestavit | et patriam.
>
> Obiit ille v die | Oct. A.D. | Obiit illa xxix | die Martis
> MDCLXXXII. A.D. | MDCXCV.
>
> Juxta situ est | Anna Dixon Mariæ Colby mater | ex Harringtoniana stirpe | prognata | ab hac vita discessit | xxii die Octobris | A.D. MDCC. | H.S.E. | Dixon Colby, | Dixon Colby M.D. Stamfordiensis | filius unicus | Pickering Colby nepos | adolescentiam suam in nequissimo seculo | summa verecundia et probitate | adornavit | inter Oxonienses dum literarum studia | excoluit | et avidissimo corruptus est morbo | placide tamen et patienter | extremum vitæ miserandæ curriculum | pertulit. | Heu tandem fato immaturo extinctus est | Diem clausit supremum xiv die Decembris | A.D. MDCCXXXIII ætat. suæ XXII.

A blue flat stone to the west of the last :

> In memory of | Mathew Robinson vicar of this parish | obᵗ 13 June 1745, æt. 32.

Another more to the west :

> In memory of | Elizabeth Robinson | mother of the Revᵈ Mathew Robinson | late vicar of this church | obᵗ 28 Augᵗ 1763, æt. 76. | Also Math. Robinson | son of the aforesaid vicar | late of Holbech surgeon | obᵗ 24 of Jan. 1772, æt. 28.

Another stone to the east :

> M.S. | Marthæ | uxoris | Rev'i J. Gregson | cui | decem liberos peperit | ob. Maii 9, | A.D. 1723 | æt. 50.

A black tablet against the east wall of the south aisle :

> Abigail | the wife of | Mr Richard Harvey | died Nov. 26, MDCCXCV, | aged LXIV years. | Mary daughter of | Richard and Abigail Harvey | died April 3, MDCCLXXX, | aged 15 years.

A flat stone at the east end of the north aisle :

> In memory of | Mr James Ellis | who departed this life | Nov. 25 1781, | aged 39 years.

A large flat blue stone at the west end of the nave, with this inscription round the edge in capitals :

> Hic jacet Antonius Conie de Kirton generosus qui obiit 12

die Novembris A.D. 1589 et Bridg. uxor ejus quæ obiit 3 die Aprilis Ano D'ni 1589.

On another with the inscription round :
> Here lyeth the body of Robert Hunt gent. was buryed the 30 day of November, Anno Domini 1663.

On another stone :
> Claxon Harrenden son | of Mr Dan¹ Hunt & | Eliz. his wife was bur | yed Septem. yᵉ xv, 1708.

A stone more to the east :
> Here lyeth the body of | Edmund Harriss senʳ gent. | who departed this life | November the 17, 1718 | aged 55 years (there is more of the inscription but is now effaced).

On another stone :
> Here lyeth the body of | John the son of Mr Edmund | Harriss interred June the 23, 1720 | aged 21 years.

On another stone :
> In memory of Alice | wife of Willᵐ Ayre, gent., | who departed this life | Feb. 20, 1703, | aged 26. | Also Will. Ault who departed | this life April 17, 1734 | aged 22 years.

A blue stone to the east of the font :
> In memory of | Mr George Ault interred | Aug. yᵉ 15, 1742, aged 41. | In memory of | Mrs Eliz. Ayscough | who departed this life | May 25, 1780, | in the 77 year of her age.

A similar stone parallel with and to the north of the last :
> In memory of | Mrs Margaret Baley | interred the 1 of Nov. 1763, | aged 68.

Another similar one still more to the north :
> In memory of | Mrs Margaret Ayre | who departed this life | the 23 of May 1779, | in the 58 year of her age.

[See also *L.R.S.* i, 166–167 ; *Churches of Holland.*]

(MS v, 167–176.)

Kirton in Lindsey

Notes taken in the church of Kirton, [*blank*] September, 1835—

A white marble monument against the south wall of the chancel (R) :
> Sacred | to the memory of | George Robert Foster surgeon | who died April the 3, 1817, | aged 24 years ; also | George Robert | his infant son | who died May 24, 1818.

A monument against the north wall of the chancel (R) :
> In | memory of | Helen Susanna Fox | who died July 1, 1811, | aged 23 years ; | also of John infant son | of the above | Helen Susanna Fox | who died July 8, 1811.

A grey and white marble monument in the nave (R) :

> In memory of | Frances Purver who departed | this life Sept.
> 27, 1785, | aged 78. | Also John Purver her son | Captain in
> the 20 Regiment | of Marines | who died August the 16, 1795, |
> aged 57 ; | likewise Elizabeth wife of | John Purver who died
> July 15, 1829, | aged 80.

At the west end of the north aisle on a flat stone (D) :

> William Trevor | thirty six years vicar | of this parish church |
> changed this state of | probation for that of retri | bution
> the 22 of January 1764, | aged 71 years, | Ann wife of the
> said | William Trevor | the 24 of March 1757, | aged 73
> years.

On a flat stone in a pew near the north door (D) :

> Anno 1657, and | upon Ascension day, | the soule of Christopher |
> Pickering ascended Heaven | and left his body to rest | in
> the earth until God | raise it up again to Glory.

On a black tablet at the end of the north aisle an inscription to (D) :

> Richard Fletcher, clerk of the parish 31 years, who | died
> 10 April 1819, aged 73, and Elizabeth his wife | who died
> 19 August 1803, æt. 59.

On a flat stone, next to that of Will. Trevor, an inscription to (D) :

> Thomas Taylor who died 26 February 1773, aged 40, and
> Ann his wife who died May 4, 1781, æt. 70.

A flat stone in the north aisle with inscription to (D) :

> Jonathan Bain surgeon died 13 Sept. 1783, æt. 84.

Next to the stone of Thomas Taylor are stones with inscriptions
to (D) :

> John Bullock who died 21 Aug. 1810, æt. 61, and also to
> John Bethel 12 Dec^r 1786, æt. 64, Elizabeth his wife 11th
> Apr. 1785, æt. 59, & John his son who died 18 Dec. 1768,
> æt. 10.

On a black tablet of wood, against the south wall of the south
aisle, inscriptions to the several members of the following
family (D) :

> Christopher son of Peter & Dorothy Baldwin who died 2 Oct.
> 1687, æt. 1.
> Peter son of the same who died 30 March 1689, æt. 1.
> Peter son of the same who died 26 June 1692, æt. 2.
> Nicholas son of the same who died 19 Jan^y 1694, æt. 1.
> Dorothy wife of the same who died 24 Oct^r 1695, æt. 39.
> Dorothy daur of the same who died 1 Nov^r 1695, æt. 4.
> Henry son of Peter & Elenor Baldwin who died 24 Jan^y 1699,
> æt. 3.

Another tablet opposite with inscription to (D) :

> Mrs Margaret Hunt widow who died June 23, 1707, æt. 73.

Flat stones in the south aisle to (D) :

William Caister who died 31 Oct. 1730, aged 37.

Benjamin Footit who died 6 March 1781, æt. 73 (?).

John Footit son of Benjamin & Sarah his wife who died May 1, 1787, æt. 39.

Christopher Footit who died March 10, 1805, æt. 19.

Robert Stow who died 31 Jan^y 1738, æt. 29.

A black tablet records that Mr Joseph Turner who died Dec^r 9, 1743, gave by his will £3 to be distributed yearly to the poor, half on Good Friday, half on St Thomas' day. He also gave a silver flagon for the service of the altar.

The church consists of a nave divided from its two aisles by four pointed arches on each side. The columns on the north side are round, with the exception of one which is octagon with a capital ornamented with birds and beasts. On the south side the pillars are octagon. The tower is of Early English, with lancet windows, and a door with toothed mouldings. Two low arched doors lead from the tower into the nave. There is a good screen of the Perpendicular style before the chancel, but the chancel has been fitted up in extremely bad taste. The east window has been blocked up by an altar piece attempted in the Italian style, gaudily painted, the capitals of the pillars gilded. The table of common wood painted in imitation of stone, and at the back of it, between the columns, the panel is painted like a curtain, not unlike the drop scene of a theatre. The roof of the chancel is unceiled, except over the altar which has a sort of canopy or half ceiling over it, painted blue. The whole indeed is in miserable taste. The font is extremely plain with an octagon top.

[See also *L.R.S.* i, 118; Peacock, *English Church Furniture*, pp. 232-3.]

(MS vii, 17–22.)

Laceby

Notes taken in the church, 29 August, 1835—

On a flat stone (R) in the chancel, within the altar rails ; arms cut above—A griffin segreant. Crest—A demi griffin [Battell] :

Here lieth the body of | Ralph Battell, clerk, A.M., | late rector of Somersby | and Bag Enderby who | died the 9 of February 1780, | in the 83 year of his age. | Resurgam.

On an old stone (R) in the chancel, with inscription round the verge, partly hid by the step to the Communion table :

Rober*tus* Laund qui obiit xx die Augusti A' D'ni mccccxxvii.

On a marble tablet on the north side of the chancel (R) :

John Holmes | ob. 4 April | 1788, | æt. 40. | He was true & just in all his dealings, | a social companion, | and the poor man's friend. | Also | Katharine Holmes | wife of the above | ob. Feb. 6, 1798, | aged 63.

At the west end of the north aisle on a stone (R) in a pew there is an inscription to Nathaniel Taylor, who died 26 May 1808, æt. 64, and Sarah his wife who died July 16, 1825, æt. 79 years.

Also on a flat stone in the north aisle an inscription to Frances wife of Joseph Nainby, who died 22 March 1804, aged 76. Also to Joseph Nainby who died 6 April 1786, aged 64.

On a flat stone within the altar rails (R) :

> Here lyeth the body of | Jonathan Winship A.M. | late rector of this parish and | vicar of Grassby who died | the 25 January 1783, | aged 46 years. | This stone is placed | in grateful remembrance | of a tender husband | by his affectionate wife | Thomazyn daughter of the | Revᵈ Ralph Battle. | Resurgam. | Also the body of Thomasyn | Winship his widow who died | 30 January 1799, aged 66.

A flat stone in the chancel (R) :

> In | memory of | Vincent Grantham Esq. | the last male heir of the | Grantham family who | died the 10 of December | 1758, in the 66 year of | his age.

This church consists of a nave, and north aisle resting on five arches, the middlemost of which is a fine Norman one ornamented with the embattled and chevron mouldings. It is altogether a handsome specimen of that style, and is singularly placed as the two on each side of it are pointed. There is a chancel, and a tower at the west end. The font is octagonal with shields in quatrefoyles. There seem to have been aisles to the chancel, as on the north side are two blocked up arches, one of which opens into the vestry, and another has a door in it ; and on the south side a similar low arch. At the west end is a small organ.

[See also *Lincs. N. & Q.* xi, 88–89 ; *L.R.S.* i, 100 ; *Gentleman's Magazine*, 1829, part i, 597–9.]

(MS viii, 129–132.)

Langtoft

Notes taken in the church, [*blank*] July, 1831—

On a small black marble monument against the south wall of the chancel, in a recess above, a lady kneeling before a desk in a black hood and gown ; over is a shield of arms, but they are effaced :

> This monument doth represent | yᵉ memory of Eliz. the wife of Bevell | Moulesworthe of Langtoft Esq. | who deceased yᵉ 4 daie of May | Anno Domini 1618, | ætatis sve 44.

On a flat stone (R) in the floor beneath, with these arms cut above — . . . on a chevron . . . three lioncels . . . , a mullet for difference [? for Moulesworthe] :

> Under this stone lyeth | interred the bodye of | Elizabeth

the wife of | Bevell Moulesworthe | of Langtoft Esq. by | whom he had issue one | sonne and one daughter, | which Eliz : deceased | the 4 of Maye Anno | 1618.

On a flat stone (R) by the north wall of the chancel with these arms cut above—Quarterly, 1st and 4th, Ermine, a chevron between three chess rooks [Walcot] ; 2nd and 3rd, Ermine, on a chief , a lion naissant, [] this inscription on a brass plate :

Here lyeth the body of Sarah the wife of | Bernard Walcot of Langtoft in the county | of Lincolne Esq. by whome he had issue fower | sonnes & three daughters who dyed the | 24 of August *Anno Domini* 1651. | Thou bedd of rest reserve for him a roome | Who lives a man divorced from his deare wife | That as they were one hart, soe this one tombe | May hold them neer in death as linckt in life. | She's gone before and after comes her head | To sleepe with her amongst the blessed dead | Deus dedit | Æternis mutasse Caduca.

On a handsome white marble monument (R) against the south east corner of the chancel with these arms above—Gules, a saltier or [for Hyde] ; impaling—Vert, three stags tripping or [Trollope] :

Sacred | to the memory of William Hyde | Senʳ Esq. who dyed 21 Novem : 1694 | aged 59 years : | and Mary his wife [eld- | est daughter of Sʳ Tho. Trollope of Case- | wick in the county of Lincoln, bart.,], | who dyed the 21 of March 1671, | aged 35 years, by whom he had | three sons & one daughter. | He was | the delight of his country, honour'd | with the title of honest, chosen fre- | quently to serve in parliament as | burgess of Stamford, a senator, | most faithfull to his God, King, | and Country. | Judith the widdow | of their eldest son piously and | mournfully erected this | monument.

On a handsome white marble monument (R) against the north east corner of the chancel, with the arms of Hyde, impaling—Sable, three pick axes argent [Pigott] :

Sacred | to the memory of William Hyde Esq. | who dyed 8 of May 1703, aged 43 years. | He was | beautiful in his person, admir'd for his | great sence and learning which he to yᵉ | last imploy'd in the service of his country, | a most tender husband and carefull | father, an example of Honour, Vertue | and Patience, he labour'd the greatest | part of his life with unparalleled chear- | fullness and courage, under the most | exquisite torments of the gout, in hope | of a blessed resurrection. | Judith his most mournful & discon| -solate widdow [who was sole daughter | and heiress of Alban Pigott of Hattford | in the county of Berks, Esq.], by whome | he left two sons and two daughters, | as a token of her sincere

and inviolable | affection, erected this monument. | The above named Judith dyed Septr 12 | in 1709, aged 43 years.

On a white stone tablet against the north wall of the chancel :
Near this place | lyeth interred the body of | Margaret the wife of | the Revd Mr Headley, | vicar of this parish, | who lived much respected and died | justly & deservedly lamented | Sept. 2d 1763, anno ætatis 57. | Hinc | Disce tunc Discite. | Near this place | lyeth interred the body of | the Revd Mr John Headley, | vicar of this parish, | who departed this life | June 4th, 1755, in the 46th year | of his age.

On a black tablet (D) against one of the pillars of the nave :
To | the memory | of | Henry Rankin | April ye 15, 1766, | aged | 57 years. | De mortuis nil nisi bonum.

On a flat stone in the floor of the nave (D) :
William | Owen Esq. | died 22nd April | 1827, | Aged 81 | years.

There is a hatchment against the north wall of the chancel with these arms—Quarterly, 1st, Hyde ; 2nd, Pigott ; 3rd, Argent, three bugle horns stringed sable [Bellingham] ; 4th, Argent, a saltire engrailed sable, on a chief of the last two mullets or [Iwarby] ; 5th, Argent, a cross voided gules ; 6th, A lion rampant, between ten crosslets or [Brewes] ; 7th, Gules, fretty argent, a chief or [Brogden] ; 8th, Argent, a bend ermines, a mullet for difference sable ; 9th, as the 1st ; impaling—Quarterly, 1st and 4th, Argent, a cross moline gules, in first quarter a torteau [Dugdale] ; 2nd and 3rd, Azure, a fess ermine between three falcons' heads argent, beaked or. Crest—A unicorn's head argent, attired and collared gules. Motto—Mors Janua Vitæ (D).

[Jeans, Supp. Add. 2.]

(MS i, 23–28.)

Langton by Wragby

Notes taken in the church, 13 October, 1840—This is a good old church with modernised windows ; it is not ceiled, has a handsome tower, and consists of nave and chancel. It is entered at the west under the tower. There are four ancient stones (D) in the nave which have had inscriptions, but now defaced, and there is one modern stone (D) in the chancel, also defaced.

On a black flat stone (D) in the chancel under the Communion table, with these arms cut in on three shields—(1) the centre bears —Semée of cross crosslets, three cinquefoils (Saltmarsh) ; (2) the dexter has—Saltmarsh, impaling—A chevron between three lions rampant [Blythe] ; (3) the sinister—Saltmarsh, impaling—On a chevron three martlets, with this inscription under (D) :

Here lieth the body of | Anthony Saltmarsh of Strubby | in this parish, esq., who departed | this life yᵉ ninth of June, [16]75, | in the 34th year of his age. | He had two wives, the first Jane | daughter to Wᵐ Blythe of Stroxton | in this county, esq., his second wife | Elizabeth daughter of Michael | Anne of Broughwallis in the county | of York, esq. She dyed March yᵉ 28, | 1672, and lyes buried under this stone. | This stone is laid in their memories by | Robert Saltmarsh their obliged kinsman.

On another stone (D) before the altar rails :

Here lieth the body of Will. Jenkinson son | of William Jenkinson, gent., | and Jane his wife | who departed this life Dec. yᵉ 6, 1726, | in the 9th year of his age.

On the east wall of the chancel north of the Communion table is a neat marble monument with the arms of Saltmarsh above— Argent, semée of crosslets gules three cinquefoils of the second [Saltmarsh]; and on the dexter side of the inscription is—Saltmarsh, impaling—Quarterly or and gules, over all a bend sable, charged with three water bougets argent [for Eure]. On the sinister side—Saltmarsh, impaling—Argent, on a chevron sable three quatrefoils or [Eyre]. In capitals :

Nere this place lyeth the body of William | Saltmarsh of Strubbie in yᵉ countie of Lincoln, | esq. whoe in yᵉ 36 yeare of his age married | Barbara the ladie and relicte of Sʳ Peter Evre | of Washingbrooke in the sayd countie of Lincolne, | kt: by whome he had issue Edward, Tho', William, | Anthony, Elizabeth, Ann & Barbara, Barbara only | surviveing was married to William Godferey of | Thoneoke, Esq. and left issue to him William and | Barbara Godferey, the Ladie Evre dying in | Anº. 1642 He married Martha Eyre daughter | of Anthonie Eyre of Rampton in yᵉ Countie | of Nottingham, esq. and by her had one | only daughter named Iane, and beinge aged | 80 yeares was on the 4th of October Anº 1657, | to the Glorie of his God & in yᵉ good esteeme | of all good men, honorably interred. | To whose memorie his beloved wife | erected this memoriall.

On a monument against yᵉ east wall of the chancel, south of the Communion table, with these arms above—Sable, a chevron between three goats' heads erazed argent [Marwood]; impaling— Quarterly, gules and vaire, over all a bend or [Constable] :

Here in hope of a joyfull | resurrection lyeth yᵉ bodie of Ann | yᵉ wife of Henrie Marwood of Great | Ayton in the county of York, esq., | daughter to John Constable of Dro- | manbie in yᵉ aforesayd county, esq: | and mother to Wᵐ Marwood of | Lawghton in yᵉ county of Lincoln, | esq: who marryed Martha yᵉ wife | & relict of Wᵐ Saltmarsh

of Strub- | bie in this county, esq: There she | dyed on yᵉ
29 of September | Aᵒ Domⁱ 1660, | in yᵉ 89ᵗʰ year of her
age. | And by her lyes Deborah yᵉ daughter | of yᵉ said
Wᵐ Marwood by a former wife | who dyed Mar. yᵉ 1ᵗ, 1665.

(MS x, 57–60.)

Laughton by Gainsborough

Notes taken in the church of Laughton, 5 September, 1835—

An altar tomb at the east end of the south aisle, but it has been
removed there, as it formerly stood in the centre of it. On it the
arms of Dalison—Three crescents, on a canton five escallops ;
impaling—A lion rampant [? for Deane] ; with this inscription in
church text cut under in stone :

> Hanc tumbam fieri fecit Willelmus Dalison pium in patrem
> gerens affectum | filius secundus huius hic humati Willelmi
> ac unus Justiciariorum dominorum Philippi | regis et Marie
> regine ad placita coram illis tenenda anno domini MCCCCCLVI.

On the table stone is this inscription in brass :

> Hic jacent Willelmus Dalison armiger quondam vicecomes
> et eschætor comitatus | Lincoln' ac unus Justiciariorum
> pacis & quorum in eodem comitatu et Georgius Dalison |
> filius et heres eiusdem Willelmi. Qui quidem Willelmus obiit
> decimo octavo die mensis | Decembris anno domini MCCCCCXLVI
> et aᵒ regni nuper regis Henrici octavi XXXVIII | et dictus
> Georgius obiit XX die mensis Junii Anno domini MCCCCCXLIX
> & anno | regni nuper regis Edwardi sexti tertio quorum
> animarum propicietur Deus Amen.

Above on the same slab is the figure in brass of a man in armour
under a canopy, and at the side of the tomb under the first inscrip-
tion mentioned is this coat—Three crescents on a canton five
escallops [Dalison] ; impaling—An antelope tripping, on a chief
two crosslets fiche [Dighton]. Over the tomb is a wooden tablet
on which are painted three coats ; and as the sinister side is occupied
by one coat, whereas the other two divide the dexter between them,
it appears like the arms of a wife impaled with two husbands.
The first on the dexter side is—Gules, three crescents or, on a
canton ermine five escallops of the 2nd [Dalison]. The second is
—Sable, on a chevron argent five escallops between three lions
or [James] ; the coat on the sinister half is—Azure an antelope
tripping argent, on a chief gules two crosses pate fiche or [Dighton].

Over the above tomb, but it is doubtful whether belonging to it,
is the bust (R) of a female in a circular recess with chincloth and
wimple, and her arms clasped, and above her is a stone bracket (R)
supported by a head and two hands upraised.

On a white marble tablet against the east wall of the chancel (R) :

> Sacred | to the memory of | Thomas Everatt | of Laughton | who departed this life Octr 24, 1828, | aged 57 years.

On a black flat stone in the chancel :

> Here lies the remains | of | Philip Wilkinson esq. | son of Philip Wilkinson esq. of Hull | and of Elizabeth Helena Beverweek | of an antient family in Holland. | He was born at Amsterdam | and died at Laughton | May the 17, 1768, | aged 70 years. | His half sister Jane Wilkinson | daughter of the above Philip Wilkinson | and of Elizabeth daughter of Richard Buck esq. | the unhappy survivor of all her family | placed this in remembrance of him.

On a stone in the chancel (R) :

> Underneath | this stone are deposited | the remains of John | son of the late Rev. I. | Cheeseborough incumbent | of Stoke near Chester | who departed this life | January the 22, 1830, | in the 21 year of his | age.

There is an old stone in the chancel, but all that can be decyphered is round the verge (R) :

> Joh'is Dalison iti

The church consists of two aisles, and a nave separated from them by four arches, those on the north side circular, those on the south side pointed. There is a large pointed arch between the nave and chancel, and a place for holy water remains on the south side of the Sacrament table. The tower is at the west end. The font is octagon, ornamented with quatrefoils and shields and a hollow moulding round the rim. There was some painted glass in the east window, but removed to Messingham by Dr. Bayly.

[See also Jeans, 38.]

(MS vii, 11–14.)

Labington

Notes taken in the church, 30 July, 1833—

A most magnificent and elaborate monument of alabaster stone against the north wall of the chancel, and reaching nearly to the ceiling. It consists of two tiers, each tier decorated by three elegant Corinthian columns dividing it in two compartments, the whole surmounted by a rich carved pediment. In the compartments of the upper tier are these inscriptions in capitals :

> (1) Fide conjugali | secundum Christi redemptoris | adventum in crypta sub proximo | marmore reposita expectat inclyta | heroina Martha una filiar. Guliel. | baronis Evre ex Margarita filia | Edw. Dymoke milit. fæmina summa | pietate modestia patientia uxor. | castiss. congruenter marito Ann. 12 | Adunata

P

mater amantiss : quatuor | filior. et sex filiar : e quibus Guliel. |
Evreum Margaretam Annam Elizabeth'. | sui ipsius imagines
et amoris mutui | pignora superstites relinquens | animam
deo reddidit anno ætatis 33 | salutis MDCI. Eliz. 44, Martii
XI. | Conjugi lectiss. maritus mæstiss. | Williel. Armyne
mil. honoris et | memoriæ ergo sibi que et suis | mortalitatis
memor devotissime | posuit anno D'ni 1605.

(2) Mors sationis instar | in Christo dormit sub hoc tumulo |
Barthol. Armyne ar. filius minimus | Guliel. Armyn. de
Osgodby armigeri ex | Katherina filia Johannis Thymelby
de | Irnham militis. Una cum illo | conditur Maria uxor
charissima | prima Henrici Sutton ar. genita. | ex Margareta
filia Ro. Huscy militis | Quæ quatuor illi liberos peperit |
Guliel. John. in conspectu patris | mortuum Katherinam
et Magdalenam. | Conjuge sua secunda Katherina filia |
Georgij Chaworth ar. mortua, Anna | fideli uxore tertia
sorore et | hærede Ro. Dymoke ar. superstite. | Obiit
anno ætatis 58. D'ni 1598 | Septembris XI. | Parent opt.
et chariss. officiosæ | pietatis ergo fil. luctuosiss. Guliel. |
Armyn mil. monumentum hoc dicavit | anno regis Jacobi
tertio.

In the two compartments of the lower tier are these armorial
bearings ; in the first on one large shield—Quarterly of four, 1st,
Ermyn, a saltier engrailed , on a chief a lion passant
[Armine] ; 2nd, A cross charged with five mullets [St Medard] ; 3rd,
Three lioncels rampant [Dacre] ; 4th, A fesse between three
escallops [St Loo] ; impaling—Quarterly of four, 1st, Quarterly,
over all a bend charged with three escallops [Eure] ; 2nd, Barry
of six, on a canton a crosslet [Aton] ; 3rd, A cross [Vessey] ; 4th,
Three Lioncels rampant, chained [Tyson]. The first crest—An
ermine [Armine] ; second crest—Two paws holding up an escallop
[Eure]. Motto above the arms—Quod superest expectans ;
motto below the arms—Spes pulvis et ambo. In the second under
compartment are three shields—(1) Quarterly, 1st, Ermyn, a saltier
engrailed, on a chief a lion passant [Armine] ; 2nd, A cross charged
with five mullets [St Medard] ; 3rd, Three lioncels rampant [Dacre] ;
4th, A fesse between three escallops [St Loo] ; impaling—Quarterly,
1st, Barry of twelve, over all three birds [Chaworth] ; 2nd, Two
chevrons [Alfreton] ; 3rd, A cross [Aylesbury] ; 4th, Paly of six,
over all a bend [Annesley]. (2) The four quarterings of Armyne ;
impaling—Quarterly, 1st, Two lyons passant, crowned [Dymoke] ;
2nd, Vaire a fess fretty [Marmion] ; 3rd, A saltier between four
crosslets [Friskney] ; 4th, A chevron between three bulls [Tourney].
(3) The four quarterings of Armyne ; impaling—Quarterly, 1st
and 4th, A chevron charged with three crescents between three
annulets [Sutton of Burton] ; 2nd and 3rd, A lion rampant [Sutton,
Lord Dudley]. This motto over all the shields—Malim mori quam

fædari. This motto below—Granum mortuum fructificat. On the projecting ledge of the base are twenty-four shields :

(1) Armyne ; impaled by— on a chief a demi-lion issuing [Markham]. (2) A fesse ermine between three water bougets [Meres] ; impaling—A fesse with a label above of three points [Birkin]. (3) In a lozenge [Armine]. (4) Two bars in a border [Dene] ; impaling—Armyne. (5) Armyne ; impaling—Three pallets [? for Thimbleby]. (6) Armyne ; impaling—A chevron embattled, between three cinquefoils [Langholme]. (7) Armyne ; impaling—A fesse and label in chief [Birkin]. (8) Armyne ; impaling—A frett and a chief [Harrington]. (9) Armyne ; impaling—On a fess between four fleur de lis two fleur de lis [D'Eyville]. (10) Armyne ; impaling—A bend [Mauley]. (11) Armyne ; impaling—On a bend three mascles [Carleton]. (12) Armyne alone. (13) On a cross five mullets [St Medard]. (14) The same ; impaling— Three pallets and a bend [Ridel]. (15) The same ; impaling —A fesse between three escallops [St Loo]. (16) Armyne ; impaling—On a cross five mullets [St Medard]. (17) Three mitres [See of Norwich] ; impaling—Armyne. (18) Ermine, a bend, on a chief a lion passant. (19) Armyne ; impaling— Three piles, a canton ermine [Wrottesley]. (20) Armyne ; impaling—Three bars [Bussey]. (21) A chevron between three trefoils [Sleford] ; impaling—Armyne. (22) Three dexter arms, armed in pale [Armstrong] ; impaling—Armyne. (23) Ermine, a chevron [Wenslow] ; impaling—Armyne. (24) Fretty [Cave] ; impaling—Armyne.

Above the capitals of the pillars are the crests of the ermine, and the supporters of the monument are ornamented with trophies. On a stone let into the south wall of the chancel, south of the altar, this in capitals :

Memoriæ sacrum. | Gulielmus Armyne armig. fil. Gulielmi Armyn | de Osgodby ar. ex Elizabetha filia Hugonis | Bussy armig. requiescit sub pavimento | juxta murum cum Katherina consorte | sua ex qua suscepit quatuor filios viz. | Guliel. prima ætate mort. Johannem et | Antonium abreptos morbo sudabundo | Barthol. hæredem et VI filias Margarit. | Elizabet. Katherin. Dorotheam Ianam et | Thomasin. deinde patribus adjunctus est | anno ætatis LIIII salutis MDLVIII Eliz. I | die Decem. XXV.

Another stone let into the south wall, also in capitals :

Mors mihi lucrum. | Hereby lyeth Jane Cha | worth wife unto John | Chaworth of Southwell | in yᵉ countie of Nott' | esq., and daught. of Da | vid Vincent of Barneck | in the countie of Nort. | esq., who had by her | husband XII sonnes and | 4 daughters. She lived | a right zelus & godly | life, & dyed yᵉ third of | July 1606.

A large black stone against the north wall of the chancel, in capitals :

> Here lieth the body of | Mrs Mary Blomer, late wife of the Rev. Dr Blomer, vicar of this parish, | who died the 20th of June 1759, in the 62 year of her age. | Here lieth also the body of the said Rev. Thomas Blomer, D.D., | who died the 29 of January 1764, in the 85 year of his age. | Memento mori. | And ye, beloved, building up yourselves on your most holy faith | Praying in the Holy Ghost keep yourselves in the love of God | Looking for the mercy of our Lord Jesus Christ unto | Eternal life. | And unto him that is able to keep you from falling and | To present you faultless before the presence of his glory | With exceeding joy. | To the only wise God our Saviour be Glory and Majesty | Dominion and power both now and for ever. | Amen.

A marble tablet against the east wall, south of the altar, also in capitals :

> In memory of the Revd Mr Francis | Hetherington, B.D., vicar of Lavington | alias Lenton and rector of Evedon, both | in the county of Lincoln, who departed | this life the 26 day of October 1768 | in the 64 year of his age. | Crux Christi | honor mihi.

In the nave is a large stone (D) where has been a brass inscription and figures, but having been taken out they are now kept by Mr Hardwick the vicar in his house for their better preservation. The figure is in armour, bareheaded, of large size, his hands clasped as if in prayer, a shield of arms was on the stone, but is now entirely lost, the inscription is in old character :

> Here lyeth Richard Quadring esq. which de | cessed ye xxix day of Septembr' the yer of our Lord | MⁿCCCCCⁿXI, on whose soule Jh'u have mercy.

A flat stone (D) at the west end of the south aisle, in capitals :

> Here lieth the body of | William Nottingham | son of Thomas | Nottingham and of | Catherine his wife. | He departed this life | November the 17, 175 . , | aged 56 years.

On another more to the east also in capitals (D) :

> Here lieth the body of | Catharine the wife of | Thomas Nottingham | who departed this life | July the 29, 1749, | aged 84 years.

Another still more to the east, likewise in capitals (D) :

> Here lieth the body | of Anne daughter of | Thomas and Catherine | Nottingham who died | April ye 22d, 1764, | aged 63 years.

Another to the east (D) :

> Here lies the body of | Elizabeth the daughter | of Thomas Knight yeoman | and Alice his wife, who | departed this

life | October 14, 1751, and | in the 20th year of her age. | While here my daughter I have lost | What fates decree cannot be crost. | Contentedly I tarry here | Till God commands me to my dear.

The church consists of a nave and south aisle, separated by three pointed arches with plain pillars ; a chancel divided by a screen (R) from the nave ; and tower with a spire at the west end. The font is an octagon, pannelled with shields in cinquefoils. In a window of the nave are these arms (D)—Argent, a lion rampant gules ; and in the east window of the south aisle—Gules, on a border argent six cinquefoils of the first [Darcy].

[See also *L.R.S.* i, 207 ; *Lincs. N. & Q.* xiv, 97–104.]

(MS iii, 3–13.)

Leadenham

Notes taken in the church, 8 August, 1833—

A white marble monument against the east wall, these arms above —Quarterly, 1st and 4th, Argent, a bear rampant sable, chained or [Beresford] ; 2nd and 3rd, Per chevron argent and or, three pheons sable [Hassal] ; impaling—Azure, a saltier engrailed argent [Tyringham] :

> M.S. | of | Christopher Beresford | eldest son of William Beresford late of | Long Ledenham in the county of Lincoln, Esq., | by Margaret daughter of S^r William Thorold of | Marston in the said county, Bart. He married Jane the | eldest daughter of Charles Halford of Edith Weston | in the county of Rutland, Esq., by whom he had issue | 4 children. He afterwards married Issabel daughter | of Sir Francis Molineux of Hawton in the county of | Nottingham, Bart., and having been High Sheriff of the | said county An^o Dom¹ 1700 and Commissioner of the | Peace in three Reigns, died much lamented the 16th day | of January 1716, aged 65. | And also of William Beresford, Esq., eldest son of | the said Christopher who married Jane y^e daughter | of John Tyringham of Nether Winchenden in the | county of Bucks, Esq. (by whom leaving issue | one son). He died the 15th day of November 1729, | aged 53. Both buried near this place. | Jana relicta præfati Gul. H.M.P. anno 1730.

On a brass plate in the floor near the last monument, and in the north of the chancel :

> Here lyeth buryed Elizabeth late wife of Xp'ofer | Beresforde of Ledenham in the county of Lincoln, | Esq^r, one of the daughters of William Cartwright of | Ossington in y^e coun : of Nott :, Esq., by Grace Dabridgcourt | his wife ; shee brought forth 9 sonns and 6 daugh- | ters and left 6 sonns and six daughters lyveing, | & dyed in y^e 42th yeare of her age y^e

24th of Dec. 1635. | Wife, mother, friend, to Kin, to poore, the best : | In vertues seate, in heaven, her soule is blest. | Posuit hoc mæstissimus ejus vir ; C : B : |

I was thy husband's kyn, & soe was thyne,
I have noe need to Idolize thy shryne,
Wee lyveing for thy vertues lov'd : all vice
Thy soule abhor'd, and's blest in Paradise.

Chr. Beresforde | of Fulbeck, | Esq.

A very elegant monument against the north wall of the chancel, being a Gothic arch, angels supporting it from under ; the arms are—Gules, a chevron between three lions' paws erazed argent, on a chief of the second an eagle displayed sable [Brown] ; impaling —Azure, a chevron ermine between three swans argent [Swan]. The inscription in Gothic character :

Charlotte | wife of the Rev^d Tho^s Brown | rector of this church, | and daughter of | the Rev^d Francis Swan and | Maria his wife, | died April xxvii, | mdcccxxxi.

On a black stone in the chancel, the arms cut above—Quarterly, 1st and 4th, A bear rampant chained [Beresford] ; 2nd, Per chevron . . . and . . . three pheons [Hassal] ; 3rd, A saltier engrailed [Tyringham] :

Here lyeth the body of | Christopher Beresford of this parish Esq. | the only Son of William Beresford | late of this parish, Esq., and Jane his wife, | only daughter of John Tyringham | of Lower Winchendon in the county of Bucks, Esq. | He was a youth blest with | a sprightly Genius, | a lively wit and | an early good sense : | All which were so crown'd with | a natural sweetness of temper, | a pious sense of every duty and | a thorough virtuous disposition : | and so happily placed | in the best way of improvement, | that he greatly promised, in his future life | to add to the honors of | the ancient families from whence he sprung : | and to be, in an eminent degree, | of ornament and service to his country. | But as it pleased God without further proof, | to take him to himself : | his mournful mother | bore this sudden and severe tryal | with an amazing steadiness, | which only religion could support : | and piously submitting to the will of Heaven, | placed this stone for him and herself. | He died Mar : 23, mdccxl, | in the 16 year of his age.

A white marble monument at the entrance to the chancel on the north side, these arms above—Quarterly, 1st and 4th, Argent, two bends wavy sable [Key] ; 2nd and 3rd, Argent, three lions' paws erazed, in a border azure [Brown] :

Near | this entablature lie the remains | of William Key | late of Nottingham, gent :, | who died May 1: 1752, aged 64. | He was a most tender husband, | a most indulgent father, | and

a most sincere friend ; | and to every person with whom conversant, | affable, courteous, and benevolent. | He was ever steady to his principle, | a zealous defender of the church, | a strenuous assertor of Liberty : | but what was above all | (and must ever prove most worthy imitation, | and be revered by posterity) | He liv'd and dy'd, | not only in profession, but also in practice, | a truly religious, and sincere Christian.

On a similar monument exactly opposite on the south side with the same arms over :

Near | this entablature lie the remains | of Ellis Key | son of William and Ann Key | late of Nottingham | who died Dec^r 25 : 1756, | aged 37.

On a flat black stone in the nave, arms quarterly of Key :

Here lies interred the body of | Ellis Key | late of Nottingham | who died Dec. 25, 1756, | aged 37.

On a black stone next to the last with the arms quarterly of Key :

Here lies interred the body of | William Key late of | Nottingham, gent., who departed this life | May 1, 1752, aged 64. | In the same grave lies the remains | of Ann wife of the said | William Key, gent., | who departed this life Oct. 21, 1729, | aged 40, | and also the remains of Thomas | son of William and Ann Key | who departed this life Aug. 30, 1730, | aged 18.

Against the east wall of the chancel is a stone shield of arms, well carved, inscribed above C.B. The arms are—Quarterly, 1st and 4th, , a bear rampant . . . chained and muzzled . . [Beresford]; 2nd and 3rd, Per chevron between three pheons . . . , a crescent for difference [Hassal]; the whole differenced by a crescent.

On the floor below on a brass plate is the following inscription in capitals :

Here lyeth Margaret late wife of William Beresforde | of Ledenham in the countie of Lincolne, Esq^r. second | daughter of S^r William Thorold of Marston in the countie | aforesaid, Kt and Baronet, who left living fower children, | Anne, Elizabeth, Christopher, and William, and departed | this life in the thirtie seaventh yeare of her age the | 20th day of November 1655. | Heere lies interred heere lies one, | Ah aske not who without a groane, | Prudence meekness all the graces, | which with our losse have lost there places, | If a chast wife a virgin may be sayd, | Who lived a woman but which dyed a mayd | Reader who soe're thou bee | Tell the world what I tell thee.

A flat stone more to the west within the altar rails :

Here lyeth Isabell the | wife of Chr. Beresford, | esq., youngest daughter | of S^r Fra. Molyneux Bar. who departed | the 12 day | of April | 1708.

A white marble monument (R) against the north wall of the chancel, the arms over—Argent, a lion rampant gules ; impaling—Argent, two bendlets azure [Key] ; a helmet over ; in capitals :

In this chancel lie deposited | the remains of Ellis Key, esq., of this place, | buried the 12th of Feb^y 1723, | aged 41 years. | Also of Anna his wife | one of the daughters of Edward Storer, esq., of Buckminster | in the county of Lincoln, | buried the 17th of June 1765, | aged 79 years. | They had six children | viz. Mary, John, Thomas, and Ellis, who died Infants, | Jane still surviving born the 29th of May 1716, | married to William Reeve of | Melton Mowbray in the county of Leicester, Esq^r., | the 9th of October 1738. | Heiress of her late brother John Key, esq., | who was born the 3^d of June 1723, and interred here | the 16th of April 1789, | aged 65 years | who by his will gave five hundred pounds for the benefit of | poor men of this parish above the age of 50 who should not have | received relief from, or lived in, any of the Poor Houses belonging | to the said parish for the space of seven years | previous to their being candidates for the said charity.

[On the floor, underneath the above, on the south side,] the figure of a lady in brass, her hands clasped let into a blue stone, inscription in capitals in brass :

Here lyeth the Right Honourable the Ladie Elizabeth | daughter to y^e right Hon. Thomas Earell of | Lincolne Lord Clynton & Saye & wife to John Beresforde, Gent., to whome shee left living | 3 children Thomas, Marye, & Fynes, shee | departed this life 26th of July Anno D'ni 1624, | ætatis sue 32.

On a flat stone more to the north in capitals :

M.S. | Maria | Jeremiæ Ellis, S.T.P., | uxor quæ geminos | Theophilum et Rebeccam | una cum Matre sepultos enixæ | decessit | ob. A.S. 1783. | Juxtaque | Anna et Harriet | ex eisdem Jeremia et Maria | susceptæ infantes conduntur.

On another more to the north :

To the memory of | John Key, esq., | who died April 1st, 1789, | aged 66 years.

Two other stones more to the west both in capitals :

Sub hoc lapide | jacent reliquiæ Rebeccæ | Jeremiæ Ellis, S.T.P., matris | ob. A.S. 1783 | ætat. LXXXVI.

Carolus | filius alter | Jeremiæ et Mariæ Ellis. | Hic humi redditus | annos XX natus | vi febris malignæ | consumptus periit | A.S. MDCCLXXXIX.

A blue stone more to the north :
> Here | lies interred the body of | Henry Reeve [third son
> of William Reeve, esq., | by Melicent Mary his wife | who
> died on the 26 day of | September 1801, | in the 13 year of |
> his age.

Another more to the east :
> Here | lies interred the body of | Jane Reeve | eldest daughter
> of William Reeve, esq., | by Melicent Mary his wife | who
> died on the 3ᵈ day of | March 1808, | in the 23 year of | her
> age.

A handsome white stone monument in the ancient style against
the wall of the north aisle consisting of a cinquefoiled ogee arch
crocketed, ending in a fine finial, these arms over—Quarterly,
1st and 4th, Reeve ; 2nd, Per bend argent and or two bends [Key] ;
Sable, on a chevron engrailed argent three escallops of the
field [for Sherard]. Crest—A horse's head couped argent collared
gules [Reeve]. Inscription in capitals on a white marble slab :
> Sacred to the memory | of | William Reeve, esq., | of Leaden-
> ham, | son and heir of William Reeve, esq., | of Melton
> Mowbray | in the county of Leicester, | and Jane his wife, |
> who died at Cheltenham December 27, 1820, | aged 69 years. |
> He was kind, affectionate, sincere, | and deeply lamented |
> by his family and friends ; | his remains are deposited | in
> the family vault beneath.

On a brass plate in the south aisle in capitals (R) :
> To the memory of | Sarah Hunton, | who died Febʳʸ 11,
> 1799, | aged 78 years. | Also of Robert Hunton | who died
> Septʳ 15ᵗʰ, 1798, | aged 58 years. | Also of Edward Muxlow |
> he died Sepʳ 8ᵗʰ, 1794, | aged 12 years.

A flat stone at the east end of the south aisle, this inscription round,
beginning at the east side, the west side covered by a pew, in old
character (R) :
> Were earth from earth : by birth or vertue kept then worthy
> Vaughan here : had never slept : but : though his bodie in
> this tombe be thrust : death hath : not laid his honor : in the
> dust : his dood [sic] deeds live : and praise him : after dreath
> [sic] : True vertue : never dyde for : want of breath. : Abiit
> 28 January, : ætatis suæ 70, : Anno Dom'i 1618. : Posuit
> Winifred : Vaughan.

On a handsome grey veined marble slab supported on four square
pillars, the arms of Beresford above and the crest a griffin's head
holding in his beak an arrow [Beresford] :
> In memory of | Christopher Beresford, gentleman, | son of
> Christopher Beresford of | Ledenham in the County of Lincoln,
> esqʳ., | by Jane his first wife | eldest daughter of Charles

Halford, esq^r., | of Edith Weston in the county of Rutland, | who departed this life August the 14th, 1738, | and in the 61st year of his age.

On a lozenge shaped marble slab in the nave (D) :

In memory | of a dutiful son and | sincere friend the Rev^d M^r | Robert Mason of Mareham | le Fen, ob. July 1st, 1737, | aged 28 years and 8 months.

This church is large and handsome. It consists of a nave separated from its aisles by three lofty pointed arches with clustered columns. A similar arch opens into the chancel, the east window of which is filled with modern painted glass. The altar is solid stone in the old fashion, with shields round it, and at the corners, at the bottom, lions. This and the east window was presented to the church by the Rev^d Tho^s Brown the present rector.

[See also *L.R.S.* i, 228 ; Jeans, 38–9.]

(MS iii, 219–234.)

Legsby

Notes taken in the church of Legesby, 14 October, 1840—The church is a tolerable size, but thatched, except the chancel. It consists of a nave, south aisle, and chancel ; there is a covered porch on the south side. The font, which is plain, has sunk down on one side.

On the east wall of the chancel is a tablet with this inscription (R) :

Near | this place lie | the remains of | William Branston Gen^t | who died Nov^r 19, 1778. | Also of | Leah his widow | who died July 17, 1806, | aged 81.

In the aisle there have been some old stones ; one has had a small brass plate, but now gone ; and another has had an inscription round the edge, too much worn to be decipherable.

(MS ix, 227–228.)

Limber Magna

Notes taken in the church, 30 August, 1835—

On a tablet against the south wall of the chancel (R) :

Sacred | to the memory of the Rev^d | George Holiwell, who having | faithfully discharged his duty | as rector of Somerby near | Brigg almost 53 years, and as | vicar of this parish 45 years, | departed this life the 15 | day of April 1787, in the 79 | year of his age. | Robert his eldest son, who died | at Swallow, was buried in this | chancel Feb. 24, 1790, in the | 46 year of his age.

On a similar tablet close by, to the west of the last (R) :

> Sacred | to the memory of Mary | Holiwell relict of the Rev^d |
> George Holiwell | who died at Brigg on the | 27 day of Decem-
> ber 1801, | in the 77 year of her age, | beloved & lamented
> by all | who knew her.

There are many flat stones, across the end of the nave, two of which are to the Byrons.

[See also *L.R.S* i, 105.]

(MS vii, 61–62.)

𝕿𝖍𝖊 𝕮𝖆𝖙𝖍𝖊𝖉𝖗𝖆𝖑 𝕮𝖍𝖚𝖗𝖈𝖍 𝖔𝖋 𝕷𝖎𝖓𝖈𝖔𝖑𝖓

Notes taken in the cathedral of Lincoln, [*blank*] August, 1833—

In Bishop Russell's Chapell on the west side a white marble monu-
ment (R) with these arms above—A saltier [Yorke] ; impaling
Sable, a bend between three garbs or [? for Oates], colours nearly
gone, the whole in a lozenge :

> In memoriam | Eliz. Yorke, cujus cineres hoc intra sacellum |
> ipsius votis depositi requiescunt. | Et si quâ restat humanitas,
> si quæ pro defunctorum votis | usquam relligio ; diu requies-
> cant. | Nata erat | Ricardo Oates de Pontefracto proles
> unica | vixit | marito, Willhelmo Yorke de Lessingham |
> valde dilecta | Amicorum deliciae ; omnibus grata | tandem |
> longa effracta valetudine, | patientia vero, fide spe salva ; |
> foelix natae pio amore, foelix pietate sua, | dei opt. max.
> tutela et præsidio freta, | doloris expers, anima furtim
> corpore elapsa, | placide obdormivit | prid. kal. Martij |
> MDCCXL | hoc posuit Pen. Yorke.

On a white marble tablet next to the last (R), with these arms
under—Quarterly, 1st and 4th, Argent, a chevron gules between
three sheaves of three arrows each sable, banded and pointed of
the second [Best] ; 2nd, Argent, a lion rampant gules, over all a
fesse sable [Whittingham] ; 3rd, Azure, a fleur de lis argent
[Digby] :

> Henry Best, M.A., | prebendary of this church, | died 1755,
> aged 57, | His relict, Mercy, | daughter of Richard Whitting-
> ham esq^r | died 1777, aged 72. | Henry Best D.D., | prebendary
> of this church, | died 1782, aged 51, | His relict, Magdalene, |
> daughter of Kenelm Digby esq^r | died 1797, aged 63.

On a white marble tablet against the north wall :

> Sacred to the memory | of | the Rev^d John Gordon, D.D.,
> F.S.A., | archdeacon of Lincoln, | Precentor of this church, |
> and Rector of Henstead | in the county of Suffolk, | who
> departed this life | January the 4th, 1793, | aged 67 years. |
> Also of | Anne Gordon | his wife | relict of the Rev^d D^r

Williams | of Barrow in the county of Suffolk | and daughter of the Rev^d D^r Dighton | of Newmarket by Elizabeth his wife, | who died | June the 15th, 1781, | aged 63 years. | The memory of the just is blessed | Prov. x : 7.

On a stone tablet against the east side in capitals (R) :
Here lieth Marye davghter to | George Fitzwilliam of Mable | Thorpe esqvire, who was first | maried to Richard Hiltofte | esqvire, after to Anthony | Nevill gent., & last to Francis | Bvllingham esqvire, who did | commend her sovle to God, & | her bodye to the grave the [11th] | of November anno 1607.

On a white marble monument against the east wall, with these arms above—Argent, a fesse wavy between three estoiles sable [Gilby] :
In | memory of | Elizabeth Hatton widow | one of the daughters of | S^r William Scroggs knt, sometime | cheif justice of the Kings Bench. | First married to Anthony Gylby esq. | of Everton in the county of Nottingham, | and afterwards to the Hon^ble Charles Hatton, | younger son of Christopher Lord Hatton, | of Kirby in the county of Northampton, | who dyed May xxii, | mdccxxiv. | Her only surviveing son William Gylby esq., | recorder of this city erected this monument | intending it for her and himself.
Underneath on the pedestal of the monument is inscribed (D) :
Here also lyeth the body of the said | William Gylby, | her son, who died the 10th of May | mdccxliv | aged lxxv years.

On a small stone in the east wall (R) :
Here lyeth Anne Cvr | wen, davghter of Sir | Nicholas Cvrwen of | Workington | within the | covnty of Cvmberland | knight, who died the | 13 day of Aprill, anno | Domini 1609, ætatis 21.

There are some old shields of arms belonging to old tombs lying about this chapel, being brought here when the monuments were removed from other parts of the church. They are on stone and as follows (some are rather broken)—(1) The Diocese of Lincoln ; impaling—A chevron lozengy between three crosslets fiche azure [Reynolds] ; a mitre above. (2) Quarterly of 4, 1st, An arm grasping a sword on which is the banner of St George's cross [Lake, for augmentation] ; 2nd, A bend between six crosslets fiche a mullet for a difference [Lake] ; 3rd, Quarterly . . . and . . . on a bend three mullets [Cayley] ; 4th, A chevron between three boars' heads [Wardall] ; the arms of Ulster on an escucheon in the centre. Crest (broken). (3) A bend, on which a mullet, and a canton with the arms of Ulster [Everingham] ; impaling— Quarterly over all a bend on which three fleur de lis [Eure]. (4) Three fleur de lis in bend between two bendlets. Crest a garb [Hackett].

In the chapel of St Nicholas

At the east end of the south aisle a black stone :

Here lyeth the body of | Catherine Brown widdow | and
relict of Hvmphry | Browne of the Close of | Lincoln, gent.,
and daughter | of Thomas Williams of | Glanagorss in the
Isle of | Anglesey, esq., who departed | this life the 21st day
of | January 1720, aged 76. | I have waited for thy salvation
O Lord.

On a black stone to the west of the last, these arms above—On
a chevron between three martlets, three mullets [for Houseman] ;
impaling—Ermine, on a canton a saltier [Jeffs]. Crest—An arm
holding a battle axe :

Here lies the body of Mrs | Lucy Houseman late wife | of
Mr James Houseman and | also daughter & one of the | co-
heiresses of James Jeffs | late of the Middle Temple, | esq.,
who died the 25th day of | August in the 21st year of | her
age and in the year of our | Lord 1714.

More to the west below the steps and near the second pillar :

Here lyeth the body of | Mrs Elizabeth Greathe[d] wife of |
Edward Greathed of the close of | Lincoln, esqr, and daughter
of | George Heneage of Hainton | in this county, esqr, | who
died June XXIXth ; | MDCCXXXVII, aged XLIX, | and their
three daughters | Elizabeth, Juliana, | and Winifred. | Also |
Mary the fourth daughter | ob : XIV November MDCCXLV,
æt : 11.

The inscription is in capitals in bas relief with these arms above
in a lozenge—Semy of martlets . . four barrulets [for Greathed] ;
impaling—A greyhound current between three tygers' heads
cabossed in a border engrailed [Heneage] :

In the Lady chapel

Immediately under the great east window, a black stone above
the steps :

Here lyes the body of Eliz. Hatton | one of the daughters
of | Sr Wm Scroggs, knight, | sometime chief Justice of ye
Kings Bench. | First marryed to Anthony Gylby of Euerton |
in the county of Nottingham, esq., | and afterwards to ye
honble Charles Hatton | younger son of Christopher | late
lord Hatton of Kirkby | in the county of Northampton, |
who dyed May the 22d, 1724, aged 75.

Next to it on a black stone in capitals cut in bas relief :

Hic sepultus est | Newcomen Wallis Armiger | quem anno
domini MDCCXXXo | Decembris die XXXIo | anno vero ætatis
XXXIVo | Immitissimae febris vis die | morbi IVo e vita exemit.
Inter | sodales suos nemo erat aut | liberalior aut amabilior
Id, | si quid vitii in se habet est | viris ceteroqui optimis |
commune, multisque ille | virtutibus compensavit, in | amicitiis

inchoandis cautus | conservandis vero constans | et fidelis ;
uxoris et filii | unici, quos superstites post | se habuit
amantissimus | denique, ut nullos | inimicos vivus sibi fecit, |
ita multos amicos | desiderio ejus moerentes | moriens reliquit :

On a black stone next to the above, with these arms above—
Quarterly, 1st and 4th, A fess ermine [Wallis] ; 2nd and 3rd, A
chevron between three bucks' heads couped [Collingwood]. In an
escucheon—On a fesse between three quatrefoils three fleurs de lis
[for Hutton]. Crest a wolf's head erazed. In capitals in bas relief :
 Tho^s Wallis | of Lincolns Inn, esq^r., | only son of | Newcomen
 Wallis, esq^r., | ob : April 13, 1761, | aged 37.

On a small lozenge-shaped stone next to the last :
 Richard Winlow | son of Moses Terry of the | close of Lincoln,
 esq., | and Sarah his wife | died October 11º, 1723º, | aged
 6 years.

On a stone next to the last to the north :
 Here | lies the body of Jane Hastings | relict of | Howard
 Hastings esq., and | daughter of Moses Terry, LL.B., | died
 Sep^r 22^d, 1759, | aged 46 years.
(A singular account of the disorder by w^ch this Lady died will
be found in Gent's Mag. 1767, p. 360.)

On the next stone to the north :
 The Rev. | Moses Terry, LL.B., | prebend of this church, |
 rector of Leadenham, | vicar of Wellingore, | and registrar
 to the Dean and Chapter of this cathedral, | died Feb. 23,
 1757, | aged 75. | Here lyes the remains of | Mrs Sarah Terry |
 ob^t Dec^br 15^th, 1762, | in the 79^th year of her age.

On a stone lower down near that of Elizabeth Greathead :
 In memory of Elizabeth | and Winifred infant | davghters
 of | Edward Greathed, esq., | and Elizabeth his wife, | 1728.

On a black stone to the north of the last, with these arms above—
On a bend five escallops between six lozenges each charged with
an escallop [Pollen] ; impaling—Three leopards' heads jessant
fleur de lis. Crest—A pelican :
 Here lyes the body of Iane the wife of | Edward Pollen, esq.,
 who departed | this life the 9th day of July in the year of
 our | Lord 1702, in the 23d year of her age.

On a stone near the last :
 The Rev^d Henry Best | 1755, | aged 57. | Mercy Best, | 1777, |
 aged 72. | Henry Best D.D. | 1782, | aged 51. | Magdalene
 Best, | 1797, | aged 63.

A handsome white marble table slab supported on square pillars.
Above these arms—A buck's head cabossed [Gardiner] ; impaling
—Per pale and three demi lions passant [Hammond] :
 Sub hoc marmore | viri maximè venerabilis | Jacobi Gardiner,

A.M., | hujus ecclesiæ subdecani : | Sub hoc etiam filiæ unicæ | Susannæ Gardiner | tali parente dignissimæ : | corpora simul tumulata jacent.

Si Patrem respicias : | Omnia, quæ in summis viris requiruntur, | in hoc eminuisse reperies. | Nè verò hìc omnia memoranda expectes. | qualis fuerit ; | Scripta sua admiranda melius indicabunt. | Illic ubique Indoles rara, et eximia elucescit. | Vita autem, quàm sancta, ac Pia, | Quàm comis, et Benigna, | In divinis suis sermonibus, | Ut in tabulâ depicta, exhibetur. | Nihil enim ibi scripsit, | Quod non moribus egregijs commendavit. | Hoc igitur amisso, | Quis dolori nostro modus, aut lacrymis erit ? | En ! qui in dubiis rebus solamen ; | Qui miseris notum perfugium mansit : | Qui non sibi, at aliis natus videbatur : | Qui amicorum omnium Deliciæ, ac decus : | Qui deniq3 hujus ecclesiæ maximum ornamentum enituit : | Nunc pulvere et tenebris flebilis urgetur ! | Non jam lingua, audientibus semper grata, loqui : | nec membra, ut antea, Gestus decoros, | Aut ullos dare sciunt : | Non amplius Pauperibus extendi dextra : | Nec casum infelicis respicere oculus potest. | Nullus sanè querelarum finis esset : | Nî, quæ decessum ejus nobis luctuosum fecerint, | Tutam ipsi ad gloriam sempiternam viam muniissent : | Hâc fiduciâ, hoc sensu animos erecti, | Mortis in eum impetus, et victoriam spernimus : | Ipsum quasi Cælos Ingressum, | Divisque jam permixtum intuemur.

Si Filiam Spectes : | Sexûs sui Gloria, et ad laudem Dux inclyta ! | magna, dum vixit, aggressa est : | Munificentiâ, aliisque virtutibus jam clara ! | majora pollicita est. | At heu ! quàm citò, | primo ætatis flore abrepta, | Spes et lætitiam nostram luctibus mutavit ! | Dum Patrem ægrotum sedula nimis curat : | Dum huic noctesq3 et dies assidet, et ministrat : | Dum hunc levare omni studio laborat : | Morbisque conflictantem Tristis videt : | Dum pro hujus salute anxia fuit, suæ negligens : | Febris ah ! dira invasit : ex quâ confecta, | Paucis post diebus Patrem, non invita, secuta est. | Sic Parentibus obsequens, et amata vixit : | Ut dubium sit illine, an hæc, plus officio vincerent. | Sic singulis amabilis, et accepta : | ut admirationi simul ac voluptati esset. | Sic Patri per omnia similis, | Atque huic assidua comes esse solita : | Ut eo orbata vix superesse posse videretur. | Sic sæpiùs, stirpe arboris principe recisâ, | Languent cito, ac marcescunt Rami Teneriores. | Omnibus multum Desiderata obiit : | Solùm ipsi placuit sua Mors. | Hic etiam Dina Gardiner, | Jacobi Gardiner subdecani | Pars altera, et sibi charior ; | Mæsta dudum, ac Manca relicta. | Nunc iterum Marito et filiæ reddita est. | In terris tumulo, ac cœlis Comes gratissima ! | Fæmina digna viro tanto ; Vir conjuge felix : | Moribus et natæ notus uterque parens.

On an adjoining white marble slab also supported on pillars with these arms above—The Diocese of Lincoln ; impaling—A buck's head cabossed [Gardiner]. The inscription in capitals :

Conditos, quisquis, cineres Beati | Præsulis calcas moriture, normam | Disce vivendi, stimuletq3 diæ | Gloria palmæ | Vera si cordi est Pietas, fidesq3. | Si pudor priscus, placidusq3 mentis | Candor ; antiquos, imitare mores | Gardinerumq3. | Qui diù patrum æmulus optimorum | Legibus vitæ, studiisq3 sanctis ; | Duxit exemplar, specimenq3 primi | Rettulit Æui. | Prosperæ pectus bene præparatum | Res, nec adversæ poterant movere : | se parem semper sibi, cæterisq3 | Gessit amicum. | Hinc et in terris superesse famam, | et datur celsas animam tenere | cælitum sedes ; nec habente finem | Pace potiri. | Disce virtutem monitus ; fugaces | Te monent anni ; monet et sepultus | Præsul : I, mortis memor insequentis | I, pede fausto.

On a stone underneath the first table monument :

Here lye together interred ; | James Gardiner, M.A., | sub-dean of this church ; | (the eldest son of Bishop Gardiner ;) | and his only daughter | Susanna Gardiner ; | who dyed soon after her father, | He dying March 24, 173½, aged 53, | she April 27 after, aged 22. | The truest worth, in loveliest manner placed | Adorn'd each breast : and all their actions graced | One glorious aim had both ; like heavnly mind | And as in life & death ; in bliss are joined. | Dinah Gardiner | wife of James Gardiner, subdean, | dyed Sept. 4, 1734.

Underneath the table slab with the saphicks this inscription :

Here lyeth the body of | James Gardiner, D.D., | Installed subdean of this church A.D. 1671, | and from thence preferd to the | Bishoprick of this Diocess | who departed this life March 1st, 1704, | In the sixty eight year of his age, | and | in the eleventh year of his consecration.

On a white marble monument against the west wall near the centre door of entrance to the cathedral the mitre and crosier above :

Episcopi quondam Lincolniensis pientissimi | Walliæ primi præsidis | academiæ Oxon cancellarii | Necnon collegij Ænei Nasi, ibidem, fundatoris primi et præcipui | quicquid infra Cælum superest, juxta hic conditur : | cujus quidem memoriam, effigiem et insignia, | posteris olim quantum potuit, prodidit ænea lamina, | Tabulæ marmoreæ perquam eleganti et magnificæ, affixa, | hanc tamen laminam tabulamq3 sacram. | prope ostium occidentale primitùs locatas | et in pristino pene statu, anno 1641mo, adhùc remanentes, | Cromwelli flagitiosus grex, paulo post rerum potiens diripuit | Lucroq3 suo avidè et sceleratè apposuit | en tamèn veteres, ipsissimasq3 inscriptiones, | a Willielmo Dugdale Armigero,

(postea equite aurato) | deq3 antiquariis præclarè merito
fideliter asservatas ; | et Domino Thomæ Yate, S.T.P., |
Collegii Ænei Nasi Princ', Anno 1668ᵛᵒ demandatas. | ad effigiei
caput se dedit hæc inscriptio | "Sub marmore isto tenet
hic tumulus ossa | "Venerabilis in Christo Patris, et domini,
domini Willelmi Smyth, | "quondam Coventriensis et Lich-
fieldiensis, et deinde Lincolni- | "ensis Præsulis qui obiit
secundo die mensis Januarii, Anno | "Domini millesimo
quingentesimo decimo tertio cujus animæ | "propitietur
Deus. qui pius et misericors, et in die tribulationis | "misericors
pecata remittit. Ecclesiastici 2, 11" | "Ad pedes vero hæc ; |
"Cestrensis Presul, post Lincolniensis ; amator | "cleri,
nam multos cis mare transq3 aluit ; | "quiq3 utriusq3 fuit
præfectus principis aulæ, | "Fundavitq3 duas perpetuando
scolas. | "Aulaq3 sumptu hujus renovata est Enea Criste |
"Hic situs est, animæ parce benigne suæ " | Ut tanta nunc
iterum de tanto Homine hic Loci pateant, | Marmoream,
quam spectus, tabulam proprio sumptu, substituendam
curavit | Radulphus Cawley, S.T.P., præfati collegii Princ',
A.D. 1775ᵗᵒ.

In Bishop Fleming's chapel
A white marble monument against the east wall flanked by two
Corinthian pilasters and surmounted by an urn. Arms below—
Azure, a bend or [Scrope] ; impaling—Gules, on three roundles
. . . . as many squirrels [Creswell]. Crest—A plume of
feathers issuing from a ducal coronet :
 Hic juxta jacet quæ mortalis erat | Elizabetha Scrope |
 Gervasii Scrope de Cockerington | in agro Lincolniensi Armi-
 geri | uxor charissima | Richardi Creswell de Sudbury | in
 agro Salopiensi Armigeri | filia unica | SS Trinitatis, dum
 vixit | cultrix pia et assidua | superioribus suis obsequens,
 paribus comis suis | inferioribus facilis, omnibus grata | quæ
 sex mutui amoris pignora | mæsto relinquens conjugi | obiit
 25 die Julii anno salutis nostræ 1719 | ætatis suæ 27.
A marble monument to the south of the last, arms above—Ermine,
on a pile sable a leopard's head cabossed jessant de lis or [Terry] ;
impaling—Argent, three lions' heads erazed gules a bordure vert
[Winlow]. Below, a lozenge of these arms—A manche . . .
[Hastings] ; impaling—the former shield quarterly (the colours
are gone) :
 Near this place lies Moses Terry, LL.B., | of Trinity Coll.
 Oxford, in the year 1729 | he went into orders, & was pre-
 sented to | the rectory of Leadenham, | by Wm Beresford,
 esq., patron thereof : | was also a prebend. of this church, |
 and vicar of Wellingore. | He married Sarah daughter, and
 coheiress to | Richᵈ Windeloe, esq., (commonly called Win-
 low) | of Sydenham and Lewknor in ye county of Oxford, |

and formerly of Notley Abbey | in the county of Bucks ; | by whom he had 3 children, | and this monument is erected | by his only surviving child, | Jane, relict of Howard Hastings, esq. ; | intending it also in | memory of her mother ; herself ; | and her brother Richard Winlow Terry, | who died October 11th, 1723 : aged 6 years. | The said Moses Terry died Feb. 23d, 1757, | aged 75 years. | Jane Hastings died Sept. 22d, 1759, | aged 46 years. | In memory of Mrs Sarah Terry relict of Moses Terry, LL.B., | obt Dec. 15th, 1762, in the 79th year of her age.

On a marble tablet between the windows :
Here lyeth the body of | John Inett, D.D., | chanter of this cathedral, | installd chanter the 27th day | of February 1681, | he dyed the 4th of March 1717, | aged 70 years. | Here lyeth the body of | Mary wife of John Inett, D.D., | she dyed November the 26, 1727, | aged 76 years. | Here lieth the body of | Ellen Roe | wife of Thomas Roe of Litchfield | both daughters of Richard Harrison | chancellor of the church of Litchfield, | aged 71 years.
Two flat stones below commemorate the same persons.

In the Ladye chapel

On a flat blue stone at the east end of the south aisle these arms over—Quarterly, 1st and 4th, Three mullets . . . , within a double tressure flory [Murray] ; 2nd and 3rd, Quarterly ; ist and ivth, . . . , a fesse chequy . . . and . . . [Stewart] ; iind and iiird, Paly of six . . . and . . . [Strabolgi]. On an escocheon—Three legs conjoined . . . [Isle of Man] ; impaling— . . . , a chaplet [Nairne] ; an earl's coronet over :
Here lyeth the body of | William earl of Dunmore | who dyed December the 1, 1756, | in the 61st year of his age.

On another more to the north, the arms over—Quarterly . . . and . . . , three roundles . . . [Howson] ; impaling— . . . a chevron . . . , between three boars' heads, couped . . . [Kirke]. Crest— A bull's head erazed . . . Motto—Quot Maria intravi duce te. The inscription is in raised capitals :
M.S. | Annæ uxoris Thomæ Howson, gen. | (episcopi et archi- diaconi | Lincolniensis Registrarii | depvtati et Iohannis Howson, | S.T.P., olim Oxon : et deinde Dvnelm | episcopi pronepotis) filiæ | Johannis Kirke de Markham | magno in agro Notting : Gen' | uxor amabilis et amata vixit | annos XXIX | et ob beneficentiam | comitatem et eximiam | chari- tatem ab omnibus | dilecta et desiderata | animam suam pie et leniter | deo reddidit xv die Martii | A.D. MDCCXXVIII, | ætatis suæ XLVII.

Another similar more to the north with arms and crest of Howson over :

> Hic jacet | Thomas Howson | qui episc. et archidiac. Lincoln. regist. | munus diu sustinuit, | vicarius inculpabilis : | Joannis Howson Dunelm. episcopi | non extitit indignus pronepos. | in officio parum amabili | amorem omnium consecutus : | magnam meruit laudem | egenis opes dando, | majorem | datas reticendo ; | verecundiæ juxta argumentum, ac charitatis ! | nec beneficentiam minus laudandam | ad amicos exercuit : | semper iis certam amicitiam | incertis in rebus præstitit : | beneficiorum, quæ iis dedit, prior, | quæ aliis accepit, posterior | oblitus. | has ob virtutes defletus obiit | die Maii xiv anno Dom. mdccxxxvii | ætat. suæ lxix.

Another more north, the arms over— . . . , on a bend . . . , an estoile . . . between two crescents . . . [Scott] ; impaling— . . . , a bend . . . [Scrope] ; over it an earl's coronet :

> Here | lyeth the body of | the right honourable | Francis earl of Deloraine, | who died the 10 of April 1739, | aged 33 years.

Another stone more to the west, arms over— . . . , a bend . . . [Scrope] ; An escucheon ermine, on a fesse . . . three mullets . . . [Lister]. Crest—A plume of feathers issuing out of a ducal coronet :

> Here lieth ye body of | Frances Scrope | 2ᵈ wife of Gervase Scrope | of Cockerington in ye county | of Lincolne, esq. ; | she was ye 4th daughter and coheir | of Thomas Lister of Coleby | in ye county of Lincoln esq. ; | she died in childbed of her | 1st child ye 20th day of April A.D. 17[23] | ætatis suæ 25.

Another more to the south with arms and crest of Scrope over :

> Hic jacet | Gervasius Scrope | de Cockerington in agro Lincolniensi armiger | qui obiit primo die mensis Julii A.D. 1741 | in exspectatione resurrectionis in die | novissimo | qualis erat dies iste demonstrabit.

Another more to the south :

> Here lies the body of | Elizabeth Scrope | the wife of | Gervase Scrope, esq., | who died the 25th of July, 1719, | and alsoe the body of | Adrian Scrope | who was born the 20th of May | 1711, and died the 5th of March | 17$\frac{19}{20}$, beinge their eldest son.

Another more to the south ; arms over—Deloraine, impaling Lister. An earl's coronet. The inscription in raised capitals :

> Here lyeth the body of the right | honourable Mary Countess of Deloraine | wife of the right honourable Francis | earl of Deloraine and daughter of | Mathew Lister, esq., in this

county | who departed this life June the XVI, | MDCCXXXVII, aged XXXII years.

On another still more to the south ; a lozenge of arms over— . . . , Semee of crosslets . . . , a cross moline, voided . . . [Knollis] ; a baron's coronet over :

> Here lyeth the body of the right | hon^ble the Lady Katharine Knollis | daughter of Charles earl of Banbury | by his wife Elizabeth daughter of | Michael Lister of Burwell in the | county of Lincoln, esq. She departed | this life July the 12th, 1730, aged 33 years.

Another at the west end of the same aisle ; arms over— . . . , two lions passant . . . , crowned . . . , a crescent for difference [Dymoke]. Crest—A sword in pale . . . :

> M.S. | Roberti Dymoke A.B. | Rob. Dymoke nuper de Grebby Arm : filii | Hon. Lud. Dymoke de Scrivelsby | regis campionis hæredis proximi : | viri | malitiâ aut vindictâ nequaquam gaudentis, | æqui tamen rectique custodis fidissimi | ob sincerum pectus | charitatem animosam, | atque erga ecclesiam Anglicanam ʒelum | non prætereundi | inter vivos esse desiit | 27 Januarii, anno salutis 1735 ætatis 35. | Eheu ! | quando parem inveniet veritas nuda.

A stone in the middle aisle :

> This temporary stone | is placed | to mark that here lies interred | Dame Harriet daughter | of L^t Gen^l Churchill | first married | to Sir Everard Fawkner. | After his decease | to Governor Pownall | She died 6th Feb^ry 1777, aged 52.

Another more to the south in raised capitals :

> H. S. E. | Thomas Newcomen cl. | hujus ecclesiæ senior vicarius | qui obiit VIII Feb. MDCCXLIX, | ætat. suæ XXIX.

Another still more to the south :

> Here lies Selina wife of | Theophilus Newcomen, esq^r., | daughter of Walter Fawnt | of North Colingham | in the county of Notingham, esq^r, | who departed this life | 15th of January 1725, | ætat. 29. | Here lies also John son of | Theophilus and Selina Newcomen | who departed this life | 25th of February 1725, | aged 8 months. | Here lyes interred the body of | Theo : Newcomen, esq., who died | Feb. xx, MDCCXL, aged LII.

Another still more to the south :

> Here lies | the body of Mary Newcomen | (daughter of | Theophilus Newcomen of | Lincoln, esq.), | who died June y^e 23, 1764, | aged 42 years ; | also | to the memory | of Catharine Newcomen | who departed this life | March 2^d, 1793, | aged 68 years.

Another more to the south in raised capitals :

> To the memory | of the Rev^d | Will^m Johnson, A.M., | who died March 21st, | 1764, aged 57.

Another still more to the south :

> In memory | of | the reverend | Sir Richard Kaye | Bart, LL.D., | dean of this Cathedral, | who died Dec^r the 25th, 1809, | aged 73 years.

Another stone about the middle of the chapel, arms in lozenge over—Per pale . . . and . . . , three demy lions . . . [Hammond] :

> Here lyeth | the body of Elizabeth Hammond | sister to the wife of James Gardiner | subdean of this church | she dyed January 13, 173$\frac{9}{10}$, | aged 50.

Another more to the west—Lozengy . . . and . . . , a stag's head cabossed . . . , between his horns a mullet . . . [Gardiner]. Inscription in raised capitals :

> Here lyeth the body | of Iane youngest | daughter of D^r James | Gardiner late ld | bishop of Lincoln, | born Iune 1685, and | departed this life | Dec^r 1716.

More to the west, arms of Gardiner over :

> Here lyeth the | body of Mrs Anne | Gardiner daughter | of Dr James Gardiner | late lord Bishop | of Lincoln, she | was born May the | eleventh, 1683, | and departed this | life August the | first, 1714.

Another in capitals very much effaced :

> Iam ventum est Lector ad | Graciæ scilicet Ianæ que filiarum | Hon. Francisci Fane equitis de Balneo | de Fulbeck in agro Lincoln | amore moribus consimilibus | conjunct . . est | concordia | pietate non victa | virginalis | non quotidianum exemplum | hoc vivit generi con gentes | idem variolarum morbus qui di[visas] | tandem tumulo conso[ciavit] | decessit prior anno domini 1705 | altera 1711.

On a black slab near the altar screen :

> Here lyeth the body of Michael | Honywood, D.D., who was grandchild | and one of the 367 persons that | Mary the wife of Robert Honywood, | esq., did see before she dyed | lawfvlly descended from her that | is 16 of her owne body 114 | grandchildren 228 of the third | generation and 9 of the fovrth.

Another to the south in capitals (D) :

> Sac. mem. | Tim. Wellfitt, S.T.P., | hujus ecc. præb. | et Eleon. uxor ejus 2^{da}. | Ille obiit Feb. 7, 1685 ætat. suæ 64 . | Hæc [obiit] March 25, 1716 ætat. suæ 9 . . .

Another more to the south also in capitals :

> Here | lyeth ye body of Samvel Fvller, | D.D., | who was

installed chancellor | of this cathedral in ye year 1670, | and afterwards made dean of ye same | in ye year 1695, | and departed this life | on ye 4th day of March $\frac{1699}{1700}$, | in ye 65 year of his age. | Blessed are the dead wch | die in ye Lord.

Still more to the south in capitals :

Sacr: mem: | Abrahami Campion, S.T.P., | decani hujus ecclesiæ qui | obiit xxi die Nov. | 1701.

Another more to the east also in capitals :

Here lyeth the body of | Daniel Brevint, D.D., late | dean of the cathederal | church of Lincoln who | departed this life May the | 5th, anno dom. 1695, | aged 79. | I have waited for thy sal | vation O Lord. Gen. 49th, v. 18th. | Here is ye body of | Anne Brevint the widow of | Dr Brevint, late Dean of | Lincoln, | who departed out of this life | Nov. 8th, 1708, in ye | 79th year of her age.

On another in capitals but much rubbed :

Here lyeth the body of Mris | Elizabeth Paulson the deare | sister of William lord bishop | of Lincolne. Shee lived be | loved 62 yeares and died | lamented October 12, 1673.
Below are some verses, but now nearly illegible.

A flat stone on the floor of St Katharine's chapel (D) :

Here lyeth the body of | Joseph Nicolson, chancellor | of this church, eldest son to | Dr William Nicolson Ld A.Bp | of Cashel in Ireland, who | dyed Sep. 9, anno Dom. | 1728, aged 39 years.

On the table monument of bishop Hugh in the Ladye chapel on a black marble slab in capitals :

Texerat hos cineres aurum | non marmora, præda | altera sacrilegis | ni metuenda foret | quod fuit argenti, nunc | marmoris esse dolemus : | degeneri ætati | convenit iste lapis, | ingenium pietatis hoc est | frugalis, Hvgonis | qui condit tumulum, | condit et ipse suum.

On a black marble slab over an altar tomb to the south of the last mentioned in capitals :

D.O.M.S. | sub hoc marmore in deposito est | qvod reliqvum Gvilielmi Fuller | qvi ex ultima Hiberniâ | ad hunc translatus præsulatum, | anno hvius sæculi christiani | sexagesimo septimo. | episcoporum sexagesimus septimus : | anno etiam ætatis svæ sexagesimo septimo, | mortem obijt vita sva lenissimâ | (si fieri possit) leniorem, | 9 cal. Mai 1675, | sedulus tam in cathedrâ qvam curia episcopus | mortis diu ante mortem adeo studiosus | vt cum monumentorum (qvæ episcopis | ecclesiæ hvius fundatoribus | prisca pientissimè posvisset ætas, | nostra turpiùs dirvisset) | svmptibus svis

non modicis, | alia instaurâsset | alia mox meditaretur instauranda, | fato importuno cesserit. | Abi, viator, imitare quem seqveris.

In the chapel to the east of the north transept of the choir is a handsome monument of white marble, flanked by two Corinthian pillars of black marble, and surmounted by an urn ; it bears the following inscription :

Michael Honywood, S.T.P., | celeberrimæ illius Matronæ | Mariæ Honywood, μακραίωνος και πολυτέκνου | e nepotibus, post nullum memorandus, | Hic juxta situs est, | collegii Christi apud Cantabrigienses olim | alumnus, & socius ; | pietatis, pacis, literarum studiosissimus | quibus vt vacaret | patriam, perduellium conjuratione perturbatam, fugit | XVII post annos, in tranquillam, Carolo IIº reduce, rediit ; | deinceps collegio huic Lincolniensi | decanus annos XXI præfuit | Vir priscâ simplicitate, | morum suavitate, | liberali munificentiâ, insignis, | qua | quidem vnicâ | monumentum sibi cum literis duraturum posuit ; | vtpote qui claustri hujus ecclesiæ dilapso in latere, | extructâ prius, | sumptibus suis non exiguis, | bibliotheca, | eam postea, libris, nec paucis nec vulgaribus, locupletaverit | tandem, spe vitæ immortalis, | morti, Honyvodios lento pede insequenti | lubenter se obtulit, | die VII mensis Septembris | Anno ætat. suæ LXXXV [Anno] Sal. Humanæ MDCLXXXI.

A flat blue stone at the west end of the nave, north of the doors ; arms over—A cross engrailed, and over all a bend . . . [Trimnell] :

Sacred to the memory of | the Revᵈ David Trimnell, S.T.P., | rector of Stoke in Bucks 48 years, | præbendary of Caistor 6 years, | archdeacon of Leicester 41 years, | and precentor of this church, and | præbendary of Kildesby 38 years, | who died May 18th, 1756, aged 81 years.

Another to the east, arms over— . . , a chevron checquy . . . , and . . . between three crosslets fiche . . . [Reynolds] ; impaling — . . . , a lion passant . . . , in a bordure [blank] of mullets [Cooper] :

Elizabeth | wife of Charles Reynolds, D.D., | May 4, 1740, | also the remains of the | Revᵈ Anthony Reynolds, B.D., | rector of Waldegrave with Hannington | in the county of Northampton, | and præbendary of Welton Rivall | in this Cathedral, | he died December 1, 1809, aged 78 years.

Another on the south side of the door ; arms—Reynolds ; impaling — . . . , a fesse . . . , in chief a lion issuant . . . [Markham] ; in base—A saltier engrailed . . . , charged with four annulets [for Leake] :

Charles Reynolds, D.D., | chancellor of this church | died

5th Oct. 1766, æt. 64. | Frances Reynolds | relict of Charles Reynolds, D.D., | ob^t 25 Apr. 1768, | æt. 70.

Another more to the south ; arms over—Reynolds ; impaling— . . . , a fret . . . , on a chief three covered cups . . . :

Anna Catherina | wife of Charles Reynolds, D.D., | deceased Sep. 9, 1751.

A flat stone in the chapel used for morning service ; arms over— . . . , on a bend between two fleur de liz . . . , a lion rampant . . . , a mullet for difference [Lany] ; in capitals :

Hic iacet eximivs | vir Thomas Lany | S. Theol. Bac., | ecclesiæ hvivs | cath : præcentor, | qvi obiit 2º die Oct. | Aº dom. MDCLXIX.

[See also *L.R.S.* i, 60–67 ; Jeans, 39–40 ; Peck, *Desiderata Curiosa*, pp. 294–323 ; *Gentleman's Magazine*, 1807, part ii, 910–11 ; 1822, part ii, 209–11.]

(MS. iii, 61–108.)

St Martin's, Lincoln

Notes taken in the church [now demolished], 7 August, 1833—

A handsome monument of grey and white marble against the north wall of the chancel ; these arms over—Vert, three flying fish in pale argent [Garmston] ; impaling—Argent, on a fesse between three griffins' heads sable as many mullets of the field [Cliffe]. Crest—A shark's head argent vorant a negro proper. Inscription in capitals (D) :

Near this place lie | the remains of John Garmston | Esquire who died on the 5th | of February 1795, aged | 75 years.

At the base :

The body of the Rev^d Francis Harvey, clerk, | and that of his son John Harvey, gent., deceased, | as well as the remains of their relative and heir | the late John Garmston, esq., | and Elizabeth his wife | are deposited in the family vault beneath.

A white marble monument more to the west, arms over—Argent, two barrulets, and in chief three mullets azure [Medley] ; impaling —Azure, a fesse wavy argent, in chief three estoiles or [Jenkinson]. Crest—A wolf's head argent (R) :

Reliquiæ Johannis Medley Armigeri | una cum Martha uxore dilecta | filia Henrici Jenkinson de Wikam in | comitatu Lincolniensi Armigeri | haud procul abhinc requiescunt | Ille vir prudens justus amicissimus | Illa omnium virtutum excellentia | Nitens | Martha festine mortem obiit 18 die Junii | 1707, Annoque ætatis 35º | Johannes lente vestigia sequens | Serus in cælum rediit | Octavo die Maii 1726 Annoque Ætatis 72º. | Johannes Medley proles unica | in piam memoriam hoc cænotaphium | extruxit.

On a neat marble tablet more to the west, with an urn over, inscribed with, within a wreath of laurel, the word ' Pyrenees.' Inscription in capitals (R) :

> Erected | by the Officers of the 91ˢᵗ Regiment | as a mark of their esteem | to the memory of | Captain Robert Lowrie of that Corps, | who died at Vittoria the 3ᵈ October 1813, | in consequence of a wound received | in action with the enemy | on the 28th of July preceding, | aged 34 years.

A neat marble tablet against the south wall of the nave at the east end, with an urn over, and the inscription in capitals (R) :

> Sacred to the memory of Mr Thomas Preston, | and of his sister Mrs Jane Hinde, | the son and daughter of Mr Alderman | Preston late of this city, | the former of whom died on the | 27 of December 1824, | aged 41 years, | and the latter on the 21 of February 1825, | aged 35 years.

On a white marble against the easternmost pillar of the north aisle (R) :

> M.S. | Gulielmi Pownall Armigeri | Ex stirpe antiqua in agro Cestriæ orti | cujus ossa simul atque cum illis | Saræ Pownall ejus uxoris dilectissimæ | Necnon Gulielmi Pownall | Filii sui natu secundi | In ecclesia antiqua sanctæ Margaretæ | non procul hinc in eodem tumulo sepulta | nunc inter ruinas istius ecclesiæ | Eheu infeliciter destructæ | diro fato dissipantur | Gulielmus Pownall senior | obiit XXIII die Februarii | Anno MDCCXXXIV æt. suæ XLII | Sara Pownall uxor et vidua Gulielmi Pownall | Matrona summo in maritum amore | summa in Deum pietate prædita | obiit Iᵒ die Januarii MDCCLXII, | æt. suæ LVII. | Gulielmus Pownall filius | Gulielmi et Saræ Pownall | natu secundus obiit in mense Julii MDCCXXX | æt. suæ VII | Johannes Pownall Armiger | filius Gulielmi et Saræ Pownall natu tertius | hoc monumentum hic posuit | Anno MDCCLXXXX.

On a black slab in the chapel north of the chancel, now used as a vestry :

> Here lies yᵉ body of Tho. | Mainwaring of Lincoln, Esq., | eldest son of | Lt Collˡˡ Chas: Mainwaring | of Martinsand in Cheshire | & of yᵉ Peever family | & of Elizabeth his wife | an heiress & grandaughter of | Sʳ Tho. Grantham of | Goltho in yᵉ county | of Lincoln. | He was an affectionate husband, | a tender parent, | & a sincere friend. | He was beloved whilst living | & his death lamented | by all his acquaintance. | He was born in 1683, | & died yᵉ 5ᵗʰ of Dec. 1734, | aged 51 years & 6 months.

On another slab in raised capitals :

> Here lies Anne | the wife of Tho. | Mainwaring of | Lincoln, Esq., | eldest daughter | and coheiress | of John Quincy | of

Aslackby | in the same | county, Esq., | who dyed August | the 9th, Anno Dom. | 1730, æt. 40. | And also | those of their | children, Anne, | Frances, and | Charles, who | died young.

Another slab :

Here lyeth the body of | Mary Mainwaring daughter | of Tho. Mainwaring, Esq., | she died June 10, 1748, | aged 24 years.

On a flat stone in the north aisle with these arms over— , a lion rampant [Pownall] ; impaling— a bend [Scrope] :

Here lyeth the body | of Elizabeth wife | of W^m Pownall, gent., | of y^e Close of Lincoln & | daughter of Rob. Scrope, | Esq., of Cockrington in | y^e county of Lincolnshire, | departed this life Sept. 18, | 1717, in y^e 22 year of her | age. | Mary Pownall sister of Will. Pownall | died Dec^r 5, 1772, | aged 84 years.

Another slab with these arms engraved over— . . . , a lion rampant [Pownall] ; impaling— . . . , a chevron . . . between three lions jambs erazed . . . , in chief an eagle displayed [Brown]. The first part of the inscription is in raised capitals, but the latter not :

Here lyeth the body of | Thomas Pownall, Esq., | who departed this life | on the 21 day of November | in the 67 year of his age, | 1706. | Also of Mary his wife | daughter & heiress of | Richard Brown, Esq., | of Saltfleetby, | who departed this life | the 19 of Nov. 1756, | aged 91.

On a white marble tablet against the wall of the north aisle surmounted by an urn (D) :

Near this place lie the remains | of the Rev^d John Mounsey | late rector of Thoresway | and vicar of Stainton le Vale | in the county of Lincoln, | who dyed on the 29 day of May | in the year of our Lord 1806, | aged 81 years.

On a white marble oval tablet more to the west of the last (D) :

Sacred | to the memory | of | Thomas Preston | late one of the Aldermen | of this City | who died May the 10, | 1810, | aged 54 years.

On a flat stone before the entrance to the chancel, in parts rubbed (D) :

Corpus Georgii Cutts | Generosi hic est depositum die Natali Aprilis 21, 168 . . , [die] Mortali Julii 4, 1726.

[See also *Lincs. N. & Q.* xii, 17–19 ; *L.R.S.* i, 56–58.]

(MS iv, 149–159.)

𝕷𝖔𝖚𝖙𝖍

Notes taken in the church, 16 August, 1833—

A beautiful altar tomb of white marble on the south side of the chancel (R), covered with a slab of black marble. On the west side are the arms—1st and 4th, Or, a chevron gules between three crosses pate fiche sable [Bradley]; 2nd and 3rd, Per chevron or and gules in chief three leopards' masks, and in base a crescent counter changed [Chapman]. The crest broken off. On the north side this inscription :

> Here lyeth y^e body of | George Bradley, gent., | son and heir of George Bradley late of Louth | in the county of Lincolne, gent., & Jane his wife | daughter of Tho. Ayscoghe, gent. He was | born y^e fourth day of August 1661, & dyed | y^e 23^d of December, when he was warden of | Louth in y^e year of our Lord, | 1688.

On a black slab in the floor of the south chancel :

> Here lieth the body of | John Bolle, Esq., son of | John Bolle, Esq., of Thorpe | Hall. He departed this life | the 12 day of March A° Dom. 1732, aged 79.

Another to the east :

> Here lieth y^e body of | Margaret Bolle y^e beloved | wife of John Bolle, Esq. She | departed this life y^e twenty | seventh day of February | in y^e year of our Lord | 1728, aged 84.

On another to the east :

> Here | lies the body of Jane Bradley the widdow | and relict of George Bradley | late of this town, gentleman, deceased, | and mother to George Bradley | near lyeing, gentleman, deceased. | She was one of the daugh^rs of Thomas | Ayscoghe of Stallingbrough in this county, | gentleman, | who was one of the sons of Sir Edward | Ayscoghe of South Kelsey, knight, | and was baptized the 28 of March | Anno Dom. 1622, | and she departed this life | December the 28, Anno Domini | 1715, ætatis suæ 93 years.

On another to the east :

> Here | lies the bodies of Edward | Ayscoghe gent. and Elizabeth his wife, who departed this | life. She the 3^d day of September | 1720, in the 45th year of her age. | He the 17th day of the same month in the 53 year of his age. | He was nephew | and heir of Jane Bradley, she | cousin and heiress of George | Bradley, both near lieing. | He was formerly of Grays Inn | the Society of London, but late | of this Town, and Warden of the | Corporation.

A monument against the south wall of the chancel, with these arms over—Quarterly, 1st and 4th, Or, a chevron gules between three

crosses pate fiche sable [Bradley] ; 2nd, Per chevron or and gules, in chief three leopards' heads, in base a crescent counter-changed [Chapman] ; 3rd, Sable, on a bend or, between three lions passant of y^e same, three fish vert. Crest— Down the east side are four shields : 1st, Bradley impaling—Argent five bars gemelles gules, over all a lion rampant sable [Fairfax] ; 2nd, Bradley— impaling, Vert, on a chevron, between three stags tripping or three mullets pierced gules [Robinson] ; 3rd, Argent, on a chevron vert a crescent or [Locton] ; impaling Bradley ; 4th, Vert, three standing cups or, in each a boar's head argent [Bolle] ; impaling Bradley. On the west side are also four shields : 1st, Bradley, impaling two coats, the dexter—Gules, on a bend argent three bulls' heads cabossed sable ; the sinister—Per bend indented or and gules [Ferne] ; 2nd, Bradley, a mullet for difference, impaling—A blank shield ; 3rd, Sable a fesse between three eagles' legs erazed or [Howson] ; impaling Bradley ; 4th, Vert, on a chevron, between three stags or, three mullets pierced gules [Robinson] ; impaling Bradley. The inscription is in gold capitals :

In hac humo cum majoribus (multa annorum serie | spec-
tantissimis incolis Villæ de Louth) Christum | moratur
Johannes Bradley armiger Ludæ natus | Familia generosa
qui Cantabrigiæ literis in hospi | tio Grayensi legibus in Belgia
sub D^{no} Fran : Vere | (Uno ex primoribus hastiariis) militiæ
operam | dedit. Vir moribus sanctiss. fide antiqua can- | dore
suavissimo acumine tam scito quam innocuo. | Æque in
publicis ac in privatis negotiis experiens. | Illustris clara
fama ubique sed cum primis | Religione laudabilis quam
Zelo sincero col- | uit Diei Dominicæ Cultor Religiosis
scientiss. | Ita moderator animi sui ut nemo homo vixit | qui
vel jurantem vel execrantem unquam | audivisset consortem
sibi adjunxit parem ex eadem | gente Janam Fairfaxiam
Fæminam lectissimam | natu claram virtute clariorem ex
antiqua | Fairfaxiarum prosapia de Waltham in com. Ebor. |
oriundam cum qua feliciter An. 43 complevit | Amore in
se mutuo hospitalitate in omnes Beni- | gna progeniem lætam
qvot liberos tot omnino | citra unum conjuges reliquerunt
cum se in 43 | libb : et nepotibus expressos vidissent
tempesta- | te inquietissima quiete una vixe- | runt una fere
vita functi in vita et morte | conjuncti una dormiunt obiit
ille annos | habens 67 ii idus Novem. illa LXIII II^{mo} calend. |
Septemb. A° D*om*ini CIƆIƆCXLIII. | Bene merentissimæ
parentum memoriæ ponunt | Hoc monumentum filii . Hoc
tantum nomine ut | virtutis et pietatis habeant exemplum
et incitamentum.

On a stone monument against the wall of the south chancel, these arms below—Quarterly, 1st and 4th, Argent, a fesse wavy between three purses stringed and tasselled sable [for Tathwell] ; 2nd and

3rd, Azure, three fleur de lis or [Burgh]. Crest—An arm couped at the elbow, vested azure :

> Sacred | to the memory of | Robert Tathwell | son of Burgh Tathwell of Stow | in the county of Lincoln, gent., | by Ann daur of Robert Cornwall | of Burford in the county of Salop, Esq., | who carried on a considerable business in this place | for above the space of 40 years | with success equal to his integrity | and in possession of the best of titles | the character of an honest man, | exchanged the cares of this life | for the joys of a better | October 11, 1751, | aged 64.

On an old black tablet below (R); with arms over—Quarterly, 1st, Gules, a chevron between three herons argent [Heron]; 2nd, Argent, semee of crosslets sable, two bendlets of the last []; 3rd, Argent, a fesse between three boars' heads, couped sable []; 4th, Argent, a chevron engrailed gules between three bugle horns sable [Walshagh]. On the sinister side is another shield bearing— Quarterly, 1st, Quarterly per fesse indented argent and gules, in y^e first quarter a mullet sable [Bretton]; 2nd, Argent, a chevron between three eagles' claws [for Yermouth]; 3rd, . . . gules, two lions passant or [Felton]; 4th, Ermine, on a chief 5 lozenges [for Charles]; 5th, Argent, a fesse between two chevrons sable [Gerbridge]; 6th, as the first. The shield on the dexter side is wanting. This inscription in capitals below :

> Here lieth interred the corps of | Edward Heron Esquire, servant to | our most gracious Queene Elizabeth, | son to Thomas Heron brother to | S^r Nicholas Heron, knight, of y^e House | of Edgecombe by Croydon in y^e county | of Surrie, which Thomas had to | wife Olive Bretton daughter | to Thomas Bretton of Felmingham | in y^e countie of Norf., Esquire, who | after y^e death of Thomas Heron | was married to Sir George Hennage | of Hainton in this county of | Lincoln, Knight, which Edward, | being son to the said Dame Olyve, | died in this town of Louth | y^e 29 of August Anno Domini | 1596, commending his | bodie to th' earth | & his soul to th' ever- | lasting joyes in | Heaven.

On a lozenge-shaped black tablet against the east wall of the south chancel ; these arms above—Or, a chevron between three crosslets fyche sable [Bradley]; impaling—Or, three bars voided gules, over all a lion rampant sable [Fairfax]; and at bottom these— A lozenge, quarterly of six, 1st, Three barrulets voided, over all a lyon rampant [Fairfax]; 2nd, A chevron between three [griffins'] heads . . [Tilney]; 3rd, Barry of six gules and or, on a canton sable a crosslet [Etton]; 4th, Or, a bend sinister sable ; 5th, Or, a chevron between three martletts ; 6th, A fesse . . . , in chief a lyon passant . . . :

> Frances Bradlie | daughter of John | Fairfax, Esq., togeather | w^th her husband John Bradlie | sonne of Thomas Bradlie,

marchant | of yᵉ staple, & her too sonns Thos : Bradlie, | Esq.,
& John Doctʳ of Physick lye all in | this place, she living
bountifulie | to yᵉ age of 84, died religiouslie | April yᵉ xv, |
1608.

Against the east wall of the north chancel a small black marble
monument, flanked by two pillars. These arms are over the
pediment—Azure, two chevrons between three mullets or [for
North] ; impaling—Quarterly azure and gules, on a bend indented
or three [martlets] [for Cracroft]. Crest—A [stork] or, holding in
its beak an axe. This inscription below in capitals :

Here lyes yᵉ body of John | North of Lowth, gent., warden |
of this towne & corporat- | ion, whoe departed this | life the
30 day of March | Anno Domini 1670, | ætatis suæ | 61.

On a flat stone in the south chancel with these arms cut under—
Ayscough, impaling—Ermine, a chief dancette, charged with three
[asses'] heads couped [Chaplin]. Crest—An ass's head :

Here lieth the body of | Edwᵈ Ayscough, Esq., who | departed
this life Oct. yᵉ 20, | 1739, aged 36 years.

Another to the north :

In memory of | Nicholas Wrigglesworth | A member of this
corporation. | He served the office of Warden in | the years
1761, 1768, 1774, 1780, 1786, | 1792, & 1798, & departed
this life the | 19 day of July 1803, aged 78 years. | Also of |
Elizabeth his wife, who was the | eldest daughter of Edward |
Ayscoghe late of this town, Esqʳ. | She died 3 May 1798, aged
70 years. | Also of Ayscoghe their eldest son who | died 25
day of April 1797, | aged 46 years. | Also of | Nicholas their
2ᵈ son who | died the 14 day of March 1797, | aged 34 years. |
Also of | James their third son who died | in Ireland the
3ᵈ January 1798, | aged 25 years. | Also of four others of their |
children who died in their infancy.

On another stone of the same kind :

Here lies interr'd | John Marshall, Esq., a late | worthy
parishioner of this | town and member of | the corporation,
and of which he | was four times warden. | In the office of
Magistrate | he was assiduous, constant and | just ; in his
private station of life | humane and generous ; in the | pro-
fession of Physick, Surgery, | & Midwifery, for forty five
years, | experience and practice with | success made him
eminent, | and to the publick useful, | his memory to be
esteemed | and his loss lamented, he | died in the 69 year of
his age, | on the 17 day of April 1759.

Flat stone in the middle chancel :

Here lieth the body of | John Cracroft, Esq., | who departed
this life | the 20th of June 1763, | aged 58. | Also of Sarah
his wife | who departed this life | the 17 of March 1764.

On another more to the south, these arms cut above— . . . , On a chevron . . . three martlets . . . [Cracroft] ; on an escocheon— A chevron between three eagles' heads erazed . . . , on a chief . . . an eagle displayed [Browne] :

> Here lieth the body of | Ann the wife of | Robert Cracroft, Esq., | who departed this life | the 6th day of July 1738, | in the 25 year of her age.

On a stone against the south wall of the chancel, the inscription is nearly now effaced, what remains in capitals at the top :

> Ad Magdalenæ Yarborghiæ tumulum conjugis [lachrymæ],

and at bottom :

> She departed yᵉ 19th of May 1606, | Having wᵗʰ hir husband sonnes and . . . daughters, ætat. 37.

The verses have been preserved through Holles MSS, and will be found in my interleaved *Lincolnshire* by Weir, p. 264. They are also in *Notitiæ Ludæ*, p. 288.

On a tomb stone in the north side of the chancel :

> Mr Charles Beaty died March the 18, 1724, aged 72.
> Mr Richard Beaty son of Mr Charles Beaty died Decʳ 1, 1735, aged 38.

[See also *Lincs, N. & Q.* xii, 21–26 ; *Notitiæ Ludæ*, pp. 288–90 ; L.R.S. i, 93–95.]

(MS iv, 181–195.)

Ludborough

Notes taken in the church, [*blank*]—

On a flat stone in the chancel :

> In memory of the Revᵈ | Mr John Mattison rector | of Ludburgh who departᵈ | this life September yᵉ 14, | A.D. 1758, aged 71. | In memory also of Martha | his wife who departed | this life March yᵉ 13, | 1757, aged 59. | Likewise Robᵗ his son | who departed this life | July the 12, A.D. 1731, | aged 4 months. | In memory of the Revᵈ | Mr Richard Mattison, clerk, |who departed this life | May 5, 1762, aged 29 years.

This is a handsome church ; it consists of a nave and aisles, a chancel, a tower at the west end, with a modern south porch. The nave and aisles rest upon three pointed arches on each side, rising from clustered columns. The arches by which the nave is divided from the tower and chancel are pointed. The chancel is of Early English style, and the east window is lancet of two lights. The roof seems to be in its original state, of very handsome oak. The windows on its north side are lancet, on the south side Decorated. The roof of the nave is also open to the timbers, but it has been lowered. The font is a plain octagon. The tower is a handsome one of Perpendicular style ; it contains three bells. On the south

of the altar is a double piscina, one arch being ogee the other round.
There remains the old benching with which all the church is filled
up, and it is kept in very good order. The east end of the south
aisle is used for a school.

[See also *Lincs. N. & Q.* x, 232.]

(MS vi, 117–118.)

Lutton

Notes taken in the church, 11 August, 1835—

Outside the church is a monument against the south wall, with
these arms under the inscription—Quarterly, 1st and 4th, . . . ,
a cross flory [for Redhead] ; 2nd, . . . , a bend or ; 3rd, A fesse
or between six fleur de lis :

> Near | this place | is interred yᵉ body | of Gilbert Redhead, |
> gent., who depᵈ. | this life the | 17 of Aprˡ 1770, | aged 56
> years.

On a black stone in the middle aisle with these arms above—Three
bucks' heads cabossed in fesse [Parke] ; impaling—A bull's head
couped affrontee [? for Huste] :

> Here lieth the bodies of | Reuben Parke, Esq., of this parish, |
> and of Mary his wife, which said | Mary was one of the
> daughters of | James Hoste, Esq., of Sandringham in the |
> county of Norfolk. They departed | their lives as followeth : |
> She departed this life the 7th day of Novembʳ | Anno Dom.
> 1710, in the 45 year of her age ; | and he departed this life
> the 6 day | of September Anno Dom. 1731, | in the 80 year
> of his age.

On a black stone parallel to the last with the Parke arms above :

> Here lieth interred the | body of Richard Parke gent. who |
> departed this life the 25 of Novemb. | in the year of our Lord
> God | 1668, | aged 46 years. | Here also lieth the body | of
> James Parke Esq. the son | of Reuben Parke Esq. who |
> departed this life the 18 | day of Novembʳ 1724, | aged 35
> years.

On a black stone to the east of the last :

> Here lyeth interred | the body of Mrs Tabitha Parke | who
> departed this life the | 7 of May in the year of our | Lord
> God 1668, | aged 67 years.

On a black stone parallel to the last :

> Thy busy and inquisitive eye | Seems to demand what here |
> doth lye | If that I must disclose my trust | Tis great lemented
> prudent dust | If yet unsatisfyed thou'lt know | And eurg
> me further read below. | Here lyeth the body of Mr Rubeⁿ |
> Parke of Lutton who deceased the | 10 of July 1659, in the

63 yeare | Of his age. | Hence Quarrell Nature tell she shall | Repeate her clymactericall.

On a black stone in the north aisle at the west end in italics :
Here lyeth the body of Mr Reuben | Parke Upholster, and citizen of London | son of Thomas Parke of Lutton, gent., and | Elizabeth his wife, he departed this life | the 31 of August 1719, aged 62 years. | A just man and one yt feared God.

In the centre of an old stone in the middle aisle (D) :
Hic jacet Rachel uxor | Bevilli Wimberley, Gent., quæ | obiit quarto die Octobris | 1704 | ætatis suæ anno vicesimo quinto | Mæstus posuit Maritus pietate | charitate et castitate | uxorem clarissimam.

Round the verge of the same stone in church text (D) :
Maria 7 Agnes quondam uxores Joh'is Chilton, que quidem Maria obiit anno Domini MCCCCCIIII 7 Agnes obiit A' Domini MVC quarum animabus Deus omnipotens misereatur.

There were two female figures engraved on the stone, but the heads have been erazed by the inscription to Rachel Wimberley.

In the middle aisle is a black stone, most probably to one of the Parkes, but almost quite concealed by the pulpit stairs. All that remains is "Heare lyes Mrs Dorothy deceas . ."

On an old stone in the south aisle partly hid by a pew :
. . . jacet Tome Harcroft qui obiit XXII die mensis Octobris Ano Domini MCCCC° XXIJ. cuius anime propicietur Ds amen.

This inscription is round the verge and the figure of a man in the centre.

A white marble monument against the south wall of the chancel, these arms over— , a pale of lozenges [Danyell] ; crest—A horse's head erazed . . . :
To the memory | of Austine Danyell, gent., | whose body is here interred | with many of his ancestors & relations | whose eminent virtues he inherited. | For love to his country and | constancy in friendship | He exerted with great zeal. | He was born 20 Sept. 1693, | and dyed 2d March 1724. | His only sister Jane the wife of | Adam Enos, Esq., | caused this memorial of him | to be erected 1725.

On three lozenge-shaped stones in the chancel, one partly hid by a pew :
(1) Here | lyeth the | body of Will- | iam the son of | William and Mary | Danyell, gent., who depart | ed this life August the 25th | 1698, | in the 39 year of | her [sic] age.
(2) Here | lyeth the | body of Dobson | Danyell the s . . | of

R

William Dan | and Jane his wife | parted this life April . . , | 1707, in the 9th year . . | his age.

(3) Here | lyeth the | body of | Mathew Danyell | who departed this life | September the 23, Anno Dom. | 1710, | in the 49 year of | his age.

On another stone similar near y^e door partly hid by a pew at the top :

Mat. Danyell son of | Mat. & Anne | dep. 8 Dec^r 1700, | aged 20 weeks. Robert his | brother dep. 8^ber 10, 1706, | aged 16 weeks.

A flat stone at the west end of the nave :

In memory of | Samuel Coddington, gent., | who departed this life | the 5th of February 1774, | aged 64 years, | and of Etheldr. his wife | who departed this life | the 23^d of December 1762 | aged 53 years.

On three lozenge-shaped stones to the east of the last, rather rubbed :

(1) Here | lyeth the body | of Judith the wife | of Adler Crapley | who departed this life the 4th | day of February 1769, in the [54] | year of her age.

(2) In | memory | of Ann y^e wife of | Adler Crapley who dep^d | this life January y^e 27, 1746, | aged 31 years, | also Eliz. their daughter died | Sept. y^e 23, 1747, in her | infancy.

(3) Here | lieth interred | the body of | Adler Crapley | who departed this life | April the 24, 1774, | in the [64 ?] year of his age.

A lozenge-shaped stone under the pulpit (D) :

Here | lieth the body | of William Coxon, | gent., from the parish | of Caythorpe in this County. | He was nephew and heir unto Mr | John Robinson, gent., of Fulbeck in | the said county, and departed this | life at his habitation in this parish | on the 11 day of Aug^t 1726, | in the 18 year of his age.

A flat stone in the north aisle in capitals (D) :

Here lieth | Joseph and John | y^e sonnes of William | and Jane Nicholas, | they died infants | Anno 1661 & 1665.

This church is built partly of brick, but old. It consists of a nave divided from each aisle by four pointed arches with plain columns, a chancel, with a plain tower and spire at the west end ; the steps of the rood loft still remain on the north side of the arch entering the chancel. The pulpit is of very handsome old oak, said to have been presented by the celebrated Dr Busby. The font is octagonal on a plain basement of two divisions parted by rosettes. It has a large oak cover. There are many remains of old pewing about the church.

[See also *Lincs. N. & Q.* xi, 90–93. *Churches of Holland.*]

(MS viii, 29–38.)

𝕸𝖆𝖇𝖑𝖊𝖙𝖍𝖔𝖗𝖕𝖊

Notes taken in the church, August 18, 1835—

In the centre of the chancel floor a figure of a female in brass (R), with this inscription under, in church text, also on brass :

> Here lieth Elisabeth dowghter of George Fitzwilliam of | Malberthorp, Esquier, wich George maried Elizabeth dowghter| of Sʳ Thomas Barneston of great Coot', knight, the said Elisabeth | the younger decessed the ɪɪᴊ day of May the yere of oʳ Lord God | ᴍº ᴄᴄᴄᴄᴄº xxɪɪ On whose soule Jh'u have mercy, Amen.

On a stone (R) in the middle aisle, which has had shields at the corners, but now all gone, this inscription in brass in church text :

> Hic jacet Thomas Fitzwilliam Armiger | qui obiit primo die Novemb' Anno d'ni ᴍº | ᴄᴄᴄᴄº ɪɪɪº cuius anime propicietur Deus Amen.

North of the altar in the north wall is an altar tomb of stone with a canopied recess, in which have been figures of brass, labels, inscriptions and shields, all now gone ; in fact the monument itself till lately has been so obscured with whitewash, two inches thick, that the beauty of the carving and freshness of the stone is quite destroyed. Over it hangs a fragment of an old helmet which has also suffered from the mania for whitewash, being deeply cased therewith. In the tomb, when it was cleaned, were found several bones and a skull with six teeth yet remaining.

Below is a large flat stone having a brass with this inscription in old letters :

> Here lieth George Fitzwilliam, knight, son of Thomas Fitz-william | of Malberthorpe, knight, wiche George dyed yᵉ xɪxᵗʰ day of yᵉ moneth of | September in yᵉ yere of owr Lorde God a. ᴍ ᴄᴄᴄᴄᴄ xxxvɪ, on whos sowle | Jhesu have mercy, Amen.

There have been two shields above the inscription and one below.

On a flat stone in the nave (R), a brass plate with this in old character :

> Hic jacet Elizabetha nuper uxor Thome Fitzwilliam | et filia Joh'is Askt que obiit nono die Junii Anno D'ni | ᴍºᴄᴄᴄᴄ ɪɪᴊ cuius anime propicietur Deus, Amen.

Below are two shields. The dexter one—Quarterly, 1st and 4th, , a chevron . . . , within a bordure . . . entoyre of roundles [for Mablethorpe]; 2nd and 3rd, Two bars engrailed [Stayne] ; impaling— . . . , three barrulets . . . , an annulet for difference [Aske]. The sinister one (D) bears—Quarterly, 1st, Three barrulets

an annulet for difference [Aske] ; 2nd and 3rd, . . . , five fusils in fesse.

This church consists of a nave and aisles divided by four pointed arches, a chancel, and a low tower at the west end. South of the altar are three stone stalls.

[See also *Lincs. N. & Q.* x, 233–234 ; Jeans, 43–44.]

(MS vi, 49–50.)

Marsh Chapel

Notes taken in the church, 17 August, 1833—

Over the south door is the following inscription cut on the stone :
Orantibus in loco isto Dimitte Domine peccata.

Over the north door of the entrance is cut this in the stone :
Non est hic aliud nisi domus Dei et porta celi.

On the wood of the north door is carved (D) :
Ano D'ni | 1606 Walter Harpham Es.

On a stone at the east end of the north aisle round the edge (R) :
Hic jacet Johanna uxor Wyllelmi Cowper sexto die Martii a. domini MCCCCVIIJ° cujus anime propicietur deus amen.

On a partially defaced stone to the west of the last (D) :
. Willelmus Cowper de Sout Stockwith qui obiit MCCCC cu

On another old stone near the last, very much defaced (D) :
. acet. Thomas Garbara

On another only the date is decypherable (D) :
" MCCCCVI."

And on another the inscription is thus far legible (D) :
Hic jacet Joh'es Pepyson qui obiit VI die

Against the south wall of the chancel is a small white marble monument. In two recesses formed by a pillar are the kneeling figures of a gentleman in a gown and ruff, and his lady opposite before a desk ; at her feet a child. The heads of the man and child are gone. Above are the arms—, a mullet . . . , in base a fleur de lis [Harpham] ; at the top is an hour glass. Below the figures is this inscription in capitals on a black slab :
To the sacred memorie of | Walter Harpham, gent., & Anne his wife whoe lived & | died in God's feare & favour. He March the 23, 1607, aged | 60 years, She March the 15, 1617, aged 76, and had issue | Alice maried to Tho. Phillips, gent : who by him had | issue Willoughby whoe died childlese, and Eliz. | married to William Wesled gent : & by him had issue | 7 sones & 3 daughters and by Chr : Broxholme, gent., | her 2d husband had issue one sone, and died | July the 20, 1628, aged 33 years.

On a flat stone in the chancel (R) :

> In memory of | Mary the daughter of | John and Mary Loft | who departed this life | May the 2d, 1794, | aged five months.

[See also *Lincs. N. & Q.* xi, 229–230.]

(MS iv, 77–79.)

Marton

Notes taken in the church of Marton, 15 September, 1835—This church consists of a nave and aisles, the north divided by two round arches and columns having foliated capitals, and the south by two pointed ones springing from plain octagonal pillars and capitals. The chancel is divided by a plain Norman arch, and has had a north aisle now used as a vestry ; it is divided from it by a Norman arch. The chancel seems to have been lately modernised. The windows of the rest of the church are perpendicular. In the churchyard is the shaft of a cross.

A flat stone in the nave :

> In memory | of Hall Bellamy who departed | this life January 17, 1799, | aged 53 years. | Also Mary wife of the above | who died August 8, 1795, | aged 38 years.

A flat stone in the chancel (R) :

> In memory of Rob't | Banks who died the 21 | day of August in the year | of our Lord 1748, aged | 51 years. | To speak Thy praise let this suffice | Thou wast a loving husband discreet and wise | Till death did ease thee of thy pain | I hope in Heaven we shall meet again.

(MS vii, 145–146.)

Messingham

Notes taken in the church, 11 September, 1835—This church has been greatly repaired and ornamented by Archdeacon Bayley, the late rector. It consists of a nave, and aisles which rest on four pointed arches on each side ; a chancel ; and a pinnacled tower at y^e west end. The east window is perpendicular of three lights, and is filled with old painted glass taken from other churches. There are several shields—(1) Gules, four fusils in fesse argent, a border engrayled or [Nevile]; (2) the same ; (3) Gules, four fusils in fesse argent, a label of five azure [Nevile] ; (4) Argent, two bars gemelles, and a chief sable, a border engrayled gules. The remainder of the window is filled up with figures of saints, and very handsome ; two more shields of the fusils, and some modern bordering. The east window of the south aisle has also painted glass filling it, in which are two shields—(1) Or, a cross engrayled between four martlets . . . , partly broken ; (2) Quarterly argent and sable, a cross flory pierced counterchanged.

The other windows of the chancel have a few pieces in them of antient and modern glass, as also most of the windows in the church. The font is modern, octagon, small, with a shaft of the same plan, and a carved oak cover. It stands in the centre of the chancel. The pulpit is very handsome, of carved oak made from a clock case in Lincoln Minster. The reading desk and clerk's desk are also made from very fine old carved oak stalls from the church of Althorpe in Axholme. A full description of the painted glass in the windows, and from whence each piece came, also of the pulpit, etc., is to be found in the register of the church.

A white marble tablet against the north wall of the chancel :
> Sacred | to the memory of | Francis Roadley | son of | Richard & Mary Roadley | who departed this life | December 12, 1796, | in the 25th year | of his age.

On another near to the last :
> Sacred to the memory of | Richard Roadley | who died March 10th, 1812, aged 71 years, | of Mary his wife | who died January 28th, 1781, aged 38 years, | of Mary Roadley his sister | who died January 18th, 1808, aged 77 years, | And of | Sarah, Carr, John, and Sarah | children of R. and M. Roadley | who died in their infancy.

A brass plate against the wall of the south aisle in capitals :
> In spe Resurrectionis. | Here lyeth interred the bodies of Martin Gravyner, | gent: and Effam his wife who lived in ye Consecrated | estate of matrimonye 36 yeares, and had issue | eight children, viz. 2 sonnes & 6 daughters, which | Martin died ye 2 of June 1616, and the said Effam ye | 3 of Sept. 1616. | (A crowned skull) Veni uidi uici. | Thus Death tryumphs and tells us all must die | Thus we tryumph by death to Christ to flye | To live to die ; is not to die but live | To die to bliss is blessed life to give | Aske how they lived and thov shalt know their ends | They dyed saintes to God ; to Poore true friends.

A black marble monument to the west of the last :
> Sacred to the memory | of the late Revd John Ferrand, M.A., | who was vicar of this parish near 28 years | and died Jany 16, 1759, aged 52, | not to mention the several parts of his private | character which was remarkably amiable and | exemplary, he was a truly pious and judicious | Divine, an able and instructive preacher, | faithful and diligent in the discharge of his | ministerial functions, and being possessed of | an handsome fortune and happy in a good | understanding with a peculiar sweetness | and evenness of temper, was not only | extremely liberal to the distress'd, | but also a great promoter of peace and charity | and very successful in reconciling differences | among contending neighbors, | and as he was

deservedly beloved so he died | greatly lamented by all that knew him. | He married Mary daughter of Thomas Hatchett | of Southwell, Esq., and Mary his wife, | by whom he had | Gerard Thomas born 2d Decr 1751, now living. | John born 2 Sept. 1753, died 11 Oct. 1753, Mary born 27 July 1755, died 10 Aug. 1758, both interred near him.

A marble monument to the west, these arms under—Per fesse gules and argent, in chief three crosses flory or [Ferrand]:
Near this place | are deposited the remains of | Mrs Mary Ferrand relict of | the Revd John Ferrand | late vicar of this parish. | Also of Gerrard Thomas Ferrand, Esq., | their only son. | She died at Cambridge Jany 2, 1776, | aged 55 years. | He died at Bristol July 10, 1779, | aged 27 years. | They were possessed of all the virtues and | affections which could possibly adorn the | characters of the parent and son. | This monument | was erected by Stephen Ferrand, Esq: | as a testimony of his respect | to the memory of his | sister and nephew.

A white marble tablet against the east end of the south aisle:
To the memory of | Mr Thomas Raven | who departed this life | the 15th of May 1800, | in the 49 year | of his age.

A flat stone on the floor of the south aisle:
In memory of | Richard Gravenor | of this parish who died | December the 23, 1778, | aged 48 years. | Also of Elizabeth wife of | the above who died at | Edwinstowe in the county | of Nottingham | May the 26th, 1815, | aged 82 years.

On a flat stone in the nave:
Sacred | to the memory of | the Revd Edward Horden | vicar of this parish | 26 years | who died 28 April 1811, | aged 56 years.

[See also Jeans, 44.]

<div align="right">(MS vii, 113–119.)</div>

𝔐inting

Notes taken in the church, 12 October, 1840—The church of Minting is a small old building consisting of a chancel, nave, and north aisle, the nave being separated from the aisle by three Saxon arches with clustered columns. There is a small piece of painted glass (D) in the window of the north aisle which appears to bear a portcullis or, but it is only a fragment. The chancel is divided off by a carved Gothic screen and before the altar is an old stone which has had both brass figure and inscription, now gone.

The only monument is against the north wall of the chancel—a brass oval convex plate with this inscription:
Gulielmus Chapman | Probus doctus lepidus facundus | Hic

jacet | Pietate fidelitate benignitate modestia | Nulli secundus |
Hanc vicariam bis 20 | et octo annos tenuit | Clarus in umbra |
Rara in senectute emicuit | Die 14 Aprilis decessit | Anno
ætat. 82, annoque Dom. | 1722.

There is a south porch (R) in the east wall of which is embedded
a well-carved old stone of oblong form with the figure of Christ
on the Cross between two figures. There seems to have been a
brass plate above.

<div align="right">(MS x, 19–20.)</div>

Morton by Bourne

Notes taken in the church, [*blank*] August, 1831—This is a large
cross church with a fine tower at the intersection, and a handsome
west window and porch, the other windows are fine. The living
is in the gift of the Bishop of Lincoln. The incumbent is the
Rev^d Samuel Edmund Hopkinson.

On a flat stone in the chancel (D) :

> Here | lies interred the body of | George Mitchel | eldest
> son of | Rob^t Mitchel Robinson, | Esq., and Jane his wife |
> who died March the 19th, 1789, | aged 17 years. | But there's
> a power above us nature | Proclaims thro' all her various
> works | Who doth delight in virtue & those | Whom he delights
> in must be happy.

On another flat stone more to the north (D) :

> Here | lies interred | Jane the wife of Rob^t Mitchell Robinson,
> Esq., | and one of the two daughters & co-heiresses | of George
> Robinson late of the Bail of Lincoln | & of Fiskerton in this
> county, | Esq., deceased, who died June y^e 20th, | 1778, |
> aged 27 years. | She was Religious, Charitable, Polite, without
> Affectation, Ostentation, Adulation, an affectionate wife | a
> tender mother | and a sincere friend.

[See also *L.R.S.* i, 195.]

<div align="right">(MS i, 61–62.)</div>

Moulton

Notes taken in the church, 23 July, 1833—

A white marble tablet on the north wall of the chancel :

> Sacred | to the memory of | Helen Jenkyns | daughter of |
> the Rev. Samuel Elsdale, M.A., | (Master of the Free Grammar
> school in this parish), | and Catherine his wife. | She died on
> the 9th March 1818. | She was a most heavenly minded,
> tender hearted child, | ever dutiful to her parents, loving &
> beloved. | The Lord gave & the Lord hath taken away, |
> blessed be the name of the Lord. | Ere grief could blight thy
> op'ning bloom | Or sin thy charms destroy | Thy Saviour
> called an angel home | To realms of peace and joy.

MOULTON 265

On a similar tablet against the wall :
> Sacred | to the memory of | the Rev^d Samuel Elsdale M.A. | late fellow of Lincoln College Oxford, | and master of the free Grammar School | in this place. | He died the 13 of July 1827, | aged 47 years. | Give alms of thy goods and never turn thy face from | any poor man and then the face of the Lord shall not | be turned away from thee. Tobit, chap. 4, | ver. 7.

On a flat stone before the chancel (D) :
> Here lieth the body of Mr Robert | Heath vicar of this place who | departed this life May the 8th | Anno Dom. 1665, aged 42 years. | Here lyeth the body of Mrs Mary | Heath the wife of Mr Robert Heath | who departed this life April the 7 | Anno Dom. 1708, aged 83 years.

On an old stone in the nave before the chancel :
> Joannes Harrox*us* funere dignus | Ampliori hic in Domino | requiescit 1560 |

On a black marble slab in the nave :
> Under this marble was buried | February the 26, 1763, | the Rev^d John Chapman | master of the Free Grammar school | in Moulton, aged 67. | On his left hand was buried | June the 30, 1751, | Elizabeth his wife, | aged 51, | and | on her left hand was buried | November the 4, 1749, | Ann their daughter, | aged 24.

On another :
> Edward Hunnings | Dec. 18, 1733, aged 36 years, | and one infant son. | Elizabeth the daughter of | Robert & Elizabeth | Butter of Spalding, merchant, | and wife to the above | Edward Hunnings | and Charles Holland | both of this parish | Nov. 14, 1780, aged 77 years. | Frances Susanna daughter of | James & Elizabeth | Sneath of Spalding | and grandaughter to the above | Edward & Elizabeth | Hunnings, | an infant.

On a black stone in the middle aisle (D) :
> In a vault | beneath this stone | lie the remains of | John Hardy, gent., | born Feb. 25, 1709, | died Nov. 26, 1792. | Also on his left side | lies Alice Tatam, she died | Nov. 22, 1788, aged 9 years. | And also John and William | Tatam who died infants | his grand children.

Close to the last on a black stone :
> Beneath this stone | lie interred the remains of Mrs Anne Tatam | the widow and relict of Mr William Tatam | and daughter of | John Hardy, gent., | who departed this life | the 3 day of February 1807, | aged 57 years.

On a stone in the north aisle :
> In a vault | beneath this stone | lieth the remains of | Mr

Samuel Wood | who departed this life | Feb. 25, 1806, | in the 63 year of his age. | Also Rebecca his wife | died November 26, 1805, | in the 56 year of her age.

In the north aisle :

Here lyeth y^e body | of John Cocke son | of John Cocke & | Elizabeth his wife | who departed | this life February | the 10, 1681, aged | 2 years.

Near the last :

In memory of | Ann the daughter of Mr Joseph | and Ann Alcock | who departed this life July the 31, | 1770, | an infant. | Also of Mary their daughter | departed this life April y^e 21, | 1771, | an infant.

On a black stone across the aisles between the doors :

Elizabeth | daughter of Mathew & Martha | Clark | died May the IV, MDCCXCV, | aged XX years.

On the next stone to the south :

Mathew Clark | died September 27, 1791, | aged 32, | and one infant son.

On the next :

Martha the wife of Edward Hunnings | of Boston in this county, | and daughter of | Mathew and Martha Clark | of this parish, grazier, | December 11, 1787, aged 23 years.

On the next (D) :

James | son of | Mathew & Martha | Clark | died September 1, 1785, | aged | XV.

On the next :

In memory of | Martha | the relict of | Mathew Clark, gent., | who died Sept. 29, 1816, | aged 77 years.

On the next (D) :

In memory | of | Mathew Clark | who departed this life | the 6 day of July 1782, | aged 34 years. | Also Sarah his daughter, | aged 12 years. | Likewise 4 children died infants.

On another flat stone (D) :

Mrs | Mary Elizabeth Anne, | wife of | Mr John Cooley, | younger daughter of | Mr John and Ann Molson, | died June 20, 1807, | aged 27 years. | Thomas | son of the above | Mr John and Ann Molson | died June 14, 1807, | aged 21 years.

On a marble monument against the south wall of the nave, at the entrance to the chancel, with these arms under—Azure, three bird-bolts in tun argent [Boulton] : the inscription is in capitals (D) :

Sacred | to the memory of | Alice the daughter of | Henry and Alice Boulton | late of Stixwould | in the county of Lincoln, | who was born Sept. 1, | 1722, | and died Dec^r 6, | 1784.

On a stone in the south aisle :

> Juvenis eximiis animi dotibus | ornatus florenti ætate | e
> vivis sublatus triste | sui desiderium reliquit | obiit 2 die
> Octobris | Anno Ætatis 23 | [Anno] Dom. 1723, Edwardus
> Staunton A.B.

There is a singular font at the west end of the nave, said to have
been executed by a travelling artizan about fifty or sixty years
back ; it is made of wood, and represents Adam and Eve standing
by the tree of knowledge, the upper branches of which enclose the
basin. Eve is just gathering the apple. On the basin are carved
these three subjects, 1st, the baptism of our Saviour by St John ;
2nd, the dove returning to the ark with the olive branch ; 3rd, the
baptism by Philip of the Eunuch. The carving (especially of the
last in its carriage and horses) is very grotesque, and is rendered
by painting still more ridiculous. The cover is suspended over,
with the flying figure of an angel which seems to support it.

On a white marble monument at the west end of the south aisle,
with arms over—Azure three bird-bolts or ; crest—A bird-bolt in
tun proper [Boulton]. In capitals :

> In the family vault beneath lie the remains of | Henry
> Boulton, Esq., | Many years a magistrate for the counties
> of | Lincoln and Rutland, | and formerly resident in this
> parish. | He died in December 1788. | He married first
> Susanna Beridge, widow, | who died in November 1749 ; |
> secondly, Sarah | daughter of Theophilus Buckworth, Esq., |
> of Spalding ; | she died in January 1754, | both of whom
> lie buried here. | He married lastly, Mary daughter of | Darcy
> Preston, Esq., of Askham in the county of York. | She died
> in February 1779, | and was buried at Uppingham in the
> county of Rutland. | Also of Henry Boulton, Esq., eldest
> son of | the above, who practised some years | at the Chancery
> Bar. | He died March 11, 1828, at Geddington House | in the
> county of Northampton. He first married Susanna eldest
> daughter | and coheiress of Mr Serjeant Forster ; | she died on
> the 5th of September 1788, | and was buried at Hampstead |
> in the county of Middlesex ; | secondly, Mary daughter of
> John Francklin, Esq., | of the county of Bedford ; | she died
> September 4th, 1795 ; | thirdly, Harriet daughter of | the
> Rev^d Baptist Isaac of the county of Dorset ; | she died March
> 3rd, 1806 ; | fourthly, Mary Winifreda daughter of | Lieutenant
> Colonel Durell ; she died April 9, 1808. | These three last lie
> buried here. | Lastly he married Emma fourth daughter of |
> Thomas Lane, Esq., formerly of | Selsdon in the county of
> Surrey who survived him. | This monument was erected by
> the surviving widow | and the children of the respective
> marriages,

On a blue flat stone below on the floor:
> In memory of Sarah | wife of Henry Boulton, gent., | (daughter of Thomas Buckworth of Spalding, | gent., & Elizabeth his wife). She died | January the 17, 1754, N.S., | in the nineteenth year of her age. | Henry son of the above Henry and Sarah | died May 8, 1754, N.S., | aged 17 weeks.

Another collateral to the last to the north in capitals:
> Here lyeth the body of | John Rea, gent., who | departed this life | October the 29, 1676.

On another more to the north:
> Christiana the wife of James | Bolton, gent., (and daughter | of Edward Numan late of | Folksworth in the county | of Huntingdon, gent.), departed | this life the tenth day of | September 1704. | In memory of | Susannah the wife of | Henry Boulton, gent., | (daughter of Robert Butter of | Spalding, merchant, & Eliza- | beth his wife), who died | November the 10, 1749, | aged 28. | Susanna daughter of | Henry and Susanna died March 10th, | 1749, aged 15 months.

On another still more to the north, partly concealed by a chest:
> The interment of Jane the wife | of James Bolton, junior, gent., | (and daughter of Samuel | Doughty, clerk, late of Stanground | in the county of Huntingdon), was | the 11th of January 1722. | James & Doughty sons of | James and Jane here interred | the 18 of January | 1722.

On a brown stone to the east of this range (D):
> Here lyeth the body | of Elizabeth the da- | ughter of James Bol | ton, gent., and Christiana his wife who departed | this life ye 29 day of | April 1700.

On a coffin shaped stone more to the east, much rubbed (D):
> Here lyeth the | body of Philip Tallents vicar of | this place who | departed this life | Dom. 1704, | ætatis suæ 76.

Another to the north:
> Here lyeth ye body of | William Staunton, clerke, | who departed this life | April ye 3rd, 1711, | aged 41 years.

On a brass plate in the south aisle in capitals:
> Heare lyeth interred the body | of John Cocke whoe departed this | life March the 8o, 1666, aged 63, | And Thomasin his wiffe whoe | departed this life November | the 1o, 1680, aged 73.

On a marble slab to the east of the last:
> Here lyeth the body of John | Cocke late of Moulton son | of John Cocke and Thomasin | his wife who departed this | lyfe the 9th day of May 1689, | aged 59. | Here lyeth allso the bodys of | John and Ann Cocke gran- | children to this John

Cocke | and son & daughter to | John Cocke of Moulton and | Ann his wife who departed | this lyfe being infants.

On a black slab to the north of the last (D) :

Here lyeth | the body of John Cocke, gent., | who departed this life March | the 2ᵈ, 1727, aged 66. | Here lyeth the body of Thomas Cock, | grandson of the above John and | Ann Cock, who departed this life | the 10th day of September 1731, in | the fifth year of his age.

A hatchment over the Boulton monument, Boulton, impaling— Quarterly, 1st and 4th, Per pale azure and gules, three saltiers or, over all three crescents argent [for Lane] ; 2nd, Or, a bend verrey cotised gules [Bowyer] ; 3rd, Gules, a bezant between three demy lions couped [Bennet]. Crest of Boulton. Round the large shield are four small ones : (1) At the top, Boulton, with an inescucheon—Argent, a chevron between three bugles, stringed sable, differenced by a crescent [Forster]. (2) At the bottom Boulton, with an escucheon—Argent, a lion rampant guardant or. (3) On the dexter, Boulton, impaling—Quarterly, 1st and 4th, Argent, on a bend sinister between three [lions'] heads sable 3 or [Francklin] ; 2nd and 3rd, Sable, three bugles argent [for Forster]. (4) On the sinister, Boulton, impaling—Sable, a bend or, on a canton argent a leopard's face proper [Isaac].

Another hatchment against the south wall—Boulton, impaling— Sable, a bend or, on a canton argent a leopard's face proper [Isaac].

Another hatchment against a pillar opposite—Boulton, on an escucheon—Azure, a lion rampant ermines crowned or [Durell].

This is a large and handsome church. The nave and aisles are supported by six pointed arches springing from massy clustered columns. There is a screen between the nave and the chancel ; and the roof of the tower, which is open to the nave by a fine pointed arch, is handsomely groined. The tower and spire at the west end are of peculiarly fine proportions and form a most beautiful object. The windows are very fine. In the rest of the church they are all despoiled of their tracery.

[See also *L.R.S.* i, 174–175 ; Jeans 45 ; *Churches of Holland.*]
(MS ii, 117–137.)

Navenby

Notes taken in the church, 8 August, 1833—

On a monument against the north wall of the chancel, with these arms over—Or, three chevrons sable on each of which five garbs of the field [for Leightonhouse] (D) :

In this Chancel lieth in- | terred the body of | Walter Leightonhouse, | Gent., | who departed this life 7 | Jan. 1760,

in the 69 year | of his age ; also near | the same place lieth
interred | the body of Deborah wife | to the said Walter
Leighton- | house who departed this life 30 | Sept. 1758, in
the 80 year of her | age.

On a black stone in the chancel (D) :
In memory of | Susan daughter of | the Rev. Dearing Jones, |
and Hannah his wife | who departed this life | May the 31,
1804.

On a black stone next to the last (D) :
In memory of | the Reverend Dearing Jones | late Rector
of this parish | who departed this life | November the 12,
1803, | In the 84 year of his age. | He might justly be called
a good man.

On a black stone (D) :
To the memory of | Hannah Jones | wife of the Rev. | Dearing
Jones | Rector of this Church | whose amiable disposition | &
prudent behaviour | were acknowledged | by a general respect. |
She died Febry 7, 1784, | in the 69 year of her age.

On a white marble slab in the floor near the last (D) :
In | memory of | Lieutenant Dearing Jones | of his Majestys
thirty third | Regiment of Infantry, | only son of | the Revd
Dearing Jones | Rector of this Church, | he departed this
life | the 27 day of May 1786, | aged 28 years, | well respected
in his profession. | No youth no strength against the hand
of fate prevail | When Heaven decrees, in all their power
alas how frail. | O fallacem hominum spem fragilemque
fortunam.

On a white marble slab near the last (D) :
To the memory of | the Rev. David Potts, A.M., | Rector
of this Parish | who departed this life | January 21, 1814, |
aged 64 years.

On a stone before the altar rails (D) :
In the memory of | Mary Smith | who departed this | life
March the 23, 1784, | aged 86 years.

There are flat stones at the west end of the south aisle to the
memory of (D) :
Thomas Maples died 13 September 1805, aged 70.
Gervase Maples died Jan. 6, 1775, æt. 72.
Frances wife of Gervase Maples died March 24, 1769, aged 61.
Thomas Maples died Octob. 28, 1727, aged 73.
Deborah wife of Thomas Maples died March 22, 1763, aged 89.

On a flat stone in the chancel (D) :
Here lieth the body | of Joseph Thorpe | who departed this
life | October ye 22, 1781, aged 80 years.

On two flat stones in the chancel rubbed (D) :

> Martha the wife of | William Chest who | Feb. y^e
> 28^th day, | 1719, æt. 27.

On the other (D) :

> Mary Evering | -ham departed | this life Dec. y^e 17, 1706, |
> aged 78.

The church consists of a nave and aisles resting on three pointed arches. The chancel is very beautiful ; it opens from the nave by a fine lofty pointed arch rising from a single column on each side. It is as large as the body of the church, and has once been very lofty, but the roof has been lowered. It is of the Decorated style, and the windows are very fine. The east window is of six lights, but the head of the tracery has been shut out and filled up by the lowering of the roof. On the north side of the chancel is a beautiful arch seemingly over a tomb, but the lower part is blocked up ; it is cinquefoiled and has over it a crocketted canopy ending in a very handsome finial. The canopy springs from crocketed pinnacles at each side. To the east of this is a beautiful niche in the wall, below which are three standing figures of men in armour with shields, the heads broken off. The arch of the niche is ogee and trefoiled, the canopy crocketted ending in a beautiful finial. At each side is a pinnacle, and between either of them and the canopy are two female figures. This is like the sepulchre in Heckington Church, but on a smaller scale, though very beautiful. In the south wall is a fine piscina, with a crocketted trefoil cut arch, and over it a canopy crocketted the finial broken off. To the west of this are three stone stalls formed by trefoiled ogee arches crocketted with rich finials, and separated by pinnacles. In the chancel is an old stone said to have been dug up out of a grave twenty five years ago, having an inscription in Saxon characters upon it, but illegible.

[See also *L.R.S.* i, 241.]

(MS iii, 191–197.)

𝔑ettleham

Notes taken in the church, 5 August, 1833—
On a white marble monument against the north wall of the chancel (R) :

> Near this place | are interred the remains of | The Rev^d Robert
> Wharton A.M. | chancellor of Lincoln, archdeacon of Stow |
> and rector of Sigglesthorne in Yorkshire, | who | on the 29^th
> of January 1808, | (and in the 57^th year of his age) | was
> released | from a long and painful illness | and summoned
> into the presence | of that Master | from whom he ever trusted
> to receive | as he studied to deserve | the reward | "of a

good and faithful servant." | Distinguished for his learning, | revered for his piety, | and beloved for his benevolent | and amiable disposition | He needs not a monument | to record his praises | or prolong his memory. | yet in grateful recollection | of his most tender regard for themselves | and unremitting care of their best interests | this humble tribute of respect | of gratitude and affection | is inscribed by those | who, whilst they deplore the loss | of a husband and a father, | shall ever love | to contemplate his virtues | and imitate his example.

On a flat stone in the nave (D) :

In memory | of | Leonard Sampson | son of Leonard | and Faith Sampson | who died Nov. the 18th,| 1778, | aged 67 years ; | also | Frances Cropper | his daughter | who died Nov. 6, | 1789, | aged 48 years. | Here lieth also the body | of William Cropper | husband of the said | Frances Cropper | who died May 6, 1795.

On flat stones near the last (D) :

In memory of | Leonard Sampson who | departed this life the 26 | September 1754, aged 79 ; | also Faith Sampson wife of | Leonard Sampson who | departed this life the 22d day | of March 1755, aged 81 years.

Here lieth the body of | Frances the wife of | Leonard Sampson | who departed this life | April the 7, 1772, | aged 54.

On another flat stone (D) :

In memory | of Elizabeth the wife | of Robert Shulson | who died . . October | 1774, | aged 64 years ; | also | Jane Fowler daughter of | the above who died June the | . . , 1780, aged 6 years.

A wooden tablet records the following benefactions :

John Aistroppe by will May 27, 1786, left £50 which was laid out in 1791 in new pewing and a pulpit.

Elizabeth Ayscough by will proved at Lincoln, 1716, left 40s. for bread for the poor.

John Moss, 9 May, 1723, gave 20s. to the poor.

A monument of white stone against the wall of the south aisle, these arms over—Ermine, a bend wavy, a chief . . . [Nethercootes] ; impaling— . . . , on a chevron . . . three roses . . . , a dexter canton ermine [Rands]. On two small obelisks at the sides are the words ' Vitæ–Morti ' and below the arms the words " in utranque paratus." This inscription in capitals below :

VX. S.C. | Dorothææ Nethercootes ejusq. | animulæ candidiss. | quæ ad cælos evolavit 29 Junij 1603, | ob pietatem, castitatem, modestiam multasq. | suavitates ac gratas gratias | tres quos tulit optima spe ac specie liberos | Martham, Mariam,

Thomam, | deniq. familiam probe curatam ac sobolem, | Gualterus Nethercootes conjunx moestissimus, | æterni desiderii et amoris ergo | posuit.

On a flat stone in the south aisle in raised capitals, partly hid by a pew :

Here lieth the body of | Charles Wolley Gent. | who departed this life | the 25th of July 1690 | aged 71. | Here also | is interred his niece | Mrs Justina Nicholson | the pious, charitable | and provident wife | of Mr Thomas Nicholson | aldn of Lincoln : she | died the 16th of Feb. 1733, | aged 74.

Another to the west, partly hid by a pew, these arms over— , three barrulets . . . in chief a greyhound courant [Skipwith]. In raised capitals :

Here lyeth Charles | Skipwith and Eliza | beth Ayscoghe both | children of Wm Skip | -with of Ketsby, esqr. | Charles dyed No | vember the 26th, 1677, | aged 19. Elizabeth | dyed ye 9th of Decem | ber 1716, aged 62.

A flat stone still more to the west :

To the memory | of | John Straw | late of the city of Lincoln. | He departed this life | Oct. the 1st, 1782, | aged 64 years. | Also the remains of George | eldest son of the above | John Straw | who dyed May 5, 1794, | aged 45 years.

A flat stone at the west end of the nave :

In memory | of | George Spencer | who departed this life | April the 3d, 1789, | aged 85 years.

On two other flat stones more to the north :

Here lieth the body | of | Mary the wife | of | George Spencer | who departed this life | July the 10, 1772, | aged 75 years.
Here lieth the body | of | George the son | of George and Mary Spencer | who departed this life | (the rest is defaced).

The church consists of a nave and two aisles supported on three pointed arches rising from clustered columns with foliated capitals, a chancel, a south porch, and a tower at the west end. This church was repaired about eight or nine years since.

[See also *L.R.S.* i, 112–113.]

(MS iii, 109–116.)

𝔑𝔢𝔴𝔱𝔬𝔫 𝔦𝔫 𝔄𝔳𝔢𝔩𝔞𝔫𝔡

Notes taken in the church of Newton, 31 July, 1833—

On a flat stone (D) :

Mrs Elizabeth Michelson | daughter of Will. and Ann | Walter late of this place | departed this life | the 21 day of February 1783, | aged 93.

On another stone much rubbed :
> Here lieth the body of | William Walker | departed this
> life | Feb. the 2, An , | aged 75 years.

On another :
> Here lies the body | of William Truzzele. | He died | April
> . . , 1775, | aged 71 years.

On a black flat stone (D) :
> In memory of | William Walker gent. | who died July 17,
> 1832, | aged 87 years.

On another (D) :
> Here lieth | Elizabeth the wife | of Wm Walker | dyed Nov.
> 14, | 1741, | aged 96.

On another stone rather defaced :
> John Walker | son of William and | Walker
> died . . . | . . . 26, 17 . . , | aged | 43.

There has been in the north of the chancel a brass, figure and
inscription now gone.

A black marble monument against the south wall of the south
chancel, arms over—Argent, on a bend sable three owls of ye first
[Savile] ; impaling—Per pale argent and azure, a chevron between
three chaplets counterchanged [Yerbrough]. This in capitals :
> Here lieth interred the | body of Mary Savile daugh | ter of
> Robert Yerbrough | of Lincolne, esq., and | 2d wife of Thomas
> Savile | of Newton, esquier. She | departed this life upon
> ye | 6th of March 1637, and to | whose pious and endeared |
> memory her husband hath | erected this | monument.

A flat stone in the nave much rubbed (D) :
> Here . . . the body | the | wife of Truwell
> and | . . . of William and | who departed | this life
> March the . . , 1768, | aged 81 years.

The church consists of a nave and two aisles resting on three
pointed arches, a chancel, and two aisles, and a tower at the west
end. North of the altar is an ogee arch crocketed with finial and
adorned with the balls in hollow moulding. On the south side is
a piscina of two arches resting on three pillars.

[See also *L.R.S.* i, 221.]

(MS iii, 21–24.)

Newton on Trent

Notes taken in the church of Newton, 15 September, 1835—
This is a very mean church, modern, being rebuilt about eighteen
years back, and added to the old tower which has an Early English
west door bearing marks of being once handsome. There are

three arches of a north aisle still remaining in the wall. These were taken in and built up at the rebuilding of the church. They are good equilateral arches with clustered columns. There is a chancel half of which—the east part—is blocked up for a burial place for the Stow family. There is no monumental inscription. On the north wall is this atchievement—Azure, a cross between four leopards' heads cabossed or [Stow] ; impaling—Gules, a chevron argent between three heronshaws of the last, a cinquefoyle for difference sable [? Armstrong]. Crest—A leopard's head cabossed between a pair of wings endorsed or ; (Stow impaling Armstrong according to the information of the clergyman).

(MS vii, 149.)

Northorpe

Notes taken in the church, 27 August, 1828—

The following monuments to the Monson family are in the chancel—

On a brass, measuring 18 inches by 7 inches, let into a stone in the middle of the chancel, is the following, in capitals :

> Here lyeth bvried the body of Anthony | Monson of Northorp in the covnty of | Lincolne, Esq., fowrth sonne of Sr Iohn | Monson of Sovth Carlton, knight, | who departed this life the 17th | day of November 1648.

Below are the following arms, on a brass measuring 8½ inches by 10 inches—Two chevronels, a mullet for difference [Monson].

On a brass plate measuring 8½ inches by 17¼ inches, which is now fixed into the bottom of the partition of a pew, but before the repair of the church in 1820 was in the floor of the chancel, a few feet from where it now is, is the following, in capitals :

> Here lyeth ye body of William Monson | eldest sonne of Iohn Monson of North | orpe in ye Covnty of Lincolne, esq : & | of Mary his 2nd wife davghter to William | Fitz Williams of Claxby in the said | covnty, esq : who died ye xxviii of | Febrvary Ao D'ni MDCXXXVIII.

The following is an inscription on a stone, measuring 17½ inches by 3 feet, in the floor of the chancel close to the south wall. Some of it is written in the centre of the stone, and some round the edge, in capitals :

> Here lyeth | the body of George Mon | son sone of | Anthony and Francis | Monson who | dyed the 2 of Ianvary 1654 | ætat. mens.

The church of Northorpe was repaired in 1820, and is now a very neat edifice ; the side door is curiously carved in oak.

[See also Jeans, 45–46.]

(MS Supp., 3–6.)

Norton Disney

Notes taken in the church, 16 August, 1833—

A brass plate fixed upright in a stone frame between the north chapel and the chancel. At the top this shield of arms—Quarterly of six, 1st and 6th, A fess charged with three fleur de lis [Disney]; 2nd, A fess dancette between three escallops [Dyve]; 3rd, Three lions passant in pale [Amundevill]; 4th, A chief on which two mullets []; 5th, billetty a lion rampant; [impaling— Per chevron [vert] and ermine, a chevron [or], in chief a pelican in her piety proper [Joyner]]. The shield is between two crests— 1st, A lion passant guardant [Disney]; 2nd, A hind lodged under a tree, gorged with a ducal coronet and chained [Hussey]. Under- neath, the half lengths of a knight, bearded, in armour and helmet, and his lady, both with their hands clasped, with this on a label between them, 'Sufferance doth ease.' Behind the man are half lengths of four sons ; behind the woman of five daughters. The names are on labels from their mouths, (1) Richard, (2) William, (3) Thomas, (4) Frances, (1) Ann, (2) Mary, (3) Margaret, (4) Katerine, (5) Briget. Under the middle figures : 'Will'm Disney, esquier, and Margaret Joiner.' In the next row under this group are three shields : (1) the centre one with the above six quarterings of Disney ; (2) the 2nd on the left—Quarterly of six, 1st, a cross [Hussey] ; 2nd, Five lozenges in fesse, charged with escallops [Cheney] ; 3rd, A bend wavy between two bendlets ; 4th, Barry of six ermine and gules [Hussey] ; 5th, Per pale three chevrons counterchanged, fimbriated [Say] ; 6th, A chevron between three garbs, over all on an inescucheon a chevron between three squirrells [Lovel] ; (3) the third shield on the right is—Quarterly of four, 1st, A fesse between three asses passant [Ayscough] ; 2nd, A saltier, on a chief three escallops [Tailboys] ; 3rd, Three chevronels in a border [Charnel] ; 4th, A cross checquy [Cokefield]. Beneath these shields, in the centre, is a man full faced in armour and helmet, between his two wives, all with their hands clasped. Behind one wife, seven sons and five daughters. All the figures are half lengths. Under the man is 'Richard Disney' ; under the first wife, 'Nele daughter of Sr Will'm Husey, knight' ; under the other 'Janne daughtr of Sr Will'm Ayscough, K[night]'. The names of the sons which were over their heads have been cut out. Those of the girls remain, and are in old English, Sara, Ester, Judeth, Judeth, Susan. Under all this, inscription in old English :

The lyfe, conversation, and seruice of the first abovenamed Will'm Disney, | and of Richard Disney his sonne, were comendable amongest ther neig- | bours, trewe and fathefulle to ther prince and cuntrey, acceptable to th' al- | mighty of whomme we trust they are receved to salvation accordinge to the stedfast fayth | Which they had in him throughe the

mercy and merit of Christ or | Savior. Thes truthes ar
thus sett fyrthe that in all ages God may be thankfully |
glorified for thes and suche lyke his gracius benefites.

[About 1780, this brass was sent up to London to be engraved
for Gough's *Sepulchral Monuments*, and it was discovered that
there was on the back an inscription in Dutch, referring to the
founding of a chantry in Holland. See Jeans, pp. 48–9, where a
translation of the inscription is given.]

In the north chapel are these other monuments of the Disney
family. On the south side of it, in the easternmost of the two
arches which separate it from the chancel, is an altar tomb on which
is the recumbent figure of a knight armed, whether in plate or
mail is indistinguishable. He wears a conical helmet, and his
throat is covered by a gorget of mail, his hands are clasped
over his breast, and he has a shield on his left arm charged with—
Three lyons passant [Amundevill]. His sword is at his left side,
the lower part broken off. His feet rest on a dog. On each side
of the tomb are three shields, the charges gone. There is no
inscription remaining. [Perhaps Sir William Disney, circa 1340.]

Below this, on a slab raised about two feet from the ground, is a
coffin-shaped stone, on which is sculptured in relief, under a canopy
a female figure, her hands clasped ; the lower part of her is covered
over, and a cross sculptured on it having a long stem ; at the
bottom is a dog. At the top are two shields : (1) Disney, (2) Three
pallets, over all a bend [Langford]. At the bottom is the same.
This inscription round in old Saxon character, partly illegible :
 vst la femme Moun' Gillam Disni et la fille Moun' |
 Gil de Langford

To the north of this, on a stone slightly raised from the ground,
is a figure of a woman in a long plaited gown fitting tight to the
neck, and covering her feet, which rest on a lion. She has loose
sleeves, and her hands are clasped. Her head is dressed in a
reticulated cap, and rests on a cushion supported by angels and
a lion. Arms on each side her head— . . . , two bars . . .
[Grey] ; in the middle, on the right Disney, on the left— . . . ,
three pallets, over all a bend [Langford]. At the bottom, the
same. At the south side is this inscription in church text :
 Hic iacet Hantacia filia | Will'i Disni domini de Norton.

To the north of this, against the wall, is a large altar tomb on
which has been a fine brass of a man cross-legged, with sword and
shield, under a canopy, and an inscription round, also in brass,
the whole now gone. [Perhaps Sir William Disney, 1276–1300.]

To the west of this, under a low arch in the north-east wall, is a
female figure in a plaited robe, and a mantle gathered over her in
folds, held by her hands which are clasped over her breast. Her

headdress covers her chin, and her head rests on a pillow, and her feet on a dog. In the wall above are two shields bearing the arms of Disney, viz. three lions passant.

The church consists of a nave and north aisle separated by three pointed arches, the chancel having a north chapel, and a tower at the west end, a screen between the nave and chancel. The font is octagonal on a round pedestal and pannelled in quatrefoils and shields. A hatchment against a pillar of the nave bears—Argent, a bear rampant sable ; impaling—Vert a lion rampant or, a chief gules.

[See also *L.R.S.* i, 245–246 ; Jeans, 47–49.]

<div align="right">(MS xii, 23–26.)</div>

South Ormsby

Notes taken in the church of South Ormesby, 17 August, 1835—

On a very elegant marble monument, with these arms over carved, but without the colors—Quarterly, 1st and 4th, Three quartrefoils, in chief a boar passant charged with a cross [Massingberd] ; 2nd and 3rd, Quarterly [or and argent], four lioncels rampant, over all a cross coupe charged with five escallops [Langton]. Crest—A lion's head erazed, charged with two arrows in saltier :

> To the memory of | Will. Burrell Massingberd | of South Ormsby, Esquire, | who died the 18th of August 1802, aged 83 years. | Loyal in his public principles, | in his personal affections | regulated by the purest sentiments | of liberality, honour, and religion, | a strict patron of Justice, | with manners equally polite and dignified. | He exhibited a proof, | daily alas ! becoming too rare ! | how valuable and respectable, | retir'd and appropriate virtue | can render the character | of a country gentleman. | In the same vault are interred | Anne his wife | daughter of William Dobson of York, Esq. by Elizabeth fourth daughter of Christopher Tancred of Whixley in the County of York, Esq. | She died July 1759, aged 37. | Catherine their fourth daughter who died an infant. | Francis Burrell Massingberd, Esq., | his only brother who died May 6, 1795, aged 72 ; | he was a respectable Merchant of the City of London, | and eminent for his integrity and virtue. | Burrell Massingberd, Esq., his father, | who died in 1728, aged 44. | Philippa, his mother, eldest daughter of | Francis Mundy of Markeaton in the county of Derby, Esq. ; | she died in 1762, aged 72. | Sir Drayner Massingberd, knt, his grandfather, | who died in 1689, aged 73, | was the third son of Thomas Massingberd of Braytoft | in the county of Lincoln, Esq. | Elizabeth, first wife of Sir Drayner, | and daughter of Abraham Burrell of Medloe Highfield | in the county of Huntingdon, Esq. |

Amy and Frances who died infants | and were with Burrell
above named S^r Drayner's children | by Anne second daughter
of Henry Mildmay of Graces | in the county of Essex.

On a flat stone in the floor very near the monument in the south
chapel of the chancel :
Beneath the floor of this vault | are deposited the remains
of | Dame Elizabeth Massingberd buried Dec^r 1677, aged
77 years. | Amy Massingberd buried Jan^y 10, 1683, aged 9
months & 4 days. | Frances Massingberd buried Feb. 19, 1688,
aged 4 months 18 days. | Burrell Massingberd, Esq., buried
Jan. 5, 1728, aged 44 years. | Catharine Massingberd buried
May 1, 1757, aged 4 years 6 months. | Philippa Massingberd
buried May 3, 1762, aged 72 years.

On a black stone partly hid under the stove :
Here lieth the body of | Thomas Taylor late rector | of Authorp
who departed | . . . 20 of March | 1710.

On an old stone in the nave, in church text, all that is legible is :
armiger qui obiit vii die m[ensis].

On another old stone to the west of the last, round the verge :
Thomas Hill quondam rector ecclesie de Ingolmels |
A'o d'ni M° CCCC LXXXXII, cujus anime | propicietur deus
Amen.

On another to the west, all that is legible is :
MCCCC . . . cujus anime propicietur deus.

On the floor of the chancel is a large blue stone on which are the
portraitures in brass of a knight and lady standing under a double
canopy pinnacled ; the knight is armed save the head in plate, his
hands are clasped, and at his feet is a dog. At his left side hangs
his sword, his dagger on his right. The lady is dressed in a long
plaited robe, confined round the waist by a cord and tassells. Her
head is covered by a coif. Over these have been two shields,
that above the knight is gone, and of the lady's the impalement
only remains, which is three barrulets [Constable]. Below
the figures is this inscription in old character :
Orate pro animabus D'ni Will'i Skypwyth militis et Agnetis
vxoris eius qui | infer iacent qui quidem Willi'us obiit
xxvii die Nov. | Anno D'ni Mill'imo cccc°lxxx°ii° quorum
animabus propiciet' [Deus].

Below are the figures of one son and two daughters, the latter in
square head-dress. On one of the steps to the chancel remains
half of the figure in brass (R) of a lady dressed in a gown, with
long open sleeves, and the flat square head-dress, jewelled at the
edges, her hands are clasped over her breast, and at her feet is a
small dog having a collar ornamented with bells about his neck.
This dog resembles much our present pug dogs in head and nose.

A flat stone in the chancel in capitals (R) :
> Here lyeth y^e body of Eliza | beth the wife of Thomas |
> Taylor rector of Authorpe | and daughter of William | Azlack
> late rector of | South Ormesby, she died | August the 11,
> 1700, | in the 30 year of her age.

On a brown stone to the east of the last (R) :
> Mrs Margaret Harris | daughter of | Mr Humphry Harris |
> and Philippa his wife | died August XIX, MDCCLVII, aged
> XXXV. | This monumental stone | is inscribed to her memory |
> in testimony of her | affection and regard | by her | relation
> and friend | Philippa Massingberd.

Against the north wall of the chancel, a plain black and white
tablet bearing this inscription in capitals :
> In memory of | the Rev. W^m Burrell Massingberd, A.M., | 42
> years rector of this parish | who died May 5, 1823, | aged
> 66 years.

A handsome white marble monument against the south wall of
the chapel, this inscription in capitals :
> Harriet Mundy | eldest child of Charles Godfrey Mundy | of
> Burton Leicestershire, Esq., | and Harriet his wife, | grand-
> daughter of Charles Burrell Massingberd, Esq., | died at
> Ormsby, January 17, 1824, in her 17 year. | In her was
> strongly marked the triumph of religious principle | over
> selfish and worldly feeling, | possessed of all the world admires,
> she resigned | its fairest prospects without a murmur, | and
> supported by faith in her Redeemer | beheld the approach
> of Death with tranquillity. | Her afflicted parents while they
> bitterly lament her loss, | sorrow not as others which have
> no hope, | for they trust that the Grace of God will enable
> them | to follow her example, | so that they may die like
> her | and may again be blessed with her society, | never
> more to suffer the pangs of separation.

A flat stone in the church is inscribed to the wife of . . . White
who seems to have died æt. 77, but the inscription and date are
entirely illegible.

The church, which stands in a beautiful situation, consists of
a nave and chancel, to which is a south aisle or chapel divided
off by two pointed arches, and a tower at the west end. There
has formerly been a south aisle to the nave separated by two Norman
arches, which still remain in the walls, having round columns.

At the west end is a small gallery containing an organ ; on the
front is inscribed :
> This organ | was the gift of | Mary Jane Massingberd | the
> wife of Charles Burrell Massingberd, Esq., | to this church
> of South Ormesby, | August 12, 1810.

The font is octagonal, and on each side is the following device in basso relievo : 1. Quarterly, 1st and 4th, Three lucies [Lucy] ; 2nd and 3rd, A lion rampant [Lovain]. 2. Four plain crosses. 3. I H C. 4. A vase with a flower and the letters A.M. 5. In God is al godnes. 6. I.H.S. 7. The cross with the crown of thorns, nails and scourges. 8. S.N. At the foot is very legibly cut, Orate *pro animabus* Radulphi Bolle uxoris eius qui fecerunt fieri hoc baptisterium.

[See also *Lincs. N. & Q.* x, 234 ; *L.R.S.* i, 82 ; Jeans, 62–3 ; Massingberd, *History of Ormsby*, 322–30.]

(MS vi, 51–58.)

Osbournby

Notes taken in the church, [*blank*] August, 1831—

On a flat stone (D) in the chancel with the arms cut above— Lozengy and , a canton ermine [for Buck] ; impaling—A chevron between three lioncels rampant, on a chief indented three stags' heads [? Skinner] ; on an inescucheon the arms of Ulster :

H. S. E. | D*omi*na Francisca Buck | Gulielmi Buck de Hanby Grange | In com. Lincoln | equitis Aurati | coniux | defuit e vita | ætat. 51, | 1711.

On the same stone but on another column (D), with a lozenge of arms above—Lozengy and [for Buck] :

Francisca Buck | spinster | Gulielmi Buck | de Hanby Grange | in Com : Lincoln | Equitis aurati | filia | ætat. 27.

On a white marble tablet with an urn above against the south wall of the chancel :

Sir Charles Buck, Bart, of Hanby Grange in the county of Lincoln, | was born 31 January 1721, died in London 7th June 1782 ; he married | April 20, 1758, Mary eldest daughter and coheiress of George | Cartwright of Ossington in the county of Nottingham, Esq., by | whom he had no issue. His widow and sisters Anne widow of Ambrose | Isted, Esq., of Ecton in the county of Northampton, and Katherine | widow of Sir Henry Englefield of White Knights Bart. in the county | of Berks, his coheiresses consecrated this marble to the memory | of their excellent and lamented friend the last of his name.

On a white stone tablet against a pillar of the nave (R) :

Direct against | this place | in the Middle Alley | lieth the body of | John Green | who was buried | July y^e 19 | 1720 aged 75 | years.

On a black and white tablet against the south wall :

> In memory of | Robert Bradley | who departed this life |
> Feb. 8, 1795, | aged 60 years. | Also Mary the wife of | Robert
> Bradley | who depart^d this life | July 3, 1798, | aged 65 years.

Over this on a hatchment are these arms—Or, a chevron gules between three crosses patee fichee sable [Bradley].

On a black tablet over the door to the gallery :

> In memory | of Robert son of | Rob^t & Mary Bradley | who
> departed this life | October the 24, 1785, | aged xxv years. |
> [Multis ille bonis flebilis occidit. | Memento Mori. Resurgam].

[See also Trollope, *Sleaford*, p. 424 ; *L.R.S.* i, 216.]

(MS i, 89–92.)

Owston

Notes taken in the church, 9 September, 1835—This church is described in the Peck and Stonehouse MSS. It is a nave and aisles resting on four pointed arches, chancel, and tower at the west end. The chancel arch which was pointed is blocked up, the roof lowered. On a hatchment against the north wall of the chancel—Quarterly, 1st, Gules, a chevron between three lions' heads erazed argent, crowned or [Pindar] ; 2nd and 3rd, Argent, a bear seiant proper in a bordure or. Crest—A lion's head as in y^e arms.

A blue flat stone within the altar rails, these arms cut over—Three fleur de lis . . . impaling—A fesse between three martlets . . . This in capitals :

> Henericus Masterman | Armiger | mortalibus | valedixit nono
> die | Martii Anno a partu | Virginis | 1674. | Alterius cineres
> tacitam dum | Cernis et urnam | Vitam mirari desine disce |
> (a skull) Mori (crossbones).

A similar one more to the south, arms cut over—A chevron between three lions' heads erazed, crowned [Pindar]. Crest—A lyon's head as in arms :

> Here lieth the body of | John Pindar, Esq., | who died March
> the 5, 1776, | aged 74 years.

Another to the south with the Pindar arms cut above :

> Here lyeth interr'd y^e body | of John Pinder, gent., who
> was | born July y^e 17, 1628, & dyed y^e | 22^d of February 1703,
> leaving issue | two sons, Robert & Matthew, | & one daughter
> Elizabeth. | Here also lyeth Anne the wife | of the said John
> Pinder, | gent., born May 1641, obiit | March 18, 1718.

A similar stone in the chancel with these arms—Quarterly, ermine and argent [Stanhope] ; impaling—A chevron between three bucks tripping [Robinson] :

> Quicquid Darcei Stanhope | Armigeri terrenum fuit, in | terram
> (nullo non lugente) | rediit undecimo die Januarii | 1681 : 2. |

Hoc marmor in amoris mærorisque | testimonium Isabella uxor eius | (dum vixit) charissima, nunc | Eheu viduarum mæstissima | poni curavit. [A skull and crossbones.]

On another next to it :
Under this marble lyeth | interr'd the body of John Stanhope, | Esq., of Mellwood-Hall who depart | ed this life October the 1st day, | Anno Dom'i. 1705, | ætatis suæ 29.

On the same stone :
To the memory of the Rev^d | Rob^t Pindar of Brumby Wood Hall | in this county, and formerly Fellow | of Kings Collage, Cambridge, | who departed this life on | the 14 of Dec^r in the year | of our Lord 1795, | aged 55. | Slowly his earthly frame decayed | His end was long in sight | Nor was his steady soul afraid | To take its awful flight.

On another next to it :
This stone | was laid down by S. Smith as | a tribute of her effectionate regard to the | memory of the late Thomas Pindar, Esq., | of Brumby Wood Hall | in this county, and late a fellow of | Magdalen Collage in the University of Oxford, | who departed this life on the | eighth day of May in the | year of our Lord 1813, | aged 78. | Forgive blest shade the tributary tear | That mourns thy loss from a world like this | Forgive the wish that would have kept y^ee here | And stayed thy progress to y^e realms of Bliss.

On another collateral (D) :
In memory of | the Rev^d Thomas Clarke | forty three years vicar of | Owston, who died on the | first day of November 1820, | aged 82 years.

A stone more to the west (D) :
Here lies the body | of Mrs Mary Burton widd^w | and relict of Mr John | Burton late of Doncaster | in the county of York, | Alderman and Justice of | Peace, and twice Mayor | of the Corporation, who | departed this life the 17th | day of October | Anno Domini 1723, | ætat. suæ 76. | Huc omnes tendimus | Hæc Domus Ultima.

A stone further on in old characters (D) :
Hic iacet Dominus Ricardus Bec | banke quondam vicarius | istius ecclesie qui obiit anno domini | MCCCC° LVIIJ° cuius anime propicietur | deus.

A stone next to it (D) :
Here lyeth | y^e body of Robert | Torksey of Owston who | departed this life 6 of Decem. | A.D. 1695, aged 58.

An old stone (D) near has had an inscription round in old characters now gone except :
. . . suam animam Obiit die mens[is].

Against the south wall of the nave is a handsome monument of stone in the old fashion, in a recess of an ogee arch with a crocketed canopy, which ends in a finial, flanked by two pinnacles with finials. In the recess is an altar-shaped stone inscribed in the old character :

To the memory of | Edward Peart, M.B., | who died Sept. the x, MDCCCXXIV, | aged LXVIII.

A similar monument, though rather larger, against the wall of the south aisle, this inscription on the altar-shaped stone (which in this monument is endways towards you) in capitals :

Sacred | to the memory of | John Littlewood | who died Sept. 16, | A.D. 1821, | aged 51 years. | Also of | Elizabeth | his wife | who died March 22ᵈ, | A.D. 1827, | aged 45 years. | Their remains are | interred in the | south aisle of this | church.

A black marble tablet with a white slab to the west :

Sacred | to the memory of | Edward Peart | of West Butter-wick | who died | on the 1st of December 1795, | in the 66 year of his age.

A flat stone on the floor below :

Here rests the remains of Mr | James Littlewood late of High | Melwood who departed this life | on the 19 day of November 1797, | aged 61 years. | Here also rests the remains | of Mrs Anne Littlewood wife of the | above who departed this life on | the 26 day of April 1797, | aged 60 years.

Near this are stones to James Littlewood died 21 Oct. 1819, æt. 51, and James son of the above and Elizabeth his wife died 19 April 1804, infans.

A flat stone in the nave to Frances wife of Robert Maw of East Lound, daur. of William & Sarah Gibson of Haxey, died 5 Janʸ 1795, æt. 28. Also her infant children Susanna and Anthony Gibson Maw.

[Stonehouse, *Isle of Axholme*, pp. 229–32.]

(MS vii, 101–109.)

Panton

Notes taken in the church, 11 October, 1840—This is a small church of nave and chancel, the bell hanging over the entrance porch at the west. In the north wall of the chancel is embedded the statue of a knight in armour ; only half of the body is visible, and it is much encrusted with white-wash, a small figure of an angel appears over the right shoulder, and on the shield, which is only half visible, may be perceived a bend, on the dexter side of which are two mullets pierced [for Breton] ; the rest is concealed in the wall (R).

There are some flat stones to the family of Gace, and one mural slab, in the south wall of the chancel, to the same ; but none earlier than the 18th century.

On a flat stone also before the altar is the following (D) :
> Hic jacent reliquiæ | Johannis Holland | Hujusce Ecclesiæ Rectoris. | Pastor fuit pius et sedulus | Conjux amantissimus | Amicus fidelis | Pauperibus munificus | Obiit 14 Junii | Anno salutis 1737, | ætatis 62.

[See also *L.R.S.* xix, 51–2.]

<div align="right">(MS x, 9–10.)</div>

Pickworth

Notes taken in the church, 30 July, 1833—

On a black stone in the chancel floor, with these arms above— Per pale argent and azure, three lions' jambs in pale barways counterchanged [for Wilson] :
> Sacred | to the memory of | the Revᵈ Isaac Wilson, | M.A., | 60 years curate of this parish, | and 55 years vicar of Caister | in the county of Lincoln, | Died December 29, 1832, | aged 88 years.

On a black stone in the chancel floor :
> Beneath | this stone lie the | remains of | Amelia wife of the | Revᵈ J. D. Glover, | M.A., rector of Haceby | and Sapperton, | she died Jan. 19, 1828, | aged 58. | Also of | the Revᵈ J. D. Glover, | M.A., | rector of Haceby | and Sapperton, | he died March 9, 1832, | aged 61.

Within the altar rails is a flat stone much defaced :
> Here lieth the body of | Mr Peter Clark late rector | of Pickworth, who [died . . . May 1703].

On a board (D) hung to the screen of the church in old character :
> Heare lyeth buryed the bodye | of Thomas Gibson of Pickworth, | yeoman, who gave to the poore of | Pickworth 13*s.* 4*d.* yearly for ever | out of the house in Grantham | called Dimsdall the 17 of June | Anno Domino 1622.

On a flat stone in the chancel :
> Johannes Owen A.B. rector | obiit August 11ᵐᵒ, 1771, | ætatis suæ 73. | Francisca Owen uxor ejus | obiit Mar. 2ᵈᵒ, 1778, | ætatis suæ 78º.

A flat stone in the south aisle :
> Here lieth interred | the body of Anne | daughter of Mr William Ridley | of Keysby, and | wife of Mr John Solomon, | of Mr John Lord, and | of Mr John Callow, | she was taken out of this | in the expectation of a better | life on the 20th of September, | in the 83rd year of her | age, and of our Lord | 1723.

The church consists of a nave and chancel, resting on four pointed arches on round columns, a tower and spire at the west end. A handsome screen between nave and chancel, and some old pewing.

[See also *L.R.S.* i, 208.]

(MS ii, 243–246.)

𝔓𝔦𝔫𝔠𝔥𝔟𝔢𝔠𝔨

Notes taken in the church, 17 July, 1833—

A large standing tomb in the chancel near the north entrance gate, with these arms sculptured at the east side—On a fesse three crosses patee between two chevrons, on a canton a lion passant [Walpole]. Crest—An arm holding a spear. Motto—Absit Gloriari nisi in Cruce Domini. On the west side are these quarterings etc.—1st and 4th, A chevron engrailed between three oak leaves [Smithson]; 2nd and 3rd, A fesse charged with three branches ? between three squirrels sejant, within a bordure engrailed charged with eight roundles [Stockwood]; empaling—On a fesse three crosses patee between two chevrons, on a canton a lion passant [Walpole]. This inscription on the south side :

<blockquote>✠ Maria Edvardi Walpole Equitis aurati et uxoris | Dominæ Catherinæ ab antiqua Germynorum patricia | gente de Rushbrooke in agro Suffolk ortæ filia uni | -ca Gulielmi Smithson M.D. conjux peramabilis | prole utriusque sexus spei opt. relicta obiit 19^{mo} Mart. | Anno salutis humanæ 1708^{to} Ætatis 44^{to} | Lux perpetua luceat ei Domine cum sanctis tuis in æternum quia | pius es.</blockquote>

Inscription on the north side :

<blockquote>✠ Edwardus Walpole unicus præfatæ Mariæ Germa | nus ac uterinus obiit innuptus 14^{to} Feb^r Anno 1725^{to} | ætatis 60^{mo} | Miserere illius Deus secundum magnam misericor- |diam tuam et multitudinem miserationum pia- | rum psallat in Æternum Amen. ODSMPGSMD.</blockquote>

On a handsome monument against the north wall of the chancel, but the colours of the arms and letters of the inscription now fast decaying ; with these arms above—Quarterly, 1st and 4th, Azure two bends, in chief three stags' heads cabossed [for Wimberley]; 2nd and 3rd, Ermine, a fesse nebule sable [for Harwedon]; impaling—Azure, a fesse nebule between three crescents or [Weld] :

<blockquote>Orta | Gulielmo Welde Generoso Cestrensi | et | Dorothea Georgij Wright Cant. Equitis filia | uxor | Gulielmo Wimberli hujus co. et parochiæ | SS^{orum} Innocentium die | chori triumphantis æmula | suam sibi nec minoris Innocentiæ | stolam induta. Primo Puerperio | ad Cælites emigravit |</blockquote>

et | Quicquid habuit terræ | hic totum juxta deposuit | ætatis anno 25, salutis 1656, | Tam gloriose resurgat quam pulchre occubuit.

On a tablet in the lower part of the monument :

Etiam præ memoria Bevilli & | Johannis fil. | Thomæ Wimberley Armigeri hinc proxime | in vicina ecclesia Spaldensi inhumati Anᵒ. | MDCXLIᵒ. Necnon Elizabethæ et Francis- | cæ uxorum | filiabus Gulielmo Welbye | prænobili ordine Balnei Equitis Eque villa | Gedeniensi | qui hic juxta jacent sub spe | Christianorum.

There are arms under, now destroyed.

On a flat stone, not far from the above monument, with these arms—Two bends, in chief three stags' heads cabossed [for Wimberley] :

Exuvias | Hic deposuit Bevilus Wimberley de Weston | Armiger | obiit 14 die Maii Ann. ætat. 46, [Ann.] Dom. 1720.

On a stone near the last, very much defaced (D) :

Hvmble modest godly wise | Pitty ever in her eyes | Piety ever in her brest | In goodness great in evil least | A loving wife a mother deare | such was she who now lies here | M. Frances Deirsley | September 29, | 1665.

On another stone in the chancel (D) :

Here lieth interred the body of | Mr Michael Michell, for many years the reverend | vicar of this parish, | eminent for his zeal loyalty | & strict virtue, | who after a life full of days | and good works | departed at Spalding the 10 | day of October, | in the 76 year of his age, | Ann. Dom. 1714.

And close by (D) :

Here lieth the body | of Frances the wife | of the Revnd Mr | Mich. Mitchell who | died at Spalding, | and buried here | June the 1st, 1702, | Anno ætatis 67.

On another stone (D) :

In memory of Thomas Heather, gent., who departed this life | Feb. the 27, 1773, aged 82 years.

On a small stone (D) :

Christopher | Humfrey, gent., was here | interred in the year | of our Lord | 1711.

On another (D) :

In memory of | Edward Browne, Esq., | who departed this | life the 28 day Nov- | ember Anno Dom. | 1724, in the 32 year | of his age.

On another (D) :

John Humfre, | gent., | was here interred | July the 23 day, | 1676. | Also Mary his wife | was here interred in | the year of our Lord | 1710.

An altar tomb is in the south aisle at the east end, from the top
of which a brass inscription and two shields have been taken out.
On the north side ten shields :

(1) Argent, a bend sable, a bezant in chief [Pinchbeck].
(2) Pinchbeck, impaling—Quarterly, 1st and 4th, Azure,
three bucks trippant in pale or [Grene] ; 2nd and 3rd,
Gules a chevron between three cross-crosslets, a lion passant
in chief or [Mablethorpe].
(3) Pinchbeck, impaling—Argent, a saltire gules, on a chief
of the last three escallops of the field [Talboys].
(4) Pinchbeck, impaling—Sable, a fess between three fleur
de lis argent [Welby].
(5) Pinchbeck, impaling Gules three chevronels [Bawde].
(6) Pinchbeck, impaling—Quarterly, 1st and 4th, Party per
pale, gules and sable, a lion rampant argent [Bellers] ;
2nd and 3rd, Azure, a bend between six mullets argent
[Houbye].
(7) Quarterly, 1st and 4th, Grene ; 2nd and 3rd, Mable-
thorpe ; impaling—Quarterly of six, 1st, Argent, a bend
between six martlets gules [Furnival] ; 2nd, Or, fretty
gules [Verdon] ; 3rd, Gules, a saltire argent [Nevile] ;
4th, Azure, a lion rampant within a bordure or [Mont-
gomery] ; 5th, Gules, a lion rampant within a bordure
engrailed or [Talbot] ; 6th, Argent, two lions in pale gules
[Strange].
(8) Quarterly, 1st and 4th, Montgomery, Talbot, and Strange ;
2nd and 3rd, Furnival, Verdon, and Nevile.
(9) Quarterly, 1st and 4th, Grene ; 2nd and 3rd, Mable-
thorpe ; impaling, Gules, a cross flory argent [Latimer].
(10) Grene, impaling Bellers.

On the west side four shields :

(11) Quarterly, 1st and 4th, [Bellers] ; 2nd and 3rd,
[Houbye].
(12) [Grene], impaling—Quarterly, 1st and 4th, [Bellers] ;
2nd and 3rd, [Houbye].
(13) Pinchbeck, impaling Talboys.
(14) Pinchbeck.

On the south side eight shields :

(15) A saltire engrailed ; impaling—1st and 4th, [Bellers] ;
2nd and 3rd, Barry engrailed argent and sable, a canton
gules [Folvile].
(16) Pinchbeck, impaling—Quarterly, Bellers and Folvile.
(17) Per chevron sable and ermine, in chief two boars' heads,
couped or [Sandford] ; impaling—Quarterly, Bellers and
Folvile.
(18) Pinchbeck, impaling— . . . three cinquefoils or roses.

(19) Pinchbeck, impaling—Gules, three water-bougets ermine [Roos].

(20–22) The shields are blank.

A grey pyramidal tablet of stone against the wall :

Near this place rest the remains of | Sarah Prockter relict of | Mr Richard Prockter. | She departed this life June 8th, 1801, aged 77 years.

On a flat stone at the west end of the south aisle (D) :

Beneath this stone | were deposited the remains | of | John Skelton, gent., | who departed this life | on the 11th of Jan^y 1807, | in the 74 year of his age.

Large black flat stone in the nave, near the west door :

In memory of | George Brabins, gent., who departed | this life the 3d day of September | 1749, | aged 73 years. | Also in memory of | Alice relict of John Withers | late of Birmingham in the county of Warwick, | & niece to the above George Brabins, | who departed this life June 1st, 1775, | aged 70. | Also near this place are interr'd the remains | of Jane daughter of Thomas and | Jane Measure of Pinchbeck & grandaughter | of the above John & Alice Withers, who | departed this life the 10th of December 1780, | in the 33d year of her age.

On another more to the east :

In memory of | Jane wife of Thomas Measure | of Pinchbeck | whose life departed 17th of October 1781, | in the 54 year of her age. | Also in memory of | Thomas Measure | whose life departed September 19, 1787, | in the 76th year of his age. | Also | near this place is interred | the remains of | Phœbe Withers | sister to Jane Measure | whose life departed 3^d of April 1801, | in the 70th year of his age.

On another close by :

In memory of | Brabins Measure | son of | Thomas and Jane | Measure | who departed this | life July 31, 1811, | aged 61 years.

A black flat stone in the chancel, with arms cut—A chevron sable between three bugle horns stringed . . . Crest—A bugle horn [for Wayet] :

In a vault beneath lie the remains | of | the Rev^d Thomas Heardson Wayet, D.D., | 29 years | vicar of this parish, | who died the 2d day of June 1821, | aged 67 years.

Upon another much rubbed (D) :

Richardus Pell | filius | Richardi Pell de Dembleby | Armigeri | hujus Eccl'iæ nuper | | 3d 1698.

[See also *Churches of Holland* ; *Lincs. N. & Q.* i, 174–7 ; *L.R.S.* i, 175–176 ; Jeans, 49–52.]

(MS i, 173–183.)

T

Quadring

Notes taken in y^e church, 12 September, 1839—This church, which stands about a quarter of a mile from the village, is large and handsome. The general character is Perpendicular. It consists of a nave and aisles, which are separated by four lofty perpendicular arches resting on plain shafts, the capitals of which are embattled with a very curious effect ; a chancel, south porch, and tower with a spire at the west end. The clerestory windows, which are eight in number, are lofty and handsome, of the Perpendicular style. The nave is of a good height, and there appears to have been preparation for a stone roof as the springers for the groining still remain in the walls. Two of these on the south side terminate in shields, one bearing a rose, y^e other a bend ragule. The rest are supported by grotesque heads finely carved. The springers of the timber roof are also carved in like manner, and all are different, producing a very fine effect. The chancel is parted from the nave by a pointed arch, partly blocked up, and a screen of good perpendicular wood-work (D), and on y^e south side is the entrance to y^e staircase of the ancient rood loft, having a very beautiful doorway, which is an ogee arch, with a crocketted canopy and finial flanked by pinnacles, and a range of pannelling which altogether forms a beautiful specimen of early Perpendicular work. The chancel windows are small, and in the eastern one is a piece or two of stained glass. The south aisle windows are Decorated, the remainder Perpendicular. The arch to the tower is sharply pointed. The tower itself as well as the spire are Perpendicular. The font is very handsome of octagonal shape at the top, which is pannelled with angels holding blank shields. It rests on a tall shaft of elegant shape which is niched and has had pinnacles now broken. Round the base is this inscription in old character :

Orate pro anima Roberti Perci qui istum ffontem ffieri ffecit.

At y^e eastern corner of the south aisle is a piscina having a trefoyled arch of early Decorated character. The parapet of the nave is embattled, except y^e gable which is pannelled and surmounted by a wheel cross, all of handsome Perpendicular character, of which style this church is a good specimen.

On a grey white marble monument against the north wall of y^e chancel, surmounted by these arms—Two lions passant guardant [for Browne] :

Here lyes the body of | Edward Brown, gent., | who dyed the fifth day of January | 1769, in the sixty sixth year of his age. | He delighted in being a father to y^e fatherless | And to them who had no friend, | which good offices he always discharged | with great integrity. | He was a hearty well wisher to the establishment | in Church and State, and shewed it on all proper occasions. | He built a house | which with

some land thereto adjoining he settled | for ever for the Master of the Charity School | of this town to live in. | He died much lamented by all who | were so happy as to know him, but | more especially by his most dutiful and | affectionate daughter who caused this | monument to be erected to his memory.

On a flat stone in the floor of the chapel (D) :

The body of | Edward Brown, gent., | whose monument is erected | on the north side of the altar | was interred under this | stone.

At yᵉ top in capitals seemingly older than the inscription below :

As yov are so were we | As we are so yov mvst be.

A brass plate in the easternmost pillar of the north nave, close to the entrance of the chancel :

Hic jacet | Bristovius Brown | summæ puerulus spei octennis | Parentum summæ dum vixit deliciæ | Qui obiit tertio nonas Januarias | anno Christi MDCLXXX$\frac{v}{vi}$.

At the east end of the north aisle are three vulgar looking stone tablets ornamented with cherubs and other figures ; in the middle one (D), which is stuck in the centre of the window, there is the following inscription :

Here | lyeth yᵉ body of | John Harryman, gent., | who had 2 wifes and by | them 21 children of wich | number he left only 7 | alive at his death viz. | Margᵗ by his first wife, | Richard, John, Theophilus, | James, Dorothy, Thomas | by his second. | He dyed | October yᵉ 2d, | 1706, ætat. suæ 74.

On the one to the north :

Here lyeth yᵉ | body of Mrs Mary | Harryman wife | of John | Harryman, gent., | who departed yˢ | life Octʳ yᵉ 6th, 1712, | aged 63 years.

On that to the south (D) :

Near | this place lieth the | body of Richard Harry | man, gent., interred No- | vember the 16, 1719, | Ætatis suæ 48, | who left Mary his | wife and four children, | Elizabeth, John, George, & | Barrot.

On a flat stone near yᵉ north door (D) :

In a vault | near this place | was laid the remains of | Mr Thos Ducket | who departed this life | on the 22 of May 1822, | aged 57.

[See also *Churches of Holland* ; *L.R.S.* i, 172.]

(MS ix, 191–197.)

Quarrington

Notes taken in the church, 2 August, 1833—

On a stone let into the north wall of the chancel (D) :

Hic infra situs est | Tho. Appleby A.M. qui | postquam hanc ecclesiam | per annos septem et tri- | ginta summa cum

vigilan- | tia rexerat . mortalitatem | exuit VI id. Martij Anno | Do. MDCLXXXIII ætat. suæ.

On a stone against the south wall of the chancel (D) :

Sacred | to the memory of | Samuel Benson | who died April 1, 1799, | aged 72 years. | Also Mary relict of the above | who died Sept. the 20, 1799, | aged 67 years.

On a stone in the floor (D) :

✠ Eleanor daughter of | David Edwards, esq., | of Dolgelly, North Wales, | and wife of the | Rev. Romaine Hervey, A.M., | died May XIX and was | interred in a vault beneath | this stone the XXX of May | MDCCCXV.

In the chancel is a stone (D), on which is very deeply cut and on a large scale what seems to be a coat of arms—A chevron in chief two castles.

A black slab let into the north wall of the chancel in capitals (D) :

Consecrated | to the memory of his deare | Father | Thomas Bouchier borne at Hanborow in the county | of Oxon, a worthy divine and sometime faith- | full preacher in this church, a man of singular | integrity and piety (who changing this fraile | life for eternity) expired Sept. 8, anno ætatis | 67, et sal. Jesu 1635. The patterne of conjugall love the rare | Mirror of a father's care | Candid to all his every action pen'd | The coppy of a frend | His last words best, a glorious e'en (they say) | Foretells a glorious day. | Erected and composed with tears | by his pensive sonne, James Bouchier.

An oval marble tablet at the east end of the nave (D) :

On ye south | side of ye middle | alley joyning to ye | quire lyeth ye body of | Samuel Barron who | was interred December | the 18th, 1715, | and in the 65th yeare | of his age.

This church consists of a nave and north aisle, and a modern chancel, with a tower and spire at the west end.

[See also Trollope, *Sleaford*, pp. 428–32 ; *L.R.S.* i, 217.]

(MS iii, 25–28.)

Raithby by Louth

Notes taken in the church of Raithby, 25th August, 1837— This is a small church, consisting only of a nave and chancel, with a south porch, and a bell turret at ye west end, containing one bell. On ye north side of ye nave are three pointed arches bricked, and the windows have been lately inserted of ye Decorated style. Between ye nave and chancel is a Norman arch adorned with the square headed moulding. The chancel is modern, having been lately built by the Revd. G. A. Chaplin. It is of a semi-circular form, having five handsome windows after ye Decorated style. The roof

is of open timber work. The font is Early English, octagonal, pannelled with quatrefoyles, on a base of clustered columns. The church is kept very neat and clean.

In the porch is an old stone which has once had an inscription round y^e edge, but it is now illegible.

On a flat stone in y^e nave :

> In memory of | two sisters | whose desire it was to be interred | by the side of each other. Christease Allenby | third daughter | of | Hinman Allenby, | gentleman, | and Maria his wife, | who died 18 July | 1821, | aged 86. Ann | relict of the late | Rev^d Arthur | Rockliffe | rector of Roughton | in this county | who died 11 Nov^r | 1824, | aged 86.

On another stone, to the west of the last (D) :

> Here | lies interred the | body of Mrs | Ann Hudson | wife of Mr | John Hudson | of Orgarth Hill | who departed | this life February | the 15th, 1754, aged 49. | Also the | body of Mr John Hud- | son husband to the | above Ann Hudson | who departed this | life the 22^d of January | 1771, aged 78 years.

Another more to the west :

> In memory | of Frances the wife | of William Hyde | who departed this life | March the 6th, 1783, | aged 59 years. | Also of Ann their daugh: | who dyed May the 21, 1782, | aged 20 years.

(MS ix, 127–129.)

Ranby

Notes taken in the church of Randby, 11 October, 1840—This church, which stands very prettily on an eminence with a view towards the adjacent wolds, consists of a tower, nave, and chancel. The former has been lately built, and is of handsome Gothic. The nave and chancel have been repaired.

The church contains but one funeral memorial, which is a tablet against the south wall of the nave, with this inscription :

> Sacred to the memory of | Mary Denton | who departed this life 5th November 1837, | aged 68 years. | She died trusting in the merits of the | Redeemer. | Also of | Oliver Walesby | brother of the above named | Mary Denton | who departed this life 3 of January 1832, | aged 64 years. | This monument is erected in affectionate | love and regard to their memory by | Mary Ann Fowler | daughter to the above named | Mary Denton.

From deeds now in possession of Mr Otter, the incumbent, it appears that most of the land in this parish belonged to an Edward Dicconson, Esq., who was attainted for high treason in 1716. He

was a Lancashire gentleman. The forfeited estate, however, seems to have been restored, and in 1723 belonged to Roger Dicconson. Tradition says there were two brothers, one lived at the Hall at Randby, and another at the Hall at Market Stainton.

[See also *L.R.S.* i, 134.]

<div align="right">(MS x, 5–6.)</div>

Rand

Notes taken in the church, 13 August, 1833—

A stone which has been fixed into the south wall of the chancel, the inscription in capitals (R) :

> God be mercifull to me a siner. I. S. | Conditur Humfridus cineris velamine Barlow | sacrato verbi qui paverat ubere Randos : | Fridswidam ducens, septem virtutibus omnes | Instituit natos a casta conjuge partos | Anno 16 mense.

Next to it against the south wall is a monument of marble (R). Above have been two shields now almost obliterated. In the first shield have been nine quarters, all that now remain at all distinguishable are—1st, Quarterly [azure and argent], with a crescent for difference [Metham] ; 4th, A lion rampant sable [Stapleton]. In the second shield was also—Quarterly, but now quite effaced. Under these is the small figure of a lady kneeling at a desk, and below, this inscription in capitals :

> Here lyeth Dame Dorothye Leigh first wife to S^r John | Leigh of Ingolsby, knight, and after wife to Charles | Metham of Bullington, Esquire, daughter of Thomas | Flower of Langare in the county of Nott., gent : and | Katharine his wife, one of the daughters of George | Chaworth of Linbye in the said county of Nott., Esquire. | She lived in the feare of God and dyed in his fayth at | Bullington the 24 day of August Anno Domini 1613.

A handsome white monument against the east wall of the chancel (R), but in some measure injured by the injudicious use of whitewash. At the top is the figure of Time with a scythe and hour glass ; and beneath, the words ' Pietatis Officium et memoriæ '. Just below are two shields of arms, but the colours, etc., much effaced. The first—Quarterly of nine, 1st, [Metham] ; 2nd, Gules, an eagle displayed [? Illey] ; 3rd, On a bend sable [three bezants—Markenfield] ; 4th, Argent, a lion rampant sable [Stapleton] ; 5th, Sable, fretty argent [Bellew] ; 6th, A lion rampant [Brus] ; 7th, Barry , a canton [Lancaster] ; 8th, Four bars gules ; 9th, Paly . . . and gules, a bend ; Crest—A bull's head couped. The second shield quarterly of fifteen, almost all effaced ; what can be discovered is—3rd, Three lions passant azure [Marmion] ; 6th, Gules, a bend [Rye] ; 9th, Barry of six argent and

gules, three crescents sable [Waterton] ; 10th, Argent, six martlets 3, 2 and 1 sable, a chief [Sparrow] ; 12th, A saltier gules [for Talboys]. Beneath is a lady kneeling at an altar, with five sons kneeling before her and three daughters behind. Underneath this line :

Hi tantum ex 15 liberis supervixerunt.

The inscription below is in capitals :

Hic jacet Anna Metham uxor Caroli Metham de Bullington, | Armi : filia prima (ex tribus) Roberti Dymoke de Scrielsbie | Armi : quæ obiit vicesimo tertio die Novem. An. Domini 1602. | In cujus sanctissimam memoriam ob vitæ integretatem | morumque probitatem Ego Edovardus Dymoke miles Regius | frater (ex quinque) primus hos funebres composui versus.

On a ledge of the monument is this :

Promanans ex vero et conjugali amore Anno domini 1603.

Then follows in two columns these verses :

(1) Anna prius Dymoke Methamo juncta marito | Vixit . . . per digne nomine stirpe sua | Methami nomen numerosa prole beavit | Nomen utrumque suis moribus eximiis | summe casta viro natis chara atque propinquis | omnibus et dulcis religeosa Deo | mundum spernebat vere peccata dolebat | In Christi meritis gloria spesque fides.

(2) Vita brevis mors cita lucrum super omnia Christus : | Lætatur superum fæmina sancta choro. | Ad sororem. | Hæc ego (chara soror) fraterni pignora Amoris | Carmina pro justis mæsta parento tibi | Quem fateor præter sexum virtute preiisti | Mortem (vita impar) æmulor ipse tuam.

On an old stone before the door, just outside the church, in old character :

. . . . jacet magist. Willelmus Mawe cujus anime | propitietur deus amen.

Against the north wall of the chancel (R) is a very fine monument of freestone. At the top are three shields of arms, that in the middle bears—Quarterly, 1st and 4th three crescents a chief ermine [Fulnetby] ; 2nd, , a fesse in chief three roundles [Colvile] ; 3rd, , three towers triple towered [Towers]. At the east— , three lions passant crowned [Dymoke]. At the west—Quarterly, 1st and 4th, , a raven . . . [Herenden] ; 2nd and 3rd, three escallops . . . [Strickland]. Below is inscribed :

Apo. 2, ver. 17. Vincenti dabo manna absconditum.

Below are three more shields. On the west— , a chevron between three garbs . . a crescent for difference [Sheffield] ; impaling Fulnetby. In the middle— , a tower triple towered . . . between three covered cups [Amcotts] ; impaling Fulnetby. On

the east—Per fesse, a fesse dancettee [Phesant]; impaling Fulnetby. On the pilaster at the west side are—1st, Fulnetby, impaling—On a chief three lions' heads erazed Below—A lion rampant double queued, holding a club surmounted by a rose ; impaling Fulnetby : the name written over, 'Maister'. On the east pilaster are two shields—1st, Fulnetby ; impaling—Barry of seven argent and gules, charged with eight martlets, 3, 3 and 2 ; the name over, 'Eland.' Below—Paly of six, . . . and ; impaling Fulnetby : name, Lauson. In the middle of the monument are twelve shields, six in a row, with the names over as follows :

(1) Fulnetby ; over it—Gef. Fulnetby.

(2) Fulnetby, impaling—A lion rampant—Sr I. F. | Braytoft.

(3) Fulnetby, impaling—A fesse, in chief three roundles— I. F. Colville.

(4) Fulnetby, impaling—Per bend, on a fesse indented three martlets—Sr T. F. Cracroft.

(5) Fulnetby, impaling—A cross engrailed, in 1st quarter a martlet—W. F. | Mossendyne.

(6) Fulnetby, impaling—A talbot passant—W. F. | Bvrgan.

(7) Fulnetby, impaling—Three bars in chief a greyhound current collared—I.F. | Skipwith.

(8) Fulnetby, impaling—Three towers triple towered—I. F. | Towres.

(9) Fulnetby, impaling—An eagle displayed—I. F. | Sothil.

(10) Fulnetby, impaling—Two lions passant, crowned—I. F. | Dymmoke.

(11) Fulnetby, impaling—On a fesse, between two lions passant guardant, a fleur de lis . . . between two crescents —G. F. | Godrick.

(12) Fulnetby, impaling—Ermine, a griffin segreant crowned —I. F. | Grantham.

Below the arms is the inscription in two columns in capitals :

(1) Here lyeth Sir Vincent Fulnetby, knight, & | his auncesters : he had two wives, the .1. Jane | the daughter of Walter Herneden, Es- | quir. She dyed Ano. 1593. he had by her | issue .4. daughters the 1. Elyzabeth ma | -ryed to Vincent Shefeild of Crox | bie, esquire. the .2. Joan maryed to | Peter Faesaunt, esquire, one of the | Counsel of Yorke. The .3. Jane mary | ed to Sir Richard Amcoats of As- | trop. Knight of the Bathe, 1606.

(2) The .2. wife Margaret the sister of | Sir Edward Dimmoke, knight, the kings | chmpian [*sic*]. He had by her issue .5. chil | dren .2. sonnes and .3. daughters : first | John whoe dyed about the age of | .7. yeares. A child of good and rare | vertew and towardnesse. The .2. | Edward Anne and Briget yet lyving.

At the west side of this monument is a fragment of a brass (R), consisting of the bust of a woman in a ruff, her hands clasped, set upon a man's legs in armour ; and on the east side, a perfect figure of a woman in a gown with fine worked border, a ruff and cap, her hands clasped. Below is a shield of arms in brass— Metham, quarterly of 9, as above (p. 294) ; impaling—Quarterly of twelve, 1st, Fretty [Willoughby] ; 2nd, A cross sarcelly [Bek] ; 3rd, Three buckles between eight cross crosslets [Roseline] ; 4th, A cross engrailed [Ufford] ; 5th, Quarterly, 1st and 4th, A lion rampant [FitzAlan] ; 2nd and 3rd, A fret [Maltravers] ; 6th, A lion rampant [Welles] ; 7th, A fesse indented between six crosslets [Engaine] ; 8th, Barry of six, three crescents [Waterton] ; 9th, A greyhound current between three wolves' heads erazed, a border engrailed [Heneage] ; 10th, three garbs [Preston] ; 11th, Two bars, a canton [Buckton] ; 12th, A cross flory triple-crossed. There are two crests : on the dexter side—A bull's head couped [Metham] ; on the sinister—A man's head crowned [Willoughby].

To the east of this, is a very handsome monument of marble (R) ; in a recess is the figure of a knight kneeling on a cushion before an altar, in armour, bareheaded ; his lady is opposite him in a similar recess, in a long gown. Over him are these arms—A fret, a mullet for difference [Harrington] ; impaling—Two squirrels sejant addorsed (Samwell). Over the lady these—A fret and a mullet [Harrington] ; impaling—A pale between two eagles displayed [Woodward]. On a ledge below are the figures of two sons and three daughters kneeling on cushions. Two of the latter are broken. Below on a black slab in capitals :

> Here lieth ye body of Sr Sapcote Harington, knt, 2d sonne to | Sr James Harington of Ridlington in the county of Rutland, knt & | baronet. He had 2 wives, ye first Jane daugh. of Sr William Samwell | of Upton in ye county of Northampton, kt, by whom he had 2 sonns | & 3 daughrs. Shee lieth intoombed at Milton in ye co. of Northamp. | His 2d wife Jane daughr of John Woodward of London, Esq., by | whom he had 2 sonnes & 3 daughrs. Ye eldest daughr lieth here | buried. He lived in ye true fear of God & died in ye faith of | Christ | ye 8th day of Apr Ao D'ni 1630 in ye 48 year of his age. | Non erit hoc jactans monimentum non fuit ille | Quem tenet, hinc rapiat Gloria vana Fugam | Factorum Pactorum et vitæ qualis Honestas | Quales virtutes hæc aliunde pete | Non dabit ista tibi hoc marmor ne forte superbum | Dum vultus simulat sit sibi dissimile.

To the east of this is a brass plate (R) in the wall, with this inscription in capitals :

> Here lyeth Willyam Metham of Bolington, Esquier, who was | the sonn of Robarte Metham, second sonne of Sr

Thomas | Metham of Cave, knight. He had 4 wyves, the 1st was the widdow | of one Good ; the second was Ellen the daughter of Mr Whytting- | ton & he had by hir issue, Charles, Susan, and Anne ; the | third Fraunes daughter of Edmound Lord Shefeild ; the fourth Mary | daughter to Willyam Lord Willoughby of Parham, and by her | had issue Catheren and Doritie. Hee dyed the 12 of January | 1590, and the 66 year of his age.

In the east wall of the chancel (R), north of the altar, is a monument of marble, the figures of a man in a furred gown and a ruff ; opposite his wife in a gown, ruff, and flat cap, kneeling before a desk. Over are the arms of Metham, quarterly of nine as above (p. 294) ; [impaling—Quarterly, 1st and 4th, Gules, three crescents argent, and a chief ermine [Fulnetby] ; 2nd, Or, a fess gules, in chief three torteaux [Colvile] ; 3rd, Argent, three towers gules [Towers]]. Below the figures this inscription on a black slab in capitals :

Here lyeth Charles Metham of Bulington, | Esq., & Elizabeth his 3d wife, eldest daughter | of Sʳ Vincent Fulnetbye, knt, first wife | to Vincent Sheffeild, Esq., a godly, vertuous, | faithful woman. Shee did dye blessedlye | in yᵉ Lord at East Rason yᵉ first day | of October 1628, in yᵉ 67 year of her | age ; he died yᵉ [blank] day of [blank].

This church consists of a nave and chancel, and a tower at the west end. In a niche in the north wall is placed a figure which seems once to have been on a tomb. It is of a female, in a long robe and mantle, and her head dress covers her chin. The hands are clasped, and the head rests on a pillow supported by angels. On her breast is a shield but the bearings are effaced.

[See also *Lincs. N. & Q.* xix, 113 22 ; Jeans, 52–53.]

(MS xii, 67–76.)

Market Rasen

Notes taken in the church of Market Raisin, 29 August, 1828—

Most of the monuments in the church are modern, with the exception of a stone on the floor, with the arms—A cross patty fitchy within an orle of estoiles [Caldwell]. V.C. 1639. [This stone represents a child of Lawrence Caldwell of Thorganby ; another child, named James, was baptized and buried at Market Rasen, 1640.]

At the east end of the chancel a stone with the arms on a lozenge—In chief, per pale three boars' heads erect [Booth], and in base—Two lions passant, crowned [Dymoke] : impaling—Paly of six, on a chief a lion passant guardant [Lodington] :

In memory of | Mary Dymoke | widow of Edward Dymoke | of Wadingworth, Esq. | She was first married to | John Booth

of | Market Raisin, Esq. who lieth | interrd near this place, |
and was one of the | daughters and coheiresses | of John
Lodington of | Fonaby, Esq. in Lincolnshire, | who died
the 22 of June 1740, | aged 90 years.

[See also *L.R.S.* i, 111.]

(MS Supp., 13–14.)

Redbourne

Notes taken in the church, 2 September, 1835—

On a marble tablet in the north chapel (R), now a schoolhouse,
with a bas relief above of a ship, and distant land on which stands
a pagoda :

> M.S. | Rogero Carter, viro | Inter ipsas orientis opes et ille-
> cebras | intemerato, integro ; | qui re modica in patriam
> rediens, | nec majoris appetens, | Castri St'i Georgii præfec-
> turam | postea sibi ultro oblatam recusavit ; | pos. frater
> Robertus Carter Thelwall | obiit A.D. MDCCLXXIIII, æt. . . .

On a white marble tablet north of the chancel :

> Sacred to the memory of | Charlotte wife of Lord William
> Beauclerk, | afterward 8th Duke of St Albans, | she was the
> daughter of | the Rev^d Robert Carter Thelwall and Charlotte
> his wife, | and had issue one son by Lord William Beauclerk |
> who was baptized on the 11th of May 1794, | and was buried
> on the 13th of the same month | She departed this life on the
> 19th of October 1797 | and was buried in this church. | This
> tablet is erected by | William Aubrey de Vere 9th Duke of
> St Albans, | as a mark of affectionate respect | to the memory
> of his father's first wife.

On a white marble tablet opposite, surmounted by a ducal
coronet :

> Sacred to the memory of | William 8th Duke of St Albans |
> who departed this life the 17 July 1825, | aged fifty eight
> years. | Also of Maria Janetta his Duchess | who died 17
> January 1822, | aged forty seven years, | leaving six sons &
> six daughters. | This tablet is inscribed | to their beloved
> memory by their affectionate son | William Aubrey de Vere
> ninth Duke of St Albans.

On a white marble tablet with an urn over, thereon a man planting
a tree between another carrying trees and a third bearing a spade :

> M.S. | Gulielmo Carter | Duodecim liberorum patri | Qui
> deo animæ terræque colendis operam dedit | pos : filius
> Robertus Carter Thelwall | necnon Susannæ conjugi ejus
> pientissimæ : | Obierunt | Ille A.D. MDCCXLIIII æt. LXIII |
> Illa A.D. MDCCLII æt.

On the north side of the chancel, set sideways in the wall, is a large black stone having the figure of a knight carved thereon in outline, gilded. He is in plate armour with peaked helm and mail gorget. At his feet is a greyhound, and his head rests on a pillow supported by two angels ; his sword hangs at his left side in an embroidered belt ; and at his right is his dagger. The figure is about the natural size. Below is this inscription in gilded letters of old character cut into the stone (R) :

> Hic jacet dominus Gerardus Sothill miles qui obiit primo die | Augusti Anno Domini millesimo cccc v. cuius anime miserere deus amen.

Above the stone is a stone crocketed canopy of ancient work, with this shield at the finial—Argent, an eagle displayed sable [for Sothill].

A white marble monument against the south wall of the chancel, with these arms cut below—Azure, a talbot passant between three buckles [for Carter] ; impaling—Nelthorpe. Crest—A lion's head, gorged with a mural crown. Above is a male figure weeping over an urn, and this inscription on a black slab in capitals :

> Here lyeth the body of Charlotte | daughter of Sir Henry Nelthorpe Bart : | and next to her (as he hopes) will be deposited that of | the Rev^d Robert Carter Thelwall, iii^rd son of W^m Carter, | who desires to record on her tomb this farther memorial | of himself (as his highest Character, Glory, & Happiness) | that from the 1st of Jan : MDCCLXVII | He was the loving | and beloved husband of the above mention'd Charlotte | a woman (according to his judgment) of most gentle | manners, mild affections, elegant accomplishments, | refined humour, and sound judgment, joined to | great piety, benevolence and charity | Heu ! Charlotta Vale ! morum placidissima conjux. | Mente tibi comitem me superesse dolet | Pos : R.C.T. | she died viii March MDCCLXXX, aged xxxviii | He died xviii Oct. MDCCLXXXVII, aged LXVII.

Below is inscribed :

> He was again made happy in a second | marriage with Hannah Spooner.

The church was rebuilt about 56 years back at the expence of Mr Carter, and has been done in good taste. It consists of a nave with two aisles formed in a circular shape, with two pillars on each side, octagonal, forming three pointed arches. The chancel is divided off by a pointed arch. There is a pinnacled tower at the west end with a porch, which is badly executed, having two arches to enter by (D). The buttresses of the aisle and chancel are pinnacled. The east window contains in modern stained glass the figures of the Apostles. The remainder are in the clerestory windows, on each side three. There are north and south aisles to

the chancel entered by ogee arches, crocketed, with a finial. The southern one is used as a cemetery, and there are niches for coffins. In the window are figures of Hope and Faith. The northern aisle is used for a school or vestry. The font is of modern white marble, handsome of its kind.

On a marble tablet, outside the church, against the south wall of the chancel (D) :

Sacred | to the memory | of Hannah Carter Thelwall, | widow, who departed this life | October the 5, 1800, | aged 52 years. | By nature formed for every social part | Mild were her manners and sincere her heart | Benevolence in every feature shone | And virtuous friendship hailed her as her own.

On a similar tablet close by (D) :

In memory of | Jane Spooner widow of | Hungerford Spooner of St Christophers | who departed this life 27 July 1788 | in the 61 year of her age. | Reader if gentle and unaffected manners | Piety benevolence & domestic virtues | Are dear to thee | Respect her grave.

In the churchyard are these flat stones to the memory of former vicars :

The Rev^d Mr Josias Morgan Rect^r of Manton & vicar of Redbourne died 27 Aug^t 1737, æt. 58.

The Rev^d Richard Branston vicar of Redbourne 44 years died 5 Oct^r 1781, æt. 71.

Another surrounded by a rail :

The Rev^d Robert Nelthorpe Palmer 26 years vicar of Redbourne died 24 Nov^r 1821, æt. 56.

And a tablet against the south wall to :

The Rev^d Christopher Metcalfe died 20 Jan^y 1795, æt. 72, and Catherine his wife died 8 Feb. 1788 | aged 60.

[See also *Lincs. N. & Q.* xi, 110–112.]

(MS viii, 133–139.)

Rigsby

Notes taken in the church, 19th August, 1835—

On a brass against the south wall (R) :

Sacred to the | memory of William Kingston, gent., | who departed this life the 1 Sept^r | 1792, aged 60. | At his request his remains were brought | from Alford, and interred near the body of | the Rev^d W^m Willoughby late vicar of Alford ; | who died the 15 July 1792, aged 45. | With their acquaintance commenced a sincere | friendship in which by walking together in | the House of God they were confirmed ; until | translated through the merits of their Redeemer | to scenes of happier intercourse.

This church, which is in a pretty situation, commanding a fine view over the edge of the Wolds and the extent of the Marsh, is a mean barn-like building, having a nave and chancel, and a box of wood for a bell at the west end. The roof is thatched. In the east wall north of the altar is a canopied niche in which are placed an old morion of the time of Charles I, and a short sword or dagger (R). South of the altar is a piscina. On the floor is an old stone (D) with a cross cut on it of a long stem, and a head similar to this [a small sketch of a cross bottonnée or flory]. The font is octagonal pannelled in arches of the Perpendicular style.

[See also *Lincs. N. & Q.* x, 235.]

(MS vi, 67–68.)

Rippingale

Notes taken in the church, [*blank*] August, 1831—This church is large and handsome, with a fine tower at the west end. The living is in the gift of Sir Thomas Heathcote, and the incumbent is the Rev^d [William Thomas] Waters.

On the north side of the Communion Table is the effigy of a knight in mail, completely armed, with his legs crossed, his head resting upon a helmet, and his feet upon a lion. It is in tolerable preservation, and the rings of the mail are plainly to be distinguished. Tradition gives it to one of the Brownlow family (R).

On a flat stone to the south (R) of this last has been a figure in brass which is now gone.

To the south of the Communion Table (R) is a white marble monument with pillars and arms above—Argent, an orle of martlets sable, on an inescucheon azure an escallop [Brownlow]:

> Hic reponuntur exuviæ | Liberorum honorabilis | Richardi Brownlowe Baroneti | et Dom. Elizabethæ uxoris ejus | scilicet | 1^mo Elizabethæ natæ Septembris 6^to | MDCLV quæ Martii die Octavo | moriebatur anno prædicto. | 2^do Mariæ natæ 21 Sept. 1656, quæ | die Feb. 15^o moriebatur 1659. | 3^tio Elizabethæ natæ 20 Feb. 1657 | quæ Decem. 17 moriebatur 1659. | 4^o Richardi Brownlowe nati | Octob. 5^o 1664, qui Oct. 29^o | moriebatur anno prædicto. | 5^o Elizabethæ natæ 28 Feb. 1666, | quæ moriebatur Martij 25, 1669, | quæ pignora prædicta Richardi | Brownlowe Baronetti et Heroinæ | Elizabethæ sibi conjugis, | Hæc servatures sui | præstolatus adventum.

On the base :

> Epitaph | Here lies a bud soon gone whose beauty might | Have (had it grown) outshined the splendid light | Of other flowers, but we know 'twill spring | And glory to its Gard'ner it will bring | Its root has left a cyon, but not lost | The price

pay'd for it was of no small cost | The byer shall preserve it to his gain | Glory 'twill bring him when in bliss 'tshall raigne.

On a white tablet against the north wall of the chancel :

In memory of | Wade Gascoigne, LL.B., | who died 19 May 1801, | aged 68 years, | and of | Anne Davison his wife | who died 19 July 1792, | aged 58 years. | Also of | Wade Davison Gascoigne | who died 22 April 1784, | aged 15 years, | and of John Gascoigne | who died at sea | off Jamaica | in Autumn 1784, | aged 14 years.

In a canopied recess in the south aisle, almost entirely concealed by pews, is a stone effigy but without any inscription.

On a neat black and white marble tablet in the south aisle :

Sacred | to the memory of | John Quincey, gent., | [late of Down Hall in this parish] | who departed this life | March 8th, 1827, | in the 80th year of | his age.

In part of the south aisle used as a school house there are two altar tombs with effigies upon them, but so obscured by whitewash as almost to be indistinguishable, and also the following on a white marble tablet (D) :

Sacred to the memory of | Richard Quincey, gent., | of Pointon, | who died on the 18 Oct. 1813, | in the 71st year of his age. | The memory of the just is blessed.

[See also *L.R.S.* i, 193–194.]

(MS i, 67–70.)

Sapperton

Notes taken in the church, 30 July, 1833—

On a stone in the east wall of the chancel (R) :

Near to this place | lies interred the body | of Susanna the wife of | the Revd Wm Lodge | and younger daughter of the Reverd Stepn Clark | minister of St John's in Beverley in ye county | of York. She was born | January the seventh, 1676, | and departed this life | the 27 of March in the | year of our Lord 1736.

On a similar stone close by :

Near to this place | lies interred the body | of William Lodge | late rector of Sapper | ton, he departed this life | ye 18 of Novem. 1737, | aged 69. | By the Bounty of Queen Ann | and the Patron this living was | augmented in 1720, two closes | laing at Ingoldsby called Worm | sikes and one on the north side | of the parsonage house | called Church Leays.

On a flat stone which goes under a pew in the nave (R) :

Here lyeth the body | of William Doughtie late of Lincolnes Inn, gent., | who dyed the 21 | day of July 1656, in the 62 yeare of his age.

A handsome black and white marble monument, flanked by two

Corinthian columns, and in the entablature these arms—Per chevron sable and argent, three elephants' heads, erazed, counterchanged [Saunders]; impaling—Ermine, on a chief sable a crown or, between two leopards' heads cabossed argent [for Taylor]:

> Sacred to the memory | of ye truly religious | and right worthy person | John Saunders, Esq., | (the dear & only husband of | Ursula Saunders | his loving wife | formerly deceased) | who died May 4th, Anno D'ni 1685, | Anno que ætatis 70. | Here lies his body mixed with ye dust | whose life was holy humble good and just | Scilicet exemplo tandem hoc ediscite vivi | Ex hujus vita vivere morte mori.

Over this is a hatchment of the arms of Saunders with crest—An elephant's head (D).

A white marble monument opposite the last (R) with the arms of Saunders over:

> Near this place | lyeth the body of Ursula Saunders eldest | daughter of Richard Tayler of Clapham in the county | of Bedford, Esq., sergeant at law, late wife to John Saun- | ders of Sapperton, Esq., eldest son of Sir John Saunders | of Marston in the county of Bedford, knt, who lived toge | ther most happily eight and forty years and left one son | and three daughters surviving her | John, Elizabeth, Mary, & Ursula. | She lived and died a true daughter of the church of England. | She was | the best of wives, | a most indulgent mother, | a generous and true friend, | and for her | singular piety, | exemplary life, | great charity, | did excel most of her time, whilst living admired and beloved, since | dead missed and lamented by all that knew her. She depar | ted this life in full assurance of a better ye 29th of May | Anno Dom. MDCLXXXIII | [Anno] Ætatis LXVII.

This church is a very small one; it consists only of nave and chancel. The door is on the south side, and there is no orient window. In a window south of the nave are two coats of arms in painted glass—(1) Ermine, a chevron gules [? Tuchet]; (2) Azure, a fesse daunce between ten billets 4, 3, 2, and 1 or [Deyncourt]. In the next window is a shield charged with a bend.

[See also *L.R.S.* i, 208.]

(MS ii, 247–251.)

𝔖austhorpe

Notes taken in the church of Saucethorpe, 17 August, 1835—

On a flat black stone in the chancel, with these arms cut above—Two lions passant, crowned, a mullet for difference [Dymoke]; on an escucheon—A fesse between three leopards' heads cabossed [Payne]. Crest—On a helm, a sword erect:

> Charles Dymoke, M.D., | third son of Charles Dymoke | of

this place, Esq., | departed this life | May ye 12, 1761, | aged 56 years. | He left issue two sons | Needham and Edward. | Elizabeth the widow | of Charles Dymoke, M.D. | who departed this life | the 10 of September 1772, | aged 56 years.

On a black stone within the Communion rails :

Here lies interr'd | the Honble Edward Dymoke, Esqr, | Champion of England | obiit Sep. ye 12th, 1760, | in ye 65 year of his age.

Upon a black stone at the south end of the chancel; a chest is over it :

Here lyes interr'd the | body of Elizabeth | Dymoke daughter of | Charles Dymoke, Esq., | and Mary Dymoke | who departed this | life July the 22, 1743, | in the 47 year of her age. | She died in London.

Upon an old stone in the chancel very much rubbed :

Here lies interr'd the | of John Dymoke | Charles | and Mary | departed | mber |

On a blue stone in the chancel partly under a pew with the arms—Dymoke, impaling—A bend engrailed between two bucks' heads cabossed [Nedham]. Crest—On a helm a sword erect :

Here lyes interred the body | of Charles Dymoke, Esq., | who departed this life | the 29 Jany 1724, | aged 61 years. | Here also lyes interred | the body of Mary Dymoke | the wife of Charles Dymoke, | Esq., who departed this life | the 25 of Jany 1756, in the | 90 year of her age | In hopes of a blessed resurrection.

In the clarke's pew is an old stone, almost entirely obliterated, of which all that can be decyphered is :

. | , gent., | departed this life Novembr | , aged 67 years.

On a hatchment against a pillar of the nave facing south these arms—Argent, on a cross between four doves gules as many bezants [Welcome]; impaling two wives—on the dexter side, Quarterly, or and gules, a plain cross sable [for Cammock]; on the sinister side, Or, a plain cross vert. Crest—On an esquire's helm a dove rising argent. This inscription below in capitals :

Near unto this place lieth | buried ye body of Thomas | Welcom, Esqr, who departed | ys life ye 23 of May 1670, | Ætatis | suæ 75.

This is a small church; it consists merely of a nave and north aisle divided by two low pointed arches, a chancel, and a low tower at the west end.

[See also *Lincs. N. & Q.* x, 235–236 ; *L.R.S.* i, 83.]

(MS vi, 45–48.)

Saxilby

Notes taken in the church, 16 September, 1835—This church has been described by C. Anderson. The old figures are on a tomb in the north aisle of the chancel, which is divided from it by two fine pointed arches, but is now separated by an ugly modern deal partition, and is used as a school. In it stands the font. The tomb is of blue stone. Between the nave and chancel is a pointed arch.

On a flat stone within the altar rails :
> Sacred | to the memory | of | the Rev^d Thomas Rees | late vicar of this parish | who died Dec^r the 27, | 1807, | aged 46 years. | Also | Ann his wife | who died April the 3rd, 1808, | aged 51 years.

Another stone within the altar rails to :
> Christopher Bell died 22 Novem^r 1792, æt. 52.

A flat stone in the chancel to (D) :
> Elizabeth wife of William Metcalfe died 15 March 1832, æt. 38.

On another stone in the chancel :
> S.M. | of | Richard Younghusband | youngest son of the | Rev^d Joseph Younghusband | & Mary his wife who died | April 4, 1812, aged 7 years.

On another collateral :
> S.M. | of | William Younghusband | eldest son of the | Rev^d Joseph Younghusband | & Mary his wife who died | March 21, 1811, | aged 21 years.

(MS vii, 173–175.)

Scothorne

Notes taken in the church of Scothern, 5 August, 1833—

There is not one single monument or inscription in this church, but there are some atchievements of the Ellison family. An atchievement on the south wall of the chancel bears—Gules, a chevron argent between three eagles' heads erazed or [Ellison]; impaling—Per pale argent and gules, two men's legs armed counterchanged [Cookson]; and underneath, 'Non omnis moriar'.

A second atchievement has—Ellison, with an escucheon—Argent, a fesse embattled erminois, between three crescents sable. Crest —A griffin's head erazed per fesse argent and or, collared gules; and underneath 'Pulvis et umbra sumus'.

Another atchievement against the north wall of the chancel has— Ellison, impaling—Argent, an eagle with two heads displayed sable, on an escucheon argent a saltier gules [Maxwell]. Crest— Ellison.

A lozenge of arms against the south wall—Ellison, impaling— Argent, a dexter hand couped at the wrist proper.

The tower of this church is ancient ; the remainder, consisting of a nave and chancel, is modern, built about 34 years ago. In the tower is an old stone with a cross cut upon it having a long stem ornamented with flowers removed from the old chancel.

(MS i, 219–220.)

Scotter

Notes taken in the church, 7 September, 1835—This church consists of a nave and north aisle divided by five handsome pointed arches, springing from clustered columns with foliated capitals, a chancel, a tower at the west end, and a south porch. The south door is Norman, but the porch is a modern one and bears the date 1820. The font is octagonal and handsomely pannelled in quatre-foyles. The roof is open timber and very good. The description of some of the monuments in this church not here inserted are to be found in the *Gentleman's Magazine*, 1806, part ii, p. 749.

On a flat stone in the nave :

Here | lieth interr'd | the remains of three of the issue | from the marriage of Chas. Aistroppe, | Esq., and Ann his wife late of | this place, to wit, Ann and Frances their | daughters, the former of whome died | in her infancy the 19th of January 1762, | and the latter the 17th of May 1768, aged | 3 years. Also of Thomas their son who | died the 20th of Oct. 1770, aged likewise | 3 years.

On another stone :

In memory | of Charles Aistroppe, Gent., | who departed this life the | of August Anno Dom. 176 . . , | ætatis 65.

An old stone in the north aisle partly hid by a pew has this inscription cut on it as far as can be decyphered :

. ate p*ro* animabus | bart & Alici . . .

A stone near the last to the memory of :

[Elizabeth wife of] James Herring 27 Sept. 1738, æt. 55.

There are stones near the font to :

John Drewry died 31 Dec^r 1754, æt. 71.
Catherine his wife died May 23, 1726, æt. 31.
Ann their daughter died 6 April 1725, æt. 7.
Also John their son died 10 June 1733, aged 17.

On a blackened tablet against the south wall of the chancel :

Near this place | lie the remains | of | Mrs Anne Tonge wife of Mr | Roe Tonge gentleman of | Gainsbro' : who departed | this life Nov. 11, 1789, | aged 66 years.

Another to the west of the last :

> Beneath this pew | lieth the body of | Elizabeth Smith |
> relict of the Rev. Abrm Smith | obiit Oct. 12, 1782, | aged
> 86 years. | Also three of their children.

A stone in the chancel with the arms and crest of Anderson
cut :

> Underneath this | stone are deposited | the remains of | Edwin
> Anderson | of Morton, Esqr, | who dyed the 28 day | of October
> 1743, in ye | 61 year of his age. | Also | Mary relict of the
> above | Edwin Anderson who | died Dec. 25, 17[4]8.

On a stone next to the last in capitals partly rubbed :

> Heu | | Anima H placidi |
> Migravit 11 die Jan. | Anno Dom. | An. Ætatis . . |
> Depositum Mariæ | Anderson uxoris | Edwini Anderson Gen. |
> fil. dicti Hen. Smith hic | jacet 23 Jan. 1716, | Ætatis
> suæ 55.

Round the verge of a stone next to the last :

> Hic jacet sep | ultus 5 Jan. Anno Dom. 1679, et Ætatis suæ
> 63 | Guil. Laughton | fil. natu max. Ed. Laughton de Throp-
> ham Com. Ebor. | gen.

On a stone close to the altar rails partly rubbed :

> Winifrid daughter | of Edmd Laughton, | Gen., & Eliz. his
> wife | was buried Oct. | ye 23, 1679, | was buried |
> May ye 15, 1682 | John was buried | Sep. ye 19, 1691. |
> George was | buried March ye | 19, 1692.

Another opposite rubbed :

> Here lieth | the bodie of | Frances Smith | daught |
> Henry & . . . Smith . . . | ed the [15] | of [August] |
> year [1673].

[See also *Lincs. N. & Q.* xi, 138–140 ; *L.R.S.* i, 148 ; Jeans,
55–56.]

<div align="right">(MS viii, 215–220.)</div>

Scotton

Notes taken in the church, 7 September, 1835—This church
consists of a nave and aisles, resting on each side on three lofty
pointed arches, a chancel separated from the nave by a pointed
arch, and a tower at the west end. The church was repaired about
five years ago, and the font is a modern one. The north door is
Early English with a dog-tooth moulding. The roof is open timber
and good. At the bosses of the north aisle are shields, one with
the Dallison arms.

On the floor on the north side of the chancel is the recumbent
figure of a knight, cross-legged, in hauberk and coif of mayle, with
hose and gauntlets of the same. A long surcoat covers the hauberk.

His sword is broken, and the bearings on his shield effaced. His hands are clasped, and his feet rested on a lion.

On the opposite side is the figure of a lady in a long robe and mantle, with a wimple or coif covering the chin. Her hands are clasped. Her head rests on a pillow, and her feet on a dog. These two figures have apparently been removed from some altar tomb which might have been destroyed at the repairing of the church.

Near the figure of the knight is an old stone with this inscription round the edge in church text :

Hic iacet Ricardus Sawnby quondam rector eccl'ie qui obiit | die mensis . . . an. d'ni MCCC . . cuius anime | propicietur deus.

On the floor at the entrance of the nave from the chancel is the figure in relief in a sunk stone of a bust of a priest in a cope, inscription gone except :

Hic iacet Magist. propiciet . . .

A flat stone in the nave to the memory of Elizabeth wife of Charles Astroppe daur. of Thomas Wattson died 31 March 1729, aged 29.

On an old stone in the south aisle has been the figure of a knight in brass, with an inscription, but now gone.

Marble tablet against the east wall of the chancel :

H.P.I. | Exuviæ reverendi viri Johannis Morley, S.T.P., | hujus ecclesiæ et Collegii Lincolniensis Rectoris | quem tanto magis amaveris | quanto propius inspexeris | egregias animi dotes testatas fecerunt | Ingenii Vultus decor | Gestusque corporis venustus pariter et urbanus. | Homo haud affectate elegans | citra supercilium doctus | Morum suavitate vitæque Innocentia | clarus et honoratus | omnia officia atque munera explevit | ad ecclesiæ Scottoniensis regimene vocatus | pro salute animarum vigilavit | et ab omni ambitionis suspicione semotus | dum latere voluit. | Ad Collegii Lincolniensis gubernacula | quod viginti tres per annos Alumnus ornaverat | importuna amicorum voce accersitus est | Hanc Præfecturam modestus et prudens rector | pie placate atque leniter administravit | Publicis Collegii commodis et utilitati prospiciens | utrumque munus fato concedens deposuit | duodecimo die Junii A.D. 1731. | Felix connubio, Annam uxorem duxit | Davidis Robinson de Fiskerton filiam | Hæc tum prospera tum infirma valetudine | Dilectissimi Mariti fidissima Comes | Avulso conjugi ægrè superstes | mærore pressa transiit in mortem | Decimo sexto die Januarii et juxta jacet.

A flat stone within the altar rails (D) :

Here | lieth interred the remains | of Ann the wife of William | Forman who departed this life Dec^r 10, | 1782, aged 52 years. |

Also near this place lies Joseph Wood | former husband of the above Anne Forman | who died Jan^y 4, 1763, aged 41 years.

On a flat stone in the chancel (D):
Here | lie the remains of | Frances | wife of the Rev^d R. Empson | who died June 8th, 1830, | aged 35 years. | Also | the remains of | the Rev^d Ric. Empson | who died Jan^y 3, 1835.

[See also *Lincs. N. & Q.* xi, 140–141.]

(MS viii, 203–207.)

Scredington

Notes taken in the church, 28 July, 1834—This church consists of a nave and north aisle, separated by three pointed arches resting on octagon columns, a south porch, and a small tower at the west end. The font is round and ancient. In the north aisle is a piscina. It is curious from the many relics of ancient monuments that remain, and stones which must formerly have covered the floor. The only registers left in the chest were modern ones.

In the wall of the north aisle, near the east end, is a handsome cinqfoyled arch with canopy which is damaged ; and under it, on a tomb almost hidden from view by a pew which has been built before it, pannelled at bottom, is the figure of a priest in stole and robes of office. His hands are clasped, and his feet rest on a dog. On the long sleeve of his garment near the bottom is an inscription of which from the obstacle of the pew I could only make out these words in old character :
Thome [Wyke] rector [ecclesic de Manchester]

In the north aisle on the south side is a large altar tomb pannelled with shields in quatrefoyles, covered with a large black slab on which is a brass plate with this inscription in old character :
Hic iacet Will's Pylet de Scredington | qui obiit xxviii^o die Junii Anno D'ni | Mill'o cccc tercio cuius anime propicietur deus Amen.

To the west of the last is another large altar tomb which has had an inscription cut round the edge, but so effaced and cut about wantonly as to be quite illegible.

Near the north door is a flat stone (D) ; all that remains of the inscription is :
Hic iacet.

On the floor at the east end of the north aisle is another large stone, with an inscription round the edge, effaced except a few words which are illegible.

In the nave are many stones which have had inscriptions on them but now lost ; one has a cross and the word ' Robertus ' apparently left.

On a flat stone in a pew in the chancel (D) :
> In memory of John | son of William and | Priscilla Sumner | died August the 10, | 1733, aged 22 weeks. | Tread lightly passenger (the rest effaced).

[See also *L.R.S.* i, 212 ; Trollope, *Sleaford*, pp. 435–7 ; Jeans, 56.]
(MS v, 97–99).

Sempringham

Notes taken in the church, 27 July, 1833—The carvings of some of the old pews are curious.

On a marble tablet north of the chancel :
> In memory of | John Robinson, Esq., | late of Pointon Cottage, | who died the 18 of May | 1828 | aged 78.

A monument at the east end of the nave (R) ; arms below— Quarterly, argent and sable, on a bend over all gules three lions passant or [Hubbard]. Crest—On a cup of maintenance azure a lion's head erazed or :
> In memory of | John Hickling Hubbard, | gent., | who died the 11 of July | 1783, | aged 51 years. | Also Susannah his wife | who departed this life | March 26th, 1798, | aged 72 years.

The church bears evident marks of being considerably reduced in size. It now consists of a nave and north aisle supported on three Norman arches, a chancel, and a tower in the middle. In the south wall is a beautiful Norman door with the zigzag and other mouldings. The door itself is ancient and adorned with iron scroll work.

[See also *L.R.S.* i, 190.]
(MS ii, 215–216.)

Sibsey

Notes taken in the church, 14 August, 1835—

On a black stone in the chancel :
> Here lies yᵉ body of | Mr Thomas Burton, | sometime vicar of this parish, | who was interred yᵉ 12 of August | 1682, | aged [blank] years. | And also yᵉ body of Mr | Daniel Burton son of | the said Thomas who was | interr'd yᵉ 2 of February | 1682, | aged [blank] years. | And also the body of Mr | Zachariah Burton | another son of yᵉ said | Thomas who was | interr'd yᵉ 30 of May | 1710, | aged [blank] years, | with three of his sons named | Zachariahs.

On a white marble tablet against the north wall of the chancel :
> Sacred | to the memory of | Mary Harrison | who died 7 of January 1821, | aged 32 years.

On a stone within the altar rails :
> In the vault beneath this stone | are the remains of Lucy the wife | of Mr John Saul, | one of the daughters of | Mr William Kelsey of Fishtoft, | who died March the 31, 1804, | aged 72 years. Also of | Mr John Saul | died Aug^t 29, 1817, | aged 83 years.

A flat blue stone on the floor west of the altar :
> Here lyeth | the body of | Sylvester Mell | the son of Samuel Mell late | of this place, gent., | who departed this life | the 2^d of May | 1698. | Also | here lyeth the body of | Mrs Elizabeth Cely widow | of Richard Cely, gent., | who died April the 3, 1752, | aged 71 years.

Another more to the east :
> Here lie the bodies | of Mr Lawrence Cely, | gent., and Marg^t his | wife daughter of Mr | Sam^l Mell, interr'd | January the 12, 1704. | Here lies the body of | Lawrence y^e son of Richard | & Eliz. Cely interr'd | December y^e 29, 1708.

A flat blue stone within the altar rails :
> Here lyeth | the body of | Samuel Mell, | gent., | who departed this life | the 9th of July | 1688. | Here lieth the body of Mrs Eliz. | Cely (daughter of Rich^d Cely, gent., | and Eliz. his wife) interr'd | January y^e 2^d, 1737.

Another more to the south in capitals :
> Here lieth the body of | Mary the wife of Mr | Samuel Mell interr'd | May y^e 14, 1702. | Also | here lyeth the body of | Richard Cely, gent., | who departed this life | November the 12, 1741, | in the 78^th year of his age.

This church consists of a nave and aisles, divided on each side by five Norman arches rising from lofty columns, a chancel divided off by a Norman arch, now blocked up, and a Norman (though late of its kind) tower at the west end, which is divided from the nave by a pointed arch. The roof of the nave is very lofty and open to the timbers. The font is Norman with intersecting arches, on a large pillar clustered with small ones. In the chancel are three stone stalls, and a piscina on the south side. The north door is Norman. The steps to the rood loft remain quite perfect to the top of the south side. The pulpit is of oak in the style of the 17th century. The church is kept very neat.

There is a list (D) of benefactions on each side the entrance to the chancel, by which it appears that John Melson, clerk, vicar, by will dated 4 Feb. 1682, devised lands in Kirton for an augmentation to the living. John Wrightson, by will, dated 2 Aug. 1700,

gave lands for a commemoration sermon on the day of his death, 17 August, and also made a devise to the poor. John Brown of this parish and Thomas Peete of Boston, gent., devised also benefactions to the poor.

An old brick house with a porch stands to the west of the road about half a mile from Sibsey.

[See also *Lincs. N. & Q.* xi, 142–143 ; *L.R.S.* i, 165.]

(MS viii, 69–74.)

Sixhill

Notes taken in the church, 12 August, 1833—

On a white oval tablet against the north wall of the chancel :
Sacred | to the memory of | Elizabeth Christina Knight, | daughter of | Alexander Knight, gent., | of Sixhill Grange, | who died Feb^y 2, 1805, | aged 20. | May she rest in peace.

On a flat stone in the nave :
✠ | Here lieth the body | of the Rev^d Tho^s Ingram | who departed this life | on the 8th of April 1803, | in the 67 year of his age. | May he rest in peace.

On another flat stone :
✠ | In memory | of | John Hinde | who departed this life | May the 10, 1798, | aged 59 years. | Also | of Agnes his wife | who departed this life | Oct. the 30, 1799, | aged 42 years. | Requiescat in Pace.

There was a north aisle formerly to this church, but now gone and the arches filled up.

On a flat stone in the nave :
✠ | Here lies the body of the | Rev^d William Hartley | who departed this life | July the 7, 1794, | aged 54 years. | May he rest in peace.

On a stone set upright against the west wall :
Beneath | are deposited the remains | of Mr William Gwillim | who died October 26, 1777, | aged 75 years. | Also of Ann the beloved wife | of the above William Gwillim who | departed this life December | the 26, 1773, aged 63 years. | Requiescant in pace.

The church consists of a nave and chancel, and a tower at the west end.

(MS xii, 61–63.)

Skegness

Notes taken in the church, 21 July, 1834—This church consists merely of a nave and chancel, divided by a screen (R), a south porch, north door, and low thick square tower at the west end. The font is handsome and octagonal with shields in quatrefoyls.

A white marble monument against the east wall south of the altar ; arms over—Per chevron argent and azure, a crescent between two leopards' faces counterchanged [Chapman] :

Near this place | rests the body of William Chapman | late of this parish, gent., who had issue 7 | sons and 4 daugh^{rs}, viz. | by his wife Mary daugh^r of Capt. Rich^d | Bold of Thettlethorpe 4 sons and 1 daughter, | viz^t W^m, Joseph, Rich^d, John, and Mary. | By his wife Elizabeth daugh^r of John | Hussey of Ashby, clerk, 3 sons & 3 daugh^{rs}, | viz^t Hussey, Thom^s, Thom^s, Elizabeth, | Sarah, & Susan. | He lived to have 44 grandchildren & dyed | the 21 day of April Anno D'ni 1708, | ætat. suæ 82.

A similar monument on the opposite side ; Chapman arms and crest (A fleur de lis or) over ; impaling—Argent, on a bend azure three manches of y^e field [for Thory] :

In memory of | Hussey y^e son of Will^m Chapman | late of this parish, gent., | who died y^e 13 of July 1748, | aged 73 years. | And also of Ann his wife | Daugh^r of John Thory | of Skendleby in this county, gent., | who died y^e 6th of Oct. 1755, | aged 66 years, | by whom he had issue, | Thory, Thory, John, William, | Hussey, Bridget, Mary, Ann, John, | and William, | three of which died in their infancy, | and lie here interred | viz. Thory, John, and William | their first born.

On a marble tablet north of the nave :

In memory of Elizabeth wife of | Lieut^t James Bunce, R.N., | who died the 23 of August 1813, | aged 52 years.

On a flat stone near the north door :

In | memory of | Mr William Pell | who died Nov. y^e 20, | 1769, | aged 75 years.

[See also *Lincs. N. & Q.* xi, 235–236 ; Oldfield, *Wainfleet*, pp. 250–2.]

(MS iv, 243–245.)

Skirbeck

Notes taken in the church, 5 August, 1834—This church is a poor one, but has been larger. It consists of a nave and aisle divided by three pointed arches rising from clustered columns, a chancel, north porch, and tower at the west end. On each side of the chancel seem to have been aisles as there are the remains of the arches in the walls. The font bears date 1662. The pulpit of carved oak seems of the same period.

A large blue flat stone in the chancel (R), with these arms over— Three water bougets [Ross] ; impaling—A bend between an eagle displayed in chief, and a cross croslet in base [Rushworth] :

Here lieth the body of William Ross late | of this place, gen^t,

who departed this life | the 25 of August 1698, | and also of Elizabeth his beloved wife, | only daughter & heir | of Charles Rushworth late of Boston, | gent. | She dyed August y^e 17, | 1701.

On another stone to the south of the last (R) :

Here lyeth the body of the | Rev^d M^r Alex. Sampson late Rector | of this place who departed this life | the 28 day of Feb. 1735, aged 47, | and also of Eliz. his wife who dep- | arted this life 1 Sept. 1720, aged 32, | also M^rs Sarah Gilbert | widow of Rd Gilbert, esq., of Leverton, | and daughter of M^r Alex^r Sampson | who died June 4, 1773, aged 66.

A small lozenge shaped black stone more to the east (D) :

Here | lieth the body | of | Mary Ann | the daughter of the Rev^d | J. F. Ogle | born May 25, | died Oct. 21, | 1826.

A lozenge shaped blue stone at the west end of the nave :

In | memory of | John Skelton, gent., | who departed this life | Dec. 16, 1810, | aged LXIV.

On a blue stone near the font :

Here lyeth the body of | Robert Lea, gent., | who departed this life | March the 29, 1734, | aged 78 years.

A stone more to the west :

To the memory of | M^r William Wrangle | late of Boston in the | county of Lincoln, | miller, | who departed this life | March 25, 1814, | aged 90 years.

At the west end of the nave are flat stones (D) commemorating the deaths of the following persons :

Elizabeth widow of Robert Thompson Jan^y 3, 1799, æt. 87.
Elizabeth daughter of Robert Evison Dec. 3, 1794, æt. 4.
Mary daughter of Robert Evison March 19, 1798, æt. 4.
Robert Evison Sept. 6, 1794, æt. 29.
Robert Evison his son July 18, 1813, æt. 21.

[See also *Churches of Holland.*]

(MS v, 177–180.)

Sleaford

Notes taken in the church, 2^d August, 1833—The following notes only comprise such monuments or observations as have been omitted in the History of Sleaford [Creasy, *New and Old Sleaford*, 50–61].

The arms above the Walpoole monument have been omitted in that work ; they are—Or, on a fesse between two chevrons three crosslets, a crescent for difference [Walpoole] ; lower, a shield of Walpoole impaling—Per pale argent and gules, a lion rampant sable ; and a third shield of Walpoole—impaling the last.

On a black tablet against the south wall of the chancel :
> Near this place ties interred | the body of Mrs Eliz. Girton |
> relict of Mr William Girton | late of Farndon in the | county
> of Nottingham, | gent. She was daugh- | ter of Mr Edward
> Secker | of Grantham in this | county, gent., and de | parted
> this life the last | day of Jan^y 1748, aged 70. | This small
> monument is | erected in grateful memo | ry of the deceased
> by her | beloved and only surviving | sister, Mrs Jane Moore.

On a black tablet (R) adjoining, with these arms over—Sable,
a swan argent [Moore] ; impaling—Argent, a bend between two
lions' [? bulls'] heads, couped sable [Secker] :
> Near this place lies interr'd the | body of M^rs Jane Moore
> Re- | lict of the Rev^d M^r Williamson | Moore rector of Carlton
> Scroop | in this county by whom she had | two sons and
> two daughters | and survived him twenty eight | years. |
> She was daughter of Mr Edw^d | Secker of Grantham of this
> s^d | county, gent., and departed | this life y^e 19 of Oct^r
> 1752, | aged 77.

On a white and grey marble monument adjoining the last (R),
with the arms of Moore impaling as before above. Crest—A
swan's head [Moore] :
> Sacred to the memory | of Edward Moore, esq., | eldest son |
> of | the Rev. Williamson Moore | of | Carleton Scroope in this
> county, | by his second marriage | with Jane daughter | of |
> Edward Secker, esq., of Grantham, | esteemed and beloved
> through life | for | every moral, social, and Christian virtue, |
> he exchanged this transitory state | for a better | August
> the 18, 1784, | aged 70 years. | His affectionate sister, |
> Elizabeth Lomax, | erected this monument to the memory |
> of a brother not more endeared to her | by the ties of blood
> than | by those of esteem and friendship. (This epitaph to
> her uncle is said to be drawn up by y^e celebrated authoress
> Mrs Brooke (*Gentleman's Magazine*, lxix, 823).)

On a monument in the chancel next to the last with an urn over,
all in white marble :
> Sacred to the memory of Mrs Elizabeth Lomax | the daughter
> of the Rev^d Williamson Moore | late rector of Carlton Scroope
> in this county | and relict of M^r William Lomax | late of
> this place, gent., who after a long life spent | in the discharge
> of every moral and religious duty, | died October 18, 1793,
> aged 84 years. | This monument is erected by | Mr John
> Hutton Cooper of this town as a proof | of his affectionate
> regard to her name and character.

On a white marble oval beyond the last :
> Below lie | the remains of | Mrs Frances Brooke | relict of
> the Rev^d John Brooke, D.D., | rector of Colney near Norwich, |

and daughter of the Rev. Thoˢ Moore | formerly rector of Carlton Scrope | in this county. | The union of superior literary talents, | with goodness of heart, rendered her | works serviceable to the cause of those | virtues of which her life was a shining | example. | She died aged 65, Janʸ 23, 1789, | but two days after her husband | whose remains lie in | Colney chancel.

On a similar oval to the last and next to it :
Sacred | to the memory | of | the Revᵈ J. M. Brooke, | clerk, A.M., | rector of Falkingham | and vicar of Helpringham | in this county. | He was son | of the late Revᵈ Dʳ Brooke | rector of Colney in Norfolk | and Frances his wife. | He died XXIV September | MDCCXCVIII, | in the XLII | year | of his age.

On a black and white marble tablet against the south wall near the entrance to the chancel (R) :
In memory of Tamerlane Gwillim, esq., | bachelor, who deceased 28 Jan. | MDCCCXXX, | aged LII.

On a flat stone in the chancel :
Robert Langton Bankes, | gentleman, | born A.D. 1747, | died 30 June A.D. 1823, | aged 76 years. | Mercy Bankes relict of | Robert Langton Bankes, | gentleman, | born A.D. 1761, | died 18 November A.D. 1826, | aged 65 years.

On a flat stone in the chancel with these arms above—A chevron between three swans. Crest—A talbot passant [Michaell] :
In memory of Mrs Mary Michaell relict | of Henry Michaell late of this parish, gent., who | departed this life the 16 of July 1756, | ætatis suæ 80. | Also by her lies | Mr Thoˢ Smith her only son | by her former husband, | Mr Langworth Smith of this parish. | And her said late husband Mr Hen. Michaell | who departed this life the 15 of July 1745, | ætatis suæ 38, lies interred by his father the | Revᵈ Mr John Michaell in the chancel of the | parish church of Algarkirk in this county. | Beati mortui qui in domino moriuntur.

On a black tablet at the west end of the north aisle :
Near this place lieth the | body of Ann wife of | William Lomax, she was youngest daugh- | ter of Robert Cawdron | of Great Hale, esq., | & departed this life | June 7, 1736, in the | 33 year of her age. | Also wᵗʰ her lie interred | the bodies of Jane & | Eleanor both daughters of the | sd Ann Lomax who | died in their infancy.

On a white marble monument with two urns over (R) :
Beneath are deposited the remains of Elizabeth Mary Cooper | who died at the Hot Wells, Bristol, July 10, 1793, aged 22 years, | and of Edward Moore Cooper her only child | who died an infant, | a victim in early life to the ravages of a lingering disease. | She contemplated the approaches of death |

with a fortitude | which Innocence alone could supply, | and met them with a complacency | which a mind " joyful thro' hope " | and elevated to brighter prospects | can only know. | John Hutton Cooper erects this monument | as a just tribute to the memory | of a beloved and affectionate wife.

On a black tablet against the south side of the west end of the north aisle (C) :
To the memory | of | Mr William Lomax | who departed this life | yᵉ 25 day of April 1761, | aged 64. | Also of William his son | who died yᵉ 1 day of Febʳʸ | 1759, aged 25, | and of two other chil- | dren viz. Jane who died | in the 8th year of her age, | and Edward an infant.

Another black tablet in the north-west corner of the north aisle (C) :
In | memory of | Ann the wife of Mr Benjⁿ Cooper | who departed this life | Decʳ 7, 1765, | in the 37 year of her age, | and of | two of their children | viz. Benjⁿ Newton & Charles | who died in their infancy.

On a white tablet against the north wall of the north aisle :
In memory | of Robert Cole gent. who died | Sept. 23,1758, aged 63, | also | of Philia his wife who died | Aug. 27, 1769, aged 77. | Both dying in faith and hope of a | joyful resurrection through the me- | rits of Jesus Christ our Lord Amen. | Also in memory | of eight of their children who | are all interr'd between this | and the opposite | pillar.

A black tablet at the west end of the nave (C) :
In | memory of Mrs Dorothy | Sanderson | interᵈ yᵉ 2 of April 1753, | aged 39 years. | Also the body of Dorothy relict of | Robt Sanderson, gent., | who died July 1, 1769, | aged 80 years.

On a white marble tablet in the west end of the nave :
Juxta jacet dominus | Lot Male Pharmacopæus | insignis Chirurgus peritus sanæ doctrinæ | et ecclesiæ verus amator probitate eximiæ | egenis (dum vixerit) dupliciter et arte | et opibus liberalis qui obiit 24 die | Septembris anno | dom. MDCCXVI. | ætatis li.

On a black stone in the nave :
In memory of | the Rev. Anthony Skepper | who died August 1, 1773, aged 74, | also | of Mrs Frances Skepper | mother of the said | Anthony Skepper | who died July 7, 1740, aged 70, | and also of Mary daughter | of the said Mrs Skepper | who died Decembʳ 9, 1747, | aged 38.

On a black stone to the west of the last with these arms above— A lion rampant [for Francis] ; impaling—A buck's head cabossed. Crest a rose (C) :
In memory of | Joseph Francis, gent., | a man of universal

benevolence, most | extensive and exemplary charity, and
a | sincere friend. | He dyed 13 January 1744, aged 52
years. | Here also lie interred 3 of his children by | Jane his
wife viz. | Alice who died in her infancy the 24 May, 1732, |
Joseph dyed 20 July 1736, aged 8 years, | Jane dyed 22
September 1736, aged 9 years.

On a black stone in the nave (C):
Sacred | to the memory of | Elizabeth Brabins | wife of Jno
Brabins, gent., | of Balderton in the county of | Notting-
ham | who departed this life | on the 20 Nov. 1797, | in the
29 year of | her age.

At the north end of the transept is a bust of a man with flowing
hair, with the inscription on a brass plate below in capitals:
Sr Edward Care sonn | of Sr Robert Care | the 4th baronet
of | the family departed | this life Dec. ye 28th | 1683.

On each side of this bust is a shield of arms. That to the west
bears—Lozengy sable and argent, on a bend of the first three
crescents of the last. Crest—On a torce gules and argent and
baronet's helmet, a falcon volant [Gargrave]. The shield to the
east bears—1st and 4th Carr; 2nd and 3rd, Or an orle azure
[Bartram], in middle chief the arms of Ulster; an inescucheon—
Quarterly, 1st, Lozengy sable and argent, on a bend of the 1st
three crescents of the last [Gargrave]; 2nd, Per fesse indented
gules and argent, in chief three crosslets fitchy of the last [Otter-
burn]; 3rd, Gules, a cock standing on an escallop azure [Otten-
bury]; 4th, Gules, a chevron between three mullets pierced sable
[for Carr]; 5th, Azure, three lions passant in bend gules, between
two bendlets indented argent [for Browne]; 6th, Sable a cross
fleury between four annulets argent [Ward]. The crest of
Carr.

On the Carre monument in this transept (R) are the following
arms which are omitted in the History: (1) On the west front
the arms just emblazoned; (2) on the north front two shields,
the dexter gone, the sinister—A bend [Scrope]; impaling Carre;
(3) on the south two shields, the dexter gone, the sinister—Two
goats salient, a label . . [Thorold]; impaling Carre. Crest—A
plume of feathers issuing from a ducal coronet [Scrope].

A white marble monument (R) against the north wall of the chancel,
arms below—Sable a swan roussant proper and a border engrailed
[Moore]:
Near this place lye | the remains of Richd Moore, gent., late |
of Castor in the county of Northampton, | 2d son of the
Revd Williamson Moore, M.A., | rector of Carlton Scrope in
this county | by his 2d wife Jane daughr of | Edwd Secker,
gent., of Grantham. | Joining application to integrity | he
considerably improved | his paternal fortune | by those

commercial pursuits | so justly honord in every free state. |
He died May 14, 1771, aged 56 years. | His widow Anne
Moore erected | this marble as a memorial of | his merits
and her affection.

Below :

Also of Mrs Anne Moore relict of the | above Mr Richard
Moore | who died October the 20, 1775, | in the 70 year of
her age.

On a black tablet more to the east :

Juxta jacent reliquiæ | Mariæ haud olim uxoris | Roberti
Bankes generosi | filiæque Georgii Denshire | olim de Stamford
in hoc comitatu armigeri | quæ obiit 17 die Octobris 1780, |
Annos nata 67. | Juxta etiam conduntur | Langley & Georgius
Bankes | duo filiorum dicti Roberti & Mariæ Bankes | qui
mortui sunt infantes. | Requiescant in pace.

A small tablet more to the east, flanked by two black marble pillars,
and surmounted by these arms—Argent, on a bend sable three
lozenges or [Peart] ; impaling—Argent, a chevron between three
martlets sable, on a chief of the last three crosslets or [Cawdron].
Crest—A pelican vulned or :

Near this place | lies the body of | Eleanor the wife | of John
Peart, gent., | who was one of the | daughters of Rob^t |
Cawdron, esq., and | departed this life | the 29 day of June |
anno dom. 1725, | ætatis suæ 34.

A neat white marble tablet more to the east in capitals (R) :

Frances | the wife of Benjamin Handley | of this town,
gentleman, | died Dec. 28, 1807, aged 51 years. | Her remains |
with those of 3 of their children, | Benjamin, Ann, and
Jane, | who died in their infancy, | are deposited near this
marble. | Also of | Benjamin Handley, esq., | who died 25
April 1828, aged 73 years.

This tablet also records the memory of | Benjamin a younger
son of the above | Benj^n and Frances Handley Lieut. in | his
Majesty's 9^th Regiment Lt Dragoons who | perished in the
Tagus, in the 22^d year | of his age, by the loss of the boat
in | which he was embarked on the confidential | duty of
conveying the standard of the | Reg^t from the admiral's
ship to the | Commanding Officer's transport on the | Reg^{t's}
return from the Peninsular War | May 22, 1813. | His
remains were recovered and interred | in the British burial
ground at Lisbon.

A small stone let into the wall north of the altar, arms cut over—
Per pale azure and argent, a chevron between three chaplets counter-
changed [Yerburgh] :

Isabel Arnall Yerburgh obiit 28 Maii 1824 infans.

A black tablet against the south wall of the chancel, arms—Argent,
a fesse ermine in chief three roses gules [for Seller]; impaling—
Sable, a lion passant guardant or [Taylor]:

> M.S. | Annæ nuper uxoris | Gul. Seller hujus | ecclesiæ preb.
> jam nunc | vicarii et sororis | unicæ Ant. Taylor | de
> Heckington in hoc | comitatu armigeri quæ | obiit 14 die
> Januarij | 1765, | æt. suæ 54º.

A marble tablet against the south east corner (R):

> Sacred | to the memory of | John Brittain, esq., | who departed
> this life | the 22ᵈ of May 1819, | aged 66 years. | A man of
> exemplary piety, | patience, and resignation, | one most
> loved, most revered, | and most lamented. | Also of Ann
> Brittain, | wife of the above, | who departed this life | the
> 5ᵗʰ day of March 1829, | aged 75 years.

On a flat stone in the chancel:

> Frances Handley | died 22 December A.D. 1807, | aged 51
> years. | Benjamin Handley | died 25th April A.D. 1828, |
> aged 73 years.

A flat stone in the chancel:

> Here lieth the body of | Mr Thomas Smith, | the only son
> and heir of Langworth | Smith late of this parish, gent., who |
> dyed the 21 of December anno d'ni | 1725, in the 22 year of
> his age. | The said Langworth Smith was the | son and heir
> of Thomas Smith of | Swineshead in this county, gent., | and
> lyes interred in the parish | church there. | Mors janua
> Vitæ.

A flat blue stone above the steps to the altar:

> Hic requiescit Gulielmus Seller A.M. | hujus ecclesiæ pastor
> dignissimus | Revᵈᵒ Patri ejus Thomæ Seller successit | 29
> Martii 1738, | & obiit xᵐᵒ Februarii | 1769, ætatis suæ anno
> sexagesimo.

On another within the altar rails (R):

> Hic requiescit Tho: Seller, A.M., per annos 25 | Lin-
> colniensis prebendarius necnon hujus | ecclesiæ per 33 vicarius
> vigilantissimus | et in concionando cæterisque parochialis |
> curæ officiis dum per valetudinem licuit | assiduuss. obiit
> 29 Aprilis anno Christi | 1737, ætatis suæ 72. | Beati mortui
> qui in Domino moriuntur. | Anna Seller supradicti Thomæ |
> conjux viduata obiit 24 die Nov. | 1746, æt. suæ 68, et hoc
> quoque | sub lapide jacet sepulta | A sinistra jacet Catherina
> Infans filia | Gul. Seller, A.M., hujus ecclesiæ jamjam |
> vicarii et Annæ uxoris ejus quæ obiit | die 28 Maii 1749.

A black stone tablet at the west end of the south aisle (C):

> Sacrum | memoriæ Josephi Ashworth chirurgi | qui non
> sine metu et spe beatæ resurrectionis | mortalitatem exiit |

anno ætatis suæ 58, | et sui Jesu 1795, | necnon | Elizabethæ
sororis | prædicti Johannis Ashworth | et uxoris Jacobi
Ainsworth | quæ obiit die sexto Julii | A.D. 1795, ætat. 47.

Another close by more to the west (C) :

Near this place lyeth | the body of | Mr John Smith | who
departed this life | November the 2d, 1773, | aged 41
years.

Another over the stairs leading to the organ loft (C) :

To the | memory of | Richard Ashworth | who departed this
life | April 24, 1792, | aged 57 years. | Also of | James Ains-
worth | who died Sept. 9, 1825, | in the 71st | year of his
age. | Deus est charitas.

A stone tablet at the south west corner of the south aisle (C) :

In memory of | Mr Andrew Kippis | who departed this life |
the 9th September 1748, | aged 79. | Also of Mrs Bridgitt |
Kippis who departed | this life yᵉ 20 April | 1752, aged 81.

A neat grey and white marble monument against the westernmost
pillar of the nave under the organ loft (R) :

Sacred | to the memory of | James Harryman, gent., | who
during a residence of 60 years | in this parish | was eminently
distinguished | by liberal beneficence, | strict integrity, |
and | the most unremitted attention | to religious duties, | he
died on the 18 day of April | 1789, | in the 78 year of his
age, | leaving to succeeding ages | an example worthy of |
imitation.

A black stone tablet at the west end of the nave (C) :

In | memory of Eliz. | the wife of Isaac | Poyntell | who
departed this life | 19 Janʸ 1767, | in the 63 year | of her
age.

Another more to the north (C) :

Near | this place lieth | interred the body | of | Isaac Poyn-
tell | who departed this life | the 20th of Septemʳ | 1759,
aged | 57.

On a brass plate in a stone frame below the last mentioned
tablet (C) :

Near this place lies | interred the body of | Theo. Harryman, |
gent., who died March | the 8th, 173⅔, aged 55. | I had rather
be a | doorkeeper in the | house of the Lord | than dwell in
the tents | of wickedness.

A flat black stone in the floor under the organ loft (C) :

Here lieth interred Susanna the wife | of Theophilus Harry-
man, gent., who | died the 3ᵈ day of April 1754, aged 80

years. | On the left hand lieth Jane the wife | of James Harry-man, gent., who died the | 31t day of July 1752, aged 34 years. | Also near this place lie William, James, | and John, three children of the said | James and Jane Harryman. William | died the 5th day of June 1747, aged 6 | months, James died the 4th day of | March 1749, aged 6 months, and John | died the 11 day of January 1753, aged | one year and eleven months. (Jane Harryman was dau. of Robert Saunderson.)

On another more to the south (C):
James Harriman, gent., | 1789.

Another to the south:
Mary Kirton 1791, | William Kirton, gent., | 1827.

Another still more to the south much rubbed (C):
Near this place lieth the body | . . . Mr Lot Male who was a noted | surgeon a harty | church and |

Another to the west rubbed (C):
In memory of Mary the wife of | Thomas Clarke . . . died January ye | . . . 1748, aged 35 years.

On a black stone near the font (D):
In memory of | Joseph Rowland | interred June 8th | 1805, aged 58.

More to the south (D):
Benjamin Rowland | interred January 7th, 1775, | aged 88 years. | Also Benjamin Rowland | his son interred June 18, 1776, | aged 66 years. | Also William Rowland | interred Novr 27, 1768, | aged

N.B.—In the *Gentleman's Magazine* lvi, part i, p. 98, it is said that against the west wall of the south aisle at Sleaford church is an inscription commemorating:

Andrew Kippis who died Sept. 9, 1748, aged 84.
His wife Bridget April 20, 1752.
Susanna Oct. 10, 1694.
Robert Oct. 22, 1695.
Rebecca May 30, 1699.
Margaret June 5, 1702.
Elizabeth Jan. 7, 1705.
Bridget May 24, 1705.

[See also Creasey, *Old and New Sleaford*, pp. 51–9 ; Trollope, *Sleaford*, pp. 155–62 ; *L.R.S.* i, 213–214 ; Jeans, 58–60.]

(MS iii, 29–60.)

Snarford

Notes taken in the church, 5 August, 1833—

A very handsome monument against the north side of the chapel. It reaches to the roof and must be twenty feet high. A knight in armour and a lady in black dress of the time of Queen Elizabeth are reclining on their sides, with their cheeks resting on their hands. Beneath is the figure of a young girl lying on her back, with her hands clasped ; on each side of her are two niches, in one of which is an angel with torch reversed kneeling on a scull ; from the other the figure is gone. The pediment is supported by four Corinthian pillars, two red and two grey marble. Above are three coats of arms : (1) the centre one—Quarterly of four, 1st, . . . , a lion rampant . . . [St Paul] ; 2nd, Argent, a fess between three martlets sable [Snarford] ; 3rd, Gules, on a bend argent three eagles displayed sable [Stroder] ; 4th, as the 1st ; the arms of Ulster on an escucheon. (2) To the west—The aforesaid four quarterings ; impaling—Ermine, a griffin segreant gules [Grantham]. (3) To the east of the centre—The four quarterings ; impaling—Quarterly, 1st and 4th, Azure, on a chief or three martlets gules [Wray] ; 2nd and 3rd, Argent, on a chevron sable between three eagles' heads erazed azure three cinque foiles argent [Jackson]. Over the centre shield is the crest of an elephant, and underneath, ' Ma Foy Ma Loy '. The top of the monument is ornamented with urns and pyramids. On the cornice of the pediment the following inscriptions in opposite compartments :

> (1) Fama volat velox, nec fama est ulla perennis, | Irradiat nomen, nec tamen omen ovat | virtus non virus magnus labor, arbor honoris : | ecce labor, nec honor tempora longa manet. | (2) Nil mundi mundo [*for* mando], cum mundo cuncta peribunt, | Ut veniunt abeunt vitreu [*for* vitrea] quœque virum | ast divina manet virtus stat sæda [*for* sæcla] futura | et nescit finem sydera clara colens.

The following inscription is on a black slab behind the figures under the arch :

> Heere lyeth the body of Sir George Saintpaule, knight and | baronett, who was the ninth heire male by linealle discent | that hath possessed this house and lordshipp of Snarford from John Saintpaule esquire who married the daughter | and heire of Sr John Snarford, knight. This knight Sr George | married Frances Wray one of the daughters of Sr Christopher | Wray, lord chief justice of England. Hee had by her onlie | one daughter Mettathia Saintpaule who died before she | was two yeares old. Hee adopted Mr George Saintpaule | sonne and heire of John Saintpaule of Campsale, esquier, his | heire to the greatest parte of his landes, and

the rest hee gave | to his nephew Phillip Terwhite esquire, and to charitable uses. | Hee builded and furnishd this house of Snarford, lived in great | honour, died in much comfort when he was LI yeares old, | and odd´ daies, the XXVIII of October MDCXIII.

Against the north wall of the chapel, and to the west of the last, is a marble monument. Within a circle is the bust of a man in armour, with ruff and beard, nearly a full face, and behind in profile the bust of a lady with a countess's coronet on her head. Above are these arms—Quarterly, 1st and 4th, Gules, a chevron between three crosslets or [Rich]; 2nd and 3rd, Sable, on a chevron engrailed between three demi griffins argent, three martlets gules [Baldry]; impaling—1st and 4th, Azure, on a chief or three martlets gules [Wray]; 2nd and 3rd, Argent, on a chevron between three eagles' heads azure, three cinquefoils argent [Jackson]. There are two crests—the dexter, A wyvern [Rich]; the sinister, An ostrich [Wray]; the whole surmounted by an earl's coronet. The inscription is under the busts in a black panel:

(1) To the everliving memorie of the right honorable Robert Lord | Rich baron of Lees, earle of Warwicke, and of the ladie | Francis his last wife. | What monument should to thy honor'd name | The love great earle of after age upreare | When in thy life thyselfe didst build the same | In fairer forme then art can frame it heere | By virtuous action and thy noble parts | That hath entomb'd thee in our livinge hearts | (2) Religious truly church and countrie's staie | To frend most faithfull mild even to his foe | Good men and learn'd advancing every waie | In all affliction patient long agoe. | In armes thy earles sole honor Warwicke stood | But thine great Rich in being doing good | (3) Ad mortem | VIATOR cum fuit unus amor mens istis una fidesque | vixeruntque deo religione pares | fare age cur tumulus non contiget unus utrique | MORS hos quia cælesti junxerat arce Deus. | Memoria justi non | peribit. [The words in capitals are in the margin.]

There is an old octagon font bearing emblems of the Passion— (1) crossed spear and reed with sponge, (2) [? crown of thorns], (3) [blank], (4) cross with two scourges, (5) face of Christ, (6) I.H.S., (7) foliage, (8) face of evil spirit.

At the south side of the chancel is a magnificent monument of marble, at least twelve feet high, which has once been painted, but the colours are now nearly gone. Upon a raised tomb under a canopy supported by six pillars of a fantastical shape, very much ornamented, reclines the figure of a knight, and his lady at his left hand. They are of the size of life. He is completely armed, save the head, in plate armour ; round his neck is a ruff, and he wears

a peaked beard and moustacheo. His right hand is across his breast and holds a book, his left grasps the hilt of his sword. His head rests on his helmet on which is a crest, viz.—An elephant passant with a tower on his back ; his feet rest on a cushion. The lady is dressed in a long plaited gown covering her feet, which rest on a cushion. She wears a ruff and a flat square cap with an edging of pearls. Her face is mutilated. Her head is supported by a pillow, and her hands are clasped over her breast and hold a book. The canopy is much ornamented within ; and above it have been eight small female figures kneeling, one of which is now gone. In the middle rises a sort of pedestal on which are the figures of a man kneeling between two females (D). In front of the pedestal looking west are these arms—Quarterly, 1st and 4th, Argent, a lion rampant, double queue gules [St Paul] ; 2nd, Argent, a fesse sable between three magpies proper [Snarford] ; 3rd, Gules, on a bend argent three eaglets sable [Stroder]. Crest—An elephant passant, bearing on his back a tower. Fronting the east are these —The last mentioned quarters ; impaling—1st, Argent, a griffin segreant gules [Grantham] ; 2nd, Argent, a crescent in base, and an estoile in chief gules [Tooke] ; 3rd, Two bars [Hilton] ; 4th, A chevron between two crescents in chief and a crosslet fiche in base sable [Gegge]. Round the edge of the tomb is this inscription in Old English characters beginning at the south side :

> Hic iacet dominus Thomas St Poll, miles, qui obiit vicessimo nono die Augusti | anno d'ni millesimo quingentesimo octo-gesimo secundo et | anno regni Reginæ Elizabethæ vicesimo quarto et requiescit in Christo. | Lector quid sim vides quid fuerim nosti futurus ipse quid sis cogita.

Below are shields of arms : on the west, St Paul impaling Grant-ham ; on the south, (1) St Paul impaling Snarford, and (2) St Paul impaling Stroder ; on the east, ———— impaling Grantham ; on the north, (1) Grantham impaling Tooke, and (2) Hilton impaling Gegge. The tomb is highly adorned with pilasters and garlands.

On a brass plate in the south wall in capitals, above have been arms but now gone :

> Bis sex nupta annos sterilis fæcunda sequenti est | Francisca, et Thermis incipit esse parens. | Thermopoli gravida est, Louthæ connixa femellam | natam edit et proles digna ea matre fuit. | indole quæ crevit mira, plusqu. puerili | (crescendo haud possunt magna manere diu) | cum subito ante duos vitæ prosternitur annos, | dum peregre Thermas appetit unde fuit | Coventry tristis struitur libitina sed hujus | Snarfordum decuit funeris omnis honos | nobile Snarfordum facit hoc matrisq. patrisq. | pignus sed matris cura dolorq. suæ | cuius nulla graves sedant sedamina questus, | liberat aut salsis fletibus ulla dies | quid fles ? Mors omnes manet æqua beatior

illos | qui facere infantes non potuere male | hos tibi jam posui versus Mattathia S^ct Poll | qui primum in sacro nomina fonte dedi | quam vellem (at frustra) te nempe superstite scriptor | essem funerei carminis ipse mihi | Ioannes Chadvicvs posui | anno 1597 mens. Sept. die 9⁰.

On a brass plate in the floor within the altar rails in old character (R) :

Hic iacet Johanna Tornay uxor Joh'is tornay de | caynby armigeri filie [sic], Joh'is Sayntpoli de snarford | armigeri que obiit IX die Ap'lis A⁰ d'ni M⁰ | cccc vicessimo primo cuius anime propicietur deus Amen.

A flat blue stone in the floor of the chancel, arms cut over— Quarterly, 1st and 4th, Two bars between three estoiles pierced [Doughty] ; 2nd and 3rd, An escocheon between eight martlets [Brownlow] ; over all an escocheon—Verrey, a chief [for Tich-borne]. Crest—A hand holding an estoile :

✠ | Here lies the Body of | George Brownlow Doughty | of Snarford Esq. | who died the 21^st of Sep^r 1743, | Aged 58 years. | He married one of y^e Coheiresses of | S^r Henry Tichborne of Tichborne | in Hampshire Bart. | by whome he had Five Sons | and Five Daughters. | Requiescat in pace Amen.

Another stone more to the south :

Here lie interred the remains | of M^r Arnold Knight | who departed this life at Snarford | on the 27 day of Feb^y 1731, | in the 62 Year of his Age. | Deservedly regretted by all his Acquaintance | As an Honest Man and Sincere Friend. | Requiescat | in pace | Amen.

On a broken iron railing (D) in the chancel which seems to have once gone round the St Poll monument is an inscription in old character :

Aspice quod prodest transacti temporis æuum omne quod est nihil est præter amare deum.

The church consists of a nave and chancel, and tower at the west end.

[See also *Lincs. N. & Q.* vi, 225–8, vii, 1–3 ; Jeans, 60–61.]
(MS iii, 121–129.)

Somerby by Grantham

Notes taken in y^e church of Somerby, 3^d October, 1839—This church consists of a nave, south aisle and chancel, a south porch, and tower at y^e west end. The nave is divided from y^e aisle by two equilateral arches with low clustered shafts, and from the chancel by a handsome Norman arch which has y^e toothed moulding.

The windows are mostly perpendicular, the eastern one a modern insertion. These arms are in a window of the nave—Argent, two bars gules, in chief three torteauxes [Threkingham]. The font is octagon and massive with ornaments of a decorated character. At the east end of yᵉ aisle is a piscina and bracket. The door from yᵉ rood loft remains in the north east corner of the nave. The tower is entered by a pointed arch, and appears by yᵉ exterior to be of modern date.

A brass plate in the floor of the nave (R) with these arms—Two bends between two martlets [Bradshaw]; impaling—A wolf's head erazed between three bugle horns stringed [Bradford]. Crest—A hart statant under a tree :

> Here lyes Peregrine Bradshaw, Esqʳ, who departed | this life the 17 of August 1669; he was youngest sonne | to Anthony Bradshaw of Duffeild in the county of | Derby Esqʳ and was page to Queen Ann and Esqʳ | to the body of Kinge Charles the first. Here | also lyes Mrs Susanna Bradshaw his wife who depart- | ed this life May yᵉ 14ᵗʰ 1673. She was daughter to | William Bradford of Hollum in the county of | Somersett, Esqʳ.

A brass plate in a stone (R) on yᵉ floor of yᵉ nave near the entrance to yᵉ chancel, above which has been a figure in brass, but it was removed in yᵉ late rector's time because it caught people's feet :

> Hic iacet Robertus bawd de somerby, | Armiger et iusticiarius pacis ac chorum |d'ni reg's in partibus de Kestewyn in comitatu | lincoln qui obiit vᵒ die mensis februarii | aᵒ d'ni ᴹᵒᶜᶜᶜᶜᶜᵒɪxᵒ cuius anime propicietur | deus Amen Iʼhu mercy lady helpe.

A small white monument of marble (R) against the north wall of the chancel, flanked by two Ionic pillars, and having these arms over in a lozenge—Or, an inescocheon within an orle of martlets sable [Brownlow]. This inscription in capitals :

> Here lyeth the body of Mrs Jane | Brownlowe eldest daughter | of Sʳ Richard Brownlowe, | Baronet, and of his wife Dame | Elizabeth daughter to John | Freke Esq. of Yorn Cortney | in the county of Dorset. | She deceased the 16 yeare of | her life the 1 of June 1670. | She was of a solid serious | temper, of a competent stature, | and a fayre compleaction, whoes | soul now is perfectly butyfyed | with the fruition of God in | Glory and whose body in his | dew time he will rais to | the injoyment of the same.

On the base also in capitals :

> Epitaph. | Here lies a Virgin whose clear conscience may | Compared with whitest vellum truly say | The spot lyes there who clensed me wrott his name | So firm upon me I am still the same | His whilst I lived he owned mee still I'm his | Preserved by him till I enjoy true Blis.

A large and handsome monument on yᵉ north wall of the chancel composed of black, white, and grey marble, and ornamented with vases, wreathes of flowers, &c. these arms below—Brownlow, impaling—Or, two barrs sable, on a chief three mullets or [Freke]:

> To the precious memory of | Dame Elizabeth Brownlowe, | grandchild of the late Sʳ Thomas Freke | of the county of Dors., kt, eldest daughter | of that worthily honored John Freke Com. præd., Esq., (by his 2ᵈ | wife that soe noble accomplished Lady Jane Shvrley) wife | & widdow of yᵉ late Honᵇˡᵉ Sir Richard Brownlowe | of Great Hvmby Com. Linc. Baronet | by whom she was yᵉ happy mother | of ten hopefull children, viz. 3 sons & 7 daughters, of which | she saw only her 2 sons Sʳ John & William survivant at | her death. She was a person whose hereditary vertues | & graceful qualifications rendered her a fair & fit | pattern for this & future ages to follow, | who, | for her sincere devotion towards God, | conjugal affection to her most oblidgingly loving husband, | maternal affection to her dear & well deserving children, | cordial kindness as well to her collateral as near relations, | Hospitality to her neighbours, charity to yᵉ poor & affability | to all persons, | deserves a far larger memorial than this marble can admit. | Having been continually carefull to make her calling | & election sure, so circumspectly still lived as | daily prepared to die, | Till at length weary of longer walking in the | wilderness of this world on the 2ᵈ of Feb. 168¾, | & 51 year of her early autumn, piously & | peacably finished her alas! too short but well | past pilgrimage, | and having through all the paths of | virtue & honor followed so good a guide & prudent | a husband (who in yᵉ 40th year of his vigorous | age went fifteen years before her) | here resteth in a fiduciall hope of a glorious Resurrection. | To whose memory her two sorrowful sons & joynt | Exequitors Sʳ John Brownlowe 4th Bart of his family, | with his dear brother William Brownlowe Esq. | as yᵉ last testimonial of their dutiful observance | erected this monument.

On a white marble monument (R) against yᵉ north wall of the chancel flanked by two Corinthian pilasters and surmounted by an urn, these arms below—Per pale sable and gules, a saltier between three lions rampant. Crest—A lion's head erazed, crowned or [for Hotchkin]:

> Near this place lyeth interred the body of | John Hotchkin, clerk, rector of | Abbot's Ripton in the county of Hunting-don, | youngest son of Robert Hotchkin, Esq., | late of Brad-more in the county of Nottingham, | and Mary his wife, | who departed this life on the 8th Febʸ | in the year of our Lord 1744, | in the 73ᵈ year of his age, | after having been rector | of Abbot's Ripton 41 years. | He married Alice the

daughter of | John Hanger, gent., of Upwood | in the county of Huntingdon | by whom he had 13 children, | six of whom he left to survive him.

A black and white marble tablet (R) against the wall to the east of the last mentioned monument :

In a vault outside of the church | lie the remains of the Rev^d John Myers, | 42 years rector of Somerby cum Humby, | born November 8th, 1764, died December 28, 1831. | The deep regret of his parishioners is the best | record of his virtues, but this stone is placed as a | memorial of grateful love by his affectionate | widow Maria Myers. | ' I know that my Redeemer liveth. | Sorrow not even as others which have no hope. | For if we believe that Jesus died and rose again | Even so them also which sleep in Jesus | will God bring with Him.'

On another below (R) :

In a vault outside of the church | lie the remains of Bridget | relict of the late Robert Cheney Esq^r | of Meynell Langley Hall, Derbyshire, | born at Wirksworth July 1739, | died at Somerby February 21, 1829. | Long spared to bless thy children and the poor | We thank that God who long the blessing gave | And strengthened thee with Christian Faith and Hope | To vanquish Natures terrors of the Grave. | Oh ! still around thy ready aid impart | And write ' Prepare to die ' on every heart.

On another more to the east (R) :

In a vault outside of the church | lie the remains of William youngest son | of the late Robert Cheney, Esq^r, and late | Captain in the first Regiment of Guards, | born December 2^d, 1780, died at Somerby | December 17, 1822. | Also the remains of Eliza second daughter | of the late Robert Cheney, Esq^r, | born September 4th, 1775, died at Somerby | October 14th, 1830. | Calm is her slumber here but she shall rise | And through her Saviour gain her native skies | For she was just and good without pretence | Artless as childhood meek as Innocence | God in His mercy bade her sufferings cease | And to her gentle Spirit whisper'd Peace.

A black marble tablet below the two last (R) :

In a vault outside of the church | lie the remains of Elizabeth Amell | who lived in the family of the late | Robert Cheney, Esq^r, and Bridget his wife 60 years, | And died at Somerby December 6th, 1826, aged 80. | In affectionate remembrance of her long tried service | And grateful attachment this stone is placed by | Maria Myers & Jemima Cheney. | ' Blessed are the dead which die in the Lord from | henceforth Yea saith the Spirit that they | may rest from their labours and | their works do follow them.'

On a flat stone in the chancel floor in capitals (R) :

> Here lyeth the body of yᵉ | Revᵈ Joshua Clarke Master | of
> Arts rector of this church | and prebendary of Lincoln | who
> departed this life | on the 22ᵈ of September | in the 60th
> year of his age | Anno D'ni 1712. | He was also Convocation |
> Man for the Diocese 1700. | Here lyeth the body of | the Revᵈ
> Thomas Pretious, | rector of this church, who | departed
> this life August the 4th, | in the year of our Lord 1739, | in
> the 46th year of his age.

Another stone (D) partly hid by the stove commemorates ye deaths
of some children of the Revᵈ Tho. Pretious, but it is so effaced
as to be mostly illegible.

Within yᵉ altar rails is a stone (D) which has had a figure and
inscription in brass, both now gone ; and on yᵉ northern side of
the altar on a slab slightly raised from yᵉ ground is the recumbent
figure of a knight in hauberk and coif of mail, with a surcoat, and
a triangular shaped shield which is broken. His hands are clasped,
and at his feet is his squire, kneeling, holding his horse. The
heads of both squire and horse are gone, but the saddle, stirrups,
and bridle of the latter are quite visible, and the whole is a very
singular design.

[See also *L.R.S.* i, 201 ; Jeans, 61–2.]

(MS ix, 173–183.)

Sotby

Notes taken in the church, 11 October, 1840—This is a small
old church containing a nave and chancel ; no tower ; the bell
hung over the entrance porch.

The only inscription is on a flat stone just before the Communion
table as follows in capitals :

> Here lieth the body of | Mr John Porter who was | rector
> of this church 30 | years, and who left this | world the 13 day
> of March | Anno Dom. 168$\frac{8}{9}$, aged 59.

(MS x, 7.)

Spalding

Notes taken in the church, [*blank*]—

A white marble monument over the door on the south side of the
chancel, with these arms above—Or, on a pile [vert three garbs
of the field—Oldfield] ; impaling—Argent, a chevron ermine
between three mullets sable [Gresham] :

> Near this place lieth the body of | Dame Elizabeth Oldfeild,
> ye relict | of Sʳ Anthony Oldfeild of this town, | Bart, &
> daughter of Sʳ Edward | Gresham of Lympsfield in the |

county of Surrey, kt. She departed | this life the 22 day of
July 1682, | in the 58 year of her age, leaving 2 | sons
& 2 daughters, viz. Sir John, | Anthony, Elizabeth, & Mary,
wch said | daughters erected this monument that so | dear
a mother and so good a lady may | not be forgotten when
they shall be | dead that would tell her virtues ; she | was
truly religious, just, chast, | generous & charitable. | Reader
consider, | 'Goe thou and do likewise.'

On a flat stone in the middle of the chancel near the altar :
Here lies interred | the remains of the Rev. John Dinham, |
23 years minister of this parish ; | he was a truly pious and
good Christian | and an ornament to his sacred profession, |
a most tender and affectionate husband, | a fond and indulgent
father, | a warm and sincere friend, | and an universal lover
of mankind ; | add to these virtues, | he was a polite scholar
and gentleman, | an able & experienced magistrate, | in
which department he acted upwards of | twenty years with
the strictest conformity to Justice ; | he died the 2d of April
1782, | in the 57 year of his age. | Four children died before
him, viz. | John, Samuel, William, and Harriet Jackson, |
and nine survived him. | Gresham Dinham | the widow and
relict of the above | John Dinham | died the 17 December
1808, | aged 76 years.

On a flat stone close by, and north of the last :
In memory of | the Reverend Stephen Lyon, near forty years
minister | of this place, a native of France of the city of
Roan, | which place he left under the guardianship of his |
mother, for the sake of the Protestant Religion there |
persecuted. | He was an honor to his profession | the delight
of every sensible man, | a proficient in all liberal know-
ledge himself, | and a great encourager of it in others, | a
true lover of the constitution of England | as it was settled
at the Revolution, | attached vehemently to no sect or party, |
an universal lover of mankind. | He died on the 4 of February
1747, aged 70. | Also in memory of | Mrs Grace Lyon his wife
the daughter of George | Lynn Esq. of Southwick in
Northamptonshire, | who in the constant exercise | of every
amiable quality | was an ornament to her sex, | a credit to
her family, | and the joy of her husband. | She died the 16 of
April 1747, aged 73. | Likewise | of two of their daughters |
Mary and Susanna | who died young.

On a flat stone at the entrance to the chancel :
Mary Johnson | eldest daughter of the late | Maurice Johnson
Esq. | of Ascough Fee Hall, | born 10 November 1758, | died
27 March 1829.

On the same stone :
>Gresham Ambler Dinham | daughter of | the Rev^d John Dinham | and Gresham his wife | born 21st March 1755, | died 11 November 1826.

On a stone near the above :
>Here was interred | the body of | S^r Anthony Oldfield | of this town, Bart, | who departed this life | the 4th day of September | anno salutis n'ræ 1668, [anno] ætatis suæ 42.

On a lofty marble monument in the south transept with these arms—Or, a water bouget sable, on a chief of the 2d three annulets of the first, a crescent for difference [Johnson] ; impaling—Argent, a chevron gules between three lions heads erazed of the same, crowned or [Johnson of Pinchbeck] :
>Sacred to the memory of | Mrs Jane Johnson. | Could height of beauty sence or goodnes save | Could love or friendship ransom from the grave | Had floods of tears or clouds of prayers prevailed | Which oft have with success high heaven assailed | O'er these dear relics now we should not mourn | Nor had such precious dust adorned this urn | How few we find an equal match for pain | Or whose firm reason holds their passions rein | Who solid greatness know but false despise | By all unless themselves accounted wise | Humble yet not demiss meek but not base | And whose well tempered mind adorns their grace | Devotion to a narrow cell confined | Is lost in shades and useless to mankind | Happy are those who like th' Angelic race | Tho' oft retired to view their Makers face | To this low world their generous cares extend | And aid the poor and aid a virtuous friend. | Such was the saint who lies enshrined beneath | And as serene her life she smiled on death. | Posuit charissimæ conjugi | Mæstissimus conjux | Mauritius Johnson. (At the base of the monument) : Nata 10 Maii | A'o D'ni 1666 | obiit 17 Julij A'o D'ni 1703.

At the west end of the south aisle is a white marble tablet, with these arms below—Argent, two lions passant guardant sable, on a chief of the first two standing cups covered azure [Worrall] ; impaling—Or, an eagle displayed sable, a chief ermine :
>Hic situm est | Quicquid mortale fuit | Georgii Worrall Generosi | Qui vicesimo nono Octobris die 1771 | ætate sua 49 | Obiit | Vir juris peritus non minus tam diligens | Quam ad clientes fidelis | Et parens et maritus in conjugem et liberos | Summo amore insignis | Hoc monumentum | Patris memoriæ optimi sacrum esse voluit | Gulielmus Henleius Worrall | Filius superstes.

Upon another more to the east, with arms over—Ermine, on a fess

gules three escallops or. Crest—On a torce gules and argent, a cock or [Ingram]:

> In memory of | Captn John Ingram | late of the 56th Regiment who | died August 23, 1781, aged 65 years. | Also Charles his son Ensign | in the same regiment | who died at the Havannah | August 12, 1762, aged 15 years. | Also George his son aged 6 years. | And also George his son aged 8 years. | This monument was erected by | Stephen Sanderson Ingram, gent., | his eldest son.

Another tablet at the east end :

> M.S. | Johannis et Catherinæ Scotney | Parentum optimorum | Quorum | Ille quadragesimum primum | Hæc tricesimum septimum | Annum agens | Obiit Nov. 11, 1720, | [obiit] March 5 1729 | Parvum hoc pietatis monimentum [sic] | Qui debuit | mærens posuit.

On a flat stone at the entrance to the chancel :

> Here lie deposited | the remains of the Revd Mr Samuel Whiteing | who was interred March the 24o, | 1757, | aged 48 years.

A flat stone in the south aisle :

> Mrs Jane Sanderson | relict of | Fullwood Sanderson Esq. | died Novr 28th, 1823, | aged 68.

On another to the west :

> Mrs Anne Cook | died Nov. XII, MDCCCV, | aged LXXX years.

Another still more to the west :

> In memory of | Hurst Fowler gent. | who died 29th of October 1780, | aged 60 years. | Also of Robert Langton his grandson | who died in his infancy.

Upon another to the south of the last, arms cut above—A chevron, on a canton a boar's head erazed [for Moore]:

> Joseph Moore | Doctor of Physick | died the 23d Decembr | 1678, | aged 75. | Bene qui latuit dum vixit | Adlardus Welby, Ar', | posuit 1680.

(MS i, 187–197.)

Notes taken in the church, August 10, 1835—

On a black stone in the south aisle, with the arms—[Azure] on a cross five leopards' heads cabossed [argent—Wilsby] ; impaling Three escallops, with a crescent for difference [Earle] ; the inscription in capitals :

> Here under lieth the body | of Margaret Willesbye the | daughter of Christofer Earle, Esq., | and wife to John | Willesbye, Esq. ; she depar- | ted this life July the 17 day, | Anno D'ni 1646.

On a stone against the south wall in the south aisle :

> Near this stone | lie the remains of John Green, gent., | who died the 23 of August 1709. | Also of Mary widow of Capt. Francis Piliod, | former wife of the said John Green, | and only daughter of Martin Johnson Esq., | who died 29 of December 1737. | Also of Jane wife of John Green M.D., | and daughter of Maurice Johnson Esq., | who died the 17 of August 1754, | aged 43 years. | Also of John Green, M.D. the only issue of | the above named John Green & Mary his wife, | who died the 1st of November 1756, | aged 48 years. | Also of John and Mary Elizabeth, | two of the children of the said Dr John | and Jane Green, | who died in their infancy. | Also of Elizabeth wife of Charles Green gent., | and daughter of John Dinham M.D. | who died the 24 of August, 1780, | aged 40 years. | And also of Elizabeth Jane, daughter of | the said Charles & Elizabeth Green, | who died the 10 of June 1794, | aged 29 years. | Also of Charles Green, Esq., | who died the 9 of February 1824, | aged 86 years.

On a monument above the last with these arms under—Argent, a lion rampant holding a cross patee fichee gules [Piliod] ; impaling —Or, a water bouget sable, on a chief of the second three annulets of the field [Johnson] :

> Beneath lyes the body | of Capt. Francis Pilliod, | a native of the Canton of Berne, | to which he was an honour, | his polite learning and clear judgment, | his love to his excellent wife, | his affection and constancy to his friend[s], | his attachment to the Protestant interest | in the illustrious house of Hanover, | with his other amiable qualities, | made him dear to all who knew him, | but in particular | to Colonel Adam Williamson of Soundherst, | in Berks, who erected this monument | to the memory of so good a man. | He died Feb. 6, 1734.

On a black stone in the floor near the last :

> Gualteri Johnson Ar. | Pii Probi Prudentis | qui obiit | XVII Novemb. MDCXCII | et | uxorum | Agnetis | fil. Will'i Wilsby Ar. | quæ ob. VIII April | MDCLVIII | et Catherinæ | fil. Will'i Downes Ar. | quæ ob. XVII Novemb^r | MDCXCVII.

There were two shields of arms, but now obliterated.

On a very handsome black and white Gothic monument at the east end of the south aisle, with these arms under—Johnson, impaling—Sable, a chevron between three cross crosslets fichee argent [Buckworth]. The inscription in old English character :

> Sacred | to the memory of | Ann Elizabeth | the affectionate wife of | the Rev. Maurice Johnson, D.D. | and daughter

of | Theophilus Buckworth Esq. | She was born | the XII of February MDCCLII, | and died | January the III, MDCCCXXVII. | Also of | the Rev. Maurice Johnson D.D., | Incumbent, Minister of this parish | forty six years, | and vicar of Moulton in this County | fifty three years, | eldest son of Lt Col. Johnson, formerly of his Majestys | 1st Regiment of Foot Guards, | he was born | the XXVIII of February MDCCLVI, | and died | May the 25th MDCCCXXXIV | aged LXXVIII.

On a monument near against the south wall; arms—Johnson, impaling—[Vert], on a bend or three crescents [gules—Bellamy]. The inscription above :

Maurice Johnson, Esq., | formerly Lieutenant Colonel | in his Majestys first Regt of Foot Guards, | Died 3 of Decr 1793, in the 80 year of his age. | Elizabeth his wife died 21 Oct. 1752, aged 30 years. | Mary his second wife died 21 Jany 1773, aged 45 years. | Walter Maurice son of the Rev. Maurice Johnson D.D. | and Ann Elizabeth his wife died 10 Nov. 1791, in his infancy. | The Rev. Maurice Johnson, clerk, A.M., | eldest son of the above | was born the 29 of March 1788 | and died December 6, 1820. | Frances wife of the said | Rev. Maurice Johnson died July | the 6, 1815, aged 28 years.

On a black stone in the floor below the last :

Lieut. Colonel Maurice Johnson | born | 14 of March 1714 | died 4 of December 1793.

On a monument in the north aisle with these arms—Per chevron azure and or, three elephants' heads counterchanged [Saunders]; impaling—Argent, two lions passant sable ; crest—An eagle's head, erased or :

H.S.E. | quod mortale fuit | Johannis Richards Armigeri | Pii probi et experti | et Elizabethæ conjugis dilectæ | Piæ castæ et modestæ | Ille ex oculis sublatus | die Octobris 30, | Anno Domini 1767 | [anno] ætatis suæ 69. | Hæc Septembris 6 | anno Domini 1748 | [anno] ætatis suæ 47. | Johannes unicus filius et hæres | grato animo impulsus | parentibus optime de se meritis | hoc marmor sacrum esse voluit.

On a monument next, to the east of the last ; arms—Quarterly, 1st and 4th, Argent, two lions passant azure [? Richards] ; 2nd and 3rd, [Saunders] ; impaling—Or, a mullet [pierced gules], an orle of fleur de lis [azure—Pulvertoft] :

Beneath this monument | are deposited the Remains of | John Richards Esquire | who died August 10, 1773, | aged 45 years. | Also | near him lies the body of | Judith Richards his widow, | daughter of John & Ann Pulvertoft | formerly of Peterborough | in the County of Northampton, | who died November 9, 1811, | aged 81 years.

On a black stone in the north aisle (D) :

P.M.S. | Thomas Buckworth of this | parish gent. who departed this | life the 6 day of July in the | year of our Lord 1740 | in the 37 year of his | age. | In Memory of | Miss Ann Buckworth daughter of | the abovesaid Mr Thomas Buckworth gent. | and Elizabeth his wife who departed | this life the 6 of Novembr | 1747, aged 16 years. | Also of Eliz. the wife of Thomas Buckworth | gent. who died January the 10, 1771, | aged 63 years.

On a stone to the west of the last, much defaced :

Next grave to this stone | lieth the body of Felix Rash | the wife of Innocent Rash | who died the ninth | Anno Domini | Under lyeth the | body of Innocent Rash | who departed | the eight and | twentieth of February | . . . Domini 1675.

On a flat blue stone at the west end of the south aisle, these arms cut above—[Sable], a cinquefoyl, a chief checquy [or and azure]. Crest—A tiger's head affrontee [Hobson] :

Hic una quiescunt corpora | Johannis Hobson de Boston armigeri | filii natu minoris Johannis Hobson de Spalding, | Gulielmi etiam Hobson de Siston Armigeri | (filii et hæredis prædicti Johannis de Boston) | Necnon Johannis Hobson de Siston Armigeri | filii ·et hæredis prædicti Gulielmi de Siston | in spem futuræ resurrectionis deposita. | Istius Augusti nono, A.C. 1652. | Alius Julii sexto A.C. 1660. | Hujus Decemb. 13, A.C. 1676. | Horum singuli majoribus etiam non minus | animo quam stemmate generosis prognati | beneficiis marmore dignis de hoc oppido | egregie meruerunt ideoque | Memoria eorum sit benedicta.

A flat stone more to the east, in capitals :

Walter Johnson | eldest son of | Walter Johnson clk | and Frances his wife, | died Dec. 10, 1799, | in the 10 year | of his age. | Also | Gresham Ambler Johnson | their fourth daughter | who died Decr 25, 1801, | aged 3 years.

A white marble monument on the wall over these last in capitals :

Sacred to the memory of | William Richardson, gent. | late of Glentworth Heath | in this County | who departed this life | Jan. 26, 1829, | aged 47 years, | and whose remains are interred | in a vault near this place.

A white and grey marble monument more to the west, with a sarcophagus over which is a drooping banner, in capitals :

This cenotaph is erected to the memory of | Lieutenant George Johnson | of His Majesty's 41 Regiment of Foot | who died at Fort St George, Madras, on the 30 of May 1823, | aged 26 years. | To his deeply afflicted family the loss is irreparable, | by his brother officers and the whole corps in which

he served | nearly 10 years he was much beloved and respected.|
He had been promoted to the rank of Capt. in his Regt | only
a few days previous to the fatal intelligence of | his death
arriving in England. | O God Thy will be done.

Another to the west, with an urn over, in capitals :

Sacred | to the memory of | Fairfax Johnson Esq. | who
was born May the twenty fifth 1753 | and died June the 7,
1818. | He was a most affectionate & indulgent husband, | a
sincere and steady friend.

A flat stone below to the same effect.

A brown stone set up against the wall at the west end of the church,
with these arms over—A fesse crenellee between three pears, in
the chief a crescent [Perry]. Crest—An armed hand, couped at
the wrist, issuing from a tower holding a dagger :

To the memory of | John Perry Esq. in 1693 | Commander
of his Majesty King William's | Ship, the Cignet, second
son of Saml Perry | of Rodborough in Gloucestershire, gent.,
& of | Sarah his wife daughter of Sir Thom. Nott, knt. | He
was several years comptroller of the | maritime works to
Czar Peter of Russia | and on his return home was employed
by the | Parliament to stop Dagenham breach which | he
effected & thereby preserved the | navigation of the river of
Thames, and | rescued many private families from ruin. | He
after departed this life in this town and | was here interred
February 13, 1732, aged | 63 years. | This stone was placed
over him by the | order of William Perry of Penshurst, in |
Kent Esq. his kindsman & heir male.

A white marble tablet by the north porch in capitals :

To the memory of | Samuel Greaves Esq. | late of Deeping
St James, | but formerly of this parish, | who died | Jany 31,
1822, aged 84 years. | Also Ann Mael Greaves | wife of the
said Samuel Greaves | died May 28, 1769, aged 32 years, | and
of Ann their daughter | who died an infant.

A flat blue stone at the west end of the nave in capitals :

In memory of | George Metcalfe gent. | who departed this
life August the 1, 1813, | aged 77 years. | Also of | Rebecca |
relict of | George Metcalfe | who departed this life | 1 May
1829, | aged 89 years | And of | Jane their daughter | who
departed this life | Sept. 30, 1775, | aged three years | And
also of | George the son of the said | George & Rebecca
Metcalfe | who departed this life | Jany 3, 1812, | aged 46
years.

Another to the north :

Here | lyeth the body of | William Peares who departed
this | life the 14 day of Sept. 1702, | in the 76 year of his

age, | and Mary his wife who departed this life the . . day of May 1704, in the 69th year of her age.

Another to the north in capitals :

Corpus Samuelis Mael | mercer Anno Ætatis | suæ **47 spe** Resurrectionis beatæ hic depositum | 16 die Augusti | 1701. | In memory of | Lot Mael gent. who was | interred the 31 of January 1747, | in the 64 year of his age, | in hopes of a joyful | Resurrection.

Another to the north in capitals :

The body of Rebekah Mael | wife | of Samuel Mael, deceased, aged | 56 years, was in hopes of a joyful | Resurrection interred here the | 8 day of December Anno Domini | 1708. | In memory of | Mrs Alice Mael wife of Lot Mael | gent. who was interred | the 12 of Feby 1742, | aged 48 years, | in hopes of a joyful | Resurrection.

A stone collateral (D) :

Here lies interred the body of Martha the wife of Thomas Eldred, gent., and of Thomas their eldest son. She departed September 9, 1708, he 5th December, 1700, aged 59.

A stone next to this has had arms cut thereon, but too effaced to be decyphered as is the inscription.

Collateral to the north, and in capitals :

Here lyeth the body of | Mrs Alice Cock formerly | the wife of Mr Anthony | Blaydwin late of Moulton | who was interred April the | 24, Anno Domini 1695, being | in the 67 year of her age.

Another to the north :

In memory of | George Stevens, gent. who | died the 15 day of January 1720, in | the 61st year of his age. | Also Elizabeth his wife. | Here | lie deposited the remains | of | George Stevens esq. | one of his Majesty's Justices of the Peace, | son of George & Elizabeth Stevens, | whose | life departed | the | 14 of July 1760 | in ætate sua 58.

Another to the north in capitals :

Here lyeth the body of | Mr Wm Chandler | interred | the 23rd of April 1707 | in the 60 year of his age.

Another close by to John Sparks of Spalding, grocer, son of John Sparks of Peterborough ; the date is effaced.

A black flat stone by the west door :

H.S. | Compton | uxor Revd Tim. Neve A.M. | F. N. Max Tho. Rowell, Armig. | Pia proba et modesta | Forma spectabilis | Pulchrior ingenio | Quæ cum quinquennali conjugio | Quarta virum auxisset prole | Beasset amore | ornasset vita | Morte sola contristavit | A.D. MDCCXXVIII, ætat. suæ 35.

Collateral to the south :

> Here lies interred the body of | Robert Brown late of this place | merchant obiit 27ᵐᵒ Januarii Anno | Domini 1714, ætatis suæ 40. | And also Elizabeth his daugh- | ter who departed this life the | 16 day of April 1715, | in the 1 year of her age. | And also Samuel the son of the | said Robert & Rebecca Brown | who departed this life the 27 day | of June 1719, aged 11 years.

A flat stone to the south, partly hid by a pew :

> Under this stone lye the | children of Robert & Re | bekah Brown | in hopes of a | Blessed Resurrection. | Robert Brown departed this | Life the 10 day of November 1699, | Henry Brown departed this life | the 22nd day of July 1700, | William Brown departed this | life the 10 day of June 1701, | John Brown departed this life | the 9th day of July, 1702, | Robert Brown departed this life | 25th day of February 170⅞, | Robert Brown the 3ᵈ departed | this life June the 16, 1710, | Mael Brown died Oct. 17, 1711.

On a flat stone by the font :

> Here | lyeth the body | of Ann Grimes. | Shee departed | this life Jan. the 21, | 1706. | Near this place lyeth | the body of James | Grimes who depar. | this life May the 17, 1708.

Another close by :

> Here lieth interred | John Hardy | son of Mr John Hardy | late of Wisbeach St Mary | who departed this life | the 24 of Nov. 1728 | aged 19 years.

On a blue flat stone in the nave :

> Rebecca | the wife of | Mr Samuel G. Harvey | died Aug. the 21, 1808, | aged 38.

[See also *Lincs. N. & Q.* xi, 170–176 ; *L.R.S.* i, 168 ; Jeans, 63–4, Supp. 20 ; *Churches of Holland ; The South Holland Magazine*, volumes i–iii (Spalding).]

(MS viii, 39–60.)

𝔖𝔭𝔞𝔫𝔟𝔶

Notes taken in the church, 28 July, 1834—This is a poor church consisting only of a nave and chancel, with a kind of wooden box for a bell at the west end. The font is plain and octagonal of an ancient make.

On a flat stone within the altar rails (D) :

> In memory of | Mary Anna an Infant | daughter of the Revᵈ | Jo. Mason and Hannah his wife | who was buried Janʸ yᵉ 8, 1753.

On another close by is cut (D) :

> M. C. R. | 1823.

In the chancel is an old stone with a cross cut upon it, and once having an inscription round the edge ; all that now remains is the following in old character (D) :

Mille*simo* cccc xiiii cuius a*nime*

There is another stone similar to the last close by, but nothing left of the inscription.

[*See also* Trollope, *Sleaford*, 441.]

(MS v, 93–94.)

Spilsby

Notes taken in the church, 17 August, 1835—

On a stone tablet over the south door at the east end (R) :

In memory of | Sherard Philip Lound | late Lieutenant R.N. | born Sept. 5, 1790, | lost at sea Dec[r] 1812 ! ! !

A marble tablet against the east wall north of the altar (R) :

In memory of | Thomas Walker Esq. | of this place, | who died Sept. the XXVII, | MDCCCXXIV, | in the LXXV year | of his age.

A white marble monument south of the altar (R) :

Sacred | to the memory of | the Rev[d] | Thomas Beaumont | rector of Raithby | in this county | who departed this life | on the 25 of Sept[r] 1781 | aged 68 | Also of | Elizabeth | relict of the above | who departed this life | March 17 1823 | aged 86.

A handsome grey and white marble monument against the wall of the south aisle over the reading desk (R), the inscription on a white slab in gold capital letters. Below, is a knight's helmet and mantling, carved with the crest—A [dolphin] hauriant [Franklin] :

This tablet is dedicated | by afflicted relatives | to the memory of | the Hon[ble] Sir Willingham Franklin, | knight, | one of the Judges of the supreme | Court of Judicature at Madras. | He was born at Spilsby. He received | his education at St Peter's College | Westminster, and at Oxford, | where | He was successively scholar of | Corpus Christi College and Fellow | of Oriel, | and was called to the Bar by | the Society of the Inner Temple. | He died, aged XLV, on the XXXI | day of May MDCCCXXIV, at Madras, | where his remains are interred.

A small marble tablet to the west of the last (R) :

In memory of | Mrs Abigal Bennet | who died May y[e] 3[d] | 1772, | in the 65th year | of her age.

On a flat stone in the south aisle in capitals (D) :

Here lyeth y[e] body | of George Baslington | who departed this | life the 14 day of | February 1704, | aged 71 years.

On another brown stone (D) :

In memory of | George Varnham | of Wilton Place, Belgrave Square, | Knightsbridge Esq. | who departed this life | at Boston in this county | on the 24 day of June 1830, | aged 58 years.

On a flat stone at the west end of the nave, rubbed (D) :

In memory of | Elizabeth the wife of | William Laine, surgeon, | daughter of the late | Carr Brakenbury Esq. | & Isabella his wife | | the 16 of August 177[1], | aged 21 years.

N.B. These monuments only are taken here of which an account is not given in the *Gentleman's Magazine*.

[See also *Lincs. N. & Q.* xi, 178 ; *L.R.S.* i, 84–90 ; Jeans, 64–66 ; *Associated Societies Reports* viii, 1–25, xxi, 158–9.]

(MS viii, 159–163.)

Stapleford

Notes taken in the church, 10 August, 1833—This is a very mean church ; it consists of a modern nave and chancel, and a tower, which is old, at the west end.

On a black stone tablet lying in the chancel (R) :

In | memory of | Ann the wife of | Edward Tonge | who departed this life | on the XXII of April | MDCCCIX, | aged XXXII years. | She had few equals.

On another lying by (R) :

In | memory of | Charles Tonge | who departed this life | on the XII of Sep. | MDCCCIX | aged LIV years. | The time is short.

These stones, however, were originally outside on the wall of the church, but on its being repaired were moved inside. The old residence of the Rothwells is now but a farmhouse, and in the occupation of the Tonges ; it stands between the church and the road.

[See also *L.R.S.* i, 246.]

(MS xii, 21–22.)

Stenigot

Notes taken in the church of Stainigot, 20 August, 1835—

On a flat stone in the chancel south of the altar :

In | memory of | the infant son of | Thomas and Elizabeth Moses | January 27, 1830. | Tho' lost to sight to memory dear.

Against the south wall of the chancel is a small monument of alabaster. In a recess formed by two Corinthian columns of black marble is the figure of a knight, armed save the head, kneeling on a cushion before a desk on which lies a book open ; above are

these arms the colours of which are nearly effaced—Quarterly, 1st and 4th, [Or], three bendlets [ermine—Guevara]; 2nd and 3rd, Gules, five leaves. Crest: A man's head, couped at the neck. Motto—Malo mori quam faedari. This inscription below the figure on a black slab in capitals (R):

> Here lieth the bodie of Sir John Guevara knight somtimes De- | putie Warden of the East marches of England under the right | Honorable Peregrine Lo. Willoughby Baron of Willovghby Beak | and Eacesby, sonne and heire to Franncis Guevara esquier who Maryed | Ann daughter of Robert Sanderson of Saxeby in the countie of Lin- | colne Esquier by whom he had issue 6 sonnes viz^t Franncis, John, | William, Thomas, Charles, and Robert, and twoe daughters viz^t | Katherine and Mary, and departed this Liefe the 6 of June 1607.

Against the north wall is another monument of marble, with arched recess in which is a male figure in a gown and ruff; above are the four quarterings of Guevara; the motto over—La. Mayor. Victoria. De. Ellas. Es Falbien. Merecilias. On the east side Guevara, impaling—A fesse between three pheons, and a canton . . . [Egerton]. On the west side Guevara, impaling a shield, but the bearing effaced. This inscription below in capitals (R):

> Here lieth y^e body of Frances Vellez de Guevara A Natu | rale Spanyarde borne in Segvra in y^e Province of Biscay | who had to his first wife Denise Read daughter & Heyre | to Ihon | Reade of Boston in y^e County of Lincolne es | quier by whome he had issue one daughter Ellene, and | after married Anne Egerton daughter to Ihon Eger | ton of Willoughby in y^e County aforesaide Esquier | by whome he had issue 5 sonnes viz^t Ihon, Peregrine, | Henry, Willam, George, and 5 Daughters viz. Anne, Susan, | Cathrine, Elisabeth, and Fraunces, and died y^e tenth of | Febrvary 1592.

This church, which is a very mean one though picturesquely situated at the bottom of a valley, consists merely of a nave and chancel, with a niche for a bell at the west end. The font is a handsome octagon, pannelled with shields in quatrefoyls.

[See also *Lincs. N. & Q.* x, 237–238.]

(MS vi, 213–215.)

𝕾tickforð

Notes taken in the church, 14 August, 1835—

In the south aisle a flat black stone (R):

> In memory of Mr | Hamon Underwood | interred Feb. 14, 1732, | aged 62.

On a flat stone to the west of the last (R) :
Sacred | to the memory of | George Swallow | of this place |
who departed this life | February 11, 1822, | aged 53 years.

On an old stone in the north aisle (D) these few words are visible
on the opposite sides in church text capitals :
Jacet Joh propitie*tur*

This is a small church ; it consists of a nave divided from its
aisles by four low pointed arches with octagonal columns. The
font is octagon pannelled with shields in lozenges. On one shield
I.H.S. There is a chancel, and a good perpendicular tower at
the west end. The windows are very poor, but there yet remains
much old benching.

[See also *Lincs. N. & Q.* xi, 93–94 ; *L.R.S.* i, 165.]

(MS viii, 77–78.)

𝔖tickney

Notes taken in the church, 14 August, 1835—

On a flat blue stone within the altar rails (R) :
In memory of | Richard Loxham, A.B., | resident rector of
this parish | 36 years | who dyed Sept. 15, 1785 | aged 61. |
Also of Elizabeth relict of | the said Richard Loxham | who
was interr'd Jany ye 10, 1794 | aged LXVI.

A flat stone in the chancel (R) :
Jane the wife of John Smith, | gent., interr'd June the 23,
1691. | Margery his second wife interr'd | August the 18th,
1711.

A tablet of donations from divers persons ; among them :
Thomas Bishop of Stickney, Esq.
Wm Strawson, clerk, rector of Stickney.
Edward Cocker of Stickney.

This church consists of a nave and aisles separated by four
pointed arches on each side rising from low columns, a chancel,
and tower at the west end, divided off by a good pointed arch, a
south porch. The windows are Perpendicular. In the tower are
two good windows of that era. The roof is open to the timbers,
and the font is modern. In the south wall of the chancel are the
remains of an arched recess, apparently a tomb (D), but it is built
now almost into the east wall ; opposite, a low arched doorway
blocked up. From these appearances most probably the chancel
has been shortened.

[See also *Lincs. N. & Q.* xi, 93 ; *L.R.S.* i, 165–166.]

(MS viii, 75–76.)

Stow in Lindsey

Notes taken in the church of Stow, 4th September, 1835—This church has been so frequently described as to need nothing further here, and many of the inscriptions have been already given in the *Gentleman's Magazine*, 1831, part i, 492–5; and 1827, part i, 585–6. Besides the following, however, there are many inscriptions at the west end that we had not time to copy.

A white tablet against the south wall of the chancel (D):
Sacred | to the memory of Thomas Stones | late of Gainsbro' | nephew to John Torr of Stow Park. | He was born May the 29, 1766, | in the parish of Hathersage, Derbyshire. | By lifting the anchor of a ship | he broke his leg | which brought on a lockt jaw | that terminated his existence | July 1, 1795. | This monument was erected | as a token of esteem | by his cousin Jn⁰ Torr of Doncaster.

On a stone in the chancel floor (D):
Here lieth | the body of Mr | Burgh Tathwell gent. | who departed this | life March the 16 in | the year of our Lord | 1689. | Here lyeth also the body | of Susanna Tathwell daughter | of Mr Cornewall Tathwell | of Stow Hall gent. & Lucy | his wife who departed this | life January the third in the | year of our Lord 1720, in | the thirteenth year of her | age. | And also Lucy the wife of | Cornewall Tathwell gent. | She departed this life | June the 26, in the year of | our Lord 1744, aged | 62 years.

On a stone more to the west (D):
Here lyeth the | body of Mr Corne | wall Tathwell of | Stow Hall, gent., who | departed this life July | the sixt in the year of | our Lord 1738, in the | 60 year of his age.

A black marble tablet against the north wall of the chancel (D):
In | memory | of | Lucy the wife of | William Byron who | was daughter of | Cornewall Tathwell | gent., who died August | the 20, 1751, aged 38.

In the south transept are some old stones which have had inscriptions round the verge, but have been so much effaced that it is impossible to decypher them. On one remains the date MCCCCCXI cuius, and on another Hic iacet CCCCXXV cuius anime propiciet

[See also *L.R.S.* i, 70–71, 144; Jeans, 75.]

(MS vii, 133–136.)

Stragglethorpe

Notes taken in the church, 9 August, 1833—

On a stone in the nave :

> In | memory of | John Upshull | who | departed this life | Janu^y 6, 1747, | aged 53.

On a handsome marble monument on the north side of the chancel, these arms above—Gules, three escallops in a bordure argent [Earle] ; impaling—A fess between three fleur de lis [Welby] ; the colours here are gone. Above the inscriptions are cherubs, and on each side a bust, one a man in flowing hair and the other a youthful face with very redundant locks and scarcely to be known whether male or female ; a little cherub sits upon the ledge of the base :

> Stay reader & observe Deaths partial Doom | A spreading virtue in a narrow tombe | A generous mind mingled with common dust | Like burnished Steel covered & left in rust | Dark in the earth he lyes in whom did shine | All the divided merits of his line | The lustre of his name seems faded here | No fairer star in all that fruiful [*sic*] sphere | In piety and parts extremely bright | Clear was his youth & filled with growing light | A morn that promised much yet saw no noon | None ever rose so fast & set so soon | All lines of worth were center'd here in one | Yet see he lies in shades whose life had none | But while the mother this sad structure rears | A double dissolution there appears | He into dust dissolves she into tears. | Richardus Earle Barn^{tus} | obiit decimo tertio die Augusti | Anno Dom. 1697, ætatis suæ 24.

On a flat stone in the chancel in capitals :

> Sir Richard Earle Bar | onet deceased March y^e 25, | 1667, an. ætat. 60. | Hiere ly great Sir till Good and Just | Shall reunite thy moulderd dust | And rayse thy once well tempered peice | To a more glorious edifice | If wise just chaste loyall are blest | Meane mortalls with eternall rest | If faith Hope Charity are proved | Jesus loved | Doubt not but these same ashes shall | Rise to a frame ætheriall. | Goe reader live & learn to dy | Like him that now lives happily.

This church consists of a nave and north aisle separated by two low round arches, a chancel divided off by a screen, and a bell turret at the west end.

[See also *Associated Societies' Reports*, xxxvi, 42–6.]

(MS iii, 255–257.)

Strubby

Notes taken in the church, [*blank*]—

This inscription in old text on the east side of the door :

Affore yᵉ porch dor vnder the stone | Lysse yᵉ body & bons of B : lotts beryed | In the ȝeyr of owr lorde god 1531 | The 14 day of January ȝerly to be notid | Wherfor fryndys I pray ȝov have me reviuyd | Wᵗ ȝovr gvd praers yᵗ soner my sall may cum | Emong the heuenly company to be concordyd | Afor yᵉ paternal deite in yᵉ celestial kyngdum | P : me I coniugem predicte anno regni regis Henrici oct' xxiii.

On an old stone in church text in the nave :

Hic jacet dominus Simon vicarius ecclesie cuius anime propicietur deus Amen. [Simon of Woodthorpe was instituted in 1350.]

On a tablet of wood is recorded that Thomas Williamson of Woodthorpe gave by his last will and testament, bearing date the 28 April 1728, lands to this parish.

On a marble monument against the east wall of the south aisle, above these arms—Argent, a lion rampant sable, in chief [gules] three [cinquefoils or] [Ballet] :

Here lyeth the body of Charles Ballett | late of Clements Inn in the county of | Middlesex, gent., deceased, which Charles | had to his first wife Elizabeth Wells | daughter of John Wells gent. in the | county of Kent, and he had issue by her | two sons and two daughters, Charles | and Tho., Elizabeth and Sarah. | He had to his second wife Ann Tingle | late widow of William Tingle gent. | in the county of Northampton, | by whom he had no issue. | Obiit 27 Jan. 1703, | ætatis suæ 69.

Against the east wall of the south aisle is a small monument of alabaster stone. In a recess formed by two red Corinthian pillars with gilt capitals, is the figure of a man clothed in alderman's robes, kneeling before a desk and, opposite, his two wives in black plaited gowns. Below are the kneeling figures of seven sons dressed in cloaks, trunkhose, and jack boots, all black, one holding a skull, and two daughters whose heads are both lost. One also has a skull. Above are three shields, the principal one—Ballett ; [crest— An eagle's head issuant from a mural crown]. On the dexter side—Ballett, impaling—An escarbuncle [Garton]. The sinister shield is now gone. Below the figures is the following inscription on a black slab in capitals :

Here lieth yᵉ body of William Ballett, Alderman of London, late of Woodthorpe in the | county of Lincoln esq., sonne and

heyre of Edward Ballett | of Vfford in y^e county of Suffolck gent., by Ursula y^e daughter | of Richard Saunders gent., wich Edward was y^e sonne & heyre | of Thomas Ballett of Ufford gent., by Alice Jay. This William | had two wives, Joan y^e eldest daughter of Francis Garton | of Billinghurst in the county of Sussex esq., and by her | had two sonnes and one daughter, John, William, & Elizabeth, dead with | out issue. His other wife was Susanna eldest daughter of Paterick | Dethicke of Westminster in y^e county of Middlesex gent., | descended | of y^e name of Dethick called Dedick of Worcestershire ; by her he had five | sonnes & one daughter, William, George, Charles, Edward, Richard, | & Rose. William maryed Mary y^e daughter and coheir of Richard Horneby | of Tothill, Esq., by Winifred y^e daughter of Robert Peyton of Iselam in y^e | county of Cambridge esq., by Elizabeth daughter of Robert Lord | Rich, wich Willa*m* had issue Willa*m*, Richard, & Anne. George marryd Ellen | y^e daughter of William Thorie of Thurleby gent., by whome he had William, | Charles, George, Frauncis, Susanna, Mary, & Ann. Charles marryd Sarah | y^e daughter of Thomas Newcomen of Wythren gent., by whome he had | issue, Charles, Samuell, & Mary. This William the grandfather dyed 9 May, | 1648, being aged 99 years.

This church, which is in a miserable condition from damp and want of repair, consists of a nave and south aisle divided by four pointed arches, a chancel, and wooden tower (D) at the west end. The east end of the south aisle is enclosed by an oak screen (D) of good Decorated work. The font is also of the same character, octagonal, ornamented with a pannelling of windows. An old chest (D) of the same stile of ornament remains.

[See also *Lincs. N. & Q.* x, 238–239 ; xi, 179–80.]

(MS vi, 59—62.)

Sudbrooke

Notes taken in the church, 5 August, 1833—

On a flat stone in the nave with these arms above—Semee of crosslets fiche, three fleur de lis [Beresford]. The stone is defaced partially (R) :

Here | lieth the remains of | Edward Beresford, | Esq., late of Holme | who departed this life | February . . , 1735, | aged 56 years.

On another flat stone in the nave (R) :

Here lyeth | y^e body of Isabell | Beresford wife of | Edward Beresford, | Esq., who died the 16 | of December 1729. | Virtus post funera vivit.

On a flat stone at the east end, arms over—Beresford ; impaling—
[Sable], a fesse between three asses passant [Ayscough]. In
capitals (R) :

> Here lieth the body of Anne the | daughter of Sr Edward
> Ayscough | of Kelsey and late wife of Mr | William Beresford
> of Holme | she died Aug. ye 24, Anno D'ni | 1678. | Non
> mortua sed dormit.

On another to the west :

> In memory | of Charles & Mary | Mr Ed. Beresford |
> & Isabella his wife. | Charles died April 7th, 1717, | Mary
> died Aug. 24, 1717. | Also Isabella | daughter of the above
> Mr Ed. Beresford & Isabella his wife ; | she died May 22,
> 1774, aged 70 years.

This church has the appearance of a barn ; it is of red brick
and has no distinction of nave or aisles or chancel.

[See also *Lincs. N. & Q.* xv, 49.]

<div align="right">(MS i, 217–218.)</div>

Surfleet

Notes taken in the church, 17 July, 1833—

On a flat stone in the chancel before the altar :

> Here | lie the remains of | Dame Anne Fraser | daughter
> of | Sr Henry Heron, Knight of the Bath, | deceased, and |
> relict of Sr Peter Fraser, | Baronet. | This excellent Lady |
> died at Cressey Hall | the 25 of August 1769, | in the 92 year
> of her age, | full of days & good | works.

On a flat stone near the above :

> Here lyeth Frances ye | daughter of Sr William | Bampfield
> of ye ancient | famyly of Poultymer in | Devonshire, she
> maryed Sr | John Brooke of Heckington | in Lincolnshire
> who was | restored to the Barony of | Lord Cobham of
> Coolling | in the county of Kent, by King | Charles ye 1st
> in the year | 1644. She lived a widow | 17 years 3 months
> and | departed this life ye 13 | of December 1676.

On a flat stone near the above with these arms cut above—A
chevron ermine between three herons. Crest—A heron's head
[Heron] :

> Here lieth the body of Henry | the sonne of the Honble Sr
> Henry | Heron, Knight of the Bath, & | of Dorothy his wife,
> borne | the 12 of July & dyed the | same day 1674.

On a stone near the above :

> Here lieth | Sr Henry Heron, | Knight of the Bath, | of Cressy
> Hall in this parish, | he was interred August 9, 1695, |
> aged 76.

On a stone tablet against the east wall at the end of the south aisle :

> Many are the friends of the rich man | be this humble stone sacred to the memory of | the poor man's friend | Samuel Elsdale | who after a patriarchal life | spent in the exercise of christian charity | died on the 18 of February 1788, aged 83 years. | The blessing of him that was ready to perish came upon me | And I caused the widow's heart to sing for joy.

On a white and grey marble tablet against the north wall :

> Sacred to the memory of | Mr John Robinson gent. | who died the 18 of September 1804, | aged 64 years, | and three of his grandchildren. | Dear wife farewell I'm gone before | My love to you can be no more | No grief no sorrow for me make | But love my children for my sake. | Also Mrs Hannah Robinson | widow of the above gentleman | died the 11th of Septe^r 1821 | aged 82 years.

On a grey and white marble monument on the wall of the south aisle with these arms under—Quarterly, 1st and 4th, Sable, a chevron between three crosslets fichee argent [Buckworth] ; 2nd. between three stars of six points ; 3rd, [Ermine], on a canton azure a pelican or [Pell] ; impaling—Azure, a chevron ermine between three martlets argent [Northon]. Crest, a demi-lion holding a battle axe :

> Sacred to the memory of | Theophilus Buckworth Esq. | younger son of Everard Buckworth Esq. | by Jane Pell eldest daughter & coheiress of | Henry Pell Esq. | of Dembleby in this county. | He departed this life the 17 day of February 1801, | aged 63 years. | Also of Ann his wife the daughter of | John Northon Esq^re | of Holbeach in this county | who surviving her beloved husband scarcely ten months | departed this life the 12^th of December 1801 | aged 55 years.

Against the wall is an atchievement of the same arms with the motto, ' Spes mea in Deo ' ; and another with the arms of Buckworth with those of Pell, viz.—Ermine, on a canton azure a pelican or, in an escucheon.

On a flat stone in the middle aisle :

> In memory | of Robinson Elsdale, gent., | he died October the 15, 1783, | aged 38 years. | Freed from the load of life the vale of woe | The husband father friend resigned his breath | For weeping virtue could not ward the blow | Nor prayers of thousands stop the hand of death. | Ah vain the pomp of praise the marble urn | Where pensive cherubs guard the polished bust. | In vain they bid the careless reader mourn | O'er trophied tombs & monumental dust. | Let such proud trophies mark some other stone | Thy worth less failing testimonies prove | The poor man's pangs the orphan's

widow's moan | The sighs of friendship and the tears of love. |
Mary Anne | daughter of the said Robinson Elsdale and
Ann his wife | died in her infancy.

On another flat stone :

In memory of | Miss Ann Elsdale | daughter of | Samuel
Elsdale, gent., | by Mary his wife | who departed this life |
March 21, 1768, | aged 21. | In Troops assembled all yᵉ virgin
train | View well this stone and if you can be vain | Ye
loveliest of her fair survivors know | Not all your charms
can ward the fatal blow | Virtue directs to everlasting joy |
Which time can't interrupt nor death destroy.

On a tablet of white and grey marble against the north wall :

In a vault near this place are | deposited the remains of |
Henry Smith, Esq., of Cressey Hall | in this county, who
died the | 7ᵗʰ of February 1823, aged 56. | Also rest here
four | children of Henry and Jane Smith | who died in their
infancy.

On a flat stone close by the above monument :

Henry Smith | of Cressey Hall | died 7 February 1823, |
aged 56.

Near to the last has been the brass of a man with an inscription
but now gone, and in the chancel in a niche north of the altar is
the effigy in stone, but now covered with white wash, of a knight
with his legs crossed, the feet resting against a lion couchant.

A marble monument against the north wall of the chancel :

In memory of Henry Heron, Esq., | descended from an ancient
and honourable family of knights ; he was | son of Sir Henry
Heron, Knight of the Bath, of Cressy Hall in this | parish,
and of Dorothy daughter of Sir James Long of Dray Court, |
Baronet, in the county of Wilts, and in him ended in a
direct | line the descendants of Sir John Heron, Knight of
the Bath, | who was representative of the ancient family of
Ford Castle | in Northumberland, and Privy Counsellor to
King Henry | the eight. As a member of Parliament he
always preferred | the interest of his country to his own, which
the Borough of | Boston & this county can sufficiently
testify, he having | represented them in several successive
Parliaments. In the | administration of justice he acted
without partiality and in | the distribution of hospitality
without an equal, following | the example of his ancestors,
and as he lived esteemed | so he died much lamented the
10 day of September 1730, | aged 55. | In memory of his
wife Abigail Hevingham | of the ancient family of yᵉ
Hevinghams of Hevingham Hall | in the county of Norfolk,
a Lady of exemplary virtue | and true Christian piety died
in the year 1735.

A marble monument against the wall of the north aisle :

Hic jacet | Everardus Buckworth Armigr | Natus [anno Christi] 1693 | Mortuus anno Christi 1751. | Qui fuerim ex hoc marmore cognoscis | Qualis vero cognoscis alibi | Eo scilicet supremo tempore | Quo ipse etiam | Qualis tu fueris cognoscam | Abi viator et fac sedulo | Ut ipse tum bonus appareas. | Also the remains of Mrs Jane Buckworth | who died the 2d of April 1770.

These arms below—Sable, a chevron between three crosslets fitchy argent [Buckworth] ; the inescucheon—Ermine, on a canton azure a pelican or [Pell].

Upon a similar one more to the west with these arms below—Quarterly, 1st and 4th, Buckworth ; 2nd, Gules, a chevron between three mullets argent [Everard]; 3rd, Pell; an escucheon—Argent, a tower triple towered between three standing cups covered azure [for Amcotts] :

Sacred to the memory of the Revd | Everard Buckworth, | LL.D., | died October 3d, 1792, | eldest son of Everard Buckworth of Spalding, Esq., | and Jane daughter & coheiress | of Henry Pell of Dembleby, Esq., | married August 2, 1754, Frances | youngest daughter of | Vincent and Elizabeth Amcotts | of Harrington, Esq., | and one of the surviving sisters and coheiresses | of Charles Amcotts, Esq., | a man of great learning, | refined by a polite education, | deeply versed in the beautiful works | of the Almighty Creator, | affectionate, benevolent, | beloved, and lamented by all. | His widow hath erected this monument | waiting until it shall please the Almighty | to reunite them in the grave | and call them to a blessed Resurrection.

On a small tablet of marble below :

Frances Buckworth | relict | of the Revd Everard Buckworth, LL.D., | died the 21st of April 1810, | aged 83 years, | and lies here interred.

On a flat stone in the south aisle with the top broken off and partly hid by a pew :

. | Susanna his wife who departed this | November the 13, 1729. | Also John who died April 3d, , | four days after his birth ; | here also lieth the body of Susan | a daughter who departed this | life Feb. 9, 1721, | Ann a daughter died June | ye 1st, 1723, | James a son died January | ye 21, 1723. [The burials of these people are not recorded in the Surfleet register.]

On a flat stone in the nave :

To the memory of | Mr John Robinson, gent., | who departed this life | September the 18, 1804, | aged 64 years. | And in

memory of | Hannah his wife | who departed this life | September the 11, 1821, aged 82 years. | Also three grandchildren of | the above who died | in their infancy.

Upon another near the window (D):

In memory of Mr John Elsdale | interr'd June 24th, 1723, aged 29. | Also in memory of Mary the wife of | Samuel Elsdale, gent., | who died Feb. 22ᵈ, 1757, | aged 46 years, | and of two of their children who died in their | infancy.

This church consists of a nave separated from its aisles by four pointed arches and a chancel. At the west end is a tower and spire in which is a peal of five bells. There is a fine south porch with an Early English door ornamented with the toothed moulding. The font is octagon and pannelled with quatrefoils. In a niche at the north side of the altar is the recumbent figure of a knight with his feet resting on a dog and his head on a cushion. His feet are crossed and he bears a shield on his left arm.

[See also *L.R.S.* i, 173–174; *Churches of Holland.*]

(MS i, 159–171.)

𝔖utterton

Notes taken in the church, 4 August, 1834—This church is curious; it consists of a nave divided from its aisles by six early pointed arches springing from round columns, the capitals of which are curiously moulded, a chancel, north and south transepts, and a fine tower and crocketed spire at the intersection. The arch from the nave to the tower is pointed with the toothed moulding. The east window is of five lights with curiously ramified tracery. The south porch has a singular outer arch and the north door is handsome and Norman. In the east wall of the chancel is a double arched piscina, and in the south wall a monumental arch.

Set upright against the north side of the arch from the chancel to the tower, facing the former, is a tombstone of ancient workmanship bearing a figure attired in a plaited robe with the hands clasped. The features are destroyed. Round the edge of the stone is an inscription, but from the position and damage it has suffered it could not be decyphered. It is in Saxon character.

On the side of the arch facing west is a similar stone with the figure of a priest in a stole and canonicals holding a cup in his hands. There is an inscription round the edge of the stone, but though more perfect perhaps than the last I could not decypher it.

On the south side of the arch facing east is another tomb, similar to the two former, bearing the figure of a female in a long plaited robe and wimple, with her hands clasped on her breast. The inscription here, which also runs round the edge of the tomb on similar characters to the other two, is quite illegible.

On an old flat stone within the altar rails with this inscription round the edge (D):

> Here lyeth the body of Joan late wife of Thomas Estcourt of Sutterton gen. who departed this life Jan. 20, An

A flat stone to the north (D):

> In | memory of | William Cash | who departed this life | July yᵉ 19, 1765, | aged 55 years.

On a flat blue stone in the nave (D):

> Here | lieth the body of | Edward Booth, | gent., | who departed this life | April the 20, | 1720. | in yᵉ 61 year of his | age.

Another stone more to the west with these arms cut—A chevron between three leaves, differenced by a crescent [Shore]. The inscription round the edge in capitals (D):

> Here lyeth yᵉ body of Ann | first wife of Robert Shore, gentleman, one of the daughters | of William [? Fretham] late of | Swineshead, gent., life yᵉ 15 of December | 1678.

On a flat stone more to the west (D):

> Here lyeth the body of | Robert Shore, gent., who | died January yᵉ 20, | 1717, aged 67 years.

A stone more to the west in capitals rubbed (D):

> Hope waiting upon | Faith said instantly | that henceforth . . . | him corruption dye | that is yᵉ Lord of life | by dying can | save men from death | and corruption. | Here lieth Rebekah | Hunn dearly love = | ing and only beloved | wife of Tho. Hunn | who dyed Novem. yᵉ . . . | & buryed yᵉ . . . | in yᵉ 32 year of her age | 1704.

Another to the west (D):

> Here | lieth the body of | The Reverend | James Whitworth, | many years resident | in this parish, | and | Curate of Algarkirk | cum Fosdyke. | He died 13 of Sept. 1786, | aged 52.

A tablet against the wall of the south aisle at the east end (D):

> Near this place | lyeth interred the body | of Beaumont Leeson | who departed this life | November the 6, | 1750, | ætatis suæ 37.

[See also *L.R.S.* i, 168; *Churches of Holland.*]

(MS v, 155–160.)

Long Sutton

Notes taken in the church of Long Sutton, 22 July, 1833—

On a white marble monument of a circular form at the east end of the north aisle (D):

> Sacred | to the memory of | Sarah Delamore | daughter of Maurice and Amy Delamore | who died the xxiv of February mdcccxxiii, | aged xc years.

On a white marble tablet against the north wall of the chancel (D) :
> In memory of | Amy | the beloved wife | of Maurice Delamore
> gent. | and | eldest daughter of Henry Blyford gent. | and
> Jane his wife | of Burnham Overy | in the county of Norfolk, |
> who departed this life December 17, | 1735, | aged 52 years. |
> She had eleven children, | three only survived her | viz. |
> William, Henry, and Sarah.

Next to the above a white marble monument with the arms above,
but scarcely visible ; they appear to be—A cross pattee flory [for
Delamore] ; impaling (D) :
> Sacred to the memory | of | William Delamore esq. | who
> died Nov. 19, 1742. | He was a man of true piety towards
> God | and | Benevolence to mankind | Diligent in the service
> of his country, | and being peaceable in his own disposition |
> He studiously promoted peace in his neighbourhood, | He
> acted in the Hon^ble commission of the Peace | in his neigh-
> bourhood for this county | with great prudence justice and
> integrity | He was an indulgent affectionate husband | A
> tender lover of all his relations | And friend to the poor |
> Which amiable qualities made his death greatly lamented |
> By all that knew him. | He married Sarah daugh^r of S^r Roger
> Jenyns knight | of Bottsham Hall in Cambridgeshire | who
> with y^e most affectionate and real respect | has erected this
> memorial of him | and now lieth interred with him. | She
> died the 11th of October 1761, aged 72.

On a white monument in the north aisle :
> Near this place | lieth interred the body | of William Gregg |
> who departed this life | the 10 of December 1763, | aged 51
> years, | also the body of | Robert Gregg | son of the above
> William Gregg | who died the 18 of April 1788, | aged 53
> years.

A very handsome monument in the north aisle composed of various
coloured marbles :
> Near this monument are interred the remains of Nicholas
> Wileman | late of this parish gent. who departed this life
> on the 24 day of June | 1758, aged 63 years, and of Mary his
> wife who died in childbed November | the 30, 1740, in the
> 40 year of her age, after bearing him twenty two | children,
> of whom only Edward, Elizabeth, and Nicholas, being | the
> nineteenth the twentieth & the one and twentieth survived |
> their parents. Eighteen of their children lye here, and one
> at | Whittlesea, who all died very young except Anne who
> departed | this life on the 7 day of June 1752, aged 22 years. |
> Also the remains of the above Edward Wileman Esq. who |
> having survived Nicholas and Elizabeth died without issue
> May the 31, 1785, | in the 49 year of his age.

On a flat stone in the north aisle, the stone is black :

> Here lieth the | body of Will. Graves jun^r gent. | interred the 12 of May 1699, aged 42 years, | and Will. Graves sen^r gent. interred the 30 of Octob^r | 1716, aged 86. | Also Hannah the relict of Will. Graves jun^r | gent. interred the 7 of December 1724, aged 69. | To the pious memory of | Mrs Judeth Graves the wife of William Graves | gent. by whom she had issue two sons and | four daughters, whereof she left William her | son the only survivour. She was a person of | exemplary vertue, and exchanged this | life for a better on the eight day of April | Anno Dom. 1726, and in the 39 year of her age. | With these his ancestors is also interred | the said William Graves gent. the 29 of | August 1740, aged 56 years.

On a black slab in the north chancel floor with these arms cut in a lozenge above—A cross flory, an escallop in the first quarter [Delamore] (D) :

> Sacred | to the memory of | Sarah Delamore | daughter of | Maurice and Amy Delamore | who departed this life | 24 Feb. 1823, | in the 90th year | of her | age.

On a black stone in the floor before the altar with these arms— [Gules], a saltier between four bezants, a chief ermine [Hyde] ; impaling—Two bends and three roundles in chief [for Wake] :

> Here lieth interred the body of | William Hyde, clerk, vicar of this parish ; | he married | Philippa daughter of John Wake, clerk, | by whom he had issue only two daughters, | Philippa and Anne. | He departed this life on July 12, 1735, aged 37.

On another flat stone near the last (D) :

> Here lieth interred the | body of Anne Morden late | wife of John Morden, vicker | of Long Sutton, and daughter | of Anthony Tompson, doctor | of Divinitie, parson & vicker | of the same parish, who | deceased the twenty sixt | day of November | 1675, in the 46 year of her | age, waiting for a glorious | resurrection.

The following is round the edge of a stone much defaced (D) :

> Io[hn Mord]en vicar 22 yeares of Long Sutton whoe departed this life ian. the 26 day, 1666, here vicar of life ian age.

On another flat stone :

> To | the memory of | the reverend | Mr John Whinfield | who died Nov. 2, | 1757, | aged 42 years.

On an old stone in the floor of the chancel (D) :

> Maria Eliz. et Maria | Scci Germani hu*jus* eccl . . | Maria et Eliz. hic dormiunt | quæ vita hac vix unita Jesu | meritis

cælesti decorantur | nata et Mar. Ann. 1710 |
Eliz. ann. 1712 vitam dedit seq. ubi | ali ann. 1719 vices
hasce subivit | infantes tamen jam mortui | provinciam patris
suscepimus | vitam vestram prorsus | intrabilem et modo |
exituram perpendite resipiscite cogitate Hic quoque Johannes |
Clement filius Ben. et Eliz. | obiit 28 die 9bris 1720. [The
inscription is corrupt. Mary and Elizabeth were the daughters
of Ben. and Eliz. Clement.]

In the chancel this quaint inscription on a stone :
[Here lyeth the body of John Bailey, surgeon, who was
murdered in the Spring of 1794.] Alas poor Bailey | and
Rebekah his wife.

At the west end of the north aisle on a black stone :
In memory of | Elizabeth wife of | Edward Waterfall who |
departed this life | April ye 5, 1750, | in the 52 year of her age.

And near the last :
In memory | of Edwd Waterfall | who died September ye 4,
1774, | aged 74 years, | and of Elizabeth his wife | who died
April ye 5, 1750, | in the 52 year | of her age.

By a tablet at the end of the church it appears lands were bequeathed
by will of Thomas Allen, dated Dec. 29, 1603, for an organist and
for beautifying the church.

A black marble monument against the east wall of the south chancel,
arms over—Azure, a bend or, a crescent for difference [Scrope] ;
an inescucheon bearing the same arms. Crest a plume of feathers
issuing out of a ducal coronet. Motto—' Non hæc sed me ' [Scrope].

This inscription on a white slab in two columns :
(1) Near this place are interred | the last remains of Mary |
the beloved wife of Joshua Scrope esq. | Lord of this manor,
who after a long | illness which she bore with religious | sub-
mission, patience, and fortitude, | yielded her latest breath
on the | third day of February in the year of | our Lord 1795, |
in the 47th year | of her age. | She was the only child and
heiress | of Thomas Vivian esq. of Cornish | extraction, who
was heir at law | in right of his mother to the Hydes | of
Langtoft, lords of this manor. | Her mother was Mary
countess | dowager of Deloraine daughter of | Gervase Scrope
of Cockerington esq. | a lineal descendant from the | Lords
Scrope of Bolton. She succeeded | to the inheritance of the
estates | of that ancient family in this county | under the will
of her uncle Frederick | James Scrope esq. in the year 1792.
(2) To her parents she was a pattern | of filial piety, to her
husband a | bright example of conjugal affection, | to a strong
understanding and cul | tivated mind she added an elegance |
of manners, mildness of temper, | and liberality of sentiment,
which | formed a character that at once | attracted the

admiration and | affection of her relatives, friends | and acquaintance. | Accept dear wife too early doomed to die | This grateful tribute to thy memory | Columns and laboured urns but vainly shew | An idle scene of decorated woe | The sweet companion and the friend sincere | Need no mechanick help to force the tear | In heartfelt numbers ever meant to shine | 'Twill flow for ever o'er a tomb like thine | 'Twill flow while gentle goodness has one friend | Or kindred tempers have a tear to lend. J.S.

A white marble tablet against the wall of the south aisle, arms over—A cross fleury . . . Crest—An escallop [Delamore] (D) :
Sacred to the memory of | Richard Delamore esq. | twenty years commander of a | merchant ship trading to the | island of Jamaica in the | West Indies ; | he died Nov. 16, 1812, | aged 63 years. | Who o'er the waves from shore to shore | The gifts of commerce bear | The wonders of the deep explore | And own that God is there.

On a black stone in the floor below (R) :
Beneath this stone lie interred | the mortal remains of | Mary the wife of Joshua Scrope esq. | lord of this manor, | who departed this life the 3ᵈ day of February 1795, | aged 47 years.

On a flat stone on the floor :
In memory of | Catherine the wife of Richard Beauty who departed | this life the 12 of June 1742, | aged 32. | Laid in the dust this speaking stone's designed | To keep my name awhile fresh in yʳ mind | But soon alas will come the fatal day | When it like me shall mouldering fall away. | Here likewise lies the body | of the said Richard Beauty | who departed this life Feb. yᵉ 5th, 1748, | in the 46th year of his age.

On a large blue stone more to the south with the arms of Delamore and crest over, differenced by an escallop :
Here lieth interred | Henry Delamore who departed | this life the 24th of September 1762, | aged 33 years. | Also near this place lie 7 of his | children by Catharine his wife, | and 5 survived him. | Janʸ 8, 1804, died | Catharine the wife of | Henry Delamore, | aged 74 years. | Also an infant son of | Richard and Mary Delamore. | Richard Delamore | died Nov. 22nd, 1812, aged 63 years.

A flat stone to the south (D) :
Thomas Jenkins | died Dec. 18, 1803, | aged 73.

A small stone to the west of the last (D) :
In memory of | Walter Johnstone gent. | and drover from Dum | fries in Scotland ; he | was a good companion, a | faithful friend, and a fair | dealer. | He died November yᵉ 21, | 1747, aged 51.

In a large blue slab in the floor to the west of the last mentioned has been a very large figure in brass, apparently of a priest, about three yards long with a canopy cut upon the stone, and a brass inscription round the edge, but the brass now all gone.

On a flat stone in the south aisle :

The body of | William Greene | late of this parish and William his | son w^ch he had by Ann widow | and relict of Francis Corye who | departed this life y^e 14 of May | in y^e 56 year of his age, | An' Do' MDCXCVIII.

Upon another to the south :

Ann | daughter of John and Susannah | Jay esq. relict of Francis Corye | and William Greene gent. | ob^t 20 May 1703.

Upon another to the west :

The body of | Francis Corye | late of this parish with 7 children | four sons and three daughters he | had by Ann his second wife | daughter of John Jay late of Fleet | in this county, Esq., who died y^e | 13 of January MDCXCI, | in the 54 year of his age. | Here also lyeth the | body of Francis Corye gent. | the son of Francis Corye, ob^t 10^mo | Feb. 1711 | aetatis suæ 30.

Upon another to the south of the last :

The body of | Judith Corye daughter of | Francis and Ann Corye who | departed this life May the 8th | 1706, aged 20 years.

Upon another more to the west :

Here lyeth the body | of Elizabeth the wife of | John Sowter who depart | ed this life May 26, 1701, | in the 28 year of her age, | who had 9 children, sons | and daughters, and 6 of | them lye very near her | in this alley.

Another to the south of the last (D) :

Here lieth the body | of John Souter gent. who | departed this life the 4th | day of June Anno Dom. | 1717 and in the 5 . . year of his | age.

On a flat stone near the south door (D) :

Here lieth the | body of John Bro | mpton schoolma | ster of this parish | who departed | this life January | the 9th day 170⅔ | in the 34 year | of his age.

On a flat stone near the west door (D) :

Here lyeth the body of | Henry Titley who departed | this life March 16, 1754, | aged 35 years.

Another to the west of the last (D) :

Here lieth the body of | Jeremiah Pix who | departed this life the | 4th day of May 1720 | in the 46 year of his age.

Upon a stone in the nave with a cross upon it, above which is ' Jh'u mercy ', and at the bottom ' Ladye helpe ', is a brass plate with

the following inscription cut upon it in the old character, in some places so much rubbed as to be illegible :

> Pray for the saule of [Alys Thomas] late wyfe | of John [Thomas, the which deceased the] vij day of January in | the yer of our Lord MCCCCLXXXV.

On a flat stone in the nave :

> Marriane Matilda Peele | died 4th Oct. 1827 | aged 4 years. | Leonora Peele | died 30th June 1828 | aged 3 years and 9 months. | Clarrissa Anne Peele | died 13 August 1828 | aged 15 years. | She believed in Christ as the only | Way the Truth and the Life. | Louisa Peele died Sep. ix 1830 | aged 13 years. | Laura Eliza Peele | died 19 June 1831 aged 11 years.

This church is very spacious and handsome. It consists of a nave and two aisles supported by six Norman arches ; and a chancel and two aisles. There is a triforium of Norman work, and in the window a good deal of painted glass with figures of saints etc. In one is the figure of a knight kneeling, but no arms to denote who it is. In the east window are the arms—Quarterly, 1st and 4th, A torteaux between three demy lions rampant argent [Bennett] ; 2nd and 3rd, Azure, a chevron between three lions passant argent [for Leigh] ; crest—A lion's head. The tower is at the west end on the south west angle of the south aisle ; it has a wooden spire.

[See also *L.R.S.* i, 171 ; *Churches of Holland.*]

(MS ii, 49–70.)

Sutton St Edmund

Notes taken in the chapel, 31 August, 1836—This chapel is modern, consisting of a nave, and bow chancel of brick, with round headed windows, and tower at the west end, having a gallery for singing. Over the chancel window, on the outside, is the following in two circles : (1) Rebuilt | 1795, | Rev^d Mr Wing, | minister, | Ch. Kingston, | warden ; (2) Benj. Taylor, | Franc. Taylor, | Jn Harber, | Edw. Diggles, | feoffees. The font is small, urn-shaped, of brown marble on a pedestal.

A white and grey marble tablet against the north wall of the chancel ; it is surmounted with an urn :

> Sacred | to the memory of | Jane Taylor | daughter of | Francis and Sarah Taylor, | who departed this life | on the 17 day of September 1823, | aged 41 years.

On a similar one below, to the west :

> In memory of | Francis Taylor | who died the 28 July 1818, | aged 77 years. | Also of Sarah Taylor | his widow | who died the 12 of April 1825, | aged 73 years.

A smaller one more to the east :

> Near this place lie the remains of | John Taylor | who died the 19 of Nov^r 1782, | aged 84 years, | and Joice his wife | who died the 31^st of Dec^r 1787, | aged 38 years.

A black and white tablet to the east of the last having on the top a sarcophagus :

> In memory of | Joseph Taylor | who died the 1 of Aug. 1816, | in the 71 year of his age. | Also of Frances Taylor | his widow | who died the 22 of April 1824, | aged 64 years.

A handsome tablet of grey, black, and white marble against the south wall of y^e chancel, having a blank shield at the bottom :

> Near this place | lie interred the remains of | Benjamin Taylor, | one of the feoffees of this Chapel, | who died the 9th of Aug. 1804, | aged 68 years. | Also of Jane Taylor | his widow | who died the 30 of June 1821, | aged 67 years.

On a small tablet to the west of the last (R) :

> To the memory | of Benjamin the son of | Benjamin and Jane Taylor | who died Oct^r the 8th, 1794, | aged 3 years. | Whatever troubles may befall | Any of us we ought to say | It is the Lord let him do what | seemeth him good.

A similar one to the west (R) :

> To the memory | of Mary Jane Taylor | daughter of | Benjamin and Jane Taylor | who died July y^e 17th, 1789. | aged 13 months. | The Lord gave and the Lord hath taken away | Blessed be the name of the Lord.

A neat grey and white pyramidal marble monument against the north wall of the nave (R) :

> To the memory of | Adlard Squire Stukeley Esq^re | who died June the 18, 1768. | This benevolent gentleman left a piece of land lying in | this parish abutting on Lutton Gate east on Gedney Hill | Drain West and bounded on the north & south by the | lands of William Kirton to be let by the chapel wardens | and the rents to be applied towards beautifying this | chapel. | In gratitude for which liberal donation the chapel | warden and parishioners have erected this monu- | ment to his memory.

Another tablet more to the west surmounted by an urn :

> Sacred | to the memory of | Joyce the wife of | Thomas Griffin, | (and daughter of | Francis & Sarah Taylor), | who departed this life | on the 20 of February 1819, | aged 38 years.

(MS ix, 41–45.)

𝔖utton 𝔖t 𝔍ames

Notes taken in the chapel, 1 September, 1836—The chapel is the chancel of the old church the nave of which has been destroyed ; (tradition says by Oliver Cromwell). It has a gallery at the east end for the sake of which the eastern window has been bricked up. The other windows, which appear to be of the Perpendicular style, have been despoiled of their tracery, and their heads blocked up, which blocking up has likewise been applied to the south door of the chancel. The tower still exists at the west end of the destroyed nave, and is a good Perpendicular erection, and has a fine moulding and arched doorway with spandrils of that style on the west side. There are some old stones which might have had inscriptions thereon lying at the eastern extremity of the nave, but the chancel as it now exists does not contain a single monumental memorial of any description.

<div align="right">(MS ix, 49.)</div>

𝔖utton 𝔖t 𝔑icholas *alias* 𝔏utton. See 𝔏utton

𝔖waby

Notes taken of the church, 19 August, 1835—The church of Swaby is a very neat, modern, brick building, built about seven years ago. It has a west porch, nave, and chancel, divided by a pointed arch. There is a bell turret at the west end, and a cross over the gable. There is no monument or flat stone in the interior.

[See also *Lincs. N. & Q.* x, 240.]

<div align="right">(MS vi, 101.)</div>

𝔖warby

Notes taken in the church, 12ᵗʰ August, 1834—This church consists of a nave divided from its south aisle by four elegant pointed arches springing from clustered columns, and from the north by three earlier arches with round pillars ; a chancel divided by a pointed arch, a south porch, and tower at the west end. The tower is open to the nave by a sharp pointed arch. Round the pulpit (D), which is old, is this inscription in capitals : ' O God my Saviour be my Sped to preach thy word Mens souls to fed ' [the *S* of Sped is reversed.] Against the wall on the south west side of the arch to the chancel is a sitting figure (R) of a small size ; one of the hands is gone. In the recess of the easternmost window of the north aisle is a niche ornamented (R).

Against the wall north of the altar is a curious old monument of freestone, surmounted by an urn, and having these arms—On a

bend, a lion passant [Williams]; impaling—A cinquefoyl, a chief
checquy [Hobson]; and this inscription :

In | memory of Anthony Williams of Swarby gent. who
was | interred here the 23 of June Anno D'ni 1681 in the | 54
yeare of his age to the great grief of Elizabeth | his wife who
caused this monument to be erected.

A flat stone much rubbed within the altar rails in capitals (R) :

Here lieth the . . . | Mrs Mary Williams | wife of | Henry
Williams | died Novem. | the 12, | A' D'ni | 166 . .

An old flat stone at the west end of the nave with this inscription
round (R) :

Thomas Betlon qui obiit XXIX die mensis CCCCCXX . .
cuius anime

[See also *L.R.S.* i, 210.]

(MS v, 123–124.)

Swaton

Notes taken in the church, 27 July, 1833—

On a black tablet against the south wall of the south aisle :

In memory of | Mr John Billings | who was interred Jan. 31,
1773 | in the 77 year of his age. | God sent his Son to die
for us | Die to redeem us from the cross | He took our weak-
ness bore our load | And dearly bought us with his blood.

On flat stones in the nave :

Here lieth the body of |
Elizabeth the daugh | ter
of John and Eliz | abeth
Spriggs who | dyed Sep-
tember | the 6, 1702.

Here lieth the | body of
Susanna | the daughter
of | John and Elizabeth |
Spriggs of Swaton | interred
July ye 26 | 1699.

On a stone close by the last (D) :

Here lieth ye | body of Mary ye | daughter of John | and
Elizabeth Spriggs | who dyed July 11th, | 1703.

On another stone :

Here | lyeth the body | of Walter Wright gent. | buryed
October ye 7th | 1702.

This is a fine cross church. The nave and aisles are supported
by three lofty pointed arches springing from clustered columns.
At the intersection of the transepts stands the tower which has a
crocketted pinnacle at each angle. At the west end of the nave
is a fine decorated four light window. The font, which is curious,
is supported on a base surrounded by attached columns. The
top is pannelled in squares. At the west end of the north aisle,
on a tomb raised from the ground, is the recumbent figure of a
woman in a gown and wimple, her hands clasped, with her head

on a cushion, and feet resting on a dog. In this church are many old benches and pews. There are arms in a window of the north aisle—Quarterly, gules and or, in the first quarter a mullet argent [Vere]; another—Checquy or and azure [Warren]; a 3rd, Azure, a bend argent, cotised or, between [six lions] of the last [Bohun].

[See also *L.R.S.* i, 190–191.]

(MS ii, 209–210.)

Swineshead

Notes taken in the church, [*blank*]—

An arched monument (D) on the north side of the chancel supported by two black pillars on each side ; under the arch has probably formerly been a recumbent figure, but now gone ; on a bracket in the middle is a helmet. Above on a black tablet is an inscription of eight lines, but nearly illegible both from the effect of time as also from the height they are placed. What is decypherable is as follows :

Speculum Mortis

What Epitaph shall we afford this shrine | Words cannot grace [this monument of] thine | His sweet perfections [summed up] were such | As Heaven I think for Earth did think too much | [Honest] religious wise [so good a liver] | He lived to die and died to live for ever | Then let each Christian's [heart] join wth my pen | [To embalm his virtues in the minds] of Men.

On the pediment above is a recess in which is a half figure of Death with an hour glass, and the top is ornamented with cornucopias. At the base are six kneeling figures of sons, (three with skulls in their hands), in black gowns and ruffs, and one in a cradle, two daughters kneeling with skulls, and two in cradles, an inscription below on a black tablet (R) :

Nere this place doth lye the boddy of S^r John Locton, | knight, whoe departed this life in the 56th yeare of his age | upon the 9 day of January in the year of our Redemption | 1610, whoe had by Dame Frances his wife 11 children, | three only living, William, John, and Francis, which | Dame Frances yet surviving at her own cost and | charges in token of her love and to the living memory | of her deceased husband hath erected this monument | Anno Domini | 1628.

On a flat black stone in the chancel :

Hic jacet quicquid mortale fuit | Gulielmi Whiting gent. qui obiit Maii | trigesimo Anno Domini MDCCXXVI | ætatisque LIV | Gulielmus Whiting filius patri charissimo | Officiosæ pietatis et memoriæ ergo | Hoc marmor posuit | Cælis Cælestis pars terris reddita terræ | Ut grave descendit sic leve summa petit | Lex universa nasci et mori. | E dextris | Reliquiæ

Gulielmi filii | Gulielmi et Elizabethæ Whiting | Depositæ sunt obiit 7ᵐᵒ die Junii | Annoque Domini millesimo | septingentesimo vicesimo septimo | Ætatis suæ 24 | Jacet ad sinistrum quicquid | mortale fuit Mariæ uxoris Thome Maultby | quæ obiit decimo Septimo die Novembris | Anno Domini MDCCXXIX, | ætatis suæ 32.

On a white and grey marble monument against the south wall of the chancel (R) :

Sacred | to the memory of | Elizabeth | wife of the Revᵈ Wᵐ Bolland M.A. | vicar of Swineshead and Frampton | and late Fellow of Trinity College, Cambridge, | who departed this life on the 21 day of March 1817 | in the 26 year of her age | with a well grounded hope of a glorious immortality.

Another monument of white and grey marble next to it, to the west (R) :

In memory of | Sarah second wife of the | Revᵈ Will. Bolland M.A. vicar of this parish, | who entered upon her eternal rest | March 9, 1827, in the 42 year of her age. | Her only hope was the finished work of | our Lord Jesus Christ which supported her | under protracted bodily afflictions, | gave her the victory over the last enemy, | and at length brought her to the full | " fruition of the glorious Godhead : " | Three of her children who died in their | infancy are also interred with her | in a vault near | this place.

On a stone in the chancel within the altar rails (D) :

To the memory of | Thomas Maidens | who departed this life | on the 22 day of May 1802 | in the 58 year of his age. | Since fallen man from Adam drew his breath | Sin is the cause that all must yield to death | But how are we his poison to expel | Most men reply that's done by living well | By living well presumptuous thought how vain | Live well thou never will till born again | And that is but a proof death is withstood | His dart is quenched alone by Jesu's Blood.

To the east of this on a flat stone (D) :

Sacred | to the memory of | Thomas Stephenson | who died Feb. 19, 1813, | aged 36 years.

On a flat stone at the east end of the south aisle in capitals :

Here lyeth yᵉ body of | Marke Dickenson gent. | who departed this life | the first day of April | Anno D'ni 1720, | in the 66 yeare of his age.

Near this last is a blue stone which had a brass and two shields, but all gone. A very large blue stone at the east end of the nave seems to have had an inscription round, but now gone.

Two or three modern stones in the south aisle are so much rubbed as to be illegible.

One close by :

> To | the memory of | Claton Stell | who departed this | life the 23 of | December 1757 | aged 31 years | by Sarah Salmon | only sister to the aforesaid | Claton Stell.

On an old stone in the south aisle is a cross with an inscription round the verge in Church text ; all that is legible is :

> the yere of our Lord Godd MCCCCXIII of whose soules

There are two wooden tablets of benefactions, by which it appears (D) :

> John Dickonson of Swineshead, gent., gave by his last will and testament land for preaching a commemoration sermon on the 27 May, and also land the profit of which to be distributed among the poor on the 27 May yearly.
>
> Thomas Cowley, gent., of Bennington, gave a messuage the profits of which to give 20s. to the vicar for a sermon on Easter Tuesday, £2 to a schoolmaster, and two dozen of white bread, as also coals, to be distributed among the poor people.
>
> Will. Whiting of Swineshead, jun., gave by will dated 20 March, 1726, land to the poor.

This is a very handsome church. It consists of a nave and aisles decorated on each side by six pointed arches, sharp in their points. The westernmost arch of the south aisle is blocked up, that end being used as a school. The roof of the nave is open to the timber and very lofty. The floor is boarded which conceals some flat stones. The chancel is divided from the nave by a sharply pointed arch. At the west end is a handsome tower and spire, separated by a pointed arch from the nave now blocked up. The font is a plain octagon on a basement of three steps. The windows are generally perpendicular, except the south aisle, as appears from the windows that remain in the school, and one at the east end, the tracery of the rest having been destroyed. There is a south porch, but the chief entrance is on the north side. The greatest part of the church is occupied with antient benching, some very good, but the pulpit, etc., is painted a flaring brick colour. At the east end of the north aisle is a low arch in the wall, and on the south side of the altar are three stone stalls and a piscina. North of the chancel is a small chapel divided from it by two low arches which, with the windows, seem Perpendicular, though the latter are fast falling in, being unglazed. It is now blocked up and used as a lumber room. The east window is Perpendicular of five lights ; the other windows are also of that age and good, though the lower part of them is blocked up.

[See also *Lincs. N. & Q.* xi, 143 ; *L.R.S.* i, 169-70 ; *Churches of Holland.*]

(MS viii, 61-68.)

𝔖𝔴𝔦𝔫𝔥𝔬𝔭𝔢

Notes taken in the church, 23 August, 1835—

A white marble sarcophagus against the north wall of the chancel with a weeping cherub leaning over :

> Sacred to Frances second daughter of | the Rev^d Marmaduke and Ann Alington of this place, | and to the Rev^d Henry Alington B.A. | of Twywell in Northamptonshire, | her beloved and betrothed cousin, | whom she survived 19 months. | Her health sunk under the efforts | made by her pious and affectionate mind | to bear and conceal the anguish of a broken heart | and to submit with cheerfulness to the will of her Creator | She died April 28, 1828, aged 28. | This memorial of their virtues and sorrows | is erected by her deeply afflicted brothers and sisters.

Against the west wall is a white marble tablet with this inscription on a black slab :

> M.S. | Jonathan Field Armigeri | hic in lucem primum suscepti | A.D. MDCCXXVII | cum apud externos vita functus esset | A.D. MDCCCXI | Huc inter majorum ossa | Ossa ejus retulerunt amici.

On a flat stone in the floor below, these arms over—[Sable], a chevron engrailed between three garbs argent [Field]. Crest—An arm couped at the elbow, holding an orb (R) :

> Here lies the body of | M^r Jonathan Field son of | Da[vid] Field esq. and | Elizabeth his wife, who died | November 4^th, 1732, aged 33 years. | And David son of Jonathan and | Ann his wife, aged 7 months. | Also M^rs Mary Chapman mother | of the said Ann Field, who | died June 1, 1729, aged 61 years. | Also Ann Field his wife who died | July 5^th, 1760.

This church, which was the chancel, and rebuilt by M^r Alington, consists of a nave, and tower at the west end, with a small chancel. The font is an ancient circular one.

[See also *Lincs. N. & Q.* x, 240.]

<div align="right">(MS vi, 121–123.)</div>

𝔖𝔴𝔦𝔫𝔰𝔱𝔢𝔞𝔡

Notes taken in the church of Swinestead, 26 July, 1833—

A very beautiful monument against the north wall of the chancel, above a sculpture in basso relievo, by Westmacott, of an aged man lying on a couch, a figure kneeling by him with his eyes and hands directed in entreaty to heaven, the figure of Charity on the left nursing a babe, with a young child hiding itself in the folds

of her garments ; on the other side is an angel pointing to heaven :

> In the opposite vault lie the remains of | the most noble Brownlow Bertie | fifth and last Duke of Ancaster and Kesteven, Marquis of Lindsey, | Lord Lieutenant and Custos Rotulorum of the county of Lincoln and | city of Lincoln and county of the same, and | Recorder of the Borough of Boston. | He had represented the county of Lincoln in several Parliaments. | He departed this life at Grimsthorpe Castle on the 8 of February 1809, | in the 79 year of his age. | His first wife was Harriet daughter of George Morton Pitt esq. | She died in April 1763. | His second was Mary Anne daughter of Major Layard | who died on the 13 of January 1804, leaving an only daughter | Mary Elizabeth, | married Thomas Charles Colyear, Viscount Milsington. | She died on the 10 of February 1797, leaving an only child | Brownlow Charles Colyear | who died at Rome on the 18 of February 1819, | in the 23 year of his age | and was interred at Weybridge in Surrey.

Against the north wall of the chancel is an atchievement : Bertie, impaling—Gules, a chevron between two estoiles or in chief, and a crescent argent in base, on a chief azure three estoiles of the 2nd [Layard] ; the motto and supporters of Bertie.

Another atchievement contains two lozenges : the dexter—Azure, three escucheons argent, bordered or, a canton of Ulster [for Burrell, Lord Gwydir] ; on an inescucheon—Quarterly, the arms of Bertie and Willoughby ; the sinister lozenge has the arms of Bertie and Willoughby quarterly. Over each is a baron's coronet, and they have the Bertie supporters.

Against the wall of the chancel are two hatchments (D) : (1) Gules, on a chevron between three wolves' heads argent, three apple trees fruited proper [Colyear, earl of Portmore] ; on an escocheon the arms of Bertie ; a viscount's coronet ; supporters— Dexter, a wolf proper, and sinister a wild man proper wreathed about the middle vert ; motto ' Avance '. (2) Bertie impaling Layard ; supporters, a crest, and motto of Bertie, with a duke's coronet.

On a black stone tablet against the wall of the south aisle (D) :

> In memory of | Mr Thomas Richardson | late steward to the Right Honourable | Lord Brownlow Bertie | who died the 8th day of May 1773 | in the 63 year of his age. | He was greatly beloved by his said master | for his long and faithful services | and highly esteemed by all his acquaintance | for his many good and useful qualities | his most sorrowful and affectionate widow | (who wanted no monument to remember him by) | erected this that others might not forget him. | For they rest from their labours and their works | do follow him.

This church consists of a nave and two aisles, supported on three pointed arches rising from plain piers, a chancel, and tower at the west end. South of the altar in the wall is a range of three ogee arches ; and in the vestry, set upright against the wall, much obscured by white wash, is the figure of a knight in mail and a long surcoat, having his legs crossed and on his left arm a shield.

[See also *L.R.S.* i, 205–6.]

(MS ii, 171–174.)

Tallington

Notes taken in the church, [*blank*] July 1831—

On a flat stone in the chancel (D) :
> In memory of | Mr Edward Woodall | late of Scarborough | who died the 18th of March | 1790, | in the 20 year of his | age.

On a gravestone close to the entrance of the chancel (D) :
> To the memory | of | Mary Anne the | daughter | of William and | Mary Ullett | who died in her | infancy | Novr ye 30, 1813.

On another to the west of the last (D) :
> Sacred | to the memory of | Edward Arden | son of Edward | and Ann Arden | who died in his | infancy | the 25 of August | 1806.

To the south of the last (D) :
> In | memory of | Mary Catharine Ullett | daughter of | William and Mary Ullett | of Spalding Marsh | who died May ye 28th 1819, | in the 5th year | of her | age.

To the west of the last (D) :
> Sacred | to the memory of | Mary relict of | Edward Garwell | late of Ketton, Rutland, | who died June ye 27, 1800, | aged 75 years ; also of | Laurence and Catherine | son & daughter of Laurence | & Catherine Thompson | who died in their infancy.

On another more to the north (D) :
> Edward | the son of Will. | and Mary Ullett of Spalding Marsh | died Oct. 29, 1822, | aged 5 years.

To the north of the last (D) :
> Here lieth interred the | body of Francis Cropley | who departed this life | January the 1st, 1729, | in the 47 year of his age.

To the north of the last on another stone (D) :
> Here lieth the body | of Elizabeth the | daughter of Francis | and Ann Cropley who | departed this life | September the 20, 1728, | in the 10 year of her | age.

On another to the south of the last (D) :

> Near | this place lie the | remains of | Robert Halking | who died | January yᵉ 28, 1782, | in the 31st year of his | age.

On a flat stone in the south aisle (D) :

> Here lieth yᵉ body of | Charman who | died Jan. yᵉ 14, 1734, | aged . . years. | Dear wife and children do not weep | For now I've gone to my long sleep | Where thousands indeed have gone before | And never here to be seen more.

On a wooden tablet in the north aisle (R) :

> Charles Bertie, Esqʳ., who | died April 12, 1730, son of the Honᵇˡᵉ | Charles Bertie, Esq., of Uffington, | did by his last will & testament | bequeath twelve penny loaves to | be distributed every Lord's Day | to twelve poor persons of the parish of Tallington | such as he & his | heirs shall nominate & appoint | for ever.

The church is small. On the singing gallery are painted the Royal arms and the arms and crest of Bertie ; on a hatchment also are the arms of the same family (D).

<div align="right">(MS i, 45–49.)</div>

Tathwell

Notes taken in the church, 16 August, 1833—

On the north side of the chancel a handsome monument about fifteen feet high. Above are these arms in the centre—Quarterly of four, 1st, Azure, three helmets or [Hamby] ; 2nd, Per Pale or and gules, three mullets counterchanged [Auford] ; 3rd, Argent, a cross engrailed gules, and an annulet of the second [Green] ; 4th, Or, semee of crosslets, and a chevron sable [Sleight] ; crest—A falcon, rising or. On a smaller shield to the west— Hamby, impaling—Gules, on a bend argent three shovellers sable [Reade]. On a small shield to the east, the four quarterings of Hamby repeated. Beneath is the following inscription on a black slab in two columns :

> (1) Would plenteous store would hospitality | Would pious pittie liberallity | Have lengthned life and freed from common fate | Then mightst have liv'd a long and endlese date | It is the comon voyce of young and old | A worthy worthy man is layd in mold.
>
> (2) One good to poore and to his kindred kind | One that to racke his rents bare no such mind | Such men from God for good of men are sent | Such men deserve a lasting monument | Such men although they ly and rot in grave | There soules with God in Heaven a mansion have.

Underneath these lines between a scull and an hour glass is the following short inscription in semi-circular black slab :

> Gulielmus Hambye armiger | septuagesimum secundis [sic] ætatis | suæ annum ingresus placide | obdormiuit in Domino | vigesimo et quinto die | Ianuarii 1626.

And beneath a gentleman in a black robe kneeling at a desk with a book ; still lower on the monument are the figures also of a gentleman and lady kneeling at a desk, and on each side are three shields of arms. On the left side : (1) A shield charged with the crest, a falcon rising or ; (2) Hamby, with a crescent difference ; (3) the four quarters of Hamby with a crescent difference. On the right side—(1) The crest of a shoveller [Reade] ; (2) Reade ; (3) Quarterly, 1st and 4th, Reade ; 2nd and 3rd, A bend or. At the back of the figures is a white marble slab evidently of much later erection with this inscription :

> Here lyes inter'd Jno. Chaplin, Esq., | son & heir of Sr Fran. Chaplin, | Lord Mayor of London, and | Eliz. his wife, only daughter & | heiress of Sr John Hamby. He | dy'd ye 11 Nov. 1714, aged 56 years, | and had by ye said Eliz. four | sons & one daughter | Porter, Fran., Jno., & Thomas | and Ann.

At the base of the monument is the following epitaph to Ed. Hamby, whose obviously are the figures above :

> Eduardus Hamby generosus uxorem duxit | Elizabetham Read filiam et hæredem | Francisci Read de Wrangle generosi ex qua | numerosam suscepit prolem septem filios et sex | filias non multo post utriq : parentes concesse- | runt fatis alter sexagenarius decimo octauo | die Decembris 1626 (rectius 1616) altera quadragesnna[sic] | et quintum agens annum decmio[sic] sexto die | Novembris 1601. | The knot of love which twixt these two was knit | It held full fast tell death untyed it | Who so in true and honest love do live | To such the Lord especiall grace doth give | Well may we hope they come to blessed end | Whom for theyr truth and love we may commend.

On one side of this inscription are six sons kneeling, the three first youths, the fourth a boy with a skull in his hand, the fifth a youth with a skull, the sixth a youth. On the opposite side the seven daughters. The three first bear skulls ; the fourth is a baby in swaddling clothes and lying in a cradle ; the three last without skulls. The monument is about seven feet wide.

Over the Communion table is a white marble monument. The figure of a female weeping over an urn ; in the back ground an obelisk inscribed O.M., and surmounted by a winged hour glass ; and over all these arms—Ermine, on a chief vert three eagles' heads

erazed or [Chaplin]; crest (D)—An eagle's head erazed or. The inscription is on the base (R):

> Memoriæ sacrum | Thomæ Chaplin armigeri | Viri humani et innocentis | Qui felici usus fortuna | et omnibus vitæ officiis probe perfunctus | Condi se voluit hic loci | Inter proavorum reliquias | Quorum simplicitatem moribus expressit | Nec famæ suæ posteros pæniteat | Si ejus habeantur similes. | Natus est A.D. 1684 | Excessit A.D. 1747. Prince Hoare Fec[t], Bath. [He was uncle of the artist of the same name.]

The church of Tathwell consists of a nave, chancel, and west tower, beneath which is the entrance. It is very neat within, but contains no other memorials but the previous two. Its situation is very beautiful on the brow of a steep hill.

[See also *Lincs. N. & Q.* xi, 200–202.]

<div align="right">(MS iv, 21–26.)</div>

Tetney

Notes taken in the church, [*blank*]—

On an old stone at the east end of the north aisle (R):

> Orate pro animabus domini | Thome Jekyl vicarii | parentum et parocheanorum suorum quorum animabus | propicietur Deus. Amen.

On the side of the second pillar reckoning from the west and facing the north aisle:

> Hoc opus factum est a[o] d[o] M[o]CCC[o] LX[o]III[o] Dominus Robertus Daẏ tunc vicarius.

At the west end of the north aisle are written or printed these words (D):

> This church was new pew'd and floor'd and otherwise repaired in the year 1778 and 1779. The Rev. I. Searle, clerk, being vicar, Maurice Searle, Thomas Hinch, churchwardens.

At the east end of the south aisle there are cut out of the back of the pew, close to the wall, the following words in capital letters:

> Though Lacons fade away ther gifts remain | To feed the poor and good works to maintain. [Edward Lacon, by his will, dated 25 October, 1612, bequeathed £5 for the poor of Tetney, 20*s.* for the repair of the church, and 40*s.*] for mending the highways.

In the north aisle is a flat stone (R) to the memory of:

> Thomas Borman who died Jan. 1, 1760, æt. 38, of John his brother who died December 14, 1769, æt. 62, of Allan another brother who died July 31, 1783, æt. 67, and of Mary the wife of Allan who died Aug. 12, 1789, æt. 69.

Another flat stone (R) is to the memory of :
> Ann wife of Richard Borman who died Feb. 22, 1819, æt. 63, of Richard Borman who died Dec. 6, 1828, æt. 79, and of Hutching Borman grandson of Richard who died æt. 11 months.

A third stone (R) is to the memory of :
> Elizabeth daughter of Richard and Ann Borman who died May 10, 1812, æt. 16, and of Frances her sister who died Oct. 28, 1818, æt. 21.

In the south aisle is a stone to the memory of :
> Susanna Borman wife of Thomas Borman of North Cotes, who died 17 May 1816, æt. 52, and of Thomas Borman who died March 6, 1829, æt. 75.

Another stone in the south aisle to the memory of :
> Maurice Searle who died 2 Oct. 1813, æt. 39, and of John his brother who died Oct. 19, 1828, æt. 47.

Another stone to the memory of :
> Maurice Searle who died 19 March 1809, æt. 79, and of Jane wife of Maurice Searle who died June 25, 1826, æt. 89.

At the bottom of the first window of the south aisle, reckoning from the east, is an old stone (R) in which is this inscription in church text :
> ✠ Hic jacet Robert*us* de | Elkyngton et X'piana ux*or* ei*us* | et obiit X'piana die Sancti Cle | mentis a*nno* d*omi*ni MCCCXXII | et Rob. die Concepcionis | Beate Marie a*nno* et mense eodem.

Collateral to this is another to the east with an inscription also in church text (R) :
> Hic jacent Willelmus de | Elkyngton et Alicia uxor eius | & obiit Will*elmus* die Sanc*ti* Luce | anno d*omi*ni Mill*es*imo CCC | XXVIII° & Alicia in | crastino Pasce anno eodem.

A flat stone (D) in the nave with these arms cut over—A chevron between three doves ; crest—A greyhound sejant [Searle]. Round the shield, ' Vive hodie ut nunquam te imparatum Mors inveniet ' ; below ' Bona fide ' :
> In memory | of | the Rev^d John Searle | vicar of Tetney and Holton le Clay | died Sept. 26, An° Dom. | 1798, | ætatis suæ | 78.

On a brass plate let into the same stone is this inscription (D) :
> Reader if thou art desirous to know what | manner of man he was whose remains rest | under this stone, the best sculptor can give | no information in that matter, but the day | will come when the secrets of all hearts shall | be revealed and the righteous judgements of God | will determine who will render to every man | according to his deeds. Rom. 2, v. 6.

On a flat brown stone more to the west :
> Beneath rest the remains | of Rebecca the wife of | the Rev^d John Searle | vicar of Tetney, she died | 23 of January 1777, | aged 70 years. | Also | Penelope the second wife | of the Rev^d John Searle | and daughter of the Rev^d | Sir Richard Temple, | who departed this life | May 30, 1793, in the 61 | year of her age.

In the south aisle is a flat stone to the memory of :
> Radcliffe Searle vicar of Tetney died [January 1757. Margaret his widow died] July 26, 1764, aged 63. Charlotte Searle, spinster, died Nov. 7, 1798, aged 26. Frances Searle, spinster, died Nov. 29, 1799, aged 29.

This church consists of a nave and two aisles resting on five pointed arches, a chancel and north aisle, with a handsome screen, a fine tower at the west end.

[See also *Lincs. N. & Q.* xi, 236–238.]

(MS iv, 81–86.)

Theddlethorpe All Saints

Notes taken in the church of West Theddlethorpe, 15 August, 1833—

On a flat black stone within the altar rails :
> P.M. | Nicolai Newcomen generosi | ob | sinceram pietatem | spectatam integritatem | ingenuum morum candorem | et | singularem humanitatem | memorabilis | Qui | post annos xxxiii in matrimonio | feliciter actos | vitam quam longiorem | meruit claudebat | Aug. xii^o, A.D . mdccxii^o, æt. lxiii^o. | Hoc monumentum | conjux mæstissima | Maria Newcomen p. | Quæ | et altare istud marmoreum | sumptibus suis erigi | curavit.

On a black stone to the south of the last within the altar rails (R) :
> Here lieth the body of Mary | the wife of the Hon^{ble} Charles | Bertie, who departed this life | the 4th of November 1725, aged | 62 years & 8 months.

On another flat black stone next to the last :
> Here lyeth the body of the Hon^{ble} | Charles Bertie, Esq., young= | est son of Robert Earle of | Lindsey who departed this life | August the 13, Anno Domini 1727, | In the 45th year of his age.

On a white marble monument against the north wall of the chancel with these arms above—Argent, a lion's head erazed sable, between three crescents gules [Newcomen] ; impaling—Argent, three martlets

in pale sable between flanches of the second, charged each with a
lion passant of the first [Browne] :

> Heare lyeth the body of | Mary the onely daughter of | Nicholas
> Newcomen, | gent., by Mary his wife (who | was the onely
> daughter of | Thomas Brown, gent.), | born the 30 of July
> 1684, | and departed this life the | 20 of May 1694, | aged
> 9 years 9 monˢ. & 3 weeks.

On a white marble monument to the east of the last, above are
the arms—Quarterly, 1st and 4th, Newcomen ; 2nd and 3rd, Browne.
Crest—A lion's paw erazed sable :

> Memoriæ sacrum | egregii juvenis Nicolai Newcomen | Nicolai
> et Mariæ filii unici | Plurimisque nominibus dilectissimi |
> Qui studiis Academicis Oxoniæ peractis | Postquam ubique |
> Ac præsertim in agro hoc Lincolniensi | Corporis morumque
> elegantia | Ingenii suavitate et mira felicitate | Aliisque indolis
> præclaræ indiciis | Summam familiaribus admirationem
> Spemque sui omnibus | quibus vel fama innotuerit | Quam
> amplissimam concitaverat | Variolis correptus Londinis | Quo
> se forte contulerat | Animam cælo maturam deo reddebat |
> Novembris 15 Anno Domini MDCCIII° | ætatisque suæ XXIII° |
> Parentibus amicis Patriæque | Triste sui desiderium |
> Relinquens.

On a very handsome marble monument adjoining, ornamented
with two well executed busts of a gentleman and lady, with these
shields of arms above—(1) Quarterly, 1st, Argent, three battering
rams in pale gules, headed and suspended azure [Bertie] ; 2nd,
Or, a fret azure [Willoughby] ; 3rd, Gules, a cross moline argent
[Ufford] ; 4th, Sable, a cross engrailed or [Bek] ; on an
escucheon—Browne. (2) Browne, impaling Newcomen. (3) The
four quarterings of Bertie, impaling—Barry of eight argent and
sable, a canton ermine [Marshall] :

> This monument was erected in memory of | the Honᵇˡᵉ
> Charles Bertie, Esq., & Dame Mary | his first wife who both
> lye in a vault which he | built under the Communion table. |
> He was the only son of the Right Honourable Robert | Earl
> of Lindsey, Lord Great Chamberlain of England, by | his
> third wife the Rᵗ Honᵇˡᵉ the Lady Elizabeth | Lee, who was
> sole daughter & heir of the Rᵗ Hon. | Thomas Pope earl of
> Downe in the Kingdom of Ireland, | & widow & relict of
> Sir Francis Henry Lee of | Ditchley in the county of Oxford,
> Bart, by whom she | had issue Edward Henry who was created,
> Earl of | Litchfield Anno Dom. 1674, & Francis Edward,
> Esqʳ. | She was the daughter of Thomas Browne late of |
> Addlethorp in this county, gent., & widow & relict | of
> Nicholas Newcomen, Esqʳ, & dyed without issue | the fourth
> day of November A.D. 1725, in the 63 year | of her age. |

He afterwards marryed Mary the daughter of the | Rev[d]
Henry Marshall, clerk, & dyed without issue | the 13 day
of August A.D. 1727, in the 45th year of his age　　And[w]
Carpenter[1].　Facit Londini.

On a white marble monument against the north wall of the chancel,
but still more to the east of the last and with these arms—Gules,
a fess between three cocks' heads, erazed argent [Alcock]:

Sacred to the memory of | Joseph Alcock, Esq[r], | who died
at Roehampton in Surrey | on the 2[d] day of August 1821, |
ætat. 61 | and was buried at Putney | in the same county. |
Also | to the memory of | his son Joseph | who died on
the 21st of December 1822, | ætat. 30, | & was buried at
Putney.

On a flat stone in the chancel floor:

Here | lieth interred | the body of Will[m] Skoopholme, |
gentlem[n], | who departed this frail life | the 19 day of April |
Anno 1710, | in the 73 year of his age, | Who rests in certain
hope and trust | Of riseing reigning with the just.

On a flat stone next the last:

Here lyeth the body of Nicholas | the only son of Nicholas
Newcomen, | gent., by Mary his wife, who depart- | ed this
life the 15 of November | 1703, in the 23 year of | his age.

On a flat stone next to the last:

Heare lyeth the body of | Mary | the onely daughter of |
Nicholas Newcomen, | gent., by Mary his wife | who departed
this life | the 20 of May | 1694, | in y[e] 10th yeare of her
age.

IN THE SOUTH CHAPEL

At the east end of the south aisle is a chapel enclosed by a handsome
carved screen enriched by armorial bearings.　The first shield—
Quarterly, 1st and 4th, Two bars with five roundles in chief
[Angevin]; 2nd and 3rd, A chevron between three roundles, each
charged with a mullet [for Hildyard].　The other shield—A
chevron between three roundles, charged with mullets; these
arms are often repeated interspersed with other shields charged
with a plain cross.

In this chapel are the following monumental remains:

A brass of a knight in the floor with his hands clasped and this
inscription:

Hic jacet Robertus Hayton Armiger qui obiit | xxv die
mensis Februarii Anno d'ni millesimo | cccc[o] vicesimo quarto
cujus anime propicietur deus amen.

Above are two shields of arms—[Vert, a lion passant or within a
bordure billetty—Hayton].

On an old stone this inscription partly effaced :
> fuit Roger*us* de Hagneby | qui obiit | vij idus Marcii a' d'ni

In an old stone this brass of arms—Angevin, impaling Hildyard. There have been figures of a knight and his lady, as well as an inscription round the edge, now all gone.

On a black stone :
> Here lyeth the body of Richard | Pilkington esq. who departed this | life April 23 Anno D'ni 1729 in the | 54 year of his age.

Next to it is the following :
> Here lyeth the body of Ann the wife | of Richard Pilkington esq. who | departed this life Jan^y 5 Anno Do*m*ini | 1728–9 in the 45th year of her age.

There is a screen enclosing a chapel at the end of the north aisle, but the only shield except those charged with plain crosses is on the south side and bears the arms of Hildyard. There are no inscriptions here.

In the chancel are the following atchievements : (1) Quarterly, Newcomen and Brown ; crest—A lion's paw erazed sable [for Nicholas Newcomen junior]. (2) The four quarterings of Bertie, with a dexter shield of the same, and the arms of Brown on an escucheon ; and a sinister shield the same, impaling Marshall ; the Bertie crest [for Charles Bertie]. (3) The four quarterings of Bertie, impaling Brown, and Brown also on an escucheon [for Mary Browne, first wife of C. Bertie]. (4) Newcomen, impaling Brown.

[See also *Lincs. N. & Q.* xi, 197–200 ; Jeans, 76–77.]

(MS iv, 9–19.)

NOTE

[1] Andrew Carpentière (d. 1737) was a well-known sculptor, who was much employed by the Duke of Chandos at Canons, Middlesex. He executed the statue of Queen Anne at the Moot Hall, Leeds.

Theddlethorpe St Helen

Notes taken in the church of East Theddlethorpe, 15 August, 1833—

A marble monument with an urn over it against the north wall of the chancel :
> Sacred | to the memory of | Henry Cracroft Marshall esq. | who died | on the ninth day of June 1789 | in the thirty first year of his | age.

Next to the last is a white stone in the north wall of the chancel
(R) :

> Near this stone | lieth interred the | remains oi Joseph
> Parish | who departed this life | March the 3rd, 1794, | aged
> 44 years.

On a flat stone (R) :

> Here lieth the body of | Mr John Marshall, who de | parted
> this life the 10 day | of January 1698 in the 26th | yeare of
> his age. Hee was | the second sonn of Ralph | Marshall of the
> parish of St | Paul, Covent Garden, within | the liberties of
> the citty | of Westminster esq. who | was borne in this parrishh |
> the 23 day of January 1636, | whose father and grand | father
> were alsoe named | Ralph and were buried | successively in
> one grave | in the middle isle | of this church.

A grey marble pyramidal monument, south of the arch entering
the chancel, surmounted by a sarcophagus, these arms over—
Barry of six argent and sable ; crest—An armed man proper
[Marshall]. This inscription in capitals :

> Sacred | to the memory of | William Marshall esquire | who
> died on the third day | of October 1770 in the forty | seventh
> year of his age, | and of Grace Marshall | his widow, daughter
> of | Robert Cracroft of Hackthorn | in this county esquire, |
> who died on the third day | of June 1790 in the fifty | sixth
> year of her age.

Below in the floor is a flat stone (D) to the same person.

The church consists of a nave separated from the north aisle
by three pointed arches, and from the south by four of the same,
a chancel, and a tower at the west end. At the east end of the
north aisle is a canopied recess or shrine in which is the figure of
our Saviour on the cross. The roof is very curious and the beams
are supported by carved figures.

[See also *Lincs. N. & Q.* xi, 196–197.]

(MS iv, 5–8.)

North Thoresby

Notes taken in the church, [*blank*]—

Round the outside of an old pew in the north aisle on the upper
moulding in old characters (D) :

> Iste [*sic*] est sedes Annæ Awdbeii dominæ [lady of the manor of
> Autby] uxoris Tristrami Smith Thoresbeien*sis* Ecclesie Patroni.

On the eastern side the inscription is partly gone ; what remains
is ' of Christopheri Smith & A . . . ' ; a little lower down
is the date 1630 ; and on the shield in the middle of the first inscrip-
tion are—Three roaches in pale [for Roche]. On the northern post

are carved these bearings—Quarterly, 1st, Per bend indented, three crosses flory [Smyth]; 2nd, A cross flory, over all a bend [Willoughby]; 3rd, Barry of six, three mullets in chief [Otteby]; 4th, Three water bougets, impaling—Quarterly, 1st, Three roaches in pale, a crescent for difference [Roche]; 2nd, On a bend, three fleur de lis between six mullets [Beseby]; 3rd, A scoop between six leaves [Scupholme]; 4th, On a fess three fleur de lis [Disney]; the last quarter much defaced.

At the west end is an old stone (D) having an inscription round it, now broken, and what remains is ' octagesimo secundo cuius anime propicietur '. Another fragment of the stone is by the north door, having " Millesimo " on it.

On a flat stone in the chancel (D):

> In memory of | the Rev. Miles Myers | who departed this life | July the 9th, 1797, | aged 40 years. | Also of | George Myers | brother of the above | who died Oct. the 10, 1828, | aged 71 years.

This church consists of a nave, north aisle, chancel, south porch, and embattled tower at the west end. The aisle is parted off from the nave by three pointed arches, and is continued to the chancel from which it is separated by another pointed arch. A similar one divides the nave from the chancel. The south porch has a cross mutilated over the gable, and under it a shield bearing a cross, charged with a fleur de lis, and the letters 𝕿 𝕯. South of the altar is a piscina, and in a window of the north aisle are three figures of saints rather defaced (R); one appears to be St Andrew by his saltier. There remains a great quantity of old benching which occupies nearly the whole of the church, bearing the initials of those who formerly occupied them; and mostly the date 1630. Under the altar is an old stone which formerly has had two brass plates, but both now gone.

[See also *Lincs. N. & Q.* xi, 17–19.]

(MS vi, 115–116.)

Thornton Curtis

Notes taken in the church, 31 August, 1835—

A monument (R) against the east wall of the chancel south of the communion table. Above, these arms—Argent, an orle of crescents gules, a lion rampant sable [Skinner]; impaling—Per pale gules and azure, three eaglets displayed [Coke]. The crest on a helmet— Two arms couped above the elbow, holding a crescent gules. Below in a circular niche the bust of a man in ruff and costume of the seventeenth century; the inscription beneath in capitals:

> Here lyeth yᵉ body of William Skinner Esqʳ the only son of Sʳ Vincent Skin- | ner knight A gent: rarely adorned

wth especiall giftes & indowments of minde | & singular
ornaments of body. He married Bridgett y^e . 2 . daughter of
S^r Edward | Coke, Knight, by his first wife (who was y^e
daugh^r of John Paston Esq^r) & had issue | by her .7. children
.3. sonnes Edward, William, & Syriack (borne after his father's
decease) | & .4. daughrs Bridgett, Elizabeth, Anne, &
Theophila, all yett living butt Anne (who dyed | before her
father). He was a most affectionate husband, a most obedient
son to his yett | surviving mother, a most indulgent father
to his yett hopefull posterity, forward to | doe good to all, &
most courteous. He deceased y^e 7th of August A^o D'ni
1626 & of his | age 32 currant, whose early losse is truely
lamented by all y^t knew him, but most | of all by his sadd
wife, who is yett comforted in y^e full hope & asurance y^t he
living | so piously & dyinge so religiously now raignes most
gloriously, a blessed Saint. | To whose blessed memory shee
hath dedicated this monument, too too | little to express
either his deserts or her affection. | Let others tombes
which y^e glad Heire bestows | Write gold in merble
greefe affects no showes | There's a trew heart intombed
him and that beares | A silent and sad Epitaph writt in
teares.

The following are written also in parallel columns :

Si quæris hospes quis sit hoc sub marmore, | Venerum
Cupidinumque thesaurum omnium, | Tegit situsque est hoc
sub ingesto aggere, | In cujus oculis tantus immicuit decor, |
Tam curiosa corporis symmetria, | Artificis ut possit perita
dextera, | Ex hoc Apollinem Jovemque pingere, | Aut quicquid
est decentiorum cælitum, | At sacra virtus pectoris pulchri
incola, | Superare quæ possit decorcm corporis, | Et cum
rapuerit illum acerbo funere | Necessitas (differre fatum
nescia) | Trieteris undecima absoluta non fuit | Illa illa dira
credidit senem dea | Virtute non ætate vitam computans. |
Viator huc accede, si tamen potes, | Juvenem hunc sepultum
flere largis fletibus, | Guttatim ocellis donec imber decidat |
Cavare marmor qui frequentia potest, | Siccoculus abeat
male, nec ipse mortuus | Ploretur, hunc plorare si minus
queat.

On an old stone in the chancel : round the verge in church
text (D) :

W Batel quondam vicarius istius eccl'e qui obiit anno
d'ni Millesimo cccc

On a flat stone in the nave (D) :

Here lyeth y^e body of | John y^e son of Thomas and | Letitia
Haworth who de | parted this life June | y^e 21, Anno Dom.
1713.

On an old stone in the nave to the west of the last much rubbed, round the verge in old character (D) :

> Ke . . an quondam obiit xxx die mens. Julii anno
> d'ni M *anime*

This inscription (R) is carved in oak on a pew in the north aisle, in old character :

> In the yere yat all the stalles | in thys chyrch was mayd, |
> Thomas Kyrkbe, Jhon Skre | by, Hew Roston, Jhon Smyth, |
> Kyrk Mastars in the yer of | oure lorde god MCCCCCXXXII.

This is a handsome spacious church consisting of a nave, two aisles, chancel, and west tower. The aisles are divided from the nave by four arches, the columns are clustered which support them, and on the south side are handsomely ornamented especially on the middle and two end ones. The chancel is lofty and spacious, with a piscina on the south side, and there has been an entrance to it on the north side now blocked up. There is a south porch and an old door. The font is early Norman, supported on a shaft clustered by four pillars. The top is square of black marble, sculptered with beasts on its four sides.

(MS vi, 131–134.)

Thornton Abbey

Notes taken of the excavated floor of Thornton Abbey, 31 August, 1835—

On a stone at the west end (D), round the verge :

> Hic iacet Johannes Bemort et Agnes uxor eius.

To the east of this (D), in lines :

> Hic iacent | Johannes | M Isabell | uxor eius.

To the north of the last, a broken stone (D) :

> quondam marrescall' huj*us* monast. q . . o
> p*r*opiciet*ur* deus.

To the east of this (D), round the verge :

> is de Gouxhill.

North of the preceding is a stone (D), round the verge of which :

> Halton et Alicia uxor eius quorum a*nima*b*us*
> propit*ietur* deus.

On another to the south (D), round the verge :

> Maria uxor propitietur deus amen.

On another stone more to the east (D) ; a tree now lies over it which prevents the inscription being so accurately read, but we have since compared it with Mr Heselden's note :

> Hic iacet Rob't' humanis fuerit nat. p'och. | quondam iacet |
> ut sit saluatus Xp'm funde peccatus | Hunc prostrat . . .

In the north transept is a stone (D), on which is the figure of a priest, and the following round the verge :

Hic iacet dom*in*us obiit xiv die mensis Septembris anno domini salvatoris millesimo quadri*n*gentesimo vicesimo nono cuius pr*o*piciet*ur* de*us* amen.

On a loose stone of coffined shape (D) ; part is now broken off, but the inscription is made perfect from Mr Heselden's notes :

Hic iacet Lisbet Rosse filia Rob'ti Rosse | gent. cuius anime propiciet*ur* deus.

Near to the last but one is a blue coffined stone with a florid cross upon it, but no inscription (D).

In the transept also there lies a large blue stone which had a brass, inscription now gone (D).

In the north transept also is a stone (D) not much excavated on account of a tree which grows near. The following two words however appear beautifully cut and as fresh as the day they were done, ' Monaster' cuius '.

In the north transept is a stone coffin, partly excavated, with the top off (D).

There is also a stone in the chancel :

Hic iacet Joh'is Gastryck | primo die decem. MCCCCLXII.

There is a large blue stone (D) which has had an inscription, and across it a crosier.

[See also *Associated Societies Reports* ii, 157–8 ; *Lincs. N. & Q.* xi, 16 ; Greenwood, *Picturesque Tour to Thornton Monastery*, pp. 18–23.]

(MS vi, 141–144.)

Threckingham

Notes taken in the church, [*blank*] August, 1831—This church is curious. The chancel has a Norman east window. In the north aisle are three large stone coffins which are said to be of three Danish kings killed near here, but by the inscription lately existing on the coffins this account has been found to be incorrect.

In the most eastern window of the north aisle are three shields of arms in stained glass (D) : (1) Threckingham, viz.—Argent, two bars gules, in chief three torteauxes, (2) Or, two chevrons within a bordure gules [Clare]. (3) Gules, three water bougets argent [Ros].

Near the entrance to the chancel on a slab (R), a little raised from the ground, are the effigies of a knight and his lady, the former having his legs crossed. The arms on the knight's shield are— Two bars, in chief three roundles, over all a bend.

A handsome marble monument at the east end of the north aisle with these arms above—Azure, a fess indented between three lioncels passant argent [for Fisher] ; impaling—Argent, on a chevron sable three quatrefoils patee or [Eyre]. Crest—An anchor, and on it, ' Crux anchora nobis ' :

> This monument is erected | to the memory of William Fyssher, eldest son of Francis | and Susanah, who died the 6th of October 1675 | in the 33rd year of his age. | Also to the memory of his | brother Robert Fyssher and Elizabeth his wife. | Elizabeth died June 16, 1710, | aged 65, | [Robert Feb. 14th, 1711, aged 61,] with 5 of there children who died young, viz. | William, Octavia, Susanah, Daniell, and Mary ; | also Lucy who died May the 25th, 1710, | in the 24 year of her age, | all whose remains | lie interred near this place in expectation of a joyful resurrection.

On a black and white marble tablet at the east end of ye south aisle :

> Near | this place | lie interred | the body of | John Warren | who departed this life | the 4th of April 1800, | aged 77 years.

On a black marble tablet near the south door :

> In memory of | John Quincey, Esq., | surgeon to his Majesty's forces, | eldest son of Jeremiah Quincey, many years of | in this parish, who died in London the 5th of October 1827 | aged 38 years. | His remains are deposited in the church of | St Gregory by St Paul's Cathedral.

On a stone tablet (R) against the west pillar of the nave with an urn over, and underneath ' Memento Mori ' :

> Sacred to the memory of | Mary the wife of | Jeremiah Quincey who died the 29 of April 1797 | aged 36 years. | Also of Jeremiah their son | who died the 19 of Sept. 1791 aged 16 months.

[On another slab adjoining the last :]

> Also of | Jeremiah Quincey | who died the 1st of January 1829, | in the 83 year of his age.

On a flat stone near the same pillar (R) :

> Hic jacet | Elizabetha Wainewright | Quæ satur dierum | Huic maligno valedixit mundo | Spe lætæ resurrectionis | 12° Augusti | A° Dom. 1719.

On another flat stone in the nave (D) :

> Maria Johannis Seagrave quæ fuit | Uxor | in terra hic dormit sub pedibus | jacet | ob. 22° May 1711°.

On another stone (R) more to the north almost entirely effaced :

> Johannes Seagrave | de Stow Green, | Gent., |

On another more to the east (R) :
> In memory of | Catherine eldest daughter of | Richard &
> Catherine | Hough | who departed this life | June 30th, 1820, |
> aged 39 years.

On another more to the east (R) :
> Here | lieth the body of | Mr Richard Hough | who departed
> this life | Oct. 14, 1801, | aged 51 years.

On another to the north (R) :
> In memory of | Catherine the wife of | Mr Richard Hough |
> who departed this life | April 25, 1820, | aged 65.

On another more to the west (R) :
> To the memory of | Elizabeth Morton | widow of | Mansell
> Morton | who departed this life | April 30, 1790, aged 76
> years.

On another more to the south (R) :
> Here lieth the body of | Eleanor daughter of | Mr Richard &
> Catherine Hough | who departed this life | April 6th, 1800, |
> aged 16 years.

On another stone more to the north (R) :
> Here lieth the body of Mr | Richard Hough who died February |
> the 22, 1786, | aged 67.

On another more to the north :
> In memory | of Sarah the wife of | Richard Hough | who
> departed this life April 12, 1764, | aged 48 years.

There is a flat stone (D) almost covered by the pulpit, the
inscription of which appears to be cut in old characters and
round the stone ; what remains is, ' qui obiit primo die Martis
cc '

On a black tablet in the south aisle :
> To the memory of | Mr Edward Dawson | who departed this
> life | April the 4th, 1787, | aged LVIII years. | Also to the
> memory of | Eleanor the wife of the | late Edw^d Dawson |
> who died Dec. 24, 1801, aged 75 years.

On a flat stone at the east end of the south aisle :
> Here lieth the body | of John Cragg | who departed this life |
> March the 10, 1758, | aged 53.

On a flat stone at the entrance of the chancel with the inscription
cut round (D) :
> Here lyeth | Octavian Fisher gent. who depar= | ted this life |
> the 4th of December Anno Domini 1610, | in the 70 year of
> his age.

The following inscription, (copied 28 July 1834), is on a white marble tablet against the east wall of the south aisle in capitals :

This tablet | is erected to the memory of | John Cragg, gentleman, | late of this parish, | who as land agent for many years | possessed the confidence of several | noble and distinguished families. | He departed this life on | Tuesday the 27 November 1832, | aged 71 years.

[See also *L.R.S.* i, 217 ; *Gentleman's Magazine*, 1789, ii, 615–16.]

(MS i, 81–88.)

Thurlby by Bourne

Notes taken in the church of Thurlby, 20 July, 1833—

On a tablet against the south wall of the chancel with these arms over—Vert, three stags tripping argent attired or, a crescent and mullet for difference ; crest—On a torce argent and vert a stag salient argent [Trollope] :

Near this place | lyeth the body of | James Trollope, merchant, | second son of James Trollope | of this parish esq., | who departed this life | August 16, 1709. | Also the bodies of | Jane and Margaret Minshull | daughters of Thomas Minshull | of Erdswick in Cheshire esq. | by Alice his wife, sister to | James Trollope merchant. | Jane dyed March 21st, 1735, | Margaret dyed June 5th, 1740.

A marble tablet opposite the last :

Sacred | to the memory of | Robert Stevens Harrison | of Thurlby rectory, | whose benevolence and hospitality | endeared him to a numerous | circle of friends, | and whose remains lie in this chancel. | He died April 6th, 1831, | in his 37th year. | Also of three of his infant children.

A flat stone in the floor of the chancel :

Here lieth interred the | body of Thomas y^e sonn | of John and Ann | Hubbard who departed | this life September the | 25, 1771, in the 23rd year of | his age.

Another close by :

Here lyeth interred the body of | John Hubbard who departed | this life October the 8th, 1771, in | the 53^d year of his age.

Another to the west of the last :

In | memory | of | Mr Richard | Hubbard | who died April | the 12, 1781, | aged 72 years. | Also Leef Hubbard | who died July 21, | 1799, | aged 88 years.

Upon a coffin shaped flat stone in the chancel (D) :

Died July 26, 1821, | Augustus | the third son of | Rob^t Stevens | and | Anna Maria Harrison | aged four months.

Upon a similar one more to the south (D) :
> Died Jany 27, 1824, | George the fifth son of | Robt Stevens | and | Anna Maria | Harrison | aged four months.

Another to the south :
> Died Novr 28, 1827, | Joseph | the 7th son | of Robt Stevens | and | Anna Maria | Harrison | aged 4 months.

Another to the south (D) :
> Robt Stevens | Harrison esq. | died April 6th, | 1831, | in his | 37th year.

A flat stone in the nave (D) :
> In memory of Hannah the | daughter of Wm Goodall of | Holewell in this county esq., | and wife of Francis Bevill | of Stamford in | the same county. | She departed this | life the 2d of April 1726, | in the 39th year of her age.

Upon another to the west (R) :
> Here | lyeth interred the | body of Joshua | Chalsworth, vicar of | this parish, who de= | parted this life | Sep. ye 19th, 1721, | in ye 70 year of his | age.

On another stone close by to the north (D) :
> Here | lyeth interred the | body of Susannah | ye wife of Joshua | Chalsworth who de = | parted this life | Novemr ye 9, 1721, | in ye 60th year of her age.

On another to the west (R) :
> Thomas Phillips gent. | died Decr 19, 1812, | aged 62 years.

On another (R) :
> In memory of | M. M. | who departed this life | April 5th, | 1818.

On two flat stones near the north door in church text (D) :
> Hic iacet Robertus Mallet. | Hic iacet Thom. Mallet.

A flat stone in the nave (R) :
> Here lies the Revd Mr Fisher | and his sister | 1769.

The church consists of a nave separated from its aisles by four Norman arches with round piers, a chancel with a chapel, north and south of it, two transepts, and a tower and spire at the west end, a porch on the north side. In the west wall of the south transept is a range of five pointed arches on single columns, and in the north and west wall of the north transept are eight arches with trefoiled heads. On the south side of the chancel are three arches, one circular with toothed mouldings ; the 2d pointed and plain ; the last trefoiled, resting on two pillars.

[See also *Lincs. N. & Q.* xii, 19–21 ; *L.R.S.* i, 194.]

(MS iv, 169–176.)

𝔗𝔶𝔡𝔡 𝔖𝔱 𝔐𝔞𝔯𝔶

Notes taken in the church, 1 September, 1836—This is a large and handsome church, standing in a churchyard surrounded by fine timber. It consists of a nave and aisles resting on each side on five slightly pointed arches which spring from circular columns. The westernmost arch on the south side is blocked up to form a vestry. There are on each side five small clerestory windows, and the other windows of the church are small. The chancel is spacious of the decorated style, and is separated by an arch of that character from the nave. The windows also are of the same character. The east one has its head blocked up. On the south wall are two stone stalls and a double piscina, very handsome ; the 3^d stall usually to be found is gone. At the west end is a tower and spire of decorated character, formed of a mixture of stone and brick. There is a south porch, and the font is of octagon shape having figures of angels thereon holding shields charged with the instruments of the crucifixion ; but they and the font are vilely daubed with paint. The top is a heavy looking carved oak one of the style of the 17th century. On a wooden tablet in the chancel is the following :

This church | repewed in virtue | of a faculty A.D. 1823. | John Halford, Thomas Abbott, | Joiners ; Rev^d John Bouverie, Rector ; Rev^d Charles Ashe, Curate ; John Sharp, churchwarden.

On a piece of old pewing preserved in the chancel is the following inscription in capitals, This frammed and sat vp by Iames Ackars carpintvr 1632.

Against the east wall of the north aisle is a large marble slab set upright. It was formerly (as the clerk informed us) lain with its face to the ground, but at the repewing of the church was taken up and found to be of beautiful white marble, but by the agency of some thickheaded churchwarden it has been smeared over nearly an inch thick with whitewash, and the figure of a knight which was engraven thereon has just been made visible by an outline of black lead. Round the edge is an inscription in the old character, but so entirely filled up with the wash that but little to be made out. [Holles gives the inscription, which shews it is in memory of Sir William de Tidde and Margaret his wife.]

On the wall of the north aisle towards the eastern end are three handsome monuments of white marble. The centre one is flanked by two cherubs, with a cornice and pediment above, on which is a shield of arms, viz. Argent, a griffin segreant gules [Trafford]. This inscription in capitals :

Juxta hunc | locum jacet corpus | Johannis Trafford | armigeri qui fuit hujus | manerii dominus. uxorem duxit | Margaretam

> filiam et unicam | Hæredem Simonis Wood armigeri | ex qua
> plures | liberos suscepit. |
> filius ejus | Sigismundus Trafford | armiger | hoc monumentum |
> posuit | Anno Domini | MDCCXIX.

The monument to the east of the last is adorned with festoons of flowers, and a drapery hanging above incloses a medallion bust of a gentleman. Below is a shield of arms much defaced, but they appear to be—Quarterly, 1st and 4th, Sable, three horse-shoes argent [Boheme]; 2nd and 3rd, Gules, a lion rampant per pale argent and or [Dilke]; impaling—Ermine, three hurts charged with a cross or [Heathcote]:

> Here are deposited the remains | of | Sigismund Trafford
> esq. | whose plain & exemplary character | Was this : | He was
> tender & indulgent to his wife | Kind & affectionate to his
> relations | Easy & humane to his dependants | Hospitable &
> friendly to his neighbours | A lover of his country & of all
> mankind. | In a word | He was in all respects an honest & a
> worthy man. | In testimony of which truths | And under a
> grateful sense of their real force | his widow | has caused this
> monument | to be erected. | He departed this life Feb^y y^e
> 1st, 1740–1, aged 47.

The westernmost monument of the three is plain, and is surmounted with this crest—On a helmet a husbandman vested quarterly gules and argent, holding a flail with a cap of the same, and these words issuing from his mouth on a label, ' Now THVS ' [Trafford] :

> In a vault beneath | are deposited the remains | of Sir Clement
> Trafford, knight, | of Dunton Hall | in the county of Lincoln |
> Lord of this Manor, | who married | Miss Jane Southwell |
> daughter of | Edward Southwell esquire | of Wisbech, | by
> whom he had issue, | Clement who died an infant, | Sigismund
> & Jane now living, | and departed this life | on the 1st of
> January | 1786, | in the 48th year of his age.

A brown stone tablet against the east wall of the south aisle, arms below—Sable, a pelican vulned proper [for Pell] :

> Thomas Sharpe died May 21, | 1781, aged 66 years. | Jane
> wife of Thomas Sharpe | died 27 August 1768, aged 36 years. |
> John their son | died 8 February 1810, aged 49 years. | Thomas
> their son | died 14 November 1762, aged 5 years. | Bridget
> their daughter | died 15 Sept^r 1762, aged 10 years. | Also
> Jane and Sarah their | daughters who died in their infancy. |
> This monument is erected | by Edmund Pell Sharp of | London
> (Supervisor of Excise) | in love and respect to his | family.

A stone below commemorates Henry Sharp died 11 Nov. 1738, æt. 34.

A flat blue stone in the nave with these arms cut over—Ermine,

on a bend, three escallops [Wensley]; impaling—An eagle displayed . . . Crest—A Saracen's head erazed in profile :

> Here lieth interred | Mary | the wife of Robert Wensley esq^e | and | relict of Clement Boheme esq. | She died vij of Septe^r MDCCLXVIII, | aged LVIII years. | Here also lieth interred | Robert Wensley esq. | who was born at Walsoken | in the county of Norfolk. | He died at Wisbeach | in the county of Cambridge | on the XXVI day of May MDCCLXXVIII, | aged LXIX years.

Another (R) to the west of the last. Arms—On a lozenge . . . a chevron, between three boars' heads [Evans]:

> Here lieth interred | Susanna Evans | daughter of Hill Evans of Petersburgh | in Russia, merch^t, and Mary his wife. | She died Nov. 28, MDCCLX, | aged 32 years. | Near this place lieth the remains of | William Evans | son of Hill Evans, merch^t, and Mary his wife, | who died Dec^r 7, MDCCLVII, aged 20 years. | Beneath are deposited the remains of | Mary Evans | daughter of Hill Evans, merchant, | and Mary his wife. | She died May 22, MDCCCVII, | aged LXXVIII years.

Another to the west of the last, these arms cut over—Ermine, on a canton a pelican proper, vulned . . . ; crest—On a helm and torce a pelican [Pell]:

> P.M.S. | Edmundi Pell gent. | Qui obiit tertio die Februarii | Anno Dom. | MDCCXXVII | Ætat. 39 | Posuerunt | Executores et Fiduciarii testamenti | Tho : Peirson & Tho. Towers gent.

On common flat stones near the font, all much rubbed, are inscriptions to the memory of :

> John Scrimshire died 16 Nov^r 1738, æt. 50.
> Anne Scrimshire died 3 July 1774, æt. 37.
> Elizabeth Clapon died Dec^r 1737, æt. 34, and two of her grandchildren daurs of Thomas and Anne Scrimshire died in infancy.

A stone near the south door much rubbed, in capitals :

> Here lyeth in hope of | a joyful Resurrection | the body of Mr William | Bennet, senior, who departed | this life the 10th day of | November in the yeare of | our Lorde 1680, aged | fortie five yeares.

On a flat stone in the chancel :

> Here lyeth the bodie | of Robert Whitaker | M^r of Arte, & rector | of Tyd St Marie nine | yeares, departed this | life the 23 of Novemb. | 1675.

Another more to the east in capitals :

> Here lies interred the | body of Mr William | Thurlby who departed | this life y^e 5th of August | 1689.

More to the east a stone to :

Elizabeth wife of Thomas Howard died 28 Dec^r 1747, æt. 46.

A large blue stone to the east of the last :

To the pious memory | of the Reverend Mr Thomas Adderley | curate of this parish who exchanged | this life in hopes of a better on the | 25 day of May in the year of our Lord | 1736, | and in the 54 year of his age

On a brown stone more to the north :

Here lyeth the body | of | Katherine Moore | who dyed Nov^r 12, 1737, | aged 13. | She was the daughter of | the Rev^d Tho^s Moore | and Mary his wife | of Carlton Scroope | in this county.

An old stone near the altar rails :

Mr Richard Harris as I remember | died the 30th of November. | He was second soone of Anthony Harris | borne at Bridgstock and died in this parrish | Anno D'ni 1653.

A large blue stone to the north of the last :

Sacred to the memory of | Roger Steevens clerk, LL.B., | who after having faithfully | discharged the ministerial duties | of this parish for upwards of 46 years | departed this life deservedly lamented | Dec^r 16, 1779, aged 75 years. | Near this place also | lie interred the mortal remains | of Sarah his justly beloved wife | who departed this life May 8th, 1756, | aged 57 years.

Another stone to the memory of :

James Scribo gent. died 13 June 1804, æt. 83.

A stone in the vestry to :

James Gibson sen^r died 31 May 1724, æt. 62, and John his son.

[See also *L.R.S.* i, 181–2.]

(MS ix, 55–66.)

Uffington

Notes taken in the church, [*blank*] July, 1831—This church is large and handsome. On the cieling of the chancel is a representation of St Cecilia with her attributes, etc.

There is a hatchment on the north wall of the chancel of the arms of Bertie, impaling—Gules, a chevron between two estoiles in chief and a crescent in base or, on a chief azure two escallops or [Tryon]. In the east window are several shields of arms—(1) Gules, three water bougets argent [Ros]. (2) The same, impaling—Or, a chevron gules [Stafford]. (3) Bertie, with this inscription under, ' The Hon^{ble} Charles Bertie of Uffington maryd Mary daughter of Peter

Tryon, of Harringworth com. Northampton, esq., Sept. 4, 1674.'
Under a canopy of stone in the north wall of the chancel is the
effigy of a knight, with his head resting on his helm, and his feet
on a lion ; there is no inscription. [On his jupon is a bend sinister ;
he is said to be Richard de Schropshire.]

On the south side of the chancel is a splendid mural monument
on which, in recesses supported by two Corinthian pillars, kneel
the figures of two knights armed save the head, with an altar before
them. On the entablature a large shield of arms between two
small ones. On the larger shield are these arms—Quarterly, 1st,
Or, two bars azure, on a chief quarterly of the second and gules,
in the ist and ivth a fleur de lis or, and in the iind and iiird a
lion passant guardant of the last [Manners] ; 2nd, Ros ; 3rd, Gules,
three wheels argent [Espec] ; 4th, Azure, a wheel or [Belvoir] ;
5th, Gules, a fess between six crosslets or [Beauchamp] ; 6th,
Checquy or and azure, a chevron ermine [Newburgh] ; 7th, Gules,
a chevron between ten crosses patee argent [Berkeley] ; 8th, Or,
a fesse between two chevrons vert [Lisle] ; 9th, Gules, a lion passant
guardant argent [Gerard de Lisle] ; 10th, Gules, three lions passant
guardant or, over all a bend argent [Plantagenet, earl of Kent] ;
11th, Argent, a saltire gules [Tiptoft] ; 12th, Or, a lion rampant
gules [Charlton] ; 13th, Argent, a fesse between two gemelles gules
[Badlesmere] ; 14th, Checquy gules and argent [Vaux] ; 15th,
Gules, an eagle displayed within a bordure argent [Todeni] ; 16th,
Or, two chevrons within a bordure gules [Albini]. Crest—Upon a
cap of maintenance a peacock displayed proper. The smaller
shield at the east end bears the first quarter of the large shield,
impaling—Argent, six fleur de lis azure, a chief indented or [Paston].
On that to the west—Or, two bars azure, a chief gules [Manners,
ancient] ; impaling—Fretty argent and azure, on a chief or a
crescent gules [St Leger]. Under the shields is this inscription :

In Rogerum Manners armiger*um* et virum nobilem qui obit
xi De. 1607.

Over the figures is this inscription in two compartments :

(1) See here the Patern of true noble blood | Thy honor by
thy vertues was made good | Godly thy life thy dealings
wyse & juste | Thy kyn & frends yt unto the did truste |
Whose vertues in ye eyes of vertuous shyne | And thou maiest |
bovste yt boothe were truely thyne | Thy purse was open
alwaies to ye poore | Founde the still kinde & tasted of thy
store.

(2) Thy howse in plentie ever was mayntaynd | The stranger,
& ye prisoner, had relief | Thy servants, schollers, & some
poore have gaynd | yt lyves wth them, though they lyve
now with grief | These be thy workes, of vertue lefte behind |
wch ay will last, though thou lye under stone | Briefely towcht

here yt men of vertuous mynde | May [passing by] thy losse
lament & mone.

Under the figure to the east :

Here lyes Roger Manneres | Esquier to the bodye of | Queene
Marye and Queene | Elizabethe and therd | sonne to Thomas
late | Erle of Rutland Anno | Domini 1597.

Under the other figure :

Here lyes Olyver Manneres | the 6th sonne of the said late |
Erle and served our Queene | Elizabeth in her warres at |
Newhaven and ther fell | sicke and died of the | same sicknes
Anno Dom. [1563].

Ellis in his history of Shoreditch says this Oliver Manners died
at Shoreditch of this sickness & ye burial is in ye Register there
Sept. 6 1563, æt. 20. He queries if he was buried at Uffington but
removed there by a faculty.

A very handsome marble monument to the west of the last men-
tioned on which, in a recess supported by two Corinthian pillars,
kneel the figures of a man in a black gown and ruff, and a woman
in like costume, behind each of them kneels a child habited in the
same manner. Above, on the top of the monument, is a shield
with these arms—Quarterly, 1st and 4th, Verry argent and sable,
on a dexter canton gules a cross patee fiche or [Stanton] ; 2nd
and 3rd, Or, a lion rampant sable. On another shield below—
Per pale azure and gules, the Virgin enthroned with the Child in
chief, and in base two lions passant or [See of Lincoln] ; impaling
the first shield. Over the man's head is this shield of arms—The
1st quarter of the large shield ; over the woman's head—Or, three
torteauxes, a label for difference [Courtenay] ; between both, the
two last shields impaled. Under the man is this inscription :

Ecce sub hac Doctor recubat Laurenti*us* urna | Stantonus
sacris multum devotus legeus | Edvardo Rutland Comiti
Fratrique Johanni | Christophero Hattono, qui Cancellarius
olim | Reginæ Elizæ servus Regisque Jacobi, | Lincolnensis
erat protomysta Decem. tribus annis. | His pius agnoscit
quis fuit unde decus. | Minor sum cunctis miserationibus
tuis et veritate tua qua | explevisti servo tuo nam cum baculo
meo transivi Jorda- | num hunc et nunc regredior cum duabus
turmis. Gen. 32, 10.

Under the woman is this inscription :

Duxit in uxorem Courtnaeo sanguine natam | Agnetem
Doley triplici qua prole beatus | Filius unus et alter erat,
simul una puella | Et Pater, et Proles, Tumulo conduntur
in isto | Quem sua fida sibi construxit nupta superstes | Donec
erit tempus qvv*m* contumulentur in vnv*m*.

On a handsome mural monument to the north of the Communion
table, with the shield of arms above—Argent, three battering

rams proper headed azure, hooped and armed or [Bertie]; impaling —Azure, a fess crenelle between six mullets or [Tryon]. Crest— An old man's head, couped at the shoulders, and crowned proper, issuing out of a ducal coronet or [Bertie]:

Here lies | the Hon^ble | Charles Bertie Esq. | fifth son of Montague Earl of Lindsey | Ld Great Chamberlain of England | by Martha Countess of Holdernesse his wife | who, having qualified himself for the service of his country | by his early travels into France, Spain, Italy, Germany, Holland, | Flanders, Denmark, Sweedland, & Poland, did first signalize his | valiour by his attendance on George Duke of Albemarle, Gen^l | to King Charles y^e second, in y^e two great battles fought against y^e Dutch | at sea anno 1666, and was afterwards prefer'd to be one of the Captains in his | Maj^tis Regiment of Guards, whence his Maj^tie was pleased to command him | his envoy extraord^y to Christian y^e 5^th King of Denmark to adjust the | difference about the flagg Anno 1671, in which negociation having | succeeded to his Mat^ies great satisfaction, he returned home in | Anno 1672, waited on his R. Highness y^e Duke of York to sea, & was | personally with him in that engagement off Sold Bay Anno 1673. | He was advanced to be secretary of the treasury under the Rt Hon^ble | Thomas Earl of Danby, then Ld High Treasurer of England, in y^e | year 1680, was again commissionated his Maj^ies envoy extraord^y | to severall Electors & other Princes of Germany, & last of all | in the year 1681 was made Treasurer & Pay master of his Maj^ties | Office of Ordnance in which he served near 20 years under three | severall reigns, & served 30 years in Parliament as Burgess of | Stamford wherein he acquitted himself with unspotted reputation. | He left 2 children, Elizabeth who married to y^e Right Hon^ble Charles | Ld Fitz Walter, & Charles his son & heir. | He departed this life y^e 22 day of March | 1710, in the 71 year of his age & lyes underneath interred togather | with Mary his most dear wife.

On the base of the monument is this inscription :

Who amongst his other acts of charity did | in his life time at his own charges repaire and | beautify this church & at his death gave fifty | pounds to the poor of this parish. | He also repaired a marble erected at Wesel | in Germany in memory of y^e birth of Perigrine | Lord Willoughby of Eresby his great grandfather.

On a handsome marble monument against the north wall of the chancel, with the arms of Bertie impaling—Azure, a fess crenelle between six mullets or [Tryon]:

Underneath are deposited the mortall remaines of | the Hon^ble Mary daughter of Peter Tryon | of Harringworth in

the county of Northampton | esq. wife of the Hon^{ble} Charles Bertie | of Uffington in the county of Lincolne, fifthe | son of Montague Earl of Lindsey Lord Great | Chamberlaine of England, by whom he had issue | Elizabeth, Thomas, Maria de Salina, & Charles, | the first & last whereof God hath been pleased | by an equal repartition to leave for com= | forts to their father, having taken the other | two unto himself to bee early partakers of | theire mother's felicity. Shee was exemplary in her piety | amiable in her person & obliging | in her conversation to all, but most dear to | her husband who erected this marble | as a monument of her great vertue | and his intire affection.

On the base :

She dyed the 13th day of | January 167⅞, in the 25th | year of her age.

A black marble tablet to the north of the entrance to the chancel (R) :

To the memory of | the Rev^d Talbot King | who was for 18 years | rector of this parish | and whose mortal remains | were interred in this chancel | June 30, 1798.

On a white marble tablet to the south of the entrance to the chancel :

Caroline Bethia Gibson | wife of | Lewis Gibson, esq., | daughter of | the very Rev^d Charles Peter Layard, Dean of Bristol | and sometime rector of this parish, | died January 4th, 1827, | aged 39. | The dead shall hear the voice of the son of God | and they that hear shall live.

[See also Jeans, 77–8 ; *Gentleman's Magazine*, 1862, i, 340–1.]

(MS i, 51–59.)

Upton

Notes taken in the church, 4th September, 1835—This church consists of a nave and large chancel with two lancet east windows, and a tower at the west end containing four bells, one of which is cracked. The arch between the nave and chancel is pointed ; the font is modern, but the base of it which seems to have been a shaft clustered with smaller pillars is placed as an ornament half way up the tower.

A grey marble tablet against the south wall ornamented with a white urn, this inscription :

Sacred to the memory of | Francis Toyne who departed this life April 1750 aged 51 years. | And of Anne his daughter | who died October 1786, aged 44 years. | Also of Anne his relict | who died Oct^r 1806 aged 92 years. | Also John Toyne

esq. | son of the above named Francis & Anne Toyne | who died February the 12, 1821, aged 77 years. | Also the remains of Jane Teale sister of | the above John Toyne & widow | of the late John Teale esq. of Hull | who died Feb^y 26, 1827, aged 78 years.

A flat stone in the floor below :

Here lyeth the body of | Francis Toyne who departed | this life April the 23 | in the year of our Lord 1730 | aged fifty years | leaving a widow | & 3 children. | Near to him lies two | more of his children who | died in their infancy.

(MS vii, 129–130.)

Waddington

Notes taken in the church, 8 August, 1833—

On a black slab against the east wall of the chancel :

Johannis Barnard | S.S. Theol : Professoris Regi Car : II | a sacris ecclesiæ Cathedralis Linc | olniensis canonici hujusq. parochia | lis rectoris meritissimi hic sitæ | sunt reliquiæ | viri (dum superstitis) virtute piet | ate vita integerrima et scientia | insignis cujus memoria bonis | omnibus quibus vivus notus | necesse est ut sit grata | et jucunda. | Diem supremum obiit XVI kal. | Septembris ætatis suæ LV | Æræq. nostræ anno MDCLXXXIII.

On a flat stone in the chancel (D) :

Sacred to the memory | of the Rev^d John | Rawlins Deacon, B.D., | rector of this parish | twenty four years, | and vicar of Harmston | and Rouston in this county, | who died Sept. 22, 1821, | aged 62 years.

On a flat stone in the nave (D) :

To | the memory of | William Harrison | who died Jan. 8, 1827, | aged 30 years.

On a stone in the north aisle (D) :

In memory of | Mary the wife of | Rob^t Fielden | who died October | y^e 5, 1749, aged 39.

There is more but much rubbed.

A white marble tablet against the wall of the south aisle :

Sacred | to the memory of | Elizabeth the wife of | John Hanson | and daughter | of | Charles and Elizabeth Clarke | who died Nov. the 20^th, 1808, aged 37 years.

On another more to the east :

Sacred | to the memory | of | Charles Clarke | who died July 2^d, 1792, | aged 44 years. | Also of Elizabeth | his wife | who died June 20^th, 1825 | aged 75 years.

On a flat stone in the floor below (D) :

> Here | lieth the body of | Charles Clarke | who departed
> this life | July the 2ᵈ, 1792, | aged 46 years. | Dear loving
> wife and children kind adieu | What in my power was I've
> done for you | My years are ended here I lie at rest | And
> trust thro' Christ with glory to be blest | Grieve not for me
> for now it is in vain | I hope in heaven we shall meet again.

Another to the west in capitals (D) :

> In memory of Anne | the wife of Charles | Clarke who died |
> May the 25th | | aged . . years. | In memory of
> Thos | Clarke who died | November the 7ᵗʰ day |

A flat stone in the north aisle (D) :

> Here | lieth the body of | Mary the wife of | John Swaine | of
> Bradford in the county | of York, and daughter of | Robert
> and Ann Fielden, | who departed this life | the 24ᵗʰ of April
> 1782, | aged 27 years.

This church consists of a nave, two aisles supported on two
pointed arches having clustered columns, a chancel, and a tower
at the west end. The aisles project to the front of the tower. The
pulpit is handsomely carved.

In Dodsworth, MSS 45 : In eccl'ia de Waddington in co. Linc.
in fenestra Orientali—Quarterly, 1st, Argent, 5 fusilles in fesse
gules (Hebden) ; 2nd, Gules, a bend ermine (Rye).

[See also *L.R.S.* i, 121–2.]

(MS iii, 175–180.)

Walcot by Folkingham

Notes taken in the church of Walcot, 31 July, 1833—

On a black tablet against the south wall of the chancel :

> Sacred to the memory of | the Revᵈ John Shinglar | 31 years
> vicar of this parish | who died June 25, 1828, | aged 72 years. |
> What else he was | in life in manners and in merit | that
> great hour will discover | when the secrets of all hearts shall
> be disclosed | and every man receive according to his works. |
> Reader farewell | prepare to meet thy God.

On a similar black tablet against the north wall of the chancel :

> Sacred to the memory of | Jane the wife of | the Revᵈ John
> Shinglar | vicar of this parish | who died Oct. 10, 1825, | aged
> 84 years. | The Lord gave and the Lord hath taken away |
> blessed be the name of the Lord.

On a brass at the east end of the north aisle :

> Here lyeth yᵉ bodye of Isaac Laughton sonn to John
> Laughton | of Walcot, gent., the yonger, who departed | this
> life yᵉ 5 day of Jvly in the | yeare of our Lord God 1635, |
> and in yᵉ 25 yeare of his age.

On a flat stone next to the last (D) :
> Here lieth the body of | Stephen son of | Stephen and Mary Oliver | of Walcott | who died July 15, 1813, | in the 13 year of his age.

On a stone quite at the east end of the north aisle (D) :
> Here lieth the body of | Ann Pell who departed | this life the 18 day of | July 1739, | aged 69.

Near to the last is an old stone with inscription round the edge, but now illegible.

A brass in a stone on the floor of the south chancel in capitals (D) :
> Here lyeth the body of Samuel Laughton | sonne to John Laughton the yonger | gent., who departed this life the xxi of month | of July in the yeare of our Lord God | 1637, and in the 26 year of his age.

A flat stone in the same chapel :
> Here | lieth the body of | John Owen and of | Elizabeth his wife. | He died June the 27, 1730, | aged 52 years. | She died | November the 3rd, 1772, | aged 79 years.

Another more to the west (D) :
> Here lieth the body of | George Owen of Walcott | who departed this life | the [blank] day of March | Anno D'ni 1722, | ætatis suæ 29. | Here lieth the body of | George Owen | who departed this life | March [blank], 1798, | aged 70 years.

Another more to the north much rubbed (D) :
> Here lieth Rich | ard Laugh . . . gent., | who departed this life | Iune 19, 702 | and in year | of | non mihi | qui be

At the entrance of the chancel has been a small brass with figure and shield now gone.

On a flat stone in the nave (D) :
> Here | lieth the body of | John Quincey jun^r | who died | March the 8th, 1773, | aged 45 years. Think nothing strange | Death happeneth to all | My Lot's to day | Tomorrow thine may fall.

Another more to the east (D) :
> Here | lieth the body of | Mr John Quincey sen^r | who departed this life | August y^e 10, 1780, | aged 84.

The church consists of a nave and aisles resting on three pointed arches with circular columns, a chancel, and two aisles separated by a low round arch, and a tower and spire at the west end. The east window is decorated and contains a beautiful figure in painted

glass of a woman holding a shield of arms, viz.—Per fesse or and gules, in chief two chess rooks sable [Walcot]; impaling two wives—Dexter, Or, a chief gules, over all a bend azure [Harrington]; Sinister, Azure, two bars, and in base a crosslet fitchy or. A piscina in the south chancel.

[See also *L.R.S.* i, 220.]

(MS iii, 15–20.)

Washingborough

Notes taken in the church of Washingburgh, 7 August, 1833—

On an old monument of white marble against the north wall of the chancel with these arms above—Quarterly of 6, 1st and 6th, Quarterly or and gules, on a bend sable three fleur de lis . . . [Eure]; 2nd, Argent, four barrulets gules, on a bordure azure ten martlets or [Merley]; 3rd, Argent, fretty azure [Lound]; 4th, Argent, on a cross azure five mullets or [Lincoln]; 5th, Barry of eight argent and gules, over all a horse's head couped or [Gardiner]. The inscription in capitals :

> Memoriæ sacrum | Petro Evre de Washingburgh Equi | ti aurato ex antiqua et prænobili | Familia Baronum de Wark- worth et | Clavering (e qua etiam Barones de | Evre) oriundo qui juvenis animum | bonis studiis et virtutibus excol | uit multas regiones perlustravit | Belgico et Hibernico bello regnan | te Elizabetha cum laude milita | vit tandemq. plenus annorum | quinq. liberis e Barbara uxore | filia Joannis Meres de Auborne | equitis aurati susceptis videl't | Radulpho Edwardo Thoma Mic | haele et Barbara certa spe Re | surgendi in Christo pie placideq. | obdormivit die 25 Junii Ann. 1612. | Optimo Marito mæstissima uxor cum lachrymis posuit.

On the base of the monument :

> Sir Peter Evre of | Washingburgh | knight.

At the side of the monument are sculptured a pair of gauntlets, a corresponding pair on the opposite side are gone, and above them have been shields of arms and helmets also gone.

A tablet against the north wall of the chancel with these arms under—Quarterly, 1st and 4th, Sable, a chevron between three crosslets fiche argent [Buckworth]; 2nd, Gules, a fess between three mullets argent [Everard]; 3rd, Ermine, on a canton azure a pelican argent [Pell]; on an escucheon, Argent, a castle between three cups, covered, argent [Amcotts] :

> Sacred | to the memory of the Rev. | Everard Buckworth, | LL.B., | died October 3, 1792, | eldest son of Everard Buck- worth of Spalding esq. | and Jane daughter and coheiress | of Henry Pell of Dembleby esq., | married August 2, 1754, | Frances | youngest daughter of | Vincent and Elizabeth

[Amcotts of Harrington, and only surviving sister and co-heiress of Charles] Amcotts esq. | A man of great learning, | refined by a polite education, | deeply versed in the beautiful works | of the Almighty Creator, | affectionate, benevolent, | beloved, and lamented by all, | was 29 years rector of this parish, | attentive to the sacred office, | in the duty of a Magistrate | mild, upright, well informed, | beloved by his parishioners and tenants, | & the last 15 years Lord of the Manor.

On a black stone in the chancel floor:
Here lyeth the body of Dame | Elizabeth the dear & beloved | wife of Col¹ Walter Palisser | second daughter to Simon | Sterne, esq., of Elvington in | Yorkshire, who departed | this life Oct. 31, Anno Dom. 1719, | in the 33 year of her age. | She left behind her | a son called Walter | and a daughter Alice.

On a stone in the floor next to the last:
Hic jacet corpus | Jacobi Bateman rectoris | Washingburgensis qui | obiit die Martis 22 | Anno Domini 1686 ætatis | suæ anno 54.

On a black stone next to the last. The arms in a lozenge above— A chevron between three crosslets [Sterne]; on a lozenge as an inescucheon—A fess engrailed between three escallops, and charged with a lion passant [Jaques]. Crest—A martlet:
Here lyeth the body of Dame | Mary relict of Simon Sterne | esq. and only daughter to Roger | Jaques esq. of Elvington in | Yorkshire, who departed this | life the 29 day of September | Anno Dom. 1721 | in the 69 year of her age.

On a black marble slab next to the last:
Sacred | to the memory of | the Rev. Francis Massingberd, | prebendary of Lincoln | and rector of this parish, | died April 12, 1817, | aged 62 years. | My trust is in the | mercy of God | through Jesus Christ.

On another stone:
Here lieth the body | of | Mrs Catherine Fairfax, | born at Pinchbeck | December 3, 1702, | died May 2, 1792.

On a smaller stone nearer the altar rails:
Here lyeth Mary | the eldest daughter | of Geo. Fairfax | rectʳ & Frances his | wife obiit 7ᵗʰ, 1726, | in the 6th year of her | age.

A flat stone before the altar rails has had an inscription round the rim, but now so defaced; these words alone can be legible, '. Evangelicum Agnus Natura qui obiit Anno X'ti 20 Aug. 1607, suæ 68.'

On a black stone in the chancel :

Sacred | to the memory of the | Rev. Thomas Christopherson | rector of Grainsby, vicar of Eagle, | and many years master | of the grammar school at Heighington, | and curate of this parish. | He was a good man | and died much lamented | by his relatives and friends | on the 23 day of October | one thousand eight hundred | aged 63 years.

On flat stones :

Sacred | to the memory | of | Elizabeth relict of the | late John Brown esquire | late of Heighington | who departed this life | April 3rd, 1816, aged 67 years. | Also of | Elizabeth Stanley | grandaughter of the above | who departed this life | Sept. 20, 1815, aged 7 years.

Here lyeth the | body of Mrs Sarah | Sympson ob. Ap. | ye 28, 1710, aged 66.

On flat stones :

Here lie the remains of | Mr Gentle Brown | who died May 21, 1801, | aged 53 years, | & also of his widow | Mrs Susanna Brown | who died Oct. 12, 1807, | aged 56 years.

Sacred | to the memory | of | John Brown late of Heighington esq. | who died the 9 Jany 1798, | aged 57 years. | Ann, Elizabeth, Thomas, Ann, and | Thomas, | five of his children who died | in infancy.

A tablet on the loft commemorates that it was built formerly on the south side by Sir Nicholas Raynton alderman of London 1622, rebuilt in 1701 by a lover of the Church who also rebuilt the pews in 1719 ; lastly it was repaired in 1802 (D).

A handsome white marble monument against the south wall of the chancel, arms over—Eure ; crest—Two lions' paws . . . holding a fleur de lis . . The inscription in italics :

Sacræ memoriæ | Radulphi Evre Petri Evre militis filii | qui obiit Jan. 16, Anno Dom. 1664. | Marmor ego quondam moles ingloria nomen | Radulphi Everii nobile fronte gero | qualis erat pietas testatur cælica mores | integri et in Regem non temerata fides. | Testantur proprio quos contulit ære cohortes | Dum forti augeret Regia castra manu | Londino cineres animam cælo et mihi nomen | sed tibi virtutes quas imitare dedit. | posuit filius obsequentissimus | Radulphus Evre.

A paper framed and hung up against the south wall of the chancel. At the top are three shields of arms—The dexter—Or, on a saltire engrailed vert, between four lions rampant gules, 5 [bezants—Lacy] ; impaling—Argent, a fesse between three fleur de lis issuing from crescents gules (Ogle) ; crest—A demy lion couped gules. In the middle—Ogle alone ; crest—A bull's head erazed or. The

sinister—Vert, a lion rampant or [for Beaumont] ; impaling—
Ogle ; crest—On a cap of maintenance gules a lion passant or.
Between the arms, this in old character :

An Epitaph. | Upon the truly noble & religious ladye | the
ladye Cassandra Beaumont daughter to Thomas Ogle of
Pinchbeck in the county of | Lincoln esquire then married
and first wife to | Robert Lacye esq. and after to S^r Francis |
Beaumont who departed this life | at her house here in
Washingborough the 23^d | day of December 1632 being of the
age of 68 | And here under lieth interred.

Below this in two columns are the following verses in separate
stanzas :

(1) Ætherii si Patris amor si candida vita | Mens humilis
necnon dives et alta simul | si pietas erga proprios castissima
conjux | cura inopum meritis semper aperta manus | omnia
post mortem famam meruere perennem | auguror hæc famâ
digna perennis erat.

Scilicet Oglorum quamvis de Sanguine Claro | et multa
insignis nobilitate fuit | cum sciret nullo cælos ab honore
parari | virtute æternas illa petebat opes | regna poli petiit
quo [? votula] plurima misit | mortua sed votis jam subit ipsa
suis. Vivat ibi æternum tua mens tuq. ipsa dolorem | Hunc
nostrum exequias despice (diva) tuas | præcipue amissam
væ lachrymantur egeni | quid tamen hæ lachrymæ quid dolor
iste valet | Nos miseri non te sed nos et nostra fleamus |
[? eternum] Christi regna beata tenes.

(2) If zeale to God if Innocence of Lyfe | An humble soule
an understanding heart | If love to kindred and a loyall wife |
Towards poorest pity, bounty to desart | In death may
challenge an immortal fame | This lady then may well deserve
the same.

And though an Ogle and of Noble race | She was to honoured
families allyed | She knowing honours gain no saving grace |
Did labour for the good that should abide | Heavens Kingdom
whither she her vows did send | And after followed at her
latter end.

Where live for ever happy soule and view | How we thy
want dear ladye do bewaile | But worst the poor who thy
great loss do rue | In Washingborough but what do tears
avail | Oh weepe we for ourselves and not for the | Who livst
with Christ to all eternitye.

At the bottom is this :

Ut tecum Christe resurgam Revived 1699 Revived 1808 dedicated

as a monument to her memory | to her honour by both her
executors Adlard Pury and Mary Brownloe.

Between the columns are five shields of arms, viz.—1^st, Ogle,
impaling—Lozengy, argent and gules [Fitzwilliam] ; 2^d, Ogle,

impaling—Azure, a chevron between three cinqfoils or [for Cooke] ; 3[d], Ogle, impaling—Sable, a fesse argent ; 4th, Ogle, impaling— Sable, a fesse engrailed between three fleurs de liz argent [for Welby] ; 5th, Ogle, impaling—Paly of six argent and gules, over all a bend wavy or, a chief sable.

A flat stone in the south aisle with inscription round in old character :

> Hic iacet Gulielm' | Garratt generosus de Heighington qui obi . . . | octavo | die Decembris Anno Domini MDCX.

Down the middle of the stone :

> Recepit | terra corpus | animam Christus | Corpus dormit | vigilat | | imago.

This church consists of a nave divided from its aisles by four pointed arches springing from round columns with foliated capitals, a chancel, and north aisle, and a tower at the west end. The arch from nave to chancel is pointed and has clustered piers. Just under the north wall of the chancel is a rude figure cut in a stone, the upper part hollowed out in the form of a niche, and the lower filled up having a cross cut on it. The font is circular with a range of Norman arches round it.

<div align="right">(MS iii, 149–162.)</div>

Welbourn

Notes taken in the church of Welbourne, August 8, 1833—

On a brass in the chancel (D) :

> Y[e] shal of your Charitie praie for the soule | of Nicholas Baylye late of Welborne who | departed y[s] world ye XIIII daie of Octob. ye yere of | our Lord MDLVII on whose soule God have mercie amen.

On a white marble monument against the south of the chancel with these arms—A chevron between three mullets [for Knight] ; impaling—A fesse between three crosses patee [for Riley] ; |crest— A griffin's head, erased] :

> Hic tumulati jacent | Alicia | Roberti Knight hujus ecclesiæ rectoris | uxor dilectissima | Richardo Riley de Welbourn Armig. nata | Robertus | ejusdem maritus | Isaaco Knight de Lincoln Armig[o] natus | et Georgius supra memoratorum filius | necnon hujus ecclesiæ | rector | obierunt | illa prid. non. Jun. 1688 | ille calend. Septemb. 1703. | Hic octav : ante calend. Octob. 1720. | In quorum memoriam hoc breve marmor | doloris sui & pietatis monumentum, | Illorum quidem filiæ | hujus autem sorores | duæ superstites posuerunt.

On a black tablet north of the chancel in capitals :

> Qui dolor e tristi prorumpit corde parentes | cum recolo hic positos sed meminisse juvat | Sed meminisse tui pater O

Venerande juvatque Et piget et grata dicere mente vale |
Tu quoque tu valeas chara ah ! charissima mater | Ipse
tamen curæ sim memor usque tuæ | Sim memor amborum
felix ita discere possim | Vivere nil optans nil metuensque
mori | J. Peckard, A.M., Ann. 45, huj : Ecc : rector | ob.
Aug. 1 die suo natali 1765, A. Æ. 76. | M. Peckard ob. Jul. 4,
1757, A. Æ. 58. | Parentibus O.M. posuit filius | P. Peckard
S.T.P. Col. Mag. Cant. Præfec. 1790 | ipse brevi moriturus.

On a white marble sarcophagus monument north of the chancel :
Sacred to the memory of | Elizabeth wife of | Rev. H. J.
Disbrowe | who died Octr 5, 1829. | Also to the memory
of | Augustus son of the above | who died an infant Oct. 20,
1828.

On a flat stone in the chancel :
Mr Francis Steevens late | rector of this church | deceased
September ye 16, 1709, | aged 35 years.

Against the north wall at the west end of the north aisle are four
oval tablets very similar with these several inscriptions :
Sacred | to the memory | of | Ann Welby | second daughter
of | the late Richard Welby esq. | and Ann his wife | obt
28 Octr | 1804. | Requiescat in pace.

In | memory | of | Richard Welby esq. | obiit March the 8, |
Anno Domini | 1780, | ætatis suæ | 67.

In memory | of | Ann Welby | relict of the late | Richard
Welby, esq., | of this place | died November 3, 1805, |
aged 78 years.

Sacred | to the memory | of the Rev. | John Ridghill, A.M., |
late rector of Welbourne | died December 31, 1817.

On a stone at the end of the nave :
George Brown | died June 2, 1791, aged 72. | Also near this
stone | lyeth Mary the wife of | George Brown | who departed
this life | November the 22, 1811, | aged 88 years. | Thomas
Brown | died Dec. 28, 1770, aged 81. | Ann his wife | died
July 21, 1765, aged 73.

On a stone in the nave :
In memory of Mr William | Green who departed this | life
Feb. 4, 1746, aged 44 years.

A brass plate in the floor of the nave (D) ; arms over— . . . , a
fesse . . . between three crosses patee . . . [Riley] ; impaling—
. . . , a cross ermine [for Camocke]. Crest—On a helmet a griffin's
head erazed. This inscription in capitals :
Here lieth the body of Robert Riley of Welbourn esq. | who
departed this life the 22d of March Ao Dom. 1702. | Prepare
to follow for you know | The debt that he hath paid you
owe.

On a similar one to the west having the same arms over :
Here lieth the body of Henrietta late wife of Robert Riley of | Welbourn esq. who exchanged this life for a better the 3 of Jan. 1696. | If youth and virtue cou^d not save | A fruitful woman from the grave | Reader prepare for you must be | Subjected to Deaths Tyrannie.

A small brass plate more to the west in capitals (R) :
Here lyeth the body | of M^{rs} Eliz. Atkinson | daughter to John Atkinson | of West Retford in | Nottinghamshire who | departed this life the | 12 of June 1705, being the | 22^d year of her age.

A white marble tablet against the wall of the south aisle at the west end :
Sacred | to the memory | of | Mary Brown | wife of Francis Brown esq. | who lived beloved | meek in manner | charitable in disposition, | virtuous in principle | a most dutiful daughter tender mother | and faithful wife. | She died lamented | on the 21 of Sep^r 1807, aged 27 years.

A flat stone at the east end of the south aisle (D) :
In memory of Avery wife of | M^r Barron Britain who died | January the 1st, 1739, aged | 53 years.

On another more to the west in capitals :
Here lieth the body | of Robert Audeley esq. | who departed this life | Feb. the 19th, 1702, | in the 79 year of | his age. | Here lieth the body of | Mary Rudd daughter of | Robert Audeley esq. | departed this life Decem. | the 15, 1729, in the 63 year | of her age.

Another more to the south also in capitals, rubbed (D) :
Here lieth interred the body | of William [Rudd] husband of | Mary Audley the daughter | of Robert Audley, esq., who | departed this life June the 20th, | 1720, | in the 74 year of his age.

A flat stone at the west end of the south aisle :
Sacred | to the memory of | Mary the wife of | Joseph Booth | and daughter of | John and Ann Beale | who departed this life | December the 28, 1805, | aged 20 years. | Also John Beale | who departed this life | July the 10th, 1808, | aged 15 years.

A flat stone near the font :
Here lieth the body of | Elinor Hutton daughter | of Thomas and Mary Hutton | of Borrill in the county | of Lincoln who departed | this life August the 14, 1707, | ætat. 17.

On another more to the north :

> Sacred to the memory of | Eleonor the wife of | Joseph Morley surgeon | who died 24th of March 1808, | aged 60 years. | Also of | Mary Brown Morley | their daughter | who died 12 October 1805 | aged 7 months.

On another near :

> In memory of | Elizabeth daughter of | George & Mary Brown | who died August 19, | 1771, aged 10 | years.

This church is very handsome. It consists of a nave with aisles supported by four very lofty pointed arches with high octagon columns. The clerestory windows are four, of the perpendicular style, and very large of three lights and a transom. The other windows are decorated. The body of the church is very lofty, but the chancel is modern about half the height of the rest, and blocking up half of a fine pointed arch from the nave. At the west end is a tower and spire crocketted. The south porch is handsome ; on each side of the outer arch is a niche crocketed, and one over it tabernacled, in which has been a representation of the Crucifixion, but it is now much mutilated. The font is modern inscribed, ' The gift of John Welby esq. Anno Dom. 1733. W^m Julian fecit'. Between each clerestory window are two arches in the wall.

[See also *L.R.S.* i, 229–30 ; Jeans, 79, Add. 4.]

<div align="right">(MS iii, 207–218.)</div>

Wellingore

Notes taken in the church, 8 August, 1833—

On a brass plate against the second pillar in the north chancel, with the arms engraved on one side thus—On a cross five crescents, a mullet for difference, charged with a crescent [Ellis]. On the other side another coat—A chevron between three crosslets [Copledyke] :

> Here lyeth the body of Mary Ellis wife to | Edmund Ellis esq. & eldest daughter of Thomas | Copledyke of Harrington in the county of Lin | coln esq. who had issue betwixt them two sonnes, | William & Thomas, & six daughters, Martha, Elizabeth, | Mary, Ann, Eleanor, & Hesther, & departed this life | y^e 23 day of November A^o D'ni 1637. Annoq. ætatis 47. | Reader if fame shouldst learne who here is shrin'de | Aske all these neighbouring parts & thou shalt finde | This was a grave wise liver whose chast dust | I'm chosen Treasurer to keep in Trust | That dust where in there once had residence | A mind well stored with religious sence | Words are unable to proclaime her worth | Which her owne actions sett far better forth | Aske all that knew her they'll avouch the same | Good was her life her death and now her fame.

On a black stone in the floor not far from the last, in bas relief :
Here | lieth the body of | Christopher Nevile | who died
December yᵉ 13, 1748, | aged 59 years.

On a stone in the chancel much rubbed (D) :
In memory of Nathaniel | Noble late vicar | of this place
25 years | who was born Oct. 5, 1659 | and died Feb. 15,
1734, | and of | Sarah his wife. She was born | in 1653 and
died Oct. 9, | 1726.

On a flat stone :
Here lyeth the body | of Ann Daughter of Mʳ Robert | Sander-
son and | Dorothy his wife. | She departed this | life April
the 12, 1732.

In the north chancel is an altar tomb of marble having thereon
the recumbent figure of a knight fully armed in plate armour with
a conical helmet and a collar of SS round his neck. He wears a
peaked beard and mustaches. His head rests on a helmet with
the crest of a lion passant. His feet are on a lion. The lady is
at his left hand wearing a long plaited gown fitting close to her
neck, and a mantle fastened across her breast by a cord and tassell.
Her head is covered by a square cap with lappets, and it rests on
a pillow. Her feet on a dog or monkey. The inscription, if there
was any, is now gone. There are four shields of arms round the
tomb, but the bearings are effaced. This monument is ascribed
to the Neville family.

To the east of this against the wall is a stone monument with these
arms cut above—Quarterly of fifteen coats, viz., 1st, On a bend,
cotised, three pair of wings [Wingfield] ; 2nd, Quarterly . . .
and . . . [Bovile] ; 3rd, A plain cross, and a border engrailed
[? Carbonell] ; 4th, Two bars, a canton ermine [Gousell] ; 5th,
Quarterly, 1st and 4th, A lion rampant [FitzAlan] ; 2nd and 3rd,
Checquy . . . and . . . [Warenne] ; 6th, Quarterly and
. . . . , in the first a mullet [Vere] ; 7th, A lion rampant [Bolebec] ;
8th, Barry wavy of six . . . and . . . [Samford] ; 9th, Two bars
gemelles [Badlesmere] ; 10th, . . . , guttee de a saltier
[Sergeaux] ; 11th, A bend ermine between six crosslets [for Howard] ;
12th, Six escallops 3, 2, and 1 [Scales] ; 13th, Per pale and
. . . , a lion passant [Plaiz] ; 14th, A chevron, in a border engrailed
[Stafford] ; 15th, Per chevron . . . and . . . , in chief three
leopards' faces [Lichfield]. Crest—A cap between two wings. This
inscription in capitals :
Charles Wyngefelde who died A.D. 1575. 25 D. of April |
Christ is my life Death was my gaine | By faith in Christ
Heaven I attayne | My flesh for sinne hath felt great paine |
My soule by Christ in joy doth raine | I long did wish to be
sett free | From extreme payne and misery | That I with

Jesus Crist might be | In endless joy and felicitye | Which wish I have by Christ my frend | To God be prayse world without end | Amen.

A flat stone in south aisle (D) :
In memory of Will | iam son of Edward | & Anne Nottingham | who died in his infancy | March 5th, 1752.

Another to the west (R) :
In memory of | Anne | daughter of Edwd | and Anne | Nottingham died | in her Infancy Aug. | 26, 1748.

On another to the west :
In memory of | William Collins | who departed this life | Sep. 25, 1793, | aged 40 years. | Also near this place lieth | five children.

Another to the north (R) :
Susanna | daughter of | Mr Jos: Mutton | and Margaret | his wife who | died Oct. 16, | 1742.

Another more to the west (D) :
In memory of Robert | Sanderson gent. who | departed this life April | the 2d, 1741, aged 60 years.

This church consists of a nave and two aisles supported on three pointed arches with plain piers, a chancel, and north aisle, and a tower with spire at the west end. In the chancel are three stone stalls. In this church there are many old benches.

[See also *L.R.S.* i, 243.]

(MS iii, 199–205.)

ꟿelton le ꟿolð

Notes taken in the church of Welton, 14 August, 1833—

On an old stone in the chancel, round the edge, in old character :
✠ Hic iacet | dominus Thomas Asterby dudum rector Ecclesie de Welton juxta | Ludam qui obiit die mensis Anno d'ni MCCCCXX cuius anime propicietur | deus Amen.

On a brass plate in the east wall of the chancel north of the altar, these arms over—A saltier, charged with another ermine, on a chief three saltiers engrailed [Dyon] ; impaling—Three bars sable, and a canton ermine, a crescent for difference [Marshall] ; there is no date :
Hic jacet corpus | Joh'is Dyon Armigeri.

The church consists of a nave and chancel and a tower at the west end open to the nave, a screen at the west end. The font is octagon pannelled with shields in quatrefoils.

In Smyth Deeds, this Rector of Welton is mentioned, Thomas Beche Rector 21 Hen. 8, 1530, late Vicar of North Elkington.

[See also *Lincs. N. & Q.* xi, 229 ; *L.R.S.* i, 128–9 ; Jeans, 79.]

(MS iv, 71–72.)

𝔚eston

Notes taken in the church, 23 July, 1833, and 23 March, 1836—

A handsome white marble monument, north wall of the chancel, the inscription in capitals, above is a sarcophagus with a book open, the page inscribed Exodus chapt. xx :

> Sacred to the memory of | the Revᵈ William Johnson A.B. | vicar of Bilsby in this county | who died December the fifteenth 1825, | in the twenty fifth year of his age. | He was the only surviving son of | Walter Maurice Johnson clerk of Spalding, | vicar of this parish, and Frances his wife, | ever zealous and attentive in discharging | the sacred duties of his profession | his parishioners deeply lamented their early loss. | His premature death is indelibly engraven | on the hearts of his attached relatives & friends. | O God thy will be done.

Underneath the preceding inscription are these arms—Or, a water bouget sable, on a chief of the second three annulets of the field [Johnson] ; impaling—Sable, two chevronels argent between three roses of the same seeded or [Weller]. Crest—Two wings sable issuing from a ducal coronet or. Motto—Onus sub honore.

A white stone monument against the north wall of the chancel :

> Beneath | lie the remains of Elizabeth | the wife of Mr Jonathan Watson | of Holbeach | & daughter of Mr Joseph Allcock | late of this parish. | She died the 13 of April 1765, in the 37 year of her age. | Also Ann their daughter | died an infant | & Mary, Jonathan & Joseph | survived her.

A white marble monument in two slabs against the south wall of the chancel with these arms over—Sable, two cross bones saltierwise between four emmets or, on a chief engrailed erminois two bulls' heads azure [Emmitt] ; crest—A demi bull azure, charged on the neck with two cross bones or, holding a bezant charged with an emmet sable :

> (1) Beneath | lie the remains of | William Emmitt | many years resident at | St Lamberts. | This world closed upon | his valued life | The first day of July | 1832 | in the sixty fourth year | of his age. | Also | three children who died in | their infancy. | Not my will O God | but thine be done.
> (2) Beneath | lie the remains of | Elizabeth relict of | William Emmitt | and daughter of | Mr John West | grassier | formerly of Swaton | in this county. | She died the 6 day of May | 1834 | in the 62 year of her age. | Be ye also ready | For ye know not the hour.

On a handsome black marble slab before the Communion table :

> In the vault beneath | lie the remains of the Revᵈ | Walter Maurice Johnson | of Spalding. | He was 28 years vicar of

this parish, | and died July 20, 1832, | in the 75th year of his
age. | Also | those of Frances his wife | only daughter of |
George Weller Poley esq. of Boxted Hall | in the county of
Suffolk. | She was born June 13, | 1763, | and died July 18, |
1835.

On a black marble slab like the last :
H.S.E. | quod mortale fuit | Reverendi Gulielmi Johnson
A.B. | de Bilsby vicarii | in hoc comitatu | qui die Decembris
quinto decimo | anno domini MDCCCXXV | obiit | ætatis
suæ XXV°.

On a flat stone in the chancel (C) :
Here | lieth the body of Mary | Farnham relict of Thomas
Farnham | gent. who left issue John, Robert, | and Mary,
died February y^e 18, 1717, | aged 53 years. | Mr John Farn-
ham | was buried near this place | Oct. the 14, 1730, | aged
31 years.

On another (C) :
M.S. | Thomæ Farnham | viri adversus Deum Principem &
Patriam | Pietate non fucata | eiusdem conjugem lectissimam
dulcesq. liberos | (quibus rite informandis operam dedit
sanctissime) | magna rerum verborum fide | gravi-
tate lepore condita | idem erat strenuus in agendis rebus |
consilii plenus | amicus fidus prudens paterfamilias civis &
bonus | obiit 4 id. Jun. MDCCXIV | ætat. XLIV.

On another (C) :
Sacred | to the memory of | Edward Still | who died April 28,
1814, | in the 72 year of his age.

On another (C) :
Here are deposited the remains | of | Thomas son of Thomas
and Hannah Still. | He died 14 of Feb^y 1792, | aged 39.

On another (C) :
In memory of | Ann Blackett who departed this | life the
28 of Dec. 1729, aged 55 | years. | In memory of | Thos. the
son of Thomas and Hannah | Still who departed this life
Dec. | the 28, 1751, aged 9 years, | and three of their children
died | infants. | Mr Thomas Still was here interred | Dec^r
the 2d, 1762, in the 63 year of his | age. | Hannah relict of |
Mr Thomas Still | died June 8, 1788, | aged 75 years.

On a black stone (C) :
In memory of | Thomas Fisher | who died Dec. 9, 1823, |
aged 70 years. | Also Hannah his wife | died Dec. 19, 1828, |
aged 71 years.

On a yellow stone at the entrance to the chancel (C) :
In | memory | of | Mr John Truman | who departed this
life | the | 16 of August 1776, | in the 66th year of his age, |

And | Mrs Mary Truman | relict of | Mr John Truman | departed this life | the 19 day of August | MDCCLXXXIII.

On a marble slab in the chancel (C) :
In memory of | Mr Joseph Allcock | son of Mr Joseph Allcock | who departed this life | the 11 day of April 1771, | in the 35 year of his age.

On a yellow and white stone monument against the east wall of the south aisle :
Sacred to the remains | of Mrs Mary Truman | relict of Mr John Truman | of Weston | who died August 19, 1783, | aged 72 years.

Stone tablet against a pillar facing the south aisle at the east end :
In | memory of | Jane the wife | of Mr So | lomon Lacy | who departed | this life the 25th of | December 1732, | in the 33^d | year of her | age.

On a flat stone near the font much effaced, in capitals :
[In memoriam | charissimi | nepotis |] John the | son of John | Benington gent. | and Catherine his wife | who was daughter to | William and Elizabeth Dellamore | lyeth here buried. | Pie vixit juvenis obiit | Maij 4º sepult. 5º anno ætatis 18º | Anno Dom. 1695. | [Ex impensis—Delamor].

Another to the west :
Here lyeth the body | of John Wilby, gent., | who departed this | life the ninth of Dece | mber 1711, ætatis suæ 37.

On a black stone monument against the west wall of the north transept :
P.M.S. | juxta in pace requiescit | quod mortale fuit | B.D. Johannis Morton hujus ecclesiæ pastoris | docti fidi integri | qui sincera in Deum pietate | morum primi ævi christianorum | simplicitate | liberati[sic] in egenos | præsertim suos hac in parochia | quibus in sempiternum vivet | beneficentia | se Deo et hominibus | gratum reddidit | obiit Feb. ix, Anno | Salutis 1720 | Ætatis suæ 47.

On a slab below on the same monument :
The above named Mr Morton gave to the minister | and churchwardens of the parish of Weston for the | use of the poor of Weston twenty pounds to be | put out to interest, and the yearly interest to be distributed | amongst the poor at the discretion of the minister and | churchwardens of the parish of Weston upon | every Good Friday.

Black flat stone in the floor below (D) :
Here lyeth the body of Mary | the truly pious and religious | relict of James Morton gent. | and the most indulgent mother

of | John Morton vicar of this church | who departed this life June the 30th, | 1710, | ætatis 68.

A flat stone more to the south in capitals :
Here lyeth the body of | Willyam Whettaker clerke | interred. A reverend minister of | God's word in Weston xx. | tie years, and was buryed the 5th of April Anno Dom. 1640.
[James Brecknock, clerk, | late vicar of this place | buried April 1, 1691.]

A flat black stone in the [middle of the] nave :
Here | are deposited | the remains of | Thomas the son of | Robert & Hannah Knott | who departed this life | April the 7th, 1829, | in the 69 year of his age.

Another to the west (R) :
Here | are deposited the remains of | Mr Robert Knott. | He departed this life | September the 15, 1765, | in the 40th year of his age. | Robert the son of | Robert and Hannah Knott | died January 6, 1756, | in his infancy.

Another collateral to the south (R) :
Here | are deposited the remains of | Mrs Hannah Knott | the relict of | Mr Robert Knott | who departed this life | May the 17th, 1790, | in the 67th year of her age. | Francis the son of | Robert and Hannah Knott | died August the 27, 1760, | in the 3ᵈ year of his age.

A black marble slab to the west of the last in capitals :
Sacred to the memory of | William eldest son of | Robert Fisher of this | parish and Ann his wife | who died March 11, 1827, | in the xxxiii year of his | age, | and of Francis | their sixth son | who died March 1st, 1815, | in the xi year of his | age. | George their seventh son | died May 28th, 1808, | in his infancy.

[On a black slab to the west :
Sacred | to the memory of Ann | wife of | Robert Fisher of Weston | and daughter of | Robert and Hannah Knott | died April 9, 1812, | in the 79 year of her age.]

A flat stone near the font in capitals (D) :
Here lyeth the | body of Jeferye | Wallet the sonne | of Thomas and | Avis Wallett ber = | ryed Marche | 8, Anno Domini | 1640.

This church consists of a nave and aisles, chancel, and tower at the west end. The nave rests upon five pointed arches. There are two transepts, and the chancel is separated from the nave by a fine pointed arch, with clustered columns, as are the other columns. The font is raised three steps from the floor, is octagon, and ornamented with flowers. There is a south porch with Early English

door ; round the porch inside are ten pointed arches on single disengaged columns.

On a tablet of black wood against the south wall of the south transept is the following list of benefactors (D) :

John Harrox gent., Sept. 1560.

William Wells gent., 22 Oct. 1629.

Mr Osborn.

George Cook.

William Seagrave.

John Burrow dec^d, March 22nd, 1718.

Thomas Farnham gent., 14 June, 1714.

Mrs Farnham widow, dec. Feb. 18, 1717.

Rob^t Farnham dec^d Jan^y 18, 1720.

Lady Trollope.

John Morton vicar, dec. Feb. 9, 1720.

Gregory Tunnard, dec. Feb. 8, 1721.

John Moor, dec^d May 20, 1722.

Mrs Susanna Farnham, dec^d April 4, 1787.

Thomas Knott, April 7, 1824.

[See also *L.R.S.* i, 169 ; *Churches of Holland.*]

(MS ii, 139–155. MS ix, 7–8.)

Whaplode

Notes taken in the church of Whapload, 23 July, 1833—This church has been described at large by Mr Oliver [in *Gentleman's Magazine*, 1829, part ii, 586–90] but the following notes have been taken as omitted by him.

On a black tablet against the south wall of the south aisle :

In memory | of | Ann the relict of | Benjamin Grant | who departed this | life the 6 of April | 1734, | aged 62 years.

Next to the preceding a monument with black letters on a gilt ground :

Neare this place lyeth | y^e body of Ben. Grant | who dyed Feb. 24, 1716, | aged 52 years. | Also 5 of y^e children | which he had by Ann | his wife viz. Wm, Ben., Ann, | Elizab., & another Ann ; | they all dyed infants.

On a black stone before the chancel (D) :

In memory of | Susannah Mariah the wife | of John Whel- dale | who departed this life | February y^e 25, 1781, | aged 28 years. | Also in memory of | William Aistrup | who departed this life | December the 27, 1787, | aged xxx years.

On a stone more to the west of the last (D) :

Here lyes the body | of the Rev^d Mr John Ekins A.M. | vicar of this church who | departed this life the 31 day of | July 1707.

On a black stone before the font :
> Here are deposited the remains of | Mr John Cook. | He departed this life | April the 5, 1790, | aged 37.

On a black marble slab at the extremity of the south aisle :
> In memory | of Edward Savage | who departed this life | the 4th of May 1791, | aged 59 years. | Here also lieth three of his infant children, | also Sarah the relict | of the above | Edward Savage | who departed this life | May xv, MDCCCII, | aged LXXII years.

On a flat stone in the chancel :
> To the memory of | Susanna | the wife of | John Oliver | who died October XXII, | MDCCCXXIV, | aged XXXIII years.

Upon another close under the north wall :
> John Thomas vicar of Whapload | departed this life October ye 7th | Anno Dom. 1688.

A flat black stone in the chancel near the entrance :
> Sacred | to the memory of | Thomas-Sooley Blackith | who died January 8th, | MDCCCVII, | aged XLIX | years. Also Mrs Jane Blackith died June 9th, 1831, aged 71.

Another collateral to the last more to the north :
> Sacred | to the memory of | Robert Tunnard Blackith | son of | Thomas Sooley Blackith | and Jane his wife | died Nov. 20, 1811, | aged XXVI.

On two white collateral lozenge shaped stones within the altar rails :
> Frances daughr of the Revd | Saml & Eliz. Oliver | died Nov. 10, 1811, | aged XXVII.
> Mary | wife of the | Rev. Jno Watkins | and daughter of the | Revd Samuel & Eliz. | Oliver | died Oct. 16, 1818, | in the 32d year | of her | age.

On a flat stone in the nave near the entrance to the chancel :
> Here | lieth the body of Elizabeth | the wife of John Aistrop who | departed this life the third day | of November 1719 | in the 29th year of her age. | In memory of Joseph son of John | and Ellenor Aistrup | who departed this life Feb. ye 2 | 1753, aged 19 years. | Also Ellenor ye second wife of John Aistrup | who departed this life Oct. ye 17th, 1755, | aged 63 years. | Beneath this stone lies interred | the body of Susanna Aistrup the wife | of Samuel Aistrup who departed this | life the 17th day of March 1777 | aged 44 years. | Also John Aistrup who departed this life Dec. 2nd | 1754, aged 71 years. | Also three of her children | who died infants. | Beneath this stone lies interred | the body of Samuel Aistrup | who departed this life the 9th day | of August in the year of our Lord | 1778, aged 53 years.

There are slabs in the nave to :
>James Hinman, died April 22, 1710, æt. 47.
>George & John sons of James & Mary Hinman, died infants ;
>>John in 1702.
>Elizabeth Johnson, died March 8, 1710, æt. 79.
>Ann daughter of Nathan & Mary Huckbody, died August 12,
>>1717, æt. 3.
>Mary wife of Nathan Huckbody, died April 18, 1729, æt. 33.
>John March, died March 10, 1728, æt. 60.
>Tobias & Eliz. son & daughter of Tobias and Isabella March.
>>Tobias died Sept. 28, 1711.

[See also *L.R.S.* i, 176–177 ; *Churches of Holland* ; *G.M.* 1829, ii, 586–90 ; 1830, i, 591 ; 1830, ii, 104 ; W. E. Foster, *Parish Church of Whaplode*, pp. 48, 52.]

(MS ii, 109–116.)

Whaplode Drove

Notes taken in the chapel, 31 March, 1836—This chapel is modern and built about 20 yards from the site of the old chapel, and to the east of it. It consists of a nave without aisles, having a bow for a chancel and a small turret for three bells at the west end. The windows are quite plain sash ones ; a gallery at the west end.

On a wooden tablet against the north wall of the nave is the following :
>This chapel was rebuilt and | enlarged in the year 1820 by subscrip | tion & rate, by which means two | hundred additional sittings | have been obtained, of which number one | hundred and thirty are hereby | declared free and unappropriated | for ever, in consequence of a grant | from the Society for promoting the | enlargement and building of Churches | and Chapels, and in addition to | forty formerly provided. | James Blundell, Minister | William Blake, Chapel Warden.

On a grey and white marble monument against the wall south of the bow to the chancel :
>Near this place | was buried the body of | John Kelk late of Postland esq. | Feoffee for this Chapel | who died July 25, 1795, | in the 63ᵈ year of his age.

At the bottom :
>And also the body of | Levina Kelk daughter of the said | John Kelk & Mary his wife | who died in her infancy.

A black tablet against the wall on the north side of the arch :
>Erected by voluntary contributions | to the memory of the | Revᵈ John Dinham A.B. | Minister of this Chapel | who departed this life Octʳ 14, 1811, | aged 50 years. | Near half

an age with every good mans Praise | Among his Flock the
Shepherd passed his days | The Friend the comfort of the
rich and Poor | Want never knocked unheeded at his door |
All mourn his death his virtues long they tried. | They knew
not how they loved him till he dyed. | Peculiar Blessings
did his life attend | He had no foe to all he was a friend.

On a flat stone (R) in the chancel of the old Chapel, now exposed
to the air, but remaining in its old position. The inscription in
capitals :

Here lyeth the body of | Alice the daughter of | Martin Heaton
cler. by | Alice his wife who departed | this life October the
6th, 1690. | Also the body of Elizabeth the | daughter of
Martin Heaton | by Alice his wife who departed | this life
June the 28, 1694. | And the body of Edward the | son of
Martin Heaton by | Alice his wife who departed | this life
March the 24, 1696. | Also the body of Martin | Heaton cler.
who departed | this life April the 22, 1697.

On another to the north of the last (R) :

In memory | of Alice Heaton the relict of | Martin Heaton
of this place | clerk | and own sister to James Boulton | of
Moulton gent. who was | buried the 10 day of Feb^y | Anno
Dom. 1706 | and in the 53 year of her age.

To the south of the first is another stone, but so defaced by mould
and grass that all cannot be decyphered (D) :

In memory | of Robert Russell who departed this life |
. day of April Anno Dom. |

There are two or three other stones (D) which were in the old
chapel, but from exposure to the air, and the effects of the rain,
grass, and mould, they are illegible.

 (MS ix, 27–30.)

Wickenby

Notes taken in the church, 15 October, 1840—The church consists
of a nave, south aisle, and chancel which is separated from the nave
by an old screen, much decayed, by which are hung up two ancient
halberts (D) which were found in a heap of rubbish in the church.
In the window of the south aisle is this shield in old glass—Azure,
a lion rampant between fleur de lis or, over all a bend gobony argent
and gules [Beaumont].

Against the east wall of the south aisle is a brass plate on which
above is this shield of arms engraved—A chevron between three
bridle bits [Millner] ; [below lies a figure in a shroud] ; and on
each side is a scull crowned with laurel in a cup, underneath
this inscription :

Behold thy selfe by me | Such one was I as thou | And thou
in time shall be | Euen dust as I am now. | Here lyeth y^e

body of Henry Millner | gent. who departed this life the |
31th day of Ivly, Anno nativitatis 65 | Anno Domini 1635.

On an old stone in the chancel is this inscription (D) :
Here lieth the body | of Sʳ Edm. Cooper | knight four times |
Lord Mayor of York. | He died April . . , 1650, | W. Reresby
being | then rector of this | parish.

On another stone close by (R) :
Here lieth yᵉ body of yᵉ | Revᵈ Samuel Batchelor | Rector of
this church | who departed this life | May the ninth, 1741, |
aged 33 years. | Here also lieth the body | of Mary Batchelor
his wife | who departed this life | November the 8, 1790, |
aged 85 years.

There is also another stone (D) inscribed to Theresa Hoyland
daughter of Sarah Hoyland who died April 15, 1770, aged 42.

[See also *L.R.S.* i, 116–17 ; Jeans 79.]

(MS x, 21–23.)

Wigtoft

Notes taken in yᵉ church, 12 September, 1839—This church is
principally of yᵉ decorated order. It consists of a nave, aisles,
and chancel, south porch, and tower and spire at yᵉ west end.
The nave and aisles rest upon four decorated arches springing from
handsome clustered shafts. The arch to yᵉ chancel has been
blocked up when yᵉ church was repaired in 1816, and a fine wooden
screen of decorated work, barbarously cut away to make room for
the pulpit stairs, which pulpit (R) is stuck right in yᵉ middle of
the nave with its back to yᵉ altar in yᵉ modern fashion. The
windows of yᵉ church are all decorated except those of the chancel
which are perpendicular, of which style is, I think, the clerestory.
The south aisle windows are very good. The eastern window is
a square modern disfigurement. In one of yᵉ windows of yᵉ north
aisle is a shield of arms, being—France and England quarterly.
One of the corbels (R) of the timber roof is very singular, being a
figure of a man with his head between his legs. The font is a
modern stone trough. The church is regularly pewed and has
quite a modern appearance inside. The tower is Norman for its
three lower stages, and has a very curious window on the western
side adorned with yᵉ toothed and chevron mouldings, and having
shafts at yᵉ side of a singular form thus :

The upper story of the tower, which is a short one, is perpendicular.
The south porch is Early English and curious, having yᵉ cornice

of yᵉ sides supported by a range of low round-headed arches like yᵉ Norman work we see occasionally on yᵉ cornices of walls.

A common stone tablet with cherubs, &c., against the east wall of the chancel (D):

> Near | this place lieth | yᵉ body of Edward | son of Edwᵈ James | clerk by Martha | his wife who | died Decembʳ | yᵉ 2ᵈ, 1722.

A flat stone in yᵉ floor near yᵉ entrance to the chancel:

> Hic jacet | D: Jesu expectans Epiphaniam Gulielmus Smyth | Ecclesiæ hujus Pastorum | unus et nemini secundus | Ecclesiæ Anglicanæ membrum vere orthdoxum. | Idem ex | Vera Pietate in Deum | Summa Integritate in amicos | Egregio amore in Suos | Nota Probitate in omnes | insigniter celebris | Vero omnium cum luctu | E Vita migravit 27º Octob : | Ætatis 45º | anno Dom. 1717.

A black stone in the north aisle, lying crossways north and south (R):

> In memory | of | John Dickinson gentleman | who departed this life the 5th day | of June 1740, aged 53. | He was a tender husband, an indulgent | and provident parent, a peaceable | neighbour, a sincere friend, In | all his dealings honest & upright, | in his faith and practise a sound pious & charitable Christian. | Go reader and do thou likewise.

Another to the south of the last (R):

> In memory of Mary the wife | of Mr William Taylor who de | parted this life June yᵉ 27th, | 1738, ætatis suæ 64. | Thomas Abbott Wright son | of Noble Thomas Wright gent. | who died in his infancy | was under this stone with his | grandmother Mrs Taylor | interred Febʸ 26th, 1741.

Another more to the south in yᵉ nave (R):

> M : H : P : S : | Brigidæ | Revᵈⁱ Trubshaw Bates, A.B., | uxoris | ob : an : Æt. suæ 38 | Sal : suæ 1740.

Another more to the south (R):

> In memory of | Mr Henry Conington | citizen of London | and late a linnen draper | in Cheepside and | free of yᵉ Fishmongers Company. | He was grandson to the late | Mr Thomas Wright | and departed this life | Decʳ the 4th, 1770, | aged 45 years.

Another more to the south of the last mentioned inscription (R):

> In memory of John Wright | son of Thomas Wright gent. | by Mary his wife departed | this life February yᵉ 17, 173⅔, | in the 22 year of his age.

Another still more to the south (R):

> Here lyeth the body of | Thomas Wright | gent. interred October | the 1st, 1723, | aged 50 years | And also Mary

his | daughter. | In the same Grave | with his father sleep | the remains of Noble | Thomas Wright, gent., | who exchanged this | life for a blessed | immortality May yᵉ | 1st, in yᵉ 29 year of | his age and of our | Redemption 1743.

In the south aisle is a flat stone which has had an inscription round yᵉ edge in old character, but it is now illegible.

A flat stone in yᵉ north aisle :

Here lieth yᵉ body | of William yᵉ son of | Thomas Wright gent. | by Mary his wife, | who departed this life | Janʸ yᵉ 22, Anno D'ni | 1697.

[See also *L.R.S.* i, 168–69 ; *Churches of Holland*.]

(MS ix, 205–211.)

Cherry Willingham

Notes taken in the church, 6 August, 1833—The Register begins in 1662, but contains very little. Daniel Bull, vicar, 1662 ; Thomas Cooke, vicar, 1664 ; J. Sedgewick, curate, 1688. 1669, Ellen wife of Mʳ John Stow buried 19 October. 1680, Mʳ Curtis buried Sept 30.

On a marble monument south of the chancel with these arms under —Or, three conies sejant proper [for Dell] ; impaling—Or, two bars dancette, on a chief azure, three annulets [Becke] ; sarcophagus over the tablet :

In | dutiful and affectionate remembrance of | Mary | the wife of Joseph Dell | of the city of Lincoln esq. | the only daughter | of John Becke esq. and Judith his wife | who died on the 16 September 1795, | aged 55 years. | This tablet | was erected by her only child | Mary Judith | the wife of Henry Hutton esq. | This marble | is also intended to keep alive | the like remembrance of | Joseph Dell esq. | above named, who died on the 8 day of May 1807, | aged 74 years, | and whose remains are also interred | in the vault beneath this chapel.

On a white and grey marble monument at the east end of the nave in the form of a sarcophagus with these arms under—Argent, on a fess three bucks' heads cabossed or [Hutton] ; on an escucheon —Quarterly, 1st and 4th, Dell ; 2nd and 3rd, Becke ; Crest—A sheaf of three arrows azure pointed or, feathered argent passed through a ducal coronet or :

To the much loved memory of | Mary Judeth the wife of Henry Hutton esq. | who died on the 23 day of August 1809, | in the 42 year of her age. | This marble in honor of her many virtues & of the high character | she uniformly maintained in the relative situations of | Daughter, Wife, and Mother | is deservedly erected by her surviving husband.

On a handsome white marble monument against the north wall
of the chancel, arms over—Becke ; crest—A fox's head (R) :

> Here repose the remains | of Thomas Becke of Lincoln, esq., |
> the founder and patron of this church, | whose experienced
> abilities in the profession | of the law | and unparallelled
> industry | enabled him to acquire a fortune | (without the
> sordid means of avaricious parsimony) | in times to whose
> extravagance few patrimonys | sufficed, | who had so much
> endeared himself to his intimates | by his meritorious conduct
> in the several relations | of Husband, Father, and Friend |
> that his death | at an age to which Temperance alone can
> extend | vitality | seemed to them as immature as it was
> sudden. | He was born 29 March 1690, dyed 19 Oct. 1757. |
> John Becke, esq., | erected this monument in pious veneration |
> to the memory of his father. | John Becke, esq. | only son of
> the said Thomas Becke | died 17 December 1763 | aged 51. |
> Thomas Kellet Becke esq. | only son of the said John Becke |
> died 7th April 1780, aged 35. | Judith Becke | widow of the
> said John Becke | died 30 January 1791, aged 75.

Below :

> This monument was repaired and additions made to it | by
> Henry Hutton esq., and Mary Judith his wife | great grand-
> daughter of the said Thomas Becke | A.D. 1799.

This church is modern and consists of a nave with a bay for a
chancel, and a bell turret at the west end.

(MS iii, 137–141.)

Wilsthorpe

Notes taken in the chapel, [blank] July, 1833—

A marble monument against the south wall of the nave before
the entrance to the chancel, the heads of three cherubims and
below these arms—Paly of six or and azure, a fesse chequy azure
and or [Curtis] :

> Sacred to the memory | of the Curtis family, | Lords of this
> manor, | this monument is erected by their heiress | Elizabeth
> the wife of Sr John Smith bart. | of Sydling, Dorsetshire, |
> particularly of her most lamented father | Robert Curtis
> esq. Barrister at Law. | He died March 18, 1743, aged 33
> years, | universally beloved and respected, | leaving her his
> only child by | Elizabeth the daughter of John Wildbore |
> of Peterborough esq. | Likewise in grateful remembrance | of
> her uncle Noah Curtis esq. | He died unmarried Oct. 12,
> 1759, | aged 56 years, | and left her his heir. | Their remains
> with those of Edward their father | (who built this church) |
> lie deposited within the chancel.

An atchievement over the door of the chancel, two shields : the dexter—Sable, a fesse cottised between three martlets or, in middle chief the arms of Ulster [for Smith] ; on an inescucheon—Paly of six or and azure, a fesse chequy azure and or [Curtis]. The other shield bears the escucheon alone (D).

An atchievement (D) over the entrance door, two shields ; dexter —the same arms as the other dexter shield ; sinister—Azure, a griffin segreant or [Morland]. Crest—A greyhound sejant chained proper.

On a small tablet (D) near the monument, the arms of Curtis ; impaling—Two boars passant [for Wildbore].

On each side of the base of the font is a shield : On the east— Sable, a fesse cottised between three martlets or [for Smith] ; on an inescucheon—Or and azure. Crest—A greyhound sejant chained or (D). On the north—Per pale gules and sable, a lion passant guardant argent [Neale] ; On the west—Curtis ; impaling—Per pale gules and sable, a lion passant guardant argent (D) ; On the south—Argent, a fesse between three greyhounds heads couped sable (D).

(MS i, 123–125.)

Wispington

Notes taken in the church, 17 October, 1840—The church is an old building with a brick tower ; and the nave communicates with the chancel by three low arches.

Over the entrance to the chancel on an oval tablet (R) :
Sacred | to the memory of | the Reverend John Martinson late vicar of this | church and rector of Screamby who departed | this life the 16 of July 1788, aged 51 years.

On an old stone (R) in the chancel, very much rubbed, on which has been the figure of a priest with his head reclining on a cushion and this inscription round the edge :
[Hic | jacet dominus Jo | hannes Hetsete] quondam Rector [istius] ecclesie | qui obiit | . . . mensis | anno d'ni MºCCCCLXXX octavo | Cuius anime propicietur deus | Amen.

On a flat black stone in the chancel, the upper part of which is hid by a pew (R) :
[Here lyeth the body of] Robert Phillips gentleman | who departed this life the | 24 day of June 1668.
And underneath is added :
On the south side of this | stone, close to it, lyes the body | of Phillips Glover esq.

On a tablet against the wall on the north side of the chancel with

these arms—Azure, a chevron between three falcons argent
[Phillips]. Crest—A demi falcon argent :

> To the memory | of | John Phillips esq. | this monument is
> dedicated | by his nephew & heir | Phillips Glover esq. | He
> was the 2nd & last surviving | son of Robert Phillips esq. |
> who lyes buried in this chancel. | He dyd unmarried on the
> 19th of | February 1719 : 20, aged 62, | and in him his family
> was extinct. | In memory of | Phillips Glover, esq. | He married
> Mary the daughter | and heiress of Richard Lee esq. | of
> Winslade in Devonshire, and left | 2 children, Phillips and
> Mary. | He died June 18, MDCCXLV. | Veri cultor et libertatis. |
> This inscription is by his order.

On a tablet on the south side of the chancel with the same arms
as the last :

> Near this place | lyeth the bodie of | Robert Phillips esq. |
> who departed this life the 24th | day of June 1668, | and of
> Stephen Phillips esq. eldest sonn of | Robert, who departed
> this life the 9 of Feb^y 168⅔, | and of Robert Phillips of
> London, | gold smith, third sonn of Robert | Phillips who de-
> parted this life | the 12th of December 1707, | and of Benjamin
> Phillips, | merchant, 4th son of the | abovesaid Robert who |
> departed this life | Aug^t the 8th, 1715, | æt. 49.

[See also J. Conway Walter, *Parishes round Horncastle*, pp. 240–1.]

(MS ix, 235–238.)

Witham on the Hill

Notes taken in the church, 20 July, 1833—

Upon a brass plate against the wall north of the altar, this in
capitals :

> Hic jacent Robertus Harington Armiger et | Alicia uxor
> ejus qui quidem Robertus obiit | Quarto die Ianuarii Anno
> D'ni 1558, et anno | Regni Elizabethæ Dei *gracia* Angliæ
> Fraunciæ et | Hiberniæ Reginæ fidei defensoris etc. primo. |
> Eademque Alicia obiit 23 die Novembris Anno | D'ni 1565,
> et Anno dictæ Reginæ octavo.

A white marble pyramidal tablet against the north wall of the
chancel in capitals :

> Sacred | to the memory of | the Rev^d Woolsey Johnson clerk |
> who died April 21 1756 | in the sixtieth year of his age, | and
> Jane his wife daughter of | Richard Russell esq. of Warwick, |
> who died February 9 1759 in the | fifty second year of her age. |
> Also of George William Johnson, esq. | eldest son of the
> above Woolsey | Johnson and Jane his wife | who died February
> 8, 1814, | in the seventy fourth year of his age. | Through life
> beloved.

On another tablet more to the west :

> Sacred to the memory of | the Rev^d Robert Augustus John-
> son | rector of Wistanstow in the county of Salop, | and of
> Hampstall Redware in the county of Stafford | Born October
> the 21, 1745, | Married January 21, 1773, Anna Rebecca |
> sister to William Lord Craven | by whom he left issue 3 sons
> & four daughters. | Died at Bath January 8, 1799. | Beloved,
> Esteemed, Lamented.

An atchievement (D) against the north wall of the chancel bears
these arms—Argent, a chevron sable between three lions' heads,
erazed gules, crowned or [Johnson]. Crest—On a torce of his
colours, a lion's head as in arms. Motto—Spes mea in Deo.

On a flat stone in the nave near the west end (D) :

> In | memory of | Henry Goodlad | who departed this life |
> October the 10th, 1781, | in the 49th year of | his age.

Upon another to the east (D) :

> In | memory of | Henry Goodlad | who departed this life |
> Feb. 11th, 1795, | aged 59 years.

This church consists of a nave, separated from the north aisle
by four pointed arches, and from the south by four Norman ones.
A fine Norman arch to the chancel (D). There is a north transept,
and a tower and spire which are both modern at the south side.
The west window is large. The church has lately been repaired.
The vicar is the Rev^d [John] Cheales.

[See also *Lincs. N. & Q.* xii, 36–7 ; *L.R.S.* i, 102 ; Jeans 81.]

(MS iv, 165–168.)

North Witham

Notes taken in the church, 16 August, 1837—

On a brass plate in the chancel, from whence a figure in brass has
been removed, this in old character :

> Hic jacet Will'us Mistarton de North Witham | armiger,
> dominus de Swæffelde qui obiit xxi | die mensis Januarii
> Anno domini mill'imo | cccc vicesimo quinto cui*us* a*n*ime
> p*r*opicietur deus.

A black marble monument against y^e north wall of chancel, arms
over, nearly effaced, apparently—A chevron between five fleur de
lys or [for Johnson]. The inscription, being on a black ground,
is very difficult to decypher :

> P.M.S. | Thome Johnson | de North Witham in Com. Linc.
> Arm. | Willielmi Johnson Armig. | et Angeletæ Filii | mortem
> secularem obiit ut in vitam æternam iniret | 6° kal. Sept.
> Anno salutis 1697 | Ætatis 51. | Hanc tabellam marmoream |
> Aureæ vice qua dignius erat curatam | illibati semper amoris
> pignus | uxor mærentissima | Maria Johnson | posuit.

A brass plate below in capitals :
> Here lyeth the body | of Thomas Johnson esq. | deceased August the 27th | 1697.

A black tablet against the south wall of the chancel :
> Nere this place lieth the body of | Richard Garnon | Master of Arts and | rector of North Wytham, who was | descended from the Garnons | of Brant | Broughton in the county of | Lincoln ; he died the fifth day of | February in the year of our Lord 1688 | And in the sixty fourth year of his age.

Below are these arms—A stag's head cabossed, a mullet for difference [Garnon] ; impaling—Three boars' heads [query for Clarke] ; above are the arms of Garnon only.

In the north wall of the chancel is a low pointed arch under which is a slab of alabaster stone with a cross cut thereon, and across the stone the following inscription in old characters much effaced :
> Hic iacet Nicholaus | . . ie cuius anime propicietur deus amen. [No doubt the tomb of Nicholas Tye, died 1410, who desired to be buried in the chancel.]

A tablet against the south wall of the chancel :
> Near this place | lieth interred the body of | the Revᵈ Mr John Plumpton | rector of this parish who | after a long & painful illness | died May the 9th, 1766, | aged 46 years.

A stone tablet (R) against the outside of the south wall of the chancel near the west end :
> Near this place lye | the bodys of Nicolas Troughton | and Elizabeth his wife. | He dyed the 17 | day of Sep- | tember 1703 | in the 78th year | of his age. | She dyed the 28th | day of March | 1689 about the | 52 year of her | age.

In the churchyard is an altar tomb which apparently has had a brass plate thereon, but it is now gone ; on yᵉ north side of it is a shield bearing—A fesse vaire between three eagles displayed [Kinardesley]. At yᵉ end a crest of a greyhound sejant under a tree [Kinardesley] ; and at the west end a shield bearing a lion rampant.

Another altar tomb bears the arms—A chevron between three boars' heads ; crest—A bugle horn. Another has a stag's head cabossed, a mullet for difference [Garnon]. Neither of these have any inscription apparent at yᵉ present time.

This church consists of a nave, and a chancel which has once had a north aisle or chapel attached to it, and an Early English tower and spire at the west end. The south porch is also of that style. The font is circular pannelled with a series of arches and pillars. There is a Norman north door adorned with the chevron moulding. There are preserved in the church two old oak bench fronts, bearing arms cut upon them as follows—Quarterly, 1st, A

fess dance between six billets [De la Launde] ; 2nd, a lion rampant, double queuée [Welles] ; 3rd, A cross between four eagles' heads [Tye] ; 4th, Ermine, a fess between three crosslets fitchee [for Wyke]. Crest—On a helm and mantling, a lion passant guardant ; supporters—Two eagles. The other shield bears the same arms except that the third is the same as the second quarter, and the crest is a lion rampant.

[There are also monuments to Johnson, Frankland, and Sherard.]

[See also Jeans, 46–7.]

(MS ix, 115–119.)

South Witham

Notes taken in yᵉ church, 16 August, 1837—This church consists of a nave and aisles, resting on yᵉ north side on two Norman arches having plain columns with sculptured capitals, and on yᵉ south side on two decorated arches with octagonal pillars, yᵉ eastern one having its capital foliated. Two transepts ; in yᵉ north, a perpendicular window. There is no chancel. At yᵉ west end is a turret containing two bells, on yᵉ larger of which is this inscription : ' Although my voice be shrill & small | I shall be heard aloud to call | Intactum sileo. percute dulce cano | 1785 Nottingham'. On yᵉ least bell is yᵉ same Latin inscription and date. Two arches (D) are on each side supporting yᵉ tower, or rather turret, one behind yᵉ other, yᵉ foremost a pointed sharp arch yᵉ hinder Norman. Yᵉ font is octagonal having fleur de lys cut on yᵉ sides apparently unfinished.

A monument against yᵉ east wall, north of yᵉ altar (R) :

> Juxta hunc tumulum jacet | corpus Dominæ Elizabethæ | uxor Caroli Halford | Armigeri filia et cohæres | Tho. Mitchel de South | Witham in comitatu | Lincolniæ Armigeri obiit | decimo septimo die | Februarii Anno Dom. | MDCXCIV, Ætatis | suæ LXIII.

A stone tablet (R) against yᵉ east wall of yᵉ north aisle, with these arms below—Three cinquefoyles, a chief [Stone] ; impaling—On a chevron between three swans a crescent [Mitchell]. Above yᵉ monument a crest of a griffin's head and wings issuing from a ducal coronet, and a motto all that could be decyphered of which was, ' Tantum Mors corporum edax '.

> Beneath yˢ monument lyes yᵉ body | of Ann eldest daughter & coheire of | Tho. Mitchell esq. by Kath. his wife, both | interred in yᵉ church, who had issue 3 sons | & 3 daughters all borne in yˢ parish & 4 | buryed as aforesaid. | She was first married to Luke Norton esqʳ | who had issue Lettice & Katharine, both | dead, yᵉ former in yᵉ 4th year of her age

& | was buried in ys church A'no 1668 as hir | father before A'no 1666. | Her second husband was Heny Stone late | of Skellingthorpe in ys county esquire | who dedicates ys memorial. | She was borne in April A'no 1623 and | dyed December ye 2d, 1673. | All flesh is grasse &c.

On a brass plate (R) in ye wall under ye last monument these arms —A fret [Harrington] ; . . . impaling—Barry of eight . . . and gules, in chief a greyhound currant [Skipworth]. This inscription in capitals :

Here lyeth buryed Elizabeth | wife to Thomas Harrington of | South Witham esq. and one of the | daughters of Henry Skipworth of | Kethorpe in the county of | Leicester esq. who dyed the x of | Februarye 1597.

On a brass plate (R) in ye east pillar of ye north aisle in old character :

Margery seconde wyffe of Frauncys Harryngton | esquier dyed 16 Aug. 1577, 19 Eliz., | and left issue betwene them two sonnes | Edward and Fraunceys & one daughter Lucy.

A stone monument (R) against ye east wall of ye north transept arms over—Two bars in chief, three stags' heads cabossed [Wimberley] ; impaling—A horse's head couped [Marsh]. This inscription in two columns :

(1) Near this place | lieth the body of | Willm Wimberley | gent. who died July 23, | 1751, aged 85.

(2) Beneath | this monument | lyeth the body of | Catherine the wife of | William Wimberley | who deceased Jany | the 19 day of 17$\frac{16}{17}$ | aged 44 years. | Also | the body of William | Wimberley the son of the | abovesaid William and Catharine | who departed this life | December the 25, 1722, | aged 22 years.

A stone tablet (R) to the south of the last :

Near | this place | lyeth the body of | Sherard Wimberley | gent. who died Oct. 17th, 1751 | aged 53. | Likewise the body of | Mrs Frances Wimberley | wife of the said | Sherard Wimberley | gent. She died Decr ye 20, 1754, | aged 52.

A square marble tablet surmounted by an urn against ye west wall of ye north transept (R) :

Sacred to the memory of | Margaret wife of Richd Lluellyn | esquire who after a life spent in the | exercise of every Christian virtue | died on the 15th of January 1822 | in the 81st year of her age. | And | in the same vault near the altar with his | beloved wife are intombed the remains | of Richard Lluellyn esq. who died Jany 5, | 1829 in his 89 year sincerely lamented.

On a flat stone before y^e altar:
> Here | lies the body of | Richard Lluellyn esq. | grandson of Elizabeth Halford | who departed this life the 27th | day of May 1768 | aged 67.

Another more to the south (D):
> M. L. 1822. | R. L. 1829.

A black flat stone to the south of the last (D):
> Sacred | to the memory of | Grace Catherine Louisa Manners | who departed this life | the 27th Jan^y 1800 | aged 18 months.

A stone tablet against the east wall of y^e south transept:
> To the memory of | the Rev^d Daniel Downe | rector of this parish | 38 years who dep^d | this life Feb. 28, 1776, | aged 66 years. | He was a tender husband | an indulgent parent | a sincere friend and good | neighbour.

A black and white marble tablet (R) to the south of y^e last with an urn over, and this inscription in capitals:
> Sacred to the memory of | James Hewerdine | Lieu^t of South Hants Militia. | He lived beloved | and died lamented | December 20, 1820, | aged 48 years. | In grateful remembrance of his honour | truth and love his affectionate widow cau = | sed this monument to be erected to his memory.

[See also Jeans, 63.]

(MS ix, 103–110.)

Wootton

Notes taken in the church of Wotton, 31 August, 1835—This church consists of a nave and aisles, resting on three pointed arches on each side, a chancel, and a tower at the west end, and a south porch. The arch between the nave and chancel is pointed, but the pulpit (D) now stands in the middle of it. The chancel was rebuilt by the late Lord Yarborough. The font (R) is ancient and round.

A white marble tablet (R) against the east wall of the chancel south of the altar:
> Near this monument lies interred y^e body of | Francis Ellis gent. third son of | Richard Ellis late Alderman of Hull. | He departed this life y^e fifth of August | 1759 in the sixtieth year of his age.

In the chancel are flat stones to the memory of:
> Mary wife of John Steel 29 May 1797, æt. 43.
> John Robert their son died 17 Nov. 1819, æt. 25.
> Samuel Steel died 26 June 1792, æt. 80.
> Ann his wife died 11 May 1812, æt. 96.
> Mr John Faulding died 8 Feb. 1761, æt. 69 (D).

On an old stone at the west end of the south aisle much rubbed :

> Depositum Samuelis filius 3 | Johannis Uppleby et Barbaræ |
> uxoris ejus de Wotton qui | sepultus fuit 20 die Aprilis |
> salutis reparatæ 1680 Annoque | Ætatis suæ 10. | Nil
> me solicitum decima post | pallida messem | Mors puerum
> hinc rapuit | Quæ mihi lucra fuit | Tu cave ne plores pauco |
> qui tempore vixi | Pauca etiam vidi | sustinuique mala |
> Quis ego ne dubitas Fælix | Sum parce querelas | Vive pie
> mecum tu | quoque prosper eris.

A marble monument over the north door surmounted by a
cherub ; arms—Azure, six martlets argent, on a chief argent three
bucks' heads proper [Bentley] :

> Near this monument lies interred the body | of Ann the wife
> of John Uppleby esq. daughter | of Christopher Bentley of
> Hatcliffe gent. | She departed this life the 18 of April 1768 |
> in the thirty second year of her age. | Also the body of the
> said John Uppleby who | died the 15 of May 1786 in the
> fifty second | year of his age. | Also of Elizabeth his second
> wife who died | the 9th of January 1813 aged 67 years.

A white marble tablet against the wall west of the north door,
these arms over—Three lions passant [Giffard] ; crest—A demy
lion holding a branch ; second crest—An arm couped above the
elbow, holding a banner :

> In a vault beneath | lie the remains of | Ann the beloved
> wife of | the revd James Giffard M.A. | she died 9 October
> 1827 | also of Elizabeth his revered mother | who died 15
> February 1830.

(MS vi, 219–222.)

Wragby

Notes taken in the church, [blank]—There are no monuments
or flat stones in this church whatever.

Against the end of the north aisle is this atchievement—Ermines,
a cross voided argent, charged with four millrinds sable [Turnor] ;
impaling—Argent, two lions passant azure [Hanmer]. Crest—A
lion passant argent holding a millrind sable (D).

The church consists of a nave and north aisle, resting upon four
Norman arches rising from round columns, a chancel, and a tower
at the west end. In the east window are the arms of King Charles,
and these two shields below—(1) Ermine, a griffin segreant gules
[Grantham] ; impaling—Sable, a chevron between three leopards'
faces or [Wentworth] ; (2) The coats just mentioned, quartered.
Crest—On a torce argent and gules, a blackamoor's head proper ;
motto—Comme Dieu Garrantit [Grantham]. Over the second—
On a torce or and gules a griffin passant argent ; motto—En
Dieu est tout [Wentworth].

(MS xii, 65.)

𝔚𝔶𝔨𝔢𝔥𝔞𝔪 𝔠𝔥𝔞𝔭𝔢𝔩

Notes taken in the chapel of Wykham, September 19, 1837—
This chapel, which is now in ruins, must once have been a very
beautiful one. It is small in length, there being no division into
nave, aisles, or chancel. On each side are three large windows,
the two opposite ones nearest ye west end are bricked, the middle
one on ye south side is decorated, very fine, ye others appear to
be perpendicular. The east and west windows are of larger size,
the eastern perpendicular, but much broken ; ye western is bricked
up. In the east wall, north and south of ye place where ye altar
has been, are two very beautiful ogee arched niches, canopied with
crockets and finials of decorated character ; they are yet very
perfect and very elegant specimens of ye style.

At ye south west corner is a small turret with a circular staircase
to the top, and on ye outside near ye summit is carved ye ' Harring-
ton Knot ', and a date which I [A. L.] could not make out being
so high, but was informed by ye person who shewed ye chapel that
it was 1580, which it appeared like, though of course ye place must
have been built much earlier. The font basin remains ; it is circular
octagonal of a simple style. The floor is overgrown with grass and
weeds, but a few flat stones yet remain legible.

Towards the east end is a stone from which two brasses of inscrip-
tions have been removed and a shield. At the bottom is carved
a shield of arms—A fret [for Harrington], with this inscription :
> Here lyeth interr'd ye Body of | James Harrington esqr sonne |
> to John Harrington of Wickham | in ye county of Lincolne esq.
> he | departed this life the 24 day of | July Anno Domini 1688,
> in the 68th | year of his age.

A stone to the north of the last, broken in parts :
> George Ravenscroft esq. | was interred under this stone |
> July 26th 1752 | and | John his son March 20 1747. | To
> whose memory the above monument | was erected.

This monument, which is now gone, appears to have been on ye
north wall of ye chapel ; the base of it is yet left.

A flat stone at the west end :
> In memory of | William Cash gent. who | departed this life
> the 16th of May | 1735, aged 81 years | in hopes of a joyful
> Resurrection.

On a black stone to ye north of ye last, nearly covered with earth,
is commemorated Rebecca wife of William Cash gent., who died
25 April 1747, æt. 65.

Another stone to Mary wife of William Bailey died 2d June 1759,
aged 37 years, to whom she left two children William and Elizabeth.

The description in the *Lincolnshire Magazine*, ii, 488, was taken about 1790, and much more then remained. Most of the monuments were then entire, and the inscriptions are fortunately there inserted. The date near the Harrington knot is there said to be 1690.

[See also *Associated Societies' Reports*, i, 356–60; Jeans, Supp. 20.]

(MS ix, 85–87.)

Yarborough

Notes taken in the church, 24 August, 1835—

On a flat stone in the chancel :

> Here lie the bodies | of the Revd William Weightman | rector of this place, | who died December 13 1760 | aged 47 years | and of Elizabeth his wife | who died June 3 1784 aged 68. | Interred near them lies the body | of his mother Alice | who died May 5, 1766, aged 80.

On a flat stone at the west end of the north aisle :

> In memory of | Revd John Crichton | who departed this life | Feby the 3 1814 | aged 62 | after being 36 years | Curate of this parish | and Grainthorpe.

This church consists of a nave and north aisle, separated by four pointed arches springing from octagonal columns, a chancel, and a tower at the west end. The arch between the nave and chancel is pointed, but the head is blocked up. There is also a screen of old oak. The east window of the north aisle is filled with modern stained glass representing the principal miracles of our Saviour, the centre compartment being the Resurrection. It was presented by the late Revd Wolley Jolland, vicar of Louth, who is buried in the churchyard under the window. The colours and figures are nearly effaced. The font is a plain octagon. The tower of this church is perpendicular in character and it has a very beautiful door, squareheaded, with a moulding of quatrefoyls running round. In the spandril of the arch is a representation of Adam and Eve standing before the tree. On the other spandril are two shields, the one bearing the emblems of the Crucifixion and the other apparently the Paschal Lamb. The inner moulding of the arch is very beautiful, of pomegranites and leaves, and it has had an inscription running round, but unfortunately so defaced that it has become undecypherable. These words appear to remain :

> Wo so looks thys work opon
> Pray for all yat [yt be gun].

[See also *Proceedings Soc. Antiq.*, xviii, 228–30.]

(MS vi, 107–108.)

GENERAL INDEX

Places for which there are CHURCH NOTES are printed in capitals, and the reference in brackets which follows such a name refers to the map at the end of the volume. Black figures indicate the pages where the CHURCH NOTES will be found.

Before the year 1700 clerks in Holy Orders are described as ' clk '; and from that date as ' rev.'

For the Index of Coats of Arms, *see* pages 469–474.

Cooling, co. Kent, 349
Coope, *see* Cope
Cooper, Anne, 318; Benj., 318; Benj.
 Newton, 318; Chas, 318; Edm.,
 knt, lord mayor of York, 416;
 Edw. Moore, 317; Eliz. Mary,
 317; John Hutton, 316, 318;
 cp. Cowper
Coot', Great, *see* Cotes, Great
Cope, Coope, Anne, 160–1; John, 160–1
Copeman, Wm, clk, 69
Copledike, Copledyke, Copuldyk, Copvl-
 dyck, Anne, 175; Eliz., 175–6;
 Francis, 175; John, 173, 175 (2);
 John, knt, 173 (2), 175 (2)–6;
 Martha, 173; Mary, 173, 405;
 Tho., 173 (2), 405
Copley, John, 11; Sarah, 11
Copuldyk, *see* Copledike
Corbett, Rich., 97
CORBY (G3), co. Linc., **89–90**; master of
 the grammar school in, 89; vicar
 of, 89
Cornwall, Anne, 253; Rob., 253
CORRINGHAM (C2), co. Linc., **90–3**;
 Dunstall in, *q.v.*; prebend of,
 91; Somerby in, *q.v.*; vicar of,
 93
Corye, Anne, 359 (4); Francis, 359 (6);
 Judith, 359
Cotes, Great, Great Coot', co. Linc.,
 259
Cotes, North, co. Linc., 373
COTES BY STOW (C2), Coates, Coates
 near Stow, co. Linc., **93–5**, 162,
 201
Coulthurst, Colthurst, Faith, 14, 15,
 49; Jane, 14, 15, 15n; John,
 14 (3), 15 (2), 15n, 49; Mary,
 15 (3); Wm, 15 (2)
Courtenay, family of, 392
COVENHAM ST BARTHOLOMEW (C5), co.
 Linc., **95**
COVENHAM ST MARY (C5), co. Linc.,
 96
Coventry, co. Warw., 326
Coventry and Lichfield, bishop of, *see*
 Hacket; Smith
Coverley, Jane, 71; John, 71 (2)
COWBIT (G4), co. Linc., **96**
Cowley, Luke, 100; Mary, 100; mr,
 112; Tho., 114, 366
Cowling, family of, 102
Cowper, Joan, 260; Wm, 260 (2); *cp.*
 Cooper
Cox, , 110
Coxon, Wm, 258
Cracroft, Anne, 51, 255; Grace, 378;
 John, 254; Leonard, 51; mrs,
 176; Rob., 255, 378; Sarah,
 254
Cragg, John, 10, 384–5
Crapley, Adler, 258 (3); Anne, 258;
 Eliz., 258; Judith, 258
Craster, rev. Tho., 211

Craven, Abraham, 127 (2); Eliz., 185;
 John, 185; Mary, 127; Wm,
 baron Craven, 422; his sister
 Anna Rebecca, 422
Crawford, Anne, 101; Chas, 101; Hugh,
 M.D., 101; Jennet, 101; John,
 101; Marg't, 101
CREETON (G3), co. Linc., **97**
Crendon, Long, co. Buck., Notley in,
 q.v.
Cressy Hall [in Surfleet], co. Linc.,
 349 (2), 351 (3)
Creswell, Eliz., 241; Rich., 241
Crewe, sir Randolph, lord chief justice,
 quoted, xx
Crichton, rev. John, 429
CROFT (E6), co. Linc., **97–9**; minister
 of, 99; vicar of, 97
Cromwell, Oliver, 54, 362
Cropley, Anne, 369; Eliz., 369; Francis,
 369 (2)
Cropper, Frances, 272; Wm, 272
CROWLAND (H4), co. Linc., xvii, **99–102**;
 Postland in, *q.v.*; rector of,
 100 (2)
Crowle, co. Linc., Eastoft in, *q.v.*
Croxby, co. Linc., 296
Croxby, John, clk, 202
Culloden [in Daviot and Dunlichty], co.
 Inverness, battle near, 172
Culverthorpe [in Haydor], Thorpe, co.
 Linc., 180
Cumberland, Wm Augustus duke of,
 2nd son of king Geo. II, 172
Cummin, Rob., 61
Curtis, Edm., 18; Edw., 419; Eliz.,
 18, 419 (2); mr, 418; Noah,
 419; Rob., barrister at law, 419
Curtois, rev. John, 152–3; Mary, 152–3;
 rev. Rowland, 163
Curwen, *see* Cvrwen
Cuthbert, Benj., 110 (3); Eliz., 110
Cutts, Geo., 250
Cvrwen, Anne, 236; Nich., knt, 236
Cygnet, Cignet, H.M.S., 338

Dabridgcourt, Grace, 229
Dagenham, co. Essex, breach, 338
Dalbiac, Chas, 45; Louisa, 45
Dallowe, Philip, 43 (2)
Dalyson, Dalison, Dallison, dame Anne,
 154; Barbara, 209; Chas, 154;
 Geo., 154, 224; John, 225;
 Martha, 154; Rob., 153; Tho.,
 knt, 154; Wm, 153–4, 224;
 Wm, J.P., 224; Wm, justice of
 the king's bench, 153–4, 209, 224
Danby, earl of, *see* Osborne
Danyell, Anne, 258; Austine, 257;
 Dobson, 257; Jane, 257–8; Mary,
 257; Matth., 258 (3); Rob.,
 258; Wm, 257 (2)–8

Fo . m . . , Geo., 34 ; Kath., 34
Foldingworth, *see* Faldingworth
FOLKINGHAM (F3), co. Linc., **126–9**, 193 ;
 master of the grammar school of,
 127 ; rector of, 317
Folksworth, co. Hunt., 268
Fonaby [in Caistor], co. Linc., 7, 299
Footit, Benj., 219 (2) ; Chris., 219 ;
 John, 219 ; Sarah, 219
Ford, co. Northumb., castle, 351
Fordham, Francis, 17
Forman, Anne, 309–10 ; Wm, 309
Forster, serjeant, 267 ; Susanna, 267
Fort St George, *see* Madras
Fosdyke, co. Linc., *see* Algarkirk
Fosse [in Torksey], co. Linc., 5n
Foster, Geo. Rob., 217 ; Geo. Rob.,
 surgeon, 217 ; Levina Davey,
 187 ; Mary, 52 ; Wm, 52, 187
Fothergill, Eliz., 117
Foulks, Hen., knt, 19 ; Truth, 19
Fovargue, Martha, 101 ; Mary, 101 ;
 Zachariah, 101 (4)
Fowler, Hurst, 334 ; Joseph, 143 ;
 Marg't Dyneley, 143 ; Mary Anne,
 293
Fox, Helen Susanna, 217 ; John, 217 ;
 rev. Rowland, 121
Foxlow, rev. Joseph, 22
Frampton, co. Linc., 190 ; hall, 35 ;
 vicar of, 365
Frampton, John, 56
France, 51, 58, 131–2, 332, 393 ; *see also*
 Calais ; Paris ; Pontoise ; Rouen
Francis, Alice, 319 ; Jane, 319 (2) ;
 Joseph, 318–19
Francklin, John, 267 ; Mary, 267 ; *cp.*
 Franklin
Frankland, family of, 424
Franklin, Willingham, knt, **341** ; *cp.*
 Francklin
Fraser, dame Anne, 349 ; Peter, bart,
 349
Freke, Eliz., 328–9 ; Jane, 329 ; John,
 328–9 ; Tho., knt, 329
Fretham, Anne, 354 ; Wm, 354
Frieston [in Caythorpe], co. Linc.,
 84
FRODINGHAM (B2), co. Linc., **130–1** ;
 Brumby in, *q.v.*
Fryer, Hen., 156
FULBECK (E2), co. Linc., **131–6**, 230,
 245, 258
Fulbeck, Mary, 91 ; Wm, 91
Fuller, Sam., D.D., chancellor of Lincoln,
 245–6 ; Wm, bishop of Lincoln,
 246 (2)
Fulletby, co. Linc., 17
Fulnetby, Anne, 296 ; Bridget, 296 ;
 Edw., 296 ; Eliz., 296, 298 ; Jane,
 296 (2) ; Joan, 296 ; John, 296 ;
 Marg't, 296 ; Vincent, knt, 296,
 298
FULSTOW (B5), co. Linc., **136**
Fysheborne, *see* Fishbourne

Gace, family of, 285
Gainsborough, Gainsburgh, co. Linc., 7,
 14, 46, 74, 130–1, 307, 345 ;
 Thonock in, *q.v.*
Gamble, Rich, 164 ; Susanna, 164
Garbara, Tho., 260
Gardiner, Gardener, Agnes, 38 ; Anne,
 245 ; Dinah, 239–40 ; Jas, sub-
 dean of Lincoln, 238–40, 245 ;
 Jas, D.D., subdean of Lincoln,
 bishop of Lincoln, 240 (2), 245 (2) ;
 Jane, 245 ; Susanna, 239–40 ;
 Wm, 38
Gare, de la, de Lagare, Wm, archdeacon
 of Lincoln, 91
Garland, Anne, 9, 145 ; Faith, 49 ; John,
 49 ; Mary, 9 (2), 213 ; Nathaniel,
 145 ; Rob., 213 ; Rob., jun., 9 ;
 Wm, 9 (2)
Garmston, Eliz., 248 ; John, 248 (2)
Garnet, John, 32
Garnon, family of, 423 ; Rich., clk, 423
Garratt, Wm, 402
Garton, Francis, 348 ; Joan, 348
Garwell, Edw., 369 ; Mary, 369
Gascoigne, Anne Davison, 303 ; John,
 303 ; Wade, LL.B., 303 ; Wade
 Davison, 303
Gaskarth, Maria, 166
Gastryck, John, 382
Gatty, Mary, 26 ; Rob., jun., 26
Geddington, co. North'ton, house, 267
GEDNEY (G5), co. Linc., **136–40**, 287 ;
 curate of, 195 ; Gedney Hill in,
 q.v. ; vicar of, 139
GEDNEY HILL (H5) [in Gedney], co.
 Linc., **140–1** ; curate *or* pastor of,
 141 (2) ; Gedney Hill drain, 361
Gelder, Eliz., 27 ; rev. John, 27 (3) ;
 Penelope, 27
Germanus, *see* Jermyn
Germany, 131–2, 393 ; electors and
 princes of, 393 ; *see also* Heidel-
 berg ; Leipzig ; Strasburg ; Wesel ;
 Wittenberg
Gibbs, John, 107 ; Mary, 107
Gibson, Caroline Bethia, 394 ; Frances,
 284 ; Geo., 107 ; Hester, 107 ;
 Jas, sen., 390 ; John, 390 ; Lewis,
 394 ; mr, 33 ; Sarah, 284 ; Tho.,
 285 ; Wm, 284
Giffard, Anne, 427 ; Eliz., 427 ; rev.
 Jas, 427
Gifford, Mary, 203 ; Tho., 203
Gilbert, Rich., 315 ; Sarah, 315
Gilby, Gylby, Anthony, 236–7 ; Eliz.,
 236–7 ; Wm, 236 (2)
Gildas, Wm, 21, 28
Girton, Eliz., 316 ; Wm, 316
Gladwin, Dorothy, 6 ; Hen., 6
Glanagorss [*sic*], Isle of Anglesey, 237
Gleed, Anne, 113 ; Jonathan, 113–14 ;
 Tho. Arnall, 113–14
GLENTWORTH (C2), co. Linc., **141–2** ;
 heath, 337 ; vicar of, 142

GENERAL INDEX 445

Halliday, Anne, 79–80; John, M.D., 78; Peter, 78, 80
Halton, , 381; Alice, 381
HALTON HOLEGATE (D5), co. Linc., **166–7**
Hamby, Edw., 371; Eliz., 371 (2); sir John, 371; Wm, 371
Hammond, Eliz., 245
Hampson, Jas, 100
Hampstead, *see* London
Hamstall Ridware, Hampstall Redware, co. Staff., 422
Hanborow, *see* Handborough
Hanby [in Lavington], co. Linc., grange, 281 (3)
Handborough, Hanborow, co. Oxf., 292
Handley, Anne, 320; Benj., 320 (2)–1; lieut. Benj., 320; Frances, 320–1; Jane, 320
Hanger, Alice, 329–30; John, 330
Hannington, co. North'ton, *see* Walgrave
Hanover, house of, 335
Hansard, Alice, 95; Hen., 94 (2)–5; Joan, 94–5; Rich., 94
Hanson, Eliz., 395; John, 395
Harber, John, 360
Harbord, Grace, 75; Wm, 75; *cp.* Haubord
Harby, Matilda, 4; Rich., 4
Harcroft, Tho., 257
Hardeby, Anne, 121 (2); Bryan, 121; Chas, 121; Daniel, 121; Daniel, J.P., 120; Edw., 121; Eliz., 121 (2); John, 121; Judith, 121; Kath., 121; Mary, 121 (2); Susan, 121 (2); Wm, 121
Hardinge, Eliz., 5n; Wm, 5n
Hardwick, Chas, 106 (2); Frances, 106; rev. mr, 228
Hardy, Anne, 265; John, 22, 265 (2), 340 (2); Joyson, 22; Mary, 22; Rob., 22 (3); Sam. Chris, 71; Susanna, 22
HARMSTON (E2), Harmeston, co. Linc., 79, **168–70**; manor of, 168, 170; vicar of, 395
Harpham, Alice, 260; Anne, 260; Walter, 260 (2)
HARPSWELL (C2), co. Linc., 142, **170–2**; curate of, 171; rector of, 171
HARRINGTON (D5), co. Linc., **172–6**, 210, 212, 352, 399, 405
Harrington, Harington, Alice, 421; Chas, 48; Edw., 48, 425; Eliza, 48; Eliz., 425; family of, 216; Francis, 48, 425 (2); Hen., 48; Jas, 48, 428; Jas, knt and bart, 297; Jane, 297 (2); John, 48, 428; sir John, 176; Kath., 48; Lucy, 425; Marg't, 48; Margery, 425; Martha, 48; Rob., 54, 421; Sapcote, knt, 297; Tho., 48 (2), 425; Wm de, clk, 171
Harringworth, co. North'ton, 391, 393

Harris, Harriss, Anthony, 390; Edm., 217 (2); Humphrey, 280; John, 189, 217; Marg't, 280; Philippa, 280; Rich., 390
Harrison, Harrisson, , 61; Anna Maria, 385–6 (2); Anne, 46; Augustus, 385; Chas, 191; Eleanor, 61; Eliz., 46; Ellen, 242; family of, 102; Geo., xvii, 61 (2), 123, 386; Hen., 46; John, 61; John Tho. Everson, 195; Joseph, 191, 386; Mary, 61, 123, 242, 312; Rich., chancellor of Lichfield, 242; Rob. Stevens, 385 (2)–6 (3); Sarah, 123; Tho., 2; Wm, 46, 395
Harrox, John, 265, 412
Harryman, Harriman, Barrot, 291; Dorothy, 291; Eliz., 291; Geo., 291; Jas, 291, 322–3 (3); Jane, 322–3; John, 291 (4), 323; Marg't, 291; Mary, 291 (2); Rich., 291 (2); Susanna, 322; Theophilus, 291, 322 (2); Tho., 291; Wm, 323
Harston, co. Leic., rector of, 89
Hartley, rev. Wm, 313
Hartopp, Edw., 37; Rebecca, 37
Harvey, Abigail, 216; rev. Francis, 248; Hen., 148; John, 248; Mary, 216; Rebecca, 340; Rich., 216; Sam. G., 340; *cp.* Hervey
Hastings, Bridget, 208; Howard, 238, 242; Jane, 238, 242; John, 208; Rob., 208 (2)
Hatcher, Grace, 75; Jane, 75 (2); Tho., 75 (3)
Hatchett, Mary, 263 (2); Tho., 263
Hatcliffe, [co. Linc.], 28, 427
Hatford, Hattford, co. Berks, 221
Hatherell, Sarah, 25
Hathersage, co. Derby, 345
Hatsell, Hen., 55
Hatton, co. Linc., rector of, 163
Hatton, hon. Chas, 236–7; Chris. lord, 236–7; Chris., knt, lord chancellor of England, 392; Eliz., 236–7
Haubord, Rich., clk, 23
HAUGH (D5), co. Linc., xv, 51 (2), **176–7**; vicar of, 176
Haugh, Hagh, John de, 176 (2)–7; his wife Agnes, 176; his wife Joan, 177; Ralph de, 177; Rich. de, 176; his wife Isabel, 176; Tho. de, 177
HAUGHAM (C5), co. Linc., **177–8**
Haughmond, Haghmond, co. Salop, 173–4, 211
Haworth, David, 24; Eliz., 24 (2); John, 380; Letitia, 380; Tho., 24 (2), 380
Hawton, co. Nott., 229
Haxey, co. Linc., 284; Lound, East, in, *q.v.*

KETTLETHORPE (D2), co. Linc., 174 (2), **210–13**; Fenton in, *q.v.*; rector of, 210 (2), 213
Ketton, co. Rutl., 369
Key, Anna, 232; Anne, 231 (3); Davey, 193; Dorothy, 3; Edw. Davey, 193; Eliz., 3; Ellis, 231 (2)–2 (2); Jane, 232; John, 193 (2), 232 (2); Lewin, 193; Mary, 3, 193, 232; Mary Davey, 193; Mary Robinson, 193; Robinson, 193; Tho., 3 (2), 231–2; Wm, 3, 230–1 (4)
Keysby, *see* Keisby
Keyser, Hendrick de, sculptor, 82; Pieter de, sculptor, 82
Keythorpe [in Tugby], Kethorpe, co. Leic., 425
Kilsby, Kildesby, co. North'ton, prebend of, 247
King, Anne, 164–5; Edw., 164–5; rev. Talbot, 394
Kingsforth, *see* Barton on Humber
Kingston, Ch., 360; Edw., 103; Eliz., 103 (2); Mary, 140; Wm, 301
Kippis, Andrew, 322–3; Bridget, 322–3 (2); Eliz., 323; Marg't, 323; Rebecca, 323; Rob., 323; Susanna, 323
Kirby, co. North'ton, 236–7
Kirby Bellars, co. Leic., 171
Kirk Langley, co. Derby, Meynell Langley in, *q.v.*
Kirkby on Bain, co. Linc., Tumby in, *q.v.*
Kirkby in Cleveland, co. York, N.R., Dromanby in, *q.v.*
Kirkby, East, co. Linc., 172
KIRKBY LAYTHORPE (F3), co. Linc., **213–14**; rector of, 213
KIRKBY UNDERWOOD (G3), co. Linc., **214–15**; rector of, 127, 214
Kirkby, *see* Kyrkbe
Kirke, Kirk, Abigail, 20 (2); Anne, 242; Eliz., 20 (3); John, 242; Mary, 90 (2); mr, 20; Molly, 20; Rich., 90; Rob., 90 (2); rev. Rob., 20 (2); Theophilus, 20
Kirkham, Chas, 208; Susanna, 207
Kirkman, Cicely, 98; Gertrude, 51; John, 51; Leonard, 51; Ursula, 51; Wm, 98
Kirton, Mary, 323; Wm, 323, 361
KIRTON IN HOLLAND (F5), co. Linc., 171, **215–17**, 312; vicar of, 146, 216 (2)
KIRTON IN LINDSEY (B2), co. Linc., **217–19**; vicar of, 31, 218
Kitchen, Tho., 17
Kitching, Edw., 129; Eleanor, 129
Knight, Alex., 313; Alice, 228, 402; Arnold, 327; Eliz., 228; Eliz. Christina, 313; Geo., clk, 402; Isaac, 402; Rob., clk, 402; Tho., 228
Knighton, family of, 102

Knollis, Chas, earl of Banbury, 244; Eliz., 244; lady Kath., 244
Knott, Anne, 411; Francis, 411; Hannah, 411 (4); Rob., 411 (5); Tho., 411–12; *see also* Nott
Knowles, John, sen., 16; Joseph, 16; Rich., 16
Kyrkbe, Tho., 381

LACEBY (B4), co. Linc., **219–20**; rector of, 220
Lack, Eliz., 43
Lacon, Edw., 372
Lacy, Jane, 410; Rob., 401; Solomon, 410; Wm, 148
Lafargue, Peter, clk, 151
Lafford, co. Linc., prebend of, 6, 321 (2)
Lagare, de, *see* Gare, de la
Laine, Eliz., 342; Wm, surgeon, 342; *cp.* Lane
Lake, Anne, 4; Eliz., 4
Lambe, Anne, 14; Eliz., 14; Geo., 13; John, 13, 32; Mary, 13 (2); Rachel, 13; Rachel Mawer, 13; Rob., 22; Rob., sen., 14; Sarah, 13; Tho., 14 (2); Wm, 13 (6)
Lambert, Wm, 148
Lambeth, co. Surrey, 84; church of St John, Waterloo Road, 70
Lane, Emma, 267; Tho., 267; *cp.* Laine
Langar, co. Nott., 294
Langford, Wm de, 277
Langley, Meynell [in Kirk Langley], co. Derby, hall, 330
LANGTOFT (H3), co. Linc., xvii, **220–2**, 357; vicar of, 222
Langton, John, knt, 201; Kath., 201; Rob., 334
Langton, Lankton, co. Linc., 172
LANGTON BY WRAGBY (D4), co. Linc., **222–4**; Strubby in, *q.v.*
Lany, Tho., S.T.B., precentor of Lincoln, 248
Larken, Arthur Staunton, Portcullis Pursuivant of Arms, and Richmond Herald, xi, xiv, 33, 33n, 43; Edm., xi; Eliza, xi
Larkham, Lucy, 70; Walter, surgeon, 70
Latham, Anne, 28
Laughton, Ed., 308; Edm., 308; Eliz., 308; Geo., 308; Isaac, 396; John, 308, 396–7; Rich., 397; Sam., 397; Wm, 308; Winifred, 308
LAUGHTON BY GAINSBOROUGH (B2), Lawghton, co. Linc., 153–4, 223, **224–5**
Laughton en le Morthen, co. York, W.R., Throapham in, *q.v.*

Lincoln, Rob., 100
Lindsey, earl of, and marquis of, *see* Bertie
Linga Lane, *see* Bassingham
Linn, *see* Lynn, King's
Lisbon, Portugal, 320
Lister, Chas Jas, 69; Eliz., 244; Frances, 69, 243; Grace, 68; Jane, 68; John Joseph, 68; Lydia, 68; Lydia Boughton, 68; Martin, knt, 68–9; Mary, 61, 88–9, 243; Matth., 61 (2), 68 (2)–9, 243; Matth. Bancroft, 68–9; Matth. Dymoke, 68; Matth. Tho., 61; Michael, 244; Sophia, 69; Tho., 88–9, 243
Litchfield, *see* Lichfield
Litchford, Abel, 47 (2)–8 (3); Anne, 48; Dorothy, 48; Eliz., 47 (2)–8 (3); Jane, 48–9; John, 48; John R., 48; rev. John Rowland, 48–9; Judith, 48–9; Tho., 48; Wm, 48
Litchford *alias* Rowland, John, 48; *see also* Rowland
Littlebury, Anne, 154; Eliz., 176; Humphrey, 154; sir Humphrey, 196
Littlewood, Anne, 284; Eliz., 284 (2); Jas, 284 (3); John, 284
Livie, Titus, 55
Llanbedrog, co. Carnarvon, 197
Lloyd, family of, of Melverley, 47 (2)
Lluellyn, Marg't (M. L.), 425–6; Rich. (R. L.), 425–6 (2)
Locton, dame Frances, 364; Francis, 364; John, 364; John, knt, 364; Wm, 364
Lodge, Susanna, 303; rev. Wm, 303 (2)
Lodington, Bodington, Ludington, Emma, 56–7; Frances, 57; Geo., 56–7 (2); John, 299; Kath., 56; Letitia, 56; Mary, 57, 298–9; Sam., 56–7 (3); Tho., 74; Tho., clk, 123, 123n
Loft, John, 261; Mary, 261 (2)
Lomax, Anne, 317; Edw., 318; Eleanor, 317; Eliz., 316 (2); Jane, 317–18; Wm, 165, 316–18 (2)
London, co. Middx, 16, 27, 37, 39, 56, 66, 70, 82, 85 (2), 89, 126, 130, 132, 137, 139, 146, 153, 168, 257, 278, 281, 297, 305, 375–6, 383, 388, 421
 lord mayor of, *see* Chaplin; Thorold
 alderman of, 347, 400
 citizen of, 43–4
 citizen and linen draper of, 111, 417
 citizen and merchant tailor of, 207
 citizen, vintner, and alderman of, 23
 Charterhouse, the, 82, 105, 117
 Cheapside, 417

London, co. Middx—*cont.*
 churches and parishes—
 All Hallows, Barking, par., 27
 St Andrew's, Holborn, ch., 26, 37
 St Gregory by St Paul's cathedral, ch., 383
 St Mary Abbott's, Kensington, ch., 116
 St Paul's cathedral, 82
 St Paul, Covent Garden, par., 378
 Savoy, the, 139
 Finchley, 76
 Finsbury square, 26
 Fishmongers' company, the, 417
 Hampstead, 267
 Inns of court—
 Clement's Inn, 347
 Gray's Inn, 54, 251
 Inner Temple, 153, 341
 Lincoln's Inn, x, 5n, 238, 303
 Middle Temple, 237
 Knightsbridge, 342
 Lambeth, *q.v.*
 Soane Museum, Lincoln's Inn Fields, 82 (2)
 Strawberry hill, sale at, 82
 Westminster, 151, 348; St Peter's college, school, 341
Long, Dorothy, 137, 351; Eliz., 23, 114, 137–8 (5); Frances, 23; Jas, 137 (3)–8 (4); Jas, bart., 351; Mary, 22–3, 114 (2), 138; Miles, 114; Penelope, 114; Rob., 114 (2); Wm, 25, 138; Wm, J.P., 22
Long Ledenham, *see* Leadenham
Longchamp, Alice de, 67
Lord, John, 285
Lorraine, 132
Lorymer, Wm, 25n
Lound, lieut. Sherard Philip, 341
Lound, East [in Haxey], co. Linc., 284
LOUTH (C5), co. Linc., xvi, 22, **251–5**, 326; vicar of, 429; warden of the corporation of, 251 (2), 254 (3)
Loutrell, *see* Luttrell
Lowe, Francis, 108–9; John, 108 (2); Sarah, 108 (2)–9
Lowrie, capt. Rob., 249
Loxham, Eliz., 344; rev. Rich., 344
Luard, Louisa, 45; capt. Peter John, 45
Lucas, Martha, 134; Tho., 134 (2); Wm, 134
LUDBOROUGH (C5), co. Linc., **255–6**; rector of, 255
Ludington, *see* Lodington
Luffenham, North, co. Rutl., 52
Lumley, rev. J., 142
Lunn, John, 24; Mary, 24
LUTTON (G5), co. Linc., xviii, 125, **256–8**; Lutton Gate, 361
Luttrell, Loutrell, Lutterell, Andrew, knt, 203–4 (2); his dau., 203

MONSON, William John—*cont.*
collections, xii; his portrait, xiii,
see Frontispiece; his association
with A. S. Larken, xiv; his
interest in heraldry, xvi; his
death, xiii
Montague, C., knt, 148
Montgomery, co. Montgomery, castle, 98
Moorby, co. Linc., 17
Moore, Anne, 320 (2); Edw., 316; Eliz.,
316 (2); Frances, 316–17; Jane,
316 (3), 319; John, 412; Joseph,
M.D., 334; Kath., 390; Mary,
111, 390; Rich., 319–20; rev.
Rich., 111; rev. Tho., 317, 390;
hon. Wm, 70; rev. Williamson,
316 (3), 319
Morden, Anne, 356; John, clk, 356 (2)
Morgan, rev. Josias, 301
Morley, Anne, 309; Eleanor, 405;
John, S.T.P., 309; Joseph, sur-
geon, 405; Mary Brown, 405
Morrell, John, 127
Morris, Anne, 90; Geo., 90
Morton, Eliz., 384; Jas, 410; John,
B.D., 410 (2)–12; Mansell, 384;
Mary, 410
MORTON BY BOURNE (G3), co. Linc.,
264; minister of, 156, 264
Morton [by Gainsborough], co. Linc.,
308
Moses, Eliz., 342; Tho., 342
Moss, John, 272
Moulesworthe, Bevell, 220–1; Eliz.,
220 (2)–1
MOULTON (G5), co. Linc., **264–9**, 339,
415; master of the grammar
school in, 264–5 (2); vicar of, 265,
268, 336
Moundeford, Kath., 65–6; Tho., M.D.,
66
Mounsey, rev. John, 250
Moyser, *dominus*, 163; Frances, 163
Multon, Joseph, 407; Marg't, 407;
Susanna, 407
Mundy, Chas Godfrey, 280; Francis,
278; Harriet, 280 (2); Philippa,
278
Munro, Nich., 109; Sarah, 109
Murray, Wm, earl of Dunmore, 242
Murthewaite, rev. Irton, 117
Mustell, Marg't, prioress of Bullington,
143
Muxlow, Edw., 233
Myers, Anne, 151; rev. D., 151 (2);
Geo., 379; rev. John, 330; Maria,
330 (2); rev. Miles, 379

Nainby, Frances, 220; Joseph, 220
Nantes, France, Edict of, ix

Naples [Italy], 132
NAVENBY (E3), co. Linc., **269–71**; rector
of, 270 (5)
Nedham, Edw., 164; Kath., 164
Negapatam, Madras, East India, ix
Nelthorpe, Charlotte, 300; Hen., bart,
26, 300; John, bart, 26; Kirke,
27
Ness, co. Linc., hundred of, 103
Nethercootes, Dorothy, 272; Martha,
272; Mary, 272; Tho., 273;
Walter, 273
NETTLEHAM (D3), co. Linc., **271–3**
Neve, Compton, 339; rev. Timothy,
339
Nevile, Nevil, Neville, Anthony, 236;
Brian, 11, 12; Chris., 12–14, 406;
Chris., knt, justice of the Common
Bench, 11 (2)–13, 32; Eliz., 1,
5n, 12–13; family of, 406; Geo.,
5n, 11–13, 211; Gervase, knt, 13;
Hen., earl of Westmoreland, 58;
his dau. lady Eleanor, 58; Horatio
Tho., 14; Jane, 12; Kath., 11 (2),
13; dame Kath., 11; Lucy Eliz.,
14; Martha, 12; Mary, 211, 236;
Sarah, 11; lady Sophia, 14
Newbold upon Avon, co. Warw., Law-
ford, Little, in, *q.v.*
Newcomen, John, 244; Kath., 244;
Mary, 244, 374–5 (4)–6 (3); Nich.,
374–5 (4)–6 (3)–7; Sarah, 348;
Selina, 244; Theophilus, 244 (2);
Tho., 348; Tho., clk, 244
New England, North America, families
of, xix
Newhaven, co. Sussex, war at, 392
Newland [in Normanton], Newland near
Wakefield, co. York, W.R., 39;
Park, 37
Newlove, Anthony, sen., 185
Newman, *cp.* Numan
Newmarket, cos. Camb. and Suff.,
236
Newstead, Newst Eade, Herbert, 97
NEWTON IN AVELAND (F3), co. Linc.,
134, **273–4**
NEWTON ON TRENT (D2), co. Linc.,
274–5
Newton, Abigail, 179–80; Cary, 179–80;
Edw. Ignatius, 204; John,
180 (3)–1 (3); John, bart, 179 (2)–
80, 182; John, viscount Conings-
by, 180–1; Michael, knt and
bart, M.P., 179 (2)–81; his wife
Marg't, 179 (2)–81; Susanna,
179 (2), 181; lady Susanna,
179 (2)–80
Newzam, Anne, 9; Hen., 9; John, 9;
Sam., 9
Nicholas, Jane, 258; John, 258; Joseph,
258; Wm, 258
Nicholls, Geo., 53; Geo. Cowie, 53;
Mary, 53

SUTTON, LONG (G5), co. Linc., xvii–xix, **354–60**; schoolmaster of, 359; vicar of, 356 (4)
SUTTON ST EDMUND (H5), co. Linc., **360–1**; minister of, 360
SUTTON ST JAMES (G5), co. Linc., **362**
Sutton St Nicholas *alias* Lutton, *see* Lutton
Sutton, Suttun, Edw., knt, 65; Geo., 193; Hen., 226; Marg't, 193, 226; lady Marg't, 65; Mary, 226; Rob., 65; Tho., 82
SWABY (D5), co. Linc., **362**
Swain, Swaine, Abraham, 135; Anne, 135; John, 396; Mary, 396
Swallow, co. Linc., 234
Swallow, Geo., 344
Swan, Anne, 84; Charlotte, 230; rev. Francis, 230; Hen., surgeon, 84; Maria, 230
SWARBY (F3), co. Linc., **362–3**
SWATON (F3), co. Linc., **363–4**, 408
Swayfield, Swæffelde, co. Linc., lord of the manor of, 422
Sweden, Sweedland, 393
SWINESHEAD (F4), co. Linc., 321, 354, **364–6**; vicar of, 365 (2)
SWINHOPE (B4), co. Linc., 68, **367**
SWINSTEAD (G3), Swinestead, co. Linc., **367–9**
Switzerland, 132; *see also* Berne
Sydenham, co. Oxf., 241
Sydling [St Nicholas], co. Dorset, 419
Sympson, *see* Simpson
Syston, Siston, co. Linc., 337

Talavera de la Reina, Spain, battle of, 91
Talbot, rev. H. P., 77n
Tallents, Philip, clk, 268
TALLINGTON (H3), co. Linc., **369–70**
Tancred, Chris., 278; Eliz., 278
Tanfield, Dorothy, 6; John, esq., 6
Tatam, Alice, 265; Anne, 265; John, 265; rev. John, 147; Rebecca, 147; Wm, 265 (2)
TATHWELL (C5), co. Linc., 178, **370–2**; Orgarth Hill in, *q.v.*
Tathwell, Anne, 253; Burgh, 253, 345; Cornwall, 345 (3); Lucy, 345 (2); Rob., 253; Susanna, 345
Taylor, Anne, 183 (2), 218, 321; Anthony, 183 (4)–4, 321; Benj., 360–1 (4); Edw., 183; Eliz., 40, 183, 280; Frances, 361; Francis, 183, 360 (3)–1; Jane, 360–1 (3); John, 184, 361; Joseph, 361; Joyce, 361 (2); Kath., 183–4; Mary, 183 (2), 417; Mary Jane, 361; Nathaniel, 220; Rich., 40;

Taylor—*cont.*
Rich., sergeant at law, 304; Sarah, 220, 360 (2)–1; Tho., 218 (2); Tho., clk, 279–80; Ursula, 304; Wm, 148, 183 (4)–4, 417
Teale, Jane, 395; John, 395
Temple Belwood [in Belton in the Isle], co. Linc., 37 (2), 39 (2)
Temple Newsam [in Whitkirk and Leeds], co. York, W.R., 11 (2)
Temple, Penelope, 374; rev. Rich., 374
Tennant, John, 71
Terry, Jane, 238, 242; Moses, LL.B., 238 (3), 241–2; Rich. Winlow, 238, 242; Sarah, 238 (2), 241–2
Terwhite, *see* Tyrwhit
TETNEY (B5), co. Linc., **372–4**; vicar of, 372 (3)–4 (2)
Thames, the river, 338
Theddlethorpe, Thettlethorpe, co. Linc., 314
THEDDLETHORPE ALL SAINTS (C6), West Theddlethorpe, co. Linc., **374–7**
THEDDLETHORPE ST HELEN (C6), East Theddlethorpe, co. Linc., **377–8**; rector of, 118
Theed, G., 149
Thelwall, Charlotte, 299 (2)–300; Hannah Carter, 300–1; rev. Rob. Carter, 299 (3)–300 (2); Susanna, 299; *see also* Carter
Thimbleby, Thimelby, Thymelby, Dorothy, 203 (2); Jane, 198; John, 203 (2); John, knt, 226; Kath., 226; Mary, 203; Rich., 203; Tho., 198
Thomas, Alice, 360; John, 360; John, clk, 413
Thompson, Tompson, Aaron, 194; Anne, 356; Anthony, D.D., 356; Edw., 151; Eliz., 315; Kath., 369 (2); Laurence, 369 (2); Rob., 315; Ursula, 31; Wm, 31
Thonock [in Gainsborough], Thoneoke, co., Linc., 223
THORESBY, NORTH (B5), *Thoresbeiensis*, co. Linc., **378–9**; manor of Autby in, 378
Thoresby, [South], co. Linc., 57
Thoresway, co. Linc., rector of, 250
Thorey, *see* Thory
Thorganby, co. Linc., 298
Thorley, Mary, 28; capt. Rich., 28
Thorney, 121
Thorney, co. Nott., 11, 12, 211
Thornhill, Eliz., 134; Rich., 134
THORNTON CURTIS (A3), co. Linc., **379–81**; THORNTON ABBEY (A4), **381–2**; vicar of, 380
Thorold, Anne, 68, 168, 170; lady Anne, 31; Anthony, 169; Anthony, knt, 168, 170; Chas, 168–9; Edm., 170; Eliz., 134 (2), 168, 170; Frances, 170 (2); Geo., 170;

Ufford, Vfford, co. Suff., 348
Ullett, Mary, 369 (3); Mary Anne, 369;
Mary Kath., 369; Wm, 369 (3)
Underwood, Hamon, 343
Universities, *see—*
Cambridge Paris
Heidelberg Strasburg
Leipzig Wittenberg
Oxford
Uppingham, co. Rutl., 267
Uppleby, Anne, 427; Barbara, 427;
Chas, 21; Dorothy, 21; Eliza,
21; Eliz., 427; Geo., 21 (2), 28;
his widow, 21; Geo. Crowle, 21;
John, 427 (2); Lucy, 21; Roger,
21; Sam., 427; Sarah, 21 (2),
28–9; rev. Wm, 30
Upshull, John, 346
UPTON (C2), co. Linc., **394–5**
Upton, co. North'ton, 297
Upwood, co. Hunt., 330

Varnham, Geo., 342
Vaughan, Winifred, 233
Vere, sir Francis, 252
Vic, Chas de, bart, 83; Eliz. de, 83;
Hen. de, bart, 83
Vincent, David, 227; Jane, 227
Vittoria, [Spain], battle of, 249
Vivian, Mary, 357 (2); Tho., 357

WADDINGTON (D2), co. Linc., **395–6**;
rector of, 395
Waddingworth, co. Linc., 298
Wade, Anne, 90; John, 90 (2)
Wainfleet All Saints, co. Linc., 3
Wainwright, Wainewright, Eliz., 383;
Martha, 69
Wake, John, clk, 356; Philippa, 356
Wakefield, co. York, W.R., 39
Walburge, Eliz., 18 (2); Kath., 18;
Marg't, 18; Rich., 17; Simon,
18
WALCOT BY FOLKINGHAM (F3), co. Linc.,
xix, 79, **396–8**; vicar of, 41, 127,
396 (2)
Walcott, , 79; Bernard, 221;
Eliz., 79; Sarah, 221
Walden, Stubbs [in Womersley], Stubs
Walden, co. York, W.R., 203
Wales, president of, *see* Smith; *see also*
Dolgelly; Glanagorss; Llan-
bedrog; Montgomery
Walesby, Mary, 293; Oliver, 293
Walgrave, Waldegrave with Hannington,
co. North'ton, rector of, 247

Walker, , 274; rev. Abraham,
3; rev. David, 102; Eliz., 274;
Jane, 102; John, 274; Tho.,
341; Wm, 274 (4)
Wallace, John, 171
Wallet, Avice, 411; Geoff., 411; Tho.,
411
Wallis, John, 95; Mary, 95; Newcomen,
237–8; Tho., 238; *cp.* Wallace
Walpole, Walpoole, Edw., 286; Edw.,
knt, 286; Horace, 82; lady
Kath., 286; Mary, 286 (2)
Walsoken, co. Norf., 389
Walter, Anne, 273; Eliz., 273; Wm,
273
Waltham, *see* Walton
Waltham [on the Wolds], co. Leic.,
183
Walton, Waltham, co. York, W.R., 252
Walton, rev. Tho., 204
Wansey, Jane, 55
Ward, John, attorney at law, 114;
Marg't Dyneley, 143; Mary, 143;
Rob., surgeon, 27; Vincent, 17
Wardour, 8th and 9th barons and
baroness Arundell of, *see* Arundell
Warkworth, co. Northumberland, 398
Warren, John, 383; Mary Maria, 153;
Tho., 153
Wars, *see* Battles
Warton, Michael, 179 (2); Michael, knt,
179–80; Susanna, 179 (2)–80;
cp. Wharton
Warwick, co. Warw., 421; earl of, *see*
Rich
WASHINGBOROUGH (D3), Washingbrooke,
Washingburgh, co. Linc., 57, 223,
398–402; rector of, 399 (3)
Washingley, Washingleys in parish of
Lutton, co. Hunt., 137
Wastney, Tho. de, 56; his wife, 56
Waterfall, Edw., 357 (2); Eliz., 357 (2)
Waterland, John, 178; Martha, 178
Waters, Kath., 117 (2); rev. Wm, 117;
rev. Wm Tho., 117, 302
Watkins, rev. John, 413; Mary, 413
Watson, Wattson, Edm., 15; Edw.,
215; Eliz., 15, 192 (2), 309, 408;
Jane, 215; John, 192; Jonathan,
192, 408; Marg't, 76; Mary, 76,
215; Tho., 15 (2), 309; W., 169;
Wm, 215
Watton, Rich. de, clk, 3
Wayet, Wayett, Anne, 3; Edm., 3;
Mary, 4, 42; Tho., 3; Tho.
Heardson, D.D., 289
Wayland, rev. D. S., 31; Jane, 31;
Sophia Jane, 31
Webber, John, 50
Webberley, Anthony, 172; Mary, 172
Weever, John, quoted, xii
Weightman, Alice, 429; Eliz., 429;
rev. Wm, 429
WELBOURN (E2), co. Linc., 83, 165,
402–5; rector of, 402 (2)–3 (2)

Welby, Adlard, 137–8 (3)–9, 334; Anne, 403 (3); Cassandra, 137 (2)–8; Eliz., 287; Frances, 287; Joan de, 177; lady Joan, 196; John, 137, 139, 405; Rich., 137, 403 (3); Rob., 137 (2); Susan, 137; Tho., 196; Wm, 137–9 (2); Wm, knt of the Bath, 137, 287

Welch, Abigail, 46; John, 46

Welcome, Tho., 305

Weld, Dorothy, 286; rev. Joseph, 182; Wm, 286

Welford, co. Berks, 179 (2), 181

Wellfitt, Eleanor, 245; Timothy, s.t.p., 245

WELLINGORE (E3), co. Linc., 14, **405–7**; vicar of, 238, 241, 406

Wells, Eliz., 91, 347; Francis, 91 (2); John, 91 (2), 347; Mary, 91 (3); St John, 136; Wm, 412

Welton by Lincoln, co. Linc., prebend of Welton Rivall, 247

WELTON LE WOLD (C5), Welton iuxta Ludam, co. Linc., **407**; rector of, 407 (2)

Wensley, Mary, 389; Rob., 389 (2)

Wentworth, family of, 149

Wesel, Germany, 393

Wesled, Eliz., 260; Wm, 260

West, Eliz., 132, 408; John, 408; Tho., 132

Westmacott, sir Richard, sculptor, 367

Westminster, see London

Westmoreland, earl of, see Fane; Nevile

Westmoreland, Wm, 41 (2)–2

WESTON (G4), co. Linc., 287, **408–12**; minister and churchwardens of, 410; St Lamberts in, 408; vicar of, 408 (2), 410–11 (2)–12

Weston, Edith, co. Rutl., 229, 234

Wetherall, Wetherill, Anne, 74; Benj., 73; Clarissa, 73; Jane, 114; John, 74 (3); Marg't, 73; Sabina, 73; Sarah, 74 (2); Tho., 74 (2); Wm, 73, 183

Weybridge, co. Surrey, 368

WHAPLODE (G5), Whaplad, co. Linc., 209, **412–14**; vicar of, 147, 412–13

WHAPLODE DROVE (H5), co. Linc., **414–15**; minister of, 414 (2)

Wharton [in Blyton], co. Linc., 46 (4)

Wharton, rev. Rob., chancellor of Lincoln, 271; cp. Warton

Wheatley, co. York, W.R., 11

Wheldale, John, 412; Susanna Maria, 412

Whettaker, see Whitaker

Whichcote, rev. Chris., 104; Eliz., 142; Eliz. Maria, 171; Frances Kath., 171; Frances Maria, 171; Geo., 142; col. Geo., 170 (2); Jane, 171 (2); Kath., 171; Tho., 170–2; Tho., bart, 102, 104

Whinfield, rev. John, 356

Whitaker, Whettaker, Rob., clk, 389; Wm, clk, 411

White, , 280; Alice, 110; Rob., 110 (2)

White Knights [in Sonning], co. Berks, 281

Whiting, Whiteing, Eliz., 365; Geo., 97; rev. Sam., 334; Wm, 364 (2)–5 (2); Wm, jun., 366

Whitkirk, co. York, W.R., Temple Newsam in, q.v.

Whitley, Edw., 139

Whittingham, Mercy, 235; Rich., 235

Whittington, Whyttington, Ellen, 298; mr, 298

Whittlesea, co. Camb., 355

Whitworth, rev. Jas, 354

Whixley, co. York, W.R., 278

WICKENBY (C3), co. Linc., **415–16**; rector of, 416 (2)

Wickham, see Wykeham Chapel

Widdrington, Wm, baron Widdrington, of Blankney, 121; Eliz. his wife, 121

WIGTOFT (F4), co. Linc., 148, 199, **416–18**; pastor of, 417

Wikam, see Wykeham, East

Wil, Tho., 71

Wilbar, Jane, 23; John, 23

Wilby, John, 410

Wilcox, Anne, 89; Francis, 89; Tho., 54

Wildbore, Eliz., 419; John, 419

Wildman, Alice, 71; Jas, 71; Jarvis, 71

Wileman, Anne, 355; Edw., 355; Eliz., 355; Mary, xix, 355; Nich., xix, 355 (2)

Wilford, Alice, 109; Charlotte, 50; adjutant Chas, 50; Joseph, 109; Sarah, 109

Wilkinson, Eliz., 225; Eliz. Helena, 225; Jane, 225; John, 191; Philip, 225 (2)

Willan, Eliz., 27; rev. Tho., 27

Willbourn, Anne, 186; John, 186

Willders, Anne, 189; Wm, 189

Willerton, Eliz., 147; John, 145, 147 (2); Sarah, 145, 147

Williams, Anne, 235–6; Anthony, 134, 363; rev. dr, 235–6; Eliz., 363; Hen., 363; Kath., 237; Mary, 134, 363; Tho., 237

Williamson, col. Adam, 335; Alice, 15; Curtis, 90; H., 15; rev. Hen., 15; Mary, 3, 90; Rob., s.t.p., 36; Tho., 3–4; his widow, 4; Tho., s.t.p., 36

WILLINGHAM, CHERRY (D3), co. Linc., **418–19**; curate of, 418; vicar of, 418 (2)

Willis, Francis, 153; rev. Francis, M.D., 152–3; John, 153; rev. John, 152; Mary, 152–3; mrs, 151; Rich., 153; Rob. Darling, 153; Tho., 153; rev. Tho., 151

INDEX OF COATS OF ARMS

Payne, 304
Paynell, 47
Pearson, 150
Peart, 320
Pelham, 58 (3)–9 (2)–60
Pell, 350 (2), 352 (2), 388–9, 398
Percy, 203
Perry, 338
Peterson, 77
Petre, 203
Phesant, 296
Phillips, 421
Pigott, 221–2
Piliod, 335
Pinchbeck, 288
Pindar, 282 (3)
Pinkney, 128
Plaiz, 406
Plantagenet, earl of Kent, 391
Pochin, 54
Pollen, 238
Popplewell, Poplewell, 37–9
Pownall, 250 (2)
Preston, 156, 159–60, 297
Pulvertoft, 50, 336

Randolph, 51 (2)
Rands, 65, 190, 272
Reade, 370–1
Rede, 75
Redhead, 256
Reeve, 233
Reresby, 81
Reynardson, 198
Reynolds, 236, 247 (2)–8
Rich, 325
Richards, 336
Richardson, 187
Ridel, 227
Riley, 402–3
Robinson, 21, 134, 252, 282
Roche, 378–9
Rokeley, 173, 175–6
Roos, Ros, Ross, 196, 289, 314, 382, 390
Roseline, 297
Rowse, le, 172
Rushworth, 314
Rye, 201, 294, 396
Ryther, 37 (2)–8

St Leger, 391
St Loo, 226–7
St Medard, 226–7

St Paul, 116, 324, 326 (2)
Saltmarsh, 222–3
Samford, 406
Samson, 164
Samwell, 297
Sandford, 288
Saunders, 304 (3), 336 (2)
Saunderson, 141 (2)
Savile, 134, 274
Saxton, 172
Say, 66, 81, 276
Scales, 406
Scott, 243
Scrope, 241, 243 (2), 319, 357
Scupholme, 379
Searle, 373
Secker, 316
Sedgwick, 122
Seller, 321
Sergeaux, 406
Sharpe, 13
Sheffield, 65, 295
Sherard, 2, 233
Shield, 84
Shore, 354
Short, 187
Shuttleworth, 200
Sibthorp, 73 (2)
Skinner, 281, 379
Skipwith, Skipworth, 156, 273, 425
Sleaford, Sleford, 213, 227
Sleight, 370
Smith, Smyth, 51 (2), 81, 379, 420 (2)
Smithson, 286
Snarford, 324, 326 (2)
Solaye, 172
Sothill, 300
South, 209
Southwell, 160
Sparrow, 295
Spayne, 120
Spencer, 133
Squire, 188
Stafford, 132, 390, 406
Stanhope, 282
Stanton, 392
Stapleton, 294 (2)
Stayne, 51, 259
Steer, 37
Sterne, 399
Stewart, 242
Stidulf, 77
Stockwood, 286
Stone, 424
Stow, 275
Strabolgi, 242
Strange, 288
Strickland, 295
Stroder, 324, 326 (2)
Stukeley, 51, 188 (2)
Sutton, 62, 65 (2), 175
Sutton of Burton, 226
Sutton, lord Dudley, 226
Swan, 230
Swinford, 132, 207

2H

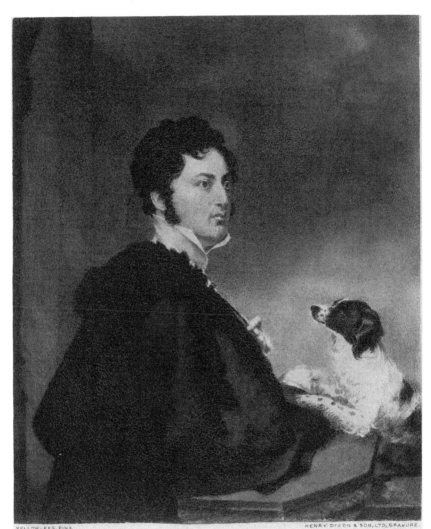

YELLOWLEES, PINX. HENRY DIXON & SON, LTD, GRAVURE.

William John Monson
afterwards 6th Baron Monson
1826.